A CONCISE
HISTORY

Mari Jo Buhle
Brown University

Teresa Murphy
George Washington University

Jane Gerhard

PEARSON

Boston Columbus Indianapolis New York San Francisco Upper Saddle River
Amsterdam Cape Town Dubai London Madrid Milan Munich Paris Montréal Toronto
Delhi Mexico City São Paulo Sydney Hong Kong Seoul Singapore Taipei Tokyo

Editor in Chief: Ashley Dodge
Editorial Assistant: Amandria Guadalupe
Marketing Coordinator: Jessica Warren
Managing Editor: Denise Forlow
Program Manager: Carly Czech
Development Editor: Maggie Barbieri
Senior Operations Supervisor: Mary Fischer
Operations Specialist: Mary Ann Gloriande
Art Director: Jayne Conte
Cover Designer: Bruce Kenselaar

Cover Image: Digital Image © [2014] Museum Associates/
 LACMA. Licensed by Art Resource, NY
Director of Digital Media: Brian Hyland
Digital Service Project Management: LearningMate, Ltd./
 Lynn Cohen
Digital Media Project Manager: Tina Gagliostro
Full-Service Project Management and Composition:
 PreMediaGlobal/Sudip Sinha
Printer/Binder: STP Courier Westford
Cover Printer: STP Courier Westford

Credits and acknowledgments borrowed from other sources and reproduced, with permission, in this textbook appear on appropriate page within text.

Library of Congress Cataloging-in-Publication Data

Buhle, Mari Jo.
 A concise women's history / Mari Jo Buhle, Brown University, Terry Murphy, George Washington University, Jane Gerhard, Mount Holyoke College.—First Edition.
 pages cm
 Includes bibliographical references and index.
 ISBN-13: 978-0-205-90593-5
 ISBN-10: 0-205-90593-5
 1. Women—History. 2. Women—Social conditions. I. Murphy, Terry. II. Gerhard, Jane F.
III. Title.
 HQ1121.B835 2015
 305.4—dc 3

 2014000314

10 9 8 7 6 5 4 3 2 1

PEARSON

ISBN-10: 0-205-90593-5
ISBN-13: 978-0-205-90593-5

CONTENTS

PREFACE

WHILE STUDENTS TODAY MAY THINK IT is obvious that women have a history worth studying, it was not always the case. Historians of women, beginning at the turn of the twentieth century, had to win a place for their field by establishing that conventional histories neglected women's contributions to U.S. society and too often left out the experiences of ordinary people in the United States. Along with scholars of African American and Native American histories, historians of women participated in larger trends in academic life that altered the definition of what counted as "history."

After nearly a half century of quiescence, the academic study of women across several disciplines took off. In 1969, U.S. colleges and universities offered only seventeen courses on women. A year later, there were more than one hundred women's studies courses, and by 1973 there were more than two hundred. No single feminist organization directed this growth. The courses cropped up spontaneously all over the country, with some campuses implementing new programs in response to sit-ins and strikes conducted jointly by students and faculty. In other places, faculty women privately pressured their departments to sponsor women's studies classes. The first women's studies program was established in 1970 at San Diego State College after a year of intense organizing.

According to the American Historical Association, the concentration in women's history and gender studies is currently one of the fastest-growing areas of the discipline. Several colleges and universities now offer advanced degrees in women's history, and courses in the area are now offered at most colleges and universities in the United States.

Since the 1960s, historians have created new frameworks for the writing of U.S. women's history. Three frameworks have proved most important to the field. The first is a framework that emphasizes that gender is a product of society and culture, not only biology. The second is that the division of social life into public and private realms simplifies what is in fact a far more complex and dynamic field of social relations. Last is the understanding that women have multiple identities that are rooted in race, class, sexuality, and religion, as well as gender.

This book explores the lives of a broad spectrum of women from the era of first cultural contact in the fifteenth century to the new globalism of the twenty-first century. This book pays special attention to the history of social activism with regard to inequality and the intimate relationships in the historical realm of sexuality. It explores both the political economy and the spheres of reproduction to shape a narrative and underscores the significance of the United States as a "nation of immigrants."

FEATURES

There are many features available in the printed and digital e-book versions of this book to engage students. Offerings in *both* print and digital versions are highlighted with ✷.

- **Timelines**, which open each chapter integrating major U.S. historical events and special events in women's history.
- Selected **"Overview"** tables that provide a quick reference to major topics.
- Selective **photographs** from historical sources.
- ✷ **Multimedia** selections to various sources including documents, images, profiles, and more.
- **Critical Thinking Questions** close out the chapter to reinforce main themes.
- **Recommended Readings** in short annotated form for each chapter.
- ✷ **Additional Bibliography** of books and articles for each chapter.
- ✷ A **Glossary** of key terms and definitions.

ABOUT THE AUTHORS

MARI JO BUHLE

Mari Jo Buhle is William R. Kenan Jr. University Professor of American Civilization and History emerita at Brown University, specializing in American women's history. She received her BA from the University of Illinois, Urbana–Champaign, and her PhD from the University of Wisconsin-Madison. She is the author of *Women and American Socialism, 1870–1920* (1981) and *Feminism and Its Discontents: A Century of Struggle with Psychoanalysis* (1998). She is also coauthor of *Out of Many: A History of the American People* (2015). Professor Buhle held a fellowship (1991–1996) from the John D. and Catherine T. MacArthur Foundation, and she is currently an Honorary Fellow in History Department at the University of Wisconsin-Madison.

TERESA MURPHY

Teresa Murphy is Associate Professor of American Studies at George Washington University. Born and raised in California, she received her BA from the University of California, Berkeley and her PhD from Yale University. She is the author of *Ten Hours Labor: Religion, Reform, and Gender in Early New England* (1992) as well as *Citizenship and the Origins of Women's History in the United States* (2013). She is the former Associate Editor of *American Quarterly*.

JANE GERHARD

Jane F. Gerhard received her BA from Hampshire College in Amherst, Massachusetts, and her PhD from Brown University. She is the author of *Desiring Revolution: Second Wave Feminism and the Rewriting of American Sexual Thought, 1920 to 1982* (2001) and *The Dinner Party: Judy Chicago and the Power of Popular Feminism, 1970–2007* (2013).

CHAPTER 1

WORLDS APART, TO 1700

Explore Chapter 1
Multimedia Resources

TIMELINE

1100	Islamic trade routes develop to African ports south of Sahara
1200	Cahokian society in Midwest at its height Aztecs begin their rise to power in central Mexico
1337	Hundred Years' War begins in Europe
1347	Black Death begins to decimate Europe
1492	Columbus arrives in the Americas Ferdinand and Isabel expel Jews and Muslims from Spain
1503–1504	Amerigo Vespucci explores New World
1517	Martin Luther begins Protestant Reformation with Ninety-Five Theses
1521	Hernán Cortés conquers the Aztecs
1545–1563	Council of Trent
1558	Elizabeth I becomes queen of England
1564	Jacques Le Moyne explores Florida

FOR CENTURIES, women in all parts of the world have been of critical importance in feeding their societies and rearing their children. Indeed, these roles were so important that their societies not only saw the productive and reproductive roles of women as linked, but societies also evolved complex laws to regulate how women produced and reproduced. Community strategies to grow food and trade goods included alliances created by marriage or other kinds of sexual relationships.

These alliances varied tremendously throughout the Americas, Africa, and Europe, creating different household structures. Women

1

might live in small families with only their husbands and children, or they might be part of a more extended lineage in which they were one of several wives, or they might live in a society in which their relationships with their mothers were more important than their relationships with their husbands. In some societies, women controlled the farmlands and took primary responsibility for agricultural production, whereas in other places their husbands or fathers were more likely to control these resources. As a result, women in different parts of the world exercised power in diverse ways, and women in some societies had more power than women in other societies.

In the thousands of years before the end of the fifteenth century, when the continents of the Americas, Africa, and Europe came into explosive contact, these different forms of social organization evolved, to a large extent, independently of one another. However, as Europeans developed deeper trade relations with Africa beginning in the middle of the fifteenth century, discovered the Americas at the end of the fifteenth century, and soon after began the forced transport of African slaves across the Atlantic, these different forms of social organization became the subject of intense scrutiny. As men and women in Africa, Europe, and the Americas took each others' measure in the years following contact, they noted with unease different patterns of dressing and social life, family organization and work, and religion and governance. Although occasionally these encounters with different cultures prompted self-reflection, more often they provided fodder for misunderstanding and conflict.

WOMEN IN THE AMERICAS

By 1000 CE, densely populated, architecturally sophisticated, and complex societies that were rooted in agricultural production had emerged not only in Mexico, with the successive domination of the Olmecs, the Mayans, and the Aztecs, but also in the southwestern United States, with the development of the Pueblo cultures, and farther east, with the Mississippian cultures that flourished along the banks of the Mississippi River. In areas farther north, other groups such as the Iroquois combined a semi-mobile existence with farming and hunting, while in some places to the west, the California and Northwest Coast Indians shared forests and streams that were so abundant these groups had little use for agriculture. Each of these societies used ideas about gender to organize work and the distribution of resources, but their execution of these ideas was different from group to group because gender is a constructed category. As a result, different societies create different gender roles.

Cultural Differences

Among the Iroquois peoples of the northeastern United States, women were a dominant force, creating both **matrilocal** and **matrilineal** families. Women not only farmed the land but also were the ones who inherited it, a system that worked well in a society in which men were often gone. The Iroquois League, initially composed of the Senecas, the Mohawks, the Oneidas, the Onondagas, and the Cayugas, had been formed in the fifteenth century to bring peace to these tribes. However, during the spring, summer,

and fall, men continued to fight as well as hunt, leaving women behind to tend to the land. Before departing, the men cleared new fields for planting with a slash-and-burn technique, and women then planted and harvested the crops of corn, beans, and squash. Women worked in their fields communally and then distributed and prepared the food—both crops and animal meat from hunting—for their families.

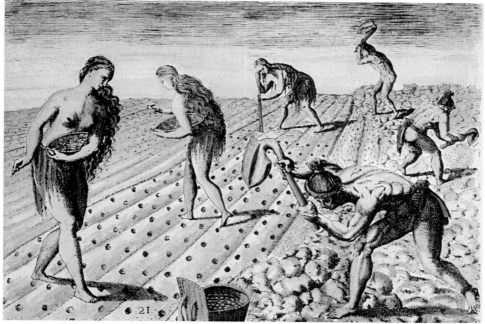

Native American women were often responsible for planting crops. Jacques Le Moyne de Morgues captured this gendered division of labor among Timucua women during the 1560s, when he traveled with an expedition through what is now Florida. His artwork was later disseminated in engravings made by Theodor de Bry at the end of the sixteenth century.

The role of women is less clear in the Mississippian societies that developed during this same period in cities and villages stretching from Louisiana and Alabama in the South to Illinois and Iowa in the North. The vast urban center of Cahokia, populated by probably twenty thousand to thirty thousand people at its peak in the twelfth century CE, was the most spectacular of these settlements. This complex culture was extremely hierarchical, composed of political and religious elites who were supported by large groups of artisans and farmers. Cahokia used the agricultural produce of outlying farmlands for its subsistence, and Cahokian leaders marshaled the labor of thousands to build huge pyramids for ritual purposes. Although both men and women of the peasant class may have been farmers in this society, women were ritually linked to agriculture and fertility in figurines depicting them with farming tools and produce.

Women were also closely tied to agriculture in the Pueblo societies that emerged in the Southwest. By the time Europeans arrived at the beginning of the sixteenth

century, many of these Pueblo societies were organized both matrilineally and matri-locally. Like the Iroquois, women owned the homes that their families lived in and the fields that they farmed; the goods that their families accumulated passed through the female line. However, unlike the Iroquois, husbands and sons of Pueblo women often did the actual farming, in addition to hunting small game to supplement the family diet. Women prepared the food that was produced and crafted beautiful pottery jars and tightly woven baskets that were dense enough to carry water and store excess food. They also built the homes where their families lived. Men cut and hauled the timber that was used to frame their pueblos, but women were responsible for the rest of the construction. While women controlled the household, Pueblo men controlled the *kivas*. Central to every Pueblo town, kivas were buildings that men shared for social-izing, for ritual practices, and for weaving. Although women in southwestern societies also wove, weaving was clearly an important activity for men in Pueblo societies.

Among the Aztecs who rose to power in central Mexico beginning in the twelfth century CE, women lived in a society that was not matrilineal, but both patrilineal and patrilocal. Men were responsible for the farming, while women were responsible for domestic activities. Girls married young in Aztec society—sometimes when they were ten or twelve years old—and went to live with their husbands' families. While much of their responsibility centered on the home, one of their activities, weaving, took on broader significance. As the Aztecs expanded their conquest to surrounding areas, they taxed both the men and the women in the societies they conquered. While men paid their tributes through work or warfare, women paid their tributes in cloth. De-mands for cloth tributes increased over the years so that women had trouble produc-ing enough to meet their obligations. Thus, some households who could afford to do so acquired female slaves to help with the weaving or husbands took additional wives.

Marriage, Family, and Gender Identities

Just as practices of work and inheritance varied among Native Americans, so too did ideas about family. Family lineages and clans were more socially significant than the smaller units formed by husbands, wives, and their children. A woman's relationship to her parents or siblings who controlled the land she farmed was usually much more important than her relationship to her husband. Because individual family units were absorbed into larger households, and because land was communally owned or man-aged, marriage negotiations were simple, and little property changed hands. Small gifts were exchanged between husband and wife as a show of reciprocity, but legal obliga-tions beyond that were uncommon.

Marriages were primarily personal relationships that could be dissolved if the rela-tionship deteriorated. Divorce was most common during the first year of marriage and less likely once a couple had children, though still accepted. Children of these mar-riages became a part of the mother's lineage.

Not only was divorce accepted by many Indians, so too was **polygamy**, the practice of having more than one spouse at a time. Where circumstances warranted, a man took more than one wife. Some of the higher-status Indians of the eastern United

States, particularly chiefs, had extensive social responsibilities that were too onerous for one wife to shoulder. An extra wife in that case was an important way to extend additional hospitality. Where warfare had reduced the proportion of men in a society, more than one sister sometimes married the same husband who would contribute hunting goods for them to share. This practice of **soral polygamy** was particularly useful in matrilineal societies, because when a man married two sisters he was still a part of the same lineage.

Because marriage had a very different meaning for Native Americans, so too did sexuality. Pueblo women viewed sex as a way of not only welcoming strangers but also limiting their power. The same was true of Algonquian women in the Chesapeake region and the Huron[1] women near the Saint Lawrence River. Indeed, unmarried women in Indian societies were usually free to engage in sexual relations with as many men as they wished. In some cases, women expected a demonstration of reciprocity when they engaged in sexual relations with men who were not their husbands. Pueblo women, for example, expected a gift such as a blanket or piece of meat. Such exchanges were not required for sex that occurred within marriage, because by the very nature of the relationship, such obligations had already been worked out.

Some women in the Great Lakes region preferred temporary relationships with male hunting companions to the commitments that marriage demanded and constructed a gender identity that was neither male nor female. These hunting women never married. They preferred traveling with men through the forests to staying with women in the villages to raise children. Their relationship with a particular man usually only lasted as long as a hunt. They provided food and clothing for their companions and expected compensation in return. They enjoyed sex with their partners and if children were produced returned them to their villages to be raised by their families. These children did not have the status that would allow them to marry into the higher ranks of their governing class, but they were otherwise accepted by their relatives, suggesting the extent to which the alternative gender identity of their mothers was accepted.

While hunting women in the Great Lakes region represented one important variation on the basic gender divisions between men and women, an even more widespread variation in gender distinctions occurred in the case of people who were biologically male but dressed like and took on the roles of women in their society. Today they are referred to as *two-spirit people* or *men-women*, though in precontact times the names for this alternative gender identity varied. Although they were never very numerous in any given community, two-spirit people could be found in most areas of North America except the Northeast where the Iroquois dominated. Two-spirit people were highly valued in their communities and sometimes functioned as spiritual leaders or took on other jobs of ritual importance such as burying the dead. In other cases, they were prized for their ability to apply the strength of a man to the jobs usually undertaken by women, such as grinding corn. The sexual relationships that were allowed for two-spirit people varied with their tribes. Among the Pueblo Indians, for example, they were allowed to have sex only with men, not women. While most of their sexual relations were with men, this was not always the case, and sometimes they did have

sexual relations with women. Indian cultures observed a strong binary division of gender between men and women, but the presence of hunting women and two-spirit people shows how these cultures also included third and even fourth gender identities for some of their members.

Exercising Power

How women exercised power was largely a result of the kind of society they lived in. In hierarchical and highly stratified societies, such as those found among the Mayans and Aztecs in Mexico or the Mississippian cultures surrounding Cahokia, power was exercised by elite classes of royalty and nobles. Women who were born into those classes sometimes wielded significant power, but they did so because of their elite status rather than their gender.

Among the Mayans in Mexico, some women exercised the power of **sovereigns**. Both Princess Kanal Ikal, who ruled from 583 CE to 604 CE, and Princess Zac-Kuk, who ruled shortly after, inherited their positions and ruled independently of any power held by their husbands. Among the Aztecs, who dominated central Mexico several centuries later, women of the royal line made strategic marriages to maintain the power of their family. Women such as the Lady of Cofachiqui also ruled in some of the Mississippian groups that survived in the southeastern United States into the period of contact with Europeans.

Women occasionally took on the role of **shaman** in some Indian societies. In the Great Lakes region, both men and women were shamans. They were often sought to predict the future or dance in a curing ceremony. In one case from 1636, a particularly powerful female shaman was called in to cure a sick woman when three male shamans had failed. According to the Jesuit priest who watched, she "began to shake the house and to sing and cry so loudly that she caused the devil to come who told them more than they wanted."

In some tribes, such as those of the Iroquois, women participated in many crucial decisions. While the chief of their tribes was always a man, Iroquois matrons chose him—and they removed him if necessary. They also chose men to speak for them at council meetings. They sometimes even demanded captives in warfare or kept men from participating in war. Thus, although men and women engaged in very different roles in society and exercised different kinds of power, Iroquois women were not subordinate to men. Buttressing their political voice, however, was their control over the distribution of food.

In many of the less-hierarchical societies, in which the household was a key social component of the larger social system, women most clearly exercised power when they controlled their bodies or the distribution of resources. When women in matrilineal societies decided whom to have sex with, they controlled access to their lineages and the inheritances that passed through their lineages. If they decided to end a pregnancy, they also controlled who would be a member of their societies. By providing food to their households, they were responsible for the physical survival of their communities.

 View the Profile on <u>Lady Xoc</u>
Lady Xoc was one of the most powerful women in Mayan civilization.

EUROPEAN WOMEN

Europe was in a state of upheaval in the two centuries that preceded its discovery of the Americas in 1492. Various parts of the continent were being transformed socially and economically by growing trade with Asia and Africa. A new class of wealthy merchants began to rival nobles for power. Peasants struggled to survive while landholders, eager to graze their own herds for commercial purposes, claimed pasturelands the peasants had been using. This social and economic dislocation was compounded by the demographic catastrophe of the bubonic plague, introduced into Europe by rats from a ship bringing merchandise from Asia. The **Black Death**, as the plague was called, struck originally in the 1340s, wiping out about twenty-five million people within three years. Periodic outbreaks added to the death toll, and within fifty years, Europe's population declined by 40 percent. Finally, the Hundred Years' War, fought largely on French soil from the middle of the fourteenth to the middle of the fifteenth century, not only exacerbated the chaos and misery caused by the plague and the demands of trade but also ended with the emergence of more modern nation-states in Europe.

All of these changes had consequences for women. In some cases, powerful female leaders such as Elizabeth I of England and Isabella of Castile gained power as a result of inheritance or marriage. With social and political hierarchies shaken to the point of collapse, gender roles adapted. Women took on new jobs, but their very flexibility in the face of catastrophe itself became a subject of debate and concern, particularly because they lived in societies that were organized around male leadership in both the home and the government.

Flexible Labor Force

Throughout Europe, many peasant women lived on small farms. Their activities were mostly confined to the household while men took charge of the fields. The household, however, was an expansive concept. Women's work included child rearing; tending gardens where they grew peas, turnips, and onions; processing food; and baking bread. During cold winter months, women turned to spinning so that they could make clothes for their family. Where possible, women collected nuts and berries from nearby woods and often tended the pigs and chickens that provided meat and eggs.

Women also performed other valuable tasks beyond the household. At harvest time, women helped the men to cut the grains and bind the sheaves. They also herded the cattle into the field after the harvest to eat what was left. Women's flexibility to work beyond the household was crucial as land became so scarce that peasant families could not support themselves with their produce and as money was demanded in the payment

of rent. Women made butter, cheese, and soap, not just for their own consumption but also for sale at local markets. Women—more than men—also worked as day laborers for wealthy families and sold produce or animals that they raised to earn extra money families need to survive as the economy became increasingly commercialized.

Many urban women also demonstrated their flexibility in the wake of the disruptions caused by the Black Death when they moved into trades, formerly the province of men. In England, many of the guilds that determined how trades would be practiced in a city allowed the wives and daughters of their members to join as well as permitting the widows of their members to carry on their husbands' trades. As a result, in 1419, thirty-nine of the members of the Brewers' Company in England were women. These women joined a small number of other female craftsmen who had established themselves in trades throughout Europe even before the plague had struck. In Paris, for example, five exclusively female guilds were operating at the end of the thirteenth century. Women were particularly active in the silk trades, which required careful handling of the delicate threads and cloth. By the end of the fifteenth century, however, as the population returned to earlier levels, women began to disappear from the guild rosters. A few hung on as grocers, locksmiths, brewers, and weavers, but most did not. Men who wanted their jobs pushed women out, and guilds changed their rules to favor men.

In all circumstances, women earned less than men for their work, usually significantly less. As one contemporary writer during this period put it, women were "half-men" whose jobs were not as important and who worked more slowly than men. Only during the peak years of the plague did women's wages more closely approximate those of men.

Patriarchal Societies

Women in Europe were paid less than men as part of a larger ideology that argued women were inferior to men in both mind and body. They had proven their weakness when Eve had tempted Adam in the biblical account of creation. Medical doctors believed a woman's temperament was ruled by her womb, which severely impaired her judgment. As a result, women were considered disorderly and irrational and could not be trusted because they lied. They caused social discord with their gossip. And because they lacked self-control, women could not control their sexual appetites. A woman's lusty sexuality was one of her most prominent weaknesses. Some writers argued that women were sexually insatiable (and thus more like animals than men were) because they could have multiple orgasms.

This view of the female character provided strong justification for not only treating women as inferior but also making sure they were under the control of men. By the sixteenth century, a lively pamphlet debate had emerged in England in which one side warned of the dangers of women's inherently shrewish natures and uncontrollable sexual urges. The other side argued that women's weaknesses were more the result of poor socialization and that if women were properly trained they could be modest and pious. Indeed, many women already measured up to this standard, their defenders claimed.

Of course, there were strong class overtones to this distinction as well. In Spain, wealthier women upheld their families' reputations with their virtue. Their sexuality had to be carefully policed lest whole families' suffered dishonor, so they therefore appeared more modest than poorer women. Among the lower classes, family honor did not have the same value, so the virtue of these women did not have to be protected or policed in the same way. It was these women who were seen as promiscuous.

Throughout Europe, regardless of their class position, women—wives and daughters—were legally under the control of their husbands and fathers. This **patriarchal order** extended from household to government, as men were expected to rule their families and their communities. In countries that followed Roman law, such as Spain, the Netherlands, and France, women still maintained important rights of inheritance and property holding. In Spanish law, for example, girls and boys inherited property from both their mothers and their fathers, just as they inherited both their parents' names. Spanish women kept the right to the property they brought into marriage; and if they died childless, their siblings and parents laid claim to the property, not their husbands. Husbands in Spain still usually managed their wives' property, and wives had to get their husbands' permission before buying or selling it, but married women made contracts and used the courts when necessary to protect themselves.

In England, a different set of legal rights evolved for women under what eventually became known as common law. Married women in England merged their legal identities with that of their husbands. In this system of **coverture**, a married woman surrendered her property to her husband along with her name. As a **feme covert**, she could not make contracts, testify against her husband in court, or engage in any other legal transactions. Only those women who never married or who became widows assumed the status of **feme sole** and were able to engage independently in legal transactions. Unless a husband made specific arrangements specifying otherwise, his widow usually received the interest in one-third of his estate when he died rather than simply regaining the property she brought with her into the marriage.

Whether structured around Roman law or common law, these patriarchal households not only were necessary to compensate for the perceived weaknesses of women but also were part of a larger political order. Families were viewed as the building blocks of the state; they were the first line of defense in maintaining a larger patriarchal order. A man ruled over his wife and children just as a king ruled over his kingdom. As Thomas Hobbes pointed out in *Leviathan*, his famous book on political philosophy published in 1651, a family was "a little monarchy." Thus, in England, if a servant killed his master or if a wife killed her husband, the crime was one of petty treason, not homicide. Female subordination was a part of political as well as family ideology.

Because marriage was crucial to both the political and social order, marriages in Europe were increasingly regulated by the sixteenth century. Many people at this time resisted actually formalizing their marriages legally. A large segment of the poor in Europe married informally, sometimes by jumping over a broom. Such informal marriages had the advantage of being broken without expensive divorce fees, should the divorce even be allowed. In Spain, a couple could establish a relationship simply by

having a contract notarized, and they could end the relationship with a second notarized contract. Concubinage, or barragania, as the practice was known, was well established in medieval Spain. Indeed, in medieval Spain, couples even performed the marriage ceremonies themselves with only two witnesses present. The marriage was usually preceded by an engagement, which was considered to be so legally binding that many couples felt it was acceptable to have sex after an engagement agreement had been signed. The Catholic Church attacked these practices at the Council of Trent in the 1560s by declaring marriage a sacrament and demanding that marriages take place inside a church, in the presence of a priest. Protestant clergy also demanded a more formal ceremony and required their followers to "post banns" before they married, announcing their intentions for all. In both ways, the churches were making sure that couples recognized the public importance of their personal relationships.

Review this source; write a short response to the following questions.

Margery Brews, Letter to John Paston (1477)[2]

1. How does this document demonstrate the financial aspects of marriage and the division of labor within marriage?
2. Using information from the text, explain how patriarchy operated in the life of Margery Brews.

Whether formal or informal, European marriages were **monogamous**. Most people in northwestern Europe lived in fairly small households of six to eight people composed of parents and children during the fourteenth and fifteenth centuries. Larger, more extended households that included grandparents and other relatives were more common in southern Europe. In either case, peasant families were careful to control the number of children they had. In northwestern Europe, where many couples waited until their late twenties to marry because they were setting up independent households, the number of children they had was automatically reduced by their late start. But couples also controlled family size through abstinence, *coitus interuptus*, abortion, or infanticide. The Catholic Church condemned abortion, forbidding it in the twelfth century after the first month or two of conception and banning it altogether in the sixteenth century. But the practice still continued. In poorer areas, some families that simply could not afford to feed more children also practiced infanticide. Girls were more likely to be killed than boys, as was clear in the gender ratios that emerged in which more men than women were present. Methods were subtle: girls were weaned earlier than boys in some areas, thus exposing them to the risk of disease, or parents might "accidentally" roll over on a baby while sleeping, thus smothering it. In a society in which men were expected to rule, boys were more likely to survive infancy than girls were.

Challenges to Patriarchy

The patriarchal order in Europe confronted an important wrinkle in its gendered hierarchy as the wives and daughters of kings took the reins of power. By the sixteenth century, women had assumed the crown in some of the most important new countries in Europe. Isabella of Castile inherited this position, as did both Mary I and her half sister Elizabeth I in England. Women did not inherit the throne in France, but Anne of Austria and Catherine de Médicis assumed powerful roles as **regents** while their royal children were young. In each case, as these women held on to their power and ruled decisively, debates erupted about their competence. Were women, even when royally born, really fit to take the reins of power? Some argued that women, even if educated, could not overcome the limitations of their bodies. Others, however, distinguished between the personal body of the queen (which could be female) and her public persona (which could assume the characteristics of a male leader), a distinction commonly made when Elizabeth I ruled England. As she herself declared, "I know I have the body of a weak and feeble woman, but I have the heart and stomach of a king."

Most women of lower status, of course, held no political power, although neither did their husbands. Like the men in their societies, their engagement with the government tended to surface sporadically in the protests and revolts that arose around taxes, unfair prices, or other injustices. Common women could not hold office and, except in countries following Roman law, did not have access to the courts for settling disputes.

One realm in which women were able to exert significantly more control over their lives was in the convents. Although convents in the early modern period had lost many of the religious privileges they held during the medieval period, they still continued to offer an important alternative to marriage for women who had the means to enter them. Women in convents were expected to live cloistered lives of prayer, and their families were expected to make a significant financial contribution upon the entry of a daughter or widow to support this sort of life. Still, nuns often conducted small schools (though forbidden to do so) or produced crafts that helped to provide for their livelihoods because most convents were not self-supporting. To run their convents, nuns often had to take on a variety of supervisory tasks connected with their lands and formal operations. Women in religious orders not only took on jobs that were usually reserved for men; they also adopted lifestyles that allowed them to live with other women, free from the day-to-day supervision of men that characterized most households of the time.

Convents, along with monasteries, came under attack during the Protestant Reformation. Beginning with Martin Luther's Ninety-Five Theses in 1517, and following with the wide-ranging theological treatises of men such as John Calvin, new Protestant denominations were created in the sixteenth century that not only undermined the power of the Catholic Church but also affected the terms by which many women exercised power in their lives. Protestants, for example, argued that the celibacy of priests and nuns was an undesirable state of existence more likely to result in sinful than saintly behavior. They thus eliminated convents from their religious practices and

urged all women, as well as men, to marry. Given the power of men over women in marriage, some women certainly found their options for exercising power curtailed. On the other hand, most Protestant religions moved away from the Catholic practice of accepting all children born of their followers into the church. Many Protestant denominations, particularly those influenced by the teachings of John Calvin, began to demand a conversion experience of all members, women as well as men. Women thus joined Protestant congregations as individuals rather than as family members, therefore assuming a kind of spiritual equality with men.

The ability of ordinary women to form a relationship with a church independent of their families did represent an important break with tradition. In European societies, most women derived their status and power from their rank (as members of a royal family, for example) or from their positions in their households. Women who lived in countries that adopted Roman law generally had more legal rights than those who did not. But in either case, they operated in societies in which male control of family and governance were closely intertwined norms, thus limiting the power that women might derive from their important activities within the home. In both the work they did and the positions they achieved, women in Europe differed not only from women in the Americas but also from women in Africa.

AFRICAN WOMEN

By the sixteenth century, the vast continent of Africa supported a wide variety of societies that ranged from complex urban traders to agriculturalists to wide-ranging groups of hunter-gatherers. While some people farmed, others herded cattle, sheep, and goats, and still others mined the rich natural resources that included gold. Salt, nuts, ivory, gold, and slaves became important commodities for trade throughout Africa and beyond. Patrilineal households were increasingly the norm by this time as Islam spread from the North into the trading cities along both the eastern and western coasts and into interior cities such as Timbuktu. Women participated actively in these urban economies, producing and trading goods. They also tended the crops on many of the inland farms, shouldering their responsibilities sometimes as wives and daughters or, if they were less fortunate, as pawns or slaves.

Work and Power

In Africa, as in all parts of the world, there was a clear, gendered division of labor in the work women did. Their economic activities varied, depending on their particular culture, but women south of the Sahara Desert tended to engage in jobs of central economic importance. They not only had primary responsibility for rearing their children, but also took an active role in the farming, craft making, and trading that sustained their societies.

Throughout Africa, women were farmers. In many of the settlements of southern Africa, women were responsible for farming while men were responsible for herding the animals. In West Africa, where agriculture was also the predominant mode

of living, labor was divided differently. Women cared for children, collected firewood and nuts, and watched after small livestock while men prepared the fields for planting. Both men and women in West Africa planted the fields, but they tended different crops.

 View the Profile of Idia, First Iyoba of Benin
Idia was one of the most powerful women in the history of Benin.

Women were responsible for weaving cloth in West Africa, and throughout Africa, they wove mats and baskets and crafted pottery. While many of these items were designed for home use, women also traded their goods at local markets, along with any surplus produce they had. In most cases, women entered the markets on very different terms from men. Among the Yorubas of West Africa, for example, men controlled the more far-flung trade of luxury items that brought a profit, while women dominated the local markets that focused on the use value of the items they exchanged. As such, men's and women's trade affected their societies in very different ways. Women's trade did not lead to stratification in society the way men's trade did because it simply did not generate the profits that would allow some to become wealthy. Instead, women's trade facilitated the day-to-day living requirements of all community members. At the highest levels, women in West African societies balanced the power held by male leaders. While most kingdoms were ruled by a king, the position of queen mother was also extremely important. She could intercede for those who had offended the king, and in certain circumstances, her influence could lead to the removal of a king. Idia, the mother of Esigie, was a particularly important queen mother in the sixteenth century who was credited with providing her son with the advice, medicine, and magic he needed to assert his power in the kingdom of Benin. In other cases, women assumed direct power. Queen Aminatu of Zazzau was one of the most famous to do so at the end of the sixteenth century. She not only fought with her kingdom's soldiers but also successfully extended the trading empire of her region leading to a powerful economic expansion.

Family Economies

Both matrilineal and patrilineal societies existed in Africa. Along the east coast of Africa, matrilineal societies were the norm when Muslim traders arrived seeking entrée into society after 1100 CE. Marriage to local women allowed traders access to land, trade, and political influence. In towns where political power was transmitted through the mothers' lines, their children reinforced the power of traders until some of these societies shifted to a patrilineal system in an attempt to undercut this access.

In West Africa, systems of patrilineal descent also came to predominate over matrilineal lines by about 1200 CE, though women still maintained some important

forms of control over their lives. In some of these societies, they were still able to obtain a divorce easily, for example, if they became dissatisfied with their husbands. Indeed, divorced women could maintain a position of high status in their societies, as was clear in the case of the *karuwai*, divorced women who were leaders in the bori possession cult among the Hausa people. In part, divorce was accepted because in many West African societies, ties to one's birth family were more important than ties to a spouse so that birth and death were more important causes for celebration than were marriages.

Marriage, however, was a crucial way of organizing labor. Land was shared communally in many African societies and use of it was determined by village elders. A man's claim on the labor of both wife and children was extremely important because labor was a relatively scarce commodity. Thus, men derived their wealth through the control of labor rather than through ownership of land. A man paid a bride-price for a wife because women were recognized as important workers and a woman significantly increased her husband's wealth when they married. Without such a payment—in cattle, cash, or other valuables—a marriage was not legitimate and a man had no claim to his children. Most young men did not have the resources to pay a bride price, so their relatives were often intimately involved in the selection and negotiations that took place around a marriage. Wealthy men could acquire more than one wife, with polygamy being an accepted practice throughout Africa, though it was limited by the economic practicality of bride-price.

Dependence and Freedom: Slavery in Africa

While marriage was one way for a family to acquire workers, pawnship and slavery were two other ways to build a family's labor force. **Pawns** were literally people who had been pawned to pay for a debt. Often they were children—and often they were girls—who were held by the creditor until the family could pay its debt and redeem them. Until that time, the pawn's labor belonged to the creditor. Because pawns still had known kin who were often nearby, they were unlikely to be mistreated or to be sold to anyone else. Slaves, by definition, had no kin and had no rights. They were outsiders in the communities where they lived. Perhaps they had been seized in warfare or perhaps simply kidnapped for sale as a slave. They could be resold and their children could be held as slaves as well.

In Africa, women were twice as likely as men were to be held as slaves. They were prized for both their productive and their reproductive value, and it showed in their price. Women cost twice as much as men in the African slave market. Given the work that women could do, this is not surprising. They were trained in crafts, farming, and domestic work. They might also be given as gifts to reward valiant warriors. For men looking to increase the labor they needed for farming, purchasing a slave to be a concubine could be cheaper than paying the bride-price for a wife. These unions were viewed as inferior to marriages between free people but were particularly common when a man wished to take a second wife and could not afford the marriage costs. Slave women who were not taken as concubines by their masters often found themselves

given to other men in the family. Thus, unlike free women, slave women had little control over sexual access to their bodies.

Slavery has existed since early times, even in a civilization as "enlightened" as that of ancient Athens. Scholars who study slavery continue to argue over the place of the slave in ancient Greek society. Generally speaking, slaves who lived in the cities were well treated; could have their own, separate jobs; and were sometimes freed for loyal service. Slaves who lived outside the cities and toiled in the mines or fields were subject to much harsher treatment and literally might be worked to death.

Slave women did find one advantage in the sexual relations their masters demanded of them. If they bore children of their union, both they and their children could be set free. This was also true if they bore children as a result of relationships with other free men in the masters' households. What this represented, in fact, was the slow incorporation of a "kinless" slave into the household of the master. Faced with the loss of control such freedom could entail, some groups changed this custom. In the West African kingdom of Songhay, for example, slave women were not allowed to marry free men to ensure that their children were kept as slaves. Askia Muhammad, who came to rule the kingdom in 1493, changed the law to allow slave women to marry free men but decreed their children should still remain as slaves. However, in most cases, within a generation or two, children or grandchildren were incorporated into the family lineage.

Women not only were more likely to be held as slaves in Africa but also were more likely to value the labor of slaves. Because women were responsible for so many agricultural and domestic duties, one way to manage that workload was to draw on the labor of slave women. Even in cases in which a slave woman was owned by a man, her labor was often very much at the service of another woman. Wealthy women sometimes purchased their own slaves. By forcing slave women to take over their domestic duties, these women could pursue other activities, including more lucrative trading practices. Slave women who were relocated to Islamic societies in North Africa or the Middle East faced the harshest conditions. Free women in Islamic societies north of the Sahara Desert were sequestered from public life, so the duties of slave women who worked for them were extensive.

THE GENDERED DYNAMICS OF CONTACT

The European discovery of the New World in 1492 and the slave trade with Africa that developed soon after brought the peoples of three continents into growing contact. Over the course of the next three centuries, the Native American population was decimated as a result of disease and warfare, while large segments of the population of Africa were forcibly transported to the New World as slaves. Europeans, who looked not only for profit but also for legitimacy in these activities, argued that they were conquering inferior peoples lacking in the essentials of civilization. Central to these arguments was the view that women and gender relationships in Africa and the New World were not simply different but degraded.

Discovering New Worlds

European merchants and monarchs began searching in earnest for new passages to Asia in the middle of the fifteenth century after conflicts with Islamic officials of the Ottoman Empire disrupted the trade routes that they had been cultivating for a couple of centuries. Portugal, drawing on advanced research in navigation, had already developed trade with Africa when Bartolomeu Dias, a Portuguese sea captain, successfully navigated the southern edge of Africa in 1488. Four years later, Christopher Columbus succeeded in persuading the monarchs of a newly consolidating Spain to fund his attempt to find a westward route to Asia. Ferdinand and Isabella were looking for new sources of wealth to support the military they had built up to drive both Muslims and Jews out of Spain. In the wake of Columbus' discovery, Spain sent a succession of explorers and conquerors to establish its empire, including Hernán Cortés, who conquered the mighty Aztecs of central Mexico in 1521.

The Europeans who explored the Americas returned with stories of wonder not only about the riches of the New World but also of the men and women who inhabited it. Many of these stories concerned dangerous women in narratives that seem to have symbolized the fears of the explorers rather than portraying the actual societies they encountered. Amerigo Vespucci, traveling through the New World in 1503 and 1504, described female cannibals who attacked and ate a Spanish sailor. At another point, he described women who forced their husbands to enlarge their penises to satisfy their sexual cravings, even though the practice was dangerous to the men. Spanish explorers, including Columbus and Cortés, wrote of islands of Amazon-like women (heard about but never quite discovered) who lived without men (except to mate) and fiercely protected their riches of gold and jewels. California's name was derived from a fictional Spanish story about an island of pagan women who were conquered, Christianized, and married by Spanish soldiers. In cases like these, explorers carried with them European myths of strange lands and used them to embellish their stories of adventure in a new world in which anything seemed possible.

Even more important, Europeans routinely characterized the New World in feminine terms—as a body both fertile and ripe to be conquered. Sir Walter Raleigh famously described Guiana at the end of the sixteenth century as "a countrey that hath yet her maidenhead." In other words, he compared Guiana to a virgin, waiting for the right man to penetrate and possess it. As Raleigh elaborated, "It hath never bene entred by any armie of strength, and never conquered or possessed by any christian Prince." Visually, America was repeatedly depicted in feminine form, greeting male European explorers. Soldiers and explorers were invited to engage in a conquest that was not only economic and political but also sexual and predicated on ideas of gender hierarchy.

Complementing this gendered ideology of European male conqueror and virgin land was the image of the impotent or dissipated Indian male who had failed to properly cultivate the nature surrounding him. As one English writer noted, the

"womb" of Indian land was "barren" because it was unknown to the Indians. In making this argument, European conquerors returned repeatedly to their perception that Indian men were lazy because they hunted rather than farmed. In Europe, hunting was a leisure activity for the upper classes and farming was officially the activity of men. By this logic, Indian men who hunted were loafing and thus not entitled to their lands.

Sexuality and Claims of Civilization

Europeans not only viewed these new worlds in gendered terms, they regarded the sexuality and sexual practices of the people living there as degraded. Repeatedly, explorers from one continent judged the practices of another by their own standards and found the others wanting. Systematically, they came to understand differences in female behavior as an indication of a society's savagery and its need to be conquered by "civilized" people.

One early English trader, venturing to the west coast of Africa in the sixteenth century, was both fascinated and repelled by the women he saw who did not cover their breasts. Describing their breasts as "very foule and long, hanging down like the udder of a goate," the trader suggested the way in which he perceived these Africans as more

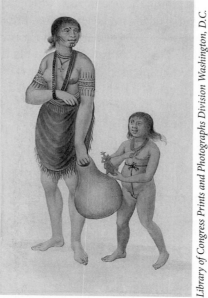

Library of Congress Prints and Photographs Division Washington, D.C.

John White, "A Cheife Herowans Wyfe of Pomeoc and her daughter of the age of 8 or 10 years." Europeans such as John White were fascinated by the domestic arrangements of the peoples they encountered in the New World. This portrait, drawn at the Roanoke settlement at the end of the sixteenth century, conveyed a sense of motherly nurture that Europeans would understand.

animal than human. European explorers in the New World made similar observations of the Native American women they encountered.

While lack of clothing was equated with a lack of civilization, African and Indian attitudes toward sex suggested immorality to Europeans. In the New World, European men repeatedly commented on encounters they had with Indian women in which it was expected they would have sex. Others expressed shock that some Indian women expected gifts from men when they had sex with them. To Europeans, this did not represent the reciprocity that it did to Indians but, rather, smacked of prostitution.

Europeans were equally appalled by the two-spirit people they met in Indian villages. Their perspective was clear in the European name that emerged for this third gender: *berdache*. The term was derived from the Arabic word *bardag* that had been adapted in Italian, French, and Spanish languages to describe the passive male in same-sex encounters. Spanish conquistadors called these men *bardaje*, a term of condemnation. Spaniards also called them *putos*, male whores, perhaps because these men-women in the Southwest were expected to have sex with any young man who demanded it of them.

Europeans were extremely curious about how Native Americans lived. Early expeditions sometimes included artists who would provide sketches of the life they found. Those sketches are an important record not only of what life was like in the New World, but what the artist chose to represent. John White traveled on several expeditions to the New World, including the one in 1585, where he produced these images of Algonquian women and domestic life in the area around Roanoke Island, off the Carolina coast. Jacques Le Moyne was a French artist who accompanied a French expedition to what is now northern Florida in 1564. Many of his watercolors were destroyed before he left, so he recreated his images from memory. Christopher Columbus wrote his letter to Luis de Sant Angel, one of his financial backers, considerably earlier, in 1493. Like Le Moyne and White, though, he considered depictions of women and domestic life to be an important part of his exploration.

View "Women of the New World"

Review the images; write a short response to the following questions.

1. What do these images tell us about the work and family life of different Native American women?
2. European men created these images. Based on your readings about European women in this chapter, how do you think European ideals of women and family life influenced what these artists chose to depict about Native American women? Did they differ from one another in their perceptions of Native American women?

Gender and the Emergence of the Slave Trade

Heavily armed with guns and a strong sense of cultural superiority, Europeans had expected the natives of the New World to work for them in the mines and plantations they set up. This expectation was challenged during the sixteenth century, however, as conflict, resistance, and disease decimated the Indian population. Thus, Europeans quickly turned to an additional source of forced labor that they had discovered early in the fifteenth century: the slaves of Africa. Patronizing the trading ports on the west coast of Africa that had begun to send slaves to Europe, they expanded this traffic in human beings during the sixteenth century to include New World destinations as well. During the next three centuries, slave-trading ports grew large and merchants grew wealthy as they increasingly financed slave raids into the interior of Africa to feed the demand for labor.

In the slave trade that developed, gender mattered. Europeans were looking primarily for agricultural laborers for their colonial plantations and mines and thus preferred men to women when purchasing their human cargo because they assumed men worked better in the fields than women. Africans, on the other hand, highly valued women as both agricultural workers and slaves. To a certain extent, this meant that the labor demands of the two continents complemented each other, with the New World taking a larger proportion of men as slaves and Africa retaining a larger proportion of women as slaves, creating gender imbalances on both continents among the slave populations. This situation had become more complicated, at least by the seventeenth century, however, as African slave traders insisted on selling more women than Europeans wanted, arguing that women could do the agricultural work demanded on New World plantations. In the give-and-take that took place in the African slave markets, more men than women were still loaded onto the ships headed for the Americas, but Europeans were also clearly forced to accept more female slaves than they would have preferred.

In the great trade cities that developed along the west coast of Africa, a cosmopolitan culture emerged in which mixed-race people known as Luso-Africans assumed an important role as cultural brokers. They emerged in the fifteenth century as Portuguese traders intermarried with African women who provided them not only with the domestic skills of a wife but also with access to society and trade in their cultures. In some of the African societies, the children of these marriages became outcasts, but in others, the children (as well as their mothers) were able to parley their novel connections into lucrative commercial undertakings. By the seventeenth century, a group of Luso-African women called *nhares* had emerged as wealthy entrepreneurs who headed extensive households staffed by servants and slaves and far-flung business ventures. Often these women became wives of English and French traders who followed the Portuguese into African trade.

For most African women who encountered the slave trade, the experience was quite different. Women who were transported to the Americas came from areas near the trading ports from which they were shipped. They could have fetched a higher

price if sold farther inland, but transportation costs were high. Instead, they were shipped to the New World in a journey called the **Middle Passage**, the second leg of a three-part transatlantic trading network. European captains exchanged their goods for slaves in Africa. Fully loaded with human cargo, ships then sailed for the Americas, where slaves were sold for sugar, tobacco, or other products destined for the European market. Packed so tightly into a ship that many on board died; slaves endured a dangerous and terrifying experience. Women faced not only the dangers of disease but also sexual abuse from the ship's crew. For the women who survived, enslavement in the New World would be a more brutal experience than what they had known in Africa.

CONCLUSION

The slave trade, along with the decimation of the Native American populations, constituted the most devastating results of the contact that began to unfold in the sixteenth century. As Europeans, Africans, and Native Americans intermingled, the consequences were social as well as physical. Household arrangements, key to the social organization of societies on all three continents, varied greatly, as did the place of women within these households. In some Native American societies, women exercised tremendous power. In both Africa and the Americas, women were often the farmers. In Europe, their rights to own property varied depending on whether their countries followed common law or Roman law. In Africa, women could be held as slaves but not necessarily for their entire lives. When new households were forged in the Americas following contact, these different conventions collided and evolved as families continued to be crucial building blocks of the new frontier. As a result, women were key players in the age of discovery that was unfolding.

 Study the Key Terms for Worlds Apart, to 1700

Critical Thinking Questions

1. How were the sexual and family lives of Indian women related to the ways in which their societies allocated resources?
2. What did patriarchy mean for women in European society?
3. Why were women more important than men in African slavery?
4. In what ways were women important in misunderstandings about what constituted civilization?

Text Credits

1. Catherine Moriarty, ed., *The Voice of the Middle Ages in Personal Letters 1100–1500* (New York: Peter Bedrick Books, 1990), p. 208.

2. John Harland, ed., *F.S.A., Ballads and Songs of Lancashire: Ancient and Moderns*, 2nd edition, (London: George Routledge and Sons and L.C. Gent, 1875), pp. 2–7.

Recommended Reading

Bonnie S. Anderson and Judith P. Zimmerman. *A History of Their Own: Women in Europe from Prehistory to the Present*, vol. 1. New York: Harper & Row, 1988. Lively and wide-ranging survey of women in European history.

Iris Berger and E. Frances White. *Women in Sub-Saharan Africa*. Bloomington: Indiana University Press, 1999. Best available introduction to the lives of women on African continent.

Karen Olsen Bruhns and Karen E. Stothert. *Women in Ancient America*. Norman: University of Oklahoma Press, 1999. Clear and current overview of women's lives and their place in different hierarchies in precontact America.

David Eltis. *The Rise of African Slavery in the Americas*. Cambridge: Cambridge University Press, 2000. Overarching survey of how slavery evolved in Africa and the Americas that pays particular attention to the role of Africans as well as Europeans in the slave trade, including an important chapter on the role of women and gender.

CHAPTER 2

CONTACT AND CONQUEST, 1500–1700

LEARNING OBJECTIVES

- How did women shape the settlement of New Spain?
- How were Native American women central to the political and economic structure of New France?
- How did patriarchy and slavery emerge together in the Chesapeake region?
- How did family structure and the status of women evolve in New England?

Explore Chapter 2 Multimedia Resources

TIMELINE

1565	Pedro Menéndez de Avilés establishes St. Augustine in Florida
1598	Juan de Oñate establishes colony of New Mexico
1607	Jamestown, Virginia established
1614	Pocahontas marries John Rolfe
1620	Plymouth colony founded
1620s	Tobacco brides arrive in Virginia
1624	First settlers arrive in New Netherland
1626	Massachusetts Bay colony founded
1634	Maryland founded
1637	Anne Hutchinson tried for heresy
1643	Tax placed on "all Negro women" in Virginia
1656	Kateri Tekakwitha born near what is now Albany, New York
1662	Law passed in Virginia stating condition of child (slave or free) will follow that of the mother
1664	English conquer New Netherland
1676	Bacon's Rebellion King Philip's War Mary Rowlandson captured by Indians
1680	Pueblo Revolt
1690s	King William's War
1692	Salem witchcraft outbreak

FRONTIERS EMERGED THROUGHOUT NORTH AMERICA DURING THE SIX-
TEENTH AND SEVENTEENTH CENTURIES, as Europeans and Native Americans
fought, traded, and intermarried. These frontiers were defined not simply by the violent
conflicts that took place, though there were plenty of those. Rather, the frontiers of the
New World were created as different cultures came into contact, forcing both newcom-
ers and indigenous peoples to adapt their social practices to new circumstances. While
the Spanish claimed much of what is now Mexico, the Southwest of the United States,
California, and Florida, French traders pushed down the Mississippi River from what is
now Canada, establishing outposts by the beginning of the eighteenth century at New
Orleans on the Gulf of Mexico. British settlers established colonies in the Chesapeake
region and farther south in the Carolinas, as well as in New England and in various
parts of the middle Atlantic region, surrounding the smaller Dutch colony in New
York. While European countries made great claims about their control over vast terri-
tories, in fact, these frontier societies were characterized by their fragility and frequent
challenges to their power, both within and without.

In this fluid social atmosphere, in which state power was often limited, house-
hold organization was critical. Households organized production, facilitated inter-
marriage (or at least sex), and provided a fundamental form of social hierarchy. As
a result, women were key players on the frontier. But, the different economic goals
and migration patterns of each European empire meant that household structures
varied in important ways. The Spanish and French, for example, counted on and
acknowledged intermarriage with indigenous peoples in a way that the English did
not. British immigrants in the southern colonies of North America relied on planta-
tion slavery and the labor of imported Africans in a way that those farther north did
not. For women, the implications of those variations were enormous. Each frontier
was different.

SPANISH CONQUEST IN THE SOUTHWEST

During the sixteenth century, the Spanish dominated exploration and conquest in the
New World. The vice royalty of New Spain was established in 1535, governing a grow-
ing number of colonies founded and led by conquistadors such as Francisco Vásquez
de Coronado, Pedro Menéndez de Avilés, and Juan de Oñate. With forced labor from
conquered Indians and enslaved Africans, the Spanish extracted gold and silver to feed
the growing empire. Expeditions north of Mexico yielded far less in the way of riches.
Nonetheless, by the end of the sixteenth century, Spain had expanded its northern bor-
der to include parts of what are now Florida and New Mexico. In 1565, Pedro Menén-
dez de Avilés wiped out a small settlement of French Protestants who had established
a fort in Florida and erected the new Spanish colony of St. Augustine nearby. Juan de
Oñate drew on the enormous wealth his father had amassed in the silver mines of
Mexico to establish the colony of New Mexico in 1598. Neither outpost was very large
or prosperous, but each introduced the government and customs of New Spain into
areas that would later become the United States.

Immigration and Work

Spanish women began arriving in the New World before the end of the fifteenth century. When Columbus made his third voyage in 1498, thirty women traveled with him to the colony of Hispaniola. In the first decades of the sixteenth century, Spanish women constituted about 10 percent of the Spanish immigrants, though as the century progressed, their proportion grew. As a result, the number of Spanish women sailing to various parts of the growing empire during the sixteenth and seventeenth centuries probably averaged close to three thousand women per year. The first female slaves came from Spain as well, though very quickly they began to be imported from Africa as part of the transatlantic slave trade. Close to half a million slaves were transported into New Spain during the sixteenth and seventeenth centuries, and probably 30 to 40 percent were female. Both African and Spanish women lived, worked, and fought with the indigenous women who managed to survive the diseases and attacks of the Spanish conquistadors.

Some of the Spanish women arriving in the New World were the wives, daughters, and nieces of conquistadors or, later, government officials and merchants. Even the Spanish wives of powerful men found themselves working hard because a lack of resources and conquests of the Indian population drew all members of the outposts into service. A couple of generations of settlement were necessary before elite Spanish women began to live in luxurious circumstances. Even then, some of those women managed businesses that they ran with the assistance of male kin who handled public exchanges when necessary.

More often, women who came to New Spain during the sixteenth and seventeenth centuries were artisans who worked as bakers, midwives, and shopkeepers; or they were servants or slaves who worked in households. Slave women were most likely to live in the cities of New Spain, working as house servants or doing more specialized jobs such as cooking, sewing, or washing clothes. Widows who needed the wages of their slaves for survival sent them out to do those jobs or to become street vendors or prostitutes.

Indian women, like Indian men, fought the Spanish and died from their new diseases. In some rural regions of Mexico throughout the sixteenth century, women wove cloth not only for their families but also as tribute for their new Spanish conquerors (just as they had done in previous years for their Aztec conquerors). In other places, as their men headed into forced labor in the mines or to cattle ranches established by the Spanish, Indian women went with them, sometimes hauling metal or clearing land, as well as engaging in more traditional female activities of housekeeping and child rearing. Others found their way to new Spanish cities by the seventeenth century, working as domestics or sellers in the marketplace.

The Spanish were not always pleased to have women working on tasks they felt men should do, but often they were forced to accept it. When Juan de Oñate's followers established their fledgling colony of New Mexico, for example, Indian women rather than men built their houses and churches. The Pueblo women resisted Spanish gender conventions that prohibited them from construction work, but they did accept some Spanish changes to their technology. They quickly began to use sheepskin, for example, rather than twigs to hold the plaster together in their buildings. Women's insistence

that they continue their responsibilities of building became a part of a new culture that mixed European and Indian traditions in the Southwest during the ensuing centuries.

Captivity and Kinship

This **mestizo** society, composed of people part Spanish and part Indian, was born in the exchange of women that took place through captivity, marriage, or less formal agreements somewhere in between. When Hernán Cortés and his soldiers landed in Mexico in 1519, for example, the Tabascan Indians gave them twenty female slaves including a young Mayan woman the Spaniards named Doña Marina, who became both a concubine and an advisor of the conquistador. The status of women such as Doña Marina reflects the complex nature of the relationships formed by women in New Spain in the years of conquest. As slaves, concubines, and go-betweens, they brought different worlds together linguistically, culturally, and physically. The power that they were able to exert, however, was usually focused on their own survival. To be a concubine was probably better than being raped or enslaved, but it was not clear where one condition left off and another began. It was possible to be both slave and mistress, and it is hard to know what kind of choice these women had in forming their relationships.

> ### View the Profile of <u>Doña Marina</u>
>
> Slave and adviser to Cortés, Doña Marina (1500–1527) was born into a noble family in Paynala and was presented—along with 19 other females—to Hernando Cortes in 1519 as a peace offering after the Tabascan defeat in battle.

Certainly, some Indian women encountered worse brutality. Francisco Vásquez de Coronado, governor of New Spain's northwestern province of New Galicia, pushed toward the Rio Grande in 1540 searching for riches. As he moved north, he and his men sacked Indian villages and raped Indian women, sparking bloody resistance.

At various points during the Spanish conquest of the New World, conquistadors were urged to marry Indian women as a way of gaining access to their lands and power, as well as to Christianize them. These marriages were most likely to occur with high-status women such as Isabel Moctezuma, daughter of the last Aztec emperor, who outlived all three of her Spanish husbands. In a similar vein, Pedro Menéndez de Avilés married the sister of a local Indian chief when he established St. Augustine in Florida. More often, however, Spanish men took Indian women as concubines. The Catholic Church was highly critical of such practices, urging marriage instead. But, the practice was so widespread that even priests engaged in informal marriages, leading the Catholic Church to encourage the friars to employ only old women as servants. These informal marriages were one of the reasons that women headed so many households in New Spain: informal marriages were more easily dissolved or ignored than formal ones. By the middle of the sixteenth century in Mexico, for example, women headed one-fourth of all households recorded.

The first-generation mestizo children were accepted as Spaniards whether they were born of legal marriages or not, and many entered into the Spanish project of conquest as soldiers. However, within a couple of generations, mestizos faced growing discrimination in colonial society as they were branded with the stigma of illegitimacy and impure blood. The few mestizo children born to legally married parents were simply accepted as **crillos** (Spaniards born in the New World), but the vast majority of children born through informal unions were less likely to gain such acceptance. Yet from the northern frontiers of New Spain to its southern borders, the mestizo population was rapidly becoming dominant. By 1650, mestizos probably outnumbered Spaniards in the New World. Spain's strategy of conquest thus created a "frontier of inclusion," in which the blood of Europeans and Indians mixed in ways that were officially recognized though increasingly difficult to classify.

The problem of classification was an important one in New Spain. When Spaniards first arrived, they established a caste society in which a Spanish elite ruled both conquered Indians and African slaves. Intermarriage and informal sexual relationships among these different groups challenged that hierarchy. **Castas**, those born of some sort of cultural intermixing, could be wealthy or poor, high status or low status, depending on the particular circumstances of their parents. A mestizo woman's marriage to a Spaniard would elevate her status while marriage to an African would lower it. Elites and government officials in New Spain devoted some time to categorizing and ranking these different combinations, an obsession that was reflected in a new genre of art emerging in eighteenth-century Mexico, the casta painting. These paintings addressed the issue of ethnic intermixing by carefully portraying the physical features of racially mixed parents and the children they produced.

Q View "Casta Paintings"

In the eighteenth century, artists in Mexico created paintings that depicted the physical characteristics of children produced by intermarriage among Europeans, Africans, and Indians. These casta paintings depicted a social hierarchy that was rooted in the physical characteristics produced through intermarriage.

Religion and Conquest

The inclusive frontier of Spain's empire in the Americas was religious as well as familial. Catholic priests traveled with the conquistadors throughout New Spain, building churches, monasteries, and convents and attempting to convert the indigenous population through persuasion—or force, if necessary. For criollo women, the convents of New Spain offered an important alternative to marriage, just as they did in Europe. In some orders, women brought dowries of land, slaves, and jewels, which they retained and managed. Convents sometimes became repositories of vast amounts of capital and offered important credit opportunities for the families of nuns who belonged.

In addition to spreading devotional practices, the friars worked hard to change the ways in which Native Americans worked and lived. The Franciscans on the frontier of New Mexico, for example, objected to the fact that Pueblo women, rather than men, built their homes. Nor did the priests accept weaving as a male activity. Believing that they were civilizing the Indians, the Franciscans encouraged the men to do construction work and the women to weave cloth. The Catholic priests also attacked the sex and marriage practices of the Indians they sought to rule. They condemned the positions used by Indians when having intercourse as bestial. They demanded an end to premarital sex and insisted on monogamy. And because the Spanish controlled many of the resources young Indians would need, the Franciscans, rather than Pueblo elders, were able to exert a powerful influence on marriage practices.

Witchcraft, Resistance, and Revolt

Both church and government officials also had to contend with witchcraft accusations, an issue that often concerned women. Those accused of witchcraft were of low status and hence almost never Spanish. Indian, African, and mixed-caste women trafficked in charms and magical potions that they shared with Spanish women as well. In almost all cases, their witchcraft was gendered (practiced by women to control men) and sexual—meant to arouse a man's ardor, punish unfaithful husbands and lovers, or end abusive behavior. While many of these spells were drawn from African or Indian traditions, they were mixed with European ideas of witchcraft as well. Despite complaints from afflicted men, Spanish authorities by and large ignored these witches, viewing sexual witchcraft as having more personal than political significance. It was a sin, but it was not treason to manipulate a man's behavior with magic potions.

Although colonial officials often dismissed witchcraft in the Spanish Empire as unimportant to larger power relations, it sometimes did have political consequences; in those cases, the punishments were far more severe. A woman in Guachichil, Mexico, who was accused of using her witchcraft to incite a revolt against Spain, was executed. More often, however, when witchcraft was associated with a political challenge, the practitioners were men. The authorities in New Mexico, for example, viewed the hexes of Pueblo shamans with great alarm. During the 1670s, the witchcraft of Pueblo shamans was considered responsible for killing seven Franciscan friars and was closely associated with talk of rebellion by Indians who were fed up with Spanish rule. Governor Juan Francisco Treviño of New Mexico hanged several of these men in 1675 and attempted to sell about forty-seven others into slavery after subjecting them to a severe beating. They were saved, however, by Pueblo warriors who forced the governor to relinquish his captives.

As tensions increased over the attack on shamans as well as Christian attacks on Pueblo gender relations, the Pueblo Revolt unfolded beginning in August 1680. Pope, one of the shamans who had been beaten by Spanish authorities in the 1670s, linked the rewards of warfare with a new regime of matrimony by claiming that the Indian "who shall kill a Spaniard will get an Indian woman for a wife, and he who kills four will get four women, and he who kills ten or more will have a like number of women." As the Spanish retreated, Pope urged his followers to please their gods by returning to their old ways of farming and worship and to abandon any wife they had married by

Spanish law. Pueblo women as well as men had attended Pope's planning meetings. Indeed, according to the testimony at a later inquiry, it was "particularly the women" who wanted to drive the Spanish out. Despite their dramatic success, however, the Indians only succeeded in expelling the Spanish for a decade; by the 1690s, the Spanish government had launched a successful reconquest of New Mexico.

The Christian tradition demanded a household structure that challenged the gender hierarchy of many indigenous societies. Some Indians continued to resist, but others were drawn in. In many cases, women became part of new mestizo households in which social, religious, and cultural practices merged into a new frontier culture. Those women who became Christian found powerful inspiration in the Virgin of Guadalupe, but it came at the price of traditional forms of behavior that had also empowered women. Indigenous women farther north faced similar issues.

TRADING VENTURES IN THE NORTH

While Spain reaped riches from the gold and silver mines of its New World empire, those treasures proved elusive for other European colonies. Both France and the Netherlands focused instead on developing a lucrative fur trade farther north. By the middle of the sixteenth century, the French had established a trading post near what is now Quebec. They pushed down the Mississippi River during the seventeenth century and by the beginning of the eighteenth century had established the port of New Orleans on the Gulf of Mexico. The Dutch gained a toehold in North America in 1624 when the Dutch West India Company sent thirty-five Flemish families to New Netherland and began organizing European trade in beaver pelts in the area that is now New York. Their colony came to encompass much of what is now New York State, but in 1664 the Dutch surrendered control to the English.

While both the French and the Dutch focused on the fur trade, their colonizing methods were different, creating two very distinct trading frontiers. A key difference developed in the domestic arrangements of the traders and the roles women played in their economies. Both colonies were dominated by single men, though by the 1650s the Dutch were sending more families. Among Dutch women who did arrive, some became quite active in the mercantile activities of the colony. The French, by way of contrast, sought to facilitate trade through marriages to Indian women. Like the Spanish, the French created a frontier of inclusion.

The Fur Trade

The French quickly discovered that Indian women were important participants in the development of the fur trade. Before trapping became a widely commercialized trade, men hunted while women processed and distributed the meat and hides that were produced. Women not only prepared the meat for eating, but also turned the animal skins into leggings, jackets, and moccasins; they also transformed the bones of the animals into needles, ladles, and other tools for survival.

The French were amazed that the men handed over the animal carcasses from their hunts to the women and accepted their control of distribution. The Jesuit missionary, Paul Le Jeune, described the domestic arrangements of the Montagnais Indians of Quebec by saying, "Men leave the arrangement of the household to the women, without interfering with them; they cut, and decide, and give away as they please, without making the husband angry." But for the Montagnais Indians and other tribes, the exchange between hunters and processors was an even one. Decision-making was done by those responsible for the tasks, whether it be distribution or moving when food production demanded it.

As the trade developed with the French, both Indian men and women altered some of their patterns of work. Men increased the bounty of their hunt with muskets and steel traps. Women also acquired goods from the French, but the goods were materials that offered the women respite from their labor rather than tools to increase agricultural production. Indian women, for example, found the copper pots they obtained from the French to be lighter and more portable than the wooden ones they had previously used. As Indian men became increasingly involved in the fur trade, their families began to rely more and more on some of the food they acquired from the Europeans—whether it was dried peas or bread—rather than food that women gathered. However, in fur trade communities that relied on agriculture, women continued to be busy tending their crops.

Those Indian women who married French fur traders found new kinds of work opening up for them as cultural brokers between the French and their Indian tribes. Such women not only processed and repaired animal skins for their husbands, but also provided crucial access to trade networks through their kin. As translators of languages and customs, these women could assist not only in trading ventures but also in diplomatic negotiations.

Catholicism and Conversion

The French hoped not only to establish a trading empire in the New World but also to re-create French society. Two of their most important cultural weapons for doing so were religion and education, both of which would bring with them the values of French culture. The French viewed Indian women as central agents of this civilizing effort and thus focused a large part of their efforts on converting them. Father Paul Le Jeune argued in the 1630s that the girls must be converted first and that they would convert the boys. The Ursuline Sisters were encouraged to set up their convents and educate Indian girls in Christian and civilized ways.

Not all Indian women welcomed these efforts at evangelization, however. French priests who interacted with the Huron and Montagnais societies between the Great Lakes and the Saint Lawrence River reported great resistance among the Indian women they tried to convert—indeed, they struggled more with the women than with the men because women saw Christianity as encouraging the subordination of women to men. Father Le Jeune encouraged one Indian man to stand up to his wife. "I told

him he was the master," reported the priest. The French priests extended their arguments about male leadership to include political organization as well as family relationships. Troubled by the relative egalitarianism in the decision-making processes of the Montagnais society, for example, the priests urged the men to choose some male leaders who would lead the decision-making process. It was the logical next step in the kind of family-building authority structure they were trying to construct. Meeting in council, some of the men who agreed to this plan and who elected three leaders informed the women and children of their communities, "Know that you will obey your husbands and you young people know that you will obey your parents, and our captains. . . ."

While Indian women sometimes resisted the subordination that came with conversion, at other times they deployed Catholicism to defend their status. Women who feared physical abuse from their husbands found advocates in the French priests. Indian women also experimented with ideals of sexual chastity and religious sisterhoods as new sources of female power. As in New Spain, some Christianized Indian women in New France developed a cult around the figure of the Virgin Mary. The Virgin was, after all, a very powerful mother—an image that would resonate with Indians who organized their societies matrilineally. As a result, by the middle of the seventeenth century, 40 percent of the Hurons had converted to Christianity.

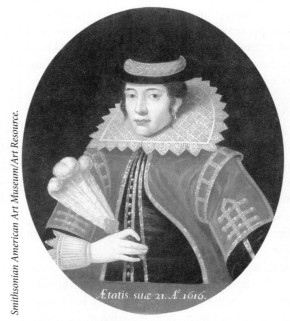

Smithsonian American Art Museum/Art Resource.

Ætatis suæ 21. Aº 1616.

Pocahontas was a Virginia Indian who converted to Christianity in the seventeenth century. She was presented as a representative of civility to English society. Her marriage to John Rolfe was the first interracial marriage in North American history.

Marriage, Sex, and Survival in the Middle Ground

French priests who tried to convert Indian women were particularly shocked by their attitudes toward sex and marriage. It was a clash in attitudes that led to repeated conflicts. The Montagnais women were quite distressed in the 1630s, for example, when Father Le Jeune[1] began his campaign against polygamy. Years of warfare had depleted the male population so that it had become increasingly common for an Indian man to marry sisters. Monogamy, the Indians felt, would create suffering for the many women who would not be afforded the benefits that came with a husband. Indians also resisted the attempts of the Jesuits[2] to curtail divorce. With a strong sense of practicality, they pointed out to Father Le Jeune that they could not "persevere in the state of matrimony with a bad wife or a bad husband." Nor did they see a reason to stay married to someone they did not love or (in the case of women) to stay married to a man who did not hunt.

Regardless of what the priests thought of Indian customs, the French government counted on intermarriage between French men and Indian women, at least throughout much of the seventeenth century. France, unlike many other European countries, worried that weakness would result from a loss of population to new colonies; thus, the government was reluctant to promote immigration. The trading empire that France envisioned required few Frenchmen, relying instead on cooperative Indians for trading partners. Thus, during the seventeenth century, fewer than thirteen thousand men and only about two thousand women (excluding nuns) emigrated from France to North America. Few French women were involved in the initial century of French colonization in the New World. With so few men and almost no women emigrating from France to the New World, French society would have to be created not only through conversion but also through marriages to Indian women. Because the French thought in both patriarchal and patrilineal terms, they assumed that cultural affinities would be tied to the father and not to the mother; they assumed the women would become French rather than the men becoming Indian. Government officials did not originally see any social distance between the commoners from France who were trying to eke out a living in New France and the Indian women they married. Indians also supported intermarriage as a way to facilitate trading relationships with the French. The **coureurs de bois**, French fur traders, were particularly interested in obtaining Indian wives. There were few French women to choose from, even if they were interested, and Amerindian women offered valuable family ties and knowledge of trapping.

The *coureurs de bois*, however, seemed to enter more into Indian life than to carry with them French civilization, providing an important wrinkle in French policy. Most of the traders and their wives, for example, married according to Indian custom rather than French law. Such marriages could be dissolved far more easily than French marriages, leaving French missionaries to complain that morality was declining rather than improving as civilization met savagery. Indeed, as French fur trappers were assimilated into the families of their wives, they became increasingly difficult for French

authorities to control, ignoring restrictions the government tried to place on the fur trade. It was only as French authorities began to shut down outposts in remote areas of the colony and order fur traders back into the interior that many coureurs de bois began to marry their wives according to French law, thus giving them stronger claim to remain with their wives' families. Local French military commanders may have winked at this behavior, both as a way to ease relationships with local Indians and as a way to promote their own side deals in the fur trade.

Through these relations between French men and Indian women, a new fur-trading society—the **metis**—began to emerge around the Great Lakes region. Some of the children of this new society were educated by the French and married French immigrants or joined Catholic religious orders. Others continued the fur trade through the colonial period, relying on a pidgin language that mixed French and Indian languages, and creating a culture that had elements of both European and Native American society. Their villages continued to flourish around the Great Lakes until the early nineteenth century, when most were overwhelmed by new settlers from the East.

New Netherland Trade

Like France, the Netherlands sent few people to its North American colonies. In the 1620s, the Dutch economy was booming, and few people were interested in leaving the Old World. As a result, about half of those immigrating to New Netherland were from other European countries, and approximately 80 percent of the immigrants were young single men. By the 1650s, the Dutch economy had slowed down and opportunities in the New World began to seem more attractive, particularly to families interested in acquiring land for farming. As a result of this growth in immigration, there were approximately nine thousand settlers in New Netherland by 1664 when the English conquered the colony, and an increasing percentage of them were women.

Some women came to the colony as indentured servants, but more commonly they came as part of a family, assisting on farms and in shops. In other cases, women managed their own businesses. Some brewed or sold beer. Others traded or managed the family estate. By 1664, there were 46 female traders operating in Albany and 134 in New Amsterdam. An additional 13 women ran their own shops in Albany as did 50 women in New Amsterdam.

Both married and unmarried women actively participated in commerce because the Dutch followed Roman law and allowed married women to operate their own businesses and to make their own contracts. They appeared in court when necessary and inherited property equally with their brothers.

The Dutch demonstrated that women could enter their trading ventures in ways quite different from those of the French. The French, reluctant to send their own settlers, had relied on Indian women as go-betweens who became key participants on the French trading frontier. Dutch women, once they actually began to settle in New Netherland, undertook trading activities themselves. The British would introduce yet other variations on this theme as English women began to immigrate to both the Chesapeake and New England regions.

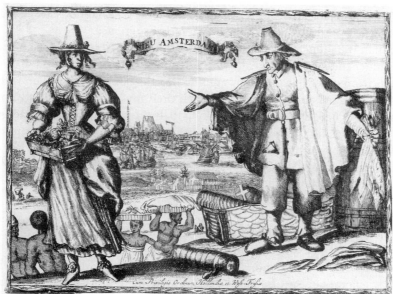

Female traders were more common in New Amsterdam than in the British colonies during the seventeenth century because the Dutch followed Roman Civil Law while the British followed Common Law. As a result, Dutch women had more legal rights than did British women.

PLANTATION SOCIETIES OF THE SOUTHEAST

While the French pushed farther through Canada and down the Mississippi River, the British developed large settlements along the Atlantic coast during the seventeenth century. Among the earliest and most enduring were those established in the Chesapeake region. These settlements were partly set up as a beachhead to challenge the Spanish empire and to plunder Spanish ships sailing back to Europe with gold. But, British adventurers also hoped to reap riches in whatever trade they could establish in the New World. The Virginia Company, operating under a royal charter from King James I, established Jamestown in 1607 for the Virginia Colony. In 1634, the Calvert family, Catholic supporters of King Charles I, began settling a large tract of land at the northern end of the Chesapeake region, which they named Maryland. Although Maryland differed from Virginia in its inclusion of a large Catholic minority, in most other respects, the colonies were similar.

The Virginia Company that established the new colony of Virginia had originally viewed its venture as one rooted in the extraction and trade of natural resources—a male venture not unlike the trapping culture of the French farther north and inland. The Chesapeake region proved worthless in terms of minerals, but the British discovered an appealing variety of tobacco and moved with speed to develop commercial agriculture. By 1630, a million and a half pounds of tobacco were exported from the fledgling colony. With the development of this early plantation economy, the British

turned to Africans for labor power, shaping a powerful variant of slavery that would become a crucial underpinning of the New World experience.

More than the French and the Spanish, the British tried to set up their own communities independent of the Indians who surrounded them. The British distinguished themselves from other Europeans by arguing that they would not take up with Indian women and bragged about the way in which their men resisted their advances. Because the British had little interest in staking their economic claims on trade with the Indians (as France did), there was little reason to officially promote intermarriage between British men and Indian women. Thus, when British men did marry or become otherwise involved with such women, their relationships were ignored. Their frontier was thus one of exclusion rather than inclusion.

The Tobacco Economy

Few women immigrated to the Chesapeake region in its early years. Unlike France, England was eager to export its inhabitants to the New World, particularly the poor who had been dispossessed of their farms and pasturelands. Most of those who came to the early colonies of the Chesapeake region were men. In Virginia, there were more than three men for every woman in the early decades of settlement. As a result, the Virginia Company began recruiting English women, who were viewed as crucial components of an agricultural society both for the stability they were thought to bring and the kinds of rural domestic work they could do. Pamphleteers enticed British women by promising them the opportunities to live much as they did in England, arguing that only "nasty wenches" worked in the fields.

In fact, throughout most of the seventeenth century, women continued the tradition of flexible labor patterns that existed in Europe: tobacco was the most important crop in the colony, and when necessary, women worked alongside men tending it. As a result, women did not have the time to sustain the subsistence crops and create the local markets of exchange that were so important in England. There were few spinning wheels to be found in Virginia and Maryland during the first decades of settlement. Instead, the cash generated by women's labor in the tobacco fields was used to purchase supplies imported from elsewhere. In the 1680s, as tobacco became less profitable, many women finally turned to more traditional kinds of female work such as raising vegetables, milking cows, making butter and cheese, washing clothes, and preparing food. Because there were few mills available, women also faced the exhausting labor of beating and grinding grain such as corn. When their financial circumstances permitted, they did hire indentured servants to take over this onerous task. "Beating the mortar," as it was called, was no more popular with servants than with housewives, and some complained that such demands violated the agreements they had made with their masters.

Indentured servants, female as well as male, constituted three-fourths of the British immigrants to the southern colonies. However, only one-fourth of the indentured servants were female. Young women agreed to work for their masters and mistresses for a stipulated amount of time—usually four to seven years—in return for the payment of their passage to the New World as well as room and board while they

were in service. Some of these young women found themselves literally worked to death. Ellinor Hues was beaten repeatedly and eventually died in the tobacco fields of Virginia.

Increasingly during the seventeenth century, slave women from Africa began to replace indentured servants on southern plantations. African women were experienced agricultural workers, and while some helped with housework, masters expected them to hoe tobacco along with the men. Both female and male slaves were only a small part of the workforce in the Chesapeake during the first half of the seventeenth century. Slaves cost more than indentured servants because masters held them in bondage for life rather than for a few years. Because so many immigrants died within a few months of arrival, there was little point in paying for an expensive slave when she could die soon; a cheaper indentured servant would do just as well. By the last quarter of the seventeenth century, as immigrants began to live longer in the Chesapeake region, slaves were a better investment. By the 1660s, there were slightly more slave women in Virginia than there were indentured serving women.

While British as well as African women actually worked in the fields, African women became associated with agricultural labor while British women did not. This distinction became clear in the laws of Virginia as early as 1643, when a tax was placed on all those expected to be working in profitable enterprises. Not only were all men over the age of sixteen supposed to pay this tax, so too were "all Negro women" whether slave or free. African women were considered producers for a market economy while European women were not—regardless of whether the work they did was really different. The taxes that either free black women or that free black families paid for all women associated with them thus created an additional economic burden for black families that white families did not face.

Wealthy Widows and Serving Wenches

Women were important for the new colonies of the Chesapeake region not only as workers but also as wives. Because England wanted to export part of its population, its vision of colonization was one that was rooted in the establishment of British families who would displace indigenous ones. However, because men were much more likely to immigrate to the New World than women were, some unintended economic opportunities opened up for those women who survived the diseases of the new continent. Many of these women married older men of some wealth who not only died before them but also left them in control of their entire estates. The **"tobacco brides"** who were brought to the colony by the Virginia Company in the early 1620s, for example, could only marry men who paid the exorbitant rate of 120 pounds of tobacco for their transportation. Women such as these became widows within a few years and sometimes inherited large estates as well as the right to administer them. There were few uncles or brothers from an extended family network to manage a widow's inheritance as there were in England. Also, because disease killed many children, family size was small and there were relatively few surviving heirs to divide an estate. It was unusual for British women at this time to inherit a

large estate and even more unusual to have the right to administer it. Widows in the Chesapeake region assumed far greater responsibilities than their counterparts in England during the seventeenth century.

Free white women exercised power not only through the control of property when widowed but also through the informal networks of gossip, nursing, and trade that they created. Midwives often forced an unmarried woman to name the father of her child at the moment she gave birth and provided testimony to local authorities attempting to determine which man needed to be punished for unlawful behavior. Midwives and other matrons could also be called upon to examine women who complained of spousal abuse. Whether through court testimony or informal networks, women created and maintained community standards of decency.

Indentured servants, however, found their opportunities far more limited. They faced the same risks of dying, particularly in their first year, as did free women, but they faced other risks as well. Female servants were not allowed to marry without their master's permission, something that was difficult to obtain because a husband's authority would conflict with a master's, and it was expected that a married woman's work would be interrupted by pregnancies. Thus, men who wanted to marry indentured servants were expected to pay masters for the amount of time the women still owed. For those couples that did not have the money or the inclination to wait, the punishments were drastic. A single woman who became pregnant while she was indentured could have her term of service extended by up to two years. She could also be whipped and fined, and she faced the real possibility of having her child taken away from her by the courts, a common occurrence for women who fell in love with other servants, slaves, or poor men who could not pay for their freedom. Even women who became pregnant because they were sexually abused by their masters got little sympathy from the courts. Most judges continued to assume that women were sexual creatures who encouraged sexual liaisons with the men they knew. In addition, folk wisdom at the time suggested that a woman could only become pregnant if she had an orgasm, which would be an obvious indicator that she had enjoyed the sexual activity.

The failure of the courts to protect servant women from abusive masters in the Chesapeake region was part of a general policy of the government to stay out of household matters, which was also one of the reasons widows were able to take over their husbands' estates. Women found little protection from husbands, fathers, or masters who mistreated them. One young servant, Elizabeth Abbott, was beaten viciously, repeatedly, by John and Alice Proctor before she died in 1624. While neighbors tended her wounds, no one stopped the beatings; nor were the Proctors convicted of any crime. Neither did courts in the Chesapeake region show much interest in wife beating. Because the colonial governments were reluctant to intervene in household relations, many settlers ignored rules that required the official sanction of the government and the church in the creation of a marriage. Instead, settlers commonly felt mutual consent and sex were all they required. As long as a woman was free, she was unlikely to be prosecuted for an informal marriage.

 Read about "Women and Power in the Seventeenth Century Chesapeake"

Free white women exercised power through the informal networks of gossip, nursing, and trade that they created. Midwives often forced an unmarried woman to name the father of her child at the moment she gave birth and provided testimony to local authorities attempting to determine which man needed to be punished for unlawful behavior. Midwives and other matrons could also be called upon to examine women who complained of spousal abuse. They not only testified in court on such matters, but might serve as a jury to judge them.

Indentured servants, however, found their opportunities far more limited. They faced the same risks of dying, particularly in their first year, as did free women, but they faced other risks as well. Female servants were not allowed to marry without their master's permission, something that was difficult to obtain because a husband's authority would conflict with a master's, and it was expected that a married woman's work would be interrupted by pregnancies.

Review the sources; write a short response to the following questions.

Women and Power in the Seventeenth Century Chesapeake
The Trappan'd Maiden[3]

1. In these documents, how do some women exercise power and how do some women have power exercised over them?
2. Why are some women able to exercise more power than others?

Slavery, Race, and Intermarriage

There was tremendous fluidity to slave law in Virginia during the first half of the seventeenth century. While slaves had always had a different status from indentured servants, the exact nature of that difference was not clear. Some slaves purchased their freedom or the freedom of their loved ones and went on to moderately successful lives. Anthony and Mary Johnson both arrived in Virginia on some of the earliest slave ships, and they had managed to buy their way out of slavery and even acquire property on the eastern shore of Virginia by the 1650s. Although they faced growing racial discrimination—such as the tax placed on black women that was not placed on white women, they still managed to live decently. After 1662, though, the laws in Virginia began to make it harder for slaves and the children of slaves to gain their freedom. A law passed in 1662 made it clear that in the case of slave women, their children's condition would be determined not by who their father was but by who their mother was—if the mother was a slave, then her child also belonged to her master. Similar laws were passed in Maryland.[4] In this way, planters laid claim to not only the productive labors of their female slaves but also their reproductive labors.

Virginia's laws on interracial sexual relations also marked African Americans as a degraded race. Unmarried couples who had children could be prosecuted for

fornication, but in 1662, the fines were doubled for cases of interracial sex. Because the law only concerned free people, masters who had sexual relationships with their slave women were not prosecuted. Most of those who were punished by the law were free white women who had sex with Afro-Virginian men, be they free or slave.

Three decades later, even legal relationships between blacks and whites were outlawed. Before 1691, Africans and Europeans could intermarry if both parties were free—and they sometimes did. After 1691, however, children of interracial relationships in Virginia automatically became illegitimate and were unable to inherit property.

Read about **"The Evolution of Slavery in the Chesapeake"**

There was tremendous fluidity to slave law in Virginia during the first half of the seventeenth century. While slaves had always had a different status from indentured servants, the exact nature of that difference was not clear. Some slaves purchased their freedom or the freedom of their loved ones and went on to moderately successful lives. However, as the century progressed, they faced growing racial discrimination. After 1662, the laws in Virginia began to make it harder for slaves and the children of slaves to gain their freedom. A law passed in 1662 also made it clear that in the case of slave women, their children's condition would be determined not by who their father was but by who their mother was—if the mother was a slave, then her child also belonged to her master. Similar laws were passed in Maryland. In this way, planters laid claim to not only the productive labors of their female slaves but also their reproductive labors.

Virginia's laws on interracial sexual relations also marked African Americans as a degraded race. Unmarried couples who had children could be prosecuted for fornication, but in 1662 the fines were doubled for cases of interracial sex. Because the law only concerned free people, masters who had sexual relationships with their slave women were not prosecuted. Most of those who were punished by the law were free white women who had sex with Afro-Virginian men, be they free or slave.

Review the sources; write a short response to the following questions.

Laws of Virginia in 1661 and 1662[5]
Laws of Maryland address slavery in 1664
Virginia Law on indentured servitude 1705

1. How do the laws of slavery and indenture change in Virginia during the course of the seventeenth century?
2. Why is it so important to control the sexuality of women in the changing laws of slavery and indenture?

With so many avenues for legitimate marriage shut off, it is not surprising that many Afro-Virginian women headed their own households and that in many cases they were responsible for protecting their children. While a difficult burden to bear, it may have been a role that free black women could adapt to because many came from parts of Africa where the mother–child bond was strong.

The ban on interracial marriages in 1691 carried over to relationships with Native Americans as well. Indians as well as Africans were held as slaves and thus suffered from many similar prejudices. As a result, one of the most celebrated in marriages in American history, that of Pocahontas and John Rolfe almost eighty years earlier, would no longer have been legal in Virginia.

View the Profile of Pocahontas (1595–1617)

Matoaka, better known by her nickname of Pocahontas, was born in the Chesapeake region at the end of the sixteenth century. One of many children of Powhatan, a particularly powerful chief, she later married John Rolfe and moved to England, where she died of pneumonia.

Anxious Patriarchs

Planters moved to define the laws of slavery in the Chesapeake region in part because slaves were becoming a more economical alternative to indentured servants but also because they were worried that white servants and ex-servants might join together with slaves and free blacks as a large and unruly underclass to overthrow the gentry. Those fears were realized in 1676 when an interracial alliance materialized in Bacon's Rebellion, led rather improbably by an elite newcomer who felt shut out of power in Virginia by Governor Berkeley and his officials. Nathaniel Bacon rallied back-country settlers from the western frontier, many of them former servants or slaves, in attacks on Indian villages during 1675. Berkeley was fearful that these raids would destabilize the colony's relationships with the Indians, so he moved quickly against Bacon and his followers. As a result, in 1676, the men turned their fury on what they called the grandees of Jamestown, burning to the ground much of the capital. This attack on the wealthy and ruling elite brought fears of class conflict to the forefront of the colony.

While Bacon's armed followers were men, many of his supporters were women and they too rallied to his cause. Bacon relied on informal networks of communication to spread news of his cause—networks that women often fostered through their gossip. Mrs. Haviland traveled throughout the countryside promoting Bacon's cause, though Sarah Drummond was perhaps the most spirited of Bacon's female supporters, at one point claiming in a meeting of the rebels, "I fear the power of England no more than a broken straw. . . ." Regardless of Sarah Drummond's brave words, the rebellion collapsed with the death of Nathaniel Bacon that year. Rebels were rounded up and executed, and though female participants escaped with their lives, they still faced harassment and economic hardship.

Even before Bacon's Rebellion, the colonial government had begun to crack down on the power women exercised through their gossip. In 1662, they passed a law allowing women to be ducked (instead of paying a fine) if convicted of slander, a much more public and particularly humiliating form of punishment. In the years following Bacon's Rebellion, white women found their independence curtailed in other significant ways as a more patriarchal society asserted itself. After 1680, courts were more likely to remind married women of their feme covert status and to demand the presence of a

husband if they wished to proceed with their cases. Widows also faced more questions as they tried to control inheritances or lead households on their own.

By curtailing the power of white women, the government in Virginia established a stronger system of patriarchal authority by the end of the seventeenth century. White men gained power from changes in the laws concerning not only women but also black men. In 1692, slaves also lost the right to own property, including livestock they raised to feed their families. For male slaves who came from African areas where men were responsible for herding, this was a powerful attack on their gender roles. The Virginia Assembly had begun to restrict slave access to guns in the years before Bacon's Rebellion and in the years following the rebellion looked suspiciously at free blacks as well. In 1723, free black men were barred from the colony's militias. By allowing all white men to own guns and property and to participate in the militia, the assembly effectively manipulated ideas of gender and race to undermine the class alignments that had developed among the poor in Bacon's Rebellion. Poor white men joined with wealthy white men in an assertion of male patriarchy.

Thus, by the end of the seventeenth century, the fluid frontier settlements in the Chesapeake region had yielded to a more settled society of racial and gender hierarchy. The division of labor was clearer as respectable white women were less likely to be found in the fields and extended family networks afforded multiple layers of male leadership. The control of slave women's sexuality ensured a permanent underclass of workers, and the stigmatization of their agricultural work ensured that race would be an important qualifier of gender. Further restrictions on black men, meanwhile, contributed to a belief in the privileged status of white men.

GODLY SOCIETIES OF NEW ENGLAND

The British settlers who landed farther north on the eastern seaboard in the early seventeenth century found a cool climate and rocky soil that precluded the kind of commercial plantation agriculture that the warmer weather and more fertile soil of the South fostered. In addition, while the immigrants to the north expected to set up successful commercial ventures, many were also immigrating for another reason: they were fleeing what they felt to be the unholy religious practices of England and hoping to set up a new world that would honor God in a way they felt was impossible to achieve in the Old World. This was particularly true for the Pilgrims who established Plymouth Colony in 1620 and for the Puritans who established Massachusetts Bay Colony in 1626. These economic and religious differences had an important impact on the presence of women in the New England colonies. Because Pilgrims and Puritans were migrating for religious reasons as much as for economic ones and because they expected to engage broadly in subsistence rather than in commercial farming, they tended to migrate as families rather than as individuals. From the beginning of settlement in New England, English women were present in approximately equal numbers to English men. Moreover, family structures similar to those in England were established quickly, conditions that were not true in the more heavily male Chesapeake region.

Goodwives

The Puritans who immigrated to Massachusetts Bay were committed to maintaining traditional social hierarchies and ways of living, and the families they brought with them ensured this development. Over 40 percent of the immigrants were women and only 17 percent were servants. The few single men who arrived in New England during these early days quickly married, so that early English setters in New England created a strong family structure as a basis for their social and economic order. The women of these families were expected to replicate their work in England, and within a couple of generations they had. As frontier areas became settled, women tended to their dairy work and their spinning. They also slaughtered small animals, brewed beer and cider, cooked, cleaned, mended clothes, and tended children. When necessary, women assisted their husbands in their shops and taverns or stood in for them if their husbands were unavailable. As such, these women fulfilled a clearly defined role, not as independent women but as **deputy husbands**.

Other women took on traditional female roles, including nursing and midwifery. Midwives were perceived by their patients as having practical experience in healing, as opposed to male healers and doctors who were perceived as having a more intellectual approach, whether or not they had been formally trained in medicine in a university. Midwives, along with other neighbors, assisted women when they gave birth, coaxing out newborns and making sure that after the birth women were properly cleaned to avoid future infection. Midwives also tended both men and women who fell sick and were particularly important in neighborhoods where no doctor was present. While a midwife was unlikely to be paid cash for her work, she received gifts of cloth or other goods.

As women engaged in nursing or assisted their husbands with their farms and their businesses, they not only contributed to the well-being of their families but also created and solidified the ties that held their communities together. They traded extra yarn or preserves at the local store, using the credit to purchase goods needed for their homes and providing useful commodities for their neighbors. Likewise, as they filled in for their husbands, they ensured the smooth functioning of larger economic transactions; and in caring for the sick, they attended to the physical well-being of their communities. These activities were also times to socialize, to exchange news, and to share opinions. As in the southern colonies, if a young woman gave birth without being married, the women who attended her delivery expected her to name the father as the baby was born and they testified about their knowledge in court. Women's work in New England carried with it an important element of social responsibility.

Girls were trained for these roles from a young age, both at home and at school. In many towns, girls attended dame schools taught by women rather than men. Their curriculum usually differed from that of boys, focusing on cooking and sewing as well as reading and writing. Wealthier girls could receive a more extensive education at home if their parents could afford a tutor, but even in these cases their training was generally geared toward their future roles as goodwives.

Read about "A Woman's Place"

Anne Bradstreet wrote poetry about the lives of many women. This first poem, Here Lyes, is an epitaph she wrote for her mother, Dorothy Dudley. The second poem was written to honor Queen Elizabeth. The virtues she celebrates in these two different women are quite different. Dorothy Dudley was a wife and a mother; her life was a private one. Queen Elizabeth, by contrast, was a sovereign; she ruled a nation. Their assigned roles in life were thus quite different.

Review the sources; write a short response to the following questions.

"Here Lyes (1643)"[6]
Queen Elizabeth

1. Why does Anne Bradstreet celebrate Queen Elizabeth? What does Elizabeth prove about women?
2. Using the information from Chapter 1 on European women, and the information on women in New England in this chapter, explain why Bradstreet thought that public and political activities were acceptable for Queen Elizabeth but not for Dorothy Dudley.

Family Government

Because of both migration patterns and geographical differences, family structure in New England differed in significant ways from that in the Chesapeake region though the settlers of both regions were from England. Not only did more families (and hence more women) immigrate to the New England colonies, but members of those families lived longer lives in the seventeenth century than did their contemporaries in old England or in the Chesapeake region. Whereas a woman in the Chesapeake region could expect to live to the age of thirty-nine during the seventeenth century, a woman in New England could expect to live between sixty and seventy years. Men were similarly healthy and long-lived. New England did not have the health problems that came from the over-crowded cities of England or from the diseased swamps of the southern colonies. These women also married younger than their southern contemporaries, in part because many of them were not indentured. As a result, they began having children at a younger age and bore more children. With children also more likely to survive than those in the South, large families quickly became the norm in New England. Eighty percent of the children born in New England during the seventeenth century survived to adulthood whereas only 40 to 50 percent of the children born in the Chesapeake region did.

The implications of these hardy families for the women who lived in them were enormous, as an English patriarchal family structure took root more successfully in early New England than was possible in the Chesapeake region. Women were not so likely to become widows as they were in the South, and they were much more likely to have a large number of surviving children. A father was more likely to stay alive in New England to rule his family—and his sons were likely to be grown and ready to assume control of family property by the time he died, thus eliminating the need for women to take over. Families could indeed function as the basis for government in

Table 2-1 Life Expectancy at Age 20 for Whites in British North America: North vs. South

Salem, MA	Seventeenth century	36 years
Plymouth Colony	Seventeenth century	48 years
Andover, MA	1670–1699	45 years
Charles Country, MD	1652–1699 (native born)	26 years
Charles Parish, VA	1655–1699	21 years
Perquimans Country, NC	Seventeenth century	30.5 years

(*Source:* Henry A Germany, "The White Population of the Colonial United States, 1607–1790," in Michael R. Haines and Richard H. Steckel, *A Population History of North America*, New York: Cambridge University Press, 163–164.)

New England, and they did. Those individuals who entered Massachusetts Bay Colony without a spouse or parent were expected to live in a household nonetheless.

The importance of the family as a basis for political order shaped the sexual relations of the men and women in the colony. Puritans expected men and women alike to enjoy sex. Indeed, like most Europeans during this period, Puritans did not believe conception was possible unless both the woman and man experienced orgasm. However, they expected sex to be procreative and to occur within the bounds of formal, state-sanctioned marriages. Sodomy, which was prosecuted more extensively in New England than in the Chesapeake region, could result in the death penalty. More commonly, New England courts meted out light punishments to the numerous couples who conceived children before being formally married. Many considered their betrothal to one another enough of a commitment to legitimize sexual intercourse, and others shared the popular belief at the time that marriages could be private affairs between two individuals. New England courts rejected both arguments, prosecuting these couples for fornication more consistently than did courts farther south.

For married couples, patriarchal order prevailed. Married women followed British law in assuming the legal status of feme coverts, merging their legal identities with those of their husbands; they could not own property or make contracts. Although a woman assumed an independent legal identity when widowed, her expected inheritance of one-third share in the interest from her husband's estate was calculated not to breed economic independence but, rather, to prevent her from becoming an impoverished dependent supported by her neighbors. Similarly, children paid careful attention to the wishes of their parents, who controlled their inheritances. Although New Englanders believed strongly in the importance of sexual attraction in a marriage and expected their children to engage in a lively courtship, they did not hesitate to advise their children about the economic and social suitability of potential partners. Life expectancy in the northern British colonies was significantly higher than in southern British colonies (see Table 2-1).

Female Piety

Religious practices in New England were important means for reinforcing the gender hierarchy in families because religious commitments had driven so many into the

northern colonies. Many of those immigrating to New England did not believe that the Anglican church created by Henry VIII in the sixteenth century went far enough in reforming the corrupt practices they saw in Catholicism, and they worried that God would be displeased with them for failing to bring the society around them into line with their religious practices. Starting out fresh in the New World where they could use their religious beliefs to organize society had a lot of appeal. In the New World, they could live as they believed God demanded and set an example to the rest of the world. This urge was strengthened at the end of the 1620s as King Charles I began to persecute the Puritans in England, forcing their exodus. By 1643, twenty thousand Puritans had immigrated across the Atlantic in the **Great Migration**. Other religious groups such as the Pilgrims and the Quakers began leaving for similar reasons, creating a world full of religious fervor.

Religion sustained women as they faced both the challenges and dangers of the New World. When Mary Rowlandson was captured by Indians in 1676 during King Philip's War, she viewed her experience as a religious trial and took comfort in her spiritual devotion. Held for three months before being ransomed, Rowlandson was relieved to return to her family and famously recounted her adventure in one of the early best sellers of New England, *A True History of the Captivity and Restoration of Mrs. Mary Rowlandson*. Repeatedly, she reminded her readers that God had tested her faith during her captivity but that He had never deserted her.

Unlike Catholicism and Anglicanism, Puritanism and most other Protestant denominations demanded a conversion experience as a central criteria of membership. Parents were expected to bring their children to church for religious training, but membership was not automatically conveyed at birth or by baptism. It was usually during teenage years that young people went through a period of self-doubt and self-examination, trying to determine if they were one of the **elect**—people chosen by God to be saved. Those who reached a positive conclusion came before church members to describe their soul-searching experiences. In the early years of the Puritan experiment, women appeared just as men did and were admitted as full members in the church as a result of their narratives.

Such active participation in religion clearly brought women growing respect. Although they were viewed as subordinate to their husbands, they were also seen as important helpers in the religious education of their children. Their spiritual nurturing moved children toward productive self-examination and (one hoped) conversion. Suspicions continued about the evil nature of women, but some ministers began to speak in favor of women's spirituality. John Cotton, one early minister, suggested that because of Eve's sin, women were acutely aware of their weaknesses and prone to be more careful because of past failures. Women were not considered the spiritual equals of men—that would challenge the patriarchal order of Puritan society—but their souls were equal to men's. More important, women became more likely to have conversion experiences than men, so that women were becoming the majority of the congregants in Puritan churches by the end of the seventeenth century. Not only were they more numerous, they also had their conversion experiences at a younger age than men, often joining congregations independently of their husbands.

While women comprised the majority of members in Puritan churches, they were not allowed to control church property, to appoint ministers, or to be ministers. They did

meet, however, in the homes of older women to discuss a minister's sermon or their own spiritual condition. Even these meetings could lead to trouble if a woman questioned the teachings of church elders. This is precisely what happened to Anne Hutchinson, who was expelled from Massachusetts Bay Colony after she was tried by both the General Court in 1637 and by an ecclesiastical court in 1638 for holding meetings in which she suggested that many local ministers were deviating from Puritan theology in their sermons. As Reverend Hugh Peter reprimanded her, "You have step out of your place, you have rather bine a Husband than a Wife and a preacher than a Hearer; and a Magistrate than a Subject."

Mary Dyer, a follower of Anne Hutchinson, was also banished. Moving to Rhode Island with her husband, she eventually became a Quaker. Quakers were considered religious radicals in the seventeenth century, in part because they allowed women as well as men to speak on religious matters. Their founder, George Fox, argued that God had created men and women equal. Although women had lost that status after Eve's sin, Fox believed women regained their equality once they experienced conversion. As a result, not only did Quaker women speak in their meetings but some felt moved to become missionaries or to travel the countryside as lay preachers. Mary Dyer was repeatedly banished from Boston and New Haven for her preaching, but she was not successfully silenced until 1660 when she was hanged in Boston for her religious zeal.

The Salem Witch Trials

The New England colonies, following the lead of northern Europe, took witchcraft seriously. Witch hunts had spread like wildfire in northern Europe beginning in the fifteenth century and exploding in the sixteenth and seventeenth centuries. Many believed the ignorance and lustiness of women made them particularly vulnerable to Satan's temptations. Between fifty thousand and one hundred thousand people were executed for witchcraft, most of them women. During the first century of settlement in New England, between 1620 and 1725, at least 344 people were accused of witchcraft, 78 percent (267) of them women. About forty-five of these women were convicted and twenty-eight were executed.

Most of these women were older, and many had challenged patriarchal conventions in wrangling over inheritances that were unusually large. Katherine Harrison, who was convicted of witchcraft and expelled from Connecticut as punishment in 1669, was the sole heir of her husband's estate. Other women who were convicted in the famous witchcraft trials of Salem, Massachusetts, in 1692 had also faced conflicts over family bequests. Rachel Clinton and Sarah Good, for example, had engaged in protracted court battles as they tried to claim their inheritances.

The Salem witch trials, by far the most widereaching in their scope—and quickly regretted by many who participated—brought to an end most trials for witchcraft in the colonies. By the time the outbreak had passed, 144 people had been charged with witchcraft (106 of them women), while 4 women and 6 men had been executed. The Salem outbreak was unusual, however, in that many of those who did the accusing were female rather than male, and many accusers were quite young or servants in households—the kind of people not usually taken seriously in a courtroom.

The outbreak may have been the result of tensions over female assertiveness, but there were other factors at work here as well. Many of those accused of witchcraft were

associated with families who were promoting economic development in their community. It is possible that fellow townsmen viewed them with suspicion for the changes they encouraged. Another factor may have been the previous experiences of the young accusers. Many of the girls who claimed to have been tortured by witches were refugees from the Maine frontier where they had seen friends and family murdered in conflicts with Indians. They may have been traumatized as a result of their experiences. Whatever the reasons, the excesses of the Salem trials spelled the demise of witch hunting in New England.

Review the sources; write a short response to the following question.

The Examination and Confession of Ann Foster at Salem Village (1692)[7]
Anne Putnam's Deposition (1692)[8]
The Conclusion of the Massachusetts Bay Elders (1692)[9]
Anne Putnam's Confession (1706)[10]
Trial of Elizabeth Clawson (Connecticut 1692)[11]

1. Based on reading these documents, what appear to be the characteristics of a witch?

CONCLUSION

By the end of the seventeenth century, colonial societies had developed throughout the New World with the Spanish, French, and British, in particular, facing off against one another and struggling with the Native American groups who had survived disease and warfare. In some cases, women were key cultural brokers, uniting different societies through their marriages and sexual relationships. Their households were expansive, as they facilitated production and trade as well as providing models of government. These were forms of social organization that would continue to be vital in the eighteenth century, though as the colonial political order matured, both the household and the place of women within it faced reassessment.

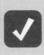 **Study the Key Terms for Contact and Conquest, 1500–1700**

Critical Thinking Questions

1. How did Christianity affect the status of women in the New World?
2. Compare and contrast the attitudes toward intermarriage in the empires of Spain, France, and England. How did these attitudes affect the status of women and the development of their colonies?
3. Why were women so important as cultural go-betweens in the New World?

Text Credits

1. Mary Beth Norton and Ruth M. Alexander, eds., *Major Problems in American Women's History,* 2nd edition. (Lexington, MA: D.C. Heath and Company, 1996), p. 21.

2. Carol Devens, *Countering Colonization: Native American Women and Great Lakes Missions, 1630–1900* (Berkeley: University of California Press, 1992), p. 22.

3. William Waller Henning, ed., *The Statutes at Large, Being a Collection of All the Laws of Virginia* (Charlottesville: University of Virginia Press, 1969). Reprinted in Dubois and Dumenil, pp. 58–60.

4. John Ashton, *Eighteenth Century Waifs* (London: Hurst and Blackett, Publishers, 1887), pp. 117–120.

5. John Ashton, *Eighteenth Century Waifs* (London: Hurst and Blackett, Publishers, 1887), pp. 117–120.

6. Laws of Virginia in 1661 and 1662; Laws of Maryland address slavery in 1664; Virginia Law on indentured servitude 1705.

7. Anne Bradstreet, 1643, quoted in Helen Stuart Campbell, Anne Bradstreet and Her Time.

8. The Examination and Confession of Ann Foster at Salem Village (1692).

9. Anne Putnam's Deposition (1692).

10. The Conclusion of the Massachusetts Bay Elders (1692).

11. Trial of Elizabeth Clawson (Connecticut 1692).

Recommended Readings

Kathleen Brown. *Good Wives, Nasty Wenches, and Anxious Patriarchs: Gender, Race, and Power in Colonial Virginia.* Chapel Hill: University of North Carolina Press, 1996. A powerful and complex study of the ways in which ideas about gender and race evolved in tandem in the slave society of colonial Virginia.

Ramon Gutierrez. *When Jesus Came, the Corn Mothers Went Away: Marriage, Sexuality, and Power in New Mexico, 1500–1846.* Stanford: Stanford University Press, 1991. A pathbreaking interpretation of the ways in which sexuality and gender relations were of central importance in the conquest of New Mexico.

Susan M. Socolow. *The Women of Colonial Latin America.* Cambridge: Cambridge University Press, 2000. A well-written summary of the personal, religious, and working lives of the diverse women who lived in New Spain.

Laurel Ulrich. *Good Wives: Image and Reality in the Lives of Women in Northern New England, 1650–1750.* New York: Vintage, 1991. Beautifully written analysis of the material and social lives of women on the New England frontier.

EIGHTEENTH-CENTURY REVOLUTIONS, 1700–1800

LEARNING OBJECTIVES

- How were women affected by the market revolution of the eighteenth century?
- How did women challenge patriarchal authority in the eighteenth century?
- How did women participate in the American Revolution?
- What were the ideals of republican womanhood?

 Explore Chapter 3 Multimedia Resources

TIMELINE

1738	George Whitefield first tours colonies
1740s	Great Awakening crests in New England
1756	Beginning of French and Indian War (Seven Years' War)
1760s	Great Awakening crests in South
1763	End of French and Indian War; Treaty of Paris
1764	Sugar Act
1765	Stamp Act
1767	Townshend Act
1773	Tea Act Phillis Wheatley gains her freedom
1774	Ladies of Edenton, North Carolina sign a petition to boycott imported goods
1775	Fighting begins at Lexington and Concord Second Continental Congress convenes Lord Dunmore promises freedom to slaves who fight against Patriots
1776	Thomas Paine publishes *Common Sense* Declaration of Independence written Women with property in New Jersey granted the right to vote
1777	Articles of Confederation Loyalist women driven from Newark
1780	Loyalist women driven from Philadelphia
1783	Slaveholding widows in Charleston collectively sign a petition protesting legislation

1787	**Constitution of the United States**
1790	**Judith Sargent Murray publishes "On the Equality of the Sexes"**
1792	**Mary Wollstonecraft publishes A *Vindication of the Rights of Woman***
	Young Ladies Academy in Philadelphia founded
1790s	**Federalists and Jeffersonian Republicans emerge as political parties**

DURING THE EIGHTEENTH CENTURY, both household and government relationships underwent dramatic changes as the colonies experienced a market as well as political revolution. Women, however, experienced these revolutions in ways that differed markedly from men. By the end of the eighteenth century, for example, the political consciousness of many women had grown as a result of their participation in the Revolution. For women in the new republic, however, husbands or fathers were still supposed to be their political representatives. Although women participated widely in the Revolution and their political consciousness had grown, the rights they gained were different from those given to men. Rather than gaining full status as citizens, women were entrusted with the training of their children to be responsible leaders in the new republic. While men assumed an increasingly direct relationship with the state, women's relationships to their government continued to be mediated largely through their households.

The households of the eighteenth century that men represented, however, also had undergone important transformations, however, in British North America. The religious enthusiasm of the Great Awakening and the intellectual challenges of the Enlightenment undermined fundamental assumptions about patriarchal authority. Even the consumer items increasingly available for purchase had begun to transform social relationships within households. Women and men increasingly viewed themselves as companions in marriage. As a result, women were mistresses of a new kind of household, and they wielded a new kind of power within their homes.

THE MARKET REVOLUTION

English control of the eastern seaboard expanded dramatically in the last half of the seventeenth century as England conquered New Netherland in 1664, transforming it into New York, and set up the new colonies of Carolina, New Jersey, and Pennsylvania. Additional colonization took place with the creation of Georgia, New Hampshire, and Vermont in the eighteenth century. The British Empire expanded even farther at the conclusion of the Seven Years' War between France and England. Known as the **French and Indian War** in North America, France surrendered its claims east of the Mississippi River to England in the **Treaty of Paris** of 1763. These colonization efforts

took a toll, of course. Thousands of settlers in frontier areas lost their lives in Indian attacks during the French and Indian War. Urban dwellers, particularly in Boston, faced other dangers. Approximately thirty-five hundred men were recruited into service for British campaigns in Latin America during the Anglo-Spanish War of the 1740s, and most of those men never returned home.

The expansion of the British Empire in North America went hand in hand with a growing capitalist revolution in which new consumer goods from abroad—exchanged for raw materials from the colonies—transformed the lives of women as well as men. Indeed, while men were almost always the merchants who arranged this transcontinental trade, women were also at the forefront of these activities, selling goods in their shops or hawking their produce on city streets, cultivating rice in the Carolinas or tending tobacco in the Chesapeake region and farther inland, supervising dairy work on their farms, or presiding over their tea tables in the cities. The exchange of goods created in different parts of the world and increasingly sold for money formed the basis of an expanding market economy that began to affect both social relationships and personal identities.

Cities of Women

Cities such as Boston, New York, Philadelphia, and Charleston were small by European standards, but they were growing at a phenomenal rate. Between 1720 and 1790, the population of New York grew from 8,000 to 33,000 residents, Philadelphia from 10,000 to 28,000, and Charleston from 3,500 to 16,000. A booming Atlantic trade of consumer goods and slaves circulated through their ports, dominating these and other cities. Immigrants included Sephardic Jews from Spain and Huguenots from France, as well as Catholics and Protestants from Ireland, Wales, and Germany. Slaves, increasingly imported straight from Africa, poured into not only southern ports such as Charleston but also northern cities such as New York. By the end of the eighteenth century, New York and Philadelphia had overtaken Boston as the largest cities in the new United States.

In many of these cities, the presence of women, particularly single women, distinguished urban areas from rural ones. By 1765, white women outnumbered white men in Boston and other New England port cities by a ratio of five to four. In Philadelphia, the sex ratio was more even, with women probably making up about 48 percent of the population, but the abundance of single women enhanced their significance. About one-third of the adult women in Philadelphia were single at the time of the Revolution. Many had migrated to the cities to find work. Although women were not paid as much as men, single women still found more economic opportunities in cities than on local farms, so many preferred to take their chances there.

This high percentage of single women meant women were much more likely to head households in the cities than they were in the countryside. In Boston, women headed 20 percent of the city's households by the end of the eighteenth century; and in Philadelphia, the percentage never dropped below 12 percent. A similar situation

prevailed in Charleston, where women headed 18 percent of the city's households when the first census was taken in 1790. These were much higher percentages than existed in rural areas, where farms continued, by and large, to be run by men.

A New World of Goods

In large cities and small, women participated extensively in local businesses. Anne Shields and Jane Vobe, for example, both ran taverns in Williamsburg, Virginia. Their work was not uncommon. Women ran most of the taverns in Virginia. If the women were married, their husbands might have held the licenses, but advertisements made it clear that women were in charge of the taverns. In South Carolina, married women actually owned as well as operated taverns because South Carolina had the strongest laws in the colonies protecting the rights of married businesswomen. They were allowed to sign legal documents and contract debts independent of their husbands, a privilege the women of Charleston were not reluctant to use in setting up their shops.

In Boston and Philadelphia, women operated close to 50 percent of the city's shops. Other women worked as artisans, making candles or buttons or tailored clothing. While women were seldom legally apprenticed to learn these trades, they often picked up their skills informally from their fathers and husbands; and it was not uncommon for a widow to take over her husband's business when he died.

While cities were the epicenters of the new consumer economy, women in rural areas were hardly isolated from the growing marketplace. In the eighteenth century, women on farms and in villages throughout New England learned to spin and sew at a young age. Often working together, they manufactured fabrics for their clothes and linens for their households, "signing" their pieces with their initials. A woman from a more prosperous family could even acquire a cabinet in which to keep her goods, taking it with her when she married. More than women of the early seventeenth century, the women of the eighteenth century cherished their embroidered bedspreads and tablecloths and napkins, all carefully spun, cut, and sewn, as the movable property they brought with them into their marriages. As men became busier with farm work and trades during the course of the eighteenth century, women also increasingly took over the weaving that many men had previously done, particularly in New England and the South. While much of what they produced was meant for their families, they also traded extra cloth for manufactured items at their local stores. Without actually working for wages, they still participated in the growing consumer revolution. Other women used their skills in casual wage work. In Maryland, for example, several white women from local farms worked for John Gresham, a prosperous plantation owner, spinning and knitting wool from his large flock of sheep to clothe his slaves.

The goods that began to circulate in the colonies during the eighteenth century were not only making domestic life more pleasurable but also creating new forms of social distinction. Wealthy shoppers could now choose from a variety of silks to make their clothing and an even wider variety of carpets to furnish their homes. These luxury items were beyond the reach of more common folk, but this was not true of cheaper items such as the highly prized Irish soap that many now purchased instead of making their own from

ashes. And while wealthy matrons acquired elaborate tea services, even poorer consumers could purchase the tea that had become a popular new beverage. Throughout the colonies, households began to acquire plates, cutlery, and chairs, which allowed a family to sit at the same time when they ate dinner—without using their hands or without eating themselves from more common folk—and common folk just as quickly sought to close the gap. Women became key players in the pursuit of status, and the proper use of these domestic goods became just as important as their acquisition. It was not enough to own a fancy tea service; a woman had to know how to properly serve tea and make polite conversation in the ritual that surrounded a tea party. More common women who found their families sitting around a dinner table together also had to orchestrate this new social event by providing greater attention to both the food they served and the conversation at mealtimes. By experimenting with these trappings of gentility, they could also experiment with new identities and new forms of sociability in their homes.

Issues of Inequality

Despite widespread participation as both producers and consumers in the market revolution unfolding around them, women did not necessarily fare well in this new economy. Changing patterns of inheritance, decreased access to the courts, and low wages were some of the problems women faced in the eighteenth century. As a result, economic participation did not translate into economic independence for most women.

Although cities were growing during the eighteenth century, most colonists were farmers, and each generation struggled to provide enough land for the next. Some parents bought land farther west for their sons (provoking continuing conflicts with Indians). But, they also made hard choices about inheritance. As land became more scarce, men became more likely to shortchange the inheritances of their wives and daughters to provide for their male heirs. In Pennsylvania, for example, women were increasingly less likely to inherit the traditional one-third share in their husbands' estates. By the 1790s, a man could demand that the son who inherited the homestead take care of his mother, alleviating the man's need to leave any property to his wife so that she could support herself. Thus, widows began losing what little economic independence they had had in earlier years.

In New York, the loss of economic independence among women was even more pronounced as English law supplanted Dutch law following the conquest of New York in 1664. The British allowed the Dutch to retain their inheritance laws, which allowed a widow one-half of her husband's estate and allowed married women the right to own property. But families gradually intermarried with the British, and Dutch customs faded. There were 134 female merchants in New Amsterdam when the British took over in 1664, but only 43 could be found in its incarnation as New York City a century later. Inheritance patterns also changed. Although Dutch men continued to will greater amounts of property to their wives and daughters than British men did, that custom, too, began to fade during the eighteenth century. Not surprisingly, as new forms of women's work, such as commercial dairy farming, expanded in New York during the eighteenth century, men commonly owned the equipment, though their wives and daughters did the work.

In areas where British law had always dominated, women also faced increasing difficulties accessing the courts. In New Haven, Connecticut, for example, the courts of the seventeenth century had been dedicated to maintaining community harmony and had operated in a fairly casual fashion. Women as well as men participated in the informal proceedings, either testifying as witnesses or bringing forth their own grievances on issues that ranged from slander to economic disputes. This use of the courts became more difficult during the eighteenth century as local merchants began to hire lawyers rather than representing themselves, and most women were unable to afford the legal representation that eighteenth-century courts were coming to expect.

Women also faced increasing economic hardship in the more complex economy of the eighteenth century because they simply were not paid as much as men when they were compensated in cash wages. In the previous century, women might have achieved greater value for their work if they bartered their products—exchanging bread for rum, for example. Such exchanges became less common in the eighteenth century, particularly in urban areas where cash was more likely to be used. Wages for women fluctuated throughout the century, but women usually made only half as much as men.

Poverty thus loomed as a real threat to women, particularly widows, whose numbers were growing as a result of the many wars of the eighteenth century. In Boston (as in other New England seaports), the number of widows had grown to twelve hundred by mid-century, partly because so many men had died in various British military campaigns in Latin America. Most of these widows were quite poor and desperate to find support for themselves and their children. The Society for Encouraging Industry and the Employment of the Poor attempted to put these women to work in a small spinning factory, but the results were disappointing. Many women did not know how to spin, and others needed to work at home where they could care for their children and rely on their neighbors for help. As their struggles made clear, the new market economy offered little improvement in the lives of many poor women.

Slavery in a Market Economy

The market revolution that brought new consumer goods to the shores of the colonies and kept shops up and down the eastern seaboard humming also underlay the explosive growth in the slave trade. Slavery supplied the demand for labor in seaport cities, in the rice and tobacco fields of the South, and on the smaller farms of the North. The different economic needs of each of these areas shaped the lives of slave women and gender roles in regionally distinct ways.

As artisans and domestic workers, slaves were also ubiquitous in eighteenth-century American cities, constituting 14 percent of the population of New York City at the time of the Revolution and 20 percent of the workingmen in Philadelphia at mid-century. Because so many slaves in northern cities worked as artisans, slave men outnumbered slave women by a significant proportion. The case was reversed in the southern cities of Savannah and Charleston, however, where slave women were used extensively for domestic work.

In cities such as Charleston, slave women who worked as weavers and seamstresses and cooks also controlled much of the petty merchandizing in their towns. Working from their street carts, they hawked goods grown by female slaves in the countryside or fish caught and meat butchered by their men folk. White citizens often complained of their noisy and aggressive behavior, branding the street hawkers as immoral women. Equally upsetting to whites was the way in which some urban slaves used their earnings to buy fine consumer goods, so that some slave women were alleged to dress as well as their mistresses. Outraged citizens repeatedly passed legislation forbidding slaves to wear such clothing, but the constant stream of laws suggests not only how threatening whites found this behavior but also how little their legislation did to stop it. Thus, consumer goods provoked status conflicts not only between rich and poor but also between slave and free.

Read about "Slave Women Making Money at the Market"[1]

Slave women were often hired out to work for other slave owners who did not own them; some portion of what they earned was paid to their owners. In other situations, goods and produce was sold by slaves on the open market, with a portion of the proceeds being paid to the slave owners.

Review the source; write short responses to the following questions.

1. Why does the author contend that the market-women are "loose, idle, and disorderly"?
2. How does the author judge the masters of these market-women? Are there expectations about the master–slave relationship built into this comment?

While urban slave women were sometimes able to manipulate the market economy in acquiring goods, they faced more of a challenge in having children. In cities such as New York, where masters had little extra space, slaves were often crammed into a back room and discouraged from marrying. Although a female slave could increase an urban slaveholder's capital by bearing children, most masters did not think the children worth the trouble. By the time of the Revolution, few slave women in either New York or Philadelphia were having children; if they did have children, they often died as infants.

In the more settled areas of the Chesapeake region and farther inland in the newly cleared lands of the Piedmont region, balanced sex ratios helped slaves there to form families. Slaves living on smaller farms were more likely to be separated from their families than those living on large plantations; but in the Chesapeake region, a stable slave community was emerging in which many families were able to stay together. Children on larger plantations of the Chesapeake region were often able to live with their mothers—and possibly their fathers, though about one-third of these families were split up as slaves were moved farther inland to open up new tobacco fields in the Piedmont region.

Farther south, in the Carolinas and Georgia, slaves faced unbalanced sex ratios that affected both how they lived and how they worked. In the rice fields that dominated plantation life in this region, new slaves from Africa took on the grueling task of tending crops. In Africa, women had been responsible for this task, but in these areas of the South, where male slaves outnumbered female slaves by a substantial margin, men were expected to farm as well. Slave men, many just arrived from Africa, thus faced not only the degradation of slavery but the further humiliation of being forced to do "women's work."

Slaves, like free people, were vital to the market economy of the eighteenth century. For women, this new world of goods could bring pleasure and new forms of socializing, but it could exacerbate poverty as well. In either case, women's lives were being transformed.

FAMILY RELATIONS AND SOCIAL RESPONSIBILITIES

Although men usually exerted more power through their access to the courts or in deciding who would receive an inheritance, traditional patterns of authority were questioned in other ways. In a wide variety of social and sexual relations, strict patriarchal control of the household, in particular, was challenged. As a result, women not only negotiated a new place in the market economy of the eighteenth century, they also negotiated new social and sexual identities.

Passions and Patriarchal Authority

Young women encountered new possibilities for family relationships in a variety of venues. Novels such as Samuel Richardson's *Pamela: Or, Virtue Rewarded* and *Clarissa: Or the History of a Young Lady*—tales of love and seduction that focused on the moral backbone of their heroines—were not only exciting to read, they popularized new ideas about human nature and social authority that were central to philosophical treatises written by Enlightenment philosophers such as John Locke as well. Locke had challenged Puritan beliefs that children were born with sinful natures and, instead, argued that children learned to be good or evil as a result of their upbringing. Parents had to educate their children not only formally but also through example to act virtuously and independently. In both Locke's philosophy and in the popular literature that celebrated it, mindless subservience to one's father was not only unnecessary but also dangerous. Voluntary allegiance rather than patriarchal control was championed as the new basis for authority in the eighteenth-century family.

This was a message that resonated with many young people in the colonies as they created their own forms of independence. Lucy Barnes of Massachusetts, for example, had no love for her wealthy cousin John, whom her father wished her to marry. She chose Joseph Hosmer instead and made sure her parents would accept her choice by becoming pregnant. Barnes was not unusual in her behavior. By the time of the Revolution, one in three brides was pregnant when she married. Ideas of independence that young women picked up from popular literature were reinforced by the changing economic structure of the countryside. Fewer parents were able to provide

inheritances for all of their children in the eighteenth century because fathers no longer had the land or wealth that had given economic clout to their patriarchal control in earlier generations. With little property at stake, daughters felt more freedom to choose a spouse they liked, even if their parents did not approve.

Even more possibilities for sexual independence existed in cities. Particularly in the rapidly growing multiethnic neighborhoods of Philadelphia, a tolerance for casual sexual encounters emerged along with a commitment to personal satisfaction in marital relationships. As the number of illegitimate children born each year increased, city officials made sure that fathers paid child support, but neither parent was punished for fornication. Popular forms of literature, such as almanacs, featured bawdy jokes about both men and women who reveled in their lusty behavior. And although legal divorces were hard to get, many spouses divorced informally by placing an advertisement in the local newspaper claiming to have been deserted. Most commonly, a man would claim his wife had left him and that he would no longer be liable for her debts. But wives seldom contested such claims, suggesting they were comfortable with the announcement.

In both popular literature and in popular practice, ideals of household organization and household authority were being revised. Individuals looked more for personal satisfaction in their relationships and worried less about responding to their parents' wishes. Fathers often had fewer economic resources to offer their children, which undercut their authority. A new ideal of personal independence and fulfillment was emerging.

Read about **"Different Perspectives on Marriage"**

Benjamin Wadsworth (1670–1737) was a Boston minister who also was president of Harvard College from 1725 to 1737. He viewed the relationships of husbands and wives as a cornerstone of the social order and expected women to obey their husbands. Eliza Lucas (1722–1793) was born into a prominent family in Antigua and as a teenager, took over the management of her family's plantations in South Carolina. Despite her father's attempts to find her a suitable husband, Eliza made her own choice and married Charles Pinckney in 1744. Both before and after her marriage, Eliza experimented with indigo seed and eventually proved its viability as a commercial crop in South Carolina. Her attitudes toward marriage reflected the changes that were taking place in ideas about family relationships as the eighteenth century progressed.

Review the sources; write short responses to the following questions.

Benjamin Wadsworth on Well Ordered family–1712[2]
Letters from Eliza Lucas Pinckney[3]

1. Describe Eliza Lucas' activities. Using information from this chapter, explain how her activities might affect her attitudes toward her family and how authority is organized in her family.
2. Compare the ideas of marriage expressed by Benjamin Wadsworth and Eliza Lucas. What factors may have influenced their different ideas?

Disorderly Women: The Challenge of the Great Awakening

Challenges to household authority also emerged from the fires of the **Great Awakening** that engulfed both men and women in the flames of religious enthusiasm during the eighteenth century. Beginning in the middle colonies as early as the 1720s, cresting in New England during the 1740s and 1750s, and continuing in the South through the 1760s, most parts of the Atlantic seacoast shared in the powerful and emotional religious experiences that not only transformed the lives of individuals but also bound them together with believers across the Atlantic in various parts of Protestant Europe, extending into the Caribbean and even Africa. New religious denominations, such as the Methodists, arose as part of this fervor, while established denominations such as the Congregationalists and Presbyterians were torn apart. **New Lights**, as the revivalists were called, fought bitterly with the **Old Lights**, who sought to preserve the status quo within their churches. The New Lights emphasized the need for a powerful, physically felt conversion experience. Preachers encouraged such transformations with evocative, heart-felt preaching, quite distinct from the dry and learned sermons of many ministers.

Critics argued that the emotionalism of the preaching and the enthusiasm of the audiences could easily turn a heavenly experience into an earthly one in which lust replaced piety. Certainly, the sight of swooning young women in the throes of religious ecstasy involved a lack of decorum that suggested sexual impropriety even where none existed. And a few very radical converts did leave their spouses for new ones after they were baptized. However, the greater challenge to family relations probably lay in the way that converted children declared independence from unconverted parents, or a converted wife from her husband.

The challenge to gender hierarchy became particularly clear as some women were inspired to preach God's word. Women's preaching usually began with witnessing, as they spoke about God from their hearts to members of their congregation. But some women carried their role further, exhorting those who would listen to hear the word of God. Bathsheba Kingsley of Massachusetts, for example, was repeatedly hauled before her church elders and rebuked for her tendency to ride throughout the countryside urging her neighbors to change their wicked ways. Because this new evangelical preaching was emotional and evocative, and because it required little in the way of formal theological training, anyone with a powerful voice and powerful convictions could become a preacher. Established clergymen bemoaned this challenge to the traditional order as not only women but also African Americans and other members of the lower classes took to "ranting" in the countryside—and as large audiences flocked to hear them.

Other women actually created new religions in this period of spiritual ferment, challenging gender ideals in their process of challenging accepted religions. Jemima Wilkinson, who was strongly influenced by Quaker beliefs, claimed to have died of typhus in 1776 and to have been resurrected as the Public Universal Friend who brought word to those on Earth about the imminent arrival of God's second coming. As her new name—Public Universal Friend—suggested, she was neither a man nor a woman, and to further confuse gender issues, she eschewed traditional female clothing, choosing instead long flowing gowns that drew on male forms of dress as well as female. Like many of the

preachers traveling the countryside, she preached spontaneously on biblical texts in a powerful voice that moved her audiences. Ann Lee, founder of the Shakers, arrived from England in the latter part of the eighteenth century and was equally charismatic. As an illiterate preacher, Lee had little use for a Bible she could not read and promoted instead a religion focused more on singing and dancing than on formal sermons.

The Great Awakening was not meant to challenge hierarchies of gender. Indeed, men were as likely as women to join the evangelical churches. However, the women who preached and exhorted the word of God stepped far beyond the usual roles accorded to women in eighteenth-century society. In doing so, they undermined common assumptions about female subservience that underlay both household hierarchy and government authority.

Female Companions: The Gendered Enlightenment

Other women fostered new ideas of gender relationships in the social activities they organized in their homes. This was particularly true in more elite households where women hosted social events promoting intellectual conversations and civilized discourse. Men in urban settings carried on political debates in the coffeehouses and taverns that filled the cities. There they made business deals or discussed politics while sharing newspapers, playing cards, and drinking their favorite beverages. But in most cases, these spaces were off-limits to women. As an alternative, elite women hosted afternoon tea parties at which men and women could mingle and share in light conversation. Critics sometimes dismissed such gatherings as little more than frivolous occasions for gossip, but their barbs inspired some women to improve the quality of conversation rather than to abandon their efforts at sociability. Elizabeth Magawley of Philadelphia, for example, bemoaned the idle chatter of teatime and undertook a more ambitious project of promoting salons on the European model. Here, men and women shared in more elevated conversation about politics and literature.

These types of interactions drew on new ideals of **complementarity** between men and women that emphasized differences between the sexes. While one important strain of **Enlightenment** thinking had followed Locke's emphasis on the natural rights of men, another group associated with the **Scottish Enlightenment** asserted that society was inherently unequal but that each individual occupied an important position in the social hierarchy that carried both responsibilities and rights. This group emphasized the need for complementary roles between men and women in promoting social progress. Civilization reached its apex, many of these writers argued, when men and women worked together, each making different but complementary contributions to the social order that were best suited to their natural abilities. *Sketches of the History of Man* by Lord Kames was one of the most widely circulated books to make such an argument, identifying key areas where women and men best used their different natures to advance society.

Whether stressing the importance of an individual's choice in marriage partner or the complementarity of the sexes, new ideas about patriarchal authority and women's roles within the family were emerging in the eighteenth century. As young couples

courted (and cavorted) and as matrons sought the attention of their husbands, women demanded respect for their opinions and their choices. To a certain extent, ideals of complementarity represented a new way of constituting family hierarchy as patriarchal authority was challenged. But these issues of authority were not only played out in eighteenth-century families. In the Revolutionary struggle for independence that engulfed the colonies during the 1760s and 1770s, the attack on patriarchal authority took on political ramifications as colonists debated the practical applications of Enlightenment ideals such as natural rights, voluntary allegiance, and complementarity in the old government they attacked and the new government they created.

DECLARING INDEPENDENCE

Colonial dissatisfaction with British rule began to crystallize in the French and Indian War that had raged through the frontier from 1756 to 1763. Although the British wrested control from the French of the territory east of the Mississippi River, they still had to worry about many of the Indians still living there. Many of the tribes had sided with the French and killed more than four thousand British settlers during the course of the war, but the British government sought to build peaceful relationships by designating the land west of the Appalachians as Indian territory. Anglo colonists hungry for land were outraged by British policy. Colonists were further angered when the British government began to tax them to pay off the war debt.

Protests turned to armed conflict by 1775, when shots were fired at Lexington and Concord. By the following year, colonial leaders calling themselves **Patriots** were moving resolutely toward establishing a new government. Members of the **Second Continental Congress** meeting in Philadelphia issued the **<u>Declaration of Independence</u>** in July 1776. As fighting continued, the former colonies scrambled to write new state constitutions that reflected not only their transformation from colonial status but also a broadening spectrum of participation by colonists in both the Revolution and their governments.

Thomas Paine, a failed corset maker who had recently immigrated to Philadelphia from London, popularized many Revolutionary ideas about popular political participation when he published *Common Sense* in 1776. The pamphlet went through numerous editions over the next few years as colonists read and debated the issues he raised. Most important, Paine challenged the idea that any king had a divine right to rule a country and argued instead that governments could and should be constituted by a social compact among individuals. This argument promoted the idea that each individual citizen, in making this social compact, should be granted the opportunity to participate in the government he had created. In this way, Paine popularized the important political concept of rights advanced by Enlightenment thinkers such as John Locke that men were born free in a state of nature and endowed equally with natural rights but that to live in harmony and gain protection, they created a government to which they surrendered some of their rights. Just as novelists had popularized Locke's ideas

of the importance of voluntary allegiance in the family, Paine popularized Locke's ideas of voluntary allegiance in the state. Inhabitants of the colonies who had not dreamed of participating in politics before now began to imagine a new political order in which they might have rights and responsibilities.

Abigail Adams, who possessed the intelligence, curiosity, and stamina to not only complement but also challenge her politically ambitious husband John, recognized what these ideas could mean for women. Most famously, she sparred with her husband in the spring of 1776 as he debated with delegates of the Second Continental Congress about what their new government could look like. Pointing out to him that men were "naturally tyrannical," Abigail enjoined her husband, "Remember, all men would be tyrants if they could. If particular care and attention is not paid to the ladies, we are determined to foment a rebellion and will not hold ourselves bound by any laws in which we have no voice or representation." Abigail Adams may have been exceptional in her abilities to connect the activities of the Revolution to the status of women, but many women were active participants in the political struggles engulfing their lives.

Read about "Abigail and John Adams on the Rights of Women"[4]

Abigail and John Adams had an extraordinary personal, political, and intellectual partnership. In these letters, exchanged during the months leading up to the Declaration of Independence, the two freely exchanged views on women's rights, among other topics. In a subsequent letter to John Sullivan, another leading figure in the American Revolution, John puts forward a new line of reasoning.

Review the source; write short responses to the following questions.

1. What are Abigail Adams' thoughts on how the Revolution should affect women? How does she reconcile her position as John's wife with her position on what a government should be?

2. How and why does John Adams have a different perspective on governance from his wife?

Daughters of Liberty

By 1765, men throughout the colonies had begun to protest the oppressive taxes levied to pay for the French and Indian War. The Sugar Act of 1764 had been followed by the Stamp Act and the Quartering Act in 1765, and the Townshend Duties in 1767. Young Patrick Henry pushed resolutions against the duties through the Virginia House of Burgesses while the **Sons of Liberty** in Boston roused angry crowds in Boston and artisans in South Carolina hanged the stamp distributor in effigy. Resistance grew from New Hampshire through the Carolinas as colonists vowed to boycott British goods and

to demonstrate their independence by providing for themselves. This strategy quickly drew women into the fray, for women were important consumers and producers of most household items.

Young women began meeting together in spinning bees by 1769 to produce "homespun" cloth to replace English textiles. Often calling themselves **Daughters of Liberty**, as many as ninety women met at a time, sometimes in the home of their local Congregational minister—if he supported the cause. They produced not only yarn and cloth but also a patriotic spectacle. Neighbors came by to watch the women and cheer them on. The *Boston Evening Post* celebrated the patriotism of New England women in helping "to bring about the salvation of a whole continent." The activities of southern women in producing homespun cloth were less likely to be noticed because they often lived on farms at great distances from one another and thus they tended to spin alone without public recognition.

Women soon joined with male patriots in boycotting other consumer goods that had become popular during the eighteenth century. Perhaps most notable was the boycott of tea. The Tea Act of 1773 had given the British East India Company the right to sell tea in the colonies without paying the same taxes as colonial merchants. The colonists viewed this favoritism as unfair to their own economic aspirations and responded by boycotting tea—an activity that women led because they were the chief consumers of tea. In Edenton, North Carolina, in 1774, fifty-one women highlighted the political implications of their activities by writing and signing a statement that they would not consume items that were being boycotted. Their behavior garnered attention on both sides of the Atlantic as one Englishman compared the women to Amazons.

Library of Congress Prints and Photographs Division [Robert Sayer and John Bennett/LC-DIG-ppmsca-19468]

This famous British cartoon lampooned the ladies of Edenton, North Carolina, who showed their political commitment by agreeing to boycott tea in 1774. The cartoon suggests that these women were immoral, manly, boisterous, and bad mothers.

By the time of the Revolution, some women were even more aggressive in their policing of consumption activities. As the war dragged on during the late 1770s, many items were in short supply, and prices skyrocketed. Some merchants hoped to make a profit selling food, in particular, to the warring armies at whatever price they could fetch. Members of their communities, however, expected merchants to sell their goods at a price locals could afford. Patriot governments mandated price controls and set up committees to make sure they were enforced. Women as well as men were in the forefront of this movement. In Poughkeepsie, New York, for example, twenty-two women demanded that a merchant's wife sell her tea to her local community at a fair price in 1777; and the following day, several of them joined with men in the neighborhood to break into the house and open casks of liquor in further protest. About one-third of the food riots that took place during the Revolution involved women, either partially or exclusively. In each case, women connected their role as consumers with the Revolutionary cause they were supporting.

Women also worked tirelessly throughout the colonies as fund-raisers for the Patriot cause. The most successful effort occurred as Esther De Berdt Reed and Sarah Franklin Bache (the daughter of Benjamin Franklin) spearheaded a major fund-raising drive in Philadelphia to provide money to the soldiers in the Continental Army. Organizing women to go door-to-door asking for donations, the campaign was a stunning success, garnering $300,000. Reed had hoped to give each soldier $2.00 in **specie**, but Washington forbade her, arguing that the money would undercut his own attempts to pay his men in paper currency and that they were likely to spend it inappropriately anyway. Finally, he agreed to let the women contribute over two thousand shirts to the troops. Women in other states followed suit with their own fund-raising drives. In addition to shirts, however, many women were kept busy at their spinning wheels and looms providing cloth and blankets for army procurement officers. Though the

Read the **"Sentiments of An American Woman"**[5]

Esther De Berdt was born in Britain, and moved to the colonies after marrying Philadelphia businessman Joseph Reed. She became an American patriot, and organized the Philadelphia Ladies Association in the summer of 1780. This organization raised money that was used to provide clothing and supplies to American soldiers in the Revolutionary War.

Review the source; write short responses to the following questions.

1. Why did Reed dwell on the achievements of the "heroines of antiquity"?
2. What sort of role did Reed suggest for women in the American Revolution?
3. How would you compare the attitudes expressed in *Sentiments of an American Woman* to the attitudes expressed by Anne Bradstreet in the two poems, *Here She Lyes* and *Queen Elizabeth*? In what ways has the Revolution encouraged Reed to adopt a different attitude from Bradstreet?

production of clothes and the purchase of foods were traditional female activities, they took on important political overtones as the Revolution unfolded.

Women's feelings of independence also surfaced as they expanded their roles as deputy husbands, taking over the farms and shops of their husbands who had headed off to battle. Less-fortunate women had to scramble to earn whatever money they could to make up for the lack of an income from their spouses.

Loyalist Wives

Those women who supported the **Loyalist** cause—and they were a significant minority—occupied a more politically ambiguous and economically vulnerable position than did women who supported the Patriot cause. As tensions with England began to unfold, their local social networks collapsed, leaving them isolated from friends and neighbors. Whether they wished it or not, a political identity was thrust upon them.

For Loyalist women, feelings of isolation began with the growing hostilities over British taxes. Social events became occasions for political debate, driving wedges into friendships. Shopkeepers who refused to participate in boycotts found their goods and homes under attack. Christian Barnes of Boston complained bitterly of the attacks on her and her husband by the Sons of Liberty, whom she condemned as a "set of wretches."

After war broke out, many men were forced to take a loyalty oath to the Patriot cause or face imprisonment. Loyalist men either joined the British forces or moved into territory controlled by the British. Their wives often stayed behind, trying to protect their homes and their children as the war unfolded around them. Patriot forces regarded them with suspicion, however, and expelled them when they gained sufficient control of an area. The wives of many Loyalists were driven from Newark, New Jersey, in 1777, as were Loyalist wives of Philadelphia in 1780.

Those who had not already left their homes by the end of the war certainly did so after the British surrender. They left behind their land, most of their valuables, and the people they had known. Some settled in England, while others headed to Canada or even the Caribbean. In their petitions to the British government, many revealed their loneliness and desolation as they requested financial assistance. They highlighted not only their poverty but also their isolation from friends and family they had left behind. "I am without Friends or Money," one petitioner explained, "a friendless, forlorn Woman."

Fighting the War

Whether they sided with the Patriots or the Loyalists, women could not help but be caught up in the military conflict. Although both the British and colonial armies were composed of men, a straggling crew of the poorest women and children who had no way to support themselves with their husbands off fighting a war were present as camp followers. Washington found them a nuisance, but he also recognized that many of his men would desert if they felt their families needed them at home. Making the best of what he considered a bad situation, Washington allowed them to receive partial rations and encouraged them to make themselves useful.

Women were indeed useful in the war effort. They sold food and supplies to the troops as they moved from place to place, as well as cooking, sewing, and washing clothes for their husbands and other soldiers. Indeed, the British soldiers, who traveled with women as well, had noted as early as the French and Indian War that the colonial soldiers were a ragged looking lot because they did not have enough women to clean and mend their clothes. Women also nursed their husbands or worked officially in foul-smelling army hospitals. Though women were paid for their labors, their pay was lower than what men received for comparable jobs. Female nurses and matrons earned less money than male stable hands. Not surprisingly, the laundresses in one camp went on strike to demand fair pay.

View the Profile Mercy Otis Warren (1728–1814)

Writing anonymously during the 1770s, Warren published a string of plays and poems lampooning the British and urging on the colonists in their resistance. She wrote her greatest work, *History of the American Revolution*, over thirty years; it was finally published in 1805.

Some women even moved with their husbands to the battlefront, carrying buckets of water to quench the thirst of fighting men and to douse the overheated canons the men were firing. The name "Molly Pitcher" evolved as a term for women who took on this task and was applied most famously to Mary Ludwig Hays, who took over loading her husband's canon at the Battle of Monmouth in 1778. Deborah Sampson, who had no menfolk to follow, disguised herself and served as a soldier for several years before she was wounded and her true sexual identity became clear to an army surgeon.

Class also played an important role in the way women participated in military life. The poor and ragged camp followers were viewed as troublesome and dangerous by commanding officers who commented on their ugliness, dirtiness, and need for discipline. Officers' wives, however, were another matter. Officers from Washington down welcomed their female family members, particularly during long winters when balls and teas created a lively social season in the homes where officers had taken up temporary residence. Elizabeth Schuyler met her future husband Alexander Hamilton in this context, and she was not the only young lady to snag a dashing officer.

As the battlefields shifted up and down the colonial coast, even women who were not camp followers found themselves pressed into military service. When troops they supported moved into the vicinity, women would vie for opportunities to house the men they supported, particularly if there was a chance they would be paid for their efforts. At other times, women were forced to house soldiers of the opposing army when their land fell into

enemy possession. In those cases, women might be less welcoming. Their homes were not only invaded but also vandalized.

Read about "Women in War"

Elizabeth Drinker lived in Philadelphia in the late 1700s; she was a Quaker. Her husband was banished to Virginia, accused of assisting the British cause. After he left, the British Army overtook Philadelphia, setting up residence in various homes around the city; British Major General John Crammond moved into the Drinker home. Sarah Osborn met and married Revolutionary War veteran Aaron Osborn; the document is a deposition filed by Osborn in support of her application for a war widow's pension.

Review the sources; write short responses to the following questions.

A Woman Alone in Philadelphia by Elizabeth Drinker[6]
Sarah Osborn's Narrative (1837)[7]

1. Compare and contrast the different experiences of these women. What accounts for the differences in their experiences? How would each view the Revolution differently?
2. How would you compare the attitudes of Elizabeth Drinker and Sarah Osborne to the Revolution with that of Esther De Berdt in Sentiments of an American Woman?

A few women faced even greater trials when subjected to violence by opposing troops. Women in Staten Island and New Jersey were raped by invading British and Hessian soldiers in 1776 as were women in New Haven and Fairfield, Connecticut, during 1779. Abigail Palmer of New Jersey was only thirteen when she was raped by British troops in 1777. Farther south, several of the McDonald girls were stripped by Patriot soldiers in North Carolina. Other women lost their lives, including Hannah Caldwell who was murdered by a British soldier in search of loot. Caldwell's murder became a rallying cry for the Patriot forces, as did the death of Jane McCrea. McCrea's family was split, with some supporting the Loyalist cause and others supporting the Patriot cause. She herself was engaged to a Loyalist officer when Indians who were allied with the British captured her. In a dispute over the young woman, the Indians scalped her, galvanizing the Patriot troops her fiancé opposed. Indeed, in frontier areas where conflict with Indians was endemic, women were sometimes taken captive. In the largest of these raids, 170 women and children from Kentucky were captured by Indians and taken to Canada.

Some women retaliated, though. While soldiers thought nothing of imposing on female hospitality and more or less expected women to be nonpolitical bystanders in the war, some women took advantage of this naïveté and bravely crossed enemy lines to share the information they had gathered with the side they

supported. Others, in less dramatic fashion, simply provided a place for soldiers to stay as they tried to elude capture from their enemies. Facing severe punishments if they were caught, Patriot and Loyalist women secretly assisted soldiers and spied for the forces they supported.

Seize the Day: Indian and Slave Women of the Revolution

For Native American women and for slave women, the Revolution raised issues of independence that were different from those confronting Euro-American women. Native American women and men had to calculate which side in this colonial struggle was more likely to protect them from land-hungry colonists. Slaves calculated questions of independence in terms of freedom from bondage. They recognized that the demands for freedom being voiced by the colonists could be extended into a critique of slavery as well. However, while some slaves fought for freedom within the rhetoric of revolution, others thought their chances for freedom were better with the British. Most Native Americans agreed with them. Neither Indians nor slaves, however, were particularly interested in the political differences between the Patriots and the Loyalists. Neither were the Euro-Americans much interested in the oppression faced by their allies. The alliances these groups formed were purely strategic.

Most Indian tribes fought with the British, calculating that the British were more likely to honor their boundaries than the colonists were; compared to the encroaching colonists, the British government seemed like the lesser of two evils. Many Indian groups had hoped to avoid participating in the conflict at all, viewing it as a conflict among Europeans. However, as conflict spread from New England to Canada as early as 1777, the Iroquois confederacy realized it would be drawn in. Mary (Molly) Brandt, a powerful Mohawk matron who had been married to Sir William Johnson, the British superintendent of Indian Affairs in the North, worked assiduously to

Read **"Concerns of an Indian Matron"**

Molly Brant[8] (c. 1736 to 1796), born a Mohawk Indian, was the sister of Joseph Brant, Chief of the Six Nations, and wife of Sir William Johnson, the British Superintendent of Indian Affairs in New York. Because of these ties, she was an important go-between for the British and the Iroquois. Although Johnson died just before the outbreak of the American Revolution, Molly maintained that role, rallying the Iroquois to the British cause. That loyalty cost her dearly when she and her people were forced to flee to Canada as the British lost the war.

Review the source; write short responses to the following questions.

1. How did Molly Brant demonstrate her confidence in representing the needs of her Indian people?

2. Did Molly Brant regard herself as an equal to the British or their inferior?

build support for the British among the Iroquois confederacy. She used her membership in the Society of Six Nations Matrons to persuade other women to support the war—and to encourage their men to join the Loyalists. Like most Loyalist women, Brandt was eventually forced to leave her home and all her possessions for a new life in Canada.

Regardless of which side Indians fought on, conflict on the frontier was vicious; and as a result, Indian women and children left behind in the villages suffered some of the worst excesses of military brutality. One chief claimed that Patriot troops had "put to death all the Women and Children" in his village, saving only a few girls "whom they carried away for the use of their soldiers." Some Indian women were mutilated after they were murdered, as their wombs were torn out of their bodies. Those who survived such attacks faced starvation and bitter cold as troops burned their fields and their houses. Mary Jemison, who had been captured by the Seneca Indians when a child and who had chosen to stay with the Senecas even though she was later ransomed by her relatives, described vividly how Patriot forces had destroyed their crops and their homes. They had "not a mouthful of any kind of sustenance left, not even enough to keep a child one day from perishing of hunger." Meslamonehonqua, a Miami Indian woman, echoed that desperation when she demanded support from the British in Detroit, saying "I am Deputized by the Women of our Villages, to pray you to send them Ammunition for to support their families."

Slaves had also been drawn into the war early on when in 1775 Lord Dunmore, governor of Virginia, issued a proclamation that any slaves in his colony willing to take up arms against their masters would be granted their freedom. Three hundred male slaves quickly mustered into the "Ethiopian Regiment." During the course of the war, over eighty thousand slaves fled their masters, many taking their chances with the British. The offer of potential freedom behind British lines had a particularly powerful impact on women. Slave women had been much less likely than slave men to run away during the colonial period because they often had small children who could not travel long distances to freedom in Florida or other colonies on the frontier. However, as the British army drew closer to slave populations in both the North and the South during different periods of the war, that calculation changed and women became much more likely to make a bid for freedom. Of the twenty-three slaves who fled Thomas Jefferson's Virginia plantation, more than half were female. Over 40 percent of more than twenty-eight hundred ex-slaves who left with the British at the end of the war were female.

Once behind British lines, however, slave women faced a new set of trials. Women were not allowed to bear arms, but they took on other duties of camp followers in nursing the sick, cooking, and doing laundry. Many died in these camps as epidemics repeatedly struck. When Lord Dunmore evacuated Virginia, for example, a smallpox epidemic broke out on his ships and he left his African

American followers on an island in the Chesapeake Bay, where many died alone and unattended.

Not all slaves supported the British. Others assisted Patriot troops and attempted to extend Revolutionary rhetoric about freedom into their own lives. Phillis Wheatley was a former slave and talented poet who connected the tyranny of slavery to the tyranny of England. As the Revolution drew to a close, another Massachusetts slave Mumbet (who would later take the name Elizabeth Freeman) sued for her freedom and won. She argued that her enslavement violated the promise of liberty that was central to the state constitution, and, eventually, slavery was ruled unconstitutional in Massachusetts. Slowly, other states in the North also abolished the practice, though slaves could be found in some parts of the North through the 1820s. In the South, such arguments for African American freedom largely fell on deaf ears. Some southern slave owners did free their slaves, but by the end of the century, slavery in the South was stronger than ever. Although women such as Elizabeth Freeman had tried to extend arguments for liberty to include slavery, their impact was limited.

> ### View the Profile of __Phillis Wheatley__
>
> Born in Africa in 1753 and sold into slavery as a child, Wheatley was purchased by John and Susannah Wheatley, a couple who recognized this budding writer's intellectual aptitude, fostering her creativity and intellect.

Female Citizens

In the heady days of 1776, as states debated the nature of their new governments, most men were no more interested in extending political rights to women than extending them to slaves. Delegates to constitutional conventions were much more focused on the extent to which uneducated and propertyless men would have access to political power. Elites worried that a completely democratic society would degenerate into the tyranny of ignorant masses with little respect for property rights. Poor farmers and artisans who were fighting to defend the Patriot cause argued that such mistrust was unfair. In New Jersey, however, this debate unexpectedly affected women when the state constitution was written in 1776. The New Jersey constitution dealt with the conflict between property holders and commoners by extending the right to vote to women but insisting on a property qualification. All adults who possessed at least fifty pounds of property were given the right to vote. Married women would not have qualified under these rules because they legally could not own property, but some single women did. Most likely, these women were being

counted upon to uphold the rights of property holders in case poorer men challenged them. As a result, single women with property received an important new right—and they used it.

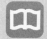

Read **"New Jersey Grants Voting Rights to All Property Holders (1776)"**[9]

The American Revolutionary War was already underway, and the Declaration of Independence was about to be signed, when leaders in New Jersey quickly drafted and ratified a state constitution. The most notable feature of this document is the relative ease of establishing voting rights.

Review the source; write a short response to the following question.

1. Is there any indication in this document as to why property requirements are so important for participating in politics?

The inclusion of women as voters in the New Jersey constitution did not arouse much comment, though by the 1790s criticism was growing. This was due in no small part to the growing competition between the **Federalists** and the **Jeffersonian Republicans** for the allegiance of voters. The Federalists were committed to a strong central government and the promotion of commerce, while the Republicans were committed to a weaker central government and the interests of farmers. Each faction viewed the other with alarm. As the two young parties jockeyed to promote their particular causes, they calculated where their support might be found; and among the groups they sized up and courted were the female voters of the state. The Federalists rounded up women in a hotly contested election in 1797. However, they soon began to fear that women might favor the Republicans. In the end, neither the Republicans nor the Federalists felt there was enough to be gained in courting the women and both sides dropped support for the female franchise when the state constitution was rewritten in 1807. Although women had actively used the vote while they had it, they did not protest their disenfranchisement when it occurred.

While the New Jersey experiment with female voting was an anomaly in female political participation during the Revolutionary period, petitioning was not. Petitions were a way subjects could approach their government directly to request anything from personal assistance to a change in the law. Few women used petitions before the Revolution, but during and after the war, an increasing number of women began to petition their governments. Some petitioned the Continental Congress or various state legislatures for economic relief if widowed or economic payment if they had rendered service to the government. Abigail Ott and Mary Munn of Pennsylvania no longer had their husbands to support them and were

starving. Nonhelema, an Indian woman, requested payment for tending the cattle of Americans fighting at Fort Randolph on the Ohio River. Mary Sansum of Charleston petitioned the state of South Carolina for back pay she believed owed her dead husband. Hundreds of these petitions flooded the legislatures of the states during and after the war.

As women became more comfortable petitioning the government, they also began to use this approach collectively in a few instances to address issues of policy. In Charleston, nine slave-owning widows protested legislation in 1783 that prohibited slave women from selling their goods in the streets. Many of these slaves were there at the behest of their mistresses who counted on the income to support themselves. A few years later, sixty-seven seamstresses in South Carolina signed another petition requesting a higher tariff on the imported clothing that was providing stiff competition to their goods and driving them out of business. As their behavior made clear, women did not have the same political rights as men, but they did have a political consciousness.

A Virtuous Republic

The new United States government faced constant turmoil in its early years. The **Articles of Confederation**, which had been adopted by the Second Continental Congress in 1777, was abandoned ten years later as too weak to hold the new national government together. The **United States Constitution** replaced it in 1787. Debates about the national government were echoed in each state as separate constitutions were written and rewritten. Repeatedly, Americans asked themselves and each other how far the Revolution would go in granting rights and promoting democracy. Debates such as these framed questions about the rights of women in the new republic.

Republican Mothers and Virtuous Wives

In the celebrations that followed the Revolutionary victory, the citizens of the new republic repeatedly toasted the role of patriotic women. Their fortitude, their virtue, and their good sense were widely acknowledged. Women themselves boasted of their political acumen. Margaret Manigault, for example, claimed she could "read the papers, & talk learnedly about them all," when she described herself as "a great Politician." Young women in the North and the South talked freely of the new president, the Constitution, and other more local political affairs.

This political awareness, however, did not lead women into political power. Rather, a consensus rapidly developed that women had proven themselves worthy and capable of rearing virtuous citizens in the new republic. This emphasis on child rearing was a serious concern. In the uncharted waters of a new republican form of government, citizens worried about whether or not the electorate would be suitably trained to govern itself. Although they had grown frustrated with British rule, the Revolutionary generation had grown up with a belief that the monarchy provided

crucial stability in a government. Citizens of the United States took seriously the need to create stability in new ways with an educated and selfless public. Elites had viewed property holding as one way of ensuring the capabilities of voters, but a new confidence also began to emerge in the capabilities of women. A well-educated and virtuous woman would be a valuable sounding board for her husband and a trusted educator of their children.

Journals of the time thus suggested that men look for wisdom and patience in a wife rather than beauty and wealth. And women were urged to wed men who would treat them as friends. These would be marriages in which men and women could share advice and contemplate problems that could have political ramifications as well as personal. Child rearing should have a similar purpose. Thus, Mary Cranch was proud of developing her son's capacity to reason. "When any thing was demanded of you the reason was given why it ought to be done," she told him later. This youthful training, her comment implied, had given him the skills to listen thoughtfully to political debate and act judiciously for the common good.

Those who championed the responsibility of women to educate their children and advise their husbands argued that it was not only their duty but also their right. Men had the right to vote, but women had the right to influence. The Lockean ideas of natural equality and social contract that had been popularized by Thomas Paine and written into the Declaration of Independence were not applied to women. The belief that men and women had different rights came from the Scottish Enlightenment tradition that stressed that individuals had different rights depending on their rank. The rights of women, when conceived in this way, were not only different from the rights of men—they were actually derived from a very different political tradition.

Educated Women

The most significant change in the lives of women following the Revolution was their growing access to education so that they could successfully assume their roles within their families. Advanced academies for elite girls proliferated, particularly in the North, where even the daughters of farmers and shopkeepers were more likely to gain a basic knowledge of reading and writing at local schools.

Girls of modest backgrounds usually received their educations in summer sessions at the town school. Of course, not all towns had schools; and even if they did, they would not necessarily allow girls to enroll or they could refuse to pay for the instruction of girls. But in Massachusetts, for example, girls were more likely to find these opportunities by the 1790s than earlier in the century. In Philadelphia, abolitionists even opened a school for girls who had been slaves because they would not have been able to attend a school for white children. Not surprisingly, female literacy rose.

Female academies provided more advanced learning. Many of these academies were founded in the North rather than in the South because the southern countryside had been so devastated by Revolutionary battles and recovery in the South was proceeding slowly. In small towns and large cities of Pennsylvania, New York, Connecticut, and

Massachusetts, educated women such as Susanna Rowson and Sarah Pierce opened establishments that drew young women from great distances. While many of these schools taught music, dancing, and embroidery (the ornamental accomplishments), they also stressed reading, writing, and basic arithmetic, as well as offering lessons in history and geography.

Benjamin Rush, an important physician who argued that Pennsylvania needed public schools to educate both boys and girls for participation in the new nation, also helped to found the private Young Ladies' Academy in Philadelphia. He argued that girls needed to be educated to instill patriotism in their children and that women needed to learn good handwriting and basic mathematics to assist their husbands in their businesses.

Not everyone accepted the idea that girls needed to be educated or that they were even capable of learning traditionally male subjects such as history and mathematics. Thus, a debate developed about the intellectual capabilities of women, with some writers going far beyond the demands of those who supported republican womanhood, arguing instead that men and women were intellectual equals and that education was an important way to create independent women. Mary Wollstonecraft of England took this position in 1792 in **A Vindication of the Rights of Woman**, which circulated widely in Europe and the United States. She claimed that while there were physical differences between men and women, female character had been shaped by environment rather than internal nature. Wollstonecraft argued that not only should boys and girls study the same subjects, but that they should be educated together.

Judith Sargent Murray of Boston, an important essayist in the late eighteenth century, saw her essays as a complement to Wollstonecraft's. In her writings, she argued that women needed to be educated so that they would know how to best influence their families, but she also pointed out that educated women would have the ability to support their children if something happened to their husbands. In this way, Murray raised the possibility that education could lead to female independence. The radical implications of Murray's arguments became clear as she claimed that women were capable of such an education because they were "in *every respect* equal to men." Whether in fortitude or patriotism, governing or literary accomplishment, women were just as capable as men. Murray challenged the assumptions about female nature that underlay the gender philosophy of the Scottish Enlightenment and the status hierarchy of republican womanhood.

People like Mary Wollstonecraft and Judith Sargent Murray were not alone in discussing female equality. Some young women preferred the rights of men to those that had been allocated to women. When Priscilla Mason delivered an oration in 1794 at her graduation from the newly established Young Ladies' Academy of Philadelphia, she not only celebrated her extraordinary education but also decried the "mighty Lords" who with "their arbitrary constitutions have denied us the means of knowledge, and then reproached us for the want

Read about "Equality of the Sexes"[10]

Judith Sargent Murray (1751–1820) wrote extensively on women's issues in the late eighteenth century under a variety of pen names. Many of her essays were gathered together and published in 1798 as *The Gleaner*. Murray repeatedly challenged arguments that women were not the equals of men, often drawing on the accomplishments of women in the past to prove her points.

Review the source; write short responses to the following questions.

1. According to Murray, in what ways are women equal to men? Why are these characteristics important?
2. Why does Murray distinguish between custom and nature in evaluating the capabilities of women and men?

of it." Turning to the broader political landscape, she further complained, "The Church, the Bar, and the Senate are shut against us. Who shut them? *Man*; despotic man." Ann Harker, another young graduate of the Young Ladies' Academy, was clearly in agreement, arguing, "In opposition to *your* immortal Paine, we will exalt *our* Wolstencraft."

A Limited Revolution

The celebration of the republican mother, virtuous wife, and educated daughter in the years following the Revolution suggests the ways in which ideas about the family had

Read about "Young Women and Their Ideas About Their Rights"

One of the most important legacies of the Revolutionary period was the expansion of educational opportunities for girls. Molly Wallace and Priscilla Mason attended one of the most famous of the new female seminaries: the Young Ladies Academy of Philadelphia. At this point in time, the young women were taught to speak publicly, a subject that had traditionally been reserved for young men as part of their training for future political responsibilities.

Review the sources; write short responses to the following questions.

Priscilla Mason's speech (1794)[11]
Molly Wallace oration—1792][12]

1. What rights did these young women value most, and why?
2. How did they see themselves as inheritors of the Revolution?
3. What competing perspectives on the role of women did they identify in their speeches?

shifted along with ideals about the political order. The growing emphasis on companionship in marriage and equality in family relations also surfaced in some of the new laws that were drafted about divorce and inheritance. However, democracy in family and personal relationships was not always realized. New ideas about family may have provided elite women with status more than power and consigned poor women to an even more marginal position in society.

As each state rewrote their laws of inheritance after the Revolution, most changed the rules about how a father's property would be distributed if he died without writing a will. British law had stipulated that in such circumstances, the oldest son would receive twice as much as his brothers and sisters. In the new republic, ten of the thirteen new states rewrote these statutes to provide equal shares to all children in a family. While this legislation was meant to create more economic equality among siblings, fathers could easily ignore the law by simply writing their own wills. Those who did tend to continue the trend that had begun before the Revolution of trying to equalize the amount of property they willed to their sons by giving less to their daughters.

Most states (with the notable exception of South Carolina) also broke with British tradition by legalizing divorce, although only in very restricted circumstances. Puritans in New England had always recognized divorce, and Quakers in Pennsylvania also had been sympathetic to the idea because these religious groups viewed marriage as a civil contract, not a religious one. The English government had disagreed with this perspective, however, and had challenged the divorce statutes of these colonies while they were still under British rule. After the Revolution, more lenient divorce laws were finally enacted. Divorce was still a difficult process, however. Laws varied with each state, but in most cases women (and men) had to petition state legislatures to receive a divorce and usually only the wealthiest women had the money and political connections to do so.

Regardless of whether or not legal divorces were within their reach, some women did continue to engage in a sexually expressive culture, at least in the first few years of the new republic. In Philadelphia, in particular, cases continued to proliferate of women who had had children out of wedlock with few consequences and others who had left their husbands when they found another who suited them better. However, arguments for sexual chastity began to increase in the newspapers and journals of the day as women, in particular, were urged to curb the licentious behavior of men. Female responsibilities for guarding republican virtue were extended from politics and education to encompass sexuality as well. As one gentleman wrote to the *Philadelphia Minerva*, "Ladies, much depends on you, towards a reformation in the morals of our sex. . . ."

This new approach to sexuality had important class implications because openly sexual behavior became associated with women of the lower classes. Servants, street hawkers, slaves, and poor women generally were excluded from the vision of virtuous womanhood. Men could engage in sexual relationships with these women because men were not charged with guarding the family virtue of the new republic as their wives and sisters were. A double standard emerged in which respectable women were

expected to restrain their sexuality as a way of promoting the virtue of the nation in a way that men were not, another form of gender complementarity between the sexes of the respectable classes. As was true of gender complementarity generally, the sexual double standard was rooted in inequality. Men were allowed sexual freedoms that women were not, and poor women were further marginalized as unworthy of either respect or responsibility within society.

CONCLUSION

The eighteenth century truly had been an age of revolution for women. Consumer goods and a lively market economy had transformed their lives as both producers and consumers. Family life had changed as patriarchal authority was challenged on numerous levels, both small and grand, and a new republic of rights had been established. But, the tradition of rights for men was different from the one established for women. For men, the tradition of natural rights had opened the door to political access and debates about equality. For women, however, rights were rooted in a very different tradition, one premised on inequality and the need for women to exercise their rights within their homes, not in public. This tradition of difference would define the debates about women's political status for the next two centuries.

Study the Key Terms for Eighteenth-Century Revolutions, 1700–1800

Critical Thinking Questions

1. How did the market revolution change the ways women lived in the eighteenth century?

2. Why were challenges to patriarchal authority in British colonial families important?

3. What experiences influenced the growth of women's political consciousness during the Revolutionary period?

4. Did women gain power as a result of the Revolution?

Text Credits

1. Olwell, Robert, 'Loose, Idle, and Disorderly,' Slave Women in the Eighteenth-Century Charleston Marketplace, in David Barry Gaspar and Darlene Clark Hine, eds., More Than Chattel: Black Women and Slavery in the Americas (Bloomington: Indiana University Press, 1996), p. 101.

2. Benjamin Wadsworth, *A Well-Ordered Family* (Cambridge: Harvard University Press, 1712).

3. Elizabeth Deering Hanscom, ed., *The Friendly Craft: A Collection of American Letters* (New York: Macmillan, 1910), pp. 3–6.

4. Abigail Adams to John Adams, Braintree, 31 March 1776; John Adams to Abigail Adams, Philadelphia, 14 April 1776; John Adams to John Sullivan, Philadelphia, 26 May 1776.

5. Esther Reed, Sentiments of an American Woman, 1780.

6. Henry Biddle, ed., *Drinker, Elizabeth Sandwith. Extracts from the Journal of Elizabeth Drinker, from 1759 to 1807, A.D.* (Philadelphia: J.B. Lippincott Co., 1889), pp. 73–75.

7. Sarah Osborn, Narrative, 1837, in John Dann, ed., *The Revolution Remembered* (Chicago: The University of Chicago Press, 1980), pp. 241–246.

8. Letter of Molly Brandt to Judge Daniel Claus, June 23, 1778, reprinted in Sharon Harris, ed., *American Women Writers to 1800* (New York: Oxford University Press, 1996), pp. 280–281.

9. Susan Rimby, *Primary Source Documents to Accompany Women and the Making of America*, pp. 69–70.

10. Judith Sargent Murray, Essay on Equality of the Sexes, *Massachusetts Magazine*, II (March, 1790), p. 133.

11. Priscilla Mason's speech 1794.

12. Molly Wallace oration, 1792.

Recommended Reading

Linda Kerber. *Women of the Republic: Intellect and Ideology in Revolutionary America*. New York: W.W. Norton, 1986. A classic interpretation of the meaning of the Revolution for women.

Cynthia A. Kierner. *Beyond the Household: Women's Place in the Early South, 1700–1835*. Ithaca, NY: Cornell University Press, 1998. Important study of the ways in which southern women's experience was distinct from that of northern women.

Clare A. Lyons. *Sex among the Rabble: An Intimate History of Gender and Power in the Age of Revolution, Philadelphia 1730–1830*. Chapel Hill, NC: University of North Carolina Press, 2006. A lively and original interpretation of the sexual lives of women in an important commercial center during the eighteenth century.

Mary Beth Norton. *Liberty's Daughters: The Revolutionary Experience of American Women, 1750–1800*. Ithaca, NY: Cornell University Press, 1996 (1980). Still one of the most comprehensive surveys of women during the Revolutionary period.

CHAPTER 4

FRONTIERS OF TRADE AND EMPIRE, 1750–1860

LEARNING OBJECTIVES

- How did the power of women within their households change in different Indian groups as a result of trade with the British and Anglo-Americans?
- How were women affected by changing laws of slavery and freedom as control of the Louisiana Territory shifted from France to Spain and then to the United States?
- What were the different ways that women created households in the western frontiers of Texas, New Mexico, and California?

Explore Chapter 4
Multimedia Resources

TIMELINE

1692	Hannah Duston captured by Indians
1704	Eunice Williams captured by Indians
1756	Seven Years' War begins in Europe
1758	Mary Jemison captured by Indians
1763	Treaty of Paris ends Seven Years' War Proclamation Line drawn separating Indian Country from eastern colonies France cedes Louisiana to Spain and territory east of Mississippi to Britain
1769	Spain begins to govern Louisiana Spain begins to construct missions in California
1781	Nancy Ward helps the Cherokee to negotiate a treaty with the U.S. government
1786	Law passed in New Orleans requiring libre women to wear a tignon on their heads
1789	Quakers establish mission among the Seneca
1797	Seneca women sell part of their land to Thomas Morris
1799	Handsome Lake has his first vision
1803	Louisiana Purchase
1804–1806	Voyage of Lewis and Clark Sacajawea assists Lewis and Clark in their exploration of the Louisiana Territory
1805	Tenskwatawa has his first vision
1817	Cherokee women petition their council not to cede any more land to the United States

1821	Mexico achieves independence from Spain
1827	Cherokee establish republic and ratify a constitution
1836	Narcissa Whitman moves with her husband to the Oregon Territory
1837	Texas becomes a republic
1845	Texas becomes a state Jesse Benton Fremont helps her husband to write his report on the West
1846	Mexican War
1848	Treaty of Guadalupe Hidalgo approved, ending Mexican War Mexican cession of land to the United States includes southwest and California

MARKET TRANSACTIONS THROUGHOUT THE NORTH AMERICAN FRONTIER IN THE SEVENTEENTH AND EIGHTEENTH CENTURIES TRANSFORMED THE MEANING OF HOUSEHOLD RELATIONSHIPS, just as they had in the British colonies. As European countries vied for power with and among different Indian tribes during this period, competing structures of gender complementarity, property holding, freedom and slavery, and general principles of governance came into conflict around ideas of household organization. The status of women was constantly being renegotiated as Native Americans shifted their alliances with one another and faced successive challenges from different European powers and, eventually, the United States.

The British colonies of North America were the first to be incorporated as part of the United States, but by the middle of the nineteenth century, the territorial reach of the young nation extended to the Pacific Ocean. The "Indian Country" that stretched from the Appalachian Mountains to the Mississippi River was increasingly overrun by land-hungry settlers in the late eighteenth and early nineteenth centuries. Control of the Louisiana Territory had passed back and forth between France and Spain during the eighteenth century, but in 1803, the United States acquired rights from France to this vast expanse of land that extended from the Mississippi River to the Rocky Mountains. By the end of the Mexican War in 1848, the United States had not only annexed Texas but also acquired from Mexico the land stretching from Texas and the Rocky Mountains all the way to the Pacific Ocean. With each of these transitions, women faced new challenges to their households and their place in society amid a shifting legal terrain.

INDIAN COUNTRY

At the end of the French and Indian War, the British tried to slow Anglo settlement west of the Appalachian Mountains with the **Proclamation Line of 1763** that designated British territory west of the line as **Indian Country** and restricted entry by

colonial settlers. Colonists were outraged, and within a few years, the British govern-
ment was backpedaling on that issue. As the American Revolution unfolded, settlers such
as Daniel Boone and his family continued to pour across the Appalachian Mountains,
demanding that they not only be allowed to farm the land they found but also be allowed
to purchase it. Indian conflicts—from the Cherokee War of 1761 to Pontiac's Uprising in
1763 to the resistance of Indians in the Ohio River Valley during the 1790s—only halted
the pressure briefly. Native Americans, including the Iroquois in the North, the Shawnees
in the Middle Atlantic, and the Cherokees in the South, were pushed farther westward.
The U.S. government representatives negotiated and renegotiated treaties demanding land
forfeitures in exchange for both cash and goods that were supposed to acculturate Indians
to Western ideas of property and family. Protestant missionaries, including Quakers,
Baptists, and Methodists, reinforced these ideals in the schools and churches they set up
for Indians. This talk of acculturating Native Americans, however self-interested it might
have been, collapsed by the 1830s. The government of President Andrew Jackson rejected
the possibility of acculturation and demanded the removal of Indians to territories west of
the Mississippi River in the newly created **Indian Territory**. As southeastern Indians were
forced into Oklahoma during the 1830s, few Indians were left in the areas that had once
been designated as Indian Country (see Map 4-1). For women in many of these tribes,

MAP 4-1 Southern Indian Cessions and Removals 1830s

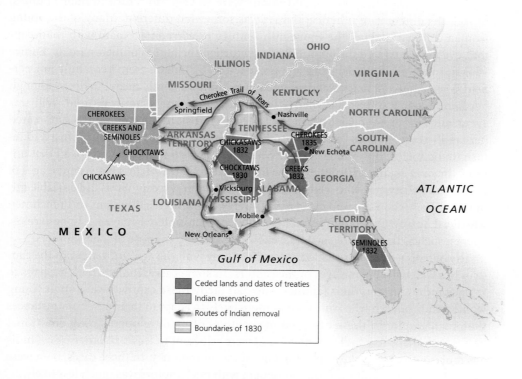

The Choctaws, Chickasaws, Creeks, Cherokees, and Seminoles were pushed off their lands in the
southeastern United States during the 1830s and forced to move westward.

European diplomatic, military, and market pressures changed their status within their households, while missionaries challenged their gender roles.

Multiple Meanings of Captivity

No women faced greater upheavals in their household status than those who were captured. Both colonial settlers and Indians faced this possibility, though their experiences were quite different.

European women who were captured by Indians during the eighteenth and nineteenth centuries faced terror, hardship, and sometimes death. But if they survived, their story could be published for all to read. Mary Rowlandson's was first (see Chapter 2), but even more dramatic stories followed. Hannah Duston, captured by Indians in Haverhill, Massachusetts, in 1692, made her escape after killing ten of her captors while they slept. Her story was told by the famous minister Cotton Mather and retold in the nineteenth century by a succession of writers. Jemima Boone, who was captured by Indians on the Kentucky frontier in 1776, was rescued by her famous father, Daniel, and became a part of the widely read adventures of Daniel Boone written by different authors in later years. The story of Almira and Frances Hall's captivity was used to stir up support for the Black Hawk War in 1832. Other stories became even more sensationalistic in the nineteenth century, drawing on a growing market for popular entertainment.

While Rowlandson, Dustin, and Boone were all eager to return to their families, in fact, the outcome of other captivities was somewhat different. Many of the young women captured during the eighteenth century preferred to remain with their captors, even when offered the opportunity to return to the homes of their parents. Eunice Williams was only a child when she was carried off by Indians from her family in Deerfield, Massachusetts, in 1704 and adopted by a Mohawk family near Quebec. Although her family sought to purchase her release, her new Mohawk family refused. Williams eventually converted to Catholicism, married an Indian in the community, and reared her family there. In later years, she visited her surviving siblings, but she refused to return to the society into which she had been born. Eunice Williams was not all that unusual. In early eighteenth-century New England, a majority of girls between the ages of twelve and twenty-one who were captured stayed with their captors, as did a sizable minority of girls who were under the age of twelve. Some married Indians or Frenchmen who lived nearby. Others converted to Catholicism and entered convents. In both cases, women such as these established households different from those of their mothers.

The outcome of these situations varied not only with the age and gender of the captives but also with the motives of the captors. In some cases, Indians took captives to replace individuals in their families who had died. These captives were often young women and children who were seen as more likely to adapt to their new circumstances than men would. In these cases, young captives often developed strong emotional bonds with their new Indian families and were reluctant to leave. In other cases, Indians took captives with the hope of obtaining ransom money. In those cases, men were as good as women, and the desire to remain with one's captors was much less likely.

Read about **"Life in Captivity"**

Captivity narratives were ubiquitous in the eighteenth and nineteenth centuries, and often focused on women. They not only provided exciting stories of adventure and spiritual challenges faced by women but propaganda for various wars against the Indians. Mary Jemison stayed with her captors, while Frances and Almira Hall escaped.

Review the sources; write a short response to the following question.

Narrative of Mary Jemison[1]
Narrative of Misses Frances and Almira Hall[2]

1. Compare the perspectives on captivity voiced by Mary Jemison versus the description of captivity of the Hall sisters. What factors account for the differences in their accounts of captivity?

Particularly in the South, captivity also began to blur into slavery. As European settlers experimented with different kinds of forced labor on their various plantations, they used the labor of not only African Americans and white indentured servants but also Indian slaves. Although slavery had existed among Indian tribes in the Southeast before the arrival of Europeans, it had generally been a by-product of war. Those captured in battle either lost their freedom or their lives. However, as Indians began to realize that captives could be sold as commodities to Europeans, some groups attacked others with the specific goal of obtaining captives for trade—a practice their English clients encouraged. Indian captives were traded by Europeans as slaves up and down the Atlantic coast and often shipped to the Caribbean. As a result, far more Indians endured captivity than did Europeans—and with far more dismal outcomes. Indian women who were sold as slaves into English households did not have the same opportunities for marriage or religious commitment as did English women taken captive by Indians. They also left behind households that were changing under the impact of trade and conflict.

Seneca Households: "A Perfect Equality"

Among the Senecas, who lived in upstate New York as part of the Iroquois League, women continued to control use of the land in the eighteenth century, farming it while their husbands and fathers hunted and traded animal skins with the British. In their matrilineal clans, they elected a chief matron each year who oversaw their farmwork, distributing parcels of land for women to work and organizing assistance for those who were too sick to cultivate their own crops. The women also organized their own ritual groups, known as Tonwisas, praying to the "three sisters" of corn, beans, and squash for good harvests. They held their own councils and continued to elect male speakers to represent their opinions at the councils held by men. It is little wonder

that Henry Dearborn, the adjutant general of Massachusetts in the early nineteenth century, described the Seneca women as acting "on a perfect equality" with the men in their community. The Seneca household structure, which allowed women to control the land, provided a basis for their political power.

The world of the Senecas was changing dramatically, however, even as Dearborn praised the gender equality in their society. The Patriot forces had burned their fields and villages in 1779, and a smallpox epidemic the following year wreaked even greater devastation. Trade with the British and Americans had flooded villages with alcohol, and excessive consumption had undermined the social fabric of the Senecas. Their population declined from ten thousand to two thousand within a few years.

The impact of this devastation was clear as women struggled to maintain control of their land and the political voice that went with it. They had lost large amounts of territory as a result of their support for the British during the Revolution. Even as they found their territory shrinking, however, Seneca women continued to assert their political voice based on their control of the land. When they wanted their men to engage in peace negotiations with the U.S. government in 1791, they interrupted a meeting between U.S. officials and the Seneca chiefs, arguing, "You ought to listen to what we, women shall speak, as well as to the sachems; for we are the owners of this land—and it is ours. . . ." In 1797, faced with poverty, Seneca women agreed to sell even more land to Thomas Morris, who was acting for his wealthy father, the Revolutionary leader Robert Morris. The decision was a contentious one, but his promise that the money for the purchase would go to the women rather than the men carried the day.

While the loss of much of their land represented one threat to the household power exercised by Seneca women, the cultural values promoted by Quaker (and later Baptist) missionaries represented an even more potent challenge. The Quakers, who established a mission among the Senecas in 1789, promoted not only their religious beliefs but their ideas about gender as well. They encouraged men to take over the farming with the use of plows and urged women to devote their time to spinning, weaving, sewing, and housekeeping. They also encouraged men to spread out their farms, to fence off their lands, and to build individual dwellings for their nuclear families. To a certain extent, the move toward smaller dwellings had been under way for the preceding century because the Senecas and other Iroquois had decided that the large longhouses of the seventeenth century and before were too easily attacked. But the move to organize the family around a couple who lived separate from the larger clan of the woman's mother directly undercut the power that women exercised through their matrilineal and matrilocal households. The changes promoted by the Christian missionaries and government agents split the Senecas into bitter factions. Some families did set up separate houses. Age mattered in these disputes as younger women tended to be the ones most willing to try new ways while older women were at the heart of the resistance movement.

In the midst of these debates, Handsome Lake emerged as the leader of a powerful revitalization movement that directly challenged the power that women had derived from their households. A war leader who fought against the Americans during the

Revolution, Handsome Lake had drowned his sorrows in alcohol in the years following his defeat in the war. But in 1799, he arose from a drunken stupor and began preaching to the Senecas that they should return to the traditional ways of the longhouse. Yet the longhouse he imagined was a far cry from the household structure that had underlay the power of women in Seneca society. His philosophy, which drew on moral tenets of Christianity, promoted a belief in frugality, temperance, and personal behavior. Most important, though, he attacked the traditional power of women in Seneca society. He urged men to give up hunting for farming, and he urged women to focus on their relationships with their husbands rather than on their bonds with their mothers. Older women who challenged Handsome Lake's notion of "tradition" faced ruthless persecution. Handsome Lake branded them witches, arguing that "The Creator is sad because of the tendency of old women to breed mischief." One older woman was murdered as she worked in her fields, and another was executed after a trial by the council.

As Seneca women entered the nineteenth century, they faced a new world of power relationships in which key aspects of their household authority were transformed. Quaker missionaries, who had promoted European-style households, helped the Senecas retain a small part of their lands in upstate New York during the 1830s and 1840s as most Indian tribes were ruthlessly pushed westward by government forces. The Senecas wrote a new constitution for a representative government in 1848, allowing women and men the right to elect judges and legislators and decreeing that all decisions had to be ratified by three quarters of the women as well as three quarters of the men. The Senecas also continued to recognize the economic importance of women's control of the land. This new constitution limited the earlier power structure rooted in households, but it provided women with a direct vote in their government. The federal government had taken over payment of the annuities due to the Senecas as a result of their land sale to Thomas Morris in 1797, and the government insisted on paying the money to male chiefs. However, the chiefs usually distributed the money to the women, recognizing both the women's original land deal and their continued importance. It is not surprising the memory lived on because, regardless of the new political structure, many of the Seneca women continued to farm.

Shawnee Society and the Incorporation of Strangers

Shawnee women saw their household positions challenged in a somewhat different way from the Senecas as their territory in the Ohio River Valley switched from French to British and then American control. Like Seneca women, they faced criticism from men in their society as their tribe struggled for survival amidst an onslaught of Europeans. For Shawnee women, however, criticism focused on their role of incorporating European men into their households.

Shawnee women exercised their political voice both through the women who were their War Chiefs and the women who were their Peace (or civil) Chiefs. These political roles gave women who held them more status than anything they could have gained in marriage. The Peace Chiefs supervised the crops women grew, they counseled war parties against fighting, and they adopted prisoners of war to replace members of their

villages who had died. The War Chiefs, on the other hand, prepared the meat that men hunted and welcomed war parties back into their villages, including the "good meat" men brought in the form of prisoners. Some of the prisoners were, in fact, burned to death and ritually consumed by the tribe.

Shawnee women not only adopted prisoners of war into their society but also incorporated European men into their households through marriage or more temporary relationships. This process of incorporation had worked well with French traders, who adopted Shawnee ways. The British gained control of Shawnee territory in 1763, after the French and Indian War, however, and the Shawnees had to shift their trade from the French to the English. British traders were not so easily incorporated. They would live with Shawnee women, but they were less likely than the French to use that relationship to enter into Indian culture. The gifts of reciprocity that were supposed to accompany these sexual relationships began to change. In earlier times, a piece of meat or a blanket that the woman could use would have been considered the appropriate gift; but British traders sometimes offered women rum, which the women resold to the men in their communities. This introduction of monetary profit into sexual relationships brought protests from Shawnee men and concerns about prostitution. Moreover, close on the heels of English traders were British settlers. These men came with their own wives and were anxious to own and farm Indian land rather than to set up networks of trade. The powers of incorporation that Shawnee women had exercised in earlier years faltered in the face of these new developments.

Compounding these problems, the Shawnees lost lands to the British and then Americans both before and after the Revolution. Their hunting lands were not only severely reduced in size but also depopulated of deer and beaver as a result of overkilling. White settlers who lived near the hunting grounds exacerbated the situation when they demanded that the Indians no longer burn the forests, a strategy necessary to create new growth that would draw deer for feeding. Shawnee villages divided over how to respond to these pressures, and village chiefs sometimes sold land to American settlers whether they had the right to or not because they feared another village chief would do so if they did not.

In the midst of this crisis, a revitalization movement developed among the Shawnees, just as it had among the Senecas. Visions of a return to earlier ways had begun with the dreams of several Indian women. One old woman bluntly told the hunters that their game had disappeared because they were imitating whites, and she commanded them: "You are to live again as you lived before the white people came into this land." Another woman had a vision that demanded an end to "evil, fornication, stealing, murder, and the like." But the most influential prophet was Tenskwatawa, brother of the powerful military leader Tecumseh and himself a failed shaman and alcoholic. In 1805, Tenskwatawa urged his followers to reject the culture they had created through exchange with Europeans: the alcohol, the clothing, the weapons, and the tools. He urged them to slaughter their cattle and other domesticated animals and to once again share the land in common.

Like Handsome Lake, however, Tenskwatawa deviated from his commitment to the past when it came to gender relationships and household structure. He demanded that men and women adopt new gender roles rather than adhering to the old. Men were to farm, not women, he explained. Even more important, women should be subordinate to men. Finally, women were to stop intermarrying with Europeans. Those "who were living with White Men was to be brought home to their friends and relatives, and their children to be left with their Fathers, so that nations might become genuine Indian." The role that women had played in incorporating European men into their societies through marriage was reviled rather than valued, and the significance of those households for female power was challenged as the Shawnees struggled to survive in the nineteenth century.

Inheritance and Power Among the Cherokee

Cherokee women found their positions of power within their households challenged as they negotiated first with the British and then with the United States. Nancy Ward, a powerful Cherokee War Woman, traveled with men from her village to meet with officials of the United States in 1781 to negotiate a peace treaty. "You know that women are always looked upon as nothing," she told the startled commissioners, "but we are your mothers; you are our sons. Our cry is all for peace; let it continue. This peace must last forever. Let your women's sons be ours; our sons be yours. Let your women hear our words." Originally born Nan-ye-hi, Ward had first married a Cherokee warrior, and after his death, a British trader. Moving between the worlds of the Europeans and the Cherokees, she knew that motherhood was a powerful ideal for the Americans she was confronting, but Ward came from a world in which motherhood had different meanings. Inheritance passed through a mother's direct line, and women like Ward had acted as cultural go-betweens in their marriages to French and British traders. As was the case with other Indian groups, their powers in a matrilineal society were challenged by the demands they faced from Americans.

Cherokee women had experienced many changes in their world during the eighteenth century, changes that affected both their economic status and their political power. They had become the anchors of village life, as their men were gone for increasingly long periods of time hunting the animals they needed for trade with the British. Access to land and other goods continued to pass through the female line, though differences in individual wealth were not great. Indeed, in most cases of polygamy, a man married two sisters so that he was only part of one clan, and his wives had control of both the children and property produced in the marriage. Unlike women of other tribes who traveled with the hunt and who faced a growing burden of work in preparing the ever-increasing number of hides, Cherokee women did not significantly alter their workload. They continued to farm while the men hunted. However, because they were not directly engaged in the trade with the British, women also became increasingly dependent on the men of their villages for the goods that were acquired from Europe. By the end of the eighteenth century, for example, Cherokee women made their clothes almost exclusively from the manufactured fabrics acquired through trade.

Even more significant, Cherokee women lost political power as the British demanded that the Cherokees adopt a more centralized political structure. Cherokee politics had been rooted in villages where both men and women found it easy to express their opinions. The British, however, found it difficult to conduct negotiations with one village after another and pressured the Cherokees to hold their councils in one centralized spot. Men had to travel great distances to attend these political gatherings, and women, as guardians of the villages, were left behind, losing a crucial opportunity to debate important issues.

As the eighteenth century drew to a close, the U.S. government urged Cherokee men to farm individual plots of land and women to spin, joining the republic as independent yeoman farmers and virtuous housewives. Cherokee women welcomed the government agents and missionaries who taught them how to make cloth as many of them tried their hand at spinning. However, most women continued to farm as well, sharing land that was held in common by the village. This was just as well, because many men refused to take on what they considered "women's work." Some men did begin to herd domesticated animals. Others, however, either rented farmland to poor whites or used African American slaves to do the farm work for them. Rather than becoming virtuous yeomen, these Cherokee men opted for a life as landlords or masters.

Many of the Cherokees who adopted these new roles were themselves the bicultural products of marriages between European traders and Cherokee women. Because their mothers were Cherokees, they were accepted as full members of the matrilineal clans, but their fathers conveyed to them both wealth and European cultural values that challenged traditional Cherokee mores. European fathers who had accumulated wealth in their trading activities not only had greater sums to convey to their heirs than did most Cherokees but also were unwilling to see their wealth passed on to their wives' families (as matrilineal customs dictated) rather than to their own children. Thus, in addition to introducing new cultural values, European men and their children provided an important constituency agitating for new laws that were more consistent with the republican form of government created and promoted by the United States. Christian missionaries, who had set up schools and churches among the Cherokees, provided further support for these changes.

As the state government of Georgia attempted to take over Cherokees lands, the Cherokees strove to establish their political legitimacy by creating their own republic. The Cherokees ratified a constitution in 1827, which resulted in a new political order that undermined the matrilineal organization of the Cherokees and attacked the power of women generally. Modeling their government on that of the United States in the hope that this proof of civilization would undercut attempts to seize Cherokee lands in Georgia and other parts of the Southeast, the new Cherokee government was divided into three branches, with courts, a legislature, and a chief. Cherokee men sat on the courts, replacing the leadership role women had exercised in determining the fate of captives or demanding vengeance. The National Council passed laws creating a social order that more closely conformed to that of the United States. The council outlawed polygamy and promoted nuclear families headed by a father. The children of Cherokee

men who married non-Cherokee women were granted membership in the Cherokee Nation, opening up access to the community through the father as well as through the mother. These laws complemented the one that had been passed in 1825, dictating that if a man died without leaving a will, his property would be divided among his children and spouse rather than being directed to the wife's clan. The only laws that were passed protecting women's power came with the creation of several married women's property laws. In part to protect women (and the Cherokee Nation) from unscrupulous traders who sometimes married Cherokee women to gain access to their property, these laws recognized the right of married women to own their own property and shielded them from having to forfeit their property to pay their husbands' debts.

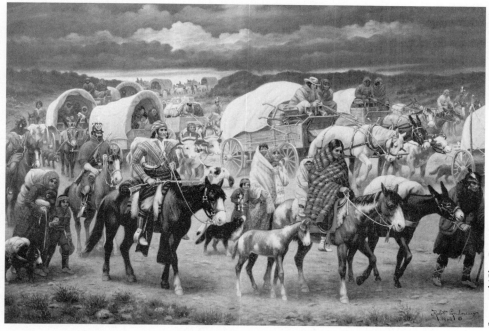

Superstock/Glow Images

As this twentieth-century painting makes clear, the Trail of Tears involved the massive uprooting of families throughout the southeastern United States. Thousands perished during the long journey.

Probably no group went further than the Cherokees in their attempts to adopt the values of civilization promoted by the U.S. government. Yet, in the end, it gained them little as settlers from the East pressured them for their lands and the federal government abandoned talk of acculturating Indians into the republic. Even women such as Nancy Ward,[3] who had worked so hard to promote cultural as well as economic exchanges between Europeans and Cherokees, began to urge resistance. She and other Cherokee women signed a petition in 1817 urging the men of their council to not cede any more lands. Women submitted another petition in 1818. When the U.S. Congress

passed the **Indian Removal Act** in 1830, Cherokee women again protested their loss of land. The Cherokees successfully challenged the act in the Supreme Court, but Andrew Jackson refused to support the ruling. By 1838, sixteen thousand Cherokee women and men were forced westward to Oklahoma on the infamous **Trail of Tears**.

Read about "A Cherokee Leader"

Nancy Ward (c. 1738–1822) was a Cherokee War Woman whose life spanned the eighteenth and early nineteenth centuries. She first married a Cherokee warrior and later a British trader. She was active in promoting interactions of the Cherokee with the British and later with their successors in the United States. Although she supported many diplomatic missions, she did not support the sale of Cherokee lands to Euro-Americans.

Review the source; write short responses to the following questions.

1. How did Nancy Ward use the concept of motherhood in her petition? How would her concepts of motherhood compare to those of women of European ancestry?
2. How did Nancy Ward show an understanding of American values in this petition?

For Cherokee women, as for other Native American women, the demands of the American government that they adopt the gender roles of Western culture cost them dearly. Those who did acculturate were still forced from their lands in most cases. More important, women had lost the power in their households that had given them a forceful voice in governance and in the creation of their societies.

SLAVERY AND FREEDOM IN LOUISIANA

The experiences of Seneca, Shawnee, and Cherokee women suggest the ways in which indigenous North American households were being transformed as a result of contact with Europeans. However, these were not the only kinds of changes that affected the status of women. In the Louisiana Territory, a growing European population that was predominantly male relied on slavery and the racial coding of inhabitants to create new kinds of households. As the Louisiana Territory shifted from French to Spanish to American control, African American and Indian women, in particular, recalculated their positions within households along with their opportunities for freedom in the shifting legal structure.

The Louisiana Territory was a vast expanse of land stretching from the Mississippi River to the Rocky Mountains, including New Orleans and St. Louis on its eastern end and brushing up against the outskirts of Santa Fe on its western end. France claimed much of the territory in the first half of the eighteenth century but ceded control to Spain in 1763 after losing the French and Indian War. The Spanish secretly returned the territory to France in 1800, and in 1803 France sold rights to the land to the United States.

Jason England/Fotolia

Born into a Shoshone Indian family, Sacajawea, with her two-month-old child and husband, joined the Lewis and Clark expedition on one of the most famous journeys across the United States. She assisted with cooking, laundry, finding food, and translation. Reaching Shoshone Territory, Sacajawea also provided information about the terrain and served as the chief interpreter.

The following year, President Thomas Jefferson commissioned Captain Meriwether Lewis and Captain William Clark, both officers in the U.S. army, to explore this new acquisition. The famous expedition lasted for over two years and involved a trek from St. Louis to the Pacific Ocean. Guiding the men was a French trader, Toussaint Charbonneau, and one of his Indian wives, Sacagawea, a fifteen-year-old girl whom he had acquired as a slave. Sacagawea's status as both wife and slave suggests the kind of complicated household relationships that had evolved for some women in the Louisiana Territory.

Read "Sacajawea Interprets for Lewis and Clark"[4]

In 1804, Meriwether Lewis and William Clark hired Toussaint Charbonneau, a French-Canadian fur trader, and Sacajawea, one of his Indian wives whom he had acquired as a slave, to assist them in exploring the Louisiana Purchase. In their travels, Sacajawea eventually encountered the family she had left behind, though her meeting with them was strained.

Review the source; write a short response to the following question.

1. Based on this passage, how would you describe the importance of Sacajawea's presence to the Lewis and Clark expedition?

The Traffic in Women

French traders arrived in the Red River Valley, along the Texas and Louisiana border, early in the eighteenth century. Their trade centered on animal skins, horses, and slaves, for which they gave the Indians guns and other products manufactured in Europe. The French were happy to trade with any Native Americans who were willing, but the alliances of various Indian tribes in the region dictated that those trading partners would be Caddos, Comanches, and Wichitas but not the Lipan Apaches, whom these other tribes opposed.

As was the case farther north, French traders cemented their trading partnerships with Indian tribes through their relationships to women (see Chapter 2). Thus, Caddo women married to French traders gained status as go-betweens, facilitating deals made by the men. However, the French also sought Indian slave women for their households, both to satisfy their sexual desires and to do domestic work. The Caddos, the Comanches, and the Wichitas captured slaves as part of their ongoing warfare with the Lipan Apaches in Texas. Realizing that slave women were a valuable commodity, these tribes increased their raids on the Lipan Apaches and solidified their trading relationships with the French through this exchange.

It was only after the Spanish began to govern the Louisiana Territory in 1769 that the fortunes of Apache women began to change. Indian slavery was not legal in New Spain. Although the Spanish government ignored the enslavement of Indian women elsewhere in its empire, Louisiana was a different story. These women were being exchanged for guns and ammunition that Indians used to fight the Spanish in Texas and New Mexico. Spanish authorities were eager to end this trade and so quickly reminded inhabitants that Spanish law prohibited the enslavement of Indians and requested that residents holding such slaves register them. Many Apache women who had been held in bondage were freed. In some cases, French owners married their slave women at the same time that they freed them. Ana Maria, an Apache woman who had been the slave of François Morvant, became his wife. Similarly, Françoise, another Indian captive, became the wife of her former owner, Pierre Raimond. While some of these women who were freed may have wanted to marry their former masters, it is not clear that all did. Some women may have simply been forced to exchange one form of legal servitude for another. One eighteen-year-old Apache woman, for example, did not marry her master after he freed her but, rather, signed an agreement that she would continue working for him.

Far fewer Indian women than African women were enslaved during the eighteenth century, and their percentage of the slave population declined even more dramatically after the Spanish took over the territory. However, even into the nineteenth century, some Indian women continued to be held as slaves in the Louisiana Territory. Sacagawea's experience, farther north, is a clear example of that continuing tradition.

New Orleans and Urban Slavery

Just as Indian women—both slave and free—were important participants in the French households of the Red River region, African women were important to the French households of New Orleans. African slaves had been brought to New Orleans

beginning in 1719, shortly after the city was founded. By the time New Orleans was incorporated into the United States in 1803, slaves constituted 40 percent of the rapidly growing population of eight thousand people. More of these slaves were female than male precisely because so many slaves were used for domestic work.

Slave women were also laundresses and seamstresses, sometimes working directly for their owners but at other times hiring themselves out and remitting at least part of their earnings to their masters, other slave women carried baskets of food or dry goods on their hips and heads as they went door-to-door with products from their owners' stores. They sold vegetables they had raised on their own plots, either keeping the profit or splitting it with their masters. These opportunities for wage work, combined with the widespread participation of slave women in the marketing of local goods, meant that slave women in cities were much more likely to accumulate capital than were slave women living on plantations.

Slave women in New Orleans sometimes used that money to set up their own households, independent from their masters, but even more important, they used it to buy their freedom. Purchasing freedom under French law had not been easy, but it was possible. A master had to initiate the process and agree to it, but it was possible for a slave to purchase her freedom. By 1769, when the Spanish officially began to govern, 7 percent of New Orleans was made up of these **libres**. Spanish law, however, offered far more opportunities for purchasing freedom. The Spanish practice of **coartación** allowed slaves to purchase their freedom if they wished, even if their masters opposed the sale. The slave woman had to be assessed to determine her economic value, but once her price was agreed upon, she could gain her freedom if she produced the money for her purchase. Under Spanish law, slaves also had the right to own property. Thus, although it was difficult, some slaves were able to acquire enough capital to purchase themselves. Maria Luisa, for example, was able to purchase her own freedom and that of her four children in 1772 for a cost of five hundred pesos. When women could not muster enough resources to pay for the freedom of themselves and their children, they would remain in slavery while purchasing the freedom of their children, as Margarita did when she paid her master two hundred pesos to buy the freedom of her two-year-old son, Pedro. Thus, slave women in New Orleans constructed households that were complicated by a variety of different legal obligations between parent and child, but they had greater autonomy than slave women in the British colonies and in the new United States.

Once the United States took control of New Orleans, these self-purchases became far more difficult. The Black Code of 1806 forbade the **manumission** of slaves under the age of thirty and required those who became emancipated after that time to leave the state. Some slaves still managed to become free, such as Marie, a slave of Jean Baptiste Laporte, who was guaranteed the right to purchase her freedom when she was sold to him in 1827. However, by then, slavery was becoming a much less important mode of labor, associated more with the plantation agriculture that lay outside of New Orleans than with the domestic service in city households. As the population of New Orleans boomed during the antebellum period, reaching over 100,000 by 1840 and 168,000 by 1860, the percentage of slaves living in New Orleans declined dramatically, constituting only 23 percent of the population in 1840 and 8 percent in 1860. Almost

exclusively employed as servants, the slave population, which had always been predominantly female, became increasingly so. By 1850, there were three slave women for every two slave men living in New Orleans.

Gens de Couleur Libre

In large part because so many slaves were able to purchase their freedom during the period of Spanish control, these libres became a large and relatively prosperous part of the New Orleans population. By 1805, when the United States took over governing the territory, libres constituted one-third of the African American population in New Orleans and about 30 percent of the free population. As was the case with the slave population, this was also a group that was predominantly female, with approximately three women for every two men. While many of these women had purchased their freedom during the years of Spanish control, others had been freed by their masters as a result of long-standing sexual relationships. Among the white population, men had outnumbered women by a significant percentage, and men in the city turned to African women rather than Indian women to compensate for the dearth of European women. Indeed, although marriage between Europeans and Africans was forbidden, during the period of Spanish rule it was possible to petition for exemptions and some couples did. As a result, interracial households existed more openly in New Orleans than in other areas of North America.

Libres acquired not only freedom in New Orleans but also property, though usually not without hard work. At the end of the eighteenth century, most of the female libre household heads were either laundresses or seamstresses, though a few were shopkeepers or ran boarding houses and taverns. Carlota Derneville, for example, purchased her freedom from her father, Don Pedro Henrique Derneville, in 1773 and the freedom of her son Carlos from Santiago Landreau in 1775. During the last quarter of the eighteenth century, she not only ran a tavern but also owned several houses that she rented out. Prudencia Cheval was even luckier. Although she worked as a seamstress, she acquired much of her property through inheritance when her father, Don Francisco Cheval, left her and her two children his entire estate, including a large house. Cheval was able to rent the top floor to a prominent city resident to supplement her income in dressmaking.

The growing number of libres in New Orleans began to create their own culture by the end of the eighteenth century, partially in response to growing discrimination by the white population. Libre women, many of whom were so light-skinned they could be mistaken for white, were required to wear a "tignon" beginning in 1786. These kerchiefs were often worn by slave women in the markets and thus were meant to identify libres with the slave rather than the free population of the city. Libre women responded by turning their tignons into fancy and fashionable headdresses, sometimes adorned by jewels and feathers. In the theaters, churches, and dance halls of the 1790s, nonwhites also were increasingly segregated from whites whether they were free or slave. Libres responded by creating their own public spaces and social events. Second- and third-generation libres also became increasingly more likely to intermarry and set up their own households, rather than forming unions (either formal or informal) with slaves or free whites. This movement was encouraged once the U.S. government took

over New Orleans and libres were legally forbidden from marrying either free whites or slaves, a restriction on household formation that was meant to strengthen the racial hierarchy in the city, bringing it more in line with the rest of the United States.

These legal restrictions were particularly problematic for libre women, who outnumbered libre men. With this continuing imbalance in sex ratios, the custom of **plaçage** emerged among some families in the libre community. Plaçage was not a marriage, but it was a legal relationship. Young white men of means met fair-skinned libre women at cotillions such as the Bal de Cordon Bleu, where mothers carefully supervised their daughters' interactions with the young men. When a plaçage was arranged, the man was expected to provide both a house and financial support for the young woman. Such relationships could end when the young man married, though sometimes they did not, but in either case, the young woman gained some amount of financial independence as a result of her relationship. However, increasingly restrictive laws about racial mixing forced women into households that deviated from the socially respectable norms of legal marriage.

WESTERN FRONTIERS

Women farther west also had to face shifting laws as different countries vied for control of their lands. During the eighteenth century, the northern provinces of the Spanish Empire were both vast and weak. Inhabited by a few settlers, Texas, New Mexico, and California were valued primarily as buffers that protected the provinces farther south. This was a goal that was becoming increasingly difficult to achieve as nomadic Indian bands relying on horses and hunting pressed the Spanish outposts. The acquisition of Louisiana in the 1760s, however, reenergized the Spanish to expand their colonizing efforts in other areas of the North. They aggressively established missions in California and brokered peace treaties with the Comanches and (less successfully) with the Apaches in Texas. By the beginning of the nineteenth century, Spanish settlers had established large ranches in the Rio Grande River Valley of Texas, expanded trading networks in New Mexico, and created flourishing mission farmlands in California. Although each of these areas operated under Spanish and then Mexican law into the nineteenth century, their patterns of settlement and the kinds of households they established varied with each region. As a result, women in Texas, New Mexico, and California operated within very different systems of household power. Some of women's legal rights in these areas would be retained by the Anglo settlers who began moving westward in large numbers during the 1820s, even as Anglo women maintained a strong attachment to the domestic ideals they had brought with them.

Texas: The Challenges of Settlement

Spanish settlement of Texas began early in the eighteenth century as an attempt to defend Spanish borders from French incursions but never surpassed a few thousand settlers. By the end of the eighteenth century, there were less than three thousand settlers who spoke Spanish living in Texas (and this figure includes Christianized Indians). Many of these **Tejanos/Tejanas** lived on large cattle ranches around San

Antonio or along the Rio Grande. Spanish women first came as wives of soldiers, who were granted land in recognition of their service. Some wives became quite active assisting their husbands in the ranching operations that developed, taking over for them if they died. Rosa Maria Hinojosa de Balli, for example, owned close to one-third of the lower Rio Grande Valley at the end of the eighteenth century.

By 1720, the Spanish sought to expand their influence to the northeastern part of Texas, building both missions and **presidios** close to the same Red River Valley area that also attracted French traders. They sent a handful of missionaries, some soldiers, and a few women to these outposts, hoping to convert the Caddo Indians in the area to a life of Christianity under Spanish rule. The Spanish were far less successful than the French were in their overtures to the Indians, not only because they refused to trade guns but also because they refused to marry Caddo Indian women, whom they regarded as heathen. While Spanish soldiers had a long tradition of establishing relationships with indigenous women, most of those relationships were with Christianized Indians. Their lack of interaction with Caddo women was compounded by the failure of the Spanish men to bring enough of their own women to their settlements. The Caddos had little respect for Spanish men who engaged in what the Caddos viewed as the womanly tasks of farming. Moreover, without enough women, the Spanish were unable to maintain their household property or to extend hospitality to their Caddo neighbors.

While the Spanish did not establish successful alliances with Indians in Texas through intermarriage, female captivity did play into their diplomatic strategies. Throughout the eighteenth century, the Spanish struggled to broker alliances with the different Indian tribes who dominated Texas. Both the Indians and the Spanish recognized that the return of loved ones who had been captured by hostile forces could signal peaceful intentions in diplomatic negotiations and pave the way for a diplomatic alliance. In some cases, Indians offered to return Spanish women whom they had obtained through trade to provincial officers with whom they were negotiating. Spanish officials made similar offers of Indian women they had acquired.

Into the nineteenth century, however, the Indians continued to have the upper hand in Texas, as the Comanches, in particular, sought to protect their extensive buffalo territory from encroaching settlers. When Mexico gained independence from Spain in 1821, the fledgling government responded to the problem of the sparsely settled province of Texas—and the fear of Indian raids—by establishing formal agreements with **empressarios** from the United States who promised to bring settlers into the territory in exchange for large grants of land. The most famous of these agreements, but not the only one, was with Moses Austin and his son Stephen, providing a large tract of land between the Colorado and Brazos rivers. The settlers were supposed to become Catholics and citizens of Mexico, thus strengthening the newly established government of Mexico, but most of the new arrivals resisted these requirements. The terms of the land grants also strongly encouraged the immigration of families rather than individuals. Heads of household received 4,428 acres of pasture for ranching at a price of thirty dollars, four times the amount of land available to single men. In a move to promote cultural ties to Mexico, the laws gave men who married Tejana women additional allotments of

land. Not surprisingly, by 1836, thirty thousand men and women, particularly from the southern states, left behind failed businesses, lost jobs, and infertile land to seek new lives in Texas, overwhelming the population of Mexicans living in the province.

Some of the new arrivals pushed south in Texas, where Tejano settlements such as San Antonio were concentrated, and married into prosperous Tejano families, thus expanding both their political and economic opportunities through their new connections. Most others, however, settled farther north and had far less interaction with the Tejano community, regarding the Catholicism and mixed ethnic heritage of Tejano settlers with suspicion. Settlers to the north preserved a stronger Anglo culture, though with some significant variations. Single settlers usually came from Protestant backgrounds and felt little desire to be married by a Catholic priest, even if one could be found. Eager to gain the land grants that were available to household heads, however, many engaged in a substitute for marriage that had been created by Stephen Austin in 1824 as a response to the lack of priests available to perform marriages. Couples who signed a formal contract indicating their intention to marry, stipulating that they would pay a penalty if they reneged on their promise, were considered to be married. These **bond marriages**, which were usually accompanied by great festivities and a ceremony in front of the town commissioner, not only offered couples access to the larger land grants but also were easily dissolved if the relationship did not work out.

Anglo women who moved into Texas during the period of Mexican rule received the same property rights as Tejana women, and they used them. Under Spanish law, women were entitled to retain the property they brought into a marriage and also had the right to half the property acquired during the marriage. Married as well as single women ran shops, restaurants, and hotels in towns, handling business accounts and banking transactions. They also supervised their ranches and negotiated contracts when their husbands were absent. Indeed, Anglo women were probably called upon to take over for their husbands more than Tejana women were because many of the Anglo men traveled for business purposes, leaving their wives to take care of their homesteads.

The huge Anglo influx from the United States quickly tipped the balance of power toward the newcomers, who fought for control of Texas in a war of independence from Mexico in 1836. Women's property rights were preserved after Texas became an independent republic. Recognizing the importance of the formation of households in the settlement process, legislators argued that given the blood and sweat women had poured into building their homesteads, they deserved to keep them. These property rights were important not only for married women and widows but for divorced women as well. In the new republic of Texas, judges routinely awarded wives half of the community property from their marriages and all of the property they had brought into their marriages, even if the wife was judged to be the guilty party in the divorce. Repeatedly, the judges indicated that the women had earned this property and they deserved to keep it. As Texas became first an independent republic in 1836 and then a U.S. state in 1845, community property laws were privileged over the British common-law traditions that would have transferred landholdings to the husband, creating an important variation in the kind of power U.S. women held within their households.

New Mexico Women and Trading Networks

Unlike the case in Texas, neither Spain nor Mexico needed Anglo women to gain control of New Mexico. The Spanish reasserted control over the province of New Mexico between 1692 and 1696, about a decade after the Pueblo Revolt (see Chapter 2). During the eighteenth century, the Pueblo Indian population dropped to almost half the size it had been in the seventeenth century, finally leveling off at between eight thousand and ten thousand people. Under Spanish domination, the Pueblo tribes increasingly shifted from matrilineal to patrilineal societies. While the Pueblo population stabilized during the eighteenth century, the Spanish population grew. By 1760, seventy-five hundred Spanish settlers were spread throughout New Mexico, and by 1800, the population had reached twenty thousand. This population grew particularly during the last two decades of the eighteenth century after the Spanish government abolished many of the trade and travel restrictions that had existed in the northern province, fueling an expansion of entrepreneurial activity and farming.

Spanish women who migrated to the area often showed the same entrepreneurial skills as their husbands. Gertrudis Barcelo became the owner of one of the most successful gambling operations in Santa Fe. When necessary, she used the courts to pursue her financial interests, as did other women such as Manuela Baca and Ursula Chavez. Often these women were in business with their husbands, but their economic independence was clear in the many legal transactions they carried out. Indeed, in some cases, they used the courts to remind their husbands of their legal rights in business deals. Francisca Romero sued her husband for using her burro to pay a gambling debt, and Gregoria Quintana hauled her husband into court for selling her grain mill without consulting her.

View the Profile of __Gertrudis Barcelo__

Gertrudis Barcelo was born into a wealthy Mexican family in 1800 and moved to Albuquerque while still a child. After she married, she and her husband set up a gambling hall near the mining camps of Santa Fe. A successful businesswoman, she regularly used the courts to collect gambling debts from patrons who did not pay up.

Spanish households on the New Mexican frontier also expanded with the widespread acquisition of Indian slaves. Although holding Indians as slaves was illegal in New Spain, rescuing them was not. In a thinly veiled set of laws that allowed Indian slavery to exist, the Spanish government urged its colonial settlers to redeem slaves by purchasing them, baptizing them, and then allowing them to work off their purchase price through years of servitude to their Spanish masters. Purchased at trade fairs or in individual exchanges, women were preferred over men and cost twice as much. Most of the Indian women who were acquired this way ended up as domestic servants, though definitions of household responsibility could be expansive. Certainly, they possessed the abilities to farm, so that some of them may have taken on extensive agricultural chores. In other cases,

women produced items for trade. Navajo slave women, in particular, became famous for producing woven blankets. Combining Mexican traditions with those of the Navajos, their watertight "slave blankets" were woven on an upright loom rather than on the horizontal type used by Mexicans but used Mexican dyes and a Mexican diamond pattern.

As many as three thousand **genizaros and genizaras** (Indian slaves) entered New Mexican households through this strategy of rescue, creating what would eventually become a lower caste. As in so many other frontier societies, genizaras sometimes became concubines of their masters or were subjected to abuse by other Spanish men in their households. Their children, however, became an increasingly significant percentage of the Spanish population in New Mexico. As the children of genizaras gained independence from the families that had purchased their mothers, they often were encouraged to settle in outlying areas of the New Mexican frontier where they might create communities that would serve as military buffers between Mexican settlements and the Indian population. These communities were not only military buffers but also cultural ones in which New Mexican genizaros traded and intermarried with their Indian neighbors. The villages they created proved to be strongholds of resistance to both the Mexican government, when it tried to impose new taxes, and the U.S. government as they tried to govern the area during the Mexican War. New Mexican villagers joined with Pueblo Indians in 1847 to attack and kill Charles Bent, the U.S. governor in Taos.

California Missions

In California, more than in other Spanish regions, the mission system was used vigorously to draw Indian women into the Spanish plans for domination. Spain had shown little interest in California until the middle of the eighteenth century, when the Russians began setting up trading posts in the area just north of what is now San Francisco. Spain quickly retaliated by establishing several military garrisons to challenge the Russians and by authorizing the Franciscans to create a string of missions to convert and "civilize" local Indians. Beginning in 1769, Father Junipero Serra, a Franciscan monk, led an effort that would ultimately result in twenty-one missions along the coast of the California territory. As had been the case with mission attempts elsewhere in New Spain, the goal was to convert the local Indians to Christianity as well as to European methods of farming and norms of family structure. If the efforts were successful, the Indians would make good allies and good workers.

The first years of conquest were rocky, however, as soldiers sometimes attacked Indian women, undercutting efforts of the government to convert Indians to both Christianity and Spanish ways. One friar in California complained to his superiors that conversions had dropped because Indians were disappearing into the mountains so that "soldiers would not take their women." At the San Gabriel Mission, early attempts at conversion came to a screeching halt in 1771 when the rape of a young Indian girl sparked a revolt by the local Indian population.

In a move to civilize the soldiers as well as the Indians, Spain moved quickly to encourage the immigration of families and women to California. Christianized Indian families were recruited from Baja California in 1773 and from New Spain in 1774 to

help run the missions and to provide a model of behavior that could entice local Indians to join in the mission endeavors. The families were few, at first. Only one family was placed at the San Diego Mission, for example, where it was hoped the woman of the family would "teach the Indians to sew and knit the wool which was beginning to come in from the sheep" of the mission. Most of the women who came from New Spain were married to the blacksmiths and storekeepers, and almost all of the women returned to New Spain when their husbands had served out their contracts. A larger group was enticed to make the arduous trek from Mexico in 1775 when promises were made of food, clothing, and pay to impoverished mestizos who had fallen on hard times. Women, for example, were promised skirts, blouses, petticoats, stockings, and shoes. The women included Feliciana Arballo, who had to cajole her way onto the expedition after her husband died. The authorities were reluctant to take a single woman, particularly one with two small children, but the impoverished widow prevailed and survived the overland journey of 165 days, which only stopped occasionally when women gave birth. Given these hardships, it is not surprising that by 1790 there were still less than one thousand settlers of Spanish descent in California and that almost two-thirds of them were men.

The Christianized women who came from Mexico and Baja California taught Indian women how to cook and sew as Europeans did, and they also worked as midwives and supervised the distribution of food to the Indians who lived there. Apolinaria Lorenzana, who had been brought to California from Mexico as a child, developed her medical skills to the point that she took care of the patients at the mission hospital despite the protests from a local priest. Lorenzana had broad powers at the San Diego Mission, where she taught sewing and oversaw the inventory of goods purchased for the mission. Eulalia Pérez occupied a similar position at the San Gabriel Mission.

Read **"Supervising a Spanish Mission"**

Eulalia Pérez[5] (c. 1766–1878) moved to the San Gabriel Mission, where her son was a guard, after her husband died in the early nineteenth century. Her responsibilities grew during her years at the mission, so that eventually she was responsible for the well-being of hundreds of Mexicans and Indians living within the complex. She, like other Mexican women, was part of an ambitious effort on the part of Spain to expand its control over California at the end of the eighteenth century.

Review the source; write short responses to the following questions.

1. What sort of activities did Eulalia Pérez supervise? How did those activities compare to the activities of women in the cities of the east coast, described at the beginning of the chapter?

2. How would you compare the activities of Eulalia Pérez with those described by Eliza Lucas Pinckney? What larger forces would account for the similarities in their activities? What larger forces would account for the differences in their activities?

The young Indian girls whom Lorenzana and Pérez instructed were brought to the mission as they approached adolescence and kept in a dormitory known as a *monjerio*, where they were locked in at night to protect their virginity. When they married, they would be allowed to leave with their new husbands to set up their own households. However, some of the young **neophytes** did not come willingly, according to foreign observers. Missionaries accompanied by bodyguards searched native villages for volunteers to join the mission, but when Indians refused the invitation, the friars took young female captives. Their expectation was that families would eventually follow the girls to the missions to be with them and that the Indians would be less likely to attack the missions if they knew their children were held inside. Reports of these strategies led church officials to urge greater restraint among its priests when searching for recruits.

Some of the young Indian men and women of the missions embraced the Catholicism and the social mores of the Spanish. Marriage among Indians in California carried diplomatic consequences in building family alliances, so parents of Indian girls usually chose spouses for their daughters (albeit after consulting with them). The friars deferred more clearly to the wishes of young women, as long as they chose Christian spouses, an option that some girls preferred. Moreover, while the Spanish taught young women to be deferential to their husbands, the friars also stressed that women were the moral guardians of their households. Isadora Filomena de Solano was proud of her role in convincing her warrior husband not to slaughter the Indians he conquered but to turn them over to the mission where they would work. The young men and women who embraced Spanish ways were trained as farmers, artisans, and domestic workers, making the mission lands in California extremely productive. As they married, they were often given the opportunity to leave the mission and move into a whitewashed hut nearby, with their own chickens, creating the kinds of households the friars wished to promote.

Other Indian women, however, suffered from the regime of Christianity imposed on them. Many Christianized Indians did not fully embrace the Spanish ideal of monogamy and continued to have sexual relations with others besides their husbands and wives. Others practiced abortion or infanticide. Chumash women, for example, believed they had to kill their firstborn if they were to be successful bearing future children. The friars thus began to assume that most miscarriages were intentional and began a campaign of public shaming. Women who had miscarriages were forced to carry wooden dolls or logs about the size of a baby for several days after the incident.

Huge numbers of both male and female Indians died in the early nineteenth century as a result of epidemics that ranged from smallpox to syphilis, but women had higher death rates than men. Women had constituted about half of the Indian residents of missions in the late eighteenth century, but by the nineteenth century their proportion in the mission population was dropping. As a result, mission raids on Indian villages increased, and women were specifically targeted to replace the dying mission populations.

The mission period came to an end in the 1830s when the government in Mexico moved to secularize the lands held by the church. Some Christianized Indian households received small plots of land, and a few Christianized Indians with powerful ties to the government received larger landholdings. But most of the mission land was sold

to **Californios/Californias**, as Mexican citizens living in California called themselves. About 13 percent of the land grants went directly to women. Daughters in these Californio families, however, inherited land equally with their brothers, creating large dowries in land for many of these young women. New household structures quickly began to coalesce as Anglo traders, particularly from the United States, began to move into the area and marry these land-wealthy Californias. The European household structure that the Spanish had hoped to use to control the land of California was firmly put in place, but the Indians whom they had tried to convert to this system did not benefit. Rather, American settlers from the East were integrated into Spanish households, providing an entrée for Anglo men and facilitating trade relationships with the United States.

The Overland Trails

Although the United States did not acquire territories in the far West until the 1840s, movement from the eastern United States had begun in earnest two decades before with immigration to Texas. By the 1830s, Americans had begun travel on overland trails that originated at the Missouri River, heading northward on the Oregon Trail all the way to the Oregon Territory or cutting off and heading south into California. Farther south, they followed the Santa Fe trade into New Mexico. By 1845, five thousand settlers had moved west to Oregon and almost three thousand had moved to California. As Anglo women moved westward, they brought with them ideals of female behavior and family life that they found superior to those of Mexican and Indian women and that they hoped would triumph in a new western United States.

Read about "Women on the Oregon Trail"

As Anglo women moved westward, they brought with them ideals of female behavior and family life that they found superior to those of Mexican and Indian women and that they hoped would triumph in a new western United States. Catherine Sager Pringle emigrated with her family first from Ohio to Missouri and then eventually further west on the Oregon Trail. Elizabeth Dixon Smith Geer travelled with her husband and children from Indiana on the Oregon Trail. Maria and Stephen King made a similar and more successful journey.

Review the sources; write short responses to the following questions.

Catherine Pringle[6]
Elizabeth Dixon Smith Geer, Journal (1847, 1848)
Maria and Stephen King
Overland Trails map[7]

1. How did these female diarists deal with death on the Oregon Trail?
2. Compare the experiences of each of these families in their westward treks. What factors most affected the perspectives of these diarists in their view of the west?
3. How did the different writers describe Native Americans?

Leading the way were Narcissa and Marcus Whitman, two Presbyterian missionaries who pioneered travel on the Oregon Trail in 1836. They established a mission school for the Cayuse Indians in the Walla Walla Valley, hoping to convert local Indians and civilize them, though their efforts in this regard were not terribly successful. The Whitmans grew increasingly frustrated with the refusal of the Indians to change their religious beliefs or their social relationships. The couple was more successful at promoting change by convincing other Americans to migrate west. Narcissa's letters back to her family and to missionary magazines fueled interest in the West, as did her husband's attempts to promote migration. In 1843, Marcus returned to the East and led a "Great Migration" of one thousand settlers westward. Unfortunately, the settlers brought diseases such as measles that killed many of the local Indians. In 1847, the Indians retaliated, killing Narcissa and Marcus, along with ten others.

Read "A Missionary's Perspective"[8]

Narcissa Whitman and her husband Marcus immigrated to the Walla Walla Valley in 1836 as missionaries. They wrote extensively of their work and kept missionary societies in the East appraised of their progress in spreading Christianity. They were murdered by Cayuse Indians in 1847, however, after the Indians blamed them for an outbreak of measles in the area.

Review the source; write short responses to the following questions.

1. What sort of maternal obligations did Narcissa Whitman feel toward the three Indian children that she and her husband have taken in?
2. What sorts of misunderstandings existed in Narcissa Whitman's perception of Native American customs?
3. What larger changes in the United States was Narcissa Whitman a part of?

Narcissa Whitman was not the only woman to promote westward movement. Even more influential was Jesse Benton Fremont. The headstrong daughter of the U.S. senator from Missouri, Thomas Hart Benton, she eloped with the impoverished John C. Fremont. With the patronage of his wife's powerful father, Fremont was given the opportunity to survey the Oregon Trail during 1843 and 1844. Jesse did not go with him, but she did write much of his report, using powerful language that provided not only a scientific description of the West but also an exciting and accessible image of a land ripe for settlement. Although the book acknowledged the dangers and difficulties of westward travel, it also described homey camp scenes of children frolicking and cows grazing. The best-selling book convinced thousands of Americans that they could make a new home in the West, with the kind of family life they recognized.

Both Narcissa Whitman and Jesse Benton Fremont promoted a vision of westward settlement that convinced Americans the West could and should be theirs. The two

women wrote of a land that could be settled and farmed as well as Christianized and civilized with homesteads that closely resembled those found in the East. In promoting this vision, they helped to create a belief in what would soon be called **Manifest Destiny**. The term was coined by a Texas newspaper in 1845, suggesting that the United States had a divine mission to extend its democratic spirit and Christian principles as far west as the Pacific Ocean. As an ideology, Manifest Destiny became crucial in legitimating American conquests both on and beyond the North American continent. While it was a tool of war used by men, it was also a concept rooted in ideas of spreading American home life and setting up the American household as a model to be adopted by all. This was the part of the ideology that many women from the United States carried forward in the conquest of foreign territory.

CONCLUSION

By the early 1850s, the United States spread from the Atlantic Ocean to the Pacific Ocean. The process of incorporating territories that had been dominated by the French and Spanish, as well as many Indian tribes, was fought not only in battles but negotiated in households as well. The place of the household within the larger political order mattered, as did a woman's status within a family, her choice of marriage partners, and her ability to inherit and control property. Not surprising, then, was the fact that women in different frontier regions found their places within their homes shifting with the demands of trade and politics.

Household ideals were important not only on the frontier but also in the lives of all women in early nineteenth-century America. Women in the North and the South also had to confront key differences in their household structures. As the new government of the United States expanded, they also had to confront both the extent and the limits of their household authority in a world in which democratic political participation was becoming increasingly important.

 Study the **Key Terms** for Frontiers of Trade and Empire, 1750–1860

Critical Thinking Questions

1. Compare the experiences of Seneca, Shawnee, and Cherokee women in confronting the changes to their households as a result of contact and trade with the British and the Americans.

2. Compare the ways in which African women and Indian women were affected by changing laws of slavery and freedom as control of the Louisiana Territory shifted from France to Spain and then to the United States.

3. How did Spanish laws of property affect women as they settled the frontiers of Texas, New Mexico, and California?

Text Credits

1. James E. Seaver, *The Life of Mary Jemison: The White Woman of the Genesee* (1824), 5th edition, (New York: J.D. Bemis, 1877).
2. Narrative of the capture and providential escape of Misses Frances and Almira Hall, 1833.
3. Karen L. Kilcup, ed., Petition of Nancy Ward and Other Cherokee Women to the United States Congress, 1818, in Native American Women's Writing, 1800–1924: An Anthology (Malden, MA: Blackwell, 2000), pp. 29–30.
4. Meriwether Lewis and William Clark, *History of the Expedition of Captains Lewis and Clark,* 2 Vols. (Chicago: A. C. McClurg & Co., 1924), pp. 406–411.
5. Eulalia Perez, "Una vieja y sus recuerdros dictados," BANC Mss C-D 139, Bancroft Library, translated and reprinted in Carlos N. Hijar, Eulalia Perez, and Agustin Escobar, *Three Memories of Mexican California* (California: University of California, 1877), pp. 78–81. Copyright © 1988 Friends of the Bancroft Library, University of California at Berkeley. Reprinted with permission.
6. Catherine Pringle, Elizabeth Dixon Smith Geer, Journal (1847, 1848), Maria and Stephen King.
7. Overland Trails map.
8. Narcissa Whitman (to her sister and brother-in-law), *The Letters of Narcissa Whitman, 1836–1847* (Fairfield, WA: Ye Galleon Press, 1986), pp. 128–131.

Recommended Reading

Juliana Barr. *Peace Came in the Form of a Woman: Indians and Spaniards in the Texas Borderlands.* Chapel Hill, NC: University of North Carolina Press, 2007. An important analysis of the ways in which tribal affiliation and diplomatic concerns resulted in different experiences for Indian women interacting with both the French and the Spanish.

Virginia M. Bouvier. *Women and the Conquest of California, 1542–1840: Codes of Silence.* Tucson, AZ: The University of Arizona Press, 2001. Interesting study of the ways in which Native American women faced the challenges posed by Spanish colonization.

Kimberly S. Hanger. *Bounded Lives, Bounded Places: Free Black Society in Colonial New Orleans, 1769–1803.* Durham, NC: Duke University Press, 1997. A valuable scholarly analysis of how free black society in New Orleans emerged.

Theda Perdue. *Cherokee Women: Gender and Culture Change, 1700–1835.* Lincoln, NE: University of Nebraska Press, 1998. Fascinating study that rewrites Cherokee history around the issue of the rights and status of women.

CHAPTER 5

DOMESTIC ECONOMIES AND NORTHERN LIVES, 1800–1860

LEARNING OBJECTIVES

- How were women's lives affected by industrialization?
- How did the market create work for women in the cities and their hinterlands?
- What did it mean to be a middle-class woman in the antebellum North?
- How did race and ethnicity affect a woman's home life?
- What were the domestic ideals expressed in popular plays and novels?

Explore Chapter 5
Multimedia Resources

TIMELINE

1812	War of 1812
1823	Lowell Mills open
1820s	Putting-out system develops in New England
1825	Erie Canal opens
1829	New York State outlaws abortion
1830	Baltimore and Ohio Railroad opens
1837	Sarah Josepha Hale assumes editorship of *Godey's Lady's Book*
1841	Catharine Beecher publishes *Treatise on Domestic Economy*
1845	Irish potato famine begins and Irish immigration increases
1840s	German immigration increases
1852	Harriet Beecher Stow publishes *Uncle Tom's Cabin*
1859	Harriet Wilson publishes *Our Nig*

THE FIRST STAGES OF THE INDUSTRIAL REVOLUTION UNFOLDED IN THE UNITED STATES AS TRANSPORTATION, TECHNOLOGY, AND LARGE CONCENTRATIONS OF CAPITAL REORGANIZED THE WAY GOODS WERE MADE. The **War of 1812** had disrupted shipping routes to Europe, encouraging wealthy merchants to invest in production at home rather than abroad. The **Erie Canal** opened in 1825 and the **Baltimore and Ohio Railroad** in 1830, the first of many waterways and rail lines that efficiently moved goods between seaport cities and regions farther inland. Finally, new forms of machinery, from power looms to steam-run printing presses, were turning out products much faster and more cheaply than had been possible before.

As the United States slowly industrialized, the North also increasingly urbanized. Although most people in the United States continued to live on farms and in rural areas, the percentage of people living in cities increased from 7 percent in 1820 to 20 percent in 1860; and with a few exceptions, those cities were located in the North. The size of cities grew as banks and mercantile houses expanded to facilitate an explosion of economic activity and as immigrants, particularly from Ireland and Central Europe, began to flood American shores.

Manufacturers in the United States often looked to young women as a desirable labor pool in their new industrial ventures. Factory owners knew that most male workers were committed to finding higher-paying jobs as skilled artisans. Ironically, as women became ubiquitous in the new industrial workforce, the very idea that women should work for wages was challenged by an ideology that stressed the importance of domesticity and the home as woman's "separate sphere." Middle-class women, in particular, were urged to stay at home and care for their families. This new cult of domesticity ignored—and even disguised—the economic value of the housework done by women in middle-class homes.

INDUSTRIAL TRANSFORMATIONS

The nineteenth century was a difficult time for many of the young men who came of age. They had expected to train as apprentices in trades their parents helped them choose and then to establish their own shops and to experience the independence that came from being able to support themselves and their families. Indeed, the entire concept of citizenship in the new republic was tied to ownership of land, so owning one's shop meant political independence as well as economic independence. The **Industrial Revolution** made those goals more difficult to attain, as small shops gave way to large industry and ownership gave way to wage work. Many of these men faced the difficulty of living with a smaller income than they expected, and they had to come to terms with the work lives of their wives, daughters, and sisters who took on wage work of their own in these newly transformed industries. Women had to negotiate the meaning of their wages not only for themselves but also for the men in their families. They did so in different ways, depending on where they came from and what kind of work they did.

Factory Families

The earliest textile factories in the United States were not the massive structures that dominated towns such as Lowell, Massachusetts, or Manchester, New Hampshire. Rather, they were small spinning factories located along the rivers and streams of southern New England. Samuel Slater, an English machinist and textile entrepreneur, brought his knowledge of spinning technology to the United States at the end of the eighteenth century and set up some of the first of these mills in Pawtucket, Rhode Island. The factories were small and tended to employ poor families. Fathers made yearly contracts with owners, promising that their children would work at

particular jobs for a stipulated amount of pay. Parents also made sure to negotiate time for schooling as well and, in the case of their sons, sometimes demanded training in one of the more skilled areas of millwork.

Traditional patterns of family authority were maintained in several ways through this arrangement. First of all, the children's wages were paid to their fathers. In addition, fathers and older brothers were more likely to work in the large farmlands owned by the mills rather than in the factory itself, perhaps to avoid conflicts with overseers over supervising their children in the mills. However, most men preferred to work in the fields as more gender-appropriate activity because factory work smacked of subservience. The mothers of these children were also scarce in the factories. Instead, they supplemented the family income by growing vegetables in their gardens, taking in boarders, or perhaps weaving cloth in their homes.

Families were paid not in cash but in scrip, which was credit at the company store. Often the stores marked up their prices, diminishing the value of wages. Mill owners provided company housing for their employees and applied the wages of the children to the yearly rent. However, this practice also meant that families had a difficult time leaving the factories if they became dissatisfied with working conditions.

This fragile structure of family relations gradually crumbled as parents increasingly found themselves unable to control the terms of work for their children. If they objected to the way factory overseers treated their children, they could find their whole family turned out. Mill owners also began to insist on paying workers as individuals rather than as families. By the 1840s, children and teenagers were paid their wages directly, giving them more independence from the father's control. When they were eighteen and thirteen years old, respectively, Amanda and Amy Jepson were placed by their father in a mill in Webster, Massachusetts. Within a year, the girls made enough money to move to a nearby boardinghouse. Amanda and Amy thus experienced the new power in controlling their lives that wage work could give young women.

Independent Mill Girls

The move by these smaller factories to pay their workers as individuals rather than as families was inspired largely by their competition farther north. Places such as Lowell and Manchester were growing with huge, integrated factories that not only spun cotton thread but also wove it into cheap and cheerful fabrics. New technology, particularly the development of the power loom, had mechanized the manufacture of cloth by the early nineteenth century, and factory owners were eager to find unskilled workers to run the machinery. Eschewing the destitute families and child labor that staffed Slater's mills, they looked instead to young single women, ages fifteen to thirty, from farm families throughout New England. The daughters of these farmers often maintained a seasonal routine, working in Lowell for several months and then returning to their families for short visits. Many kept up this pattern—entering and leaving the payrolls of large companies such as the Hamilton, the Appleton, the Suffolk, and the Lawrence—until they married several years later. These patterns of employment were so successful that by 1860, the factories of New England employed over sixty thousand women.

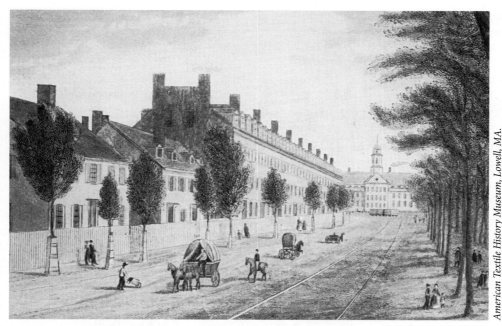

American Textile History Museum, Lowell, MA.

Merrimack Mills and Boarding Houses, Lowell, MA. Boardinghouses were an important aspect of the mill experience in the nineteenth century. They provided young women (and their parents) with the assurance that female mill workers live in respectable circumstances while away from home.

Read about "Young Women at Lowell"

The young women who went to work in Lowell factories during the early nineteenth century were often literate enough to write letters home, as was the case for Barilla Taylor and Mary Paul. They also wrote about their lives in more public forums, such as the *Lowell Offering*.

Review the sources; write short responses to the following questions.

"A Second Peep at Factory Life," *Lowell Offering, Vol. V* [1845][1]
Mary Paul letters
Barilla Taylor letter

1. Summarize what a day was like for a young woman working in a mill in Lowell, Massachusetts, in the early nineteenth century.
2. Why did the young women work in the mills?
3. Compare the descriptions of Lowell in the letters of Mary Paul and Barilla Taylor to that published in the newspaper. Are there any significant differences? If so, what are they?

MAP 5-1 Lowell, Massachusetts in 1832[2]

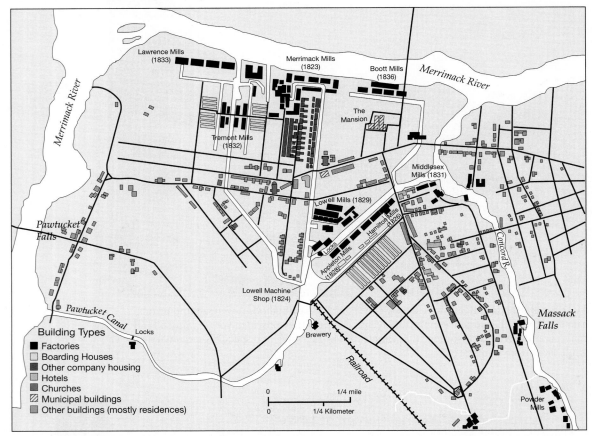

Boardinghouses and factories were located close to one another in Lowell as part of one, large, comprehensive plan for living and working for young women.

For these young women, work in a large textile factory was a ticket to independence. In a factory town such as Lowell, for example, a newcomer could make only about forty-four cents per day, but more experienced workers made from sixty-six to seventy-eight cents per day. These were among the top wages a woman could make at that time, though they were still below what men were paid for similar labor. Some young women contributed their wages to family needs, such as a brother's education or their parents' mortgage, and all were responsible for paying for room and board at their dormitories, but most managed to save some of their wages for their own goals: education, dowries, and new clothes.

Culture and education also drew young women to Lowell. The women patronized a wide variety of **lyceums**, churches, and clubs. Famous authors came from around the country and the world to see the factories and to lecture to rapt audiences. Many of these workers came from country towns where even good sermons were hard to come by, so

Table 5-1 Wages of Lowell Factory Workers[3]

Men		Women	
Job	**Mean Daily Pay**	**Job**	**Mean Daily Pay**
Overseer	$2.09	Speeder	$0.66
Second hand	1.20	Drawer	0.52
Operative	0.85	Spinner	0.58
Machinist	1.27	Weaver	0.66
Watchman	1.10	Dresser	0.78
		Warper	0.73
		Drawing in	0.66
		Sparehand	0.44
Overall	$1.05	Overall	$0.66

Although even the highest paid female workers in a factory did not make as much as the lowest paid male operatives, some women earned high wages for the time, particularly as warpers and dressers.

(*Source:* Thomas Dublin, *Women at Work: The Transformation of Work and Community in Lowell, Massachusetts, 1826–1860*, New York: Columbia University Press, 1979, p. 66.)

the churches were equally exciting. Factory hands usually did not come from families that were able to afford the tuition of a female academy, but with the cultural riches surrounding them in towns such as Lowell, they still got an education. Cheap fabrics produced by their textile factories meant that fashionable clothes also were within their reach.

Still, criticisms were raised about the choices these young women were making. Women were not supposed to work for wages, nor were they supposed to be traipsing around the countryside on their own, so respectability was an issue. One of the ways factory owners in large towns such as Lowell and Manchester dealt with the issue of respectability was to provide company dormitories supervised by a matron. In Lowell boardinghouses, curfews were strictly enforced in an effort to make sure young women spent their nights under maternal supervision. Many young women also exerted peer pressure to make sure their friends behaved, and boardinghouse keepers intervened when they felt their charges were behaving improperly. When Delia Page, a Lowell factory worker, began seeing a married man, the matron refused to let him visit. Delia left the boardinghouse, but both the matron and a former roommate continued to pressure her about the relationship and within a couple of months Delia had given up the unsuitable gentleman.

Family-Wage Economy

The young women in the factory towns of New England were not the only ones swept into the new world of industrialization. Other women found wage work in their own homes, particularly in the rapidly reconstituted trade of shoe making. This sort of

industrialization relied not on machinery but, rather, on a division of labor. In a new **putting-out system**, owners of large shoe companies paid skilled male shoemakers in a central shop to cut leather for premade shoes before handing it out to women across New England for stitching. Sometimes women worked alone, while at other times they worked together. Once their work was returned to the merchant, the shoes were shipped south and west to slave owners and farmers looking for cheap clothing. Women who engaged in shoe binding were paid far less than most female factory workers.

Read about a "Better Life in the Factory"[4]

Ann Swett left a poorly paid job of shoe binding in Haverhill, Massachusetts, to work in one of the large textile factories in Manchester, New Hampshire. While shoe binding was an activity that women could do at home and in the company of female friends, it paid very little. Women were lucky to earn $1.00 per week shoe binding, money that they often used to contribute to their families' comfort. This was approximately half of what a man would be paid for similar work, which was why manufacturers were eager to recruit women as they reorganized the production of shoe making.

Review the source; write a short answer to the following question.

1. What advantages did Ann Swett find in her new life in Manchester, New Hampshire?

Many single women abandoned shoe binding for more lucrative opportunities in the mills, but others did not have that flexibility. Many of the women who worked as shoe binders were married and contributing to a **family-wage economy**. Their husbands were farmers or fishermen who were not making enough to support their families, or their husbands were shoemakers who had seen their incomes decrease as a result of this new industrialization of the shoe trade. So, in between housework and caring for their children, women stitched shoes to help make ends meet. It was not the most lucrative employment available for women, but for those who needed to be at home to care for their children and do their housework, the small amounts of money they made contributed to the economic stability of their families. This family-wage economy was an adaptation of an earlier tradition in which wives and daughters had helped the men in the family making shoes. Binding had traditionally been women's work, but during the colonial era, they had done it for family members rather than for merchants. They had not been paid a wage, but that did not matter because the profits came to their families. In the new system, families lost most of that profit.

Town and Country

While industrialization was transforming the New England countryside, the financial backbone and trading networks that facilitated this new economic world lay in the rapidly growing cities. Here, too, young women arrived from rural areas and took many

of the new jobs available. In cities such as New York, immigrants also poured in from England, Germany, and, most of all, Ireland after 1820, so that a housing crisis ensued. Old houses were broken up into apartments to squeeze in more families. Kitchens and parlors were combined in these newly created tenements, and if lucky, tenants would have a couple of cubicles in back for sleeping.

Seamstresses, Servants, and Shopgirls

In these crowded settings, working mothers struggled to provide a home for their children while trying to earn enough money to feed them. Most did so by taking in laundry or sewing for the rapidly expanding trade in ready-made clothing. During the first half of the nineteenth century, seamstresses in New York earned between $0.75 and $1.50 per week. A single woman might get by on this amount, but a woman trying to support her family could not. As was the case with shoe binders, employers assumed that women were not family breadwinners in the wages they paid, though in many cases women were trying to support their families without the assistance of a husband. Thus, many of the poorest women supervised their small children who scavenged for firewood and food to supplement their mothers' wages. The women also worked as informal tavern keepers, selling food and alcohol to neighbors, often from their kitchens. As a result, their homes were places of work and public socializing as well as places where their families lived.

Single women in New York found the opportunities provided by wage work to be more liberating than they were for mothers with children. Young single women found employment in book binderies and dress shops or in the other small manufactories that existed throughout the cities. However, domestic servitude was the most common form of employment. Although wages in 1835 averaged only $1.50 per week, servants were provided room and board so that they had an opportunity to save some of their wages. Still, domestic work was an unpopular alternative as young women found their social independence curtailed by long hours and strict supervision.

Shopgirls and servants in New York City sometimes joined churches or attended lectures, but many found that the streets themselves offered entertainment. Sallying forth in groups, young women headed to the Bowery, where they encountered high-spirited young workingmen and opportunities for dancing and theatergoing. Young women and their beaux could see variety of shows at Vauxhall Gardens or visit ice-cream parlors, which had become a popular venue for socializing after a new method was developed for cheaply making the frozen delicacy. On summer evenings, they also took boat rides and on holidays, short trips to Staten Island. The young women of the Bowery used their money not only to venture out but also to buy brightly colored clothes that caught their fancy. The bold colors favored by working girls drew attention to their bodies, as did the tighter-fitting skirts they favored. Their hats revealed their faces rather than shielding them from public view. The dress of these workingwomen was fancy enough to show the independence they gained from their wages and revealing enough to signal a rejection of middle-class codes of modesty.

In cities such as New York, where young workingwomen were less supervised than in towns such as Lowell and where the streets were an accepted place of socializing, slight misunderstandings of body language could have severe consequences. A young woman out with her friends was understood to be respectable (and protected) whereas a young woman who ventured out alone faced the possibility of seduction or rape. She could be mistaken for a prostitute, or her solitary state could signal boldness and sexual interest. Court cases from that time reveal a number of women raped by one or more men who assumed them fair game.

Sex for Sale

The streets of large cities such as New York were dangerous for young women in part because the expanding commerce in sex rendered the behavior of young women ambiguous. In New York City, for example, several thousand prostitutes plied their trade during the **antebellum period**, probably somewhere between 5 and 10 percent of the young women in the city. The sex trade was one of the largest enterprises in New York, exceeded only by the clothing trade in terms of dollars spent. Prostitution flourished in a variety of venues; prominent madams staged fancy masquerade balls, and theaters presented "tableaux vivants," living female paintings in which young women posed nude or in transparent clothing.

Women were much more likely than men to run brothels during the antebellum period, when women exercised more control over prostitution than they would later. For some of New York's most successful prostitutes, sex was an important avenue to upward mobility. Maria Williamson owned and operated several whorehouses in New York that were valued at ten thousand dollars in the early 1820s as did other women of the time.

View the Profile of Julia Brown

Prostitute and madam, Brown entered a Manhattan brothel as a prostitute in 1830; shortly thereafter, she left to run a brothel of her own. Dubbed Princess Julia, she was said to have given fabulous balls and been toasted herself at the most distinguished galas of New York's upper crust.

Most of the prostitutes operating in New York at the middle of the century had either been born in the Northeast or emigrated from Ireland. With the exception of madams, who tended to be older, prostitutes were teenagers or in their early twenties. Many had started out in trades such as sewing, shoe binding, or domestic service and found the wages too low for survival. Faced with poverty and deprivation, girls as young as twelve years old (and in one case, nine) contributed to a growing epidemic in child prostitution. Men were attracted to child prostitutes because they were thought to be free from venereal disease. Girls were attracted to prostitution because selling one's virginity could bring a high price. Some child prostitutes were

the victims of rape or seduction; in fact, children under the age of twelve accounted for approximately one-third of the rape and attempted rape cases prosecuted in New York City during the early nineteenth century. In other cases, however, prostitution was a family-sanctioned activity; sex was a vital commodity to sell for family or individual survival.

Read about "Why Women Enter Prostitution"

William Sanger[5] was a physician in New York City during the nineteenth century. During the 1850s, he interviewed two thousand prostitutes there for the Board of Alms-House Governors and published the results in his research work *History of Prostitution* in 1858.

Review the source; write short responses to the following questions.

1. What assumptions were embedded in the survey questions?
2. Did Sanger consider any attributes of identity other than gender in analyzing sexual desire?

Prostitution was, without a doubt, the highest-paying trade available to women, but it was also dangerous. In addition to the likelihood of contracting venereal diseases, prostitutes risked violence in their daily lives. Vigilantes would attack prostitutes and their brothels in moral outrage or, more likely, assault them during a drunken rampage. The three men who broke into Amanda Smith's house "destroyed her furniture" and "beat her on the face and head so as to blind her entirely" before they went after her son.

Butter and Eggs

While factory towns and cities were transforming the landscape of the North, most women still continued to live in rural households during the first half of the nineteenth century. As a result, their domestic lives were tied to farm chores as much as to their homes, giving their lives a different cast from that of their urban counterparts. Particularly in areas that were located near enough to cities to supply them with food, women became an important part of a network of commercial as well as subsistence agriculture.

In the farmland surrounding Philadelphia and Baltimore, for example, many women not only cared for their homes and their children but also aggressively entered the dairy trade, producing milk, butter, eggs, and feathers for the local market. The income from butter could be a significant contribution to a family's income. In the Brandywine Valley of Delaware, the 1850 census shows that the average farm produced $125.00 worth of butter over the year.

Women took their dairy products to market and returned with foods they could not grow such as sugar and coffee or some of the new textiles that were being produced

farther north, providing their families with the new goods becoming available in the booming economy surrounding them. However, these women were entering the new market economy as producers as well as consumers, and their economic role was well recognized. Farmers' almanacs reminded their readers that a good wife must be both industrious and productive in her farm work and that the economic well-being of the entire family was hinged to her efforts. Mothers trained their daughters to help with dairying, and if they had no daughters they relied on slaves or hired girls from poorer families. This recognition of the economic productivity of farm wives differed in some significant ways from the ways in which the roles of women in the rising middle class of the cities were being construed.

PRIVATE LIVES: DEFINING THE MIDDLE CLASS

In cities and towns throughout the North, the new industrial economy meant a change in the living and working arrangements for many who were caught up in it. In earlier years, artisans and merchants had lived above or near their shops, an arrangement that allowed their wives and children to easily help them. Home and workplace were closely associated, if not actually the same. As shops and stores became larger during the course of the nineteenth century, they were more likely to be located some distance from the homes of the owner and his employees. For women who stitched shoes or shirts, their homes were still clearly places of work as well as rest. But for women of the emerging middle class, whose husbands were clerks or shop owners or successful artisans, the workplace had moved and their homes were increasingly viewed as moral and emotional retreats. This did not mean that middle-class women did not work; it simply meant that their work was construed differently than it was for wage-earning women: it wasn't recognized as work.

Hidden Economy of Housework

The housework these women did carried an enormous but unacknowledged value. The cost of cooking meals, cleaning, and laundry was not insignificant. An unmarried man living in a boardinghouse could expect to pay seven hundred dollars per year for such services, a large sum given that the salary of many middle-class men at that time was about one thousand dollars per year. In addition to their unpaid housework, many middle-class women also brought in cash for their families or bartered for goods; some engaged in the more prosaic activity of taking in boarders. In places like Utica in upstate New York, about one in five women cooked, washed, and cleaned for paying guests. In addition, women could earn cash selling kitchen fat, rags, berries, and eggs from their kitchen gardens.

The cash generated by these activities provided the family with important resources for gaining a foothold in the middle class. A mother who took in boarders relieved her teenage sons of the responsibility of working to contribute to the family well-being. As a result, teenage boys could stay in school longer and get the education they needed for the growing number of white-collar jobs. These young men pushed into the middle class aided by the work their mothers carried on at home.

Although a housewife's contribution to the family economy was quite significant, it was hard to recognize. The very houses families lived in muted the economic activity that was occurring there. Parlors grew in importance as the focal point of the new middle class. Furnished with soft carpets and upholstered furniture, these rooms allowed families to demonstrate their middle-class status through the purchase of consumer goods. The mother presided over family gatherings in the parlor, reading to her children or encouraging prayer. She also welcomed friends and hosted social events here, creating the impression that the home was a site of consumption rather than production, a site of leisure rather than work.

Cult of Domesticity

The middle-class home was invested with new significance by many of the leading authors of the day. The home was the place where mothers nurtured Christian consciences, trained young patriots, and fostered civilization. Such work was critical to the well-being of the nation, and it required careful training on the part of the women who were charged with this task.

Read about "Early Advice on Housekeeping"

As young women set up household in the nineteenth century, they increasingly relied on advice manuals for both practical advice and a running commentary on the significance of their work. Two of the most famous manuals were produced by Lydia Maria Child and Catharine E. Beecher. Child eventually became better known as an abolitionist, but her book *American Frugal Housewife* was an early best seller. Beecher was well-known for her educational forays as well as her book *Treatise on Domestic Economy*. Review the sources; write short responses to the following questions.

For Child: Introductory Chapter of *The Frugal Housewife*[6]
For Beecher: Chapter one of *Treatise on Domestic Economy*[7]

1. What were the issues of social significance that Child and Beecher attached to the domestic activities of women?
2. How did the two authors differ in their perspectives on the significance of domestic activities?

No one spelled out the significance of domesticity more clearly than did Catharine Beecher, and she did so in clear practical terms in her best-selling book *Treatise on Domestic Economy*. Beecher first published this book in 1841 and reissued it yearly for the next fifteen years. In 1869, she enlarged and revised the book with her sister, Harriett Beecher Stowe, into another best seller, *The American Woman's Home*. Beecher's book was filled with practical advice for young wives about how to make

their homes run smoothly. She told them precisely how to set their tables, the kind of plumbing system they needed for a good kitchen, and the best kind of diet for a growing family. She gave women tips on how to save time when doing household chores if they could not afford a servant to help them. She showed women how the body functioned so that mothers could attend to sick family members. Beecher did not simply offer practical advice in these works; she also argued for the larger significance of these household activities, championing what scholars have since called the cult of domesticity. She argued that a woman's home was an important complement to the democratic institutions of the new nation and that one could not function without the other. In the home, moral, religious, and civic values were fashioned. Ideals of civilization were upheld.

Domestic Happiness, 1849 (oil on canvas), Spencer, Lilly Martin (1827–1902)/Detroit Institute of Arts, USA/Gift of Dr and Mrs James Cleland Jr./The Bridgeman Art Library International.

"Domestic Happiness," painted by Lilly Martin Spencer in 1849, conveys the family ideals that were so central to middle-class formation in the nineteenth century. Both parents share an intimate bond with the children pictured here, but the mother also shows her dominance within the family as she stands in front of her husband, positioned between him and the sleeping children.

Women like Catherine Beecher believed that women should voluntarily take on the responsibilities of the home to bring order to their society. Others, such as Sarah Josepha Hale, believed that women had no choice. Hale, the powerful editor of *Godey's Lady's Book* from 1837 until 1877, believed that women were innately different from men and spiritually superior to them. Presiding over their homes was not

simply a choice but, rather, the outgrowth of their different natures. Women were physically and psychologically suited to child rearing and housekeeping according to Hale, because they themselves were morally pure. Most important, this was a virtue that meant sexual purity. Women were increasingly imagined as both uninterested in sex and unaware of it. "I would have her as pure as the snow on the mount," claimed one author in *Godey's*, "as pure as the wave of the crystalline fount." The cult of domesticity marked an important turning point in the discourse of gender complementarity. The idea that women were not inferior to men but simply different had been growing during the eighteenth century. Now, this idea of complementarity became a cornerstone of middle-class formation. Women were expected to protect their virtue and provide a private refuge for their husbands in the **separate sphere** of their homes as a counterpoint to the public and morally compromised world of business and politics. The doctrine of separate spheres became an important ideology in the nineteenth century. Even though women engaged in both public and economic activities within and outside their homes, the doctrine of separate spheres argued that respectable women should not do so.

Unfortunately, it was harder for wage-earning women to live up to their ideals of writers such as Beecher and Hale. They had not the time to clean or the parlors to use for private moments of child rearing. Their homes were obviously places of work as well as refuge. As one farm woman noted, "If ever I had a sphere, I must have lost it long ago." This was one of the most problematic aspects of this ideology of domesticity. While democratic on the one hand in assuming that all women could and should live this way, it in fact reinforced distinctions of class because some women due to economic circumstances would not be able to live up to these universal ideals. One of the most important characteristics and contradictions of the cult of domesticity was that while it purported to describe universal, natural characteristics of women, in fact, it described a condition most closely associated with white, middle-class women, particularly in the urban Northeast. The middle class, or bourgeoisie, was formed as a social group around a belief in this ideal. One of the ways the northern middle class became powerful was to argue that its ideals applied to all women, not just women of its own group.

Courtship and Marriage

Just as the middle-class home was no longer viewed as the locus of work in the nineteenth century, the middle-class marriage no longer centered on questions of inheritance and land. The emphasis on love that had been developing in the eighteenth century blossomed in the nineteenth century. While members of the new middle class were certainly aware of economic advantages that could derive from a strategic marriage, they had other avenues in acquiring capital, including their banks and credit ratings. When Mary Smith and Samuel Smith decided to get married in 1834, she wrote to her suitor, "As well as I love my parents—as well as I love my connections to friends—Yet *all* I could resign most willingly—most happily for your sake. . . ." Their romantic love trumped any other emotions she felt for family and friends.

The families that these couples formed were both smaller and more emotionally intense than those of the colonial period. At the beginning of the nineteenth century, American families had, on average, seven children. By 1850, they had only about five or six children, and by 1900 about three or four children. This decline in family size was most pronounced among native-born whites in the urban areas of the Northeast. Here, children were becoming more of an expense than an asset. Whereas children on farms contributed to their family's well-being by taking on a variety of chores, salaried families in the Northeast did not reap these benefits. Indeed, those who set their sights on white-collar work faced the opposite problem of having to pay for educating their sons to take a place in the new middle class.

As family size declined and emotional intensity grew, a new philosophy of child rearing dominated the middle-class home, a philosophy that eschewed colonial practices of corporal punishment in favor of strategies rooted in love and persuasion. Whereas the colonial father whipped a disobedient child, the nineteenth-century mother formed a child's conscience to make the right choice. A middle-class mother was expected to instill internalized controls that young men and women could rely on as they moved from one community to the next looking for work. The ability to display self-control and a strong conscience was critical in the ability to succeed in a business career and to gain access to credit. But, these new forms of socialization also meant that women began to dominate their households during the nineteenth century. As a system of discipline emerged in which the internal restraints of conscience nurtured by the mother replaced the external constraints of physical punishment meted out by the father, women became the heart of family organization. The bonds of intimacy created by the parents were communicated to the children through their mothers.

Read about "Motherly Discipline"

Elizabeth Buffum Chace[8] was the wife of a prosperous manufacturer and was an abolitionist and woman's rights activist from Rhode Island. She worked hard managing her lively family, as is clear in this letter to her husband, Samuel Chace. Review the source; write short responses to the following questions.

1. How did Elizabeth Chace exercise power over her children?
2. Why did Elizabeth Chace wait for her son to "acknowledge his fault"?

Sexual Boundaries

By the middle of the nineteenth century, the idea that women were naturally lusty was long gone. A virtuous, middle-class white woman was expected to know little, if anything, about sex when she got married. Having said this, however, it is clear men and women continued to have sex in the nineteenth century—a lot. Indeed, as married couples sought to limit the size of their families in the nineteenth century, they increasingly associated sex with romantic love rather than procreation. A "Christian

gentleman" was supposed to moderate his carnal passions for the woman he loved, but he was also expected to use sex to promote spiritual intimacy in his marriage.

Unmarried women also continued to have an interest in sex. Young women still developed erotic relationships with their fiancés as they built their romantic relationships. Mira Bigelow thus wrote to her suitor Elias Nason in 1831: "O! I do really want to kiss you. . . . How I should really like to be in that old parlor with you. . . . I hope there will be a carpet on the floor for it seems you intend to act worse than you ever did before. . . . but I shall humbly submit to my fate and willingly too, to speak candidly." What is important about the nineteenth century, however, is her fiancé's response. He made it clear to Mira that he expected her to draw limits when he embraced her. Couples such as Bigelow and Nason were far more careful about premarital sex than their parents or grandparents had been. The premarital pregnancy rate had begun a precipitous decline from its peak at the time of the American Revolution. About 20 percent of the women who married in the 1830s were pregnant, and by 1850, that number dropped to 10 percent. In the mobile society of the nineteenth century, young women could not count on their communities to force a marriage if they became pregnant.

In addition to the romantic relationships they formed with men, middle-class women also formed romantic relationships with other women, though of a very different type. At a time when men and women believed in separate spheres, intimate relationships within one's sphere were an accepted part of middle-class behavior. Young women formed intense relationships with one another at boarding schools and seminaries or in their normal course of socializing. In their letters to one another and in their diaries, they wrote of the electric excitement produced in such relationships, of rapture and pain, and of deeply felt emotions. Indeed, even women married, friendships such as these often continued after the marriage. Making visits to one another, they shared the same bed and each other's embraces. While this kind of physical intimacy would be considered deviant later in the century, it was considered quite acceptable for middle-class women during the antebellum period as long as codes of etiquette were followed. Advice books at the time reminded young ladies that their kissing and caressing should be done while they were alone and never in front of young men.

Controlling Family Size

Middle-class families in the North did not simply get smaller by accident. Men and women were clearly practicing contraception. Some practiced a version of the rhythm method, trying to have sex only when the women were not ovulating. However, until the 1840s, many believed that women were least likely to conceive a child halfway through their menstrual cycle, which was exactly when women were most likely to conceive. Men also could have practiced withdrawal, a method they could have learned about from lecturers on marital physiology, or they could purchase condoms. Until the 1830s, condoms had been fairly expensive, costing about one dollar a piece (close to a week's wages for a workingman), but by the 1860s, condoms could be purchased for half that price and by the 1870s were often only twenty-five cents. Women could use vaginal sponges, as well as metal or rubber shields and **pessaries** (glass

shields) that were early versions of a diaphragm. Many of these devices were meant to stay in for long periods of time, though they were often painful and women had to remove them.

Knowledge of abortion as an alternative form of contraception was also widespread. Until the middle of the nineteenth century, most Americans believed that the fetus came to life about three months after conception in a process called "quickening," the point at which the fetus began to move. Regular medical doctors opposed the practice of abortion, and as the medical profession became stronger, doctors became increasingly critical of midwives and other "female doctors" who performed abortions. However, at the beginning of the nineteenth century, abortion before quickening was legal in all states and even if performed after quickening was seldom prosecuted with much vigor.

During the 1830s and 1840s, however, a variety of states began to pass laws regulating who could perform an abortion and punishing those who performed illegal abortions. Some potions were also outlawed as abortion remedies because they were poisonous. Even so, juries were reluctant to convict people on abortion charges and self-induced abortions, in particular, were largely ignored. New York was the only state to pass more restrictive legislation in 1829 outlawing abortions of any type at any point in a pregnancy except to save a woman's life. In many of these debates, abortion was considered immoral because it was associated with licentious sex and with dangers to the mother's health rather than because it was considered an attack on the fetus. This view affected doctors' attitudes as well as those of lawmakers.

MULTIPLE IDENTITIES: RACE, ETHNICITY, AND THE FEMALE EXPERIENCE

A large number of immigrants who began to flood the country during these same years were drawn by the new industrial and commercial activities that were transforming the United States. While less than 2 percent of the population had immigrated to the country in 1820, by 1860 more than 10 percent had. The two largest groups came from Ireland and the Germanic states of Central Europe. German immigrants often headed for farmlands in the Midwest, though a sizable minority set up shops and stores in growing cities. The Irish crowded into the cities along the Atlantic, so that in New York City, for example, almost half of the population in 1860 had been born abroad. Poor and uneducated, the Irish fought for jobs that none but African Americans had been willing to take in the past. The free blacks with whom they competed for employment were a much smaller community. About a quarter of a million African Americans lived in the North by the time of the Civil War, almost half of them in cities. However, during the first half of the nineteenth century, as cities exploded in size, the percentage of free blacks making up a part of that population actually declined. In Philadelphia, for example, although the actual number of the free black population increased from a little over four thousand in 1800 to almost eleven thousand in 1850, the percentage of free blacks in the population declined from 10 to 8 percent.

African American Independence

In the free black communities of this period, ideals of respectability circulated as a goal to be achieved by black women as well as white. *The Colored American*, a newspaper published by and for African Americans, repeatedly reminded women to be mindful of propriety. Thus, the newspaper urged its female readers to be sensible in dress and careful not "to seduce by her appearance, but only to please." Reminding women in another article to always welcome their husbands "with a smile," the paper also suggested attention to child care and cooking.

For many African American women, this responsibility for domestic life—along with the need that they work for wages—created a demanding schedule. Chloe Spear of Boston, for example, operated a boardinghouse and worked as a domestic servant for a local family. Her husband, Cesar, took care of the boardinghouse while Chloe worked as a servant, but when Chloe got home, she cooked dinner, cleaned, and washed laundry while Cesar "was taking his rest." Chloe's schedule was exhausting—more exhausting than her husband's. But, Chloe Spear also disposed of her money in a way that many white women did not. Although her husband legally held control over her earnings and her property, he did not exercise that right. When Chloe Spear decided to purchase a house for seven hundred dollars, her husband argued at first that they could not afford it. His wife, however, produced the necessary money and her husband acquiesced. Chloe Spear kept her own wages and determined their disposition, something her husband supported. It is not surprising that free African American women constituted a significant percentage of the property holders in the free black community.

Free women of color needed to be independent. In most cities of the North (and of the South), women outnumbered men among the free black population. This may have been one reason they were less likely to marry than white women were, but it was not the only reason. Even where black women did not outnumber men, they were still less likely than whites to marry. Single-parent families became increasingly common among free African Americans during the first half of the nineteenth century. In Cincinnati, black families headed by women increased from 11 percent in 1830 to 22 percent in 1850. This imbalance may have been caused by high rates of mortality among black men as well as their difficulty in finding employment in the cities. Many black women were widows by the time they reached their forties.

African American women such as Chloe Spear often created extended families in the boardinghouses they ran. Men and women who migrated to the cities found not only food and shelter in their boarding houses but also contacts for work, opportunities for socializing, and a helping hand if economic disaster struck. In several instances in Boston, members of boardinghouses joined together to rescue fugitive slaves. Lydia Potter provided a more informal boarding arrangement for Sarah Hall, an African American newcomer, when she arrived in Boston during the 1850s. Potter employed Hall as a servant in her house in exchange for her bed and board, but she also provided Hall with access to the social networks of African Americans in Boston. Most African American women, however, worked as servants for white families, not for black ones.

Though lowly and demanding, even these opportunities were threatened in the 1850s as large numbers of Irish women increasingly competed for domestic work.

Irish Domesticity

Before the great famine in the mid-1840s, women seldom immigrated to the United States from Ireland. Ireland had few jobs, so families often chose which child should emigrate as part of a larger financial investment, and boys were considered more likely to find employment and send their wages home to the rest of the family. As a result, about two-thirds of the Irish who immigrated to the United States in the first half of the nineteenth century were men. That proportion changed, however, after the potato famine struck Ireland in 1845, when more and more women left Ireland to seek their fortunes abroad. Still, immigration continued to be a family decision, even if individuals migrated alone. With footholds established by brothers and uncles, young women began migrating in large numbers to the factory towns and cities where their relatives lived and worked. Like their male relatives, women often sent home part of their wages as they could. While some of these women began working as seamstresses or in textile factories, most of the Irish women who came to the United States—both before and after the famine—found jobs as servants.

Native-born women usually scorned domestic service, but these jobs represented an attractive option for young Irish women who found virtually no paid employment in Ireland. Domestic work was demanding, because servants often lived in their employers' homes and were at their beck and call night and day. But, domestic workers earned more than seamstresses. And servants could change households, as their mistresses never failed to bemoan, abandoning a tyrant in the hope of finding a more compliant mistress. Domestic service was an important, if brief, activity in the life cycle of young Irish women. Even if living with their parents, Irish girls began work as domestic servants when they were as young as eleven years old. In Buffalo, New York, over half of the young Irish women who were age seventeen were working as domestic servants and by age twenty-one most of them were. In New York City, young immigrant girls were quickly absorbed into the world of domestic service when they were sent over. While Irish men, like other male immigrants, tended to drift away to other cities and regions in search of work, women did not do so until they married, at which point they were influenced by the inclinations of their husbands. As a result, by 1850, almost two-thirds (58 percent) of the Irish immigrants living in New York City were female.

Read about **"An Irish Immigrant"**

Margaret McCarthy[9] immigrated to the United States in the late 1840s. Scholars do not know what happened to her or her family in later years.
Review the source; write short responses to the following questions.

1. What sort of responsibilities did Margaret McCarthy feel toward her family?
2. How was Margaret's life better in the United States than it was in Ireland?

Because most of these young women were working in households of middle-class, native-born whites, they were exposed to ideals of domesticity and middle-class gentility that their brothers and future husbands knew little about. These young women carried their ideals of gentility into their own households when they married. Marriage often provided a welcome end to days of service. The ability to create a domestic environment in which the woman was the moral center of the household offered many young Irish women a much more desirable alternative to the patriarchal controls exercised by their fathers in their Irish homeland. By the time they married, young Irish women shared many of the domestic ideals of their native-born counterparts, but not all. Most important, they did not share the same commitment to limiting family size.

German Guardians of Tradition

Catholic, Protestant, and Jewish immigrants from the Germanic states in Central Europe also poured into the United States during the antebellum period. The United States offered jobs in growing cities to peddlers and artisans as well as land in the Midwest to poor farmers who faced the same potato famine as the Irish. Immigrants also came to escape discrimination. Both poor peasants and Jews faced difficulties marrying in some German states where they had to wait years for permission to marry and had to pay high fees for the privilege. In the United States, no such restrictions existed.

Men were the primary immigrants in the early decades of the nineteenth century, though women soon began to follow as part of family groups. Catholic and Protestant women, like their male family members, were most likely to end up on farms. Some of these women worked first as servants, trying to save money for a dowry that would contribute to the purchase of a family farm. Jewish immigrants were more likely to head for cities, seeking work as skilled artisans and, most important, as peddlers, a job many had left behind in Europe as their trade routes disappeared.

Like many of their native-born neighbors, German women also ran boardinghouses. Jewish women took in young Jewish peddlers who traveled from town to town and needed a place to live. For those who kept kosher (following strict dietary rules about what to eat), the ability to live in such a household was highly valued. Catholic and Protestant women also catered to German boarders who were new to the country, offering food from the old country and a shared language for socializing.

German girls who migrated to the United States found their opportunities to marry expanded given the large number of German men in their new communities. Throughout the nineteenth century, 60 percent of the immigrants from the German states were men. As a result, German women were more likely to marry German men than vice versa. German women nourished ethnic traditions in their cooking and their celebration of traditional holidays. They prided themselves in keeping their houses cleaner than their native-born counterparts.

However, there were other ways in which some immigrants quickly adopted American ways. The Jewish women who came to America, for example, had expected their parents to arrange their marriages. They had little knowledge of the world of romantic love

that was becoming so important to many of their native-born neighbors. They expected to grow closer to their husbands as their lives became intertwined, but they viewed marriage as a practical matter. In the United States, though, these attitudes began to change. Hannah Marks, a young orphan from Philadelphia, for example, caused a family crisis in the 1850s when she jilted her suitor from California. He had paid for her passage west, but when she met him, he was not to her liking. Hannah instead took a job teaching at school for the next decade and eventually married a man she preferred. Like other young immigrants, she had embraced the culture of sentiment flourishing around her.

The Culture of Sentiment

The urbanizing and industrializing world of the urban Northeast spawned a varied and wide-reaching cultural market. Theaters sprang up in cities large and small, though by mid-century, New York was the capital of drama. Perhaps most influential and widespread, however, was the revolution in publishing that unleashed an unprecedented number of books and periodicals on the public. Important technological innovations made printing both cheaper and faster.

As in most forms of business, men maintained control, but women participated extensively in this cultural revolution. In all cases, women had to proceed cautiously. The world of culture was essentially a public world and, thus, the realm of men. Women who spoke in public, whether on stage or in print, risked their respectability and their status as ladies. Moving carefully, many of these women addressed their performances to the domestic world of women, not only creating a cultural interpretation of domesticity but also, ironically, turning domesticity into a commodity. Although conceived as a separate sphere, a world apart from that of business and even antithetical to it, domesticity circulated as an economic product just as shoes, cloth, and teapots did.

Women on Stage

Theaters proliferated in the new urban atmosphere, and with them came jobs for women. The time had long since passed when young boys played female parts, so theater managers paid handsomely for women with good memories and strong elocution skills who were willing to tread the boards. Early in the nineteenth century, one actress earned one hundred dollars per week while another, Agnes Gilfert, earned two hundred dollars per night. Often, these were women who took to the stage in the company (and protection) of their husbands. Susanna Rowson, for example, worked as an actress for five years with her husband William before she quit the stage in 1791 to open a girls' school.

The fact that Rowson could open a successful girls' school suggests that she was able to retain her reputation despite her association with the theater. Other famous actresses of the period also worked hard to preserve their reputations. Fanny Kemble, one of the most famous actresses of the nineteenth century, drew admirers from the most respectable quarters of society when she arrived in the United States from London in the 1830s. She abandoned her career for what turned out to be a disastrous marriage to a southern wastrel, Pierce Butler, who lived off the work of his slaves and squandered his fortune.

Kemble was horrified with both aspects of his life and finally left him. When her husband sued her for divorce, Kemble deftly defended herself in the press as the injured party: an honest and hardworking woman who had been deceived and abused by an unfaithful, irresponsible husband. With her reputation intact, Kemble embarked on a new and lucrative career reading Shakespeare to audiences around the country.

Charlotte Cushman also guarded her reputation as she came to dominate the stage in the 1840s and 1850s. Cushman, who never married, took to the stage to support her mother and various other relatives after the bankruptcy of her father left them destitute. Early on, Cushman wrote for *Godey's Lady's Book*, and, as she dragged her sister Susan onto the stage with her, she made sure Susan joined an appropriate female benevolent society to shore up her reputation. Cushman not only played powerful women on stage such as Lady Macbeth, she also played men: most notably Romeo opposite her sister who played Juliet. Such "breeches" roles were popular for several conflicting reasons. When women played men, they often wore tights and revealed their legs to a titillated audience. But, the audience also associated purity of purpose in the relationship between characters such as Romeo and Juliet when they knew both roles were being played by women. Charlotte Cushman herself may have enjoyed these roles because she was strongly attracted to women and shared two successive relationships with women: Mathilda Hays, to whom she pledged "celibacy and eternal attachment," and later, when that relationship disintegrated, Emma Stebbins. In a world in which such relationships had not yet been labeled "perverse lesbianism," Charlotte Cushman lived a respectable life.

Respectability had become a predominant concern of many theater owners by the middle of the nineteenth century as they decided middle-class women constituted an important part of the audience they wanted to draw. By the 1850s, most theater owners had barred prostitutes and many had also outlawed the sale of alcoholic beverages. They also created afternoon matinees, knowing that middle-class women would be the ones most likely to have the flexibility in their schedules that would allow them to attend. Finally, theater owners encouraged moralistic presentations such as the successful temperance play, *The Drunkard*, which enjoyed a long run in Boston as well as other cities.

To be sure, not all theaters carried these marks of middle-class respectability. In the Olympic Theater in New York, working-class audiences cheered their Bowery B'hoi hero Mose and his girlfriend Lize. Model artist shows and various other productions in which women revealed parts of their bodies also occupied a well-defined niche. But, these were shows that defined the boundaries rather than the center of nineteenth-century theater. By the middle of the nineteenth century, a variety of women had found ways to use notions of domesticity and female virtue to promote their dramatic activities.

Scribbling Women

Novel reading continued to be just as scandalous in the early nineteenth century as it had been in the eighteenth century: a peculiar female folly bemoaned by ministers and educators who feared that the young women of the country had lost what little good sense they might have had. The hand wringing did no good, however. Novels exploded as a literary genre in the nineteenth century, overwhelmingly produced and consumed

by women. Nathaniel Hawthorne, who viewed himself as a more serious contender in the literary arena, famously complained that "America is now wholly given over to a d—ned mob of scribbling women, and I should have no chance of success while the public taste is occupied with their trash—and should be ashamed of myself if I did succeed. . . ." Despite this carping, female novelists sold more books than most of their male colleagues and, in doing so, shaped this literary form around the concerns of middle-class women: their families, their love lives, and their homes.

View the Profile of <u>Sara Parton (Fanny Fern) (1811–1872)</u>

Fanny Fern, the pen name of Sara Willis Parton, was one of the most famous and well-paid writers of the nineteenth century. Like most of the women who entered that profession, she did so out of financial need after the death of her first husband and her divorce from her second husband.

Catherine Maria Sedgwick was one of the first of these writers, capturing public attention in the 1820s with the publication of *A New England Tale; Or, Sketches of New England Character and Manners*. Like many of her female contemporaries, she worried about the respectability of appearing in print and only did so after being nudged by supportive family members. Many of the other women who took up professional writing abandoned their reservations only when faced with economic hardship. Some were widows, others deserted by their husbands, and still others faced with supporting their families because their husbands for reasons of health or temperament were unable to command the salaries they needed for survival. Calvin Stowe fretted endlessly about his ability (or rather, inability) to support his family. Trying to calm him at one point, his wife, Harriet Beecher Stowe reassured him that God would watch out for them, but better yet, she would "bring things right." E.D.E.N. Southworth had to support herself and her daughter after her husband deserted her.

Many women writers concentrated on issues of home and heart in sentimental novels. They created dramas of love, often fraught with misunderstandings between a heroine and her lover, not to mention conflicts with parents who could never seem to understand who was the appropriate mate for their daughters. Susan Warner spun a story of female submission in her popular novel *The Wide, Wide World*, with a heroine who faced a series of trials after the deaths of her mother and her close friend. Most stories, however, ended in marriage, anchoring women in the place they were expected to occupy.

Despite their heavy emphasis on personal feelings, some of these stories also raised larger political and social issues. Lydia Maria Child's early novel, *Hobomok*, depicted the marriage of a white woman to an Indian man. More famous, however, was Harriet Beecher Stowe's *Uncle Tom's Cabin*, which when it was published in 1852 kindled a storm of sympathy for the antislavery movement. Writing a story of domestic disarray,

Stowe adapted the conventional themes of the nineteenth-century novel to argue that slavery perverted family relations by denying slaves the ability to form their own families and by encouraging cruelty and sloth among the white families who owned the slaves. In a less well-known but equally hard-hitting novel, the African American writer Harriet Wilson condemned the racism found in northern society in her 1859 novel, *Our Nig; or, Sketches from the Life of a Free Black*. Wilson explored the abuse suffered by Frado, an African American servant, at the hands of her heartless northern employer, Mrs. Bellmont. As both Wilson and Stowe recognized, the injustices and hierarchies of society were easily replicated in the home and could be explored symbolically in the context of sentimental fiction.

Earnest Readers

Female authors and their novels found a large, eager, and increasingly literate audience in the nineteenth century in part because the structure of society was changing. Publishers in Boston, New York, and Philadelphia used newly available technology to print books more cheaply than before and distributed them along the canal and railroad lines that became available in the 1830s. During the eighteenth century, only about 50 percent of the women in the North could read. By the time of the Civil War, the figure was closer to 90 percent. No doubt this increase was due in large part to increasing opportunities for women to receive at least a rudimentary education at local town schools.

In big cities and small towns, lending libraries proliferated, bringing books within the reach of the masses. Almost all of these lending libraries were private, and membership in some of the most well-known athenaeums was quite expensive. Fortunately, more modest libraries were also available. A shopkeeper would have a room above his store where he kept popular novels, for example, charging a membership fee of a dollar a year that could be paid in monthly installments.

Women formed reading societies to discuss and debate the issues raised by new books in towns and villages that were large enough. Sometimes the reading societies were composed of men as well as women so that chairs were pushed aside after some quick discussion to facilitate dancing and games. In other instances, women preferred to talk among themselves. They not only discussed published works but also shared their own poetry and essays. As a result, literary societies became a kind of public space for women to discuss a wide range of ideas.

While many of the literary societies established in the North were composed of white (and middle-class) women, African American women also formed some of these organizations. African American women not only shared their readings but, like most of their white counterparts, wrote for their societies as well. However, literary societies took on additional levels of meaning for African American women, in part because many of these women faced widespread discrimination. Literary societies provided a way for African American women to show that they could generate the same levels of intellectual engagement and cultural refinement as their white counterparts. With this recognition of the way in which a consciousness of racism influenced their approach

to literature, it is not surprising that some of these societies devoted a good part of their time to reading and writing about issues related to slavery.

CONCLUSION

The early stages of the Industrial Revolution, along with the growth of transportation networks and urban centers, opened up a new world of material goods in the United States. It also changed the way men and women in the North worked and, consequently, the way in which they related to one another. The family relationships of the colonial period, rooted in shared economic as well as social activities, steadily crumbled in the new world of market relations. Employers looked to women wageworkers for cheap labor that would boost their profit margins. In some cases, this brought economic opportunity to young women who had few alternatives on their family farms. For other women, their earnings were far from sufficient to feed their children without additional income from other family members. Yet, even as women took on these new forms of wage work, the very idea of women working came under attack in the domestic literature that circulated, particularly among the new middle class. The cult of domesticity increasingly associated women's virtue with the emotional work of rearing their children. This ideology of a separate sphere, which was celebrated in the literature of the day, masked the economic value of the work that many middle-class women did at the same time that it cast suspicion on the morals of the many women who took on wage work to support themselves or their families. Yet, the middle-class home and the factory were products of the same economic transformation that was changing the place of women in northern society; and in both places women often were asserting themselves, either morally or economically, in new ways. Some women found independence in their wages while other women found new power in the moral influence they wielded in their homes.

Study the <u>Key Terms</u> for Domestic Economies and Northern Lives, 1800–1860

Critical Thinking Questions

1. When women worked for wages, how was their independence limited?
2. How did the Industrial Revolution shape the notion of separate spheres?
3. How did the cult of domesticity shape the middle class?
4. How would you assess the control that women exerted over their bodies in the antebellum North? How would you compare the way a prostitute controlled her body to the way a middle-class married woman controlled hers?
5. How did a woman's race or ethnic background affect her ability to be middle class?
6. Did literature create a domestic ideal or merely reflect it?

Text Credits

1. Susan Rimby, Primary Source Documents to Accompany Women and the Making of America (Upper Saddle River, NJ: Pearson, 2009), pp. 92–95.

2. Lowell, Massachusetts in 1832.

3. Thomas Dublin, *Women at Work, The Transformation of Work and Community in Lowell, Massachusetts, 1826–1860* (New York: Columbia University Press, 1979), p. 66.

4. Appleton, Ann Swett Appleton Letters, 1847–1850. Manchester Historical Association, Miscellaneous Pearson Papers.

5. Mary Beth Norton and Ruth M. Alexander, eds., *Major Problems in American Women's History,* 2nd edition (Lexingon, MA: D.C. Heath and Company, 1996), pp. 219–220.

6. Lydia Maria Child, The Frugal Housewife, 1832.

7. Catherine E. Beecher, Treatise on Domestic Economy, 1845.

8. Lucille Salitan and Eve Lewis Perara, eds., Elizabeth Chace to Samuel Chace, 1854, in Virtuous Lives: Four Quaker Sisters Remember Family Life, Abolitionism, and Women's Suffrage.

9. Lowell Offering, *A Second Peep at Factory Life,* Vol. V (1845), pp. 97–100; Susan Rimby, Primary Source Documents to Accompany Women and the Making of America (Upper Saddle River, NJ: Pearson, 2009), pp. 92–95.

Recommended Reading

Jeanne Boydston. *Home and Work: Housework, Wages, and the Ideology of Labor in the Early Republic.* New York: Oxford University Press, 1994. An important study that examines how, during the nineteenth century, housework ceased to be recognized as a valuable economic contribution to a family's well-being.

Hasia Diner, and Beryl L. Benderly. *Her Works Praise Her: A History of Jewish Women in America from Colonial Times to the Present.* New York: Basic Books, 2002. Lively account of the ways in which Jewish women lived and worked as well as the ways in which they adapted their cultural traditions to the demands of American life.

Thomas Dublin. *Women at Work: The Transformation of Work and Community in Lowell, Massachusetts, 1826–1860.* New York: Columbia University Press, 1980. A highly readable statistical study that analyzes the backgrounds and life trajectories of young women who worked in the Lowell mills and shows how they responded to deteriorating conditions of labor.

Timothy Gilfoyle. *City of Eros: New York City, Prostitution, and the Commercialization of Sex, 1790–1920.* New York: Norton, 1994. A careful study of how women's lives were shaped by prostitution and how prostitution was deeply entrenched in the culture of New York City.

Kathryn Sklar. *Catharine Beecher: A Study in Domesticity.* New York: Norton, 1973. A classic study of Beecher and of the cult of domesticity, which she did so much to articulate and popularize through her writings.

FAMILY BUSINESS: SLAVERY AND PATRIARCHY, 1800–1860

LEARNING OBJECTIVES

- How did slavery shape the life of African American women?
- What issues did white women confront on plantations?
- How did poorer black and white women struggle to maintain independence?
- How did southern women represent their experiences?

Explore Chapter 6
Multimedia Resources

TIMELINE

1793	Invention of cotton gin
1806	Laws in Virginia decree that henceforth freed slaves will have to leave the state
1808	International slave trade ends in the United States
1820	Missouri Compromise
	Nat Turner's Revolt
1850	Compromise of 1850
	Mary Eastman publishes *Aunt Phillis's Cabin*
1854	Kansas-Nebraska Act
	Caroline Hentz publishes *The Planter's Northern Bride*
1856	Margaret Garner kills her daughter in Cincinnati to protect her from slave catchers
1861	Harriet Jacobs publishes *Incidents in the Life of a Slave Girl*

WHILE NORTHERN MIDDLE-CLASS IDEALS OF FAMILY NARROWED IN THE ANTEBELLUM PERIOD TO FOCUS ON INTENSE EMOTIONAL BONDS AMONG PARENTS AND THEIR CHILDREN, southern ideals of family remained much broader and became increasingly complex. Even the wealthiest plantations were sites of production rather than refuge. Family ties were far-reaching and complicated. Women cherished their relationships with distant cousins as well as those with siblings. Yet another layer of kinship relationships tied white and black residents together. Slaveholders argued that they viewed slaves as part of their extended families, but the sexual activities of masters created blood relationships that white southerners preferred to

ignore. Even more problematic was the family life of slaves, who were denied the legal rights to marry or control their children. If the family was the arena in which women were most likely to exercise power, then southern women, whether slave or free, would have to do so in very different ways from northern women.

Slavery withered in the North during the years following the American Revolution, and all the northern states abolished slavery by the 1820s. However, the invention of the cotton gin in 1793 gave new life to the slave system in the South. Cotton quickly became the South's most important crop, drawing farmers more deeply into a system of commercial agriculture that eclipsed significant interest in developing industry or trade routes. Agriculture provided surer profits than industry, though the two were inextricably linked. Cotton produced in the southern United States was shipped to textile factories in the North and even more commonly to England, making slave labor an integral part of the transatlantic Industrial Revolution. As a result of the commercial demand for cotton and, to a lesser extent, other crops such as rice and tobacco, the slave population in the South expanded dramatically during the antebellum period. In 1820, about 1.5 million slaves lived in the United States, but by 1850 that number had expanded to over 3 million. Unlike other slave societies in the New World, this increase was largely the result of natural reproduction because Congress had outlawed the international slave trade in 1808.

Fear of this expanding slave population had led to successive battles in Congress over whether slavery would be legal in new states joining the Union. The **Missouri Compromise** of 1820 was meant to ensure an equal number of slave and free states by prohibiting slavery north of the 36°30′ parallel. Acquisition of territory farther west in the 1840s upset that balance, leading to the **Compromise of 1850**, which allowed states in the new territories to choose whether they would be slave or free. The **Kansas-Nebraska Act** of 1854 further fanned antagonisms by stipulating that states still to be carved out of the Louisiana Territory could disregard the old rules of the Missouri Compromise that they had been operating under for twenty-four years and that they, too, could vote whether to be slave or free.

These struggles about whether to allow slavery or not were about more than controlling Congress. The North had developed as a society that increasingly championed industrial production, individualism, and contractual relationships in the workplace, while the South had developed as a society that was more clearly based in commercial agriculture, patriarchal control, and the extended household as the model of both production and interaction. Women in the South were regarded as nurturers, but they were also more closely and clearly tied to activities of production. While many embraced growing notions of romantic love, the power that white men held over both white and black women wreaked havoc in such relationships. For African American slave women, the situation was particularly brutal. Aside from the personal tragedies created by slavery, different notions of family and hierarchy that were central to the South's embrace of slavery meant that the status of women was closely tied to the ways in which the South increasingly defined itself as a distinct society from the North in the years leading up to the Civil War.

ANTEBELLUM SLAVERY

Women as well as men experienced slavery in many different ways in the South. Living as the only slave of a white family on a dilapidated farm was far different from living on a large plantation with many slaves. Region mattered also. Rice farming in the Carolinas demanded different kinds of work from cotton farming in Alabama. And because cotton depleted the soil quickly, slavery was a system that was expanding rapidly in the newly opened fields of the Lower South and Southwest rather than on the overworked plantations of the Upper South. The slave population was increasingly concentrated in the Lower South so that by the time of the Civil War, slaves made up 47 percent of the population in those states but only 29 percent of the population in the Upper South and 13 percent of the population in the Border States.

MAP 6-1 Population of the South in 1850[1]

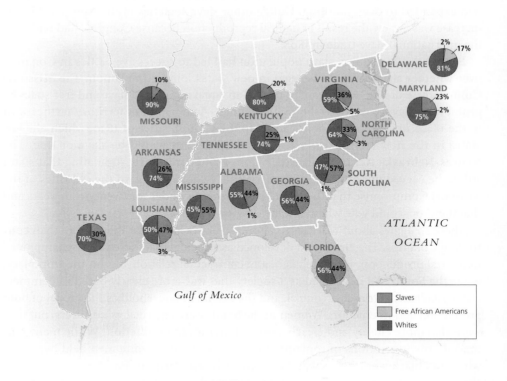

By 1850, slaves were a large percentage of the population in states of the Deep South, even constituting a majority of the population in South Carolina and Mississippi. Slaves were a much smaller percentage of the population in states of the Upper South.

Strong as Any Man: Slave Women's Work

In an 1859 broadside advertising the sale of Luther McGowan's slaves in Savannah, Georgia, Minda, a twenty-seven-year-old cotton hand was priced at twelve hundred dollars, slightly more than Adam, a twenty-eight-year-old cotton hand. Callie May, a twenty-seven-year-old rice hand cost one thousand dollars, just like twenty-six-year-old Deacon. As prices in the slave markets made clear, women were valued as much as men. Slave women made up a substantial proportion of the field hands on large plantations and were flexible enough to help indoors as well on smaller farms. Most slave women spent at least part of their lives in the fields doing the same work as male slaves. In some areas, this meant tending tobacco; in other areas, it meant picking cotton; while in the lowlands of Georgia and the Carolinas, it meant cultivating and harvesting rice. Slave women cut down trees, hauling the logs away using leather straps; they plowed the land when needed. Although slave owners often argued that they adjusted the workload of their slaves to accommodate their age, physical condition, and gender, this was not always the case. When Fanny Kemble arrived at the Georgia plantation of her new husband, Pierce Butler, she quickly noted that despite claims to the contrary, men and women did the same labor in the fields. It was, Kemble sarcastically observed, "a noble admission of female equality." Despite these demands, slave women were able to carve out small areas of autonomy for themselves.

Those slaves who grew rice in Georgia and the Carolinas, for example, had much more autonomy than slaves on cotton plantations. As part of a negotiated practice that had evolved during the colonial period, masters continued the **task system** for rice cultivation. Each slave, male or female, was responsible for tending a specific plot of rice. The work was extremely dangerous because slaves stood in disease-infested swamplands to tend their crops, facing the dangers of malaria, alligators, and poisonous snakes. However, once a slave had tended her crop, she was free to focus the rest of the day on her own work, including the cultivation of her vegetable garden and chickens. Some of these slaves produced not only enough food for their own subsistence but also enough to trade at market. Slave women continued their eighteenth-century traditions of hawking their wares in cities such as Savannah, Georgia, and Charleston, South Carolina. In Savannah, slave women elbowed out competition from most free white and black women by cutting their prices to the bone when necessary. With control over the street markets, these women began to charge white shoppers a higher price than black shoppers, leading to ugly words with some of the poor whites who bought their groceries there. Although selling independently, these slave women had clearly formed a female network strong enough to affect prices.

On large cotton plantations, female slaves used their work activities to develop social networks that provided a significant underpinning for the stability of their communities. Work in the cotton fields was organized around the **gang system** rather than tasks, and women often worked in gangs that were separated from men even if they were doing similar kinds of labor. Women also formed the backbone of the **trash**

gangs, which were composed of women who were pregnant, nursing, or old, as well as boys and girls in their early teens. Working in groups, they cleared fields, weeded, picked up trash, and lightly hoed. These women also ate, sang, and gossiped together for most of the day as they worked and cared for their babies.

While slave women did not always face a gendered division of labor during the day when working for their masters, they did face one at night when working for their families. In slave families as in white ones, women were responsible for most of the domestic work such as cooking, cleaning, and sewing. Fannie Moore remembered that her mother would work in the fields during the day, then "piece and quilt all night." Betty Brown's mother made not only her children's clothes but also their moccasins. As with the trash gangs, however, women tried to do these activities together when they could, thus providing an opportunity to socialize while they worked. Mary Frances Webb remembered how women on her Missouri plantation enjoyed talking to one another on Saturday afternoons when they did their laundry.

Status and Special Skills

Not all slave women worked in the fields. On large plantations, some worked in the "**Big House**" as domestic servants while others cooked in the kitchen or tended the young and the sick. Such jobs bore a mark of distinction because not all slaves had the requisite skills. As Lucy McCullough noted, "De house servants hold that dey is uh step better den de field niggers. House servants wuz hiyyah quality folks." However, the distinctions were not always welcomed, because domestic servants were at the mistress's beck and call twenty-four hours a day and close enough to the white folks that they could be easily struck when they made mistakes.

Plantation mistresses felt that the best way to get good house servants was to begin training them when they were young. Many slave girls between the ages of six and twelve were separated from their families in the slave quarters and moved into the master's house. Assigned simple tasks such as shooing away flies or running errands, young slave girls were kept busy and assessed. At night, they usually slept at the foot of the bed of their mistress and master or one of the white children so that they could respond to any needs and prepare the morning fire. Those with promise were trained in more difficult tasks of housekeeping as they entered their teenage years, while less likely prospects were returned to the trash gang and slave quarters.

Cooks, who operated away from the main house in separate kitchen buildings, had more autonomy than other servants. While sometimes men were cooks, usually women did this job, many of them trained by their mothers in the craft. Cooking not only provided more autonomy but also provided a better diet, because cooks could help themselves surreptitiously to the food they were preparing for their owners.

Other slaves took on the job of nursing both free and slave members of a plantation household. Some slave nurses developed skills as midwives or "root doctors." These slave practitioners who used herbal remedies to treat a wide variety of complaints provided important medical care to slaves on plantations and, sometimes, to whites.

Slaves also took on child care. Though some slave owners worried about the irresponsible habits of slave girls, they still put them to work tending both white and black toddlers. Older slave women with babies of their own were called upon to share their breast milk with the mistress's babies as well. A woman particularly apt in caring for children would rise in status within the household to care for successive generations of white children. Achieving a kind of revered status in a household, these nurses provided the basis for the **mammy** figure that many southern whites celebrated in their depictions of their extended households. An aristocrat among both whites and slaves on a plantation, the mammy maintained standards of deportment as well as health. Susan Eppes recalled how her mammy would scold her, saying "you ain't got no call to say dat—you ain't no pore white trash—nor no nigger nuther—take yer finger out of yore mouth—held your hed an' don't forgit your manners."

The status of mammy, like that of other privileged slaves, was neither as secure nor as uncomplicated as white southerners wanted to believe. White mistresses, in most cases, still maintained control of the plantation. Slave nurses were also challenged by white doctors who dismissed their work as either ineffective or dangerous. And as mammies grew too old to work, the white families they had nurtured did not always care for them. Frederick Douglass recalled how his grandmother was moved to a cabin in the woods and left to die.

A Burden'd Heart: Slave Mothers and Wives in Antebellum United States

Slave women in the antebellum United States constructed their families in ways that had to differ from their free counterparts. After all, they were not legally allowed to marry their husbands and they had no legal right to control their children; worse yet, their loved ones could be sold from them at any time. The breakup of families through sale was a growing problem in the nineteenth century as fields became depleted in the East and slavery expanded farther west and south. Between half a million and a million slaves were carried by slave traders into the new states of Alabama, Mississippi, and Louisiana between 1820 and 1860, in many cases causing the breakup of family units. Despite the hardships, however, slaves continued to marry and have families, even though their marriages and family units were not legally recognized. Indeed, because slaves could not control property and slave men had no legal authority to exert over their wives, more gender equality was possible in slave marriages than among those who were free.

Particularly in areas of the Upper South, where slaves were more likely to be sold away due to soil depletion, slaves faced challenges in creating strong nuclear families. Slave owners were often reluctant to separate a mother from her small children, but they did not have the same reservations about selling the father, creating a situation in which families were matrifocal. Extended kin and even **fictive kin** became particularly important in these situations. Slave children were taught to address their elders as "aunt" or "uncle" regardless of their blood relationships. Slaves sometimes married abroad, meaning that husband and wife lived on different plantations and the husband would only be able to visit his wife once or twice a week. Some slaves preferred abroad

OVERVIEW

Types of Slave Labor

Task System	The slave, male or female, took control of a plot of land and was responsible for raising the entire crop. This system was used particularly in rice cultivation. Slaves had more control over their time in this system of work, though the rice fields were dangerous.
Gang Systems	Slaves worked in gangs, usually segregated by sex. This form of labor was often used on large cotton plantations. Supervised by overseers, slaves had little control over their time.
House Servants	Slaves who worked in the house were often women who had been chosen in childhood for training as cooks, nurses, and maids. Housework carried more status than fieldwork, but the hours were long and autonomy was difficult because further demands were made on servants from early morning to late at night.

marriages because it meant they did not have to witness the abuse of their partners. Slaves were particularly upset to see their spouses beaten, whipped, or raped, because there was little they could do to stop it. Women who lived in abroad marriages took on the traditional responsibilities of men as well as women in raising their families. This could involve stealing pigs to feed her family, as Eliza Overton's mother did, or hunting raccoons and deer, as Betty Brown's mother did.

Sometimes masters intervened to choose a mate for their slaves, but they also knew that having slaves choose their own spouses could produce even better results in terms of both production and reproduction. Slaves who were happy in their home lives would work better and be more likely to reproduce. Young slaves thus carried on a lively courtship leading up to marriage. Although the marriages were not legal, a ceremony still occurred. Sometimes it involved jumping over a broomstick—a tradition similar to the one employed by free couples engaging in informal marriage practices.

Because slaves were not legally married, they did not have to face any legal hurdles in getting divorced. A woman could just give up her husband or request that her master move her to a more distant plantation if it was possible. Marriages disintegrated for slaves for many of the same reasons they did for whites, though in some cases it was because women found themselves unhappily married to men who had been chosen by their masters. Regardless of these issues, however, many marriages among slaves were quite long lasting. After the Civil War, when freed slaves registered their marriages throughout the South, a large number indicated that they had been together many years. In North Carolina, for example, 49 percent of the slaves registering their marriages in 1866 had been together for ten years or more.

Read about **"Family Sorrows in Slavery"**

Slave women faced numerous emotional challenges as their masters tore their families apart through sales or pushed them into marriages they did not want. Slave women had to construct their family life with the ever-present realization that legally they and their family members were commodities.

Review the sources; write short responses to the following questions.

An Enslaved Wife's Letter to Her Husband (1840)[2]
An Enslaved Wife's Letter to Her Husband (1852)
Rose Williams's Forced Marriage in Texas
Poem, "*The Slave Auction*," by Frances E.W. Harper[3]

1. What do the letters of enslaved women reveal about the ways in which their masters interfered with their family lives?
2. What, if any, actions, did these women undertake to protect themselves or their children?
3. Compare the poem by Frances Harper to the letters by slave women. What are the differences in the ways in which the impact of slave auctions on family life are depicted?

Sexual Demands of Slavery

While slave women may have experienced more gender equality with slave men than free women were likely to experience in their relationships, slave women faced another situation altogether in their dealings with white men. Many slave women recalled being sexually assaulted by white men or fighting off their advances. Others entered into quiet and even long-lasting relationships with their owners. Either way, however, the details of these encounters highlight the specific ways in which African American women experienced their loss of freedom and power in antebellum slavery.

Whether they successfully resisted or not, slave women were considered fair game by many of the white men who lived in their households or nearby. Sometimes they were even purchased to satisfy the sexual cravings of their masters. A particularly attractive and light-skinned young woman would sell for a high price as "a fancy," a code word that indicated her sexual desirability. Celia, a young slave in Missouri, was only fourteen when purchased by Robert Newsom, a sixty-year-old widower, in 1850. She quickly learned what her role in his household would be when he raped her soon after buying her.

In many other cases, the pressures placed on slave women for sex resulted in hard choices. Cynthia, a slave in Saint Louis, was given "the choice" of being the mistress of her white master, where she would live as his housekeeper, or being sold to a plantation in Mississippi where she would face a grueling life as a field hand. Her survival dictated her response more than her sexual inclinations did. Harriet Jacobs also had

to make a difficult choice. Faced with the unwelcome advances of her master, and despised rather than protected by her jealous mistress, Jacobs forsook the free black carpenter she wanted to marry. Instead, Jacobs, at age fifteen, turned to an unmarried white man for protection. He pleased her more than her master and she hoped he would be able to buy her. She also preferred a lover she had chosen to one who forced himself on her. They had two children, but only after a protracted struggle with her owner did Jacobs and her children gain their freedom. In both cases, it is clear that the choices slave women made about many of their sexual relationships with white men were really quite limited.

Read about **"Masters and Sex"**

Slave women often had to tolerate the sexual advances of their masters and other white men on their plantations. They responded in different ways, struggling to make the best choices they could with possibilities. The relationships that were created were difficult not only for the slave women involved but sometimes for white women on the plantation as well. These documents come from a variety of sources. Some, such as the one by Virginia Boyd, is a private letter. Virginia Boyd was pregnant, probably by her master, Judge Samuel Boyd, when he turned her over to the slave trader Rice Carter Ballard with instructions to sell her. Boyd wrote to Ballard begging not to be sold. Harriet Jacobs, on the other hand, recounted her story in a narrative published in support of the antislavery movement. Mary Reynolds' testimony was collected much later, during the 1930s, as part of the government-sponsored Works Progress Administration (WPA) project to collect stories about slavery from ex-slaves.

Review the sources; write short responses to the following questions.

Virginia Boyd letter[4]
Harriet Jacobs
Mary Reynolds testimony

1. The perspectives of slave women and white women are expressed in these documents. How do their perspectives on the sexual relationships between white men and slave women differ?
2. How did slave women negotiate the sexual demands that were placed on them by white men?
3. These documents were created for different purposes and different audiences. Does that make a difference in how sexual relations are portrayed?

In part to justify this sort of sexual exploitation of slave women, southerners constructed the stereotype of the **jezebel**. Young slave women, described as jezebels, were an extension of the image of the black wench that had emerged in the colonial period. The jezebel was lascivious and particularly attracted to white men. This idea of an

oversexed black slave, eager to have intercourse with white men, not only justified the activities of masters but also made sense of many of the other indignities slave women suffered. Whether their bodies were being physically examined in a slave market or they were forced to pull up their skirts to work in the fields, slave women had to reveal their bodies in ways that white women did not. Moreover, there were no laws in the antebellum period to protect the bodies of slave women. Even children were unprotected. When a slave named George raped a ten-year-old girl in Mississippi in 1859, the judge refused to uphold his conviction, pointing out that it was not against the law for anyone to rape a female slave. The Mississippi legislature passed a law the following year making it illegal for a black man to rape a slave under twelve years of age, but the limits of the law are as striking as its effect. Slave women over twelve years of age were still fair game, and nothing was said about white men attacking female slaves of any age.

Violence and Resistance

Slave women, like slave men, were well aware of the injustices they faced by being enslaved, and they too tried to defend themselves. However, they were not able to respond in quite the same ways. Slave men, for example, were much more likely to run away than slave women were, in large part because slave women did not feel they could leave their children. In Huntsville, Alabama, less than 20 percent of the fugitive slave advertisements placed during the antebellum period were looking for women. Most slaves who ran away were young adults between the ages of sixteen and thirty-five, but that was precisely the time when women were likely to have small children who needed care. There were exceptions, of course. Ellen Craft successfully ran away with her husband in the 1840s, but she did so before they had children. Women who tried to escape with their children were more likely to be caught; children simply could not run as fast—nor did they have the stamina to survive without food for as long as adults.

As a result, many slave women engaged in **truancy** rather than escape. After a severe beating, a slave woman would hide in nearby woods for several days or even several months. Harriet Jacobs, who eventually escaped to freedom in the North, began her flight as a truant, hiding for seven long years in the attic of her grandmother's house.

There were more tragic forms of resistance as well. Although slaves had children at a higher rate than whites and worked hard to nurture and protect their children from the abuses of the slave system, some slave mothers could not bear to see their children enslaved. A few chose instead to kill their children. While infanticide was not widespread on plantations, it did occur. One woman who had seen her first three children sold away from her determined that this would not happen with her fourth child. "I'm not going to let Old Master sell this baby," she told another slave. Having made up her mind, she poisoned the newborn. Margaret Garner, whose story became the basis for Toni Morrison's novel *Beloved*, fled with her husband and four children from their slave owners in Kentucky. When slave catchers cornered them in Cincinnati in 1856,

Garner claimed she would kill herself and her children rather than go back into slavery. Her husband tried to fight off their assailants, but as his efforts failed, Garner slit the throat of one of her daughters and tried to kill herself before they were captured.

Other slaves used physical violence to protect themselves. When Ellen Cragin's mother was whipped by her young master for falling asleep at the loom, her mother hit back hard. As he backed away and begged for mercy, she moved to a verbal assault, telling him, "I'm going to kill you. These black titties suckled you, and then you come out here to beat me." Celia, who for five years was repeatedly raped by her master, Robert Newsom, finally killed him as he tried to have sex with her yet again. Newsom had ignored her demands that he leave her alone, so Celia struck him with a heavy stick and burned his body in the fireplace of her cabin. Although Celia's lawyers argued that she was acting in self-defense to protect her honor, the white, all-male jury who heard the case declared her guilty and Celia was executed.

Plantation Households

Only about one-third of the southern population owned slaves when the Civil War broke out. Of those who did own slaves, most owned only a few. The large plantation owners who lived in luxury with more than fifty slaves never constituted more than 2 to 3 percent of the population in the South. However, this small group was extremely influential in shaping southern politics and ideology. Supervising the lives of slaves on these plantations were mistresses of the elite planter class. They considered the home their sphere, but their homes were quite different from those in urban, commercial areas of the North. Like rural households everywhere, their homes continued to be a center of production rather than consumption. Moreover, their social relations with their husbands, their children, and their slaves were structured by a commitment to the kind of patriarchal control that was dissipating in the North. Thus, while they were extremely privileged on the one hand, plantation mistresses worked hard and operated in a world that was more explicitly hierarchal than the one occupied by their northern counterparts.

Life on the Plantation: The Plantation Mistress

Plantations were more than homes; they were small communities, far more self-sufficient than comparable households in the North. They were spread among outbuildings for smoking meats, housing livestock, and sheltering slaves with the plantation mistress supervising many of the activities on these plantations. She held the keys to various storerooms, which were usually locked to keep slaves from stealing supplies. It was she who released hams and flour and sugar from the storerooms to the cook. While some fancy clothes were bought ready-made or fine fabrics purchased from abroad, much was still made at home, including slave clothing. Slave women sewed most of the clothing for the slave community, but the mistress would do fancywork for her own family or take on delicate tasks of cleaning crystal and china. It was also the mistress who oversaw the nursing of both her own family and slaves—a job that reflected not only her nurturing abilities but also the economic value of the slaves she

tended—losing one was a costly expense. Because plantations were such large enterprises, the domestic responsibilities of the plantation mistress were far more extensive than those of her northern counterparts.

Management of slave labor was probably the most challenging task the plantation mistress faced. Young brides, with little experience in housekeeping, were particularly intimidated when faced with an experienced cook or housekeeper. Mistresses complicated matters by assuming that slaves identified with the interests of their owners and simply needed proper direction.

Southern women, in contrast to their northern counterparts, operated in a clearly defined hierarchy. The plantation mistress often supervised the labor of slaves rather than doing the work herself. Her slaves beat the carpets, cooked the food, and walked the crying baby. But just as white women dominated slaves on their plantation, their husbands dominated them. While the household was considered the woman's sphere, the plantation mistress did not have the same autonomy as her northern counterpart. Her sphere was not separate from her husband's because the plantation was also a place of business, ruled by the male owner who expected obedience from all dependents including his wife and children as well as his slaves. The wife who challenged the authority of her husband knew she was setting a bad example for slaves.

Defense of Patriarchy

Planters saw themselves as guardians of weak women and even weaker slaves—or "servants," as many masters preferred to call them. All were a part of their extended households. Planters saw themselves as benevolent rulers and maintained the ideal that the family, with its relations of power, provided the basis for government. They were horrified at ideals in the North that relied on a growing belief in individual rights and direct relationships between individuals and the state. Slaves, they argued, were unable to carry such a responsibility. Both family and slavery were benevolent despotisms that created stability among individuals born to different ranks in society.

The men who saw themselves as protecting their extended households did not shy away from physical violence. They valued their physical prowess in hunting, and they preserved traditions of dueling as an important means to defend personal and family honor. Their gender identity as men was tied to their ability to render justice (as well as corporal punishment) both within their families and in defense of them. They expected to discipline their slaves by beating them, if necessary, and some extended that logic to their wives. Marion Singleton Converse actually jumped from a bedroom window in fear of her husband, Augustus Converse, after he loaded his gun. While she escaped that time, she did not the next, when he beat her severely.

The privileges that white women had gained, many of these theorists contended, came with their acceptance of a subordinate position in this hierarchy. Southern writers such as Thomas Dew argued that it was the labor of slaves that had freed white women to advance from a state of savagery to one of civilization. Like slaves, they were part of a larger hierarchy that underlay the advance of civilization. Men were their protectors and rulers, but in exchange for accepting their own subordination and the

subordination of slaves below them, white women were rewarded with comfortable and fulfilling lives. As George Fitzhugh summed up, "A husband, a lord and master, whom she should love, honor and obey, nature designed for every woman."

This belief in the benevolent rule of male patriarchs over their extended families, white and black, carried with it some enormous contradictions. Selling one's kin, as slave owners did with their slaves, challenged all conventional definitions of family relationships. Abolitionists repeatedly pointed this out, and slave owners had to scramble in defense. Sometimes a slave had to be sold for financial reasons, they argued, but this was for the greater good of the remaining family members. Slave owners argued that the relationship between master and slave was one of affection and respect, yet in the law, it was a relationship of property above all else. Plantation mistresses as well as masters confronted a complicated and contradictory system in the extended household of the patriarchal plantation.

Family Networks

When elite young women in southern society reached their late teenage years, they entered an exciting period of balls and parties. No longer girls, they became **belles**, making their debuts to society in cities such as Richmond, Charleston, and Washington, D.C. With ball gowns that may have come from as far away as New York or Paris, belles were expected to draw a bevy of admirers. The dinner parties and long nights of dancing were not simply for fun, however. As they engaged in their whirl of social activities, southern belles were announcing that they were of marriageable age, and it was fully expected that within a couple of years of they would have made a suitable match. The guest lists of the parties they attended were carefully supervised so that they would meet young men whom their parents would find socially acceptable.

Like their counterparts in the North, elite white women in the South looked for love and companionship in their spouses. However, despite this growing commitment to companionate ideals in marriage, southern courtship and marriage differed in some subtle ways from patterns in the North. Marriage in the South tended to be more of a family matter, in the broadest sense of the term. Elite young women expected their parents to intervene in their deliberations about choosing a mate, and they expected to be supervised in their courtships. They expected that the landholdings and financial resources of both bride and groom would be carefully considered.

Extended family ties were further solidified as cousins often intermarried. While in some instances marriages among cousins solidified landholdings, many of these marriages may have also been the product of rural settings where few other options were available. Sometimes families disapproved of the practice, but it was commonly accepted in many others. Such marriages provided another way in which southern women continued to operate in densely constructed kin networks.

Southern elite women did their fair share to create these kin networks as they continued to have more children than did their counterparts in the North. Although deeply committed to their children, the dangers of childbirth and the high mortality rates of youngsters made motherhood a bittersweet experience for many. Slowly, elite women in the South began to limit their childbearing as their counterparts in

the North had already begun to do. In Virginia, some plantation mistresses began to limit their childbearing once they reached their mid-thirties. They were more likely to have six children than the eight their mothers would have born in the previous century. Like women in the North, they feared the dangers of childbirth, a perception that became clearer as they and their husbands began to speak of pregnancy as an illness.

The strong sense of family and elaborate kin networks of elite southern women were complicated by the unacknowledged family ties that extended to the slave quarters. As plantation mistress Mary Chesnut famously noted in her diary, "Every lady tells you who is the father of all the mulatto children in everybody's household, but those in her own she seems to think drop from the clouds." Elite women were well aware that men in their households sexually exploited slave women, though usually they tried to ignore the situation. However, when the relationship between a master and a slave became common knowledge, wives and their husbands battled. When Catherine Hammond had to confront the fact that her husband James had a long-standing relationship with their slave Louisa, she left him for several years. White women who could not influence their husbands sometimes took out their anger on the slave women or their children. One slave remembered a white mistress angry about her husband's infidelity. She "slipped in a colored gal's room and cut her baby's head clean off 'cause it belonged to her husband." Mistresses blamed the slaves as much as their menfolk for sexual improprieties and used their authority over slave women to punish and torment them for their husbands' misbehavior.

Read "A Confederate Lady's Diary"

Mary Chesnut lived a privileged life in the plantation South. Chesnut never publicly challenged the social system in which she lived, but her diary reveals the ways in which she sometimes questioned the legitimacy of slavery and its effects on the world.

Review the source; write short response to the following question.

1. What are the chief concerns about slavery expressed by Chesnut?
2. Evaluate the ways Chesnut alludes to the sexual relationships between white men and slave women.

Breaking Ties

In part because kinship ties were so important in the South, migration farther westward posed a particularly bitter challenge for women in planter families. Yet many men, faced with limited inheritances or concerned that their farms in the East were not productive enough, struck out for lands in newly created southwestern states such as Alabama, Mississippi, and Texas. Their wives usually had little input into the decision, though their dismay with the situation was clear. Israel Pickens ignored his wife's fears about moving from North Carolina to Alabama, while Sarah Gordon Brown's husband refused

to even discuss their impending move with her. "He sais he is going to move but makes no farthere preparation and none of us know what he is going to do," she told her son.

For young men, such moves represented an opportunity for independence, which they relished, and an opportunity to gain wealth that would not have been available to them in the East. Their wives, however, usually found themselves without family support just at the time they most needed it: during their childbearing years. They lost the support of their sisters and mothers who would have otherwise been present to help them with pregnancy, childbirth, and child rearing. It is not surprising, therefore, that women, unlike men, thought of their moves as a kind of death. One woman cried bitterly as her daughter left, saying "Oh, Mary, I will never see you again on earth."

The rough surroundings they confronted did little to ease their concerns. While the "big house" of eastern plantations was not necessarily opulent, it was certainly more luxurious than the log cabins that planters threw up on their land when they first arrived. Women in these circumstances found it difficult, if not impossible, to re-create the lives they had known in the East when confronted with homes composed of one or two rooms and a dirt floor, crawling with bugs and poorly lit. Even if family members had been able or willing to visit, it was hard for a woman to imagine how she would have the room to accommodate them if they came.

With few relatives surrounding them, planter households in these frontier areas of the South tended to be slightly smaller than those in the East and were usually confined to the nuclear family. For the women on these plantations, life without kin was lonely. Fanny Polk described herself as "depressed" in her new home in Tennessee. Ann Finley wished desperately for "a good talk" with her family, and Adelaide Crain reread letters from her relatives so often that she had them memorized. For these women, whatever their husbands earned in wealth was not worth the loss of their loved ones.

Review the Map of **"Slavery in the South"**[5]

Slavery expanded dramatically into the Deep South and Southwest during the antebellum period as planters moved their wives and children in search of more fertile land. Many slaves were sold from the Upper South to planters in these newly developing regions, also breaking up an increasing number of slave families.

STRUGGLES FOR INDEPENDENCE

Most southerners lived on the margins of plantation society with few or no slaves, drawing on the physical labor of all family members to eke out a living on their farms. These **yeoman farmers** valued their independence and counted on the work done by their wives and children to help them achieve economic self-sufficiency. While the vast majority of these farmers were white, a few were black. *Independence* was the watchword in all of these households, white and black, as those who were free struggled to distinguish their lives from those who were enslaved.

By the Sweat of Their Brow: White Yeoman Households

Many yeoman wives not only labored in their gardens and dairies but also labored in the fields. Their labor was particularly important at harvest time or if their husbands were not wealthy enough to own a slave or two. Those families who put their women to work hoeing or harvesting cotton, though, were usually making a public admission of poverty.

View the Profile of __Nancy Beard__

At the end of the Civil War, when federal officials asked Nancy Beard of Alabama exactly what kind of work she had done on her farm that year, she answered without hesitation that she had killed 13 hogs, and they "weighed about 125 or 130 lbs. each." Like other southern women who lived without the help of slaves, Nancy Beard's labor was central to the productivity of her family. Yeoman wives milked cows, slaughtered animals, spun and wove the fabric to make clothing for their families, and often produced enough excess to trade at country stores.

Women in these yeoman households had little time and no money for the domestic niceties that plantation mistresses and the middle class of the North could increasingly afford; they often settled for rough furniture, bare floors, and straw mattresses. For many wives of the yeoman class, an addiction to nice things was dangerous. If families had any money to spare, they preferred to plow it back into their farms as a way of guaranteeing their independence rather than succumbing to the temptations of worldly goods.

Some white families who were unable to support themselves on the land tried textile production. There were few factory opportunities in the South before the Civil War, but by 1860, about three thousand people were employed in mills that were mostly located in Georgia. Women outnumbered men in these factories by about three to two, sometimes living in boardinghouses as single workers but more often living with their families in company housing. Both working and living conditions in these factories were so wretched that New England mill girls hired to work in the factories quickly departed. Families with few economic options put their children, usually girls, to work in the mills when they were as young as ten years old. This child labor purchased a kind of yeomanly independence for destitute families. Mothers stayed home with small children while fathers farmed on company land and collected the wages of their daughters. Parents were able to at least imagine themselves in traditional gender roles as independent farmers and housewives, even though they were, in fact, dependent on the mills for their livelihood.

Although urbanization was taking place much more slowly in the South than in the North, some white women also found wage work as baby nurses in cities of the Upper South. Plantation families put their slaves to work tending children, but city families were more reluctant to trust their children to African American women. Perhaps because popular ideals of domesticity and motherhood were increasingly associated with white women, they were deemed a more appropriate choice for child care. In cities such as Louisville, Kentucky, and Baltimore, Maryland, over half the advertisements placed

for nurses in the antebellum period specified that the applicant be white. One advertisement requested, for example, "a middle-aged white woman who understands the management of small children." In addition to nursing, white women also took in boarders, another form of work that still conformed to domestic ideals of white womanhood. A few were shopkeepers, but in those cases, they clearly faced a more public world of exchange than would be evident in either nursing or keeping a boardinghouse.

Freedom in the Midst of Slavery: The Free African American Community

During the antebellum period, free black families who struggled to maintain their independence not only faced the crushing demands of work but also faced increasing legal discrimination, particularly after Nat Turner's Rebellion in 1831. Turner, an educated and deeply religious slave in Virginia, led a revolt in which fifty-five white southerners were killed. Slave owners feared that the free black community raised the hopes of freedom among slaves such as Turner to dangerous levels. They increasingly restricted the abilities of free blacks to get an education and practice their trades, leading many to head north. They also made it increasingly difficult for slaves to purchase their freedom or even for slave owners to manumit their slaves. By the 1850s, only Delaware, Missouri, and Arkansas still allowed masters to free their slaves. Not surprisingly, the growth of the free African American community in the South slowed dramatically during the antebellum period. Although the number of free African Americans in the South increased from about 134,000 to 262,000, they made up a smaller proportion of the overall population.

As manumissions decreased during the nineteenth century, the percentage of free blacks who were female grew. This growing gender imbalance was probably due to several factors. First of all, as the general sympathy for emancipation that existed in the years after the Revolution dissipated, slaveholders were less likely to free their slaves for ideological reasons and more likely to do so for personal reasons. They freed slaves whom they knew well and cared about, usually slaves who worked in their homes. Because women were more likely to be domestic workers, they would have benefited from these personal feelings. Moreover, women were seen as less of a threat than men in causing rebellions. Finally, masters were most likely to free slave women who had been their mistresses as well as the children they had had together.

Once free, African American women usually lived lives of poverty as they struggled to secure a living for themselves and their families. Jobs they had done as slaves, such as nursing and child care, were often unavailable to them as free women, so most turned to laundry or sewing. But just as was the case in the North, these jobs were among the worst paid. Free African American women had to work to support their families and were much more likely to do so than white women. In Savannah, Georgia, for example, 80 percent of the free black women between the ages of twenty and sixty worked, as compared with a little over 30 percent of the white women. If fortunate, some African American women could acquire enough capital to open their own bakeries, taverns, or boardinghouses, but such opportunities were rare.

Although poor, some free African American women did acquire property, and they did so at almost the same rate as African American men. In Petersburg, Virginia, for example, 46 percent of the free blacks who owned property were women. This was

 View the Profile of <u>Elizabeth Hobbs Keckley</u>

Hulton Archive/Getty Images.

Elizabeth Hobbs Keckley was born a slave in Virginia in 1818. Keckley moved to Baltimore and then to Washington, D.C., where her dressmaking shop catered to the wives of prominent politicians in the years leading up to the Civil War. It was in this context that she met Mary Todd Lincoln and became her dressmaker and confidante. Keckley's successful career came to a halt when she published her autobiography, *Behind the Scenes: Thirty Years a Slave and Four Years in the White House.*

a much higher percentage than was found among white women, who constituted 24 percent of the white real estate owners. In many other towns throughout the South, similarly high rates of female real estate holding occurred among free blacks.

Property holding extended not only to land but to slave owning as well. A few free black men and women owned slaves in the South, but their numbers were quite limited. In some cases, the slaves they owned were their spouses or children. Restrictive slave laws made it difficult to free one's own kin. In Virginia, for example, any slave freed after 1806 was required to leave the state. Free persons living in Virginia often preferred to keep their families in bondage rather than sending them away. Others, however, held slaves for the same kind of economic advantages that white people held them. Milly Swan was a free black woman who built successful businesses as a washerwoman and a farmer in Memphis, Tennessee, beginning in the 1840s. In building her businesses, she managed to purchase and free her husband, Bob Price, who worked with her, and Price's daughter from an earlier relationship. But Swan acquired other slaves as well, slaves she did not free. These were probably slaves who were not related to her but crucial to her business ventures in laundering and farming.

Living with the Law

Both poor white and poor black women struggled to create families in ways that differed markedly from their more affluent neighbors. In the South, for example, the practice of informal marriages continued more strongly than in the North, particularly among couples for which property was not at stake or for which an interracial union made an official marriage illegal. State courts throughout the country recognized these unions as legal, as long as the couple had lived as man and wife. Virginia was the first state to pass a law allowing children born of such unions to inherit property from their mothers, though other states soon followed suit. North Carolina did not officially recognize informal marriages, but courts nonetheless acknowledged them in a variety of contexts, particularly if the couple had lived together and if their neighbors accepted them as a married couple. Informal marriages occurred because of problems finding local officials, because interracial unions were illegal, and also because of the great difficulty couples faced in getting a legal divorce. Couples who married informally could just as easily divorce informally—usually with the husband moving away.

A variety of complicated reasons brought free black women, in particular, to informal marriages. One issue was cost. In states such as Virginia, free blacks were prohibited from becoming ministers in 1832, after Nat Turner's Rebellion. Black ministers had charged less than white ministers to perform a wedding ceremony, and the fees a white minister charged overwhelmed many African Americans. Moreover, because of manumission practices in the antebellum period, free black women outnumbered free black men, particularly in cities. This meant that some of these free women, if they wanted to have children, formed relationships with slaves whom they legally could not marry. In the eyes of the state, therefore, these women headed their own households, their husbands hidden from census takers by the legal restrictions of their times. Jane Cook considered herself married to Peter Mathews. Because Jane was free, however, and Peter was a slave, no legal marriage existed. Jane handled the property in the family, including two boats that she had bought for Peter, apparently with money he had earned, and property that she had independently acquired. When she wrote her will, Jane appointed an independent guardian to look after their daughter and the property their daughter would inherit. Peter, as a slave, was allowed no place in these legal proceedings.

Other African American women formed relationships with white men and faced similar bars to marriage. During the antebellum period, states throughout the Union passed laws prohibiting marriage between blacks and whites. Of the twenty-three states and/or territorial legislatures passing such legislation, three were in the North, seven in the Midwest, four in the West, and nine in the South. South Carolina, Alabama, Mississippi, and Georgia did not have such laws before the Civil War, though they did after the war. The absence of legislation in these states of the Lower South, where most free blacks were mulattos, may have grown out of West Indian traditions that gave mulattos a special status. It was clear, though, that even in frontier areas where such relationships were often tolerated, public acceptance of interracial marriage was declining as slavery expanded.

In the frontier setting of Memphis, Tennessee, for example, Mary Loiselle married Marcus Winchester during the 1820s; over the next couple of decades, the Winchesters had eight children. Loiselle was a free black woman from Louisiana while Winchester

was a white man of some status. He was the first mayor of Memphis and managed to govern successfully into the 1830s. By that time, however, the community was becoming more settled and free African Americans were under attack in the state. The Whigs successfully attacked Winchester, a Democrat, in the 1836 election because of his interracial family. Winchester continued on as an alderman and as postmaster but never again as mayor. Community disapproval was voiced in a new ordinance passed by the city council that forbade citizens from "keeping colored wives."

Free white women who lived with black men also faced discrimination, though their interracial relationships were more easily tolerated in the antebellum period than in the years after the Civil War, when such behavior could have led to a lynching. In 1860, the federal census for South Carolina revealed sixty-one interracial couples. More than two-thirds, forty-four of those couples, were African American men living with white women. In other states, where interracial marriages were illegal, such relationships surfaced indirectly. When John Weaver, a free mulatto in North Carolina, got into a dispute over a cattle sale in 1827, the court had to confront the fact that he lived in an informal marriage with a white woman. Records of these relationships usually came to light when one or both of the individuals entered the court system for other reasons. They were not usually brought to court for their interracial relationships, and it is clear from the court records that in many cases, their relationships had existed for some time and had been tolerated by their communities.

It is also clear that white women who engaged in interracial relationships could run into trouble, not simply because of the nature of their relationships with black men but because of their class status, which was usually low. The courts did not hesitate to discipline them and their families. Susan Williford, a white woman, lost custody of the children she had with Peter Curtis, a free black man. The North Carolina court placed the children in apprenticeships, as it did other children who were "illegitimate." Williford and Curtis also faced recurring court charges of fornication. For women who lost control of their children to the courts, the limits of their freedom were clear. Crossing the color line in creating sexual relationships would not necessarily lead to a lynching, but it could still carry significant penalties, particularly for those who were without property and family ties to protect them.

REPRESENTING THE SOUTH

Although their family structures differed from those in the North, southern women wrote avidly about their own vision of domesticity. Southern domestic writers, aiming for a national audience, addressed the same issues of sentiment and family that held their northern counterparts in such good stead. However, southern writers often addressed these issues with slavery in mind. As a result, domestic writing often became the occasion of political commentary.

Constructing Virtue: Slave Women

The few slave women who wrote about their experiences did so for northern audiences. Because they could address the abuses of slavery to both their families and their bodies, the narratives they produced engaged the conventions of domestic writing in powerful

ways. Their stories also embodied an extra layer of complexity as the authors negotiated the treacherous terrain of trying to convey the degradation they endured in slavery at the same time that they conveyed the feminine virtue they had managed to preserve.

Harriet Jacobs produced *Incidents in the Life of a Slave Girl* under the pseudonym "Linda Brent" in 1861, just as the Civil War was breaking out. Vividly describing the abuse she suffered from her lecherous master and jealous mistress, Jacobs was faced with the challenge of arousing northern sympathies in spite of the fact that she had voluntarily had an affair with another white man in her town. Jacobs was careful to describe why she needed her lover's protection and to modestly express embarrassment at her behavior. She urged her northern readers to recognize that slave women sometimes had to live by different rules of morality than did free women in the North. This was an extremely powerful argument, given that the general sentiment of domestic writers in the North was to assume that all women could live by the same code of morality and domesticity and that those who did not were morally corrupt rather than legally deprived.

The kind of domestic independence demanded of African American women in slavery was clear in their stories of bondage. They celebrated the domestic values that were cherished by their northern audiences. Yet, in each case, as women who were denied conventional domestic lives, they provided alternative models of virtuous female behavior that were rooted in their own self-reliance as their source of salvation.

Plantation Novels

Not surprisingly, many of the white women writing in the South produced a much more celebratory vision of the southern household and plantation society. Their stories were often a variation of the plantation novels, which had developed during the first decades of the nineteenth century. Originally written by male authors such as William Gilmore Simms and espousing values of agrarian harmony rather than northern competition, these novels portrayed an idealized version of plantation life in which benevolent masters presided over a harmonious extended family. Their wives were both virtuous and submissive, while their slaves were well treated and grateful. Female writers such as Caroline Gilman, Caroline Hentz, Mary Terhune, Augusta Evans, and Maria McIntosh combined the ideology of the plantation novel with the sentimental novel popular in the North.

 View the Profile of Caroline Hentz (1800–1856)

Caroline Hentz became the sole support of her family after her husband became ill. She ran a school for girls and wrote poems and other works. Her most popular and famous book was the novel, *The Planter's Bride* (1854), in which she defends slavery as a caring institution between master and slave.

While their novels stressed the harmonious relationship between master and slave, they also highlighted the responsibilities of the plantation mistress. The heroine of Martha Hunter's *Sketches of Southern Life*, for example, had a busy day working with her seamstresses, cooks, gardeners, and housemaids before turning her attention to

her male cousin who needed help writing a political speech. Heroines such as these were both more politically informed and more independent than the typical woman portrayed in the southern novels pioneered by male writers. The same could be said about the authors of these novels. Although they identified with the wealthy planter class, many of these women supported their families with the money they earned, just as female authors did in the North. Caroline Hentz was the sole support of her family after her husband became ill. Caroline Gilman and Mary Terhune supplemented the salaries of their clergymen husbands, and Augusta Evans provided her parents with financial stability before she married relatively late in life.

View the Profile of <u>Augusta Evans (1835–1909)</u>

Evans achieved financial success and fame as the author of popular novels. During the Civil War, she was a Confederate nurse and dedicated a book to the Confederate troops.

While focusing on plantation life, female novelists in the South saw their projects as national ones. Northern presses generally published their books, and these presses sought a northern as well as a southern audience. By writing of southern slavery in a favorable light, women writers hoped to ease tensions between the North and the South, countering a conflict they saw as rooted in partisan politics. In these novels, writers used marriages across the Mason-Dixon line to explore the differences between northern and southern society, critiquing not only the acquisitiveness of northern businessmen, for instance, but also the indolence of southern planters. As cousins from the North and South married one another, their interactions worked metaphorically to mitigate the faults of both regions.

Many of these writers abandoned that hope, however, when Harriet Beecher Stowe published *Uncle Tom's Cabin*. Stowe had thrown down the gauntlet with her indictment of southern plantation life, and for many southern writers, a strong response was necessary. Both male and female southern writers penned a large number of "anti-Tom" novels. Caroline Hentz attacked northern hypocrisy in *The Planter's Northern Bride*, published in 1854; while Mary Eastman, in *Aunt Phillis's Cabin*, described a woman who was so content living as a slave that she refused freedom when it was offered her.

Fighting for the South

Most women who wrote in the South, like those in the North, confined their literary expressions to novels and poetry. A few, however, went further and took up nonfiction writing. Most often they expressed their opinions in diaries and journals, but in a few cases, they wrote essays on politics or economics—literary genres generally reserved for men. Many of these writings showed a subtle understanding of the social hierarchy in which the writers lived, including the meaning of a patriarchal society both for elite white women and the slaves who served them.

Mary Chesnut became the most famous diarist of the South, though her journal was not published until much later in the nineteenth century. Her descriptions of plantation life in South Carolina, mostly recorded during the Civil War, provide some of the most important commentary on life among planters and their slaves. She had married James Chesnut in 1840 when she was still a teenager. Life on his parents' well-staffed plantation and the couple's inability to have children left her with plenty of time for reading and writing, in addition to the assistance she provided her husband in his expanding political career beginning in the 1850s.

Although deeply committed to the southern cause and unable to imagine a world other than the one she inhabited, Chesnut's diary is compelling because of the way it demonstrates her ambivalence about the system of slavery and patriarchy that characterized the antebellum South. She bemoaned the sight of a slave woman being sold at a slave market even as she commented on the silks in which the young slave was dressed and the way in which she ogled her potential buyers. She acknowledged that slavery was a flawed system doomed to disappear, but she despised abolitionists and she saw the wage labor of northern factory workers as a brutal substitute. Most famously, perhaps, Chesnut critiqued the system of patriarchy that subordinated both women and slaves to men who abused their power. Comparing planters to "patriarchs of old" who added more wives to their households by taking slave mistresses, thereby humiliating their legal wives, Chesnut deftly highlighted the power relations of the South. Yet, Chesnut felt little empathy for the slave women engaged in these relationships, asserting instead the purity of white southern women as her point of contrast.

Chesnut's friend Louisa McCord expressed none of Chesnut's ambivalence as she defended the power relations and economy of the South. McCord did, however, have to reconcile her enthusiasm for arguing about political ideas normally considered the province of men with her deep commitment to a social hierarchy in which women were both subordinate and retiring. Penning essays on slavery and labor for the *Southern Literary Messenger* during the early 1850s, McCord resolved this conflict by signing her essays with her initials only, letting her readers believe that she was a man rather than a woman. Her ability to live with this contradiction was no doubt due in part to the larger social argument she saw for women's subordination: the need to maintain social order. Although McCord championed the principles of a free-market economy, she argued that such an economy operated best with a social order that was hierarchical and based on a recognition of racial differences. African Americans, in her view, were racially fit for manual labor while white Americans were not, and white Americans were racially fit for freedom, while African Americans were not. Thus, slavery offered the best solution for the different racial abilities in the United States. White women were the equal of men intellectually but not physically, so this hierarchical system demanded that women take their place in the private world of the home rather than in the public world of politics—unless they were willing to sign their initials.

Although Chesnut was more ambivalent about slavery than McCord, both recognized that their own privileges rested on its existence. They imagined their lives as women not as separate from their social status but as part of it. Just as ideals of

northern domesticity were strengthening the power of a growing middle class, ideals of elite southern womanhood reinforced the power of the planters.

Read how "Women Engage Slavery"

While Harriet Beecher Stowe[6] was an articulate critic of slavery, Louisa McCord was an ardent defender. In the following documents, Stowe's piece is taken from her famous antislavery novel, *Uncle Tom's Cabin*. McCord's response, in a letter to her cousin, suggests how serious Stowe's criticisms were.

Review the sources; write short responses to the following questions.

Harriet Beecher Stowe
Louisa McCord, letter to Mary Dulles[7]

1. How did Stowe critique slavery?
2. In McCord's view, what had Stowe misrepresented about slavery?

CONCLUSION

Women in the antebellum South experienced the early Industrial Revolution and growing market economy in the United States primarily through agricultural activities rather than through industrial production and commercial transactions. With their homes continuing and sometimes expanding traditions of household industry, even elite women engaged the cult of domesticity differently than did their counterparts in the North. While celebrating their roles as nurturers, they did not fully embrace their homes as "separate spheres." A planter's wife needed to recognize her husband as master of a household that extended beyond the big house and into the slave quarters. Women in the more modest dwellings of yeoman farmers believed the well-being of their families lay in economic independence and the productivity of their land, so this was where they focused their energies. Slave women, of course, provided the antithesis: lives without land; without legal control of their bodies, children, or families; and without the same protection of the law that was afforded white women. Working within these constraints, slave women constructed social networks to protect their families as best they could and, in fashioning their domestic worlds, demonstrated both resourcefulness and independence. Whether slave or free, black or white, southern women experienced gender in ways that were different from women in the North, and these differences were central to the ways in which the two regions increasingly defined their societies as different from one another.

Study the Key Terms for Family Business: Slavery and Patriarchy, 1800–1860

Critical Thinking Questions

1. What were the most important ways that slavery affected ideals of womanhood in the South?
2. How did patriarchy operate as a system of both racial control and sexual control?

Text Credits

1. Copyrighted by Pearson Education, Upper Saddle River, NJ.
2. Mary Beth Norton and Ruth M. Alexander, eds., *Major Problems in American Women's History,* 2nd edition (Lexington, MA: D.C. Heath and Company, 1996), pp. 144–145.
3. "The Slave Auction" by Frances Ellen Watkins Harper (1825–1911) reprinted in American Poetry: The Nineteenth Century (The Library of America, 1993).
4. *Women's Letters: America from the Revolutionary War to the Present* (New York: Dial Press, 2005), pp. 226–227; Harriet Ann Jacobs, *Incident in the Life of a Slave Girl: Written by Herself, 1813–1897.*
5. Copyrighted by Pearson Education, Upper Saddle River, NJ.
6. Harriet Beecher Stowe, *Uncle Tom's Cabin: Or, Life Among the Lowly* (Boston: J.P. Jewett, 1851).
7. Louisa McCord, Letter to Mary Dulles, October 9, 1852 from Richard C. Lounsbury, ed., *Louisa S. McCord: Poems, Drama, Biography, Letters* (Charlottesville: University Press of Virginia, 1996).

Recommended Reading

Elizabeth Fox-Genovese. *Within the Plantation Household: Black and White Women of the Old South.* Chapel Hill, NC: University of North Carolina Press, 1988. A wide-ranging book that argues powerfully for the importance of class in determining the attitudes of southern women, both slave and mistress.

Stephanie McCurry. *Masters of Small Worlds: Yeoman Households, Gender Relations, and the Political Culture of the Antebellum South Carolina Low Country.* New York: Oxford University Press, 1995. Innovative study of the lives and values of white women who lived without slaves.

Melton A. McLaurin. *Celia, A Slave.* New York: Avon Books, 1993. Engaging narrative of a slave woman who killed her master and the trial that followed, situating the story in the larger context of conflicts over slavery and contradictions in slave law.

Deborah Gray White. *Ar'n't I a Woman? Female Slaves in the Plantation South.* New York: W.W. Norton, 1985. Concise and important argument, based primarily on narratives of ex-slaves, about the ways in which slave women worked and lived in the antebellum South.

RELIGION AND REFORM, 1800–1860

LEARNING OBJECTIVES

- How did women participate in religious activities during the antebellum period?
- How were different religious practices related to different ideas about women's authority?

Explore Chapter 7
Multimedia Resources

TIMELINE

1790s	Beginnings of the Second Great Awakening
1796	Lucy Wright becomes leader of Shakers
1817	American Colonization Society formed
	Cherokee women petition their National Council not to cede Cherokee land to the U.S. government
1819	First missionaries sail to Hawaii
1825	Seamstresses in New York City start first strike by women
1826	American Temperance Society founded
1828	Oblate Sisters of Providence established in Baltimore for Catholic African American women
1829	Catharine Beecher secretly spearheads women's petitioning campaign against Indian Removal
1830	Congress passes Indian Removal Act
1830s	High point of Second Great Awakening
1832	African American women form first female antislavery society in Salem, Massachusetts
1833	William Lloyd Garrison founds American Anti-Slavery Society
1834	Ursuline Convent in Charlestown, Massachusetts, burned; New York Female Reform Society founded to combat prostitution; Shoebinders in Lynn form Female Society to protest wage cuts
1835	Rioters attack William Lloyd Garrison in Boston during an antislavery meeting; female workers in Lowell mills go on strike

1836	*Awful Disclosures of Maria Monk* published
1839	Mary Gove publishes *Solitary Vice*
1840	Washingtonian Temperance Society formed in Baltimore; American Anti-Slavery Society splits over issue of women's leadership in the movement; those opposed form American and Foreign Antislavery Society
1848	Oneida Community founded by John Humphrey Noyes; Fox sisters hear rappings that will begin Spiritualist religious movement

FREE WOMEN OF THE UNITED STATES ENGAGED IN UNPRECEDENTED ACTIVISM DURING THE NINETEENTH CENTURY. They were at the forefront of the religious revivals of the Second Great Awakening, and they also played a central role in most of the reform movements of the time. Many women prayed, while a few even preached. Some attacked brothels, others went on strike, and thousands signed petitions protesting slavery. Although they viewed themselves as the guardians of traditional family values, female activism posed significant challenges to traditional patterns of male authority. Although concerned about how far to go with their activism, women began to create new social identities for themselves as they moved beyond their households to form female organizations. Some even began to engage political and economic issues collectively—as women.

Not surprisingly, the racism and ethnocentrism that underlay slavery and western expansion also infected these movements for reform. Women usually organized themselves along class, racial, and religious lines, unintentionally replicating—and in some cases exacerbating—the hierarchies of the larger society. But for better or for worse, in both their demands for change and the relations of power they created, these women were reshaping civil society in the United States.

REVIVALS AND RELIGIOUS VIRTUE

In the aftermath of the American Revolution, urban women, in particular, had demonstrated their civic consciousness not only through their commitment to republican womanhood but also in their creation of benevolent societies to assist the poor. This notion of virtue was transformed during the first decades of the nineteenth century as women adopted a central role in promoting the religious messages of the Second Great Awakening. Working to protect and convert their families and those of others, women expanded their female networks and in some cases began to challenge the authority of men in their society.

Gendered Revivals in the North

Religion was at a low point at the end of the eighteenth century. Churches were scrambling to reorganize in the wake of the Revolution, and their congregations

had diminished. However, by the 1790s, faint glimmerings of religious fervor began to appear in scattered revivals, foreshadowing the dramatic outbreak in religious enthusiasm spanning the first half of the nineteenth century that became known as the **Second Great Awakening**. As women became caught up in this spiritual upheaval, they encountered a new world of religious inspiration and reorganized their social worlds.

The evangelicalism of the Second Great Awakening swept through many denominations, including the Baptists, Methodists, and Presbyterians. It was characterized most forcefully by a conversion experience in which the convert came to the belief that he or she had been saved and was therefore ready to join a church. Many people experienced their conversion during a **revival**. Some revivals occurred in a particular town as ministers from local congregations along with visiting preachers hosted frequent and intensive religious gatherings in their respective churches over the period of a few months. Other revivals occurred at **camp meetings** that were held in open fields, usually in the summer, attracting campers from throughout the region for days or even weeks of religious activity. In either case, followers left their homes and their jobs for days on end to hear powerful and emotional preaching. Sometimes they collapsed in anguish as they confronted their sinful pasts and tearfully sought a new path to salvation. Regardless of their exact form, revivals occurred everywhere in the United States, from New England mill towns to southern agricultural communities to western frontier settlements, and they echoed similar religious enthusiasm across the Atlantic in England. Indeed, itinerant preachers crossed the Atlantic both ways, connecting England and the United States in an evangelical awakening.

Wherever revivals occurred, women were far more predominant than men. Female participants came from all walks of life. Believers could be found among women of the emerging middle class or those who worked in factories, as well as farmwomen on the frontier. Evangelical religion provided these women with a strong internal moral compass as they confronted the vicissitudes of a new market economy or life in a new factory town. Evangelicalism, with its emphasis on a religious understanding of the heart rather than the mind, meant that adherents did not have to be highly educated to feel a mastery of its principles. In addition, evangelical churches offered female adherents a space of sociability beyond the home that they could attend with propriety.

As women joined evangelical churches in greater numbers than men did, many women necessarily declared a kind of spiritual independence from their husbands and fathers. These women not only asserted their right to choose their own beliefs and achieve their own salvation, but also brought these beliefs back into their homes in child-rearing activities, because evangelicals of the nineteenth century believed that individuals could improve their chances of being saved by improving their moral behavior. Mothers took on increasing responsibilities in supervising the spiritual welfare of their children. In most cases, this new assumption of religious authority went smoothly, reinforcing a trend begun during the colonial period that associated women

with spirituality. However, it is also clear that female religious independence could be disruptive within families. Revival meetings, held at all times of day and night, could mean that meals were not cooked, clothes were not washed, or sleep was disrupted as a result of midnight meetings. At camp meetings, young women mingled with young men under relatively lax supervision, leading to charges of licentious behavior. Equally disturbing were the close relationships women developed with their ministers as their new sources of spiritual and moral guidance. Not surprisingly, ministers sometimes faced charges of seduction or lewd behavior in their relationships with female converts. Elder Ray Potter was run out of Pawtucket, Rhode Island, in 1820 after his affair with a young follower was revealed; he was also burned in effigy.

Regardless of the spiritual independence exercised by women, there were still important limits to their power, and women's participation in church governance was limited.

Evangelical Commitments in the South

In the South, women were also more likely than men to join evangelical churches. As was the case in the North, religion provided an important refuge for many women. Slave women on large plantations sometimes slipped away for private prayer meetings that reinforced their collective will to survive. One such woman, a slave named Elizabeth, found solace in her prayers. "I betook myself to prayer, and in every lonely place I found an altar," she claimed.

Southern women also took it upon themselves to exhort as well as pray. Arriving in a new settlement where there was no religious leadership, for example, women in the backwoods of Georgia felt empowered to take on preaching duties. On a plantation in Mississippi, Aunt Sylvia led services for her fellow slaves. Plantation mistresses sometimes extended their responsibilities for the well-being of their slaves into the realm of religious instruction through exhortations on occasion. One exuberant mistress moved from one house to another in the slave quarters on Sundays. One of her ex-slaves recalled that "Sometime she git so happy she git to shoutin."

However, even more than in the North, women in the South faced strong opposition when they pushed too far in assuming positions of religious leadership. Some southern denominations tolerated female exhorting, but they drew the line at more formal preaching. Indeed, although southern men had not been initially swept up in the earliest revivals of the nineteenth century, they moved quickly to join these churches and assert their leadership once it became clear that female participation in evangelicalism could challenge their authority as the heads of their households. Women (and African Americans) in southern congregations were universally excluded from voting on church business. In religion, as in household matters, patriarchal authority in the South remained strong.

Mothers and Missionaries

Women who were barred from church governance found alternative outlets for spiritual leadership in maternal associations and missionary societies, organizations that

added a new religious layer to the traditions of organized benevolence begun in the 1790s. In maternal associations, women met regularly to share strategies for raising their children in a godly manner and to pray for their salvation. These groups did not challenge social hierarchies, but they highlighted the growing spiritual leadership of women within the domestic sanctuary.

In missionary societies, women supported efforts to spread Christianity abroad and increasingly focused their attention on religious issues closer to home. As a result, many poor relief efforts that had been more secularly oriented in the late eighteenth century took on an increasingly evangelical cast. Many of these efforts were rooted in a particular denomination so that Catholics and Jews were often careful to maintain separate organizations. In this new tradition of religious benevolence, an ideal of womanhood rooted in spiritual ideals began to emerge, subtly transforming the more secular definition of the late eighteenth century. Republican mothers of the eighteenth century, who had proven their capacity for civic virtue, were being replaced by the new ideal of the religiously inspired women who were expanding their domestic capabilities to help those in need. This spiritual ideal was linked to a powerful drive to "civilize" as well as convert large parts of the world, a zeal that was clear in the activities of Marcus and Narcissa Whitman on the Oregon frontier (see Chapter 4). As a result, religious commitment was freighted with powerful social consequences.

Missionary activities of women who traveled overseas usually occurred in the context of their status as wives; it was not considered appropriate for female missionaries to travel overseas alone. Missionary wives, however, played an explicit and important role in efforts to convert others. They not only were expected to run their husbands' households but also were expected to set an important example of civilized values for those who were considered unenlightened. One of the most famous of the missionary wives was Ann Hasseltine Judson, who traveled to Burma with her husband, Adoniram, and threw herself into the business of trying to convert Burmese women to Christianity and Western values. Women throughout the United States read her letters

Q View the Profile of <u>Anne Hasseltine Judson (1789–1826)</u>

Missionary. One of the most famous of the missionary wives was Anne Hasseltine Judson, who traveled to Burma with her husband, Adoniram, and threw herself into the business of trying to convert Burmese women to Christianity and Western values. She was the first American woman to leave the United States for missionary work and the first to live in Burma. Although Judson found the Burmese to be a depraved and heathen people, she took the time to at least observe their practices. Ann Judson died, at the age of thirty-seven; her biography became a best seller, assuring her continued fame in the nineteenth century.

to missionary journals detailing her triumphs and concerns. When Ann Judson died at the age of thirty-seven, her biography became a best seller, ensuring her continued fame in the nineteenth century.

The women who traveled with their husbands to Hawaii with companies of missionaries found the local population "uncivilized," the Hawaiian women devoting little time to child care and spending much of their time in leisure activities. To illustrate the virtues of "civilization," that is, domesticity, the missionary wives did their utmost to set an example through their contrasting style of dress and child-rearing practices. They went to great lengths to abide by the principles of "separate spheres," a prime indicator of civilization, and took pride in their clean, orderly houses and ladylike—if impractical—clothing. Indeed, if they fell short in converting Hawaiian women to Christianity, missionary wives could measure their success by how well they themselves became exemplars of civilization under primitive conditions.

The missionaries had a particularly large impact on native life in Hawaii. By 1853, one-fourth of the islanders were at least nominally Protestant. Within just three decades, missionaries had written down the local language, printed primers and hymn books, and translated the Bible. They also built schools and medical dispensaries and set the Hawaiians on the track of constitutional government, helping years later to plan the 1893 coup that dislodged the monarchy of Queen Liliuokalani, who herself had been educated by missionaries.

Preaching the Word

Although most women found their religious enthusiasm channeled into maternal associations and missionary societies, a few women actually became preachers within their denominations. Quakers and Shakers had always allowed female leaders, but new evangelical sects that were growing in prominence during the early nineteenth century, such as the Freewill Baptists, Christians, African Methodists, and Methodists, also began to welcome female preachers. This was one way in which they demonstrated their differences from the established churches, such as the Congregationalists and Presbyterians. Because these evangelical sects opened themselves to the poor and the uneducated and because they preached a religion of the heart, conceivably anyone could be a preacher—slave, day laborer, or woman.

Female preaching began, in part, because upstart evangelical churches in both the North and the South had allowed women to speak about their religious experiences in churches or in informal social gatherings. This practice of exhorting could (quite literally) give women a very powerful voice within their congregations. They called on God to guide them, shared their struggles with temptations, and looked to fellow believers for support. In addition, they tried to draw sinners to God, warning of the damnation that awaited those who ignored his rule. Most female preachers were itinerants, traveling from town to town and from one camp meeting to the next. They recounted powerful conversion experiences and calls from God that drew them away from family and work to carry their religious beliefs to potential converts. Female preachers lacked

formal theological training, so that they spoke from the heart, rooting their preaching in their everyday experiences that resonated with their audiences. Camp meetings were a particularly inviting spot for women to try their preaching. They did not have to rely on an invitation from a potentially hostile minister to occupy his pulpit, and normal social rules were suspended. Women who took on these roles compared themselves to prophetesses of the Old Testament who had a special mission to preach the word of God.

This independent lifestyle left female preachers open to criticism and led them into conflicts with church superiors. Nancy Towle, an itinerant preacher from New Hampshire, refused to join any particular denomination because she feared that church leaders would seize the opportunity to silence her. She traversed the eastern seaboard several times and crossed the Atlantic to Ireland and England during the 1820s and 1830s before finally abandoning her ministry. Jarena Lee, a free black woman in Bishop Richard Allen's African Methodist Episcopal Church in Philadelphia, struggled for eight years to receive permission to preach. Allen insisted at first that Lee confine her activities to exhorting and leading prayer meetings. Only after Lee became a widow did Allen relent and allow her to travel through New England and the Middle Atlantic states as an itinerant preacher. Lee had to combat frequent innuendo that she was sexually promiscuous or mannish, charges that dogged African American women more than their white counterparts. Lee was careful of her dress and deportment when she traveled, and she also took great care to present an image of respectability in the portrait of herself that she included in her memoirs.

Read about **"Receiving the Call to Preach"**

In 1836, Jarena Lee,[1] the famous African American preacher, recalled how she finally received recognition to take up her calling.

Review the source; write short responses to the following questions.

1. How did Jarena Lee use the authority of God to justify her calling to preaching?
2. How did Jarena Lee demonstrate to the bishop that she had been called to preach?

Although Lee, Towle, and other female preachers took great pains to assert their respectability, they did not encase themselves in the trappings of domesticity. Carrying the word of God from one town to another, they lived in a spiritual but public world in which housekeeping and child rearing were of minor importance at most. Without addressing the gender hierarchy that came with a commitment to domesticity, they, nonetheless, challenged it in their daily lives, a trend that continued until the 1840s, when many of the denominations that had previously tolerated female preaching began to silence those voices. This change may have occurred for a variety of reasons. Some churches may have feared being associated with the more radical female speakers in the burgeoning antislavery movement. In other cases, upstart denominations

that had once welcomed female preaching were becoming more settled, stocked with a growing pool of male converts eager to assume the reins of leadership.

RELIGION AND FAMILY AUTHORITY

The explosion in religious activities during the early nineteenth century extended far beyond the confines of the Second Great Awakening. In a variety of nonevangelical contexts, women engaged in religious practices that challenged or complicated the dominant ideals of gender hierarchy. Small sects such as the Shakers challenged the institution of marriage and divided worshippers into separate groups of men and women. Spiritualists championed female autonomy. Immigrant Jewish women who participated in the growing Reform Tradition in their religion asserted themselves in new ways within their synagogues, while Catholic women, particularly those who took the veil and entered convents, confronted nativist mobs and domineering bishops. Intentionally or not, they contested patterns of authority that were rooted in a model of the male-headed household.

Quakers, Spiritualists, and Female Autonomy

During the nineteenth century, Quakers continued their belief in the importance of an **inner light**, which had been so important in encouraging female as well as male ministry. However, as a growing number of Quakers achieved financial success, some Quakers criticized the growing worldliness of their religion, including the participation of some members in the slave trade, and important splits occurred. Controversy over these issues waxed and waned for decades, but came to a head most pointedly in a bitter split between critics of worldliness and slavery led by Elias Hicks (known as the Hicksite Quakers) and the Orthodox Quakers. Many Quaker women who would later emerge in more radical antislavery and women's rights activities followed the Hicksites in this split.

Some of these Quakers who had been cut off from their religious base formed the core constituency of early **Spiritualism**, a movement of people who believed they could communicate with the dead. The movement began in 1848 when Kate and Margaret Fox, aged twelve and fourteen, heard unexplained rappings at their home in upstate New York and soon after began to convey messages to their friends and neighbors from the spirit world that they heard in these rappings. Spiritualism soon spread from upstate New York to California, offering those who were living the hope of contacting those who had died. Others stepped forward claiming that they too had received messages from the spirit world. Eschewing any formal religious structure, Spiritualists met in each other's homes, often circled around a table in which at least one individual acted as the **medium** and relayed messages between the world of the living and the world of the dead. This connection to loved ones who had died was particularly meaningful to women, who were traditionally the caregivers for children and other relatives in the time leading up to death. Mediums could be either men or women, but frequently they were female because women were seen as more spiritually

sensitive than men and thus more receptive to communications from the spirit world. Moreover, because mediums were constructed as passive vehicles of communication between the living and the dead, their role as mediums was viewed as feminine, even if the medium was a man. Spirits sought them out; mediums did not act as agents in choosing this role. These characteristics were evident among female trance speakers as well. As Spiritualism spread throughout the country, mediums addressed audiences that could be as large as several thousand. Usually men called the meetings to order and presided over the proceedings. Women, as passive mediums, spoke in a trance, unconscious of their surroundings. As a result, they were able to speak in public while still maintaining some commitment to gendered notions of propriety.

Unlike other religions, Spiritualism fostered the public speaking of women and also fostered an explicit commitment to woman's rights. Spiritualism eschewed all institutional conventions, such as churches and ministers, in the communications that took place between the living and the dead. Both male and female Spiritualists repeatedly indicated their strong support for the individual rights of women as part of a larger move to challenge the institutional constraints of organized religion. Spiritualists argued that women who sought the truth needed an education equal to men's, for example, and that women did not deserve to be subjugated to men in either marriage or employment. Not all advocates of women's rights became Spiritualists, but it is understandable why some did given these positions on female autonomy.

Reform Judaism and Gender Hierarchies

Challenges to patterns of male authority took place in more established religions as well, as became clear in the Reform Tradition of Judaism. In the years immediately following the Revolution, there were very few Jews living in the United States—no more than a few thousand—who mostly congregated in cities from Charleston, South Carolina, to Philadelphia, Pennsylvania, and Newport, Rhode Island. Many were merchants who thrived economically and moved in elite circles. While maintaining their own religious practices, their wives and daughters were as well educated as their Protestant counterparts and engaged in shared cultural and benevolent concerns. Elite Jewish women such as Rebecca Gratz of Philadelphia shared leadership positions with Protestant women in running the city's Female Association for the Relief of Women and Children in Reduced Circumstances and the Philadelphia Orphan Society. Gratz also read the Bible with her non-Jewish sisters-in-law, suggesting the extent of religious tolerance between Protestants and Jews in this early period, when there were few Jews in the United States and class affinities often trumped religious commitments.

However, between 1840 and 1860, approximately 250,000 German Jews migrated to the United States because of religious persecution in their home country (see Chapter 5). As a result of these growing numbers and in response to the more clearly defined Protestant identities of women participating in the Second Great Awakening, Jewish women began setting up educational and benevolent organizations, such as the Hebrew Benevolent Society of New York, which were comparable to those run by Protestant women.

To a certain extent, female participation in Jewish benevolent organizations was the result of widespread changes among a segment of the Jewish community that sought to modernize their religious practices in a movement known as Reform Judaism. Jewish religion, as it had been practiced in Europe during earlier centuries, had separated the religious activities of women from men, and female religious duties were oriented toward aiding men in the fulfillment of their religious responsibilities. This subordination came under scrutiny during the eighteenth century, particularly in countries such as Germany and France where Enlightenment principles were widespread.

In the United States, women of the Jewish Reform Tradition set up benevolent organizations and also began to participate more in their synagogues. By the 1840s, the Reform Tradition deemed women to be equal to their male counterparts. They were counted as full members of their congregations and sat with men during services just as women in evangelical congregations often did—and sang on occasion. The previously male realm of the synagogue became increasingly feminized as the scope of women's activities expanded.

Power and Danger in Catholic Convents

Roman Catholicism grew during the antebellum period to become the largest denomination in the United States. While periodic revivals or renewals of religion contributed a small amount to this growth, the real reasons for this stunning transformation lay in the massive migration of Catholics, particularly from Ireland and Germany, during the 1840s and in the acquisition of vast amounts of Spanish territory in the West, particularly after the Mexican War (see Chapters 4 and 5).

Catholicism was not an evangelical religion, but women still outnumbered men in Catholic Churches. This gender imbalance became more pronounced as the century progressed because, increasingly, female immigrants outnumbered male immigrants from Ireland. Among Catholic families, as among Protestant families, women provided the active religious instruction of children. Unlike their Protestant counterparts, however, Catholic women generally ceded more institutional efforts at benevolence to religious orders of sisters. Convents brought to the United States a distinctive form of female benevolence and spirituality because they consisted of women who defined their lives outside of the traditional boundaries of the family structure.

During the nineteenth century, nuns migrated from Europe to set up convents and native-born women established religious orders, in both cases creating communities that had more freedom than those that existed for their counterparts in Europe. In part, the nuns were able to operate with more flexibility because during the nineteenth century the United States was still considered a mission territory and the sisters were unlikely to lead the cloistered lives that existed among some orders in Europe. Indeed, nuns in the United States often did not have the financial endowments or dowries that made a truly cloistered life possible; they needed to engage in some kind of work to support themselves.

Most commonly, religious orders took on the work of education. The Ursulines established the first convent in New Orleans in 1727, and the Visitation nuns established

a school at Georgetown in 1799. In some cases, schools took in both paying students who covered the bills and charity students who benefited. This was the pattern established by Elizabeth Seton, who founded the Sisters of Charity and established a school in Emmitsburg, Maryland, in 1809. In addition to schools, nuns also ran hospitals and orphanages throughout the country. In many of the religious orders established in southern states during the early nineteenth century, the nuns relied on slave labor to do their farm-work or household chores while they took on the more skilled activities of nursing and educating. Slaves were an important form of wealth that new sisters from the South brought with them when they entered convents and that wealthy southern donors supplied.

In addition to the religious orders being created by white European and American women, women of African descent, migrating from the Caribbean, established the Oblate Sisters of Providence in Baltimore in 1828. Led by Sister Mary Elizabeth Lange, who migrated from Saint Domingue as a relatively privileged mulatto with both prop-erty and status, the Oblates opened a school for the education of black girls. Convent life in Baltimore may have offered Lange and other mulatto women more of the sta-tus and autonomy they had enjoyed in the Caribbean than they found in Baltimore. The Oblate sisters did not own slaves, but they largely kept silent on the issue of slav-ery. Women entering the order were (with one possible exception) free blacks, though some had begun their lives as slaves. With a large and growing free black population in Baltimore, including refugees from Saint Domingue (Haiti), the school founded by the sisters was an important resource.

Nuns who ran schools, hospitals, and orphanages in some ways lived far more in-dependently than most American or European women at the time. They held mana-gerial positions normally closed to women, supported themselves, and acquired and managed property for their religious orders. However, they were still subject to a male religious hierarchy, which resulted in conflicts on numerous occasions. Elizabeth Seton, although now recognized as a saint by the Catholic Church, was almost expelled from the Catholic Church as a result of conflict with her male superiors. Rose Philippine Duchesne, who founded the Society of the Sacred Heart in America, was refused com-munion by her bishop in the Louisiana Territory because she tried to resist his control of convent affairs. Struggles involved everything from the specific teaching and nursing activities nuns were to undertake to the disposition of the money they raised.

Distrust of convents extended far beyond the male leadership of the Catholic Church. The influential writer and editor Sarah Josepha Hale urged the creation of Protestant schools to counter the effects of Catholic schools. Anti-immigrant sen-timent, which began to flourish in the 1830s as more foreigners arrived, sometimes focused violently on convent schools. In 1834, the Ursuline Convent in Charlestown, Massachusetts, was burned to the ground while other convents were threatened.

Equally as sensational was the salacious literature printed by the anti-Catholic press claiming to expose convents as little more than bordellos kept for corrupt priests. The most famous example of this kind of attack came from Maria Monk, whose claims of sexual intrigue were laid out in the *Awful Disclosures of the Hotel Dieu Nunnery of Montreal* (1836). Maria described in graphic detail how she (like all nuns) was forced to

have sex with priests in a nearby rectory and how babies born of these sinful practices were baptized and then strangled at birth. Although her allegations were proven false, her books continued to sell well to a Protestant public fearful of both the Catholic Church and women who lived beyond the controls of a male household head.

The pornography that flourished about the sex lives of nuns revealed the deep skepticism harbored by many Protestants about the viability of celibacy as a respectable and realistic sexual choice. Many Protestants saw celibacy as a sure road to moral corruption in its denial of natural impulses. Even if nuns were imagined to be sexually passionless (as other white women were), priests were not; and there were no husbands, brothers, or fathers to protect nuns from these male predators. A community of women, unprotected by family ties, posed a dangerous challenge to the social order embodied by Protestant families. This pornography provided a vivid and expanded portrayal of the fate that awaited any woman who declared her independence from her family, whether she was a factory girl, a convert at a camp meeting, or a Catholic nun.

CONTROLLING THE BODY, PERFECTING THE SOUL

The religious enthusiasm that brought women into churches in the nineteenth century infused their voluntary associations as well. Spiritual beliefs were manifested in bodily behavior, and salvation was increasingly tied to worldly activities. Not surprisingly, movements aimed at perfecting the soul by controlling the body gained prominence during this period. However, approaches to bodily control varied dramatically. The Shakers rejected all sexual contact. Members of the Oneida community outraged the nation by attacking sexual monogamy, whereas other reformers drew attention to the dangers of masturbation. More commonly, though, reformers took aim at sexual promiscuity, the consumption of alcohol, and the family violence that accompanied drunkenness.

Female reformers who attacked family violence, drinking, and prostitution sometimes adopted controversial techniques in their crusades against immorality, and they engaged in public behavior that many of their critics found unladylike. As was the case with evangelical women, these reformers were not social revolutionaries. They took up their causes as the spiritual guardians of their homes, not as secular critics asserting political rights. Yet, their activities were deeply enmeshed in a dual revolution in power relations in American society: the creation of a bourgeois ethic of self-control that was fundamental to the creation of a middle class and a critique of marriage for unfairly allowing men to physically dominate or even abuse their wives. As women moved to defend their homes, in various ways they also undermined the structures of authority that lay at the heart of household relations.

Celibacy of Shakers

The Shakers, who had established themselves as a small sect during the First Great Awakening under the leadership of Mother Ann Lee, expanded in concert with the rhythms of the Second Great Awakening (see Chapter 3). With communities in

New England, New York, Kentucky, and Ohio, Shakers created an alternative family structure rooted in their belief that sexual intercourse—even between a married couple—was sinful. This meant that they could not expand through the procreation of their members and were thus a sect of converts that had largely died out by the end of the nineteenth century. In the antebellum period, however, Shakers were not worried about this problem because they believed the end of the world was at hand. They continued their beliefs in celibacy throughout the nineteenth century and institutionalized roles of religious leadership for women, two factors that may explain the appeal Shakers held for many women. Women who were worried about the dangers of childbirth and the demands of traditional family life found Shaker communities an attractive alternative.

The commitment of Shakers to celibacy and their belief in the strict separation of men from women meant that women needed their own leaders. For this reason, Lucy Wright became the spiritual leader for female Shakers after Ann Lee died in the late eighteenth century. Wright struggled valiantly to organize women into a religious group independent of male control, and by 1796 she had become a powerful enough figure within the movement to become its new leader. Although female leadership was central to the Shaker religion, this does not mean the Shakers were intent on attacking all gender distinctions or forms of gender hierarchy.

Read the Profile of Mother Ann Lee (1736–1784)

Leader of Shakers. Born in Manchester, England, Lee spent her early years of adulthood increasingly convinced that marriage was incompatible with God's way and that the only way to salvation was to purify the soul by confession and letting the Spirit of the Lord shake the sin out of the body. She was imprisoned on several occasions for her unconventional "blaspheming," but this made her all the more ardent and a leader of her sect. Called Mother Ann, she and her followers left persecution in England for the United States, settling outside Albany, New York. Expanding in concert with the rhythms of the Second Great Awakening, the Shakers created communities in New England, New York, Kentucky, and Ohio, providing their membership with an alternative family structure rooted in their belief that sexual intercourse, even between a married couple, was sinful. In expectation of the Second Coming, the Shakers continued their beliefs in celibacy throughout the nineteenth century. For many women, celibacy and the institutionalization of religious leadership for women made the Shaker sect attractive.

With leaders chosen from each sex, large families of anywhere from thirty to one hundred members were established. Husbands, wives, and their children who converted to Shakerism were reconstituted as part of this larger communal order in which religious leadership, child rearing, and labor were divided broadly along gendered lines. Although duties of religious leadership were shared equally, conventional gender

distinctions dictated other allocations of labor. Men, for example, worked in the fields and shops while women cooked, cleaned, and cared for children. Yet, for women who felt isolated on individual farms or who chafed at the spiritual domination of their husbands or who wished to limit their family size, Shaker communities offered an important alternative to traditional social patterns.

As in other religious movements, women were predominant. By 1800, in all Shaker communities in the East, women outnumbered men. As the sect grew, the philosophy of separate but equal gender segregation that was so crucial to Shaker beliefs was ritualized. One of the most potent forms of expression came in the Shaker dance during religious services. Men and women lined up in separate rows facing one another, singing, clapping, and jumping. In some cases, believers stood in place while in others they engaged in a circular movement in which four concentric circles were formed to symbolize the four great periods in religious history.

Bible Communism: Complex Marriage in the Oneida Community

The Oneida community established one of the most radical experiments in bodily control by incorporating sexual intercourse into their religious practices. Founded by John Humphrey Noyes in 1848, members of this community in upstate New York practiced **complex marriage**, a system in which every man and woman was married to one another and available to one another as sexual partners. In its critique of marriage, the Oneida community undermined traditional sources of male household authority, though in other ways, new forms of gender inequality were instituted.

Noyes was converted during the revivals of the Second Great Awakening and after his theological training began to incorporate ideas of perfectionism into his theology and preaching. He eventually established communities, first at Putney, Vermont, and later at Oneida, New York, where he and his followers attempted to achieve spiritual perfection in the living of their lives. By 1851, they had just over two hundred members. They opposed not only monogamous marriage but also private property, so that adults pooled their resources to support their communal lifestyle. Children were raised communally in the Children's House, which they entered when they were fifteen months old. Men and women shared the responsibilities of rearing each other's children as well as the more mundane chores of housework. The rearrangement of child rearing and housework meant that women had more time to pursue other activities of self-improvement—and they were encouraged to do so. However, not all women were comfortable surrendering their children to community control.

The most controversial aspect of the Oneida community was its practice of complex marriage, a practice intended to liberate women from slavery to their husbands and to promote a more highly developed form of communal relations. Promoting male continence, Noyes argued that orgasms were desirable for women but not for men, because male orgasm resulted in the ejaculation of semen and the possible creation of children. Men were expected to practice male continence, which meant they did not ejaculate during intercourse. In that way, sexual pleasure could be separated from procreation

and shared by community members as a form of spiritual bonding that would not re-sult in dangerous or debilitating pregnancies for women.

Although complex marriage was meant to be liberating for women, women still did not maintain full control over their sex lives. Shortly after young women began to men-struate, they were initiated into the sex life of the community by older men, who were chosen by Noyes and a small group of male and female advisors. Young women were not allowed to have sex with men their own age until they could prove they would not engage in a monogamous relationship. Young women often received many requests for sex, and while in theory they were free to reject some, in practice this was not always possible. Thus, although the Oneida community sought to free women from domestic drudgery and recognized women's interest in sexual pleasure, it did not grant women full autonomy. In 1879, the community voted to abandon complex marriage in favor of more traditional monogamous relationships, thus dramatically changing the character of the group.

Moral Reform Societies: Combating the Sex Trade

A more widespread approach to bodily control came from the women's societies set up to combat prostitution. Evangelical women in New York City established the New York Magdalen Society in the early 1830s and opened the House of Refuge for prosti-tutes wishing to repent. They were supporters of Rev. John McDowell, who began his crusade against prostitution during the spring of 1830. By 1834, the women had also founded the New York Female Moral Reform Society, which was particularly rooted in the Third Free Presbyterian Church, a hotbed of evangelicalism.

Although legal charges of prostitution tended to occur in larger cities such as Boston and New York, where there were many brothels, smaller towns in the Northeast and Midwest with very few cases of prostitution also established moral reform societies. Women in these towns did not have to contend with widespread prostitution, but they were very concerned about the sexuality of young people who had become increasingly mobile in the nineteenth century. Young, single men showed up in any number of small towns as college students, and young people of both sexes were migrating to jobs in factories and businesses at far-flung loca-tions. Mothers wanted to make sure that new men in their towns would not seduce their daughters and that their daughters would be safe if they went to work in another location.

The women who joined these moral reform societies supported antiprostitu-tion journals such as the *Friend of Virtue* and *McDowell's Journal*, which became the *Advocate of Moral Reform*. The Female Moral Reform Society put the onus of illicit sex on the men. In graphic terms, these newspapers described scenes of seduction and the dreadful consequences wreaked by brutal male libertines. Even more controversial, the newspapers listed the names of men who had been reported to visit a brothel. Indeed, in New York City, members not only paid missionaries to visit brothels to stage prayer meetings of repentance but also eventually visited the brothels themselves. The women

who engaged in this behavior opened themselves to public ridicule and censure for venturing where true ladies did not belong. Yet, they created a powerful critique of a sexual double standard in which men usually escaped censure whereas women were singled out for punishment in an illicit act.

Read about **"Protecting Sexual Morals"**

With the founding of the Female Moral Reform Society in New York City in 1834, women mobilized not only to protect female sexual purity and rescue "fallen women" but also to punish men for their sexual misconduct. The moral reform activist who wrote the article about the death of Miss L in New Hampshire for the *Friend of Virtue* describes the disgrace and grim punishment suffered by a woman who transgressed sexual norms for female respectability. Although the dead woman is considered the "author of her own ruin," the document also attempts to expose and dishonor the man. As members of female moral reform societies attempted to protect young men and women, they worried about many paths to ruin that young people might face, as is clear from Emily Porter's letter and the "Warning to Mothers."

Review the sources. Write short responses to the following questions.

Female Moral Reform Society of New York, excerpt from first annual report[2]
Friend of Virtue, Died in Jaffrey, N.H.
Emily Porter's letter[3]
A Warning to Mothers from the Female Moral Reform Society[4]

1. Do these documents suggest that religious belief, in and of itself, will protect young people from sexual vice? Why or why not?
2. How do the participants in moral reform societies expect to change the behavior of men and women?
3. How do these documents characterize the double standard that exists for men and women with respect to sexual purity?
4. What sorts of debilitation are caused by masturbation? Compare descriptions of those who masturbate to those who engage in other forms of illicit sex. Are the results the same or different?
5. Do these documents suggest that women are gaining power as a result of participating in Female Moral Reform Societies or losing power?

Many of the issues raised by the Female Moral Reform Societies surfaced again in the Rosine Societies of the 1840s, which also opposed prostitution. The Rosine Society, however, moved one step further in trying to establish a sense of community among reformers and the prostitutes they were trying to reform. Members of the Rosine Society noted that economic circumstances rather than lax morals could push women

into prostitution. Moreover, they made a biting connection in noting that it was the same lack of economic opportunity that forced other women into marriage.

Bodily Purification and the Dangers of Drink

Concerns about prostitution were part of a wider range of concerns about sexuality that became particularly clear in the early health movements, which many women supported. Sylvester Graham, who began his career as a temperance lecturer, articulated a philosophy for regulating food as well as alcohol, insisting on strict vegetarianism and homemade bread. During the 1830s, thousands of people flocked to his lectures. Graham and his followers argued that debilitating diseases and insanity were often caused by sexual stimulation, particularly masturbation. A bland diet would not only nourish the body but also control unhealthy sexual impulses that Graham attributed to the consumption of alcohol, caffeine, meat, and sugar. Although he was dismissed as a quack by a growing medical profession and attacked by mobs in several instances when he attempted to lecture on chastity, Graham still developed a following. Boardinghouses that served a Graham diet were established by his followers, including Mary Gove Nichols.

View the Profile of Mary Gove Nichols (1810–1884)

Women's health activist. Influenced by a popular healer, Sylvester Graham, Nichols ran a Graham boardinghouse and began to write and lecture on health issues, directing her attention particularly to women. She stressed the importance of diet and the dangers of masturbation, arguing in her 1839 pamphlet, *Solitary Vice*, that self-pollution wasn't just a male problem. Although Nichols focused on the dangers of masturbation, her writings and lectures brought women detailed information on their bodies, sources of sexual pleasure, the nature of passion, and the mechanics of reproduction. A woman's control of her body, rather than the state's control of it through marriage, became her guiding principle. Rejected by Quakers for some of her more radical free-love ideas, Nichols joined the Spiritualist movement where she became a well-known medium as well as a health practitioner. By the 1850s Nichols moved toward Catholicism. She recanted positions that violated church doctrine and spent several years traveling among different Catholic convents, aiding the nuns with their medical responsibilities. With their vows of chastity, convents presented her with a tradition of bodily control that she felt comfortable embracing.

Although the control of sexual behavior received widespread attention during the antebellum period, the temperance movement dominated the reform efforts of nineteenth-century Americans and became the most visible attribute of middle-class respectability in cities and villages where commerce flourished and workshops

hummed with activity. The consumption of alcohol became a concern early in the nineteenth century for two reasons. First of all, drinking did increase dramatically after the American Revolution, particularly as whiskey became a popular product of grain. Second, an increasingly regimented workplace demanded workers who were sober and industrious while they were at work. As a result, temperance organizations, led originally by members of the new middle class, began to spring up in the 1820s.

Throughout the 1820s and into the 1830s, temperance organizations led by men formed an important counterpart to the maternal associations and benevolent groups headed by women. Men dominated these groups, in part, because drinking was construed as a male problem. There are numerous examples to suggest that women drank, but they were not usually targeted in temperance campaigns. Women were more often depicted as the victims of a drunken husband rather than the perpetrators of alcohol abuse. Women did not lead the temperance organizations, but they did join them and constituted between one-third and two-thirds of the membership in the 1820s and the early 1830s. They were important advocates for the movement, attending meetings and encouraging their family members to limit their consumption of alcohol. This subordinate role within the temperance movement reinforced ideals of domesticity central to the temperance literature that described women as victims of alcoholic husbands in a disintegrating family.

By the end of the 1830s, however, women of various social and ethnic backgrounds began to play a more active role in temperance reform through the creation of their own independent or auxiliary organizations. Among the most important female temperance societies to be created were those of the Martha Washingtonians, whose members often came from the ranks of the working classes and represented a new phase in the temperance movement as reformed drunkards took over leadership of the temperance movement from more respectable businessmen and shopkeepers to preach a philosophy of total abstinence. Many Martha Washingtonian members were related to the male members. The Martha Washingtonians were particularly important because they broke the taboo of talking about female drinking. They visited women who drank and worked to reform them, helping them to see the centrality of women to family morality and cohesiveness, as well as the extent to which alcohol could make an already tenuous economic existence unbearable.

By the 1840s, a more radical edge developed around the temperance movement, with some female temperance supporters demanding the legal right of women to divorce husbands who were habitual drunkards; by 1850 they had achieved that goal in fourteen states. As women were repeatedly portrayed as victims of abuse from drunken spouses, more radical temperance advocates began to urge women to fight back. From fictional portrayals of women who forced their husbands to sign a temperance pledge at knifepoint to actual attacks on local saloons, this more assertive wing of the temperance movement pushed women to reimagine the nature of marriage and their roles as guardians of their homes, creating warriors at the gates rather than angels of the hearth.

Library of Congress Prints and Photographs Division [Sinclair, Thomas S/LC-USZ62-90146]

As this certificate for membership in a temperance society makes clear, temperance was considered a central value for family stability. Excessive drinking was viewed as one of the causes for spousal abuse and family collapse.

Curbing Domestic Violence

Temperance reformers who raised the issue of physically abusive spouses were challenging older ideas of bodily discipline that accepted corporal punishment as a legitimate way for a man to maintain order in his home. Wife beating was not legal in most states in the Union during the antebellum period. In fact, as early as 1650, it had been outlawed in Massachusetts Bay Colony. But common law did allow husbands the right of modest chastisement of their wives.

Modest chastisement referred to a husband's right to inflict physical punishment on his wife to keep order in his household. During the 1840s, when two women on a wagon train headed for Oregon began pulling each other's hair in a dispute, the captain ordered their husbands to administer corporal punishment: "a good licking that nite not over the Back But not far from the ass and all wod bee well." In North Carolina, the court ruled that husbands were allowed to strike their wives in order to maintain discipline but not out of "mere wantonness and wickedness." Both of these cases reflected a patriarchal order in which fathers were expected to keep charge of their households, and one in which external forms of punishment, such as a beating, were a bedrock of the social order. As families began to organize around nurture and conscience, however, corporal punishment became increasingly controversial.

In addition to the question of corporal punishment, there was another side of wife beating that also drew attention: vicious and even life-threatening attacks on spouses. Wife beating had always been illegal, but it was also tolerated in many communities, with some people turning a blind eye to abuse that sometimes even ended in death.

Some courts were reluctant to interfere unless it could be proven that a wife's life was in danger. Neighbors could ridicule a brutal husband, but that did not always stop him. In other cases, wives held back from calling for help because the financial burdens resulting from court intervention were also distressing. When Patrick Cook was fined forty dollars and sentenced to forty days in jail for beating his wife Betsy in 1846, his whole family suffered the financial consequences. A woman whose husband was jailed or fined for beating her lost the income he would have provided had he been working or not paying the fine. Either way, she suffered.

As temperance advocates noted, many of the men who beat their wives were drunk. Husbands regularly defended themselves against spousal abuse charges by claiming that they were drunk. Not surprisingly, female temperance reformers took up the issue, arguing that women should be protected from their drunken spouses and allowed to divorce them if necessary.

CONTESTING THE NATION: SOCIAL AND POLITICAL REFORMS

While most women focused their efforts on moral reform, smaller groups of women carried their moral concerns into women's movements that collectively addressed employers and legislatures. They often used a language of sin and morality in their campaigns, but unlike moral reformers, they sought to change government policies and laws about work, slavery, and Indian removal through their direct intervention. Thus, their activities were controversial because of the challenges they posed to economic elites and government leaders and because they ventured the farthest beyond traditional definitions of women's separate spheres.

Working Women and Labor Protests

Women in industrial towns and cities throughout the North organized during the 1830s and 1840s. In all areas of wage work, pay was declining and working conditions deteriorating as employers sought to maintain profits in an increasingly competitive marketplace and through a series of recessions. As women engaged in their collective labor protests, they moved into territory that men had been defining since the 1790s.

In 1825, the seamstresses of New York went on strike, the first all-female labor protest on record in the United States. A few years later, in 1831, the tailoresses of New York turned out to protest the lowering of prices they were to be paid for their work. New York was not the only place where women staged protests. In Lowell, Massachusetts, factory workers began to protest as well. When mill owners reduced wages by 25 percent in 1835, female factory workers signed petitions and eight hundred of them turned out and paraded through the streets. They stressed the importance of their independence from both their families and their employers, claiming their rightful heritage as "daughters of freemen." To those who witnessed the turnout, this expression of independence was clear; one newspaper reported a "flaming Mary Woolstonecroft speech on the rights of women," and a mill agent described the strikers as Amazons.

In 1836, they turned out again when mill owners tried to raise the rates at boardinghouses, a move that just as effectively reduced the earnings of the factory operatives as a wage cut would have.

Smaller industrial towns such as Lynn, Massachusetts, also experienced unrest in 1834 from the women who worked as shoe binders, because they too faced a reduction in their wages. Many of the women who formed the Female Society to protest the wage cuts were the wives and daughters of male shoemakers, living in family units different from the boardinghouses of the young women in Lowell or the seamstresses in New York. Thus, they justified their demands not only in terms of independence and economic fairness but also in relationship to the cost of the housework they would otherwise be performing. These women made it clear that their labor should not be bought cheaply because many of them were contributing to a family income, providing a necessary supplement to the wages of their husbands and children.

During the 1840s, workers began to argue that their working conditions undermined the commitments to spiritual salvation and moral reform that they had pledged in the revivals and temperance meetings that spread through factory towns. This commitment to moral reform infused the ten-hour movement begun among male carpenters in the shipbuilding and construction trades, as the men demanded that their workday extend only from 6:00 A.M. to 6:00 P.M. with two hours off for lunch. Female factory workers, who faced equally long hours in the summer, adopted this demand in the 1840s,

Read about "Labor Activism at the Lowell Factories"

During the 1840s, women in the Lowell factories joined with other workers to protest the long hours they worked in the factories. They circulated petitions asking the Massachusetts state legislature to limit their working days to ten hours, formed their own labor organization (the Lowell Female Labor Reform Association), and eventually purchased the labor newspaper, the *Voice of Industry*. Their labor activism brought them into contact with reformers from other movements, including the ardent supporter of woman's rights, Angelique Martin (who was, incidentally, the mother of artist Lilly Martin Spencer).

Review the sources; write short responses to the following questions.

Harriet Hanson Robinson, *Lowell Textile Workers* (1898)[5]
Letters to the Voice of Industry[6]
Letter, Sarah Bagley to Angelique Martin[7]
Female Labor Reform Association testimony before the Mass legislature[8]

1. What are the key issues that women in factories are protesting?
2. How does Bagley's letter to Martin suggest a growing consciousness of female inequality?
3. What are the main ways that women organize for rights during this time period?

creating a powerful and organizationally sophisticated movement. Their interest was propelled not only by the length of their workdays but also by the rapidly increasing amounts of work they faced in speedups and stretch-outs. **Speedups** meant that operatives had to tend machinery operating at a faster speed, and **stretch-outs** meant that operatives were being required to operate more pieces of machinery. While operatives saw their pay increase slightly as a result of these changes, most of the resulting profit went to the mill owners and many operatives found themselves exhausted.

By the end of 1844, a few factory women in Lowell had joined together to form the Lowell Female Labor Reform Association (LFLRA). They spearheaded a massive petition drive in 1845, garnering signatures from over one thousand individuals, three-quarters of whom were women. The LFLRA, under the leadership of Sarah Bagley, also went on to purchase *The Voice of Industry*, an important labor newspaper, in 1846.

View the Profile of Sarah Bagley (1806–1883?)

Bagley was born in New Hampshire and began working in the Hamilton Company at Lowell in 1837. Initially, she embraced the mill town's cultural life, joining the First Universalist Church and writing articles for the *Lowell Offering* about the benefits of millwork. Within a few years, her view of factory life became more critical. She joined with others to form the Lowell Female Labor Reform Association (LFLRA) in 1844, working with laborers throughout New England to enact a ten-hour day. As president of the LFLRA, Bagley led several petitioning campaigns to the state legislature and arranged for LFLRA control of *The Voice of Industry*, an important labor newspaper. However, in 1846, replaced at *The Voice of Industry* by male leadership, Bagley left to become the first female telegrapher in the United States. Bagley was dismayed with the wage discrimination she experienced there and soon after left Lowell for Philadelphia where she joined the Rosine Society, which was dedicated to rehabilitating prostitutes. By the middle of the 1850s, she was living in Albany as a doctor, tending to women and children with the patent medicines made by her husband, James Durno.

Women in Lowell and other factory towns did not succeed in gaining a ten-hour workday. While the state legislature in Massachusetts agreed that abuses existed, it refused to act. However, the women who had pushed for the legislation did demonstrate how the ideals of moral reform that were being used to legitimate the goals of an expanding middle class could be used by working-class women to defend their goals as well.

Protesting Indian Removal

The labor petitions submitted by working women in the 1840s continued an important political tradition begun by women opposed to President Andrew Jackson's Indian removal policies. As debate heated up on this issue, leaders from the American Board

of Commissioners for Foreign Missions, a group that had been actively working to convert Indians, joined a gathering storm of criticism, claiming that Indian removal was not only illegal but sinful. Cherokee Indian women, as early as 1817, had submitted petitions to their National Council urging the Council not to cede Cherokee lands to the U.S. government (see Chapter 4).

 White women, who had been supportive of missionary work among the Cherokees, joined in the protests. Catharine Beecher initiated a petitioning campaign among women in 1829 to protest Jackson's policies. This was the first mass petitioning movement of its kind. Beecher knew she was pushing far beyond the bounds of normal propriety and moving women into a sphere of political activism, so she kept her participation in the movement a secret. She sent her circular to women's benevolent groups throughout the United States, urging them to petition Congress. Hundreds of them did, from Hallowell, Maine, to Steubenville, Ohio. Many of these women were prominent women in their communities, carefully chosen by Beecher because of their elite status. Cherokee women also submitted some petitions as part of this campaign. Female petitioners described their activities as moral rather than political (by which they meant partisan). They couched their concern for Indians as part of their expressions of domesticity and benevolence, using very submissive language and prostrating themselves before Congress to influence debate rather than assert a right of participation.

 Despite the supplicating posture, members of Congress attacked the female petitioners for failing to understand their appropriate gender roles. Most of the petitions to Congress were tabled by opponents, but they did at least have the effect of stimulating further debate on the issue. Moreover, many activists who went on to lead antislavery movements began their criticisms of social injustice in their defense of Indians.

Race, Hierarchy, and the Critique of Slavery

During the early nineteenth century, organized opposition to slavery began in 1817 with the American Colonization Society (ACS). The ACS founded the African colony of Liberia that year and began to purchase the freedom of American slaves, paying their passage to Liberia and promoting emigration among free blacks as well. Although this movement received some support from African Americans, it was condemned by others. During the 1820s, free blacks began setting up societies throughout the North that argued slavery was immoral and sinful and demanding an immediate end to slavery instead of gradual emancipation. In 1832, the white abolitionist William Lloyd Garrison introduced this radical critique of slavery to the white community, spawning a powerful but contentious abolition movement.

 In 1832, black women in Salem, Massachusetts, organized the first female antislavery society in the United States. Maria Stewart, an African American woman in Boston, became the first female antislavery lecturer. During the 1830s, she became well known for her fiery speeches attacking slavery and her challenge to other African Americans that they rise up against the brutal institution.

Eventually, however, her verbal attacks on African American men for not doing enough to combat slavery led to bitter retaliation from her audience. Stewart argued that she was being attacked because as a woman she had dared to speak, and she left for New York.

The antislavery societies created by African American women continued a broader tradition of racial uplift that was central to traditions of organizing among free black women. Whether providing loans to members of their benevolent societies or supporting schools for African American children or asylums for orphans, the tradition of mutual aid societies begun by African American women had burgeoned during the antebellum period and inspired the activities of antislavery activists. Opposition to slavery was never an end in itself for the African American organizations; rather, it was part of a broader commitment to achieving racial equality, opportunity, and mutual aid. African American antislavery advocates struggled to keep these broader issues alive in the antislavery movement.

White women quickly followed the lead of these African American women, establishing antislavery societies in cities such as Boston, New York, and Philadelphia. Some of the associations were integrated—but not all—and African American women continued to maintain all-black associations as well, sometimes participating in both. In part, this was due to the reluctance of white women to share positions of leadership with African Americans. In New York City, for example, white antislavery women refused to allow African American women to hold any positions of leadership, and few African American women joined. White women were often more narrowly focused on antislavery issues, which frustrated the broader goals of African American women who were concerned with issues of equality and the well-being of free blacks, as well as with the goal of emancipation.

Assumptions about racial hierarchy were also encoded in the literature and visual symbols of the antislavery movement. Hiram Powers' statue *The Greek Slave* (1841–1843) was widely viewed in Europe and the United States. Depicting a Christian Greek woman sold in a Muslim Turkish slave market, it encouraged white women to empathize with the indignity of slavery. But it did not necessarily lead them to identify with the travails of black American slaves, who were portrayed differently, as was clear in the image of *The Virginia Slave* that appeared in the British humor magazine *Punch*. In another case, one of the most popular emblems of female antislavery societies depicted a female slave, half-clothed and in chains, kneeling before her white female liberator who was standing. Although they shared their identities as women, it was the white woman who was viewed as powerful. Similarly, in antislavery stories by authors such as Lydia Maria Child, "the tragic mulatta" was often the central character in the narrative depicting the evils of slavery. This mulatto figure was white rather than black in appearance, a racial characterization that would lead northern whites to identify with the sufferings of slaves. However, such descriptions also undermined sympathy for real African Americans and effectively denied them the same feelings as whites in antislavery literature.

Politics and Gender in the Antislavery Movement

The women who became involved in abolition during the early years of the 1830s did so in part because they believed slavery was a sin. William Lloyd Garrison's abolitionist crusade was a moral and spiritual one in which adherents borrowed ideas and strategies from the revival movement to provoke an awakening of conscience. Literature that stressed the immorality of slavery and its attack on the family also made slavery a women's issue. It was part of their moral responsibility as women, therefore, to eliminate that sin from the world. But antislavery activists struck both at the heart of the U.S. government, whose Constitution legalized slavery, and at the basis of millions of dollars of wealth held by white southerners in their slaves. Female antislavery activists undertook their crusade with a firm conviction that they were fighting sin, but their experience was a radicalizing one. They emerged from their struggle with a much broader sense of the structural inequalities that permeated society.

Women who joined antislavery societies drew on skills they had developed in other benevolent organizations. Although their numbers were comparatively small, probably no more than 1 percent of the population, antislavery women used their organizing skills to maximize the impact of their efforts. They sponsored antislavery fairs as fund-raising activities in cities and towns throughout the North and newly settled Midwest. They sold articles that they had sewn or that had been donated, sometimes from abroad. British women, for example, showed support for the American cause by shipping goods to the antislavery fairs in the United States once emancipation had been achieved for slaves in the British territories of the Caribbean in 1833. These fairs raised impressive sums of money to keep antislavery associations and presses afloat. Over a period of about a quarter of a century, the Boston Female Anti-Slavery Society raised sixty-five thousand dollars. In addition, these fairs were important public rituals aimed at celebrating freedom and ending slavery.

As antislavery women pushed forward in their attack on slavery, they found themselves increasingly drawn into public and political activities that previously had been reserved for men. They drew on the experience of activists who opposed Indian removal to stage massive and repeated petitioning campaigns. Antislavery women also supported and contributed to antislavery newspapers such as *The Liberator* and *The National Anti-Slavery Standard*. Sometimes they went door-to-door in their communities, looking for readers and/or subscribers. Their public speaking, however, was their most controversial behavior. Sarah and Angelina Grimke of South Carolina, for example, had grown up as slaveholders and could speak powerfully from firsthand experience about the evils of the system. Although they had originally expected to speak only to women in domestic settings, they had to change their speaking venues to more public spaces to accommodate large audiences, which soon included men as well as women. Such gatherings ignited mob violence on more than one occasion.

 Read about "Women Make a Plea for the Abolitionist Cause"

Abolition was the most radical reform that women undertook. Women who participated in the movement demonstrated a commitment to not only a moral cause but also a political and economic one. Thus, in trying to persuade other women to join the abolitionist cause, advocates had to pay particular attention to justifying it as an appropriate activity for the female sex. African American women, such as Maria Stewart, went even further as she criticized African Americans for not doing more to end slavery and racism. Sarah Mapps Douglass, another African American antislavery advocate, spoke powerfully of the way in which racism pervaded society around her.

Review the sources; write short responses to the following questions.

Resolution of the Anti-Slavery Convention of American Women[9]
An Address to the Daughters of New England[10]
A Call for Women to Become Abolitionists[11]
Maria Stewart, Address Delivered at African Masonic Hall[12]
Elizabeth Emery and Mary Abbott to The Liberator[13]
Sarah Mapps Douglass, Letter to William Bassett[14]
Lydia Maria Child, Excerpt from the Appeal[15]

1. What are the different ways in which these authors see slavery and racism (even in the North) intertwined?
2. What different solutions are proposed here to end slavery? What solutions are proposed to end racism? Which solution seems the most radical? Why?
3. What different arguments are advanced to suggest that women should undertake the work of abolitionism?
4. How do Maria Stewart and Elizabeth Mapps Douglass, as African American abolitionists, provide a unique perspective on the abolitionist movement?

As the antislavery movement evolved during the 1830s, however, the very radicalism of the cause provoked intense self-scrutiny among the women and growing fissures developed. The entire antislavery movement split in 1840, in large part over the "woman question." Many of the participants in the antislavery movement (women as well as men) were uncomfortable with the public speaking of women and their leadership role in antislavery activities at the national level. However, Garrison and his followers argued that the inequality that women faced should be included in a broader antislavery agenda. This was the minority wing within the organization, but it retained control of the name, the **American Anti-Slavery Society**. The other group formed the **American and Foreign Anti-Slavery Society**, advocating a more traditional role for women, a focus on the single issue of slavery, and entry into politics as a legitimate way to abolish slavery.

Despite the split, women on both sides continued their antislavery activities and found themselves inexorably drawn into the political controversies their agitation created. Lydia Maria Child, an avid abolitionist who had eschewed political topics in the 1830s, admitted to a growing interest during the following decade. More than with any other voluntary group, antislavery pushed the women involved toward a political culture. Not surprisingly, many of the antislavery activists became leaders in the woman's movement that was starting to form.

OVERVIEW

Antebellum Reform Movements

Moral Reform Societies	Antiprostitution societies were founded in the 1830s. Originally centered in New York City, these societies spread throughout the Northeast and Midwest. Societies broadened their focus to support a variety of reforms in sexual behavior.
Temperance Societies	Beginning in the 1820s, temperance societies promoted moderate drinking. By the 1840s, they were promoting total abstinence. While men originally led these movements, women eventually began to create their own, arguing they needed to protect women from drunken spouses and, in some cases, reaching out to female drunks.
Diet	Beginning in the 1830s, several reformers, including Sylvester Graham and Mary Gove Nichols, argued for dietary reforms to promote sexual restraint. Health food reformers encouraged followers to give up alcohol, coffee, meat, sugar, and spices.
Indian Removal Opposition	Campaigns were initiated beginning in 1829 to petition against legislation in Congress that would forcibly divest Indians of their lands and push them westward across the Mississippi River. Led by Catharine Beecher, women as well as men submitted petitions to Congress opposing this legislation.
Labor Protests	Beginning in 1825, wage-earning women in cities and industrial towns began to organize strikes, public demonstrations, and petition campaigns to protest low wages and/or long hours.
Antislavery	Beginning in the 1830s, black and white women began to organize their own local antislavery societies and participate in a broader national movement with men demanding an immediate end to slavery. The movement split in 1840, in part over the question of whether women should assume positions of leadership in the movement.

CONCLUSION

Many of the different strands of social activism that had been created in the 1830s and 1840s would reconfigure around demands for women's rights in the 1850s. While many women had taken up moral reform activities with the intention of saving souls and maintaining a stable family life, they, like other activist women, created a variety of public roles for themselves. The ideals of republican womanhood that developed in the wake of the Revolution had assumed that women would demonstrate their civic consciousness within their homes by influencing their sons and husbands, and the cult of domesticity had reinforced that belief. However, through their participation in a wide variety of religious and reform movements in the antebellum period, women had begun to directly and collectively address a wide range of social, political, and economic issues. These activities necessarily provoked questions and debates about their "natural sphere," debates that were central to the emerging women's movement.

 Study the _Key Terms_ for Religion and Reform, 1800–1860

Critical Thinking Questions

1. Did religion empower women?
2. How would you compare the power exercised by Catholic women, Jewish women, and Protestant women?
3. How did the movements to reshape sexual practices, drinking, and eating affect family structure and household authority?
4. What is the significance of women's involvement in social and political movements?

Text Edits

1. Jarena Lee, _The Life and Religious Experience of Jarena Lee, A Coloured Lady, Giving an Account of Her Call to Preach the Gospel_ (1836). Reprinted in _Digital Schomberg African American Women Writers of the 19th Century_.
2. Licentious Men (1835), reprinted in Ellen Skinner's _Women and the National Experience: Sources in Women's History_ (2 volumes).
3. E.E. Porter to the New York Female Moral Reform Society Corresponding Secretary, April 21, 1838, _Advocate of Moral Reform_, June 15, 1838. Reprinted in Daniel S. Wright and Kathryn Kish Sklar, _What Was the Appeal of Moral Reform to Antebellum Northern Women, 1835–1841?_
4. Mary Beth Norton and Ruth M. Alexander, eds., A Warning to Mothers from the Female Moral Reform Society, 1836 in Major Problems in American Women's History, 2nd edition (Lexington, MA: D.C. Heath and Company, 1996), pp. 218–219.

5. From *Harriet Hanson Robinson, Loom and Spindle or Life Among the Early Mill Girls* (New York: T.Y. Crowell, 1898), pp. 16–22, 37–43, 51–53.

6. *Voice of Industry* (Lowell, MA), March 13 and April 24, 1846.

7. Ohio Historical Society, Lilly Martin Spencer Collection. Transcribed: University of Massachusetts Lowell, Center for Lowell History.

8. Report of the Special Committee on Hours of Labor, House Report No. 50, Massachusetts General Court Legislative Document 1845, House 1–65, 2–4.

9. *An Appeal to the Women of the Nominally Free States Issued by an Anti-Slavery Convention of American Women* (Boston: Isaac Knapp, 1838), pp. 3–8, 11, 13–14, 20–21, 23–24.

10. *The Liberator,* March 3, 1832.

11. Elizabeth Margaret Chandler, *The Poetical Works of Elizabeth Margaret Chandler* (Philadelphia, 1836), pp. 21–23.

12. Maria Stewart, Address Delivered at African Masonic Hall, 1833 from Ellen Skinner, *Women and the National Experience: Sources in Women's History* (2 volumes).

13. Elizabeth Emery and Mary P. Abbott, Letter to the Liberator, *The Liberator* 6 (August 27, 1836): p. 138.

14. Sarah Mapps Douglass, *Letter to William Bassett,* 1837. Weld-Grimké Collection, Clements Library, University of Michigan, Ann Arbor.

15. Lydia Maria Child, *An Appeal of That Class of Americans Called Africans* (Boston: Allen & Ticknor, 1836).

Recommended Reading

Catherine A. Brekkus. *Strangers and Pilgrims: Female Preaching in America, 1740–1845.* Chapel Hill, NC: University of North Carolina Press, 1998. A study of the female preachers who traveled up and down the East Coast preaching during the Second Great Awakening.

Thomas Dublin. *Women at Work: The Transformation of Work and Community in Lowell, Massachusetts, 1826–1860.* New York: Columbia University Press, 1979. A classic study of the lives of women who worked in the Lowell mills during the early nineteenth century.

Lori Ginzberg. *Women and the Work of Benevolence: Morality, Politics, and Class in the 19th-Century United States.* New Haven, CT: Yale University Press, 1990. Important study of the ways in which women's benevolence and social activism evolved during the nineteenth century, responding in different ways to changes in the political and economic conditions of the country.

Christine Leigh Heyrman. *Southern Cross: The Beginnings of the Bible Belt.* Chapel Hill: University of North Carolina Press, 1997. Analysis of religious practices in the South during the antebellum period, which challenges the idea that revivals opened up opportunities for women and democratized social relationships.

Shirley Yee. *Black Women Abolitionists: A Study in Activism, 1828–1860.* Knoxville: University of Tennessee Press, 1992. A study of the ways in which African American women led the antislavery movement and the ways in which their goals sometimes diverged from those of white women.

POLITICS AND POWER: THE MOVEMENT FOR WOMAN'S RIGHTS, 1800–1860

LEARNING OBJECTIVES

- What were the debates about the relationship of women to property in the antebellum period?
- How was "woman's sphere" expanding in the antebellum period?
- What were the different ways women approached questions of influence and political participation in the antebellum period?
- What was the nature of the woman's rights movement in the 1850s?

Explore Chapter 8
Multimedia Resources

TIMELINE

1816	Pennsylvania moves divorce proceedings from legislature to courts
1820s	Democratic Party formed
1825	Robert Owen establishes New Harmony in Indiana
1828	Andrew Jackson elected president
1830s	Whig Party formed
1833	Oberlin College founded
1835	Florida and Arkansas pass laws continuing Spanish practices protecting women's property
1836	Angelina Grimké publishes *Appeal to the Women of the Nominally Free States*
1837	Mount Holyoke Female Seminary founded Catharine Beecher pens *An Essay on Slavery and Abolitionism with Reference to the Duty of American Females*
1838	Sarah Grimké writes *Letters on the Equality of the Sexes*
1839	Liberty Party established Mississippi passes married women's property law
1848	Free Soil Party established Revolutions sweep Europe Elizabeth Blackwell enters Geneva Medical College Woman's Rights convention in Seneca Falls Declaration of Sentiments
1849	Fanny Kemble wears new fashion that will be called "bloomers"

1850	Woman's Medical College of Pennsylvania established
1851	Sojourner Truth delivers "Aren't I a Woman" speech at Woman's Rights Convention in Akron, Ohio
1852	Paulina Wright Davis establishes the *Una*
1855	Dred Scott case
1855	Massachusetts passes earnings act
	New England Female Medical College chartered
1868	Women's Medical College of the New York Infirmary opened

THE GOVERNMENT FORMED AFTER THE REVOLUTION HAD ASSUMED A HIER-ARCHICAL SYSTEM IN WHICH MALE PROPERTY HOLDERS WERE EXPECTED TO REPRESENT THE BEST INTERESTS OF SOCIETY. Women did not vote in this system, but neither did many men. During the first decades of the nineteenth century, this view was dramatically refashioned as state after state rewrote their constitutions and, in almost all cases, gave the right to vote to white men without property. Andrew Jackson, as president of the United States from 1828 to 1836, symbolized this new political spirit, as did the new **Democratic Party** that formed around him. The **Whig Party** emerged a few years later in opposition to Jackson's policies but with a keen appreciation for building a mass base of political support that could successfully challenge the Democrats. Both political parties courted votes with barbeques and torchlight parades, leading to a boisterous new democracy that invited broader scrutiny about how political representation should be constructed. How were women to be represented in this new kind of government? Imagining the household as the basic political unit was an increasingly anachronistic concept. The many reform movements in which women were participating during this period had already raised questions about the extent to which they could extend their "sphere," and these questions began to converge with new ones about whether or not successful reform would require the same political tools that had heretofore been the province of men. Thus, from many different directions, questions about how women would participate in their rapidly changing world necessarily arose. From questions of property holding to marriage to political participation, the rights of woman as well as the rights of man demanded debate.

LIFE, LIBERTY, AND PROPERTY

The control of property was closely tied to the exercise of power in the new United States. Many believed that one of the main reasons to have a government was to protect property and in the early years of the government, property was a necessary prerequisite for voting. These beliefs meshed well with a civil code that folded the legal identity of a

wife into that of her husband and a political system in which families were represented politically by the father, who was the head of the household. In this world of household representation, a husband's right to control his wife's property made perfect sense. This world of property ownership became the focus of reform efforts during the early nineteenth century as both wealth and poverty exploded and the economic risks faced by an emerging middle class threatened the stability of many families. Reforms in property laws, however, struck at the relations of power existing between men and women.

Communitarian Experiments in Family and Property

The ideals of equality that had been raised in the revolutions of France and the United States were effectively channeled into narrow debates on political representation during the early nineteenth century. Radical proponents of early **communitarian** experiments decried this limitation, as they forcefully argued that true equality also demanded a more equitable distribution of wealth and an end to male dominance over women. Thinking about these issues emerged most clearly among the **Owenites** of England and the **Fourierists** of France, both of whom eventually established and inspired utopian communities in the United States. Robert Owen, leader of the Owenites, purchased an Indiana town of thirty thousand acres of land and buildings in 1825 to showcase his ideas. Changing the name to New Harmony, Owen recruited residents to his model community. A decade later, followers of Charles Fourier established communities known as **phalanxes** in towns throughout New England and the Midwest.

Mary Evans Picture Library/The Image Works.

During the 1820s, Robert Owen established New Harmony in Indiana as a socialist community that promoted economic and gender equality. Some women found their experience at New Harmony liberating, though others were overwhelmed by the amount of work expected of them.

Fourierists and Owenites criticized the competitive spirit and physically degrading work regimes of early industrial capitalism, substituting instead a collective work ethic in which members of their communities pooled their resources and supported one another. They also viewed marriage and capitalism as parallel systems of oppression in which financial profits and women were both greedily sought as forms of property. The wealthy unfairly exercised power over the poor and men unfairly exercised power over women. True equality demanded an attack on marriage as well as property, because, as Robert Owen argued, it was in marriage and through the family that men dominated the women who were their daughters and wives.

New Harmony and dozens of other **socialist** communities experimented with a variety of ways to promote economic and gender equality. The attack on property meant that everyone at New Harmony received the same small allowance each week to spend at the company store. The minimal wages paid at Fourierist phalanxes even extended to payment for domestic chores, a revolutionary concept that recognized the economic value of housework. Attempts to create gender equality surfaced in ideas about clothing, property, and living arrangements. Women and men in New Harmony, for example, were encouraged to adopt an almost unisex clothing style that included trousers under a knee-length tunic for women. In many Fourierist phalanxes, where members bought into the community by purchasing stock, women as well as men were allowed to buy shares. Both Owenite and Fourierist communities also allowed women to vote on community matters, and in an attempt to limit the power of patriarchy in nuclear families, many communities constructed large structures to house most members of their groups, only reluctantly giving separate quarters to families who wished to live together. Indeed, both Robert Owen and Charles Fourier had originally suggested that their communities would promote a liberated sexual life in which the constraints of marriage would be eased. Fourier actually imagined a variety of sexual relationships that ranged from monogamy to polygamy to homosexuality and even to incest. However, in actual practice, the sex life in most of these communities was considerably more staid, as followers focused instead on issues of sociability, work, and governance.

Many of the women who came to these communities, particularly single women, enjoyed the conviviality of communal households and the opportunities for independence they found. However, it was also clear that these communities were far from achieving the kind of gender equality they espoused, in part because communal leaders were still trapped by conventional expectations of male and female behavior with most women doing traditionally female domestic work for the most part. And in some communities, as wages became attached to labor, the work of men was valued at a significantly higher wage than that of women. This was particularly problematic because the activities of the women, particularly cooking and child rearing, were necessary and unrelenting, leading to a much harder workload for women than for men.

Unable to solve problems of either class or gender inequality and unable to sustain themselves economically, these communal experiments were fleeting. However, their attempts to link questions of gender inequality with economic inequality and their

attempts to reformulate their structure of governance to include direct rights for all raised important possibilities for future thought.

Family Assets: Married Women's Property Laws

While communitarians tried to restructure both property and gender relations, many other Americans confronted questions about women and property in a more prosaic way: through the passage of married women's property laws. During the antebellum period, one legislature after another passed laws that increasingly gave married women ownership of the property they had brought into marriage. While this legislation would eventually become a rallying point for woman's rights activists, the roots of this movement had far more to do with protecting family legacies in a volatile market economy than it did with woman's rights.

The movement for married women's property laws was rooted in a legal loophole that wealthy families had exploited for years: families could establish a "separate estate" for a married woman that her husband could not control. This was a particularly useful instrument if a son-in-law or potential son-in-law was viewed as a ne'er-do-well of some sort. When Agnes Ruffin of Virginia hitched herself to T. Stanly Beckwith in 1838, for example, her father, Edmund Ruffin watched with dismay and anger as his son-in-law contracted debts to cover his failing medical practice and patent medicine ventures. Ruffin had no intention of letting a man he considered shiftless and lazy get his hands on Agnes's inheritance, so when he divided his property among his children, he left Agnes a farm, ten slaves, and railroad stock in a separate estate that her brother controlled for her. Agnes's inheritance was safe from her husband's clutches, but she was hardly financially independent as a result. Her financial fortunes were simply controlled by two different men rather than simply one.

Of course, the goal was not to promote female independence but to protect family property (and by extension, the well-being of the family). Given the volatility of the antebellum economy, even husbands found the creation of separate estates for their wives to be desirable in many cases, realizing that should disaster strike their businesses, assets that were held in their wives' names would be beyond the reach of creditors. The married women's property laws that began to be passed by state legislatures in the 1830s were originally meant to eliminate the complicated legal proceedings that were required to set up such estates and to make the benefits of separate estates available to all women with property. In many cases, they also were part of a more widespread movement to enact bankruptcy legislation after the **Panic of 1837**. During the Panic, the banking system of the United States collapsed, leaving many businessmen and farmers in debt with little recourse to pay their creditors and no ability to protect their families. Legislatures scrambled to pass laws that set up bankruptcy proceedings and abolished imprisonment for debts.

The first married women's property law was passed in Mississippi in 1839, allowing women to keep both the property they brought to their marriages and property they individually inherited after their marriages, including slaves. Women were not allowed to keep any money they earned, however, nor did they have the right to control their property. Their husbands were expected to make all management decisions concerning the use

of their wives' property. A Michigan law passed in 1844 simply stated that creditors could not seize a wife's property to pay her husband's debts. As state constitutions were formed in the newly organized territories of the West, protections of women's properties were included there as well. Married women received protection from the California Constitution in 1849, the Oregon Constitution in 1857, and the Kansas Constitution in 1859. Most states offered some form of a married women's property law by the end of the Civil War.

The need to pass married women's property acts derived not only from concerns about a more volatile market economy but also in response to conquest and acquisition of vast amounts of territory previously held by France and Spain. Under Spanish law, a woman did not merge her legal identity with that of her husband. She was allowed to own her own property, prosecute her financial interests in court, and shield her assets from her husband's creditors (see Chapter 4). As territories from the Spanish Empire were incorporated into the United States, many of these property arrangements were preserved. Territorial legislatures in Arkansas and Florida passed laws in 1835 continuing earlier policies that protected a woman's property from debts her husband had incurred prior to marriage. Shortly after Texas declared its independence from Mexico in 1836, the Lone Star legislature incorporated Spanish law on women's property holding into their new constitution.

Probably the most famous set of women's property laws emerged in New York State, where debate focused on woman's rights as well as family protection. Thomas Herttell, an assemblyman in the New York legislature, introduced a bill in 1837 arguing that the French example allowing married women to own their own property was far superior to what existed in the United States and a source of greater stability in marriage. Herttell defended his bill not only as a boon to marriage but also as a natural right of women, leading him to support not only a woman's right to own property but also, by logical extension, her right to vote. Herttell's bill did not receive an outpouring of public support. Ernestine Rose, recently arrived from Poland, managed to garner six signatures on a petition from Utica, New York, supporting Herttell's effort, and another small petition of women was also submitted. But Herttell had clearly identified why married women's property rights could be so powerful—they linked women directly to the political tradition of property holding and the natural rights that were supposed to be tied to that ownership. Property rights involved more than simply preserving family assets.

While some activists seized on this connection as an entering wedge in debating women's equality with men, others studiously avoided connecting the question of property with the question of rights. Sarah Josepha Hale, editor of *Godey's Lady's Book*, ignored Herttell's arguments about voting, even as she lent support to his goals of female property holding in the pages of her magazine. Hale would never support voting rights for women, and she eschewed any notion that women deserved equality to men. Instead, Hale legitimized her support for property laws by arguing that women needed this legislation to protect their separate sphere. Marriage without property protection for wives was slavery in Hale's view. Herttell's bill did not pass, but over the next decade, the issue surfaced repeatedly in the New York legislature, receiving support both from advocates for women like Hale, who emphasized their separate sphere, and from those like Ernestine Rose, who emphasized their shared rights with men.

Work and Wages

While legislatures scrambled to pass legislation to protect the property that women brought into marriages, they were far less enthusiastic about recognizing a woman's right to another form of her property: her labor. In most states, husbands retained the legal right to their wives' wages before the Civil War. Only Massachusetts passed an earnings act in 1855. In part, this lack of agitation may have been due to the fact that widespread wage earning was a fairly recent phenomenon, not only for women but also for men. Moreover, many married women who were paid a wage, such as shoe binders in Lynn, Massachusetts, saw themselves as contributing to a family economy and thus did not see themselves as independent wage earners. Their earnings, like those of their husbands and children, were meant to be shared.

This new world of female wage work meant that women also had to contend with another form of discrimination: they were paid less than men. Workingmen who criticized the lower wages paid to women saw this more as an injustice to men than to women. They argued that women were dragging down wages for men by working for so little. Employers, of course, exploited the fact that they could pay women less than men for the same work, and some women, to find employment, took what they could get. Workingwomen began to challenge this injustice as early as the 1830s. When the tailoresses in New York City went on strike in the spring of 1831, the secretary of their society, Louise Mitchell, demanded to know why women were paid less than men. "When we complain to our employers and others, of the inequality of our wages with that of the men's, the excuse is, they have families to support, from which females are exempt." As Mitchell pointed out though, this was poor reasoning. "How many females are there who have families to support, and how many single men who have none, and who, having no other use for the fruits of their employers' generosity, they child like, waste it." Some of these seamstresses may well have been inspired by Fanny Wright, the socialist and reformer who had lectured to large audiences during this period. At one point, Wright had argued that women were an economic underclass in society, forced to depend on the larger salaries of men for survival—either as housewives or as prostitutes.

View the Profile of <u>Frances "Fanny" Wright (1795–1852)</u>

A wealthy orphan from Scotland, Wright was a Socialist and reformer who by 1825 had cofounded the *Free Inquirer* newspaper and published *Views of Society and Manners in America* (1821). Joining the economic theories of the socialist reformer Robert Owen, who had founded the community of New Harmony, Indiana, to her own trenchant critique of slavery, Wright set out to reform the problems of the United States (and the world) by devoting a considerable part of her inherited fortune to the establishment of an interracial community in Nashoba, Tennessee. The community failed, but it demonstrated the way in which utopian ideals could be extended beyond economic equality to promote racial equality as well. After Nashoba failed, Wright began to publicly lecture on reform topics with Robert Dale Owen, the son of Robert Owen.

A decade later, Ellen Munroe made a similar criticism in the *Boston Bee*, with stinging prose that was reprinted in the labor newspaper of Lowell, the *Voice of Industry*. Mocking the claims of men that they were the general protectors of women, Munroe directed their attention to "the thousands of women, doomed to lives of miserable drudgery, and receiving 'a compensation which if quadrupled, would be rejected by the man-laborer, with scorn.'" The factory workers in Lowell may have been particularly interested in Munroe's argument. Inspired by their correspondence with French immigrant Angelique Martin, a strong woman's rights advocate and communitarian reformer from Marietta, Ohio, the workingwomen of Lowell had hired a lecturer on women's rights.

The sporadic complaints voiced by workingwomen about inequitable wages converged with similar concerns raised by antiprostitution reformers in the 1840s. Female moral reform societies had begun to link prostitution with economic distress rather than moral depravity. Like many middle-class reformers, they criticized the pitiful wages of seamstresses and tailoresses and demanded to know how these women could support themselves. Groups as far away as Oregon began to demand better compensation for female wageworkers.

Those who fought against wage discrimination, like those who fought for a married woman's right to own property, did so for many different reasons. They were not part of a unified women's movement. They were, however, all part of a dynamic and volatile capitalist economy in which economic relations were being radically transformed. Businesses could easily go bankrupt, and employers looked for every opportunity to cut wages to make a profit. Regardless of what their ideals of domesticity were, women were a part of this new economic world. Whether as wage earners or wives, they were increasingly economic individuals in need of legal protections independent of their husbands or fathers.

CHALLENGING THE DOCTRINE OF SEPARATE SPHERES

While controlling property and wages represented one set of issues confronted by women in the antebellum period, defining the nature of the domestic sphere represented another. This was an issue that struck at the heart of the contemporary organization of power, for it was the husband who represented his family to the state on the one hand and who ruled his wife and children on the other. Redefining the relations of power within that sphere thus carried tremendous implications. The educational responsibilities of women, tied to their roles as mothers, were promoted in a growing number of ambitious educational ventures. At the same time, the legal bonds of matrimony were reexamined as the grounds for divorce in many states were broadened. While women continued to be legally incorporated within their husbands' identities, the extent of their domestic sphere was expanding and the relations of power within their domestic world were being challenged.

The Rise of the Female Seminary

The seminary movement that began after the Revolution blossomed during the nineteenth century with female academies and colleges proliferating in the South even

more than in the North during the antebellum period. The elite young women who attended these schools sometimes studied classical languages such as Greek that were more commonly the province of men's colleges. They also took on science, mathematics, and history. For southern women, the mastery of such subjects was a mark of class distinction, evidence of their family's wealth and status. Parents thus embraced the opportunity to provide their daughters with a higher education if they could afford it because they felt it would make their daughters more desirable when the time came for them to marry.

In the North, women were educated not only to mark their status but more often to provide them with training in case they needed to support themselves. Emma Willard had always imagined her students at the Troy Female Seminary could become teachers, even though men dominated the teaching profession at the time. Catharine Beecher raised the stakes by arguing that teaching should become a woman's profession. After running her Hartford Female Seminary during the 1820s, Beecher began to formulate an argument that this kind of rigorous education fitted women to properly extend their sphere from teaching their own children to teaching others as well. Mary Lyon, who founded Mount Holyoke Female Seminary in 1837, focused on the creation of Christian missionaries who would use their training to both convert and civilize the world.

Read about "Female Seminaries in the Nineteenth Century"

During the nineteenth century, female seminaries proliferated. These seminaries made it possible for the elite young women who attended them to study classical languages, science, mathematics, and history: subjects that had generally been the province of men. The women who headed these seminaries argued that such an education would make women better wives and mothers, but it is also possible that such an education spurred some young women to think more critically about their position in society.

Review the sources; write short responses to the following questions.

Mary Lyon, *Letter to Mrs. Cooley*, [Feb. 1843][1]
Course of Instruction, Mount Holyoke Female Seminary[2]
Catherine Beecher, *The Evils Suffered by American Women and American*[3] *Children* [1846]

1. In her letter to Mrs. Cooley, what did Mary Lyon think the woman's niece needs to thrive academically? What does this letter say about Lyon's commitment to education?
2. What was Catherine Beecher's impression of Lowell? What did she think is best for the men and women in that mill town?
3. How did schools reinforce gender expectations for young women? How did they challenge them?

These northern seminaries produced a more independent woman than the southern seminaries did, but almost all of the leaders of this movement were at great pains to avoid pushing too far beyond the bounds of "woman's sphere," with women like Emma Willard and Mary Lyon advising women to direct involvement in political affairs. Catharine Beecher anguished over the problem—becoming perhaps the most vociferous opponent of political activism at the same time that she secretly engaged in it with the campaign against Indian removal. Overall, these schools worked hard to create an expanded woman's sphere rather than a challenge to woman's sphere, though some of their students used their educations for more radical purposes. Elizabeth Cady Stanton, one of the most famous women's rights activists, graduated from Emma Willard's seminary. Moreover, despite the commitment to motherhood, women who

 View the Profile of <u>Mary Lyon (1797–1849)</u>

Library of Congress Prints and Photographs Division [LC-D4-70341].

Grave of Mary Lyon, Mt. Holyoke Seminary.

Founder of Mt. Holyoke College, Lyon was a pioneer in women's education, a believer in Christian missionary work overseas, and adamant in avoiding direct involvement in political affairs.

graduated from Troy Female Seminary and Mount Holyoke in the antebellum period were less likely to marry than their peers—evidence of independence their teachers had not anticipated.

Confronting Educational Barriers

Students in female academies demonstrated the intellectual capabilities of women, and their successes encouraged women to seek higher degrees that challenged traditional boundaries between male and female education. As colleges experimented with coeducation and as women demanded postgraduate training, the boundaries of woman's sphere were repeatedly questioned. One of the first places women confronted these barriers was at Oberlin College in Ohio. Oberlin opened in 1833 with a revolutionary commitment to educating not only men and women together but also black and white students together. Inspired by the fires of the Second Great Awakening, Oberlin was the first great experiment in coeducation, though many other small private institutions and public colleges set up by the states would soon follow suit. However, while Oberlin was coeducational, women there soon encountered—and challenged—some of the assumptions about separate spheres built into its curriculum.

Read about "Oberlin's Commitment to Education"

Oberlin's commitment to educating men and women as well as black and white students together was a radical one. Observers watched closely to see if the experiment would succeed. The author of the first document, William Woodbridge, served as a legislator and governor in Ohio and Michigan in the early to mid-1800s. The author of the second document, Sally Rudd, worked as a housekeeper for the president of Oberlin College.

Review the sources; write short responses to the following questions.

Oberlin Collegiate Institute[4]
Letter from Sally Rudd to Mary Rudd[5]

1. Why did the author of the first document assume that these developments were cause for women to rejoice?
2. Why did Mary Rudd's father object to her going to college?
3. In their writings, do Rudd and Woodbridge see the same benefits of an Oberlin education?

Men and women at Oberlin attended the same classes and ate together in the dining halls, where the ideal of civilized discourse between the sexes was enshrined. However, men and women used the library at different times and, more problematic, women were expected to receive a different college degree. The "Ladies' Course," which was eventually renamed "the literary course," did not demand the same level of competence in

classical languages as did the "bachelor degree" that men received. Women at Oberlin who entered with training in classical languages quickly complained, and within a decade of its founding, Oberlin was awarding its A.B. degrees to women who qualified while continuing to offer the Ladies' Course to most of the women at the school.

Even more troubling was the demand one early graduate, Antoinette Brown, made to become an ordained minister. Women at Oberlin received theological training to become the wives of ministers, not ministers themselves, and Brown's dogged pursuit of her own pulpit raised hackles around campus. The Ladies Board, which was responsible for the education of women at Oberlin, tried to dissuade Brown. Brown persevered, but when she completed her studies and asked to be licensed as a preacher, the college committee refused. Brown became an active speaker on behalf of religious and reform causes, but ordination was an elusive and difficult goal. She was finally called in 1853 to a small parish in upstate New York, but even then, local Congregational ministers refused to participate in the ordination ceremony. Women could function as informal traveling preachers, but Brown's challenge made it clear that recognition among the regulars was a different matter.

Brown's challenge to the theological establishment and the schools it controlled was echoed in the attempts of women to become doctors. This was particularly clear in the experience of Brown's sister-in-law, Elizabeth Blackwell. Blackwell applied for admission to Geneva Medical College in New York in 1847 after having attended a course of medical lectures in Cincinnati. It was the only medical college that would take her, and that occurred in part because the male students, viewing the possibility more as a joke than a real possibility, voted to let her in. Soon after she received her medical degree, Geneva instituted a new policy that forbade the admission of women. Most other medical schools followed the lead. Keeping the regular medical profession male was one of the ways doctors sought to establish their legitimacy and to distinguish themselves amidst the broad array of midwives, botanists, and irregularly trained doctors in the country.

The medical education of women, however, attracted support from a variety of quarters for different reasons. Most women, including Blackwell, argued that providing medical relief had longer been the province of women and that women needed female doctors to attend them. Sarah Josepha Hale argued that it was part of woman's sphere to attend to the sick and that no one but a woman should be examining another woman's body. With such issues as female propriety and tradition to back them up, medical study could well be argued to be a natural extension of woman's sphere. Formal medical training had been the province of men, however, and it was hard to avoid the egalitarian implications of offering women this sort of training. Because medical schools were slamming their doors shut to women, supporters of regularly trained female doctors began to organize medical schools for women. The Female Medical College of Pennsylvania was established by the Quakers in Philadelphia in 1850, and the New England Female Medical College in Boston was chartered in 1856. Blackwell herself, along with her sister Emily, who also became a doctor, opened the Women's Medical College of the New York Infirmary in 1868.

Demands for Divorce

Divorce laws had been liberalized in the early republic following the Revolution; however, divorce was still difficult to obtain and women in particular felt that burden. A person had to petition the state legislature for a divorce, a process that required both money and influence. Given the difficulty of such proceedings, many unhappy couples found that a more informal tactic worked better: one of the partners just moved. This was a solution that only worked, however, when there was no property at stake or one of the partners was willing to relinquish his or her claim to it. Frontier areas such as Texas were filled with men (and women) who had left behind unhappy marriages to make a fresh start—a situation that led to a surprisingly casual tolerance of bigamy. William Smith abandoned his wife and three children in Missouri in 1826, moving to Texas where he married Maria Jesusa Delgado of San Antonio in 1830. Smith's first wife divorced him a few years later, but Smith's reputation appears to have suffered little from his complicated marital situation: he was repeatedly elected mayor of San Antonio in the 1830s. After his death in 1845, his first wife and her children sued for control of his estate, arguing that Smith could not have legally married Delgado in 1830 and that she had no right to his estate. The courts thought differently, however, upholding Maria Delgado's claims and the claims of her children.

During the antebellum period, states in both the North and the South increasingly moved divorce proceedings out of the legislatures and into the courts, making them more routine and more accessible to residents. Pennsylvania began this trend in 1816. Even in the South, where colonial divorce laws had been stricter than in the North, all states except South Carolina had passed divorce laws that allowed courts to end marriages in particular circumstances. As a result of these changes, divorce became more common in the United States. In New Jersey, for example, only thirteen divorces were granted between 1788 and 1799 (roughly one per year), whereas in 1860 alone, eighty-six divorces occurred.

Divorce became more accessible not only because it had become a matter for the courts rather than the legislature but also because the grounds for divorce were expanded in most states. One of the most important new criteria for divorce was that of mental cruelty. In a variety of states, legislators accepted the idea that a marriage could be intolerable as a result of not only physical abuse but also mental abuse. However, the courts had to give teeth to these laws, and many justices maintained a very high standard in judging mental cruelty. When Huldah Barber sued her husband Hiram for divorce in Ohio in 1846, the court accepted her contention of mental cruelty because not only had her husband humiliated her by charging her with sexual incapacity and forcing her to have a medical examination to prove it, but he had repeatedly tried to have sex with her daughter. The courts in Connecticut were considerably less open to the mental cruelty plea in a divorce case in which the wife claimed she had been forced by her husband to have sex repeatedly against her will. Describing the husband's actions as "harsh," the court dismissed any notion of mental cruelty and argued that he was exercising his marital rights. In North Carolina, where local justices usually gave

plaintiffs a sympathetic hearing, the superior court was far more stringent and seldom granted divorce. As Judge Pearson explained when he overturned the divorce decree from a lower court of a woman whose husband had committed forgery, "She agreed to take him for better or worse."

In addition to the problems associated with actually obtaining a divorce, women also faced hurdles in maintaining their relationships with their children after divorce. Courts in the nineteenth century did increasingly recognize the rights of mothers to custody rather than necessarily giving children to fathers, as they would have done in the colonial period. This was due not to ideas of woman's rights but to woman's nurture—that women were the more natural protectors of children. In one case, a New Jersey court even awarded custody to a woman in 1813 who had left her husband for her lover. The court cited the need of the children for their mother's nurture and pointed out that while the mother had behaved badly toward her husband, she had been exemplary in her treatment of her children. However, the courts were much less likely to recognize women's ability to control the legal or financial aspects of their children's lives. Fathers were the ones who were expected to control the property of children, even if their former wives were the nurturers.

Woman's Influence versus Woman's Rights

These debates about women's property rights, women's education, and what constituted legitimate grounds for divorce took on heightened significance in the volatile world of reform and democratic politics. In a variety of forums, from temperance to antislavery, women were working to shape public policy in a political world that was rapidly changing. One state after another held constitutional conventions in the antebellum period to ratify new documents defining the precise nature of their polity. Old patterns of political hierarchy and deference were being swept away as voting rights were extended to the masses. How would the views of women be represented in this new democratic world? As these questions were debated, two broad lines of reasoning about woman's rights emerged. One focused on the difference between men and women, stressing their separate spheres and complementary roles, while the other focused on the shared characteristics of the two sexes and egalitarianism in their relationships. Those who focused on difference saw women exercising power in society through influence—advising their husbands, educating their children, and providing an exemplary model of virtue in their behavior. They continued the tradition that underlay the celebration of republican womanhood at the end of the eighteenth century. Those who focused on egalitarianism stressed rights over influence. They began to articulate a philosophy that stressed direct relationships between women and the state, women and their property, and women and their employers. In doing so, they laid claim to the tradition of natural rights that had been claimed by men during the Revolution. While continuing to champion the value of woman's sphere, they nonetheless discounted it as the route to power, arguing instead that women needed to exercise

power as men did, through political and economic rights. This philosophy would become most clearly articulated in the woman's rights movement of the 1850s, but the outlines were becoming clear by the 1830s.

The Beecher–Grimké Debate

The different philosophies inherent in the influence versus rights approaches crystallized in the mid-1830s as Catharine Beecher conducted a two-year-long pamphlet debate with the Grimké sisters about their antislavery activities and more broadly, the proper relationship of women to political questions. Although Beecher opposed slavery, she was outraged by the *Appeal to the Women of the Nominally Free States* penned by Angelina Grimké in 1836, which not only attacked the religious and legal defenses of slavery but also urged women to combat it by petitioning the government. "Are we aliens because we are women?" Angelina Grimké demanded. "Are we bereft of citizenship because we are the *mothers*, *wives*, and *daughters* of a mighty people? Have *women* no country . . . ?" Although Grimké did not demand the right to vote for women, she pointedly noted that the American Revolution had been fought over the problem of taxation without representation, and that single women in the nineteenth century faced exactly the same problem: they had to pay taxes on their property but had no voice in the government.

 View the Profile of <u>Angelina Grimké (1805–1879)</u>

Library of Congress Prints and Photographs Division [LC-USZ61-1609].

Angelina Grimké was a powerful antislavery advocate in the antebellum period. Her *Appeal to the Women of the Nominally Free States* in 1836 provoked a debate in the press with Catharine Beecher about whether or not women should become involved in political conflicts.

As Angelina Grimké embarked on a speaking tour of northern cities in 1837 to rouse women to the cause of abolition, Beecher penned her first volley in the attack on the Grimké sisters' public speaking and political agitating: *An Essay on Slavery and Abolitionism with Reference to the Duty of American Females.* Beecher saw little hope in the factionalism, patronage, and torchlight parade politics that the Democrats and Whigs had created. Ignoring her own role a few years earlier in the petitioning campaigns against Indian removal (see Chapter 7), she argued instead that women needed to hold themselves above the fray, promoting their political ideals through the influence they wielded in their homes. Beecher's view was a hierarchical one in which women were subordinate to men but also powerful within this hierarchy. She did not feel that women should divorce themselves from all knowledge of politics but that they should engage it within their homes.

In their counter to Beecher's attack, Angelina and Sarah Grimké stressed the importance of women responding the same way as men to the world's problems because both were endowed with the same souls and moral capacities. The Grimké sisters thus advanced a kind of natural rights argument, one that stressed the shared spiritual characteristics of men and women. However, their natural rights theory was legitimated not by reference to a social contract (which was commonly imagined to have been made by men) but by reference to God. The natural rights of woman were both "sacredly and inalienably hers." Angelina Grimké published her response in *Letters to Catharine Beecher*, which focused mostly on the immorality of slavery. Even more famous, however, was Sarah Grimké's defense in a series of essays for the New England *Spectator* and *The Liberator*, which were gathered together and reprinted as *Letters on the Equality of the Sexes*.

Read about "The Beecher–Grimké Debate"

Catharine Beecher may have led a petitioning campaign against Indian removal, but she was appalled by the involvement of women in the abolitionist movement. Her critique of the Grimké sisters was particularly important in the emerging debate over woman's rights.

Review the sources; write short responses to the following questions.

Catharine Beecher, An Essay on Slavery and Abolitionism in Reference to the Duty of Females[6]
Sarah Grimké, Letters on the Equality of the Sexes[7]

1. Compare the way the two authors invoke religion to defend their position about the appropriate role of women in their response to slavery.

2. What sorts of political activity did Beecher consider acceptable for American women?

Sarah Grimké argued powerfully for the equality of women and men before God, challenging biblical translations that suggested women were inferior to men. Grimké also drew extensively on history, specifically Lydia Maria Child's *History of Women*, to argue that men had repeatedly abused and dominated the very creatures they were supposed to love. Although Sarah Grimké shied away from suggesting women should vote or serve in the military, she made it clear they were just as capable as men in doing both. She also took on issues of inequality that had been simmering in other venues, pointing out that married women faced injustices as their husbands squandered their inheritances and wages even as women received far less pay than men for performing the same jobs. Property, wages, rights, and religion were joined together in Sarah Grimké's plea for equality.

Political Participation

The debate over rights versus influence and equality versus difference was inspired not only by the activities women were undertaking but also by changes in the larger political system around them. By the 1840s, only Rhode Island and South Carolina still restricted the franchise to property owners. Two political parties, the Whigs and the Democrats, emerged during this period to compete for the votes of the newly enfranchised masses. The number of white men participating in elections skyrocketed. In 1824, only 30 percent of adult white men voted in the presidential election, whereas by 1840, the figure was closer to 80 percent. While this new democracy has led some historians to characterize this period as the "Age of the Common Man," it is important to remember that not everyone benefited equally. Even as many propertyless white men were gaining voting rights, free African American men were losing theirs because state conventions often inserted new and higher property qualifications for black men who wanted to vote. Women, whether they had property or not, were universally excluded from direct participation in the new democracy.

However, many American women still participated in the new mass political order. Particularly within the Whig Party, and eventually within the Democratic Party as well, women attended political rallies and parades. In cities from New York to New Orleans to San Francisco, women filled the balconies on political parade routes, waving their handkerchiefs. Some even rode in parades, dressed in white to symbolize purity or to symbolize liberty or the larger body politic. They cooked food for the rallies and made banners in support of their candidates. Politicians for a variety of reasons welcomed their presence. First of all, women symbolized a kind of disinterested virtue that rose above the grimy competition of political campaigns. Women, presumably, were interested not so much in winning but in creating a virtuous society. Somehow, politicians could feel ennobled by female presence. In this sense, women were passive spectators and symbols, meant to be protected but hardly active agents.

However, some of the women who participated in these political events embraced the partisanship of their selected parties. One of the most forceful female supporters of the Whig Party was Lucy Kenney of Fredericksburg, Virginia. An aspiring writer and originally a Democrat, she had written pamphlets supporting Andrew Jackson during the 1830s and was willing to continue writing for presidential candidate Martin Van Buren if he would pay her. Van Buren offered her a dollar for her services, and Kenney, insulted

by the offer, switched her allegiances to the Whigs (who paid her considerably more). During the 1840 election, Kenney criticized Van Buren in a pamphlet attack that escalated when Eliza Runnells, defending the honor of the Democrats, accused Kenney of having been "transfigured from an angel of peace, to a political bully." On a more popular level, women joined with men at times in cheering on their candidates, particularly in the frontier regions of the South and Midwest. Mary Ann Inman of Tennessee addressed a crowd of five thousand when she introduced the chief speaker at a Whig rally. Jane Field whipped up her Illinois convention in support of William Henry Harrison's candidacy for president by reminding her audience, "When the war whoop on our prairies was the infant's lullaby, our mothers reposed in security for Harrison was their protector."

Some of the most politically active women in the United States were those who campaigned for the support of private military adventures aimed at taking over foreign countries, some of the most flamboyant expressions of the belief in Manifest Destiny (see Chapter 4). **Filibustering**, as the activity was known, occurred most famously when William Walker of the United States overthrew the government of Nicaragua in 1855. Anna Ella Carroll, daughter of one of Maryland's governors, attacked President Franklin Pierce in print for refusing to recognize Walker's ambassador to the United States. Jane McManus Cazneau of Texas pressured the *New York Sun* to promote Walker's adventures and dragged her husband to Nicaragua for Walker's inauguration as president. Sarah Pellet lectured on behalf of Walker in New Orleans after visiting him in Nicaragua. Using the press and the podium, women such as these pushed the belief in Manifest Destiny to new heights.

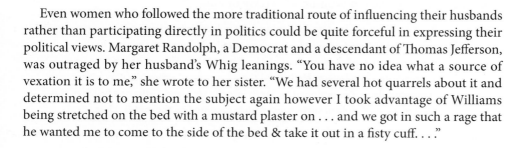

View the Profile of Jane Cazneau

Jane McManus Cazneau was one of the most prominent advocates of U.S. expansion during the nineteenth century. Beginning in 1847, she began campaigning for the annexation of Cuba, carrying her advocacy into her column "The Truth," which was published between 1848 and 1853 in the newspaper *La Verdad*. She also became a supporter of William Walker in his attempts to take over Nicaragua during the 1850s.

Even women who followed the more traditional route of influencing their husbands rather than participating directly in politics could be quite forceful in expressing their political views. Margaret Randolph, a Democrat and a descendant of Thomas Jefferson, was outraged by her husband's Whig leanings. "You have no idea what a source of vexation it is to me," she wrote to her sister. "We had several hot quarrels about it and determined not to mention the subject again however I took advantage of Williams being stretched on the bed with a mustard plaster on . . . and we got in such a rage that he wanted me to come to the side of the bed & take it out in a fisty cuff. . . ."

From Moral Suasion to Political Action

By the 1850s, many moral reform causes were moving out of the realm of moral suasion and into the realm of legislative initiative. Whether fighting for temperance or chastity

or even more explosively, an end to slavery, reformers began to seek political solutions to problems that had been the target of their moral reform concerns during the 1830s and 1840s. Women who wanted to continue pushing for those reforms had to come to terms with this new political world and figure out how they were going to be a part of it.

The beginnings of this move toward political involvement lay in the petition campaigns of the antebellum period (see Chapter 7). In protesting Indian removal, slavery, and labor conditions, women had affixed their names as individuals to political causes and sought political solutions to these problems. They passed petitions among their friends, and they also knocked on the doors of strangers and submitted their petitions in the impersonal halls of the legislature. The petition campaigns continued to expand to other reform efforts, and reformers increasingly sought legislative solutions.

Of course, elite women had always had informal access to political leaders. If they were not married to them, they socialized with them. Sitting at dinner, contributing financially to their campaigns, and facilitating introductions, these women effectively utilized informal networks to lobby effectively for their benevolent causes: local orphanages, schools, or other worthy ventures. Many of the women who became involved in more radical and national causes, however, did not have this kind of access. They usually did not have the same social connections and their causes were far more controversial. If they wanted to reach politicians, they had to rely on more public methods.

By the end of the 1840s, as moral reform stalled and political participation was defined increasingly in terms of the vote, it was difficult to ignore politics as an arena of potential change. The **Liberty Party**, which was established in 1840, established an antislavery beachhead in the political system. The **Free Soil Party**, established in 1848 and largely incorporated into the Republican Party in 1854, continued this trend. Temperance also became more of a political issue in the 1850s as laws against the sale and consumption of alcohol were debated. If women wanted to continue to provide leadership in these movements, they would have to come to terms with the political world in which their causes were now being agitated.

OVERVIEW

Different Approaches to Women's Exercise of Power

Influence	Built on ideals of separate spheres and the cult of domesticity, this approach argued that women should exercise power in society by influencing the men in their families through prayer, education, example, and persuasion. This approach accepted participation in reform societies and the education of women as part of women's separate sphere. Championed by Sarah Josepha Hale and Catharine Beecher, this view of women's role in society was widely accepted by the middle class.
Rights	Although accepting the idea of separate spheres, this approach argued that women should receive the same rights as men in society and government, including the right to vote. Led by women such as Susan B. Anthony and Elizabeth Cady Stanton, this movement was championed by a small group of men and women, many of whom had participated in the antislavery movement.

Forging a Movement

The movement for woman's rights emerged in the 1850s as Americans of all stripes debated ideas of citizenship and worried about the protection of their rights. Not only were established states rewriting their constitutions, new states were conceiving of theirs as they sought entry into the union. The **Dred Scott decision** focused national attention on the Supreme Court decision in 1857 that a slave could not be a citizen. Both northerners and southerners were increasingly suspicious that their rights were being trampled by each other's demands. The woman's movement, however, focused attention on how rights were affected by gender rather than by race or region. Composed of a very small group of devoted supporters, the movement was a regional one in some important respects—it never gained any support in the South, for example. Yet, because it took on the issues of what a government should be, it had national implications, and as correspondence with supporters abroad made clear, the woman's movement in the United States was part of a larger set of concerns about the shape of governments of western Europe as well.

Seneca Falls and Other Conventions

The debate over woman's rights versus woman's influence took an important turn in July of 1848. Approximately three hundred women and men packed the Wesleyan Methodist Chapel in Seneca Falls, New York, to self-consciously proclaim a long list of women's rights. They were northerners, many of them tied together by shared struggles in the abolitionist movement. The New York legislature had finally passed a Married Woman's Property Act in 1848, inspiring Lucretia Mott, Elizabeth Cady Stanton, Martha C. Wright, Mary Ann McClintock, and Jane Hunt to plan a meeting to discuss additional issues related to women. Stanton drafted eleven resolutions for debate in a **Declaration of Sentiments**, a document that bore more than passing resemblance to the Declaration of Independence. The convention and its resolutions signaled the way in which the organizers hoped to reconstitute the government of the United States around issues that would include women rather than exclude them. The audacity of such a move was clear. Although Mott and Stanton were veteran reformers, they still hesitated to chair the meeting, so that James Mott, Lucretia's husband, presided over the event. The issues that had been swirling around the civic identity of women for the past several decades finally came to a boil.

Another small convention was held a few weeks later in Rochester, and soon plans were afoot for a national convention. Throughout the 1850s, national conventions were held yearly in locations that ranged from Philadelphia, Worcester, and New York to Akron and Cincinnati, Ohio. These meetings often drew thousands of participants in rather boisterous circumstances as reformers of all stripes took the floor and as rowdies and hecklers sought to disrupt debate. Rising above the pandemonium, however, was the sense that just as an earlier convention had legitimated the U.S. Constitution, and just as many states were convening conventions to debate revisions to their own constitutions, a new voice of the people would be heard in the National Woman's Rights Conventions. How could the legitimacy of rule be established, after all, without the consent of the people?

The women's rights movement during the 1850s was neither tightly organized nor unified. Supporters struggled and differed over a variety of issues that tried to reconcile

Read "A Bold Declaration: Stanton's Declaration of Sentiments and Resolutions"[8]

Elizabeth Cady Stanton's "Declaration of Sentiments and Resolutions" asserted that "all men and women had been created equal" as its most basic principle and then articulated eighteen ways in which men had injured women and usurped their rights, including their property, their wages, and their civil identity in marriage; the imposition of a double standard of morality; discrimination in marriage and divorce; and taxing women without allowing them a voice in the government. Arguing that women had a natural right to equality with men, the convention debated eleven resolutions attached to the Declaration of Sentiments that asserted the equality of women with men, the right of women to speak in church and in public, and the right to equal participation in trade and commerce. The most controversial of these resolutions by far was the one that stated, "[I]t is the duty of the women of this country to secure to themselves their sacred right to the elective franchise." While Stanton's convictions on this score had been clear for several years, many of her fellow reformers were still shocked. Some were personally opposed to the idea of women voting; others felt that such a radical demand would undermine the movement. Debate on the issue was overheating when the abolitionist and reformer Frederick Douglass rose to speak passionately in defense of woman's suffrage. The balance tipped and the resolution passed. From that time forward, suffrage became a defining issue of the woman's rights movement, though it was far from the only concern.

Review the source; write short responses to the following questions.

1. According to Stanton, how did women at this time feel about their place in society? What did Stanton hope to achieve by publishing her *Declaration of Sentiments*?
2. In the "Resolutions" at the end of the document, how does Stanton attempt to persuade men to agree to equal rights for women?

the problem of what it meant to be both a woman and a citizen at the same time. Convention debates, rather than a clearly structured platform, provided the intellectual core to the movement. Both within these conventions and in response to them, woman's rights advocates explored a variety of issues that were specific to confronting how a *woman* should go about being a citizen.

The Female Citizen

The woman's rights conventions that took place during the 1850s repeatedly called for access to education and stressed the importance of women controlling their own property. They demanded citizenship, and they demanded the vote. In doing so, they still maintained a belief in the importance of a woman's separate sphere and upheld her responsibilities to domesticity. Their view of rights, by and large, still accepted a belief in gender difference. They wanted equality with men but not sameness. They wanted a

> ### Read "A Religious Defense of Woman's Rights"
>
> Jane Cowen[9] of Indiana sent this letter of support to the organizers of the National Woman's Rights Convention held in Worcester in 1850. Although the letter was not read at the convention, it was published in the proceedings.
>
> Review the source; write short responses to the following questions.
>
> 1. How did Jane Cowan use the Bible to justify a belief in women's rights?
> 2. Why did Jane Cowan criticize churches?

state that recognized the issues that had been raised during the previous half century about women's place in the public and political sphere. In raising these issues, they distinguished themselves from those who saw the route to women's power in influence rather than rights. But they also had to think about gender inequality in relationship to problems that women, in particular, faced.

One of the earliest questions many reformers tackled was that of dress. The heavy skirts that middle-class women were expected to wear were expensive, uncomfortable, and unhealthy, with waists tightly cinched by constricting corsets. Thus, women's rights activists took notice when the famous actress Fanny Kemble donned "male attire" in 1849. Amelia Bloomer, editor of the temperance journal *The Lily* championed the loose-fitting trousers and long tunic. Although a variety of woman's rights activists, including Elizabeth Cady Stanton, adopted the new style, the publicity generated by *The Lily's* editor led to the outfit being called "bloomers." Proponents of bloomers pointed out that women would be able to conduct household chores and take vigorous, healthy walks far more easily with the new style. Although the outfits were quite different from what men wore at the time, they did more closely approximate male dress and provide many of the physical freedoms associated with male clothing. This challenge to gender distinctions, however, brought down a hailstorm of criticism on women who tried to wear the outfits. Newspapers across the country ridiculed the women for their manly costume. Children followed them in the streets, harassing them and calling them names. The symbolism of dress was so powerful and so volatile, it was impossible for women to adopt it, even if it was more comfortable and healthy. By the middle of the 1850s, dress reform advocates were ready to give up. The criticisms from the press and conflicts within the movement over appropriate attire were too exhausting. Their decision to abandon dress reform, however, was not without consequences. Gerritt Smith, a wealthy abolitionist, was so dismayed over the loss of dress reform as a cause that he ceased funding the national conventions. This is one of the reasons a national convention was not held in 1857.

Women also had to confront the long-standing tradition that associated female public speaking with moral turpitude. Most woman's rights activists had thrown aside their reservations about public speaking by the middle of the 1850s, but that did not mean they

were comfortable with speaking or that they were particularly good at it. At the Syracuse Convention, Elizabeth Cady Stanton objected to the leadership of Elizabeth Oakes Smith because she lacked a powerful speaking voice. Stanton argued that a woman should not be allowed to address the audience unless her voice was loud enough to be heard by everyone in the hall. Paulina Wright Davis was outraged by Stanton's motion and urged the convention not to "gag" any of the women present. Davis also went further in 1852, using her wealth to establish a newspaper, the *Una*, that would provide an alternative public sphere to the boisterous conventions that were the focus of organizing.

Aren't I a Woman?

The issues of the woman's rights movement grew not only from the potent convergence of questions of citizenship and difference but also from issues articulated in debates over slavery. Many of the men and women who participated in the woman's rights movement came out of the abolitionist movement. Lucy Stone and Lucretia Mott, for example, were important antislavery lecturers; Susan B. Anthony helped slaves escape on the Underground Railroad. Their consciousness about discrimination against women had been raised through their antislavery experiences, as they increasingly compared the condition of women to the condition of slaves. Elizabeth Cady Stanton and Lucretia Mott had famously formed their friendship—and begun to contemplate the issue of woman's rights—at the 1840 World Anti-Slavery Convention in London when female delegates such as Mott were rejected from participation and speaking. The issue of women's leadership had precipitated the split in the American antislavery movement.

Just as antislavery activists had debated whether to support woman's rights, woman's rights activists debated whether to support antislavery. Jane Swisshelm, in particular, provoked controversy by arguing that the woman's rights movement was not strong enough to bear the burden of antislavery agitation as well. She criticized participants of the 1850 Worcester convention for introducing slavery into their debate. As she put the question bluntly in an article for the *Saturday Visitor*, "There are many of both sexes who are, or would be, anxious for the elevation of woman, as such, who nevertheless hate 'the niggars' most sovereignly." Parker Pillsbury, an ardent abolitionist, was appalled by Swisshelm's argument, and most woman's rights supporters distanced themselves from her point of view.

Despite Swisshelm's comments, African American women did cross over from abolitionism to support woman's rights. Harriet Forten Purvis and Margaretta Forten were two of the lead organizers of the Fifth National Woman's Rights Convention in Philadelphia in 1854. Nancy Prince, one of the first African American authors, attended the convention, where she addressed the audience on the way slavery degraded African American women. Sarah and Charles Remond, a brother and sister from Boston, also took up the cause, as did Mary Ann Shadd Cary. Many of the African American activists were particularly prominent in pushing women not only to demand rights but also to disregard ideas about woman's sphere that essentially limited the ability of women. As Mary Ann Shadd Cary and her sister Amelia Shadd argued in their newspaper, "[W]oman's work was anything she put her mind or her hand to."

View the Image of **Abraham Lincoln and Sojourner Truth**

Born a slave in New York State in 1797, Isabella Baumfree escaped from slavery 30 years later, changed her name to Sojourner Truth, and joined the crusade against slavery. She encouraged women's rights activists to work closely with abolitionists.

Sojourner Truth, the most famous African American woman to participate in the woman's rights movement, continued the arguments of these African American activists about disregarding woman's sphere. Truth had been born a slave in New York and freed when slavery was abolished in 1825. Her white colleagues worried at first about having her speak at their conventions, fearing both her illiteracy and her commitment to abolitionism. However, Truth was a powerful orator whose speeches brought audiences to their feet cheering. Her most famous speech, at the Woman's Rights Convention in Akron, Ohio, in 1851, has been the subject of some debate. Not all of those who reported it remembered her saying, "Aren't I a Woman?" as Frances Gage claimed she had. But they do agree on the gist of her message: she could do as much as any man. As Marius Robinson reported at the time, Truth argued, "I have as much muscle as any man, and can do as much work as any man. I have plowed and reaped and husked and chopped and mowed, and can any man do more than that? I have heard much about the sexes being equal; I can carry as much as any man, and can eat as much too."

Read about **"Different Perspectives on Woman's Rights"**

Participants in the woman's rights movement of the 1850s drew on different experiences and perspectives to legitimate their beliefs. Sojourner Truth had been a slave. Jane Cowen of Indiana was a deeply committed Christian. Lucretia Mott was a Quaker who had long experience in the abolitionist movement before she turned her attention to woman's rights.

Review the sources; write short responses to the following questions.

Sojourner Truth's Address[10]
Lucretia Mott Discourse on Woman[11]

1. How are women compared to slaves in these documents?
2. Compare the different rationales for woman's rights in each document.

African American women understood the importance of separate spheres in definitions of respectability, but they had had to violate its terms much more obviously and regularly than middle-class white women. Whether in wage earning, in property holding, or in heading their own households, African American women had shouldered burdens as great as their menfolk, and they brought that understanding with them into the struggle for woman's rights.

Reaching Out

The woman's rights conventions that were held throughout the 1850s took place in the Northeast and the Midwest, reflecting the home base of their constituents. Even within these regions, the woman's rights movement was a small one. Few women or men (and men often numbered close to half the audience at these conventions) were willing to commit themselves to ideals of gender equality at this time. However, the movement was widely recognized, hailed by some and criticized by many.

Support came early from several women in Europe. The year 1848 was not only the year of the woman's rights convention at Seneca Falls, it was also the year in which revolutions erupted in Europe, ending conservative monarchies that had been engineered by Austria's powerful foreign minister, Metternich, and leading to democratic upsurges in France and Germany, among other places. Participants in the revolutions included women who moved quickly to place women's issues on the broad agendas at hand. In France, socialist Jeanne Deroin assisted in organizing a variety of groups dedicated to improving the condition of women and to supporting the rights of workers while Louise Otto made sure the minister of the interior in Saxony heard her demand that women be involved in the reorganization of labor. These revolutions were quickly undermined by conservatives, who squelched demands for woman's rights as well as workers' rights. But into the mid-1850s, agitation continued—from jail cells if need be.

Jeanne Deroin and Pauline Roland, who had both been jailed for their socialist activities, wrote to the Worcester Woman's Rights convention in 1851 to offer their support. When Harriet Taylor Mill published her essay, "Enfranchisement of Women," in England, she began by telling her readers about the convention in Worcester. Mill's son took copies of the essay to Lucretia Mott in Philadelphia, who made sure that her compatriots in the United States read it. Louise Otto in Germany also wrote about the woman's rights conventions in the United States in her *Women's Newspaper*. Thus, the women who participated in the woman's movement in the United States were part of a larger transatlantic debate about the place of women in the rapidly shifting political order of both the Old World and the New.

Despite this worldwide recognition, most Americans (as well as Europeans) remained skeptical of the demands for woman's rights. *Harper's Magazine* published cartoons of women trying to act like men, lounging about, dressed in pants, and smoking cigars. *Godey's Lady's Book* published stories on woman's rights that recast the very notion, suggesting that women felt most rewarded when exercising their "rights" to feed the poor and clean the dirty faces of children. Even many of the women active in reform movements were reluctant to add woman's rights to their list of causes.

Women in the South remained unanimously hostile to the movement for woman's rights. To a certain extent, this may have been because there was such a strong overlap in the supporters of woman's rights with participants in the abolition movement. It may also have been that the issues raised by the more contractual economy of the North had less meaning in the South. Whatever the reason, newspapers in the South lambasted supporters of the woman's rights movement as "cackling geese." Rebecca Hicks, writing for her journal *The Kaleidoscope*, argued, "[I]t is absolutely necessary that we should

please the men, before we can ever hope to conquer them. This important truth has been entirely overlooked by the Woman's Rights women." Thus, as the woman's rights movement rose in the North, those southern women who had been actively involved in politics, speaking in public to support their political candidates, became a little quieter. Women from Virginia did not speak as frequently in the 1856 presidential election as they had in the 1852 election, preferring to make their remarks known through male representatives instead. Although woman's rights was not a terribly popular cause anywhere, southern women made it clear that woman's rights was a northern issue.

Marriage and Divorce

The most contentious conflict among woman's rights activists was over divorce. Some of the more radical supporters of the temperance movement had been pushing to liberalize divorce laws for over a decade, arguing that women and children should not have to live in a house with a drunkard. In this sense, divorce legislation was very much a "woman's issue," tied to her distinctive position within the home as both a dependent of her husband and nurturer of her children. But marriage was also a legal contract between two freely consenting individuals. In this sense, it was a question of citizenship. Framing marriage as a contract, however, moved it into a category of business relationships that scandalized even the most dedicated of women's rights activists.

Elizabeth Cady Stanton had been one of the most ardent supporters of liberalizing divorce laws for the wives of drunkards, but as she argued for changing divorce laws, her arguments moved beyond protecting wives from drunken husbands to a more dramatic revisioning of marriage as a contract between two individuals rather than a sacred bond. Marriage reform, she argued, was of central importance in creating a society based on equality; for in marriage, men had the right to dominate their wives.

The issue came to a head at the 1860 Woman's Rights Convention. Brushing aside the concerns of Lucy Stone that her goals were premature, Stanton demanded in her address, "How can she [woman] endure our present marriage relations by which woman's life, health, and happiness are held so cheap that she herself feels that God has given her no charter of rights, no individuality of her own?" Stanton's speech sparked a wrenching controversy at the convention. Ernestine Rose, who stood shoulder to shoulder with Stanton on the divorce issue, argued that it was a question of rights. The state had an obligation to protect its citizens, even if it meant abrogating a marriage contract. Antoinette Brown Blackwell struck back, defending marriage as a sacred institution. Even if a woman had to protect herself from a drunken husband by obtaining a divorce, Blackwell argued that the man and woman would still be married in the eyes of God and that the divorced wife should still recognize the spiritual connection. Wendell Phillips, a famous abolitionist and supporter of woman's rights, was so appalled by Stanton's position that he wanted the entire discussion struck from the convention proceedings. Phillips argued that men and women were treated equally under laws of marriage, so that marriage reform was not really a proper topic for the woman's movement. The focus, he argued, should be on areas such as political rights where women were truly discriminated against.

The debate over divorce was the last big debate to take place in the woman's rights movement of the 1850s. Woman's rights activists were almost all deeply committed antislavery activists as well. Sectional tensions between the North and the South had been growing during this time period. With the outbreak of the Civil War in 1860, reformers turned their attention wholeheartedly to the conflict that was tearing the nation apart.

CONCLUSION

The woman's rights movement of the 1850s challenged fundamental beliefs about the household as the basic political unit of government, stirring bitter debate about how women could be citizens in the democratic government that had developed in the United States. Proponents of woman's influence had pushed the limits of the domestic sphere to encompass a broad range of educational and economic demands, even as they shunned agitation for the vote. Proponents of woman's rights, although acknowledging the differences between men and women, had struggled with a more radical agenda that would allow women autonomy in the control of their property, their education, and their political representation. But even among woman's rights activists, there were differences, most particularly around the issue of marriage and divorce. With the coming of the Civil War, woman's rights activists postponed these pressing discussions about the legal rights of women in both the state and the family.

Study the Key Terms for Politics and Power: The Movement for Woman's Rights, 1800–1860

Critical Thinking Questions

1. How were demands for woman's rights tied to a changing economy?
2. Why was education tied to debates about woman's rights?
3. Which of the demands of the woman's rights movement would most significantly affect women's ability to exercise power?
4. Why was divorce a more controversial issue than suffrage in the woman's right debates?

Text Credits

1. Ellen Skinner, *Women and the National Experience: Sources in Women's History* (2 volumes).
2. Mary Lyon, Third Annual Catalogue of the Officers and Members of the Mount Holyoke Female Seminary, South Hadley, MA, 1839–1840, "Appendix: Course of Instruction." pp. 8–12.
3. Catharine Beecher, *The Evils Suffered by American Women and American Children: The Causes and the Remedy* (New York: Harper & Brothers, 1846), pp. 3, 5–12.

4. William Woodbridge, *Annals of American Education*, 1838.

5. Sally Rudd to Mary Caroline Rudd, March 26, 1836, Oberlin College Archives, reprinted in Carol Lasser and the students of History 266 at Oberlin College, How Did Oberlin Women Students Draw on Their College Experience to Participate in Antebellum Social Movements, 1831–1861? in Women and Social Movements Web site, Alexander Street Press.

6. Catharine Beecher, *An Essay on Slavery and Abolitionism in Reference to the Duty of Females* (Philadelphia, Boston: Perkins & Marvin, 1837).

7. Sarah Grimke, *Letters on the Equality of the Sexes and the Condition of Women* (Boston: Isaac Knapp, 1838), p. 16.

8. Elizabeth Cady Stanton, Declaration of Sentiments (1848).

9. Jane Cowen to National Woman's Rights Convention, Worcester, 1850.

10. E.C. Stanton, S.B. Anthony, and Matilda Joslyn Gage, eds., *History of Women's Suffrage,* Vol. 1 (Rochester, NY: Charles Mann, 1881), pp. 115–117.

11. Anna Davis Hallowell, *James and Lucretia Mott: Life and Letters* (Boston: Houghton, Mifflin and Company, 1884), pp. 500–506.

Recommended Reading

Nancy Isenberg. *Sex and Citizenship in Antebellum America*. Chapel Hill, NC: University of North Carolina Press, 1998. Close examination of the ways in which questions of citizenship and women's rights were analyzed in light of gender differences.

Nell Painter. *Sojourner Truth: A Life, a Symbol*. New York: W.W. Norton, 1996. Fascinating and detailed study of one of the most important African American activists of the nineteenth century.

Elizabeth Varon. *We Mean to Be Counted: White Women and Politics in Antebellum Virginia*. Chapel Hill, NC: University of North Carolina Press, 1998. Study of the surprising extent to which women in a southern state engaged the growing democratic politics of the antebellum period.

Susan Zaeske. *Signatures of Citizenship: Petitioning, Antislavery, and Women's Political Identity*. Chapel Hill, NC: University of North Carolina Press, 2003. Detailed study of the ways in which early petitioning activities of women developed political meanings.

CHAPTER 9

THE CIVIL WAR, 1861–1865

LEARNING OBJECTIVES

- How did women in the North respond to the outbreak of the Civil War?
- On the battlefront, in what ways did women transgress the bounds of femininity?
- What were the particular hardships endured by Confederate women?
- How did women help to shape the memory of the Civil War and its place in American history?

Explore Chapter 9
Multimedia Resources

TIMELINE

1861	Confederate States of America secedes
	Abraham Lincoln inaugurated president
	Harriet Jacobs's *Incidents in the Life of a Slave Girl* published
	Attack on Fort Sumter, war begins
	Soldiers' aid societies form in North and South
	Women's Central Relief Association forms
	United States Sanitary Commission established
	Dorothea Dix appointed Superintendent of Women Nurses for Union Army
	First Battle of Bull Run
1862	Congress repeals law prohibiting African American men from serving in military
	Confederate Hospital Act places women nurses in military hospitals
	Contraband Relief Association forms
	Julia Ward Howe writes "The Battle Hymn of the Republic"
	Preliminary Emancipation Proclamation
	Battles of Antietam and Fredericksburg
1863	Lincoln issues Emancipation of Proclamation
	Woman's National Loyal League forms
	55th Massachusetts Regiment begins to form
	Federal Conscription Act
	Louisa May Alcott publishes *Hospital Sketches*
	Harriet Tubman foments Combahee River slave rebellion
	Battle of Gettysburg
	Surrender of Vicksburg
	New York City draft riots
	Great Sanitary Fair, Chicago

212

1864	Metropolitan Sanitary Fair, New York
	U.S. War Department allows military hospitals to employ African American women
	General Sherman's march to the sea
	Working Women's Protective Union forms
	Woman's National Loyal League petition presented to U.S. Senate
	Lincoln reelected president
1865	House of Representatives passes Thirteenth Amendment
	Freedmen's Bureau established
	Richmond falls
	Lee surrenders to Grant at Appomattox
	Lincoln assassinated
	Thirteenth Amendment ratified

JUST ONE MONTH AFTER PRESIDENT ABRAHAM LINCOLN TOOK THE OATH OF OFFICE, eleven southern states withdrew from the Union to form the Confederate States of America. Although Lincoln had hoped for a peaceful resolution to the secession crisis, an attack on federal troops stationed at Fort Sumter prompted him to prepare for war. He called for the immediate enlistment of seventy-five thousand troops to preserve the Union. By the time the war ended in May 1865, more than two million men had served in the union army, making the Civil War the largest mobilization of armed forces in U.S. history.

Many women were determined to do more than merely keep the home fires burning and rushed to the battlefields to offer their services. The majority of Union women, however, stayed in their communities, building on decades of work in voluntary associations to organize the procurement and distribution of supplies for the regiments

Read "A Union Volunteer Nurse Writes Home"

Writing to her husband of nearly thirty years, Emily Bliss Thacher[1] Souder (1818–1886) described her experiences as a volunteer nurse for the Union army during the Civil War. Women loyal to the Union like Souder often spent months on the battlefield, feeding and caring for the wounded and consoling them.

Review the source; write short responses to the following questions.

1. How did Souder depict the differences between the roles of men and women during the war?
2. What was her motivation for pursuing activities that threatened her safety and put her in harm's way?

from their area. For their part, Confederate women literally lived with the war, for the fighting took place primarily on their own soil. Most dramatic of all were the actions of southern black women: they secured their emancipation from slavery. Writing early in 1862, the popular writer Fanny Fern accurately predicted that "there's one thing certain. This war won't leave women where it found them, whatever may be said of men."

THE NORTHERN HOME FRONT

For many northern women, the call of duty did not overcome the anxiety provoked by war. Ann Dexter, writing to her husband, expressed herself without reservation. "I am more a wife than a patriot," she acknowledged, "& although I do care for my country, I care for you much more."

Although many women, perhaps the majority, shared Dexter's feelings, large numbers by either necessity or desire stepped into new roles. By the end of the war in May 1865, nearly 40 percent of all men of military age had served in the Union army, leaving much of the work on the home front in women's hands. For many middle-class women, experience in organized benevolence charted a clear path into relief activities, including nursing. For those women who lost the family breadwinner, wage-earning jobs in wartime industries often kept them and their children from the brink of starvation. Attuned to local and national politics, many women emerged from the war ready to test the limits of power that these new roles seemed to offer.

Woman's National Loyal League

Woman's rights advocates had contemplated the coming of the Civil War with mixed feelings. For a long time, they had rallied with fellow abolitionists and insisted on "No Union with Slaveholders!" Yet, with so many Quakers and peace activists among them, a large sector detested the idea of war and greeted with trepidation Abraham Lincoln's election to the presidency in November 1860 and the secessionist fever it provoked in the South. In December, after South Carolina became the first state to secede from the Union, abolitionist Maria Weston Chapman resigned herself to accept what now seemed inevitable and "not so bad as Slavery."

Elizabeth Cady Stanton and Susan B. Anthony viewed the outbreak of military conflict as a signal to push for the emancipation. They called upon women to prepare for war by taking a public stand against slavery. Indeed, if the Union were restored with slavery intact, Anthony wrote to a member of Congress, "[O]ur terrible struggle will be invested with no moral dignity, and it will have no moral value as a historical lesson for the human race."

Anthony did not see her wish granted as quickly as she desired. In April 1862, Congress abolished slavery in the nation's capital while compensating slaveholders for their loss of property. In July, the Second Confiscation Act allowed the Union army to grant freedom to all slaves who escaped behind their lines. But only after the war had raged for nearly two years did Lincoln issue the Emancipation Proclamation. Even then, in January 1863, he made "forever free" only those slaves in areas held by the Confederacy while specifically exempting the Border States.

Woman's rights advocates, declaring "a temporary moratorium" for the duration of the war, invited the "Loyal Women of the Nation" to a meeting in New York City on May 14, 1863. The event, organized by Stanton and Anthony, attracted many seasoned activists, including Lucy Stone, Angelina Grimké Weld, Ernestine Rose, and Antoinette Brown Blackwell. The participants pledged their loyalty to Lincoln and to the Union while insisting that "freedom to the slaves was the only way to victory."

Stanton, the new president of the Woman's National Loyal League (WNLL), and her coworker Anthony hoped to give northern women a broad purpose for their war work—to "labor for a principle," as Matilda Joslyn Gage put it, rather than merely carry on the benevolent activities that for decades had been women's avocation. They set their sights on a constitutional amendment prohibiting slavery. By 1864, the WNLL had gathered four hundred thousand signatures on a petition requesting Congress to pass an amendment to the Constitution "emancipating all persons of African descent held to involuntary service or labor in the United States." Two African American men carried the first installment of one hundred thousand signatures into the Senate and turned it over to the abolitionist senator, Charles Sumner, who presented the Emancipation Petition to his colleagues on February 9, 1864. Lincoln endorsed the amendment, which was passed by the House of Representatives in January 1865. Ratified in December 1865, the Thirteenth Amendment forever prohibits slavery and involuntary servitude.

The activism of the WNLL marked a further departure from the moral suasion that drove the majority of antebellum women's organizations. Whether campaigning for the Thirteenth Amendment or producing uniforms for the troops, women were looking beyond their local communities and toward the state and federal governments to redress injustices and to solve the nation's problems. Nevertheless, the WNNL, which ultimately claimed a membership of five thousand, did not become a vehicle for woman's rights. Stanton and Anthony could not convince the members to endorse unanimously their bold resolution that declared that "true peace in this Republic" cannot be established "until the civil and political rights of all citizens of African descent and all women are practically established." The majority of northern women chose more conventional means to support the Union cause.

Bonnet Brigades

The state governments supplied the volunteer army with little in terms of equipment, clothing, or food provisions; the federal government did even less. The Union army therefore relied on women to assume responsibility for their hometown regiments.

Women formed soldiers' aid societies in great numbers. Members gathered into bandage-rolling teams, collected handcrafted items of clothing, and expressed boxes of prepared foods to the military encampments of local regiments. Local committees also raised money to purchase supplies by canvassing their neighborhoods and staging fairs, dinners, and entertainments. Although often enjoyable, this was serious work. One member of a soldiers' aid society in Rochester, New York, explained that

 Read about "The Emancipation Proclamation"

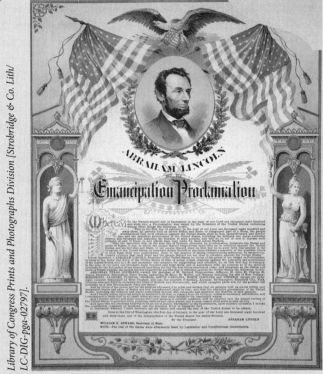

Library of Congress Prints and Photographs Division [Strobridge & Co. Lith/ LC-DIG-pga-02797].

This lithograph, produced in 1888, includes the full text of the Emancipation Proclamation issued on January 1, 1863. Lincoln's proclamation declared "that all persons held as slaves" within the states that had seceded and not yet under Union control "are, and hencefor-ward shall be free."

Review the source; write short responses to the following questions.

The Emancipation Proclamation [1863][2]
Resolutions and Debate, Woman's National Loyal League Meeting, New York City, May 14, 1863[3]

1. Which states and/or regions were exempted from the Emancipation Proclamation? Why?

2. What rights did Lincoln grant those who were free? Give two examples of these provisions under the Emancipation Proclamation.

3. What were the goals of the Woman's National Loyal League with regard to the emancipation of enslaved people?

"the service required is something more than the result of occasional spasms of patriotism; that it is work, undisguised, continuous work, that we must render."

After 1863, African American women rallied to support the Colored Troops. Although many African American men had rushed to enlist with the outbreak of war, they were turned away. Only in July 1862 did Congress repeal a law dating to 1792 that prohibited African American men from serving in the military. Then, after President Lincoln issued the Emancipation Proclamation in January 1863, black men swamped the recruiting offices, and within six months more than thirty black regiments had formed. In response, African American women, usually in conjunction with their churches, took on the work of supplying their troops, fearing that the soldiers would be ignored by white-led societies.

The leaders of local societies soon acted to bring greater efficiency to scattered efforts and proposed plans for statewide or regional coordination. Annie Wittenmyer of Keokuk, Iowa, a center of military activity, decided to transform the city's soldiers' aid society into a clearinghouse for the entire state. Advertisements appeared in newspapers throughout Iowa advising local societies to send all contributions to Keokuk, and Wittenmyer herself took responsibility for distributing supplies to all Iowa troops.

In New York, Dr. Elizabeth Blackwell and her sister Dr. Emily Blackwell, founders of the New York Infirmary for Women and Children, nurtured even greater aspirations. They outlined a plan to "organize the whole benevolence of the women of the country into a general and central association." Nearly four thousand enthusiastic women responded to their call and gathered in the great hall of Cooper Union in April 1861 to form the **Woman's Central Relief Association (WCRA)**.

Managed by "Ninety-Two Respected Ladies," the WCRA invited local societies in New York State and throughout southern New England to forward their donations to the central office in New York City. "The response made to our appeals is grand," wrote Louisa Lee Schuyler, the recording secretary of the WCRA, "and it is a privilege to know and feel the noble spirit that animates the women of the loyal states." However, despite their ambitions, the WCRA and local soldiers' aid societies soon became auxiliaries to a yet more powerful organization, the United States Sanitary Commission (USSC), which was presided over by equally dedicated men.

United States Sanitary Commission

In June 1861, President Lincoln approved the establishment of the USSC as a quasi-official organization funded and managed entirely by civilians. The USSC took charge of military hospitals and eventually laid claim to the network of more than twelve thousand local soldiers' aid societies. The USSC became, according to activist Mary Livermore, "the great channel, through which the patriotic beneficence of the nation flowed to the army."

Although officiated by men, the USSC made it possible for a cadre of middle-class women to play major roles in a vast, centralized organization of war relief. Women served as directors of all twelve regional branches. In addition to coordinating the

relief work of local soldiers' aid societies, the regional branches established scores of additional programs and maintained soldiers' homes and lodges for men separated from their regiments; claims agencies to secure bounties, back pay, or pensions for soldiers and their widows; and a directory of the names and locations of injured and deceased soldiers. After African American men began to serve in the army, a group of well-to-do women in Philadelphia formed the Colored Women's Sanitary Commission, which performed similar services.

In 1863 and 1864, regional directors organized their most noteworthy contribution to the war effort, sanitary fairs. Held in Chicago in October 1863, the first great fair drew crowds estimated at six thousand daily for two weeks and raised more than one hundred thousand dollars. The Metropolitan Fair in New York City, held in April 1864, was even more successful, attracting up to thirty thousand visitors and raising a million dollars for the USSC treasury.

Read about **"Working for the U.S. Sanitary Commission"**

Mary Rice Livermore (1820–1905)[4] was the regional director of the northwestern branch of the U.S. Sanitary Commission, which she believed prepared her for a future life of activism in the woman's movement. Before the Civil War, Livermore had been involved in temperance, antislavery, and benevolent reform activities but had kept her distance from the nascent woman's rights movement. After the war, she shook off all reservations and organized the woman's suffrage movement in Illinois.

Review the source; write a short response to the following question.

1. How and why does Mary Livermore present herself as a woman new to activism?

Despite the apparent success of the USSC, some activists hesitated to turn over control of local soldiers' aid societies to a seemingly impersonal national organization. Such was the case in Keokuk where Annie Wittenmyer balked at the idea of relinquishing her authority to the group of men who headed the Iowa branch of the USSC. Ignoring their entreaties, she continued to solicit supplies from local societies and distributed the provisions herself to her "boys" in the Union army. Many of her coworkers supported her decision. They viewed the work of the male "honorables" as self-aggrandizing and insisted that women's long tradition as caretakers made them the "natural" overseers of relief work.

Toward the end of the war, relationships had become so strained that local women accused USSC agents of fraud and corruption. Then, too, by this time, heavy tax burdens and inflation made it nearly impossible for many women to handle more than the responsibility of caring for themselves and their children at home or, at best, in their own neighborhood. As before the war, they put the welfare of their own communities first, looked with suspicion on national organizations, and concerned themselves primarily with providing a decent homecoming for injured and indigent soldiers.

Freedmen's Aid Societies

With the outbreak of war, northern African American women organized to assist fugitive slaves who sought protection behind Union lines. Dubbed "**contrabands of war**" by the abolitionist general Benjamin F. Butler, these displaced people received only minimal help from either Union troops or the federal government. To ease their suffering, African American women organized a small network of local societies that became the basis of a national commission. Toward the end of the war, in March 1865, the U.S. Congress provided official sanction and federal coordination by establishing the Bureau of Refugees, Freedmen and Abandoned Lands, better known as the **Freedmen's Bureau**.

One of the most active societies was the Contraband Relief Association (CRA), which had formed in August 1862. Its president was Elizabeth Keckley, a former slave who worked in the White House as a confidante and seamstress for Mary Todd Lincoln (see Chapter 6). The CRA provided food and clothing to destitute African Americans and, after enlarging its field of activities, became the Ladies' Freedman and Soldiers' Relief Association.

Women affiliated with the Baptist and African Methodist Episcopal (AME) churches were the mainstays of these organizations. They organized first to assist the growing number of fugitive slaves in their communities and eventually extended their range to provide assistance to freedpeople in the regions of the South occupied by federal troops.

The writer Harriet Jacobs proved especially effective as a fund-raiser, partly as a result of her renown as the author of *Incidents in the Life of a Slave Girl*, which was published during the first year of the war (see Chapter 6). She used some of the money to sponsor a school for the children of refugees at Freedmen's Village in Alexandria, Virginia, and to help African Americans manage it. "I do not object to white teachers," she explained, "but I think it has a good effect on the freedpeople to convince them their own race can do something for their elevation." After the war, the Freedmen's Bureau devoted much of its resources to the educational needs of southern black communities.

Wartime Employments

With so many men serving in the army and as industry geared up to meet the increased demands of wartime production, many women took jobs outside the home. In 1861, the U.S. Treasury Department hired women to trim notes and continued to employ them as clerks and copyists despite intermittent expressions of concern about the propriety of men and women working together in close quarters. Several branches of the printing trades, retail sales, and light manufacturing for the first time admitted women to their ranks. War-related manufacturing, such as shoemaking, provided the largest number of new jobs, while teaching offered the best wages. Overall, an estimated three hundred thousand women became wage earners during the Civil War.

Despite increased opportunities, the majority of workingwomen lived on the margins of subsistence during the war. With inflation soaring from the effects of war production,

their wages remained steady at about half the amount paid to men. Congress helped to stabilize this disparity by setting the salaries of women clerks at approximately one-half of men's. Women's wages lagged far behind the rising prices of food and shelter, which, because of shortages, nearly doubled during the war years. As a sign of the times, the *New York Times* reported a raucous demonstration of "half-starved . . . wives, mothers, and relatives of volunteers" who demanded "bread, bread, bread" and who shouted "maledictions" on those who sent "their male protectors" to war.

As the news of these hardships traveled to the battlefront, desertions among soldiers began to increase while the rate of enlistment fell so low that Congress passed a conscription law, requiring all men ages twenty to forty-five to register for the draft. However, the weight of service fell hardest on working-class men because the new law allowed the wealthy to pay a three-hundred-dollar fee to send a substitute. Antidraft riots broke out in several cities, the most violent in New York City, which in July 1863 took the lives of more than one hundred people.

As the war dragged on, working conditions only worsened, especially within the garment industry. To keep up with orders for army uniforms, commercial manufacturers hired masses of women to sew, often in their own homes, while they sold the finished articles of clothing to the U.S. government at a considerable profit. Working by hand, a needlewoman could make six pairs of drawers in a day and receive an income of thirty-four cents, scarcely subsistence. The Civil War, it could be said, served as midwife to the increasing widespread practice of subcontracting known as the *sweating system*. Nevertheless, women, especially "war widows," were desperate to earn whatever they could.

Many local aid societies began to sponsor relief programs for soldiers' families and hired impoverished women to sew garments for Union troops. The organizers procured government contracts and, vowing to shun the exploitative practices of commercial manufacturers, pledged to pay a living wage. For example, a group of prominent Boston women organized the **Ladies Industrial Aid Association of Union Hall** and employed approximately one thousand women, who produced nearly 350,000 garments for soldiers. The association also maintained emergency funds to help families in dire need. By 1864, many soldiers' aid societies were just as concerned with the welfare of soldiers' families as they were with the work of supplying the army. Many soldiers wrote letters thanking the societies for sending provisions to the front lines but closed by begging them to pay greater attention to the needs of their wives and sweethearts. "Succor them," one solider pleaded, "and withhold your charity from us."

In several cities, workingwomen organized to protest low wages and long hours. Groups of seamstresses in Philadelphia and New York sent petitions to Washington, D.C., complaining against their employers and demanding a living wage. In 1863, New York workingwomen began to strike for higher wages; the following year, they invited wealthy philanthropists to help them form a mutual-benefit society. The **Working Women's Protective Union** soon began to maintain a registry of jobs that met wage standards and placed women, many of whom were soldiers' wives or widows, in these positions. The new organization also supported numerous claims against fraudulent employers.

ON THE BATTLEFIELDS

In April 1861, the famed Lowell textile operative Lucy Larcom wrote in her diary: "I have felt a solider-spirit rising within me, when I saw the men of my native town armed and going to risk their lives for their country's sake." A small minority of women acted on this impulse. They put away their skirts and crinolines, resized military uniforms to fit their figures, cropped their hair, and once disguised as men headed for the battlefields. Others took an opposite tack and engaged in espionage. More than a few women became international celebrities for strategically deploying their feminine charms to ferret military secrets from officers on the other side.

With far less fanfare, a much larger number of women volunteered as nurses in the bloodiest war in U.S. history. In the end, it was not the glory of battle—the "red badge of courage," in the words of novelist Stephen Crane—that made heroes of men and saviors of these women. "Camp diseases" such as smallpox, dysentery, typhoid, pneumonia, malaria, and infected wounds killed more soldiers than combat injuries and sent many frontline nurses to an early grave.

Explore "Women on the Battlefield: Army Nurses"

At the outbreak of the Civil War, nursing was not a profession but a womanly obligation, for the most part work performed at home and without formal training. Despite women's desire to help, neither the government nor the medical profession was eager to employ women as nurses. Public opinion also ran against them, underscoring a commonplace notion that women were too frail to cope with the sight of blood and too delicate to handle naked male bodies. However, as casualties mounted, resistance weakened, and white women began to serve in large numbers as nurses in military hospitals and on the front lines.

Review the sources; write short responses to the following questions.

Clara Barton, Passage from Her Memoirs about Medical Life at the Battlefield [1862][5]
Phoebe Yates Levy Pember, A Southern Woman's Story, (1879)[6]
A Confederate Nurse's Story[7]

1. According to Barton, what were conditions like at the Fairfax hospital where she was caring for patients?
2. How was Phoebe Pember's appearance at a southern hospital received by the men there?
3. What kind of work did Kate Cumming did as a southern case nurse during the Civil War?
4. Why were there so many objections to women volunteering for this service?

After adjusting to the horrors and rigors of war, hospital nurses tried their best to alleviate suffering and to provide comfort. They dressed wounds and assisted surgeons in the grisly tasks of amputations. They cared for their patients by serving them meals, delivering medicines, combing their hair and bathing them, changing their bedding, and providing companionship.

Women accompanying regiments handled a greater variety of tasks and even tended to the livestock. Because they often performed under fire, their risks were far greater, their experiences more gruesome. A famous Civil War nurse, Mary Ann Bickerdyke, for example, routinely searched the fields in the aftermath of battle, shoving corpses aside in the hope of recovering one live soldier.

It was said that nurses often ignored the rules of military discipline and even tried to temper the surgeon's impulse to amputate. Eventually, though, the War Department ultimately acceded to the wishes of surgeons and allowed them, beginning in October 1963, to terminate Superintendent of Nursing Dorothea Dix's right to appoint nurses and to create their own staffs of more compliant assistants.

Three Lions/Hulton Archive/Getty Images.

Dorothea Dix (1802–1887). Pioneering reformer and well known for her work on behalf of the mentally ill, Dix volunteered to organize a nursing corps during the war. She was appointed Superintendent of Nurses for the Union Army and was dubbed "Dragon Dix" for her stern manner.

The Civil War brought women into the public eye as nurses, affording them training, salaries, and titles. In the North, a sizable number emerged from the experience ready to take their place as professionals. For their part, many doctors who had initially resisted women's service in military hospitals now supported the new profession. In 1868, the American Medical Association passed a resolution recommending the establishment of hospital-based training schools for women nurses.

Soldiers

Conventions of womanhood at midcentury dictated a supportive wartime role for women. Nevertheless, patriotism did not always obey the rules of gender. In letters and diary entries, more than a few writers exclaimed: "If only I was a man!"

Some women toyed with temptation. Sarah Morgan Dawson of Baton Rouge, Louisiana, musing on the prospect of Confederate troops recapturing her city in 1862, considered the idea of putting on "the breeches, and joining the assailants." After further reflection, she decided she was not quite ready for such a bold move: "How do breeches and coats feel, I wonder? I'm actually afraid of them. . . . I have heard so many girls boast of having worn men's clothes; I wonder where they get the courage."

Other women showed far less restraint. An Ohio woman, writing to Lincoln, insisted that she "could get up a Regt. in one day of young Ladies of high rank." Although the president refused all such offers, hundreds of women managed to slip through the ranks. It is known that at least eight women fought at Antietam and five at Gettysburg. Mary Livermore claimed that more than four hundred women served as Union soldiers, although the actual number remains unknown. What records do exist relate primarily the activities of white women with African American women rarely serving as soldiers.

Many women became soldiers primarily to stay close to their husbands. Rather than challenging the rules of gender, these women adapted a centuries-old tradition to modern warfare and quartered with their husbands, not to join them in combat but to cook meals and do laundry. Their actual roles proved far more extensive and more often than not extended to nursing the "boys" of their regiment.

Occasionally, women served in a paramilitary capacity. Katy Brownell, for example, accompanied her new husband into the sharpshooter division of the 1st Rhode Island Infantry Volunteers. After commanded to leave by General Burnside, she appealed to the governor of Rhode Island who granted her petition and appointed her "daughter" of the regiment. Wearing a modified military uniform, a knee-length skirt covering her trousers, Brownell occasionally served as color-bearer, an honor usually reserved for men. At the Battle of Bull Run, she proved steadfast in guarding the regimental flag. She later received a government pension for her wartime service.

However, the Union army afforded few opportunities for women to serve in even limited capacities. In 1802, Congress had passed an act restricting the number of women who could accompany the troops to no more than four per company. As a consequence, only the most determined women accompanied their husbands or brothers into combat. Disguised as men and often enlisted as regular soldiers, they managed to stay close to their male companions, sleeping beside them in the makeshift tents and fighting alongside them on the battlefield. Lucy Thompson Gauss, for example, served for nearly a year and a half with her husband Bryant in the 18th North Carolina Infantry before returning home to give birth to their daughter.

Passing as a man was certainly a challenge, but many women succeeded for years at a time, the average for documented women soldiers being sixteen months. The preinduction medical examinations were often hurried, and the loose-fitting military uniforms worked well to conceal the female figure. The battlefield custom of

infrequent bathing also worked in their favor. Moreover, many of the women who enlisted hailed from working-class or farm backgrounds and were exceptionally fit as well as intimately familiar with hard work and rough living conditions. Especially in the Civil War army of citizen-soldiers, many of them but beardless youths, these women were scarcely at a disadvantage. The majority of soldiers, men and women alike, had to learn how to drill, dig trenches, and handle muskets. Not poor performance but combat injuries and death were the primary causes of a woman's discovery in the ranks.

Spies

Other women who were attracted to adventure or moved by patriotism did not hide their femininity but, to the contrary, exploited it in the work of espionage. Women spies, who were more often middle and upper class than were their soldier counterparts, could more easily gain access to the officer ranks of the army. As well-heeled ladies, they could also take full advantage of the fashionable clothing popular during the era. A lot of secret and coded messages could be hidden in hoop skirts, parasols, and even corsets. The greatest asset of the southern spy in particular was femininity itself. Contemporary northern newspapers, which printed many stories about their escapades, commonly branded them as "loose women" or "secesh harlots."

One of the most infamous was Maria Isabella ("Belle") Boyd, a graduate of Mount Washington Female College. Early during the war, she shot a Union soldier who broke into her family home in Martinsburg, Virginia, and insulted her mother. Vindicated at a military hearing, she turned to nursing injured soldiers before discovering her true calling. She became an intrepid spy for the Confederacy. Celebrated for her late-night horseback rides through Union camps, Boyd perfected the art of flirtation to the point that federal officers commonly leaked precious secrets to her, which she delivered to Confederate commanders. General Thomas "Stonewall" Jackson commended Belle Boyd for her "immense service" to the Confederacy by providing him the crucial information about the position of Union troops that gave him an important victory in the Shenandoah Valley in June 1862.

The Union, too, inspired some women to take on the risky business of espionage. Pauline Cushman, for example, successfully gathered information about Confederate operations by posing as a secessionist. She also used a variety of disguises, occasionally wearing men's clothes. In 1864, "Major" Cushman was awarded an honorary military commission for her wartime service.

View the Profile of Pauline Cushman (1833–1893)

Union spy who used a variety of disguises, occasionally wearing men's clothes to infiltrate enemy camps. After the war, Cushman toured the North, dressed in the uniform of a Union soldier and telling stories of her adventures as a spy.

PLANTATION SOCIETY IN TURMOIL

Fought mainly on southern soil, the Civil War disrupted nearly every aspect of Confederate society. The war brought freedom to between three and four million African Americans—40 percent of the population of the South—and destroyed much of the wealth and political power of the planter elite. Of the 1,064,000 men who fought for the Confederacy, 250,000 died and more than 137,000 were wounded. In addition to bringing a fundamental change in race and class relations, the Civil War also posed an immense challenge to the prevailing gender system.

Unflinching Loyalty to the Cause

High-ranking Confederates flaunted the loyalty and dedication of their women. Indeed, women of the planter elite had cheered wildly from the balconies at state assemblies where secession was declared. On February 18, 1861, when representatives from the secessionist states met in Montgomery, Alabama, to ratify the formation of the **Confederate States of America**, women of slave-owning families dressed in their best finery and lined the halls to celebrate their new president, Jefferson Davis.

After the declaration of war, the Confederate government and local newspapers alike extolled the patriotism of those white women who put aside their private feelings and joyfully sent their men into battle. "When you write to soldiers, speak words of encouragement; cheer their hearts, fire their souls, and arouse their patriotism," one counselor wrote. "Say nothing that will embitter their thoughts or swerve them from the path of patriotic duty." Stories abounded of southern women refusing to consort with any man not wearing the gray uniform of the Confederacy and even sending frilly underwear to those who refused to enlist.

Love of the Confederacy went hand in hand with hatred of the Yankees. "If all the words of hatred in every language under heaven were summed up together into one huge epithet of detestation," one young woman wrote, "they could not tell how I hate Yankees. They thwart all my plans, murder my friends, and make my life miserable." Southern women showed their disrespect of Union soldiers so forcefully that the commander of Union occupation forces in New Orleans, Benjamin F. Butler, issued a proclamation to quell all jeering, spitting, and otherwise insolent behavior. Should a woman violate this ruling, the general warned, "she shall be regarded and held liable to be treated as a woman of the town plying her avocation," that is, as a prostitute. Most women demonstrated their loyalty in more reserved ways, such as by pinning small Confederate flags to their bodices.

Despite early displays of enthusiasm for the war, Confederate women lagged behind Yankee women in providing support services for the troops. Women of the planter and mercantile elite lacked a strong tradition of female benevolence and organized more slowly to assist the war effort. However, within a few months, more than one thousand voluntary associations formed and pledged, like their northern counterparts, to keep soldiers outfitted. "Our needles are now our weapons," one Charlottesville woman proclaimed, "and we have a part to perform as well as the rest. . . . Yes, Yes, we women have mighty work to perform for which we will be responsible." Relieved to assist

"the great cause, in the way best suited to the sphere of woman," one soldiers' aid society observed, they learned quickly and produced thousands of flags, uniforms, tents, and sandbags. However, elite women, in line with the customs of a regional aristocracy, preferred fund-raising to sewing and served the Confederacy primarily by sponsoring elaborate dinner parties and extravagant bazaars and entertainments.

With much of the South cut off from supplies by the Union blockade, women's contributions were indeed crucial to the Confederate conduct of the war. Yet, as the number of injured soldiers mounted, many women discarded their needles and moved beyond their sewing circles and into the hospitals where they attended to the wounded and dying. Eventually, the wreckage of war forced many Confederate women to abandon both voluntary societies and hospital work altogether. On the brink of destitution if not already displaced from their homes, they did what they could to protect their children and merely survive.

Plantations without Patriarchs

In the absence of men, the Civil War plantation became a woman's world. Three of every four white men of military age had left their homes to fight for the Confederacy. By 1862, the Confederate government had began to impress male slaves to do manual labor, such as hauling supplies, constructing and fortifying the camps, digging ditches on the battle-front, and working in military hospitals. In regions of the South occupied by the Union troops, those male slaves still on the plantation usually fled to fight for the Union.

Women, black and white, remained on plantations that had been, in the words of one South Carolinian woman, "thinned of men." Many female slaves, especially the mothers of young children, chose to stay, less from loyalty to their mistress than from determination to keep their families together and to maintain the ties of kinship during insecure times. Although some planter wives followed their husbands to military camps or took refuge with relatives, the majority tried to hold fast. And with the odds of experiencing the death of a husband or son three times that of their northern counterparts, many white women saw their new roles become permanent. What did it mean to them personally as well as to the plantation system at large for white men to vacate their roles as heads of household, that is, as slave-owning patriarchs, and turn over the whole enterprise to women?

Many planter women faced a great challenge in not only overseeing the entire plantation but also taking responsibility for increasingly restless and insubordinate slaves. As the Union troops moved ever deeper into Confederate territory, many slaves were willing to continue working but only if recognized as free laborers. They could not readily demand wages because money was in short supply for everyone, but they did try to negotiate working conditions with their mistresses. According to reports by Union soldiers serving in occupied territories, slaves felt free to make demands because "there was nobody on the plantations but women and they were not afraid of them." The disciplinary rules that had defined slavery during the antebellum period no longer held the same power.

Some plantation mistresses embraced the challenge, being accustomed to taking charge during the frequent absences of their planter husbands. But, given the

uncertainties of wartime, they more commonly expressed doubt and fear. They wrote complaining letters to their husbands and occasionally sent petitions to state and Confederate governments. "I fear the blacks more than I do the Yankees," a Mississippi woman explained. Ironically, the absence of the master forced his wife to become more dependent on her slaves than before the war. The anxiety created by this situation caused a few mistresses to express their disillusionment with the institution of slavery, if only in the privacy of their diaries. More commonly, they became more assertive in their racial animosity and more aggressive in wielding their power as white women.

The Union blockade and the Confederate military mobilization combined to create more work for everyone in the household. For the plantation mistress, unfamiliar domestic chores—cleaning, cooking, and sewing, as well as child care—became routine. But even more untried were the tasks associated with running a plantation in wartime. To feed the army, the Confederate government had encouraged the growth of staples like corn and grains instead of the usual crops of cotton and indigo. The plantation mistress also took over her husband's responsibility of balancing the books as well as finding the money to pay the high taxes levied by the wartime government. Enslaved women found their work becoming even more burdensome. With consumer goods such as textiles in short supply or prohibitively expensive, even field hands were forced to spin and weave. And during planting and harvest seasons, many slave women who had previously worked solely as servants within the confines of the big house found themselves tending the crops. Overall, slaves worked harder than before the war, often because their mistresses refused to endure shortages or bear the humiliation of wearing calico dresses.

As the war dragged on, even elite women could not find the resources to maintain the plantation. The most adventurous—or the most desperate—sent their daughters to the relative safety of boarding school and ventured outside the household for the first time in their lives. They hoped to earn a livelihood as school teachers or as clerks in the Confederate government.

Not a few white women flourished in such unfamiliar roles. An exceptionally bold group in Virginia even mobilized to defend themselves and their property against the invading Yankees by forming small drill teams and asking the governor of Virginia to send them some pistols. Others, however, could not help feeling that, by assuming such independent roles, they had violated the sacred principles of southern womanhood.

During the last years of the conflict, when the Union army adopted tactics designed specifically to demoralize Confederate soldiers and citizens alike, looting and burning houses and arming slaves against their former masters, many Confederate women felt they could no longer bear the burdens. "Yankees stripped us bare of everything to eat; drove off all the cattle, mules, horses; killed chickens; and turned their horses into a wheat field so that what the horses could not eat was destroyed by trampling," a Georgian woman reported. Fearing for their own safety, on the brink of starvation, and virtual paupers, many gentry women left their homes and joined the growing ranks of refugees who traveled the countryside, staying temporarily in camps, and often headed for towns and cities. Not a few withdrew their support from the patriotic endeavor. White women of yeoman and propertyless families, who were typically poor before

the outbreak of the war, suffered far more deprivation. These women often became vocal opponents of the war and helped men who deserted.

Confederate women, rich as well as poor, began to petition the government to return the men who had not yet died in battle. But for many, as one in three white southern men lay dead, there would be no return.

Camp Followers and Contrabands

After the Emancipation Proclamation, large numbers of slaves began to follow the Union army as it reached farther into the South. Men and women alike—perhaps as many as 15 percent of the slave population—fled the plantations, choosing to taste the first fruits of freedom by securing themselves behind the new Union lines. In Mississippi alone, nearly one-half of the slave population, estimated as more than one hundred thousand, set up camps near the Union troops or worked on plantations seized by the U.S. army and transferred to Yankee management. Although many officers regarded fugitives, especially women and children, as a nuisance, the soldiers themselves often encouraged former slaves to accompany them. Sally Dixon of Mississippi later recounted that when "the Union cavalry came past our plantation [and] told us to quit work, and follow them, we were all too glad to do so." Former slaves who crossed Union lines were often designated *contrabands*, that is, as confiscated property or the spoils of war.

The experiences of freedmen and freedwomen differed considerably. African American men at first did manual labor for the Union army and later became soldiers. Women, however, had less clearly defined roles. One observer reported that after Grant took Vicksburg on July 4, 1863, freedwomen could be seen "following the army, carrying all their possessions on their heads, great feather beds tied up in sheets and holding their few belongings." Where African American soldiers were encamped, their wives and children sometimes lived in tents provided for them or in shantytowns on the edge of cities occupied by Union troops. Some women became nurses, cooks, or launderers for the colored troops and lived in barracks. Harriet Tubman, who had helped slaves escape through the Underground Railroad, offered assistance to contrabands. Susie King Taylor,[8] for example, traveled with her husband's regiment, working as needed as a laundress or nurse. "My services were given at all times for the comfort of [the] men," she later recalled. "I was on hand to assist whenever needed." She also made certain that she could handle a musket and assisted the soldiers by cleaning and reloading their guns.

In December 1862, General Grant ordered the exclusion of women and children from the field and encouraged the organization of contraband camps near the cities where the U.S. Colored Troops were quartered. In these camps, freedwomen worked to support themselves and their families but also to provide supplies to the troops. Overcrowding and outbreaks of infectious disease were typical of these camps. Freedmen's Village in Alexandria, Virginia, for example, grew from three thousand people in 1863 to seven thousand a year later. Plagued by measles, smallpox, and whooping cough, these camps registered far more deaths than births. Partly in response to the high infectious disease and death rate, Union officials preferred to relocate African American women to abandoned or confiscated plantations.

Read "Reminiscences of an Army Laundress"

African American women had their own, compelling reasons to support Union military campaigns, but they rarely did so as soldiers. However, at least one former slave, Maria Lewis, fought valiantly. Serving with the 8th New York Cavalry, Lewis traveled with the troops to Washington, D.C., to deliver seventeen captured Rebel flags to the War Department. Women like Susie Taylor King went a different route, joining the 33rd U.S. Colored Regiment, in which her husband served, as an army laundress. Taylor and her husband were two of the thousands of slaves who escaped to the Union army, a decision that came with indignities unique to the African American men and women who made this decision.

Review the source; write short responses to the following questions.

1. What were conditions like at the camp where Susie King Taylor was a laundress?
2. In addition to her duties as laundress, what other types of responsibilities did Taylor have?

Union officials also aimed to create a distance between African American women and the troops for the purpose of reducing the sexual commerce that flourished near the garrisons. Although the ranks of prostitutes were filled with both white women and black women, the officers singled out African Americans as "women of bad character" and viewed them as more licentious by nature than their white counterparts. And whereas they merely scolded white soldiers for inappropriate dalliances, Union officials induced black soldiers to marry their lovers. In fact, a large number of the women who engaged in sexual relations with black soldiers were already their wives, unrecognized as such by the white officials who did not recognize slave marriages as legal unions. Proof of a legal marriage became a requirement for the right of many black women to live in many camps or towns controlled by the Union army. As Colonel John Eaton Jr., who oversaw the camp at Corinth, Mississippi, explained, "untold evils resulted from the presence of lewd women; to meet this, marriage was started on the basis of the laws of the U.S., [and] regular registration [was] established."

But even a certificate of legal marriage and paid employment did not guarantee a freedwoman the right to keep her family intact. In Mississippi toward the end of the war, for example, military officials allowed African Americans who worked for the Union army to remain in Natchez but forced others to leave the city. Although many African American soldiers and their wives protested this policy, the general in charge of the Mississippi Valley insisted that freedpeople "should be put into a position to make their own living. The men should . . . be mustered into the service as soldiers, and the others with the women and children placed on abandoned plantations to till the ground."

In rural areas controlled by the Union army, freedwomen became field laborers on reorganized plantations, which the federal government leased to white northerners or

View the Profile of <u>Harriet Tubman (1820–1913)</u>

Abolitionist, Underground Railroad conductor and war hero who was born into slavery, Tubman eventually escaped from her abusive master in 1849. She settled in Philadelphia, where she embraced the role of conductor on the Underground Railroad; in 19 rescue missions, she brought out of bondage between 300 to 400 people, including her sister and her aged parents.

to white southerners who took an oath of loyalty to the United States. Working now for wages, these women and their children performed many of the same tasks that had been theirs under slavery and did so under the direction of and for the profit of whites. They picked and baled the cotton that, unattended, would have gone to seed. Although the federal government emphasized the humanitarian goals of this system, the actual conditions on badly managed plantations rivaled those of the contraband camps, producing in some cases even higher mortality rates. Moreover, the common practice of irregular payments of wages and in some cases outright fraud denied many field-workers their rightful compensation. Poorly paid, their mobility restricted, freedwomen were forced to endure conditions of labor little better than slavery. As early as 1862, the *Weekly Anglo-African* newspaper condemned this system as "but another name for Government slavery."

By 1864, the African American women and children who constituted the majority of refugees suffered the deprivations that accompanied the final battles of the war. Eager to flee the plantations, they attached themselves to Union troops. Thousands of African American women braved General William Tecumseh Sherman's destructive 285-mile march through Georgia. "Babies tumbled from the backs of mules to which they had been told to cling, and were drowned in the swamps, while mothers stood by the roadside crying for their lost children," one Union officer reported. By the time Sherman's army reached the sea, less than seven thousand of the estimated twenty-five thousand African Americans who attempted the journey were still alive.

A WOMAN'S WAR

"I have never studied the art of paying compliments to women," President Lincoln confessed toward the end of the war, "but I must say, that if all that has been said by orators and poets since the creation of the world were applied to the women of America, it would not do them justice for their conduct during this war." Quite a few women, such as Elizabeth Stuart Phelps, were eager to write and publish their own assessments. They filled the pages of popular magazines and illustrated weekly newspapers with their commentary on women's contributions to both the home and battlefronts. However, for the most prolific, writing itself served as a form of war work. "I thank God that instead of giving me a wash-tub, or a needle, or a broom to work my work with," Mary Dodge, a popular writer better known as Gail Hamilton, wrote in 1864, "he has given me a pen, and a whole country for my family."

A Moral Crusade to End Slavery

Even before the attack at Fort Sumter, several prominent abolitionists had accepted the inevitability of a bloody conflict and pledged themselves to make the eradication of slavery the principal goal of the war. To this end, Lydia Maria Child set herself to editing *Incidents in the Life of a Slave Girl*, Harriet Jacobs's semiautobiographical narrative that is unremitting in its documentation of slavery. As if by design, Jacobs's novel was published on the eve of the war in April 1861 and soon became one of the most important abolitionist missives of the decade. Published in 1863 as a timely complement to the Emancipation Proclamation, Fanny Kemble's *Journal of a Residence on a Georgian Plantation* added to Jacobs's revelations about the horror of slavery. The book by the well-known British actress, which had been written nearly a quarter-century earlier, told the world, in the words of a sympathetic reviewer, "what the black women of the South have so long endured."

The longtime abolitionist Julia Ward Howe wrote the most popular and enduring tract of the war years. In November 1862, after a White House reception with President Lincoln, she and her husband, Samuel Gridley Howe, attended a military review a few miles away, and along the way their party sang patriotic songs. Someone urged Howe, who was already well known for her poetry, to update the abolitionist hymn they all loved so well. That night, she woke up feeling inspired and drafted new lyrics to the tune of "John Brown's body lies a-mouldering in the ground; His soul is marching on." The next month, the *Atlantic Monthly* published her poem, which included the moving stanza,

> In the beauty of the lilies Christ was born across the sea,
> With a glory in his bosom that transfigures you and me:
> As he died to make men holy, let us die to make men free,
> While God is marching on.

Reprinted in newspapers and magazines throughout the North, Howe's stirring lyrics called upon Americans to view the war as retribution for the sins of their nation and to seek redemption by freeing the slaves. Union troops soon began to sing the "Battle Hymn of the Republic" while they headed into battle.

View the Profile of <u>Elizabeth Stuart Phelps</u>

The writer Elizabeth Stuart Phelps was one of the many women who helped create the myth of the Civil War as a "woman's war." Born in Boston in 1844, she followed in her mother's footsteps as a writer of children's stories and religious works. It was her memorial to the war widows, *The Gates Ajar*, however, that turned her into an author of international renown.

Other women excelled as orators. Born free and raised as an abolitionist, Frances Ellen Watkins Harper wrote poetry and lectured to raise funds for the war effort and became an extraordinarily popular speaker for the African American community. "The Union of the

past, thank God, is gone," she proclaimed in 1864. "Darkened by the shadow of a million crimes, it has sunk beneath the weight of its own guilt, and now we stand upon the threshold of a new era—an era whose horizon is gilded with promise, and flushed with hope."

Harper's rhetorical flourish found its equal in the impassioned oratory of the youthful white abolitionist Anna Dickinson of Philadelphia. Just nineteen years old when the war broke out, Dickinson had been raised in the Quaker tradition of female preaching. "While the flag of freedom waves merely for the white man," she warned, "God will be against us." Huge crowd's listened in awe as she rebuked President Lincoln for hesitating to emancipate all slaves.

Memoirs and Memories

In mid-1863 Louisa May Alcott began to serialize several short stories based on her nursing experiences at the makeshift Union Hotel Hospital in the Georgetown area of Washington, D.C. She served there for only two months before typhoid fever nearly took her life. Yet, even this short stint provided the thirty-year-old aspiring writer with enough material to make heroes of both injured soldiers and the female nurses who cared for them. Her main character, Nurse Tribulation Periwinkle, draws on conventional notions of womanhood while continuously enlarging her realm of responsibility in the hospital. She showers her wards with the affection a mother would give to her sons and, at the same time, proves herself a competent and skilled nurse. Alcott went on to write the perennial children's classic *Little Women* but achieved her first moment of fame with the publication of her wartime nursing tales.

Alcott was far from alone in developing this important genre. By the end of the war, more than two dozen stories or books had already appeared in print, and after the war several hundred more nurses wrote their memoirs. Unlike their fictional counterparts, they offered more pointed criticism of male physicians and described their relationships with them as contests over authority. Still, both the tragedy and romance of the war remained fixed elements, as indicated by the subtitle of Sophronia Bucklin's engaging memoir, *In Hospital and Camp: A Woman's Record of Thrilling Incidents among the Wounded in the Late War*, published in 1869. Writers, northern and southern alike, determinedly illustrated women's capacity to be as heroic in their roles as soldiers were in theirs.

Yet, no nursing memoir rivaled the exciting tales written by former spies. Rose O'Neil Greenhow, for example, was one of the first women to exploit her adventures in print. The Washington socialite had served the South by transmitting vital information and became instantly famous for contributing to the Confederate victory at Bull Run in July 1861. She was soon captured and, with her small daughter, detained in a federal prison. After her release, Greenhow traveled to England and France where she wrote about her espionage activities. *My Imprisonment, and the First Year of Abolition Rule at Washington*, which was published in 1863, ensured her fame. However, fate cut short her promising career as a writer. On her return trip in 1864, Greenhow drowned off the shore of North Carolina.

The Confederate spy Belle Boyd met with longer-lasting acclaim. After the war, she capitalized on her fame by narrating her adventures as a spy for audiences across the country. Boyd was especially popular with veterans' groups who, according to lore, remembered her fondly as "the most daring woman in the Confederacy."

Memoirs were not just the domain of white women during this time of great strife and unrest in the United States. African American women published memoirs as well but their stories tell a much different tale from that of their white counterparts. What the Civil War meant to them was vastly different than what it meant to white women and their narratives detail a life of bondage and sometimes one of hope as they realized what the War could mean for them in the long run.

Annie Burton's[9] memoir is one such example of a slave story. Born in Alabama in 1858, three years before the outbreak of the Civil War, Burton's mother had run away, but she returned to the plantation after the war. Annie later moved to Boston, where she married and published her memoir in 1909. She also composed a biography of Abraham Lincoln. Her story offers the unique perspective of a slave child who experienced the war without fully understanding all of its implications.

Read "Memories of Childhood's Slavery Days"

Review the source; write a short response to the following questions.

1. What happened after Annie's mother came back to get her and her siblings?
2. Why did the mistress want to keep the children, in your opinion?

Mattie Jackson's[10] was another story that came to light shortly after the war ended. Jackson was from St. Louis, Missouri, but she traveled to Lawrence, Massachusetts, in April 1866. Her memoir was published that same year. Part of Jackson's story details her flight to Union lines to escape the cruelties of her owners, even though it meant separation from her mother. The title page of the published text states that it was "written and arranged by Dr. L.S. Thompson (Formerly Mrs. Schuyler), as given by Mattie." Dr. Thompson explained that Ms. Jackson had plans to lecture and continue to tell her story of life under slavery to draw attention to the needs of the freed slaves of the South.

Read "The Story of Mattie J. Jackson: A True Story"

Review the source; write a short response to the following question.

1. Why did Mattie's mother send her to the Union-controlled Arsenal alone?

The first official histories of the USSC, written shortly after the war by the men who spearheaded the venture, played down the friction between the regional branches and the local soldiers' aid societies and instead duly praised the women who contributed so much to the war effort. They erred primarily on the side of excessive flattery, deploying such familiar gender phrases as "self-sacrifice" and "motherly devotion" to praise individual women. Although many women basked in the glow of such adulation, the majority who served in the leadership ranks did not.

The regional directors of the USSC countered the official histories with their own interpretation of the significance of women's role in the USSC. In charge of the

northwestern region, Mary Livermore and Jane Hoge understood quite clearly that they had transformed volunteer charity work, a staple of antebellum female activism, into a salaried profession. As directors, they had not only set their own agenda but demanded pay for their work. In New York, the youthful Louisa Lee Schuyler ran the branch on a voluntary basis but nevertheless launched herself on a lifelong career in charity organization. Such was also the case with Boston activist Abby May, who envisioned the USSC as the mechanism for creating a "sisterhood of states" of the local relief organizations.

By building a bridge between community activism and the exigencies of the growing nation-state, regional leaders of the USSC fostered a new civic culture for women and created a network of activists comfortable with national organizational goals. Moreover, before the war, these middle-class women had enlarged their domestic sphere by undertaking philanthropic endeavors, but after the war, a sizable number put aside domesticity altogether for public service and careers.

CONCLUSION

Shortly after the beginning of the Civil War, Julia Le Grand pined: "I wish I had a field for my energies. I hate common life, a life of visiting, dressing and tattling, which seems to devolve on women, and now that there is better work to do, real tragedy, real romance and history weaving every day, I suffer, suffer, leading the life I do." Ultimately, the war that emancipated four million slaves put new demands on this otherwise privileged southern woman as well as nearly everyone living in its path. Barred from combat, women took on untried roles, availed themselves of new opportunities, and gained unprecedented access to power.

At the same time, for both Northern and Southern women, the specter of suffering and death hung over them—for good reason. The Civil War was the most devastating war in American history. At least 50,000 civilians died, and military casualties topped 500,000. Approximately 360,000 Union soldiers lost their lives. The toll was proportionately greater in the South, where an estimated one in four Confederate soldiers— approximately 258,000—were killed. Of the men who managed to survive the carnage, a large number returned home maimed or psychologically scarred.

Despite bearing the weight of personal tragedy, many men and women emerged from their wartime experiences with new perspectives on the roles of men and women. "During the war, and as a result of my own observations," Mary Livermore wrote, "I became aware that a large portion of the nation's work was badly done, or not done at all, because woman was not recognized as a factor in the political world." She nevertheless anticipated that with the return of peace women would eagerly resume their domestic roles. Such was not to be because, she later noted, "during those days of hardship and struggle, the ordinary tenor of woman's life had changed. She had developed potencies and possibilities of whose existence she had not been aware, and which surprised her, as it did those who witnessed her marvelous achievements." Like so many women of her generation, Livermore believed that the Civil War had wrought revolutionary changes, perhaps not least in a "great awakening of women." Those women involved in the woman's rights movement came to a similar conclusion, claiming that the Civil War "created a revolution in woman herself, as important in its results as the changed condition of the former slaves."

 Study the <u>Key Terms</u> for The Civil War, 1861–1865

Critical Thinking Questions

1. In what ways did notions of womanliness affect the ways women responded to the Civil War?
2. What were the major regional differences in the ways women experienced the Civil War?
3. How did women's experience in antebellum voluntary societies prepare them for a new role in the Civil War?
4. How did enslaved women respond to the outbreak of the war?
5. Why did many women writers view the Civil War as a turning point in American women's history?

Text Credits

1. *Leaves from the Battlefield of Gettysburg: A Series of Letters from a Field Hospital, and National Poems* (Philadelphia, PA: C. Sherman, Son & Co., 1864), pp. 15–19.
2. The Emancipation Proclamation (1863).
3. Resolutions and Debate, Woman's National Loyal League Meeting, *New York City,* May 14, 1863.
4. Mary A. Livermore, *The Story of My Life; or the Sunshine and Shadow of Seventy Years* (Hartford, CT: A.D. Worthington and Company, 1899).
5. Clara Barton, Passage from Her Memoirs about Medical Life at the Battlefield (1862).
6. From Perry Epler, *Life of Clara Barton* (New York: Macmillan, 1915), pp. 31–32, 35–43, 45, 59, 96–98.
7. Kate Cumming, *A Journal of Hospital Life in the Confederate Army of Tennessee from The Battle of Shiloh to the End of the War* (Louisville, KY: John P. Morton & Co., 1866), pp. 44–45.
8. Susie King Taylor, Reminiscences of an Army Laundress (1902).
9. Slave Narrative of Annie L. Burton, "Memories of Childhood's Slavery Days," Boston (1909).
10. Mattie J. Jackson, *The Story of Mattie J. Jackson: A True Story* (Lawrence, MA: Sentinel, 1866).

Recommended Reading

DeAnne Blanton, and Lauren M. Cook. *They Fought Like Demons: Women Soldiers in the American Civil War*. Baton Rouge, LA: Louisiana State University Press, 2002. A study of women who cross-dressed to disguise themselves as men and fought as soldiers in both Union and Confederate armies.

Catherine Clinton and Nina Silber, eds. *Divided Houses: Gender and the Civil War*. New York: Oxford University Press, 1992. A collection of essays illustrating the impact of social history on recent scholarship of the Civil War. Includes several essays about men and masculinity.

Laura F. Edwards. *Scarlett Doesn't Live Here Anymore: Southern Women in the Civil War Era*. Urbana and Chicago: University of Illinois Press, 2000. Making the household the center of her narrative, Edwards charts the relationship between the private and public spheres for African American women and white women of both planter and yeoman families.

Drew Gilpin Faust. *Mothers of Invention: Women of the Slaveholding South in the American Civil War*. Chapel Hill, NC: University of North Carolina Press, 1996. Based on the writings of more than 500 Confederate women, Faust's book examined the ways Confederate elite women negotiated their womanhood amid the turmoil of the Civil War.

Ella Forbes. *African American Women during the Civil War*. New York: Garland, 1998. Documents the role of both free black women and those emerging from slavery in making the Civil War a struggle for liberation.

Judith Ann Giesberg. *Civil War Sisterhood: The U.S. Sanitary Commission and Women's Politics in Transition*. Boston: Northeastern University Press, 2000. Examines the network constructed by women in the USSC as a transition between the local activism of the antebellum period and the wider postwar reform endeavors and political movements. Giesberg's study also covers the commission's program to employ women as nurses in Civil War hospitals and on the battle front.

Libre R. Hilde. *Worth a Dozen Men: Women and Nursing in the Civil War South*. Charlottesville, VA: University Press of Virginia, 2012. Hilde challenges the notion that southern women were less active and organized than their northern contemporaries by examining their role in establishing hospitals and providing medical care to wounded Confederate soldiers.

Elizabeth D. Leonard. *Yankee Women: Gender Battles in the Civil War*. New York: W.W. Norton & Co., 1994. Stories of three Union women—Sophronia Bucklin, Annie Wittenmyer, and Mary Edwards Walker—who pushed the boundaries of woman's role through their wartime activism.

Nina Silber. *Daughters of the Union: Northern Women Fight the Civil War*. Cambridge, MA: Harvard University Press, 2005. Provides a compelling argument that the Civil War was not a transforming moment for many Northern women, that it instead in many ways reaffirmed their subordination to men.

Lyde Cullen Sizer. *The Political Work of Northern Women Writers and the Civil War, 1850–1872*. Chapel Hill, NC: University of North Carolina Press, 2000. Focusing on the work and lives of nine writers, including Louisa May Alcott and Elizabeth Stuart Phelps, Sizer provides a rich context for examining their fictional works about the Civil War.

Wendy Hamand Venet. *Neither Ballots Nor Bullets: Women Abolitionists and the Civil War*. Charlottesville, VA: University Press of Virginia, 1991. About the women, such as Anna Dickinson, who worked for abolition during the civil war and organized to secure a political and constitutional end to slavery with major emphasis on the activities of the Woman's National Loyal League.

IN THE AGE OF SLAVE EMANCIPATION, 1865–1877

LEARNING OBJECTIVES

- How did Reconstruction policies affect black and white households in the South?
- What were the major issues facing the postbellum woman's rights movement?
- How did the debates about women's wage earning intersect with discussions of marriage?
- In what ways did the temperance campaign challenge male authority within the family?

Explore Chapter 10
Multimedia Resources

TIMELINE

1865	Freedmen's Bureau established
	Civil War ends
	President Abraham Lincoln assassinated
	Andrew Johnson begins presidential Reconstruction
	Black Codes introduced in southern states
	Thirteenth Amendment ratified
1866	Civil Rights Act of 1866 enacted by Congress
	Congress passes Fourteenth Amendment
	Kansas Campaign to secure universal equal rights in state constitution
	National Labor Union forms
	Ku Klux Klan forms
1868	*The Revolution*, published by Stanton and Anthony, debuts
	Fourteenth Amendment ratified
	Most Southern states readmitted to the Union
	Workingwomen's association form in New York and Boston
	Sorosis forms in New York City
	New England Women's Club forms in Boston
1869	Fifteenth Amendment passed by Congress
	Troy Collar Laundry Union strikes
	Daughters of St. Crispin organize
	National Woman Suffrage Association forms
	American Woman Suffrage Association forms
1870	*Woman's Journal* begins publication
	Victoria C. Woodhull announces her candidacy for president
	Fifteenth Amendment ratified
	Woodhull memorial presented to Congress
1871	Woodhull speaks before House Judiciary Committee
	Woodhull attempts to vote
	Mary Ann Shadd Cary attempts to register to vote

1872	**Woodhull exposes Beecher–Tilton affair**
	Woodhull arrested under Comstock Law
	Susan B. Anthony, Sojourner Truth, and Virginia Minor
	attempt to vote
	The NWSA abandons "new departure" strategy
1873	***Bradwell v. Illinois* turns down Bradwell's petition to practice law**
	Financial Panic begins long depression
	Fortnightly forms in Chicago
	Association for the Advancement of Women forms
	Woman's Crusade begins in Hillsboro, Ohio
1874	**Woman's Christian Temperance Union forms**
	U.S. Supreme Court, in *Minor v. Happersett*, rules that voting is
	not a right of citizenship
1876	**Chicago Woman's Club forms**
1877	**"Susan B. Anthony" amendment introduced in Congress**
	Federal troops pulled out of South; Reconstruction ends
1878	**Frances Willard elected president of WCTU**
	WCTU endorses woman suffrage for "home protection"

PLANS FOR **RECONSTRUCTION**—RECONSTRUCTING THE NATION—HAD BEGUN WELL BEFORE THE END OF THE CIVIL WAR, but the assassination of Abraham Lincoln on April 14, 1865, made these matters even more urgent. His successor, President Andrew Johnson, pardoned all white southerners except Confederate leaders and left the status of freedpeople under the jurisdiction of the former Rebel states. Southern legislatures took this opportunity to draft the highly discriminatory **Black Codes**, which granted some civil rights to African Americans, such as the right to own property and make contracts, but at the same time severely limited their freedom.

In December 1865, Congress reconvened and condemned the Black Codes and repudiated Johnson's plans. In 1866, Congress passed a civil rights act that for the first time clearly designated all persons born in the United States as citizens and denoted their rights without regard to race. To give Constitutional backing to these provisions, legislators proposed the **Fourteenth Amendment** and the **Fifteenth Amendment**, which prohibit racial distinctions in the law and introduce additional measures to guarantee African Americans the same civil and political rights enjoyed by whites.

These measures did more than redefine race relations in the United States. By specifying the rights and responsibilities of citizenship, legislation enacted in the decade after the Civil War had a profound impact on the laws governing marriage and the family, including the relationship between husband and wife and both to the state. The new legislation gave more power to the state to govern the affairs of the household, such as establishing the terms of marriage, the ownership of property, and custody over children.

MAP 10-1 Dates of Former Confederate States Readmitted to the Union[1]

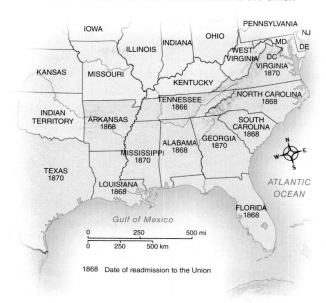

In 1867, Congress enacted the First Reconstruction Act, creating five military districts in the former Confederacy. To be readmitted to the Union, ex-Confederate states had to ratify the Fourteenth Amendment, which barred former Confederates the right to hold public office, and guarantee the right to vote to all men. Explore the Map **"Atlas Map: Reconstruction."**

📖 Read about **"The Revived Woman's Rights Movement"**

In the decade following the Civil War, then, the government cast new light on the status of women and the power of men within marriage and the family. For this reason, the revived woman's rights movement asked a new series of questions. As persons "born or naturalized in the United States" and defined as citizens, could women enjoy all the rights and privileges now ostensibly assured to freedmen? Did the Fourteenth and Fifteenth amendments, which guaranteed political rights to freedmen, advance or hinder women's own claim to the ballot? Could women who worked outside the home expect to receive the same guarantee to the fruits of their labor as men did? What were the limits of women's power within marriage and the family?

Review the sources; write short responses to the following questions.

Contracts Undertaken by Freedwomen (1866, 1867)[2]
Washerwomen of Jackson to Mayor Barrows (1866)[3]

1. Summarize the specifics of the contract between James Alvis and Dianna Freedwoman.
2. What arguments were used by the washerwomen to get a pay raise?

RECONSTRUCTING SOUTHERN HOUSEHOLDS

The Civil War had effected major changes in the dynamics of the households of both large plantations and small farms and for both blacks and whites. By necessity, many white women had taken on a greater number of responsibilities while their husbands were away fighting for the Confederacy and emerged from the war with a greater feeling of self-respect. After the war, while their husbands were trying to piece together the fragments of their former lives, many of these women continued to gain power within the sphere of domesticity. In contrast, many African American women sought to build a new life with men, impoverished but "free" and eager to occupy a new position of authority within their families.

The Meaning of Freedom

The majority of four million freed slaves welcomed the end of the war as an opportunity to realize their dream of freedom and, foremost, to come together with their families. "In their eyes," an agent of the Freedmen's Bureau[4] observed, "the work of emancipation was incomplete until the families which had been dispersed by slavery were reunited."

To find their husbands, many women turned first to the **Freedmen's Bureau**, which had been established by Congress in the last month of the war to provide relief to the refugees from slavery and to assist their transition to freedom. The agents encouraged former slaves to marry, believing that marriage ensured a degree of family stability and sexual self-discipline that slavery had denied. As a legal arrangement, state-sanctioned marriage forced freedmen and freedwomen to be accountable for the welfare of their children and, in effect, released former slave owners as well as the state from such obligations. This responsibility, the agents noted, was to be borne primarily by men, thereby encouraging manhood and preparing freedmen for the rights and privileges of citizenship.

Read about "Life after Emancipation"

Free women undoubtedly hoped to live out their lives—now as free persons—with little interference from whites. The goal for many was to reunite with husbands and to gather their children into stable families. The prospects for reaching this goal, however, depended not merely on the sentiments of their husbands or even their financial resources. Much rested on the policies implemented by the government to rebuild the nation, that is, the terms for readmitting the former Confederate states to the Union and the parameters of freedom on the recently emancipated slaves.

Review the sources; write short responses to the following questions.

We Are Your Sisters: Black Women in the Nineteenth Century.
A Woman's Life-Work: Labors and Experiences of Laura S. Haviland[5]

1. In what ways does Grey's desire to reunite with her husband and to establish a family reflect the promises offered by emancipation?
2. Why did freed slaves try so desperately to reunite as families?

But the new state laws enabling freedpeople to marry did not necessarily overcome old customs. A large number of men and women chose to make do with familiar arrangements. For example, older freedpeople usually accepted their slave marriages as adequate and simply ignored the new legislation. War widows, who risked losing their pensions upon remarrying, perpetuated informal practices and "took up" or "sweethearted" with men without the benefit of legal marriage. Other women found common-law marriage preferable to the more cumbersome state-sanctioned relationship.

The fluidity that characterized family life during slavery persisted into the new era. Households continued to incorporate kin, especially in the case of children orphaned by the war. Women in particular benefited from extended families because they could turn to kin for assistance if they chose to quit a relationship with an abusive or unsupportive spouse. Moreover, the community continued to sanction premarital or occasional extramarital sexual relationships, although men or women who were repeatedly unfaithful to their spouse risked censure by friends and neighbors.

Read "A Slave's Child Remembers Their Quest for Freedom"

Annie L. Burton[6] was born in Clayton, Alabama, around 1858 to a white planter and an enslaved mother who worked on a nearby plantation as a cook. When Annie was little more than a toddler, her mother suffered a whipping at the hands of her mistress and ran away. Annie and her two siblings stayed behind to live through the harsh years of the Civil War. At the end of the war, her mother, like so many former slaves, returned to reclaim their children and other kin. In 1909, she published *Memories of Childhood's Slavery Days*.

Review the source; write short responses to the following questions.

1. How does Annie Louise Burton describe the quality of her life after slavery?
2. How did emancipation affect the ability of her mother to keep her family together?

In short, the new legislation governing marriage granted African American husbands a source of power within the family that had long been denied to them under slavery. For her part, a wife could expect support and protection while she fulfilled her primary obligation to maintain the home and care for children and elders. She could in addition work outside the home, but the law required her to turn over all earnings to her husband and, in essence, subordinate her personal identity to his. In slavery, a woman and her children bore the surname of her master; in freedom, they carried the surname of her husband.

Despite these new restrictions, freedwomen married for love as well as for practical reasons. Able to earn only one-half to two-thirds of the wages paid to men, most women simply could not afford to live and provide for their children by themselves. Whether inside or outside the law, adult men and women tended to live as married couples. By 1870, for example, 80 percent of black households in the populous region of the Cotton Belt included both a husband and a wife, a proportion equal to that of the nearby white population.

Negotiating Free Labor

During the last year of the war, the Freedmen's Bureau began to distribute forty-acre plots of abandoned or confiscated property to former slaves, and in some regions, such as the South Carolina and Georgia low country, freedpeople farmed the land with the expectation that they would some day become its lawful owners. However, in May 1865, Lincoln's successor, President Andrew Johnson, restored the property rights of the original white owners, and within one year the planter class had recovered virtually all its land.

By 1868, most former slaves had returned to the countryside and were working as tenant farmers or sharecroppers. Conditions varied depending on the local geography and the choice of crops, but, as free laborers, former slaves contracted to work for white planters, sometimes for their former masters and often as entire families. A typical contract lasted for one year, and black families received one-third to one-half share of the harvest plus rations. At first, white planters had tried to organize former slaves to work in gangs on the big plantations and even to live in the old slave quarters, but freedpeople overwhelmingly resisted the centralized plantation system. Setting up their own households in small homes spread out on the plantation, they worked as much as possible without white supervision. Equally important, they now made a clear distinction between the work they did for their landlord and the work they did for their own household and aimed to achieve a suitable balance between them.

Married women often chose to leave fieldwork to men and to devote themselves as much as possible to their own households. They often found themselves with more chores because white planters no longer supplied food and clothing, as they did during the days of slavery. Freedpeople had to produce all such items themselves, purchase them from local merchants, or barter among friends.

Most African American women disliked working as live-in servants on plantations, a situation that was too reminiscent of slavery. But because their families needed cash, many former slave women did hire out as day-servants, cooks, or laundresses.

Read more about "Negotiating Free Labor"

Freedpeople, both men and women, took satisfaction in managing their own household economies. Although few prospered, their families grew stronger than slavery had ever allowed.

Review the sources; write short responses to the following questions.

A Sharecrop Contract [1882][7]

Legal Form for the Restoration of Confiscated Property Held by the Freedman's Bureau [1865]

1. What were the implications for a failed sharecropper, given the wording of this contract?
2. What was Jenkins required to do to fulfill the requirements of the legal form for the restoration of confiscated property?

White Women on the Old Plantation

Elite white women often continued to perform many of the domestic tasks that had been forced upon them during the war, and they were mostly unhappy about it. Still, some formerly wealthy mistresses surprised themselves. They expressed relief and even joy in the departure of their "servants" and embraced their new responsibilities. Rarely, however, did they relish the arduous work of laundry. Kate Foster complained that handling the washing by herself for six weeks nearly ruined her because she had been "too delicately raised for such hard work." In contrast, the younger women who had come of age during the wartime emergency were more likely to accept general housekeeping as woman's lot in life and ultimately came to regard domesticity as a measure of their womanhood. Cooking, cleaning, and generally caring for husband and children became the principal avocation of many postbellum elite women.

Some elite white women embraced domesticity with a fervor if only to help their husbands to cope with their public defeat and economic reversal. It was as if, one editorial writer suggested, "the mighty oak" had been "hit by lightning" and only the "clinging vine now kept it erect." The men of the former Confederacy, now stripped of the right to hold another human being in bondage, viewed the domestic sphere as the sole remaining source of their power to dominate. These husbands undoubtedly found some satisfaction knowing, as one newspaper writer put it, that "there is still a little world at home of which he is monarch." And their wives often went along. Indeed, willing subordination to the needs of her husband became the signature of the southern lady.

In contrast, poor white women found far fewer sources of pride or satisfaction in their postwar roles. Many had lost both their husbands and their land and found themselves trapped in a cycle of debt from which they would never escape. By 1880, one-third of all white southerners were sharecroppers or tenant farmers, and wives found themselves spending their days in the field rather than in the home, hoping to maintain their households amid the grinding poverty of the postwar South.

"Freedom Was Free-er" in Towns and Cities

With the countryside devastated, food and shelter were in short supply, and many freedpeople headed for nearby towns and cities. The towns, which housed the local offices of the Freedmen's Bureau, seemed to offer not only the prospect of relief but also employment. However, freedpeople rarely found either. "Sometimes I gits along tolerable," a widow in Atlanta reported, "sometimes right slim; but dat's de way wid everybody;—time is powerful hard right now."

Agents of the Freedmen's Bureau, overwhelmed by refugees, encouraged freedpeople to return to the countryside. Also, the Black Codes often included harsh vagrancy and curfew laws that virtually forced any African American without a labor contract or a place to live to leave the city or face arrest. Local authorities further discouraged former slaves from settling in their towns by imposing licensing fees and taxes on jobs available to freedpeople and directing landlords to rent only to whites. Formed in 1866, the Ku Klux Klan burned down the shantytowns that served as the first black

settlements and murdered their residents. Under such duress, freedpeople returned to the countryside in such numbers that by 1870 only one in ten southern African Americans lived in towns with populations greater than twenty-five hundred.

Yet, a sizable minority persevered. In the decade following the outbreak of the Civil War, southern towns and cities experienced a huge rise in the proportion of black residents, as much as 75 percent in some places. By 1870, Atlanta, Richmond, Norfolk, Montgomery, and Raleigh all had become home to nearly an equal number of blacks and whites.

Women played a disproportionate role in the upsurge of the black urban population. Widows and single women with children headed to towns and cities where they could earn wages as housekeepers or, in smaller numbers, as seamstresses, nurses, cooks, and laundry workers. Especially with the added benefit of a military pension, they could begin to imagine a new life for themselves. In several postbellum southern cities, women came to outnumber men by a ratio of ten to eight; in Atlanta and Wilmington, North Carolina, women outnumbered men by a ratio of four to three.

Although the absolute number of women living in southern towns and cities remained small compared to the countryside, this first sizable generation of urban dwellers set trends that would become apparent decades later in both the North and the South. For example, women headed more households in the city—according to some estimates, as much as twice as many as they did in the countryside. Opportunities for black male employment were so restricted that few men could earn enough to support a household. Thus, black families became increasingly reliant on the wages women brought in.

Towns and cities also offered opportunities for education. Believing that ignorance and bondage went hand in hand, freedwomen urgently desired education for both themselves and their children. With a 90 percent illiteracy rate in 1860, freedpeople pursued the basics of reading and writing, even if it meant taking evening classes after a long day at work.

The Freedmen's Bureau, in cooperation with the American Missionary Association, set up schools as quickly as possible. By 1869, nearly thirty-three hundred teachers had staffed nearly as many schools, and about half were African American, many of them volunteers from the North. A large number were northern white women, commonly known as "Yankee schoolmarms" for their strict disciplinary habits and, too often, their condescending attitude. Whenever possible, freedpeople preferred to support their own schools and hire teachers of their own race. Young women, scarcely out of their teens, sought these positions as soon as they learned how to read and write. To train these teachers, four universities were established: Howard University in Washington, D.C.; Hampton Institute in Hampton, Virginia; Morehouse College in Atlanta, Georgia; and Fisk University in Nashville, Tennessee.

The streets of the city also afforded young women, black and white, opportunities for new pastimes. Young white women indulged themselves in rounds of dances and seemingly endless flirtations with young men. White southerners commented profusely on freedwomen's fashion, in particular their preference for bright fabrics,

colored ribbons, and large earrings, as well as what they perceived as infringements on white women's own sense of style. Black women were "putting on airs," they complained. Moreover, such outrageous dress, in their perspective, was often accompanied by "impudent" behavior. One white woman described freedpeople as "very insolent in the streets," refusing to step aside for her or lowering their eyes when passing, and even daring to make such rude remarks as "'look at dat rebel.'"

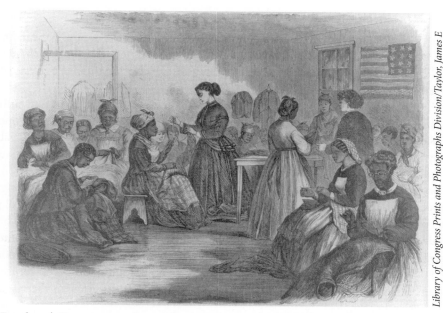

Library of Congress Prints and Photographs Division/Taylor, James E [LC-USZ62-37860].

The Freedmen's Bureau opened more than one thousand schools during the Reconstruction Era. This engraving, which appeared in Frank Leslie's *Illustrated Newspaper* in September 1866, shows a sewing class at the industrial school in Richmond, Virginia.

Although black women rarely rose out of poverty in towns or cities, they often found the pleasure of camaraderie and friendship with other African Americans. The majority of the eighty thousand black occupation troops were stationed in towns and cities, thus increasing a woman's chances of finding a mate. Also, the city became the site of a growing black community and its institutions. Schools, churches, benevolent societies, and political groups all sprang up and gave women as well as men additional purposes for congregating with other members of their race.

WOMAN'S RIGHTS REEMERGE

Antebellum woman's rights activists had viewed the right to vote as only one of many demands. Property rights; educational opportunities; equal wages for equal work; and changes in the laws governing marriage, divorce, and child custody had all figured

prominently in their agitation. The Civil War shattered this constellation and, at the same time, linked the prospects for a democratic nation to broader participation in the political process. "Now in the reconstruction is the opportunity, perhaps for the century," Elizabeth Cady Stanton[8] announced, "to base our government on the broad principle of equal rights to all." As national attention turned toward assuring freedmen of their rights as citizens, woman's rights activists began to assess their rights within the institutions of marriage and family and their rights as citizens of the United States.

"The Negro's Hour"

Woman's rights activists emerged from the Civil War ready for action. Now, with the war over and the Woman's National Loyal League disbanded, they hoped the nation would acknowledge women's wartime contribution by granting them the full rights of citizenship, foremost the right to vote.

Their longtime abolitionist allies disagreed. They targeted black manhood suffrage as a priority and, furthermore, warned that linking woman suffrage to their proposed legislation would doom the black man's chances. As early as December 1865, Elizabeth Cady Stanton commented with profound displeasure that many abolitionists were already designating this as "**the Negro's hour**."

Prospects for women's voting rights grew dimmer when in June 1866 Congress passed the Fourteenth Amendment, which conferred national citizenship on all persons born or naturalized in the United States and at the same time, in a section of the bill dealing with state representation, introduced the word *male* into the Constitution. Many woman's rights activists who in principle stood for universal suffrage endorsed the Fourteenth Amendment as a matter of expediency. Stanton, however, refused to compromise and taunted her opponents: "Do you believe the African race is composed entirely of males?"

Stanton distanced herself even farther from her longtime allies during the summer of 1866 when she and Susan B. Anthony intervened in a campaign against a state referendum in Kansas that would restrict the right to vote to white males. In touring the state, they shared the platform with George Francis Train, a virulent racist who implored Kansas voters to place the "Woman first, and the Negro last." They also accepted Train's financial backing to publish a new weekly magazine, *The Revolution*, which debuted in January 1868. After the Kansas campaign ended in defeat, and Stanton and Anthony paid dearly for their opportunism by losing many of their allies.

Finally, during the winter of 1869, the rift widened nearly to the breaking point. The Fifteenth Amendment to the Constitution, which aimed to guarantee the right to vote without regard to "race, color, or previous condition of servitude," contained, in Stanton's opinion, a glaring omission, the word *sex*. The passage of this amendment, she insisted, would ensure the establishment of an "aristocracy of sex on this continent." Anthony shared Stanton's opinion, pledging: "I will cut off this right arm of mine before I will work for or demand the ballot for the negro and not the woman." However, a sizable contingent of woman's rights activists, loyal to their abolitionist heritage, threw their support behind the Fifteenth Amendment.

OVERVIEW

Amendments to the Constitution and Federal Legislation during Reconstruction, 1865–1875

Thirteenth Amendment	*Passed by Congress January 1865; ratified December 1865* **Prohibited slavery in the United States**
Freedmen's Bureau Act	*Passed by Congress March 1865* **Established the Bureau of Refugees, Freedmen, and Abandoned Land within the Department of War to provide social services such as food, housing, education, and employment to former slaves making the transition to freedom. Disbanded in December 1868.**
Civil Rights Act of 1866	*Passed by Congress March 1866; presidential veto overrode April 1866* **In reaction to the Black Codes, the act defined rights of national citizenship for all persons born or naturalized in the United States and granted African American citizens equal rights to make contracts, own property, and marry.**
Fourteenth Amendment	*Passed by Congress June 1866; ratified July 1868* **Strengthened the Civil Rights Act by prohibiting states from violating the rights of their citizens** **Reduced state representation in Congress proportionally for any state disfranchising male citizens** **Denied former Confederates the right to hold state or national office** **Repudiated Confederate debt**
Fifteenth Amendment	*Passed by Congress February 1869; ratified March 1870* **Prohibited denial of suffrage because of race, color, or previous condition of servitude**
The Civil Rights Act of 1871	*Passed by Congress April 1871* **Known as the Ku Klux Klan Act, the act was enacted to enforce the Fourteenth Amendment, particularly to protect African American citizens from intimidation by illegal action, such as by the KKK, in cases where states could not, or would not, secure their safety or protect their rights.**
The Civil Rights Act of 1875	*Passed by Congress February 1875* **Entitled all the "full and equal enjoyment" of "public accommodations," such as hotels, restaurants, transportation, and amusements** **The act was generally unenforced and was declared unconstitutional by the Supreme Court in 1883.**

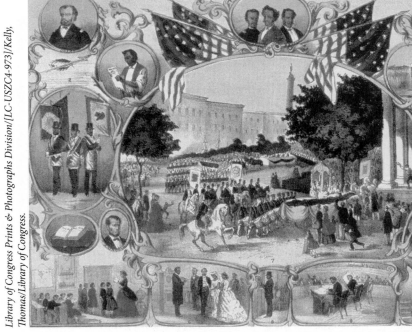

The center image of this lithograph depicts the grand parade held in Baltimore, Maryland, in 1870, to celebrate the passage of the amendment granting African American men the right to vote. The surrounding images depict prominent abolitionists, African Americans, and ordinary black citizens partaking in the economic and social life of the nation.

The esteemed black abolitionist and longtime supporter of woman's rights, Frederick Douglass, expressed his regret that women had not been included in the Fifteenth Amendment but offered an impassioned plea for "The Negro's hour": "When women, because they are women, are hunted down through the cities of New York and New Orleans; when they are dragged from their houses and hung upon lamp-posts; when their children are torn from their arms, and their brains dashed out upon the pavement; . . . then they will have an urgency to obtain the ballot equal to our own." Someone asked if what he said was not true for black women. "Yes, yes, yes," Douglass responded, "but not because she is a woman, but because she is black." By May 1869, the woman's rights movement had divided into two camps.

Organizing for Woman Suffrage

With the fault line clear, the two factions proceeded to organize into rival associations. The **National Woman Suffrage Association (NWSA)**, led by Stanton and Anthony and headquartered in New York City, introduced itself in 1869 by speaking out against the Fifteenth Amendment and, equally important, by pushing a sixteenth amendment that would guarantee women the right to vote. This

strategy—campaigning for a federal amendment—would remain its signature. The association also revived topics that had been the staples of the antebellum woman's rights conventions, most prominently marriage and divorce reform, education, and equal wages for work.

The **American Woman Suffrage Association (AWSA)**, which viewed NWSA as little more than a small clique, formed in Cleveland in November 1869. Its leaders, including Lucy Stone and Henry Blackwell, had laid the foundation a year earlier when they formed a regional network of woman suffrage societies, the New England Woman Suffrage Association. Headquartered in Boston, the AWSA pledged to work for the ratification of the Fifteenth Amendment. As Julia Ward Howe stated simply: "I am willing that the negro shall get [the ballot] before me."

On the question of strategy, the AWSA chose to work at the local level, primarily by initiating referenda to remove the word *male* from articles covering voting rights in state constitutions and also by supporting such "limited" voting rights as the right to participate in school board elections. The AWSA also published its own paper, the *Woman's Journal*, "Devoted to the Interests of Woman, to her Education, Industrial, Legal and Political Equality, and especially her right to Suffrage." With solid financial backing, the weekly paper championed the campaign for woman suffrage to its conclusion in 1920.

What was striking about the AWSA was its success in attracting recent converts to the suffrage cause, including men as well as women and a large number of Midwesterners. Like the NWSA, the AWSA rarely reached beyond the circles of the middle class, but it did manage to recruit a coterie of women who had achieved prominence during the Civil War. The list was impressive, headed by Julia Ward Howe, Louisa May Alcott, Mary Livermore, and other longtime abolitionists such as Abby Kelley Foster, Frances Dana Gage, and Lydia Maria Child. A larger number of prominent African American suffragists, such as Charlotte Forten and Frances Ellen Watkins Harper, chose to affiliate with the AWSA.

The Notorious Victoria C. Woodhull

On March 30, 1870, President Ulysses S. Grant announced the adoption of the Fifteenth Amendment and, unwittingly, opened yet another chapter in the woman suffrage saga. Acting alone, Victoria C. Woodhull decided to test the limits of the new amendments. In December, she presented a memorial to Congress in the form of an elegant argument that the Fourteenth and Fifteenth Amendments, by guaranteeing civil and political rights to all citizens, had in effect enfranchised women. The Reconstruction amendments, she concluded, had rendered "void and of no effect" all previously enacted state laws prohibiting woman suffrage. Woodhull advised Congress to devise the "necessary and proper" legislation so that all citizens "without regard to sex" could exercise their right to vote. A month later, she appeared before the House Judiciary Committee, the first woman to do so, and restated her argument at greater length.

Read about "Lecturing on Woman's Rights"

After the Civil War, Elizabeth Cady Stanton embarked on a grand lecture tour under the sponsorship of the Lyceum Bureau. She spoke on behalf of woman's rights, providing herself with a source of income and her audiences with a strong political message. She spoke frequently on woman suffrage and also managed, when she could, to engage women alone in conversations concerning family limitation and reproductive health. Mostly she advocated higher education for women.

Review the source; write short responses to the following questions.

1. Judging from Stanton's report, what was it like to campaign for woman suffrage in the era after the Civil War?
2. Why did people attend Stanton's lectures?

Woman suffrage leaders were both taken off guard by Woodhull's actions and very curious about this newcomer to the cause. Although born into humble circumstances, the thirty-three-year-old Woodhull and her younger sister Tennessee had managed to befriend the railway capitalist Cornelius Vanderbilt and, with his assistance, establish their own brokerage firm on Wall Street. The two sisters also found sufficient financial backing to put out a newspaper, *Woodhull & Claflin's Weekly*, which ranged widely and boldly across the spectrum of reform. Stanton and Anthony hoped to make the most of Woodhull's celebrity and invited her to speak at the NWSA's convention in May 1871.

Woodhull did indeed put woman suffrage in the spotlight. At the meeting, she went so far as to advise voteless women to break away from the Union and form their own government. "We mean treason! We mean secession, and on a thousand times greater scale than that of the South!" she warned. "We are plotting Revolution! We will overthrow this bogus republic and plant a government of righteousness in its stead."

But Woodhull gained even more attention as an unrelenting critic of the institution of marriage. She soon delivered a yet more infamous speech. Speaking in New York to a crowd of three thousand, she announced: "Yes, I am a Free Lover. I have an inalienable, constitutional and natural right to love whom I may, to love as long or as short a period as I can; to change that love every day if I please, and with that right neither you nor any law you can frame have any right to interfere." Rather than dissociating themselves from such flamboyant rhetoric and radical ideas, Stanton and Anthony saw in Woodhull an opportunity to broaden the discussion of woman's rights well beyond suffrage.

Woodhull, however, had not yet revealed all her cards. She decided to run for president of the United States, and in May 1872 she transformed *Woodhull & Claflin's Weekly* into a publicity sheet for her campaign. The mainstream news media began to caricature Woodhull and her sister as the "Famous Family of Free Lovers."

Woodhull retaliated by making an object lesson of Henry Ward Beecher, a pastor of a wealthy congregation, a presumed pillar of society, and a former AWSA

president. *Woodhull & Claflin's Weekly* reported that Beecher was involved in an illicit sexual relationship with one of his parishioners, Elizabeth Tilton, a married woman and mother of four, and went on to condemn the popular preacher not for his actions but for hypocritically shrouding his affair in secrecy. Woodhull and her sister were then arrested under the provisions of the newly enacted federal antiobscenity legislation, the **Comstock Act**, which carried the name of its proponent, Anthony Comstock. The two sisters spent four weeks in jail for using the U.S. Postal Service to send "obscene" literature.

Read about "Victoria Woodhull: Activist and Presidential Candidate"

Victoria Woodhull was a force of nature, her work as a newspaper editor and activist having an impact on the debate surrounding women's rights in the late 1800s.

Review the sources; write a short response to the following question.

The Memorial of Victoria C. Woodhull (1870)[9]
Victoria Woodhull, Nomination for President of the U.S. (1872)[10]

1. How did the woman's rights movement test the provisions of the Reconstruction Amendments with regard to woman's rights?

Woodhull's persistent attack on the institution of marriage reopened old wounds among suffragists. At the last convention before the Civil War, in 1860, the fledgling woman's rights movement nearly split apart when the discussions on marriage went, in the opinion of some, too far (see Chapter 8). The debate had become so heated that the participants agreed to hold to a "narrow platform" that excluded marriage as a subject for discussion, and the Civil War moratorium kept the opponents at bay.

Now, as questions of citizenship became more pressing, Woodhull took the lead in reviving the discussion of marriage as, in her words, an "*insidious* form of slavery." Stanton shocked many of her coworkers when she endorsed Woodhull's proposition, similarly describing marriage as an institution that designated "one to command and one to obey." She reaffirmed what she had the prescience to write to Anthony in 1853: "This whole question of woman's rights turns on the pivot of the marriage relation."

Woodhull, however, proved to be an unreliable ally. In the wake of the **Beecher–Tilton scandal**, her presidential candidacy collapsed. Several years later, she and her sister headed to England, where they both married into wealthy families.

Woodhull's attack on the institution of marriage widened the divide between the rival suffragists. By siding with the mercurial Woodhull, the NWSA suffered a loss of credibility, and a disheartened Stanton soon withdrew from the organization. In contrast, the AWSA remained relatively unscathed, instead gaining status as the premier suffrage organization.

The New Departure

Despite her misadventures, Victoria Woodhull did help to shape a strategy that she herself termed "a new direction" for the woman suffrage movement. She claimed that the Reconstruction amendments ensured the right to vote to *all* citizens. She now invited women to act on their citizenship and join her in testing the provisions in practice.

In November 1871, Woodhull headed a contingent of women who went to the polls to cast their ballots. They were unsuccessful, but they nevertheless encouraged other women to keep the pressure on. Sojourner Truth was also turned away from the polling booth in Battle Creek, Michigan. More celebrated was the case of Susan B. Anthony. Anthony had hoped that if she were denied the right to vote she would be in a position to carry a civil suit all the way to the Supreme Court. Instead, she was allowed to vote and then arrested and later convicted of violating a federal law. At her highly publicized trial, the presiding judge fined her one hundred dollars, refusing a jail sentence to prevent her from appealing his decision and bringing yet more attention to her cause.

Where Anthony failed, Virginia L. Minor succeeded. She, too, decided to test the provisions of the Fourteenth Amendment. When the St. Louis registrar, Reese Happersett, refused to let her register to vote, she and her husband Francis Minor—married women could not initiate legal action on their own—brought suit against him for abridging her rights as a citizen. In 1874 the U.S. Supreme Court unanimously ruled against her. In effect, the **Minor v. Happersett** decision established that citizenship and the right to vote were not synonymous and thereby put to rest all cases for woman suffrage made in the name of the Reconstruction amendments.

In the wake of these cases, the NWSA decided to campaign for a sixteenth amendment, the **"Susan B. Anthony" amendment**, which was introduced into Congress in January 1878. It read: "The right of citizens of the United States to vote shall not be denied or abridged by the United States or by any State on account of sex." The AWSA meanwhile supported the petition for the federal amendment and simultaneously restated its intention to appeal first to state legislatures to extend voting rights to women.

In the short run, neither the AWSA nor the NWSA made much headway. When the Sixteenth Amendment finally reached the Senate floor in 1886, only forty of seventy-six senators bothered to vote, and those who did vote it down, thirty-four to six. Before 1890, only eight states held referenda on woman suffrage, and all went down in defeat. The only victories suffragists could tally were in the nineteen states that granted women the right to vote in local school board elections and, in a few locations, municipal elections.

WOMAN'S RIGHT TO LABOR

In 1860, Caroline Healey Dall issued a critique of marriage from yet another direction. She called into question the concept of the **family wage**, the idea that designated the man as a family's sole breadwinner. Under the provocative title *Woman's Right to Labor*,

Dall published a series of lectures that amply demonstrated that more women—including married women—were supporting themselves than most people cared to admit. "The old idea, that all men support all women" was, she insisted, "an absurd fiction." Dall joined other woman's rights advocates to demand "equal wages for equal work" both for themselves as salaried professional workers and for those women who could find only menial jobs in the growing postwar marketplace.

> **Q** **View the Profile of Caroline Healey Dall (1822–1912)**
>
> Born to a prominent Boston family, author and activist Dall devoted much of her life to abolition, the woman's rights movement, and social reform both as an activist and writer.

Women's Clubs

In 1868, the first women's clubs formed in New York and Boston and soon served as beacons for similar clubs in large cities such as Chicago and most small towns. The New England Women's Club (NEWC), headquartered in Boston, and Sorosis of New York gathered seasoned activists and aspiring professional women and developed a philosophy and program for what would become, twenty years later, a mass movement.

Although the constitutions of the first two clubs specified companionship as their primary purpose, the founders all vowed to campaign for woman's right to labor. As the first president of Sorosis explained, the purpose of the club was "to open out new avenues of employment for women, to make them less dependent and less burdensome, to lift women out of unwomanly self-distrust, disqualifying diffidence, into womanly self-respect and self-knowledge." The right to vote was, for the majority, a secondary concern compared to equality in the marketplace.

A sizable portion of clubwomen were white and middle class, advanced in age, and married or widowed. They were also aspiring professionals. The founder of Sorosis, for example, was Jane Cunningham Croly, a pioneering journalist who wrote the first syndicated column by a woman under the name "Jennie June." The roster of Sorosis, which by its first year listed more than eighty names, included artists, writers, editors, teachers, lecturers, philanthropists, and physicians. Some of these women were working outside the home by necessity, others by choice. They met biweekly to discuss such questions as: "In which profession can a woman do the most good: that of the ministry, the law, pedagogy, or medicine?"

The Civil War had prepared many of these women for work outside the home. Such was the case with Julia Ward Howe, the NEWC president from 1871 until her death in 1910. Howe had served as a volunteer to the U.S. Sanitary Commission despite her husband's strenuous objections to her extradomestic activities. When Samuel Gridley Howe died in the mid-1870s, he bequeathed his sizable fortune to his daughters,

OVERVIEW

1868	New England Women's Club Sorosis	Organized to promote self-improvement and to reform philanthropic endeavors of women activists in the Boston area
	Women's Organizations Formed 1868–1876	Organized for women's self-improvement at the same time as the NEWC by mostly professional women in New York City
	Working Women's Association	Organized in New York City and aided by Elizabeth Cady Stanton and Susan B. Anthony to link labor and suffrage
1869	Troy Collar Laundry Union	Short-lived union of women laundresses led by Kate Mullaney in upstate New York
	National Woman Suffrage Association	Formed to promote woman suffrage and led by Elizabeth Cady Stanton and Susan B. Anthony, with headquarters in New York City
	American Woman Suffrage Association	Formed to promote woman suffrage and led by Julia Ward Howe, Lucy Stone, and Josephine Ruffin with headquarters in Boston
	Working Women's League	Organized in Boston with assistance of suffragists
	Daughters of St. Crispin	Organized as an international union of mainly women shoeworkers, centered in Massachusetts
1873	Association for the Advancement of Women	Organized by Sorosis members as a series of congresses to showcase women's achievements
	Chicago Fortnightly	Formed by a group of women for the purpose of "intellectual and social culture"
1874	National Woman's Christian Temperance Union	Growing out of the Woman's Crusade, founded in Cleveland to organize women's protest against the sale and consumption of alcohol
1876	Chicago Woman's Club	Organized to provide members with "mutual sympathy and counsel" and to assist them in the work of social reform

leaving his financially strapped widow with a compelling reason to work outside the home. With the encouragement of the NEWC members, Julia Ward Howe supported herself through her writing and public speaking while leading the postbellum suffrage and peace movements.

The NEWC also developed programs to help young women support themselves. Club members helped fund the Girls' Latin School, which prepared students for college, and a small horticultural school, which trained women for vocational work.

To promote the formation of women's clubs in other localities, Sorosis and the NEWC founded the **Association for the Advancement of Women (AAW)** in October 1873. The AAW held an annual congress in a different city each year with programs adapted from the format of women's club meetings. Leading lights of the movement presented papers on a vast array of topics, including woman's right to the ballot. These programs were so successful that occasionally local schools closed so that teachers and students could attend the sessions.

> **View the Profile of Myra Colby Bradwell (1831–1894)**
>
> Born in Vermont, lawyer and activist Bradwell had been refused a license to practice in Illinois in 1869 because she was married. She pressed her case for civil rights until 1892, when the Illinois Supreme Court finally granted her a license.

The membership of the AAW, never more than five hundred in its twenty-five-year history, constituted a national network of the most prominent and steadfast "lady agitators," as the mainstream press described them—or, according to its own assessment, "The First Who's Who of Women." Ambitious career women and reformers such as Mary Livermore, Catharine Beecher, Harriet Beecher Stowe, Elizabeth Cady Stanton, Emily Blackwell, Clara Barton, and Elizabeth Stuart Phelps all appeared on its platform. President Julia Ward Howe expressed their collective aspirations. "The cruel kindness of the old doctrine that women should be worked for, and should not work, that their influence should be felt, but not recognized, that they should hear and see but neither appear nor speak," she predicted, will soon be exposed as a sham and pummeled into retreat.

Associations for Working Women

In August 1866, representatives from labor unions from thirteen states created the first national labor federation in the United States, the National Labor Union (NLU). Although no women served as delegates, the new assembly pledged to support the "daughters of toil in this land." Woman's rights advocates took heart in this declaration and expected the NLU not only to recruit wage-earning women but also to endorse woman suffrage. As one suffragist explained, woman is the "NATURAL ALLY of the laborer, because she was the worst paid, and most degraded laborer of all." However, the majority of male trade unionists showed little enthusiasm for organizing

women wage earners and kept their distance from the controversial woman suffrage movement.

Undaunted, Stanton and Anthony invited a group of women typesetters to the office of *The Revolution* to organize a "Working Women's Suffrage Association." One of the typesetters complained that the word *suffrage* would couple the organization with the idea of women "with short hair and bloomers and other vagaries." Stanton and Anthony gave in, and the Working Women's Association formed in 1868 with the goal of improving opportunities for wage-earning women.

The alliance proved short-lived. A few months later, when an all-male typographical union called a strike in the New York printing industry, the Women's Typographical Union voted to honor it. In contrast, Anthony saw the strike as an opportunity for women to replace the male strikers and get hands-on experience in the trade. The male strikers condemned Anthony's maneuver, and the members of the Women's Typographical Union, refusing to become "scabs," pulled out of the Working Women's Association. In the aftermath of this debacle, Anthony retreated. "[T]he one and only question in our catechism," she concluded, "is, Do you believe women should vote?"

Clubwomen also reached out to wage-earning women. During their first year, both Sorosis and the NEWC set up committees to investigate working conditions in their respective cities. The NEWC's Committee on Work concluded their survey by calling for the creation of day nurseries for working mothers and temporary lodgings for women who came to the city to search for jobs.

Wage-earning women often accepted such support from middle-class allies but also, believing that class differences could not be easily overcome, guarded their independence. In April 1869, for example, at their founding meeting, Boston Working Women's League members extended a warm welcome to NEWC dignitaries. They cheered Julia Ward Howe's rejection of the home as woman's "only true sphere," affirming that at least half of all women have no homes. Nevertheless, the short-lived Working Women's League did not seek formal ties with the NEWC and restricted membership to "any working-woman of Boston, dependent upon the daily labor of her own hands for her daily bread."

Trade Unions

For a few years after the Civil War, prospects for organizing women into bona fide trade unions appeared to brighten following the appointment of Kate Mullaney as assistant secretary of the new **National Labor Union**.

View the Profile of <u>Jennie Collins (1828–1887)</u>

Born into humble conditions in Amoskeag, New Hampshire, Jennie Collins spent a lifetime exploring the many dimensions of women's work and, in her later years, trying to forge an alliance between middle-class activists and hard-pressed wage earners.

Mullaney, who had been the chief breadwinner in her immigrant family since her teens, led a strike in May 1869 of the mainly Irish workers who washed, starched, and ironed the detachable collars for the men's shirts manufactured in the "Collar City" of Troy, New York. The local male unionists supported the striking women, but the business community set out to crush the union. Mullaney responded by enlarging her base of support, raising funds and staging mass rallies. She traveled to New York City and appealed to the Working Women's Association to support sister workers in Troy. When she netted a meager thirty dollars, Mullaney concluded that the organization sponsored by Stanton and Anthony was not a "real" association of working women. After the strike petered out, she switched tactics and invited the striking workers to join her in establishing a laundry workers' cooperative.

Women shoeworkers embarked on a similar uphill struggle. In Lynn, Massachusetts, the Knights of St. Crispin, the nation's largest trade union, organized an all-women's branch, and by 1869, sister locals of the **Daughters of St. Crispin** had formed in ten other cities. Although the shoe-producing state of Massachusetts enjoyed the largest membership, nine states in the East, Midwest, and West, including California, and Canada helped to make the Daughters of St. Crispin the first international trade union of women. The union resolved to demand equal pay for equal work and warned the factory owners that "American Ladies Will Not Be Slaves."

By 1872, all the women's unions and workingwomen's associations had vanished. Employers had successfully destroyed the unions by hiring scabs and by blacklisting strikers. Meanwhile, the NLU leaders tightened their ranks against women. Prospects dimmed even further in 1873 when the nation's economy collapsed, and a major depression followed. "There never was a period at which working women were in more need of help than now," the *New York Times* reported, but little help was forthcoming.

THE WOMAN'S CRUSADE

The Panic of 1873, as it was called, forced many workingwomen into destitution and took an especially heavy toll on women whose livelihoods depended on men who, even in the best of times, squandered their wages on liquor. What could the drunkard's wife do to protect her family? Answering this question, women by the thousands began to crusade against the demon rum. Unlike the antebellum agitation, the temperance movement that formed in the mid-1870s was led by women who, in addition to advocating prohibition, challenged their subordination within marriage and, ultimately, within the broader society.

In the name of temperance, women became involved in direct action as well as political lobbying and soon formed permanent organizations with an all-female leadership and rank and file. "The seal of silence is moved from Woman's Lips by this crusade," one activist attested, "and can never be replaced."

"Baptism of Power and Liberty"

During the hard winter of 1873 and 1874, groups of Protestant women took to the streets and barged into saloons where they implored men to give up drink and sign a pledge of abstinence. They sang hymns as they marched through their towns and staged all-night prayer vigils, kneeling on the sawdust floors or, if denied entrance, on the snow-covered ground outside the taverns. They were soon holding mass meetings, organizing societies, and vowing to carry out this agitation until they closed every tavern in the nation. With the press covering the events in extravagant detail, the agitation that first concentrated in Ohio spread like wildfire throughout the Midwest and into cities and towns in New England.

Hillsboro, Ohio, became known as the birthplace of the **woman's crusade**. It was there that the popular reformer, Dio Lewis, delivered a lecture at Music Hall on December 23, 1873. He repeated a story that he had told many, many times, how his own mother, who was distraught about her husband's habitual drinking, invited several of her friends to pray in the saloon until they succeeded in closing down the business. This time, according to local lore, women in Ohio outdid Lewis's mother. They issued a call to women in other communities, and within fifty days, the newly formed temperance leagues had driven the liquor traffic—"horse, foot, and dragoons"—out of 250 communities. Six months later, the crusade took credit for closing more than three thousand saloons. The following summer, several crusaders, working mainly through their church networks, put out a call for a national convention in Cleveland.

In November 1874, approximately two hundred women representing seventeen states gathered to form the **Woman's Christian Temperance Union (WCTU)**. The first president was Annie Wittenmyer, who had headed up soldiers' relief work in Iowa during the Civil War and served as editor of the *Christian Woman*, an enormously popular magazine. While the initial movers in Ohio and the regional leaders were the wives of mainly professional men, the women who came to fill the ranks in the nation's heartland described themselves proudly as "farmers' wives."

The WCTU made temperance the premier issue of the late 1870s. The new organization also capitalized on a shift in strategy from moral suasion to direct political action. Activists continued to implore their menfolk to abstain from drink, but they also made targets of the brewers and distillers of beer and liquor and especially to the distributors who encouraged men to drink.

Equally important, the WCTU promoted the crusade as a means to empower women. As Mary Livermore later reflected, the value of the woman's crusade could not be measured merely by its accomplishments in the realm of temperance alone. Rather, "that phenomenal and exceptional uprising of women . . . lifted them out of a subject condition where they had suffered immitigable woe . . . to a plateau where they saw that it had ceased to be a virtue!"

Frances E. Willard and Home Protection

Under the brilliant leadership of Frances E. Willard, the WCTU developed into the largest, most powerful organization of American women in the nineteenth century. Born in 1839, considerably younger than the luminaries of either the NWSA or the

AWSA, Willard had grown up on a Wisconsin farm and, with great determination, had become the first dean of women and professor at Northwestern University in 1873. A year later, she decided to dedicate herself wholly to the WCTU. As president of the Chicago WCTU, Willard pushed for the "temperance ballot" and then carried her message far and wide as corresponding secretary of the national organization.

In 1879, Willard began in earnest to exploit the principle upon which the WCTU was founded, that "much of the evil by which this country is cursed" is the fault of "the men in power whose duty is to make and administer the laws." Having succeeded Wittenmyer as president, she became within a few years the most prominent woman in the United States. During her own lifetime, she was esteemed as the "Woman of the Century," canonized "Saint Frances" by her admirers, and known as just "Frank" to her friends. Possessing nothing less than an uncanny talent for leadership, Willard soon transformed the WCTU from a holy crusade against drink to a mass movement with wide-ranging goals.

Almost immediately, Willard pled with WCTU members to consider the ballot as a means to advance their cause. As a member of the Illinois Woman Suffrage Association, she argued simply that women as citizens deserved the right to vote; as a temperance organizer, she promoted woman suffrage on the grounds that women needed to participate in elections and legislative initiatives that concerned the sale of liquor in their communities. Although several founding members discouraged her, Willard introduced a suffrage resolution at the 1876 national WCTU and won the day.

Under the banner of "Home Protection," WCTU members followed Willard's lead and demanded the right to vote on referenda related directly to the liquor traffic, such as licensing and prohibition. Soon, they began to enlarge their agenda and openly to denounce men's disproportionate power in both family and civil society. Not only did women lack the right to vote in most states, they could not control their own property or wages or claim custody of their children in case of divorce. For the most part,

Read about **"Home Protection"**

Frances Willard paved the way to equal rights under the banner of "**home protection**."[11] The phrase at once challenged male authority and granted women all the conventional rights and responsibilities invested in woman's sphere. Drinking was, her followers already knew, mainly a male prerogative that endangered the home: the drunkard harmed his family by throwing away his money on liquor and, moreover, often by abusing his wife and his children. Armed with the ballot, Willard explained, women could protect themselves and their families against the violence perpetrated by drunken men.

Review the source; write a short response to the following questions.

1. Why did WCTU use the petition to make their case for temperance reform?
2. How does Willard's argument before the Illinois state senate raise the question of women's voting rights?

women and children lacked legal protection. Rape was rarely prosecuted, and the "age of consent" in some states was as low as seven years of age.

The WCTU, in effect, exposed what Willard and other woman's rights advocates knew to be a sham, the presumption of male protection. The ballot, Willard's followers claimed, would serve to counter women's defenselessness against men's abuse of the power.

Willard made the Illinois WCTU a major force for woman suffrage, followed closely by state unions in Iowa, Indiana, Nebraska, North and South Dakota, and Colorado. Women in the western states and territories seemed especially eager to abide Willard's advice. Just three years into her presidency, Willard had secured the national WCTU's endorsement of equal voting rights for men and women. "We must first show power," Willard insisted, "for power is always respected whether it comes in the form of a cyclone or a dewdrop." Over the next two decades, the WCTU would continue to pick up speed and storm the nation.

CONCLUSION

The era between 1865 and 1877, when federal troops withdrew from the South and Reconstruction formally ended, defined the civil rights of African Americans, although not with absolute clarity or with the genuine force of law. Nevertheless, for the first time, former slaves gained the right to own their own person, including the right to sell their labor on the free market and to marry and establish a household. The Reconstruction amendments to the Constitution, along with other legislation, marked out the meaning of freedom and the privileges of citizenship.

At the same time, Reconstruction also provided a new context for the struggle for woman's rights. The woman's rights movement, which had suspended its activities during the Civil War, revived in its aftermath and immediately began to demand the rights and privileges of citizenship as guaranteed to former male slaves. Women demanded the right to sell their labor and own property on the same terms as men; to preserve their autonomy as individuals even when married; and to participate in the affairs of government on the same basis as men. Woman's rights activists such as Victoria Woodhull thus protested the laws governing the marriage relationship and at the same time tested the provisions of the Reconstruction amendments by insisting on the right to vote. Other activists demanded "equal wages for equal work" and promoted programs to assist women who aspired to support themselves by their own labors. They disputed the principle of the "family wage" and demanded the right to negotiate labor contracts in their own names. They also organized to protect their families from men's abuse of their privileges, particularly in the realm of alcohol consumption.

Victories were few. By the mid-1870s, the Supreme Court had ruled in *Minor v. Happersett* that voting is a privilege and not a right of citizenship, and that woman's "natural" sphere was the home. Despite these setbacks, groups of women had formed scores of organizations to struggle for their rights as citizens. They had created a nascent woman suffrage movement, numerous clubs and associations to advance women's interest in the labor market, and a network of organizations—the powerful WCTU—that would increase women's power within the home and over the family.

 Study the Key Terms for In the Age of Slave Emancipation, 1865–1877

Critical Thinking Questions

1. How did the politics of Reconstruction affect the dynamics within African American households in the South? What kinds of work did black women perform during this era?

2. Why did the woman's rights movement focus on the ballot in the years following the Civil War? How did the Fourteenth and Fifteenth amendments affect women's strategy for gaining women's political rights?

3. What kinds of organizations did women create to ease their entry into wage labor? How did marriage affect women's right to earn a livelihood?

4. Why did the temperance movement revive in 1873 and 1874? What role did Frances Willard play within the revived movement? How did temperance agitation challenge men's authority within the household?

Text Credits

1. Copyrighted by Pearson Education, Upper Saddle River, NJ.

2. Contracts Undertaken by Freedwomen (1866, 1867) from Dorothy Sterling, ed., *We Are Your Sisters: Black Women in the Nineteenth Century* (New York: W.W. Norton, 1984), pp. 326–328.

3. The Daily Clarion (Jackson, Mississippi). June 20, 1866, from Dorothy Sterling, ed., *We Are Your Sisters: Black Women in the 19th Century* (New York: W.W. Norton, 1984).

4. Dorothy Sterling, ed., Bureau of Refugees, Freedmen and Abandoned Lands, Record Group 105 from Richmond, Virginia, National Archives, in *We Are Your Sisters: Black Women in the Nineteenth Century* (New York: W.W. Norton, 1984), p. 316.

5. Laura S. Haviland, *A Woman's Life-Work: Labors and Experiences of Laura S. Haviland* (Cincinnati: Walden and Stowe, 1882).

6. Annie Louise Burton, *Memories of Childhood's Slavery Days* (Boston: Ross Publishing 1909), pp. 11–14.

7. A Sharecrop Contract (1882); Legal Form for the Restoration of Confiscated Property Held by the Freedman's Bureau (1865).

8. Elizabeth Cady Stanton, *As Revealed in Her Letters, Diary, and Reminiscences,* Vol. I, Theodore Stanton and Harriot Stanton Blatch, eds. (New York: Harper & Brothers, 1922), pp. 218–236.

9. The Memorial of Victoria C. Woodhull (1870) from Susan Rimby, *Primary Source Documents to Accompany Women and the Making of America* (Upper Saddle River, NJ: Pearson, 2009), pp. 166–167.

10. Barbara Goldsmith, Other Powers: The Age of Suffrage, Spiritualism and the Scandalous Victoria Woodhull, *Woodhull and Claflin's Weekly* (June 29, 1871): pp. 212–213.

11. The Home Protection Ballot and the Hinds Bill of 1879 from www.franceswillardhouse.org.

Recommended Reading

Karen J. Blair. *The Clubwoman as Feminist: True Womanhood Redefined, 1868–1914.* New York: Holmes & Meier, 1980. A comprehensive overview of the history of the woman club movement with detailed coverage of the founding of Sorosis and the New England Women's Club as well as the Association for the Advancement of Women.

Jack Blocker, Jr. *"Give to the Winds Thy Fears": The Women's Temperance Crusade, 1873–1874.* Westport, CT: Greenwood Pub, 1985. Analyzes the woman's crusade as a function of the suffering women experienced as a consequence of the excessive drinking of their male relatives.

Ruth Bordin. *Woman and Temperance: The Quest for Power and Liberty, 1873–1900.* Philadelphia: Temple University Press, 1981, 1990. Offers insightful chapters on the founding of the Woman's Christian Temperance Union in the 1870s and the role of Frances Willard in broadening its agenda beyond the prohibition of alcohol.

Jane Turner Censer. *The Reconstruction of White Southern Womanhood 1865–1895.* Baton Rouge, LA: Louisiana State University Press, 2003. Focuses on elite white women utilizing evidence from the postwar historians of women in Virginia and North Carolina. Censer argues that the end of slavery allowed Southern women's lives to resemble more closely those of their northern counterparts.

Nancy F. Cott. *Public Vows: A History of Marriage and the Nation.* Cambridge, MA: Harvard University Press, 2000. Includes a chapter delineating the changes affecting marriage during the Civil War and Reconstruction especially with regard to freedpeople.

Faye E. Dudden. *Fighting Chance: The Struggle over Woman Suffrage and Black Suffrage in Reconstruction America.* New York: Oxford University Press, 2011. Examines a crucial period marking the split between abolitionists and woman's rights advocates over the Reconstruction Amendments and race.

Laura P. Edwards. *Gendered Strife and Confusion: The Political Culture of Reconstruction.* Urbana and Chicago: University of Illinois Press, 1997. Makes a forceful argument for the importance marriage and particularly the household as key to the meaning of emancipation.

Suzanne M. Marilley. *Woman Suffrage and the Origins of Liberal Feminism in the United States, 1820–1920.* Cambridge, MA: Harvard University Press, 1996. Examines various expressions of the demand for equal rights for women, including the right of women to defend themselves and their children from injury caused by drunken men.

Amy Dru Stanley. *From Bondage to Contract: Wage Labor, Marriage, and the Market in the Age of Slave Emancipation.* New York: Cambridge University Press, 1998. Offers a brilliant interpretation of contract law as the link between the abolition of slavery and a married woman's right to labor.

Leslie A. Schwalm. *A Hard Fight for We: Women's Transition from Slavery to Freedom in South Carolina.* Urbana, IL: University of Illinois Press, 1997. A close study of African American women on South Carolinian rice plantations and their efforts to define the meaning of freedom in the aftermath of the Civil War.

THE TRANS-MISSISSIPPI WEST, 1860–1900

TIMELINE

1840	Mormons settle in Great Salt Lake Basin, Utah
1848	California gold rush begins United States–Mexican War ends
1860s	Texas cattle drives begin
1862	Homestead Act passes in Congress Morrill Anti-Bigamy Act passes Congress
1867	Patrons of Husbandry (the Grange) organizes
1869	Transcontinental railroad completed
1870	Women in Utah gain the right to vote
1873	Woman's Crusade begins
1875	Page Law restricts Chinese women's immigration
1877	Defeat of the Nez Perce
1879	Women's National Indian Association forms
1881	Helen Hunt Jackson publishes A *Century of Dishonor*
1882	Edmunds Act passes Congress
1885	Annie Oakley joins "Buffalo Bill's Wild West" company
1890	Wounded Knee Massacre

THE DISCOVERY OF GOLD IN CALIFORNIA IN 1848 SPARKED A MOVEMENT OF THOUSANDS OF PEOPLE FROM ALL PARTS OF THE WORLD, making the West the most ethnically diverse region of the United States. Moreover, new communities formed at such an unprecedented rate that by the end of the century nearly one-quarter of the U.S. population lived west of the Mississippi River. The new settlers

carved a niche for themselves in the expanding western industries—mining, cattle ranching, and agriculture—and helped to make the western states and territories a crucial element in the growing national economy by furnishing both capital and raw materials.

After the completion of the transcontinental railroad in 1869, the trip westward became easier than earlier settlers had endured. Nevertheless, the challenge of making a home in unfamiliar, often harsh surroundings persisted. Some women never adjusted. Other Euro-American women demonstrated courage and resourcefulness and adapted to the new setting. Whether they found themselves living in the primitive dwellings of an army camp, the complex households of a ranching community, or the hurriedly constructed houses that dotted the plains and prairie, most of these women tried to create and maintain their homes in the wilderness. The doctrine of separate spheres became a prime marker of not only a stable community but "civilization," as measured by their own precepts (see Chapter 5). However, their domestic ideals often conflicted with those of other women who were struggling to hold on to their own households amid the aggressive westward expansion of the United States.

Contrary to the image of the West popular among some easterners, the trans-Mississippi West was not an unsettled wilderness. The newcomers interrupted and often displaced established communities and helped to destroy centuries-old ways of life. They sparked warfare, brought poverty and disease, and altered the natural environment at the same time that they helped to make the United States the leading industrial nation in the world.

Read about **"Calvary Life"**

Many Euro-American women left their childhood homes to journey to the western states and territories in the decades after the Civil War. Just a few months after marrying in October 1867, Frances Mullen Boyd[1] joined her husband, a recent graduate of West Point, at Camp Halleck, Nevada, where they set up housekeeping. For nearly two decades, she accompanied her officer-husband to outposts in Nevada, Arizona, New Mexico, and Texas.

Review the source; write a short response to the following question.

1. Summarize the conditions in which Mrs. Boyd lived in the tent community of the American West of the 1800s.

ON THE RANGE AND IN MINING COMMUNITIES

The industries that flourished in the trans-Mississippi West—cattle driving, mining, freighting, and lumbering—attracted a disproportionate number of men and encouraged the growth of towns and cities that appeared virtually overnight to cater to their needs and interests. Dodge City, Kansas, and Butte, Montana, for example, were

wide-open towns where gambling, drinking, and prostitution prospered and where "respectable" women were in short supply. The few women who settled in the region often found fault with its "masculine" character. "The more I see of men," one complainer wrote, "the more I am disgusted with them . . . this is the Paradise of men— I wonder if a Paradise for poor *Women*, will ever be discovered—I wish they would get up an exploring expedition, to seek for one." However, some women relished the opportunity to take on the challenge of a rough and often rowdy environment. Through a combination of luck and hard work, they achieved a degree of financial independence and status rare among their contemporaries back East.

Home on the Range

The two decades after the Civil War witnessed the creation of a spectacular cattle market that produced not only a steady supply of beef for eastern consumers but the legendary Wild West. The muscular cowboy dressed in leather chaps and a broad-brimmed Stetson hat, with a pair of silver-handled pistols strapped to his narrow hips, played the starring role. A few women tapped into this imagery: Annie Oakley was the most famous. Born in 1860 in a log cabin on the Ohio frontier, Oakley was such a skilled sharpshooter by age nine that she was supporting her entire family. In 1885, she joined "Buffalo Bill's Wild West" touring company, and, billed as "Little Sure Shot," she soon became the main attraction. Oakley, like Buffalo Bill himself and his troop of fancy-dressed cowboys, had little to do with cowpunching. They found their niche as well-paid entertainers.

The popular image of cowboys and cowgirls obscured the reality of an exhausting and tedious job that only men performed. Driving a herd several hundred miles from Texas to the stockyards of Wichita or Abilene, Kansas, took a toll on even the strongest young men who made up the workforce. Most cowboys hung up their spurs after only one run. Except for the prostitutes who worked in trailside "hoghouses," very few women made the long drive. Sally Redus once accompanied her cattleman husband, riding side saddle and carrying her baby on her lap all the way from Texas to Kansas. In 1871, Mrs. A. Burks made the journey in a little buggy while her husband led a group of Mexican vaqueros. Despite the dangers of stampedes and confrontations with rustlers, she relished both the excitement and her special status as the only woman in camp. "The men rivaled each other in attentiveness to me," she reported, "always on the lookout for something to please me, a surprise of some delicacy of the wild fruit, or prairie chicken, or antelope tongue." Wives of prosperous ranchers, Redus and Burks were in no danger of becoming one of "the fellers."

Back on the ranch, a familiar division of labor prevailed, although most wives crossed over to do men's work when necessary. "The heavy work of the ranch naturally falls to men," a Wyoming woman explained in 1899, "but I think most ranch women will bear me out in saying that unless the women . . . be always ready to do anything that comes along, . . . the ranch is not a success." Not infrequently, husband and wife worked as a team. After her husband died, Elizabeth Collins turned their

ranch into such a prosperous business that she became known as the "Cattle Queen of Montana."

For the majority of ranch wives, the daily routine was far more conventional and often very demanding. Women handled the "inside work," that is, the usual domestic chores of housekeeping and tending children. However, if their ranch was large, so too was their household, encompassing perhaps dozens of servants, hired hands and their wives, and perhaps a tutor or schoolteacher for the children, as well as a stream of visitors.

Read **"A Lady's Life in the Rocky Mountains"**[2]

Isabella Lucy Bird was one of the most famous tourists of the nineteenth century. A sickly youth, she sought "a change of air" and traveled to far distant parts from her home in England. In 1873, after venturing to Canada, Australia, and Hawai'i, she made her way to Colorado, where she traversed the Rocky Mountains on horseback. She coped with many physical hardships, including bouts of frostbite, cholera, and broken bones. In this document, a letter to her sister in Scotland, dated October 2, 1873, Bird described daily life as she experienced it.

Review the source; write short responses to the following questions.

1. How did Bird describe the division of labor by gender? How did the rough conditions of daily life disrupt preferred practices?
2. How did she describe her responsibilities in the household?

Not all women, especially those who were recent migrants to the West, possessed the emotional or physical stamina for this work. Angie Mitchell, who lived on a ranch near Prescott, Arizona, kept a pistol on the trunk near her bed in response to the regular nocturnal invasion of skunks. More frightening, however, were the bands of stampeding cattle that threatened her insubstantial homestead. "We took a firm hold of our sheets flapped them up & down & ran forward yelling as loud as we could," she reported, while her friends beat a tin pan with a stick and waved their aprons. The cattle, which had been startled by coyotes, swerved just past their flimsy shack before crossing the creek to safety. Two nights later, the cattle panicked again, this time in response to the screaming of mountain lions. Once again, the women rallied and diverted the stampede. "A few more nights of this sort of business," Mitchell concluded, "& we'll all be crazy."

Their daughters, however, often thrived in the wide-open spaces. Rejecting sunbonnets and petticoats for wide-brimmed hats and split skirts, they worked alongside their fathers and brothers, riding horses "clothespin style," roping calves and branding cattle, and shooting guns. One young woman reported that her grandmother, after visiting their ranch near Laramie, Wyoming, complained that her father was "making a boy out of me." However, such fears did not hold back the many young women who relished "outside work."

The Sporting Life

As many as fifty thousand women in the trans-Mississippi West sold companionship as well as sex in burgeoning cities like San Francisco and Denver and in the many small, makeshift towns and mining camps. Although few conformed to the myth of the racy madam who made a fortune or the dance-hall girl with a heart of gold, prostitutes did play important parts in shaping the culture and institutions of western cities. A vivid example of the division of labor by gender, their trade nevertheless undermined some of the treasured tenets of the doctrine of separate spheres by making certain behaviors usually associated with marriage major items of commerce.

With men far outnumbering women in mining camps, on the range, at military forts, and in the towns that sprang up along the freight routes, prostitution supplied women with the largest source of employment outside the home. Prostitutes traveled first from Mexico, Brazil, and Peru and later from other regions of the United States and from Europe, Australia, and China. As the lyrics of a mining song from Butte, Montana, where the first hurdy-gurdy house opened in 1878, attested: "First came the miners to work in the mine./ Then came the ladies to live on the line."

Read about "The Plight of Chinese Women in Mining Towns"

Chinese prostitutes,[3] often kidnapped as girls or sold by their impoverished fathers to procurers, served the nearly thirty-five thousand Chinese men who had immigrated to the American West in search of the "Gold Mountain." Called "Chiney ladies" or "she-heathens" by their white patrons and "wives to a hundred men" by their Chinese patrons, these women worked in big cities like San Francisco and in the remote mining towns as well. The Page Law of 1875, implemented by the federal government in response to rising anti-Chinese prejudice, targeted prostitutes and effectively halted the immigration of all Chinese women. Nevertheless, as late as 1880, nearly half of the prostitutes in the mining town of Helena, Montana, were Chinese.

Review the source; write short responses to the following questions.

1. What were the terms of the contract that Xin Jin was subjected to for food and passage to San Francisco?
2. What happened if the young woman became sick or pregnant?

In general, prostitutes represented a stratified, ethnically diverse, and youthful population. The most impoverished Indian women turned to prostitution after mining operations encroached on their settlements and drove them to the brink of starvation. However, the majority of prostitutes were native-born white women. Prostitutes ranged in status from the lowest, the women who plied their trade on the street, to the higher-class ladies who worked in brothels. Yet, the majority of prostitutes remained

flexible, picking up paying customers wherever they could. Having grown up in poverty, many accepted hard work, even servitude, as their fate.

Although prostitutes routinely practiced some form of birth control, such as the use of pessaries and douches, and frequently terminated pregnancies by abortion, many gave birth. However, motherhood was rare. Local authorities would not allow children to live in the red-light districts, even if it meant sending them to the county poor farm.

A few "soiled doves" managed to become rich as well as notorious by running profitable bordellos. A successful Denver madam explained, "I went into the sporting life for business reasons and for no other. It was a way for a woman in those days to make money and I made it." In addition, the "summer women," the prostitutes who moved into the mining camps or cattle towns during the busy season, could earn wages in just a few months that far exceeded the annual income of local retail clerks or domestic servants.

Although highly publicized, such success stories were rare and became increasingly so by the turn of the century. By that time, town officials had responded to the demands of the "respectable" citizenry and forced many prostitutes out of business. The majority of prostitutes responded to diminishing opportunities and increasing threats of arrest by quitting. Those who chose to persevere often turned for protection to men who, for a large cut of their earnings, acted as pimps and solicitors. Addicted to drugs

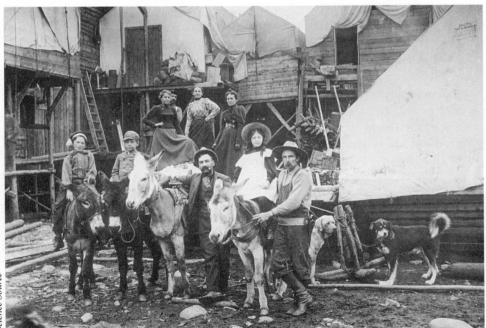

Science Source

The discovery of gold in 1897 in the Yukon region of Canada prompted as many as one hundred thousand fortune-seekers to head for the region. One in ten participants in the Klondike Gold Rush, as this movement was called, was a woman. As one adventurer reported: "when our fathers, husbands and brothers decided to go, so did we, and our wills are strong and courage unfailing. We will not be drawbacks nor hindrances, and they won't have to return on our account."

or alcohol, often infected with syphilis or tuberculosis, many had little choice but to live out their lives in the trade. Prostitutes commonly lived in destitution and faced an early, sometimes violent death. Suicide rates were especially high.

MORMON SETTLEMENTS

In the 1840s, Joseph Smith, the founder of the Church of Jesus Christ of Latter-day Saints, claimed an angel had told him that it is "the will of Heaven that a man have more than one wife." After newspapers exposed and ridiculed this revelation, Mormons became the targets of persecution and violent physical attacks. Forced to abandon their prosperous settlement in Nauvoo, Illinois, a group led by Brigham Young migrated to the Great Salt Lake Basin in 1846. In the Utah wilderness, they rebuilt their exclusive community. By 1870, Mormon missionaries had recruited settlers from the East and from as far away as Scandinavia, and their population exceeded eighty-seven thousand. And unlike other western territories, Utah could boast a sex ratio that was nearly equal.

Plural marriage quickly became one of the defining characteristics of the Mormon community. Brigham Young, the first territorial governor and president of the Church of Jesus Christ of Latter-day Saints, wedded twenty-seven women and fathered fifty-six children. However, even at its peak, polygamy was practiced by no more than 15 percent of Mormon families, and the majority of male practitioners took only two wives. Nevertheless, plural marriages affected all members of the community, always remaining a possibility and serving as an important symbol of their spiritually unique way of life.

The Doctrine of Plural Marriage

As sanctioned by their faith, Mormon families were strictly patriarchal, and a woman's spiritual salvation depended on her relation to her husband. If their marriage were "sealed" as a "celestial marriage," it would last through eternity and qualify both husband and wife for the highest degree of spiritual glory, exaltation. However, all Mormons bore a unique responsibility: to serve the needs of the ethereal spirits who required a mortal body to prove themselves worthy of salvation. Brigham Young proclaimed it "the duty of every righteous man and every woman to prepare tabernacles for all the spirits they can." Thus, a woman's spiritual destiny was determined in part by the number of "tabernacles"—that is, children—she brought into this world. In turn, men aspired to take at least two wives, each ideally bearing between seven and eight children.

Among the minority of Mormons who practiced polygamy (more precisely, polygyny, for only men were allowed more than one spouse), families functioned much like families in other regions of the West. Wives sometimes shared a single home, each keeping her own bedroom and together sharing common household chores and child rearing. Occasionally, if the husband were sufficiently wealthy, his wives lived in separate homes and even in different towns. Plural wives sometimes formed strong bonds, although it was not unknown for jealousy to figure into these relationships, especially

if their husband favored one wife over others. However, in other aspects of family life, such as fertility and divorce rates, Mormons deviated little from the average.

Like other newcomers to the western territories, women expected to work hard. Women spun and wove cloth, made clothing, and tended household gardens. In the face of the enormous challenge of growing crops in the semiarid land, women joined men in planting and harvesting and often in the vital work of irrigation. It was not uncommon for a wife, particularly a first wife, to manage the household in her husband's absence and often for long periods. Church leaders explicitly encouraged women to be competent and to teach their daughters to be self-reliant.

The church invited women to work outside the home as a means to strengthen the local economy. By the late 1860s, women were running cooperative stores for the sale of homemade products; eventually, they were overseeing a successful silk manufacturing industry. Women also formed female relief societies, which sponsored religious programs, such as Bible readings and lectures, and administered local charities.

"The Mormon Question"

By the time of the Civil War, the population of the Utah territory was growing quickly enough to warrant a bid for statehood; from the perspective of the Christian Northeast, the prospect of a new state that promoted polygamy—allegedly a "relic of barbarism"—was intolerable. The popular press and government officials likened polygamy to slavery and portrayed plural wives as hapless victims of male lust. In 1862, Congress passed the **Morrill Anti-Bigamy Act**, which made plural marriage a federal crime. Nevertheless, because Mormons did not publicly record second or subsequent marriages, and because juries in Utah typically refused to enforce the new law, the Morrill Act had little impact on Mormon communities.

With the completion of the transcontinental railroad in 1869, which brought new settlers to the territory, Mormon marriage practices once again attracted national attention. The bulk of the commentary focused on Mormon women. The former abolitionist Harriet Beecher Stowe equated polygamy and slavery and waged a new campaign "to loose the bonds of a cruel slavery whose chains have cut into the hearts of thousand of our sisters." The popular Civil War orator Anna Dickinson, who visited Salt Lake City in 1869, returned to the East with a new lecture in her repertoire, "White Sepulchers," in which she described the debasement of plural wives by sexually craven men. Like many other critics, she alleged that Mormon women had been either seduced or tricked into a relationship no better than prostitution.

Mormon women refuted these charges. In 1870, when Senator Shelby M. Cullom of Illinois introduced a bill in Congress that would strip Mormon men of the bulk of their rights as citizens should polygamy continue to prevail in Utah, Mormon women staged mass demonstrations to protest this "mean, foul" legislation. One spokeswoman praised the outpouring of women for giving "lie to the popular clamour [*sic*] that the women of Utah are oppressed and held in bondage." To those who would abolish the Mormon way of life, she charged: "[W]herever monogamy reigns, adultery,

prostitution, free-love and foeticide [abortion], directly or indirectly, are its concomitants. . . ." Mormon women, she insisted, look upon polygamy as a "safeguard" to these common evils.

The Woman's Vote in Utah

The protest by Mormon women had also undermined a novel plan to curtail the practice of polygamy. Several members of Congress proposed enfranchising Utah's women, assuming that Mormon women, if given a chance, would use their votes to eradicate polygamy. The "great indignation meeting" of five thousand angry women protesting the **Cullom Bill** quickly put this plan to rest. However, for their own purposes, the Mormon-controlled territorial legislature gave the ballot to the women of Utah in February 1870.

Within the week, according to Brigham Young, twenty-five women voted in municipal elections in Salt Lake City, proving to the world that Mormon women were no slaves to a religious patriarchy. Moreover, these women wielded their new political power primarily to show themselves as willing participants in plural marriage. Equally significant, by placing women on the roster of eligible voters, Mormons had increased their representation in territorial elections to more than 95 percent.

These events took the national woman suffrage movement off guard. The leaders greeted the enfranchisement of Utah women as a major victory for their side. Elizabeth Cady Stanton and Susan B. Anthony made a long journey to Utah in 1871 to celebrate; a representative of the American Woman Suffrage Association (AWSA) likewise visited Salt Lake City. Yet, all this goodwill could not obscure the fact that most suffrage leaders detested the association of their cause with plural marriage. With Victoria Woodhull whipping up controversy by advocating free love, neither the National Woman Suffrage Association (NWSA) nor the AWSA could afford to be linked to yet another heterodox position on marriage.

In 1882, after Congress passed the Edmunds Act outlawing "bigamous cohabitation," a major movement for the disfranchisement of Utah women gained force. Finally, in 1887, Congress passed the **Edmunds-Tucker Act**,[4] simultaneously disincorporating the Mormon church and disenfranchising the women of Utah.

Although suffragists formally protested the antisuffrage clause of the Edmunds-Tucker Act, they did so only halfheartedly. Moreover, suffragists adamantly refused the requests of Mormon women to defend plural marriage. By this time, the woman's vote in Utah had become a liability to the suffrage movement—just as polygamy had become a liability to the Mormon church. In 1887, the Mormon leadership announced that the church would no longer sanction plural marriage, thus clearing the way for admission of Utah to statehood.

After enjoying voting rights for seventeen years, Utah women would not give up the ballot graciously. The most militant formed the Utah Territory Woman Suffrage Association and spearheaded a vigorous campaign. When the state was finally admitted to the Union in 1896, Utah women regained the right to vote and won the right to hold public office.

Read about "Plural Marriage in the 1800s"

The editor of the *Anti-Polygamy Standard*, Jennie Anderson Froiseth, collected stories by apostate Mormon[5] women, that is, by women who had abandoned their faith to illustrate the abuse and degradation they allegedly endured under the system of plural marriage. "If the wives and mothers of American could only be made aware of the extent and character of this degradation of their sex. . ." she explained, "the onrushing tide of public sentiment, once set in motion, would sweep away the curse of polygamy in a single year."

Review the source; write short responses to the following questions.

1. How did the selection of "second wife" take place, according to this report?
2. How do we interpret this document given its purpose to expose the evils of plural marriage?
3. According to the Edmunds-Tucker Act, what was the punishment for breaking this law?

SPANISH-SPEAKING WOMEN OF THE SOUTHWEST

"My life is only for my family," wrote Adina de Zavala in 1882. "My whole life shall be worth while [*sic*] if I can render happy and comfortable the declining years of my parents and see my brothers safely launched on life's troubled seas." This San Antonio matron paid tribute to **la familia**, that is, the enduring bonds of affection and duty extending from biological kin to close friends that characterized Mexicano settlements in the region that came to be known as the American Southwest. They respected the authority of their husbands—*machismo*—and revered marriage and motherhood as the primary source of a woman's self-affirmation and esteem. However, in daily life, the actual behavior of Spanish-speaking women often diverged from these ideals. Moreover, by the 1880s, Anglos were settling in the Southwest in such great numbers that old mores could not survive intact.

During the last half of the nineteenth century, Spanish-speaking women were drawn into the processes of incorporation into the United States (see Chapter 4). In 1848, the Treaty of Guadalupe Hidalgo, which marked the end of a war between the United States and Mexico, granted to the United States half of all Mexican territory— what would become the states of California, Arizona, Nevada, and Utah; most of New Mexico; and parts of Colorado and Wyoming. In 1853, the United States purchased an additional strip of land between El Paso and the Colorado River that rounded off the accession of all the land north of the Rio Grande River. The Mexicanos who lived in this region were formally guaranteed the "free enjoyment of their liberty and property" as citizens of the United States, although Anglo developers and land speculators

MAP 11-1 Land Accession, Treaty of Guadalupe Hidalgo[6]

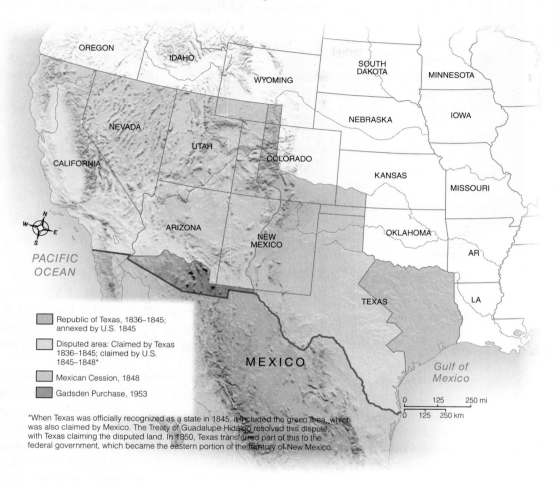

Republic of Texas, 1836–1845; annexed by U.S. 1845

Disputed area: Claimed by Texas 1836–1845; claimed by U.S. 1845–1848*

Mexican Cession, 1848

Gadsden Purchase, 1953

*When Texas was officially recognized as a state in 1845, it included the green area, which was also claimed by Mexico. The Treaty of Guadalupe Hidalgo resolved this dispute, with Texas claiming the disputed land. In 1850, Texas transferred part of this to the federal government, which became the eastern portion of the territory of New Mexico.

By the terms of the Treaty of Guadalupe Hidalgo, which marked the end of the war between the United States and Mexico in 1848, Mexico ceded large parts of its land to the United States.

soon took over the local economy. By the 1880s, Anglo-owned industries, including railroads, lumber mills, and mines, and the transformation of subsistence agriculture into a thriving commercial enterprise had effected dramatic changes that encompassed *la familia* and women's role within the Mexicano household.

Landowning Elite

Through the 1870s, elite Spanish-speaking women continued to benefit from the well-established practice of intermarriage with Anglos as well as from the customary right to accumulate property jointly with their husbands and to inherit and maintain

Read about "The Treaty of Guadalupe Hidalgo and Its Implications for Women"

Review the sources. Write short responses to the following questions.

Eulalia Perez, Reminiscences [1877][7]
Isadora Filomena, Testimony of the Widow of Prince Solano [1874][8]

1. What were the circumstances that led to Eulalia Perez getting the keys to the mission?
2. What were the responsibilities of the *llavera*, according to Perez?
3. According to Filomena, what were some of the ramifications of the "blonde men" stealing everything her tribe had?
4. What happened to Rosalia Vallegjo Reese after the Bear Flag was raised?

property in their own names (see Chapter 4). Following the United States–Mexican War, this long-standing Spanish tradition was incorporated into the legal system of several southwestern states, including Texas, where big cattle ranches flourished. Several wealthy Texan widows took their place among the largest landowners in the state, registering their own cattle brands as well as filing homestead claims with the county courts.

However, only the wealthiest women benefited from this system. The majority of women, like their male contemporaries, fared less well with the rise of Anglo-owned commercial ranching and agriculture. In the Lower Rio Grande Valley, for example, where Mexicanos outnumbered Anglos, they lost the bulk of their property to Anglos who were better equipped to manipulate the new court system. While their husbands and sons found themselves herding cattle or tending sheep and goats for Anglo landowners, Mexicanas worked as domestic servants, cooks, gardeners, or field hands. It was not uncommon for whole families to join the ranks of migrant workers, finding a meager source of income as pickers in the cotton fields of South Texas.

Communal Villagers

Well before the United States–Mexican War, in an effort to encourage settlement in what had then been the northern outpost of the nation, the Mexican government had conferred communal property rights to groups that petitioned for land. After the accession of this region by the United States, thousands of Mexican families continued to live and work in villages scattered throughout the mountains and deserts of northern New Mexico and part of Colorado. The women who lived in these communal villages of small-scale cattle and sheep herders enjoyed similar benefits of inheritance and property rights but nevertheless lived very different lives from those of the elite landowners.

As in other agricultural communities, Mexicanas cared for the home and maintained nearby a small garden plot and perhaps a patch of land reserved for a few grazing sheep and goats. Their husbands in turn took responsibility for the heavy outdoor labor, such as herding sheep and cattle and plowing the fields. The community as a whole shared the principal resources, including the large pastures and water supply, and took collective responsibility for their maintenance. Men and women also pooled their labor. Women often worked in groups to prepare foodstuffs, spin wool, and plaster their adobe homes, an annual chore, and men worked together in the physical and seasonal labor typical of agricultural economies. Men also managed the external trade, selling grain and livestock on the open market.

By the 1880s, the transcontinental railroads that passed through this region served as a catalyst of change in the work of men and women. Anglos came in great numbers, bringing new commercial opportunities for men. Mexicanos took advantage of a growing cash economy, finding jobs on the railroads and in the mines. They also worked for Anglo ranchers, digging irrigation ditches and herding sheep and cattle. While the actual tasks were often familiar, the location and exchange of labor for cash were not. Men now left their villages for long stretches of time, hoping to earn enough money to keep up with rising taxes and household expenses. Left behind, women assumed more responsibilities.

Although religious and ethnic traditions continued to support the patriarchal authority invested in *machismo*, the new economic arrangements worked against old customs. With men absent for months at a time, women gained power in their family and community. Women took on the work of herding sheep or tending the communal fields. Equally important, they strengthened their own networks.

Women's networks, which were rooted in kin relationships, extended far into the tightly knit neighborhoods. For example, most married women maintained very strong ties with parents and in-laws. Grandparents customarily served as godparents for a family's first- and second-born children; they were called *comadres* and *copadres*, and their responsibilities often included child rearing. Godparents not only officiated at christening services, a common Catholic custom, but also acted as surrogate guardians. Maternal grandparents usually served as godparents for the first child, paternal grandparents for the second, and then other relatives and friends assumed these important roles. In this fashion, kin and kith became links in a network of reciprocal obligations, which in the absence of men became women's sole domain.

While men were away, women also took responsibility for the physical and spiritual well-being of the village. Some older women whose children were grown served as midwives, delivering babies, caring for new mothers, and acting as counselors to the whole village. Even within the male-dominated Roman Catholic Church, the locus of spiritual life from baptism, feast days, weddings, and burial, village women played unusually prominent roles. Although men sustained the *Penitentes*, a religious and mutual aid society known for its flagellant practices, women carried out their own rituals and formed auxiliaries to men's societies. They prevailed in religious ceremonies during May, the month devoted to the Blessed Virgin Mary. In general, **Mariolatry**

muted the masculine character of many rituals and legitimated women's participation in church affairs. So, too, did the chronic shortage of priests.

As Anglos encroached on their land and drew more and more villagers into the market economy, even the determination of women could not save the community. Whole families began to pull up stakes, heading for the burgeoning towns and cities where women joined men in the expanding system of wage labor.

Urban Householders

In the decades following the United States–Mexican War, the new Anglo settlers drove out many longtime Mexican residents, reducing the Hispanic population by as much as half in southwestern cities such as San Antonio, Texas. However, by the end of the century, this trend had reversed. Expanding trade and industry worked like a magnet, attracting not only Mexicanos from the communal villages but also many immigrants from Mexico. Single women and widows in particular took advantage of expanding opportunities for wage work, flocking to Texas cities as well as to well-established urban enclaves such as Santa Fe, Albuquerque, Tucson, and Denver. They moved in such numbers that before the century ended, the majority of Mexican Americans had become urban dwellers.

Upper-class, Spanish-speaking women often came from families that had lived in these cities for generations; they considered themselves distinct from the growing populations of *mestizos*, Mexicans of mixed Spanish and Indian blood, and they tended to identify with Spain rather than Mexico (see Chapter 4). They maintained their high status by spearheading the emerging consumer culture, although by the 1880s even women in the communal villages had access to sewing machines, cook stoves, and manufactured furniture. Wealthy women, however, ordered their furnishings and fashions from prominent retailers, such as Bloomingdale's in New York.

At the other end of the social scale were the women who had fled rural poverty to build a better life for themselves and their family in the city. They lacked the means to enjoy the new consumer goods and instead found themselves barely able to scrape by on the wages they could earn as cooks, domestic servants, seamstresses, or laundresses for wealthy Anglo or Hispanic families. Mexicanas staffed the open markets, selling produce, bowls of chili, baked goods, and handicraft. Overall, though, few women earned more than subsistence and, as a group, far less than men. The move to the city usually made Mexicanas dependent on their husbands for support, unraveled the networks that had sustained them in the communal village, and ultimately reduced their power within both the family and community.

Despite such setbacks, Mexicanas continued to play important roles in preserving old traditions, including their allegiance to the Roman Catholic Church. Their families continued to baptize their children, celebrate the feast day of their patron saints, mark the transition from girlhood to womanhood at age fifteen by the *Quinceañera*, and marry according to prescripts of the church. National holidays of Mexico, such as *Cinco de Mayo*, which marked the Mexican victory over French invaders in 1862, continued to give the community distinctive reasons to celebrate its heritage.

BUILDING COMMUNITIES IN THE HEARTLAND

"The average farmer's wife is one of the most patient and overworked women of the time," one writer proclaimed in 1884 in *The American Farmer*. Many European-born and Euro-American women who settled the western territories, including the nation's heartland, may have agreed with this sentiment. They tended to put aside the drudgery and tedium that often characterized life in the wilderness and instead took pride in their contribution to the welfare of their family and community. Women worked hard to create a home and sought to reestablish old ways, including familiar patterns of love and labor. In the 1880s, for the three of every four people who lived in rural areas, the most enduring element was the household, the primary site of production that required the labor of all able-bodied members.

Library of Congress Prints and Photographs Division [LC-USZC4-1267].

South Dakota, which became a state in 1889, advertised free land for homesteading in this poster prepared for the Columbian Exposition, held in Chicago in 1893. Although the early days of settlement were over, the state continued to encourage the formation of new communities.

The Homestead Act and Immigration

The **Homestead Act of 1862** made landowning a possibility for adventurous, free-spirited Euro-American women. The act allowed a household head, male or female, to file for a quarter section (160 acres) of the public domain with the option of buying

it at a bargain price at the end of six months' residence or owning it outright after five years of improving the land. Legally subordinate to her husband, a married woman could not qualify as a household head.

Unmarried women, however, were eligible to file claims. Wyoming homesteader Elinore Pruitt Stewart insisted that "any woman who can stand her own company, can see the beauty of the sunset, loves growing things, and is willing to put in as much time and careful labor as she does over the washtub, will have independence, plenty to eat all the time and a home of her own in the end." Few women accepted Stewart's invitation. Women filed less than 15 percent of all claims, and those who did file were more often than not acting as proxies for sons or brothers who for some reason failed to meet the terms of the Homestead Act. Only rarely did women homesteaders farm or ranch on their own. Stewart herself fudged on the details of her own, highly publicized success story: one week after filing her claim, she married the rancher who lived on the adjacent lot, thus securing for the newlyweds enough acreage to support a household.

Although land speculators took the greatest advantage of the Homestead Act, the completion of the transcontinental railroad in 1869 encouraged many prospective farmers and ranchers to head west in droves. At the same time, marketing campaigns describing the rich bounties to be had in the American West targeted Europeans, many of whom lacked access to land in their home countries. Promotional literature often emphasized the opportunities available to women in particular, underscoring the possibility of attending school, earning a living, and holding property. By the end of the century, more than two million Europeans—from Germany, Scandinavia, Poland, Ireland, Russia, and many smaller countries—had relocated to the Great Plains, re-mapping the region as a potpourri of tightly knit ethnic communities.

A few African American families took advantage of the Homestead Act and left the South in the hope of becoming farmers. At the close of Reconstruction, as many as fifteen thousand black people, known as **Exodusters**, moved to Kansas, where they formed a handful of distinct communities. A smaller number moved to Indian Territory, which later became Oklahoma, while others scattered throughout the Great Plains and Rocky Mountains. Meanwhile, white farming families—known as "Yankees" to both European immigrants and African Americans—created a steady stream of migrants from states bordering the Mississippi River.

The Homestead Act helped to bring ethnic diversity to most regions of the nation's heartland. It was not unusual for neighbors to lack even a common language. Nevertheless, despite such diversity, the basic patterns of women's lives varied little from group to group.

Woman's Work, Never Done

A familiar division of labor governed most farm households. Men tended the fields and outbuildings; women performed their customary tasks, such as sewing and knitting, preserving and preparing food, and cleaning the house, as well as the especially burdensome chore of laundering clothes. Although these everyday jobs fell to married women nationwide, housekeeping could prove especially challenging to even

the most dedicated farm wife. For instance, because so few trees grew on the plains, settlers typically used bricks of compacted soil instead of lumber to build their houses. "Soddies," as they were called, provided sufficient protection from most elements of nature, although not the bugs and snakes that made their own home in the walls. Moreover, the walls of sod houses continuously shed bits of dirt while the ceilings let in rain, and the mud that formed eventually ruined most carpets and furniture. In addition to the Herculean chores of housekeeping, women took responsibility for several outdoor tasks. They tended chickens and gathered eggs, milked cows, and maintained a vegetable garden to keep their household supplied with produce.

Although farm communities readily acknowledged the importance of women's labor in the family economy, it is unclear if women's status was commensurate with their contribution. For example, rural isolation forced husbands and wives to rely on one another for companionship, but this situation could either foster a more egalitarian marriage or make a woman more vulnerable to domestic violence. However, men continued to enjoy the privilege of both custom and law in making major decisions, such as buying more property and equipment or pulling up stakes altogether. Also, the seasonal nature of men's work gave them an advantage. Men enjoyed enough leisure to make trips to town, where politics and fraternal activities eased the tedium of their routine. In contrast, women's work was unremitting, especially when it came to the care of children.

Farm wives did find ways to contribute to the family economy that were often more satisfying than the ceaseless rounds of cooking, cleaning, and washing. Many women ran small-scale businesses. By selling baked goods such as breads, pies, and cookies, they could earn a small amount of cash, or they could barter for needed supplies, such as trading eggs and butter for household items like soap, linens, and clothing produced by neighboring women.

There were times, however, when the customary division of labor broke down. Men pitched in to help with the housework and child care, typically when their wives were recovering from illness or childbirth. In turn, women were prepared to take over when their husbands were called away to scout out new land, herd cattle, or take crops to market and, in such cases, assumed responsibility for the entire farming enterprise for weeks or months at a time. It was not unknown for farm wives to take on outdoor work, such as helping with the planting and harvesting, digging cellars, and building barns and sheds. However, as soon as cash could be spared to hire male helpers, most wives retreated to the home.

View the Profile of <u>Laura Ingalls Wilder (1867–1957)</u>

Laura Ingalls Wilder grew up in a pioneering family constantly on the move, finally settling in De Smet, a market town in the Dakota Territory with a population not much more than eighty. In later life, at age sixty-five, Laura began to use her memories of small town life as settings for seven historical novels, the *Little House* books that have been read and savored by children across the generations.

Immigrant women, in comparison to native-born farm wives, were more likely to pitch in whenever and wherever needed. "Among us Yankees," one Iowan observed, "the German habit of working women in the field was the sure mark of the 'Old Countryman,'" Whereas many such "Yankees" viewed immigrant farm wives as they did the women of many Indian tribes, as victims of lazy men, most immigrants considered the absence of Anglo women in the fields a sign of degeneracy. Coming from the European peasantry and accustomed to farm labor, most immigrant women simply assumed they would tend the fields and dairies and then, when time and energy allowed, tackle housekeeping. For similar reasons, immigrant farm families tended to be larger than those among the native-born families because they viewed children as an asset, as essential components of the household labor pool and insurance to parents in old age.

Turning Wilderness into "Civilization"

"I feel quite lonesome & solitary," one woman complained to in her diary. "My spirits are depressed. I have very little female society." Frequent moves made friendships fragile, and many women new to the region yearned for the friends and family left behind. To ease the isolation, settlers often built their homes on the adjacent corners of their allotments. Even strongly held prejudices did not keep some women from seeking female companionship from neighbors of different ethnicities or races from themselves. Mothers and daughters often found their relationship develop into an enduring friendship. While sons moved on to greener pastures, daughters were more likely to stay close to their mothers, often marrying local farmers and remaining in the community.

Farm wives typically turned to their neighbors and friends as much for help with chores as for companionship. Planting and harvesting brought neighbors together as did the occasional work of building new houses or barns. Childbirth summoned neighboring women to serve as midwives and supporters.

After the initial period of settlement, men and women broadened their range of social contacts beyond their families and neighbors and began to build the basic institutions of the small town or village. First came the school, which was built by men and staffed by women. The church was not far behind. As in other regions, western women formed auxiliaries and involved themselves in missionary activities. They organized Sunday schools and carried the gospel to nearby Indian reservations. Men and women alike joined clubs, although usually along gender-exclusive lines. Men organized themselves into fraternal associations and sporting clubs; women constructed a network of voluntary associations and benevolent societies as well as clubs devoted to education and culture. Quilting bees were popular forms of amusement for women, while county fairs attracted whole families.

Men and women often nurtured diverging aspirations for their communities. Men looked to the town to provide services relevant to both their business and their leisure. They promoted the establishment of banks, saloons, and brothels. Women more typically sought to impose order and morality, favoring Sunday-closing laws for retail establishments and financial institutions and the abolition of drinking, gambling, and

prostitution altogether. As in other regions of the country, women assumed their role as moral guardians, an ideal that was affirmed in print media, church sermons, and public lectures.

Temperance rallied the largest number of women. The Woman's Crusade of 1873–1874 recruited women across the West, from the mining frontier as well as from numerous towns of the plains and prairie. The first president of the national Woman's Christian Temperance Union (WCTU), Annie Turner Wittenmyer, hailed from the farming state of Iowa. Although native-born women provided the bulk of WCTU membership, some immigrant groups, Swedes in particular, formed their own chapters and sponsored a variety of programs to discourage the use of alcohol.

The Patrons of Husbandry

The household basis of the farm economy was reflected in the region's largest organization, the Patrons of Husbandry, better known as the Grange (a word for *farm*). The **Grange** began as a secret fraternal society in 1867 and grew in the 1870s to some 1.5 million members. For men and women alike, the Grange became the center of social life, the chief sponsor of picnics in the summer and holiday dances in the winter. The Grange organized cooperatives to sell grain and to buy equipment and household items and promoted state legislation to regulate shipping rates.

From its inception, the Grange set itself apart from most other fraternal societies by inviting both women and men to join. "The Grange door swings inward as readily at the gentle knock of woman," one Granger announced, "as to the ruder knock of man." Grangers thus emphasized the distinctive and complementary roles of farm husbands and wives. One woman explained that the Grange resembled a healthy family, with the husband supplying "rude and vigorous force" and the wife adding "the refinement of her more sympathetic impulses to his energy." Only men served on the committees dealing with cooperatives or lobbying legislatures, while women managed the educational, charitable, and social activities of the order.

In their newspapers and at their meetings, Grangers thoroughly addressed issues of rural domesticity, exchanging tips on housework and cooking as well as child rearing. They also acknowledged the repetitive, exhausting nature of these tasks and identified the farm woman's plight as one of drudgery. The Patrons of Husbandry emerged as one of the few national organizations to endorse woman's suffrage and saluted the WCTU as a kindred organization and required all members to take a vow of abstinence.

INDIAN WOMEN, CONQUEST, AND SURVIVAL

Ravaged by disease and pressured by the onslaught of Euro-American traders, prospectors, and homesteaders, Native American tribes nevertheless survived in far greater numbers than they did east of the Mississippi (see Chapter 4). At the close of the Civil War, approximately 360,000 Indian people lived in this region, the majority on eight reservations where white Christian missionaries taught them to speak English, convert to Christianity, and become farmers. Greater changes lay ahead. In response to

lobbying by white settlers and corporate interests, the federal government drastically reduced the land allotments that had earlier been promised to native peoples "for as long as the grass grows and the water runs." Large-scale war broke out, marked by intermittent bloody conflicts that lasted until 1886, when the Apache warrior Geronimo surrendered to the U.S. Army.

All the while, groups of Christian reformers were lobbying the federal government to implement more humane assimilationist policies on the reservations. The noted author Helen Hunt Jackson was one of the most influential. Her book, *A Century of Dishonor* (1881), exposed the cruelties that had been inflicted on Indian peoples and became to Indian reformers what Harriet Beecher Stowe's *Uncle Tom's Cabin* was to abolitionists. Jackson was also active in various reform organizations, including a branch of the **Women's National Indian Association** (WNIA), which had formed in 1879. The WNIA raised money to promote assimilationist programs, sponsoring teachers, missionaries, and physicians to work among various Indian tribes. It also staged a massive petition campaign, urging Congress to phase out the reservation system, to make homesteaders of individual Indian families, and to establish a school system for children.

The WNIA was the chief force behind the **Dawes Severalty Act** (1887), named after the senator who sponsored it, which allowed the United States to convert communal tribal lands to individual ownership. The government distributed allotments of 160 acres to heads of households, that is, to Indian men who agreed to be "severed" legally from their tribes and to become farmers; in return, they could petition to become citizens of the United States. Indian women were to relinquish their roles as producers to become farm wives and care primarily for home and children. In sum, the Dawes Severalty Act strengthened the authority of the federal government to prescribe a nuclear family system and to proselytize the doctrine of separate spheres as the chief means to assimilate Indian men and women into "civilization."

The Nez Perce

According to tribal lore, it was a woman who facilitated the first friendly contact between white explorers and her tribe. Wet-khoo-weis was so grateful to a white woman for rescuing her from captivity by rival Indians that when the Lewis and Clark Expedition arrived in Nez Perce territory in 1806, she persuaded tribal leaders to "do them no harm." From this point on, the Nez Perce regarded themselves as friends to white traders and settlers.

Living on the plateau where Idaho, Washington, and Oregon now meet, the Nez Perce remained on good terms with the U.S. government until the 1860s, when, following the discovery of gold, they were forced to cede nearly nine-tenths of their land. A substantial portion of the tribe refused assignment to a reservation and, in 1877, followed Chief Joseph to search for sanctuary in Canada. During the long journey, Nez Perce women performed the essential tasks of setting up and dismantling the camps and caring for the wounded warriors. When their husbands were killed in battle, women occasionally retrieved the guns, mounted their horses, and joined the

fight. United States troops finally forced Chief Joseph's band to surrender in northern Montana, just thirty miles from the Canadian border.

Meanwhile, those Nez Perce women who had accepted reservation status became enmeshed in assimilationist programs based on the doctrine of separate spheres. In 1869, President Ulysses S. Grant put Christian missionaries in charge of reservations, and the Presbyterians who volunteered to work among the Nez Perce did more than instruct the tribe in the tenets of their religion. The missionaries pleaded with tribal members to abide by the sexual division of labor deemed appropriate to "civilization." For example, they advised the Nez Perce to replace their tipis with the wooden-frame houses typical of sedentary American farmers. Such houses, which could comfortably accommodate only a few people, would undermine the prevailing extended-family living arrangements and induce the Nez Perce to live as nuclear families, or so the missionaries believed. Moreover, the missionaries insisted that men construct the new homes, thereby displacing the women who customarily built the tipis and thereby served as the chief providers of housing.

The missionaries had less success, however, in persuading women to reject traditional clothing styles and functions. Used to fashioning buffalo skins into ornately beaded garments, Nez Perce women welcomed the sewing machine and woven textiles traded by the Euro-Americans. Even in the building of tipis, they readily switched from buffalo hides to canvas. However, they were reluctant to follow the advice of missionaries to forsake highly decorated clothing, which the Protestants denounced as "heathen" and wasteful. Viewing clothing as an important marker of identity and status, most Nez Perce women continued to savor beaded leggings, feathered hats, and shell jewelry.

However, Nez Perce women did adapt to farming as a way of life, although in ways that undoubtedly surprised their Protestant instructors. Men resisted the role of farmer because, traditionally among the Nez Perce, gardening was "women's work." In contrast, women readily accepted basic farm chores as routine. But contrary to the missionaries' wishes, Nez Perce women also took on the heavy outdoor work of cultivating, threshing, and harvesting. At first, they used horses to drag the equipment; later they drove tractors. The women also refused to stay put on their own farms and instead continued the customary practice of working in groups, even pitching tents in the field and spending the night together. In the few instances when the missionaries convinced men to farm, their wives still refused to retreat to the home and instead hired out, earning wages by sifting and winnowing wheat.

Plains Indians

The role and status of Plains women underwent similarly dramatic changes as a result of the U.S. government's determination to turn Indians into self-sufficient farmers. By the 1870s, the buffalo, which had inhabited the plains for thousands of years, were on the verge of extinction, a consequence of reckless slaughter by white overland traders wielding powerful new weapons. Various tribes, with the mainstay of their livelihood disappearing, agreed to cede large portions of their land in return for the right

to live in security in Indian Territory or on a reservation. Believing that the prospects for "civilizing" these tribes lay in the hands of women, federal agents and missionaries then began to implement vigorous programs to transform Indian women into homemakers.

Such was the case of the Sioux women who lived on the Devil's Lake Reservation in North Dakota, which had been established in 1867. More quickly than the Nez Perce, it seemed, Sioux men accepted responsibility for agricultural production. Federal agents persuaded them to take up what had traditionally been "women's work" by offering such incentives as kerosene, tools, and clothing and even plots of land for the most adept farmers. Eventually, some Sioux men became very successful wheat farmers. With their husbands now acting as chief breadwinners of the family, women left the fields and tended only small gardens for domestic consumption.

Read "Leaving for the Mission School"

Gertrude Simmons Bonnin,[9] who wrote under her chosen name Zitkala-Sa (Red Bird), trained as a musician and devoted much of her life to pan-Indian activism. She was born and raised on the Yankton Sioux Reservation in South Dakota until she enrolled, at age eight, in the Quaker mission school in Wabash, Indiana. In this autobiographical piece, she recalls her mother, Ellen Simmons, whose Yankton-Lakota name was Tate Iyohiwin (Every Wind or Reaches for the Wind).

Review the source; write short responses to the following questions.

1. How does Zitkala-Sa, who left the reservation when she was a young child, describe her relationship with her mother?
2. In this work of fiction, how much do you think Zitkala-Sa draws from her own experience?

The reservation boarding schools, established in the 1870s to "uplift" the Indians, reinforced this arrangement. Immediately upon arrival, children had their long, straight hair shorn and their distinctive tribal clothing stripped away, while their Christian teachers attempted to refashion them in the style of Anglo boys and girls. The teachers promoted acculturation by establishing curricula clearly delineated by gender. They taught Sioux boys agricultural methods, as well as other vocational skills such as carpentry and blacksmithing with the expectation that as adults they would take on the role of chief breadwinner of the family. In contrast, girls prepared for a life of economic dependency. They studied and practiced the homemaking arts, including cooking and baking; housecleaning; and quilting, crocheting, and knitting. In addition, Sioux girls received a heavy dose of moral training to prepare for their future role in sustaining a Christian home. However, a small number of girls flourished in the new educational setting and went on to become doctors, writers, and teachers themselves.

Ultimately, the majority of Sioux women lost considerable status as tribal members. At one time highly skilled in tailoring and decorating buffalo hides, tribal women adapted readily to the new forms of needlework. And quilting soon emerged as major decorative art on the reservations, and quilts were important items for sale or exchange. However, women's handicraft and homemaking activities did not carry the same weight as men's contribution to the livelihood of family and tribe alike. Women retained some traditional prerogatives, such as the right to dissolve a marriage and to participate in ceremonies and rituals. However, women were no longer consulted about intertribal dealings nor could they negotiate with federal agents who recognized only men as heads of household.

A small group of Sioux women faced their greatest trial in 1890. Their land area reduced by the federal government, the Sioux could no longer sustain their tribes and suffered for want of food and other necessities. Many believed that the day of judgment was near, and they joined an ecstatic spiritual movement, the Ghost Dance, which swept the plains and simultaneously provoked federal officials who interpreted it as a war dance. In December, representatives of various Sioux tribes gathered at the Wounded Knee Creek near the Pine Ridge and Rosebud reservations in South Dakota and on December 19 were massacred by the 7th U.S. Cavalry. At least forty-four women and eighteen babies died in the **Wounded Knee Massacre** considered the final armed conflict between Native Americans and the federal government.

The Southern Ute

At one time, the Southern Ute lived by hunting and foraging in a wide region spanning the Rocky Mountains and the Great Basin, and by the early nineteenth century, they had become powerful actors in a flourishing trade economy among other Indians, Mexicans, and Anglos. However, when the land they occupied became part of the United States in 1848, the Ute started down a path that ultimately led to reservation status. By the terms of the Dawes Severalty Act, the reservation became an administrative unit of the Office of Indian Affairs (OIA), which, along with missionary and reform organizations, acted to undermine the remaining vestiges of the Ute's collectivist society and egalitarian gender system.

View the Profiles of <u>Susan La Flesche Picotte, M.D., and Susette La Flesche Tibbles</u>

Susette was a prominent activist for Indian rights while Susan became the first Indian woman to receive a medical degree.

Prior to the reservation, Ute men achieved status in the highly masculine role of raider and warrior, while women derived their authority from the responsibility of guarding the camp and protecting the children. On occasion, when the fighting neared

their home territory, armed women joined the men in battle, scalping their enemies and carrying back the spoils. In the victory ceremonies, women received their share of the honor.

Like other Indian women, Ute women found it increasingly difficult to hold on to their customary roles in the aftermath of the Dawes Severalty Act. The terms of the act decreed their husbands the head of the household, and the OIA similarly assumed that political leadership on the reservation belonged to men alone. Government agents therefore dealt only with all-male councils on matters ranging from allotments to educational programs.

Ute women resisted these changes in governance and continued to participate in tribal-sponsored forums about various aspects of reservation policy. For example, Ute women, reluctant to send their children to boarding schools that had high rates of contagious disease, forced the OIA to open a day school in 1886. Four years later, 150 women presented their opinions at a major meeting about tribal finances. Within their families, they preserved their authority to make decisions about the care of their children and the welfare of their household. They also served as liaisons with Ute families in other jurisdictions, thereby helping to maintain the regional tribal community. And given the stringencies on the reservation, especially the prevalence of disease, the tribe had little choice but to value women's contributions.

CONCLUSION

In 1890, the director of the U.S. Census declared that the nation's "unsettled area has been so broken into by isolated bodies of settlement that there can hardly be said to be a frontier line." The trans-Mississippi West had been incorporated into the United States. Americans had brought to this region their political, legal, and economic systems, as well as their cultural and social institutions. For women, this transformation had pivoted on the doctrine of separate spheres, foremost the tenets of domesticity.

Even as the federal government marked the closing of the frontier, the trans-Mississippi West served as home to more and more women whose cultures intersected, often clashed, and encouraged new meanings for traditional practices. They found themselves enmeshed in a continuous struggle that would define ethnic, racial, and class hierarchies in this region while they simultaneously reconsidered established practices of women's work and markers of women's status within their families and their communities. In other words, domesticity served as a major site of contest, an arena for asserting power and establishing identity, and a measure of civilization over wilderness.

 Study the Key Terms for The Trans-Mississippi West, 1860–1900

Critical Thinking Questions

1. What factors promoted the imbalanced sex ratio in the states and territories west of the Mississippi?

2. Why did woman suffrage come first to the western territories and states?

3. How did the incorporation of Mexican lands into the United States affect the lives of Spanish-speaking women?

4. How did men and women manage their households on the Plains and prairies?

5. How did Indian women respond to the assimilationist programs sponsored by the U.S. government and carried out by missionaries?

Text Credits

1. Mrs. Oremus Boyd, *Cavalry Life in Tent and Field* (New York: J. Selwin Tait & Sons, 1894), as reprinted in Christiane Fischer, ed., *Let Them Speak for Themselves: Women in the American West, 1849–1900* (New York: E.P. Dutton, 1978), pp. 11–12, 16.

2. Isabella Lucy Bird, *A Lady's Life in the Rocky Mountains* (New York C.P. Putnam's Sons, 1886), pp. 127–135.

3. Labor Contract for Chinese Prostitutes (1886).

4. Edmunds-Tucker Act, 1887.

5. Jennie Anderson Froiseth, ed., *The Women of Mormonism: Or, the Story of Polygamy as Told by the Victims Themselves* (Detroit: C.G.G. Paine, 1882), pp. 77–78.

6. Treaty of Guadalupe Hidalgo, 1848.

7. Eulalia Perez, *Reminiscences Transcribed in Testimonios,* translated by Rose Marie Beebe and Robert M. Senkewicz. Copyright © 2006 Heyday Reprinted by permission.

8. Translated by Rose Marie Beebe and Robert M. Senkewicz. Copyright © 2006 Heyday Books. Reprinted by permission of Heyday, www.heydaybooks.com

9. Zitkala-Sa (Gertrude Bonnin), *American Indian Stories* (Washington DC: Hayworth Publishing House, 1921), pp. 7–11.

Recommended Reading

Brenda J. Child. *Holding Our World Together: Ojibewe Women and the Survival of Community*. New York: Viking, 2012. Chronicles change and perseverance in this Great Lakes community from the era of European settlement to urban migration. Child illustrates the importance of wild rice cultivation to the status and role of women.

Kathryn M. Daynes. *More Wives Than One: Transformation of the Mormon Marriage System*. Urbana, IL: University of Illinois Press, 2001. A 150-year study of polygamy in Manti, Utah, this book provides an especially vivid portrait of plural marriage in this locality during the last half of the nineteenth century.

Sarah Deutsch. *No Separate Refuge: Culture, Class, and Gender on an Anglo-Hispanic Frontier in the American Southwest 1880–1940*. New York: Oxford University Press, 1987.

Traces and analyzes the increasing marginality of Hispanic women as their communities moved into Anglo areas to the north of their original communal villages of New Mexico.

Deborah Fink. *Agrarian Women: Wives and Mothers in Rural Nebraska, 1880–1940*. Chapel Hill: University of North Carolina Press, 1992. Centered on Boone County, Nebraska, this well-researched book explores the lives of farm wives and mothers with an eye on their roles in a family economy dominated by their husbands.

Dee Garceau. *The Important Things of Life: Women, Work, and Family in Sweetwater County, Wyoming, 1880–1929*. Lincoln, NE: University of Nebraska Press, 1997. Emphasizes ethnic diversity and studies in close detail the roles of women in both mining and ranching communities across two generations.

Caroline James. *Nez Perce Women in Transition, 1877–1900*. Moscow, ID: University of Idaho Press. 1996. Based in part on forty-six interviews with Nez Perce women, this book covers many facets of reservation life in the process of acculturation and supplements a rich narrative with extraordinary photographs.

Elizabeth Jameson and Susan Armitage, eds. *Writing the Range: Race, Class, and Culture in the Women's West*. Norman, OK: University of Oklahoma Press, 1997. A collection of essays emphasizing the cultural diversity of the American West and highlighting the interconnections of gender, class, race, and ethnicity in four centuries of history in this region.

Katherine M.B. Osburn. *Southern Ute Women: Autonomy and Assimilation on the Reservation, 1887–1934*. Albuquerque, NM: University of New Mexico Press, 1998. Provides compelling evidence that Southern Ute women resisted many of the assimilationist programs imposed by the Dawes Severalty Act and continued to participate in tribal affairs well into the twentieth century.

Jane E. Simonsen. *Making Home Work: Domesticity and Native American Assimilation in the American West, 1860–1919*. Chapel Hill, NC: University of North Carolina Press, 2006. Presents domesticity as a contested category, a measure of women's work used by western women of various backgrounds to mark their identity.

Benson Tong. *Unsubmissive Women: Chinese Prostitutes in Nineteenth-Century San Francisco*. Norman, OK: University of Oklahoma Press, 1994. Tells a complicated story of the women who came from China to work in the burgeoning commercial sex industry. Less a study of victimization than one of survival in a new land.

CHAPTER 12

NEW WOMEN, 1857–1915

TIMELINE

1857	New York Infirmary for Women and Children opens
1862	New England Hospital for Women and Children opens
1868	Woman's Capitalize Medical medical College of the New York Infirmary established
1872	Montgomery Ward begins as a catalog-order business
1875	Page Act prohibits entry of women for prostitution
1878	Boston physicians form first women's medical society
1879	Mary Baker Eddy organizes Church of Christ (Scientist) in Boston
1880	Anna Howard Shaw ordained as first woman minister in Methodist Episcopal Church
1881	Atlanta Female Baptist Seminary, renamed Spelman, opened
1882	Chinese Exclusion Act halts Chinese immigration
1893	Columbian Exhibition (Chicago World's Fair) held World Parliament of Religions convenes
1897	White women protest the hiring of black women in Atlanta textile mill
1898	Charlotte Perkins Gilman publishes *Women and Economics*
1900	Woman's Convention of the National Baptist Church formed
1908	American Home Economics Association formed
1909	National Training School for Women and Girls established
1914	*Infant Care* published
1915	American Medical Associations admits women for the first time

AFTER THE DECADES AFTER THE CIVIL WAR, immigrant women from Ireland, Germany, and Scandinavia together accounted for nearly half of all domestic servants. Immigrant women from southern or eastern Europe, in contrast, filled the growing ranks of factory operatives and retail clerks. Even in the South, where King Cotton continued to dominate the economy, the development of industries like textiles drew both black and white women from the countryside to burgeoning towns and cities. Those married women who continued to work primarily in their homes caring for their families saw their roles transformed by the emergent consumer economy. In light of these changes, contemporaries began to discuss the arrival of the "new woman" and acknowledged that she appeared in many guises—middle as well as working class, native-born as well as immigrant—and in virtually every part of the country.

Read "A German Immigrant Writes Home"[1]

The late 1800s marked the rise of the New Woman, a concept more commonly associated with the youthful representatives of the middle class by nevertheless elastic enough to encompass a diversity of women exploring possibilities—either by choice or by necessity—outside the familial home. A large proportion was recent arrivals, and, like Wilhelmine Wiebusch, they helped to form the biggest wave of immigration in the nation's history. They often found themselves not only living in a strange land but doing unfamiliar work.

In this letter to her friend in Germany, Wiebusch shares her first impressions of life in America and describes her new job as a cook in a Brooklyn household.

Review the source; write a short response to the following question.

1. How does the woman writing about her new job feel about the job and America in general?

NEW INDUSTRIES, NEW JOBS

The New Woman owed a great deal to the **second industrial revolution**. The development of electricity as a replacement for steam power; a breathtaking expansion in transportation systems; and the emergence of mass production all helped the nation ascend, in terms of productivity, from fourth to first place in the world. By the turn of the century, Americans were manufacturing one-third of all the world's goods. And much of this activity was taking place in the nation's big cities.

In 1870, scarcely one in eight women was working for wages; in 1910 one in four women was gainfully employed. Women were also moving into new jobs, rejecting domestic service whenever possible to work in manufacturing, retail sales, business, and education. The overwhelming majority of women wage earners were unmarried and young, usually between the ages of fourteen and twenty-four. Wage earning gave these New Women just enough time, space, and pocket change to experiment beyond

the range of their parents' supervision before marriage pulled them back into the domestic circle.

Manufacturing

The best-paying jobs remained firmly in the hands of white male workers. Women displaced men in a few occupations, such as in the manufacturing of shoes and occasionally worked in different divisions of the same industry, such as in cigar making. But only rarely did women find jobs in premium trades like steel production or transportation and instead worked for low wages in mainly light manufacturing. However, by 1900 less than 3 percent of African American women found employment in manufacturing.

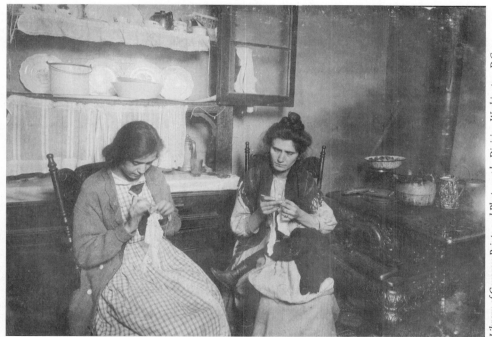

Library of Congress Prints and Photographs Division Washington, D.C. [LC-DIG-nclc-04110].

The documentary photographer Lewis Hine used his camera to educate the American public about the poor conditions in sweatshops and tenements of New York City. Here, in this 1911 photograph, he shows two women, one with a baby in her lap, making lace collars on the subcontract system.

As early as 1860, women outnumbered men in garment manufacturing. By 1900, more than two hundred thousand workers were producing an ever-expanding array of ready-made clothing. Men worked as skilled cutters or tailors, while women handled the bulk of simple stitching and piecework, such as the sewing of collars and cuffs and buttonholes and buttons. In general, men produced the finer grades of clothing, such as suits and cloaks, while women contributed to the production cheaper items like skirts, shirtwaists (blouses), and underwear.

Centered in New York, Philadelphia, Boston, and Chicago with smaller operations in St. Louis, Cleveland, and Baltimore, the garment industry employed large numbers of foreign-born women, with Jews clustering in women's wear and Italians in men's wear. The majority of these women worked in large "inside shops" that employed as many as several hundred workers and produced entire garments. However, a sizable number worked in the "outside shops" that had characterized the garment industry since the antebellum era.

In the small outside shops, women assembled precut pieces of garments through a system known as subcontracting. Gathering six or seven women in tenement shops, subcontractors paid these workers by the piece and then charged the merchants or manufacturers who bought the final products a price large enough to ensure themselves a profit. Subcontractors also tapped the pool of needy women whose household responsibilities kept them at home; these women worked at very low rates, often by hand and with the help of their children. By the end of the century, the garment industry had become notorious for its **sweatshop** conditions.

Retail Sales and Office Work

For white women fluent in English, department stores and offices offered alternatives to the factory. Although supervision was intense and chances for advancement virtually nil, the work was cleaner and often steadier, the hours shorter, and the pay just a little bit better. African American women, however, could find such jobs only within their own communities; managers of big department stores like Macy's hired African American women to operate elevators or to stock shelves in the storeroom but rarely to sell the merchandise.

Read about **"The First Day on the Job"**[2]

Rahel Gollup (1880–1925) emigrated from Russia in 1892, when she was twelve years old, and settled with her family in New York City. She soon took a job in one of the sweatshops of the Lower East Side's garment industry.

Review the source; write a short response to the following questions.

1. What does Rahel Gollup Cohen's reminiscences tell us about gender relations in the turn-of-the-century garment industry?
2. Why did she think the older workers did not like her?

New technologies facilitated the employment of women in the office. Calculators, dictaphones, and stencil and mimeograph machines, as well as bookkeeping and billing machines, simplified many office tasks. In this way, office work was becoming akin to light manufacturing, a sector already associated with women. However, no machine became so quickly and so completely tagged as "feminine" as the typewriter, which was widely introduced in the 1880s. Stenographer-typist soon became the first office position to be dominated by women.

Saleswomen and office workers epitomized the working-class New Woman. Required by their employers to dress simply but smartly, they cut stylish figures as they headed to their downtown offices. Women in retailing often lived apart from their families, skimping on groceries to pay the rent in a fashionable neighborhood. Better-educated than their factory-working peers and inclined to see themselves as "business women" rather than "operatives," they set a standard for working-class respectability.

Domestic Service

With business and industry offering more desirable alternatives, the proportion of women working in domestic service began to shrink. In 1870, one of every two female wage earners worked as a domestic servant; by 1910, the proportion had declined to one of four. However, the growing urban middle class created such a huge demand that the absolute number of domestic servants in the United States doubled in the half century after 1870 to nearly two million.

Young women did not want to work as servants. It was not so much the wage scale or even the actual labor, repetitive and strenuous as it was. The major disincentives were the hours, which were virtually unlimited, and the mistress's intrusive supervision. Domestic servants resented being forced to wear livery, for example, and being addressed by their first names. "I am Mary to every guest in the house," one worker complained, "and every stranger who appears at the kitchen door; in fact, how can I respect myself when no one else shows me any!"

Read about "Wage-Earning Women at the Turn of the Century"

By the end of the nineteenth century, many women in the nation's leading manufacturing and commercial centers were entering a variety of occupations, including new positions in offices and banks that supported the expansion of business. The widespread introduction of the typewriter in the 1880s created a new category of women's work and, at nearly the same time, fostered the development of stenography, which also became a stronghold of women's office work through much of the twentieth century.

A major depression in the 1890s increased the number of women in the labor force. Many worked to keep their family afloat after their husbands or fathers had lost their jobs. A study of working-class families in 1901, after the depression had ended, showed that more than half of principal breadwinners, mainly men, were still out of work.

Review the sources; write short responses to the following questions.

Clara Lanza, *Women Clerks in New York* [1891][3]
"Everybody Works but Father" [1905][4]

1. Why were women preferred as clerks?
2. In what way does the popular song illustrate through humor the division of labor by gender?

By the turn of the century, Irish, German, and Scandinavian immigrants dominated the field, with Irish women representing more than half of all servants. Twenty years later, while white women moved on to better jobs, African American women were catching up, representing nearly 40 percent of all servants.

NEW IMMIGRANTS

Irish and Scandinavian women often traveled alone, but most other "new immigrant" women made the journey with their husbands. Occasionally, a married man came in advance to secure work and a place to live, but he usually sent for his family as soon as possible immigrant women quickly reconstituted their households and acceded to such traditions as arranged marriages. Nevertheless, many women sought more than mere escape from the poverty of their Old World village. As one observer of immigrant life noted, wives routinely warned their husbands "that in America things will be different, for women have more power there."

MAP 12-1 Patterns of Immigration, 1820–1914[5]

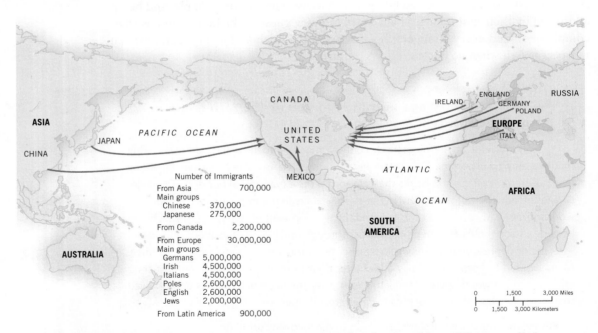

Between 1880 and 1924, nearly twenty-five million people immigrated to the United States. These so-called new immigrants came mainly from southern and eastern Europe and settled in the nation's cities.

Chinese

Between 1848, when the gold rush began, and 1882, when the Chinese Exclusion Act was passed by Congress, as many as three hundred thousand Chinese entered the United

Read about **"How Boston Working Women Lived"**[6]

In the mid-1880s, the head of the Massachusetts Bureau of Labor Statistics conducted an investigation of the living conditions of those women employed in Boston in occupations other than domestic service. He, like many other concerned citizens, hoped to get a picture of their "moral, sanitary, physical, and economical conditions." Many feared, for example, that the harsh conditions of their labor might drive a portion of working women into prostitution. To this end, Wright sent agents to interview more than one thousand working women and ascertained that the great majority lived at home, usually with their parents or relatives, in "orderly" households.

Review the source; write short responses to the following questions.

1. What were living conditions like for the women described in this report?
2. Why would this type of life be preferable to life in the native countries of these women?
3. Why does the report emphasize the wholesomeness of their living conditions?

States, but very few of this number were women. In the mid-nineteenth century, the majority of Chinese men who worked as itinerant laborers in railroad construction or mining simply lacked the resources to provide for a wife and family. Nor did they want to subject family members to the intense racism they had to endure. Chinese customs also impeded women's immigration. A married woman was duty bound first not to her husband but to her children and her parents-in-law, and she therefore stayed behind to serve them. Those few young women who did immigrate to the United States often did so because their fathers had sold them into domestic service or prostitution. The Page Act of 1875 and the Chinese Exclusion Act of 1882 brought the immigration of Chinese women to a virtual halt (see Chapter 11). In no other immigrant group did men come to outnumber women to such an extent: twenty to one.

For nearly a half century, the Chinese population in the United States was frozen in this state of gender imbalance. The number of Chinese women remained too small to replenish the population, and **antimiscegenation laws**, introduced in 1880, prevented men from marrying outside their ethnic group. Many men had wives and children living in China, and they visited them intermittently.

The approximately four thousand Chinese women per year who immigrated to the United States during this period were usually the wives or daughters of merchants. Most settled on the West Coast in exclusive ethnic enclaves known as Chinatowns. San Francisco was the most popular destination; at the turn of the century, nearly half of all Chinese women in the country lived there. Like other immigrant women, when the family economy demanded it, Chinese worked with their husbands in running laundries, grocery stores, and restaurants.

The wives of wealthy merchants rarely left their homes. The hostility of white Americans provoked sufficient fear to keep wives from venturing out alone; and

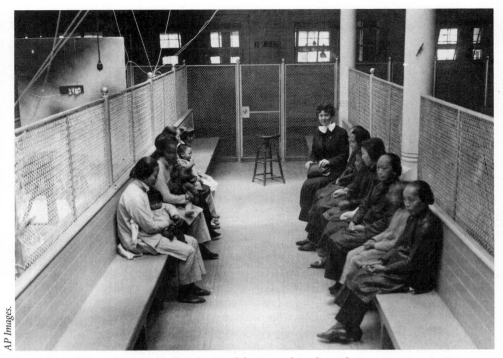

AP Images.

Immigrants from China were often detained for several weeks at the immigration station at Angel Island, which opened off the coast of San Francisco in 1910. At this time, court decisions in reference to the Chinese Exclusion Act allowed only those women who were the wives or children of Chinese merchants and U.S. citizens to enter the country. Between 1882 and 1943, approximately forty thousand Chinese women were admitted to the United States.

Confucian philosophy, which deemed women inferior and justified male domination, allowed them few freedoms. Isolated in the home, confined to their community, Chinese women had far less opportunity to develop an independent spirit than immigrant women of other ethnic groups. Nevertheless, although many customs survived the Pacific crossing, many Chinese women benefitted from the disruption of arranged marriages and extended families.

Their daughters, like those of other ethnic groups, were yet more able to resist the constraints of Old World customs. Daughters learned both ethnic pride and housekeeping from their mothers but often challenged parental authority to make their own decisions about vocation and marriage.

Italians

Between 1880 and 1920, of the nearly five million Italian new immigrants, the majority from southern Italy, men outnumbered women by three to one. At first, most of the men came to the United States to make money and then bring their earnings back to their families in their homeland. Only after 1900 did Italians immigrate mainly as families.

After recovering from the stressful ocean crossing, immigrant wives quickly reestablished their households, often in crowded tenements near their kin and in cities

concentrated in the Northeast and mid-Atlantic states. In much smaller proportions, Italians settled in California, while sizable communities also developed in New Orleans, Chicago, and Detroit. Italian parents expected sons and daughters to pitch in, as had been the practice in rural Italy. Little children helped their mothers with such tasks as gathering firewood or hanging clothes; older children left school to work in factories. Because of widespread prejudice against them, the vast majority of Italian men could secure only low-paying jobs in manual labor.

Compared to other new immigrant women, Italian wives rarely worked outside the home, except in cities where light industry was both plentiful and inviting. This is not to say that they did not help to stoke the family coffers, often contributing more than half of a family's income. Seasonal work in canneries provided an occasion to earn money; piecework at the kitchen table supplied more regular wages; and the money paid by boarders helped greatly to make ends meet. In New York City, for example, a government report estimated that 98 percent of home garment finishers were Italian women. In other cities, such as Chicago and Baltimore, where the men's clothing trade flourished, Italian women could also be found in the factories. But the income derived from these labor-intensive activities did not dispel the idea that married Italian women were first and foremost wives and mothers.

Their daughters, however, did not follow directly in their mothers' footsteps. After childhood of helping their mothers with chores and sharing the piecework—stringing rosary beads and stemming artificial flowers—daughters took a big step and looked for jobs in factories and offices.

By age fourteen, most Italian girls had quit school to join the ranks of wage earners. Dutiful daughters handed their wages to their mothers. However, peer culture often pushed girls to tamper with tradition and withhold a portion of their pay for themselves. One young woman described receiving her first paycheck: "I'll never forget the time I got my first pay, you know. . . . I went downtown first, and I spent a lot, more than half of my money . . . I just went hog wild, I guess." Control of a daughter's wage became a major source of conflict between the generations.

Daughters tended to marry later than their mothers had and often continued to work until the birth of children. They also gained more authority within their marriages. "Now I am an American girl," one woman exclaimed as a way to insist upon respect from her husband.

Eastern European Jews

As part of the second largest ethnic group among the new immigrants, Jewish women from Eastern Europe hoped to find greater opportunities in America as well as freedom from the religious persecution sweeping across their homeland. Before the outbreak of World War I, two million Jews—men and women in nearly equal number—sought refuge in the United States, and, unlike many other new immigrants, they had no intention of returning.

Like Italians, Jews entered through **Ellis Island**, and a very large proportion remained on the East Coast. In 1920, the majority lived between Boston and Baltimore, and nearly half lived in New York. Resettled close to their *landsleit* in ethnic enclaves

such as New York's Lower East Side and sections of Brooklyn and the Bronx, Jewish women set about making a new life for themselves and their families.

Jewish women came to the United States with considerable experience in wage earning. Married women who hailed from peasant villages had worked alongside their children in agricultural labor while their husbands ran small businesses in nearby towns or worked in shops of various kinds. A far larger number of women came from manufacturing centers and, married or single, took jobs in the garment industry. In the Old Country, then, it was common for husbands and wives to share the responsibility of breadwinning, and most mothers trained their daughters in a marketable skill.

Although many Jewish women found a warm welcome from kin upon their arrival and even secured a familiar job in the garment industry, they also discovered much that was new and unexpected. The actual living conditions of the ethnic neighborhood quickly deflated many dreams of what the New World held in store. Dark and dingy tenements, families crowded into tiny rooms—such realities hardly matched the stories they had heard in the Old Country. Marie Ganz, later a prominent Jewish activist, described her mother's disappointment when she finally joined her husband in their dingy tenement apartment. In disgust, she exclaimed: "So, we have crossed half the world for this!" But knowing they were going to stay, Jewish women coped with their disappointments and helped to reestablish what has been described as "a family culture of work." Like Italians, Jews assumed that everyone in the household would help to sustain it.

Although Jewish men were likely to earn higher wages than Italian men, they, too, found it nearly impossible to support their families on their own. Nevertheless, their wives broke with Old Country traditions and rarely worked outside the home. However, such was not the case for daughters. By age sixteen, most single Jewish women were working for wages.

Although most Jewish daughters, like their Italian contemporaries, accepted the responsibility to help support their family, many also dreamed of the education denied them in Russia, where Czarist law restricted schooling to wealthy Jews. Yet, although their parents often considered education a major mark of accomplishment for men, they saw schooling beyond the elementary grades as irrelevant for girls destined for domesticity or, worse, as a luxury that would spoil them for marriage. Despite such discouragement, many young women persisted. More than any other ethnic group, Jewish women had the highest rates of attendance at the evening classes sponsored by the New York public school system; by the 1920s, they could make comparable claims for college attendance.

By working outside the home and attending school, Jewish daughters adapted to American mores much more rapidly than their mothers did. They soon gave up their Old World names and quickly learned English. From their peers in the shops and schoolrooms, they learned to fashion themselves in the latest clothing and hairstyles. Popular amusements, such as movies and stage plays, reinforced these lessons. Leah Stern recalled that by high school, she imagined a life for herself that was far different from her mother's. "I didn't mean to go to work at fourteen or fifteen, marry at sixteen, be a mother at eighteen and an old woman at thirty," she recalled. To the contrary, Stern imagined herself a New Woman.

Read about "The Promised Land"

The majority of Jews who immigrated to the United States at the turn of the twentieth century, lived on the East Coast, mainly in Baltimore, Boston, and Greater New York. Mary Antin, who was born in the Russian Pale in 1881, came to Boston, where she flourished in the public schools. She published her first book, a memoir, at age thirteen and earned enough from royalties to pay the tuition at the prestigious high school, the Girls' Latin School. This excerpt is from her best-known work, which was a huge success and set her on a career as writer and lecturer.

Review the sources; write short responses to the following questions.

Immigration Figures for 1903[7]
Mary Antin, from *The Promised Land* (1912)[8]

1. Which region saw the most immigrants coming to America in 1903? Why do you think that was the case?
2. How did Mary Antin describe her mother and father? According to this excerpt, did Antin fully assimilate into the American culture and lifestyle?

THE NEW SOUTH

The surge of manufacturing that drew large numbers of women into the workforce in northern cities did not happen in the South. The majority of southern women, along with their families, remained bound to the single-crop agricultural system—cotton, tobacco, sugar, or rice—that persisted as the mainstay of the regional economy. Nevertheless, despite the small scale of development, by the 1880s the prospect of a boom in industry— a New South—had sparked optimism among its boosters, including many women.

Toward the end of the century, several manufacturing sectors—furniture, cigarettes and cigars, and textiles—offered white women opportunities for employment. Towns and cities sprang up around new factories, drawing African American women into a growing service economy. As women came to earn their own income, as small as it was, family dynamics began to change, particularly as young wage earners demanded more personal autonomy and power within relationships.

Tenant Farming and Sharecropping

For African Americans, 90 percent of whom lived in the South, the promises of the new era rang especially hollow, and the majority continued to endure a harsh routine that was reminiscent of slavery. Too often, it seemed, women of sharecropping families found themselves, with children in tow, working alongside their husbands in the fields. Like farm women everywhere, they also brought in a little cash by marketing crops from the family garden or selling eggs and butter. But even those women who had special skills, such as midwives, usually bartered their services or earned just small amounts of money. The promises of the New South were few, and poverty remained their lot in life.

 Read about "African American Life in a Post-Slavery World"

Although years removed from the blight of slavery that had permeated the landscape before the Civil War, African American women still faced many obstacles when it came to work or just basic human rights. Women of color faced racism that prevented them from getting the jobs and education that were now available to white women.

Women like Mary Church Terrell, an outspoken proponent of civil rights, and Ida B. Wells, an African-American journalist and early antilynching advocate, used their writing to encourage African Americans—and women in particular—to demand and fight for equal rights. They also provided vivid descriptions of day-to-day life for African American men and women.

Review the sources; write short responses to the following questions.

Mary Church Terrell, What It Means to Be Colored in the Capital of the United States[9] [1906]

Events in Paris, Texas, from Ida B. Wells, *A Red Record* [1895][10]

1. Summarize the types of obstacles that Mary Church Terrell chronicles about her day-to-day life as an African American Woman in Washington, D.C.
2. What event is Ida B. Wells describing in *A Red Record*? Who was accused of the crime and why?

Forced to rent a one- or two-room log cabin with shabby furnishings and to pay steep prices for supplies, tenant families often remained trapped for generations in a vicious cycle of dependency. The best a family could do was to reckon accounts at the end of the year, give the white landowner his share of the crop (usually between one-third and one-half), pay their debts, and move on while hoping for better luck on another plantation.

Despite high rates of mobility, African American women maintained a relatively stable network of kin. Tenant families frequently moved in groups, a custom that allowed women to pool their labor. Most women found it nearly impossible to manage single-handedly such demanding tasks as caring for children and the infirm alongside outdoor labor like hoeing or chopping cotton.

One consequence of persistent poverty was a sharp decline in fertility. Although farm families tended to be larger than average, with children an asset when many hands were needed, African American families were an exception. Poor nutrition and disease promoted infertility, miscarriages, and stillbirths—as well as early death. The life expectancy of African American men and women was thirty-three years.

The situation of poor white women was not much better. By the turn of the century, with fully one-third of all white farmers working as tenants, these farm women also juggled domestic responsibilities and outdoor labor. However, their families tended to be larger than those of neighboring black women. Indeed, white southern farm women had the highest birthrate in the nation, bearing an average of six children.

Despite women's important role in the family economy, men held the reins of power. In both black and white families, men negotiated with the landowner, squared away the accounts at the end of the year, took the crops to market, and managed the income from the sale. Men also assigned the chores and decided when and where to move.

Black and white women in farm families knew little beyond the boundaries of the countryside, and most admitted that southern rural life—especially as the price of cotton declined as the century came to a close—was unremittingly hard. But they could always hope for better lives for their children, particularly if their sons and daughters took advantage of the emerging urban economy. As one observer noted, "The young girls and boys are hastening to the towns and cities."

Domestic Service

"When a Southerner speaks of servants," a white Virginian woman commented, "negroes are always understood. Irish biddy, English Mary Ann, German Gretchen, and Scandinavia maids are as yet unknown factors. . . . Black Dinah holds the fort." In 1900, upward of 90 percent of all African American women working for wages in the South did so as domestic servants.

Girls not yet in their teens hired out as nursemaids, while older girls and unmarried women often worked as live-in maids or housekeepers for white families. Servants were in such short supply, though, that married women could limit their hours and refuse to sleep on the premises. For example, African American cooks, who earned the highest wages of all household workers, usually returned to their own homes after preparing the evening meal.

View the Image of "A Carolina Spinner"

In 1908, when Lewis Hine took this photograph, nearly one-quarter of the workforce in southern textile mills were children. Girls worked primarily in the spinning room, which was also known as the "Children's Department." (Lewis Hine [American 1874–1940], "A Carolina Spinner," 1908. Gelatin silver print, 43/4 x 7 in. Milwaukee Art Museum, Gift of the Sheldon M. Barnett Family. M1973.83)

Laundry work did not pay nearly as well as housekeeping but provided more flexibility. Workers typically carried huge bundles of soiled clothing and bedding back to their own neighborhoods, where they set up laundries outside their homes or shared common space—as well as conversation and even child care—with other washerwomen. Although vital to their families, their wages were so low that even white working-class families could afford to hire at least one black washerwoman. As a consequence, laundry work reigned as the largest single category of household service for African American women.

By the turn of the century, some African American women were rejecting domestic service to reap a small amount of what the New South had to offer. Even dirty, low-paying jobs like shucking oysters or stemming tobacco seemed preferable to cleaning a white woman's house or doing her laundry. Better yet was work in dressmaking and

millinery. Skilled seamstresses responded aggressively to white women's growing demand for fancy clothing by establishing their own retail shops.

Textiles and Mill Villages

African American women made little headway in the textile mills, where white women were determined to prevail. In 1897, more than a thousand white textile operatives in Atlanta walked off their jobs to protest the hiring of twenty black women. The strike ended after the mill owner discharged all African American women except scrubwomen.

For white men, women, and children, textiles, the New South's premier industry, offered new opportunities for wage earning. By the turn of the century, the number of operatives neared one hundred thousand, two-thirds of them working in the Carolinas alone. Textile production flourished in the Piedmont, a region that had once been the South's backcountry. Bolstered by hundreds of new, well-equipped factories and burgeoning mill villages and even a few sizable cities, the Piedmont now surpassed New England in the production of yarn and cloth.

Like the first spinning factories in New England, southern mills relied on the **family system of labor** (see Chapter 5). Because employers paid very low wages, children as young as seven or eight joined their parents in the mills. Employers even accommodated the schedules of nursing mothers. They sometimes allowed them to return home intermittently during the day to tend to their babies, but it was not unknown for a nursing mother to keep her baby in a box to the side of her machine. Despite such complications, mill owners preferred to hire women for the simple reason that they paid them about 60 percent of the wages paid to men.

Mill families lived in small houses that they rented from the mill owner. Without electricity or running water, these simple, wood-frame houses were usually no better and no worse than the cabins provided to tenant farmers. However, the mill superintendent usually extended his watch from factory to village, policing the behavior of the mill hands at both locations. A woman pausing to smoke a cigarette on her own porch could earn a reprimand from a vigilant superintendent.

Despite these restrictions, unmarried women found more opportunities for courtship than they did in the countryside. By their mid-teens, most of the boys and girls in the village were working in the mills and determinedly intermingling beyond the watchful eyes of parents. "My wife worked in the spinning room," one husband recalled. "We met, and it must have been love at first sight because it wasn't very long after we met that we married. She was a spinning room person, and I would go, when I could, up to the spinning room, and we'd lay in the window and court a little bit. We decided then just to get married." Such freedom would have been much more difficult to achieve on the farm, where parents put a high premium on a daughter's labor.

Nor were these marriages patterned on those of their parents. Their fathers had once enjoyed a high degree of authority as head of a complex family enterprise; their own husbands, mill operatives like themselves, could not claim the privileges enjoyed by the patriarch of a farm family. Moreover, married women, through their domestic networks of kith and kin, fortified their ties to the larger community, while their husbands, lacking

the opportunity to work collectively with male neighbors, stood at a greater distance from the social affairs of the village. Although poverty haunted the second generation of mill women, they found a modicum of comfort and security and a degree of friendship that had eluded their mothers. In their own way, they had joined the ranks of New Women.

NEW PROFESSIONS

The surest sign of the New Woman was women's increasing visibility in professional occupations. By 1920, nearly 12 percent of employed women enjoyed professional status. Although the overwhelming majority—nearly 75 percent—worked in two occupations long associated with domesticity, teaching and nursing, a sizable number had moved into professions that had been, for the most part, previously closed to women. More than a few became renowned for their achievements in higher education, medicine, the ministry, and visual arts.

Education

After the Civil War, women were hired specifically to carry into the nation's schools the "feminine" attributes of purity and piety—at approximately half the salary paid to male teachers. At the elementary level, women frequently entered the classroom with no more than a sixth-grade education themselves. However, a rapidly expanding school system, especially in the western states, created such an enormous demand for teachers that college graduates soon joined their less-educated peers. By the turn of the century, two-thirds of all professional women worked in education, and women represented 75 percent of the nation's teachers. However, turnover was high; most school boards required women to resign when they married.

Barred from most other professions, African American women pursued careers in teaching. After the Civil War, approximately six hundred thousand former slaves,

Table 12-1 Women Enrolled in Institutions of Higher Education, 1870–1920[11]

Year	Number of Women Enrolled (Thousands)	Percentage of All Students Enrolled
1870	11	21.0
1880	40	33.4
1890	56	35.9
1900	85	36.8
1910	140	39.6
1920	283	47.3

After American colleges and universities opened their doors to women, the percentage of women students grew quickly, such that by 1920 they represented nearly one-half of the student body.

(*Source:* Mabel Newcomer, *A Century of Higher Education for American Women.* Zenger Pub: New York, 1959, p. 46.)

adults as well as children, enrolled in elementary schools, many organized by the Freedmen's Bureau and run by Northerners. From this beginning, a black school system staffed mainly by southern African American women gradually developed. Four universities were founded in part to train black teachers: Howard University in Washington, D.C.; the Hampton Institute in Hampton, Virginia; Morehouse College in Atlanta; and Fisk University in Nashville. The Atlanta Female Baptist Seminary, founded in 1881 and renamed Spelman Seminary in 1884, made teacher training the core of its academic program and sent its students into communities that lacked even a single elementary school. A 1906 survey conducted reported that nearly 90 percent of Spelman alumnae had worked as teachers at some point in their lives.

Overall, according to census reports, in 1910, more than 22,500 black women were teaching nationwide, three times the number of black men in the profession. Respected for their ability to provide students with the benefits of literacy and other skills, these teachers frequently became community leaders. Nevertheless, a highly discriminatory pay scale forced many African American teachers to supplement their meager salary by working during weekends and summer months, usually as washerwomen or seamstresses.

During this period, white women made headway at the secondary level, although white men continued to hold the best-paying positions in the nation's high schools. A much smaller number, mainly those with graduate degrees, found positions in higher education as professors, deans, or administrators, although primarily in the women's colleges. Only on rare occasion did state or private coeducational institutions appoint women at faculty rank.

In the environment of the women's college, however, women professors and administrators thrived. Some educators, such as M. Carey Thomas who presided over Bryn Mawr, abjured marriage to devote their lives to their career, although they often forged partnerships with other women who shared their dedication to the college. Several women's colleges, such as Mt. Holyoke, provided apartments for faculty, replete with communal kitchens and dining rooms as well as strictly enforced curfews. Relieved of the most burdensome domestic tasks, these women could pursue their scholarship and enjoy the companionship of their colleagues.

Medicine

Although male physicians admitted that the practice of medicine was as much an art as a science, the majority nevertheless did not believe that women could make good doctors. As a consequence, aspiring female physicians found the doors to the mainstream medical colleges closed to them and trained instead at the "irregular" schools that specialized in various brands of **sectarian medicine**, such as homeopathy, water cure, or botanics. As late as 1893, only 37 of 105 "regular" medical colleges, such as those affiliated with major state universities, admitted women.

Pioneering physicians such as Marie Zakrzewska and Elizabeth Blackwell favored coeducational training and established their own colleges and clinics only after female applicants were repeatedly denied admission to the existing medical colleges. The Woman's Medical College of the New York Infirmary, which Elizabeth Blackwell and her physician sister, Emily, founded in Manhattan in 1868, introduced a rigorous three-year curriculum that combined laboratory and clinical training in advance of many other

medical colleges. By the turn of the century, nineteen women's medical colleges and nine women's hospitals had been established; by that time, many public universities admitted women, beginning with the University of Michigan in 1869. Women took advantage of these new opportunities, and the number of female physicians increased from only two hundred in 1860 to approximately seven thousand by the end of the century, when they represented 5 percent of all physicians in the United States. The American Medical Association admitted its first female member, Sarah Hackett Stevenson, in 1876.

Several cities served as major centers of professional activity. Chicago hospitals, for example, extended privileges to both male and female physicians. In Boston, by 1890s, nearly one in five physicians was a woman. In Washington, D.C., Howard University, which had opened its medical department in 1868, invited both black and white women to apply for admission. However, once enrolled, female students endured so many discriminatory practices that groups of Howard graduates set up their own clinics to train women.

African American women, who matriculated from medical schools at a higher rate than white women, confronted more postgraduation obstacles. Male-run hospitals excluded them entirely from clinical and research posts, and women's hospitals, which did offer residencies to black women, were too few in number to meet the demand. For example, none of the clinics founded by white women doctors in Washington, D.C., enrolled African American women in their training programs by the end of the century. A larger proportion of black women physicians used their medical diplomas, not as a credential to practice medicine but to secure a position in another profession, most commonly in education.

Ministry

Through much of the nineteenth century, the ministry, along with law, reigned as one of the most respected professions in the United States, and the nation's largest denominations—Roman Catholic, Episcopalian, Lutheran, Presbyterian, and Baptist— denied women ordination and the right to preach. Women nevertheless provided the bulk of membership, taught Sunday school, and performed the essential social services for their parishes. Their auxiliaries raised the funds to establish and maintain such important institutions as parochial schools, hospitals, orphanages, and asylums for prostitutes or unwed mothers. Women raised the funds to send hundreds of thousands of male missionaries to the West and around the world and to provide scholarships to train young men for the ministry. Yet, despite the impassioned pleas of such luminaries as Woman's Christian Temperance Union president Frances Willard, most denominations acknowledged women's service but refused them a position in the church hierarchy. Only by relying on their own networks within organized religion did women forge religious careers and avocations for themselves—mainly along the periphery of established churches.

African American women excelled in creating a vast social ministry and were especially active within the black Baptist Church. In the 1880s, they began to organize their own conventions at the state level and targeted education and missionary work. They also formed local Bible study classes for their own enlightenment, and although they made no claim on the right to ordination, women did become increasingly vocal in church governance as well as in the interpretation of doctrine.

View the Profiles of <u>M. Carey Thomas (1857–1935)</u> <u>and Maria Zakrewska</u>

Martha Carey Thomas was a noted suffragist and proponent of women's higher education, becoming the second president of Bryn Mawr College.

Marie Zakrzewska, one of the most determined of her generation, founded one of the most important institutions to foster women's medical training, the New England Hospital for Women and Children.

In 1900, Nannie Helen Burroughs built on this legacy, appearing before the National Baptist Convention held in Richmond, Virginia, to proclaim the "righteous discontent" of black women with their role within the church. Her speech stirred the women in attendance to form the Woman's Convention, Auxiliary to the National Baptist Convention. The **Woman's Convention**, separate from the all-male governing structure of the Baptist Church, became the largest representative body of black women and a major catalyst for social activism.

Within the Roman Catholic Church, religious communities of women continued to staff charitable institutions, including hospitals and orphanages. After 1880, women entering religious orders—mainly French, Irish, German, and French-Canadian immigrants—helped to develop a system of parochial schools in the major cities and, with virtually no training, became the principal teaching staff. For the most part, they did not aspire to take on larger diocesan roles or become priests. To the contrary, nuns, who lived communally in convents, took vows of celibacy, poverty, and obedience.

Other women found a smoother path to the ministry within the small denominations and emerging sects. The Quakers, Universalists, Unitarians, Freewill Baptists, and Christian Congregationalists, for example, allowed and occasionally encouraged women to serve as ministers. In 1870, women represented only five of the slightly more than six hundred clergy affiliated with Universalists and Unitarians; by 1890, the number of women ministers in these two liberal sects had grown to about seventy. The Unitarians took pride in the size of their delegation to the World Parliament of Religions, held in conjunction with the Columbian Exhibition of 1893 (Chicago World's Fair), particularly the number and prestige of the women who spoke from their platform. One reporter at the meeting insisted that "most of the Unitarian ideas were voiced by women," a group that included the aged Julia Ward Howe and the famed suffragist Elizabeth Cady Stanton.

In the so-called new religions of the late nineteenth century, women found the space to carve out leadership positions for themselves. New Thought and Christian Science developed in response to women's leadership. Mary Baker Eddy, who published the key text, *Science and Health*, in 1875, took credit for founding Christian Science. In 1879, she organized the Church of Christ (Scientist) in Boston and two years later opened a metaphysical college where she charged very large sums for lessons in spiritual healing. By the time of her death in 1910, the Christian Science movement had grown to perhaps as many as ninety thousand members, and she herself died a millionaire. New Thought, meanwhile,

Read "The Right to Be Ordained: Anna Howard Shaw"[12]

One who fought for the right of ordination within the Protestant churches was Anna Howard Shaw, who enrolled in Boston University to prepare for the ministry only to discover that she, the only woman in the class, would have a tougher time than her relatively well-to-do male peers. Ever determined, she applied for ordination to the Protestant Methodist Church and in 1880 became its first woman minister. However, Shaw soon tired of her assignment to a remote and small congregation, returned to Boston University, this time to its medical school, and earned a medical degree in 1885. By 1892, she was working full time as president of the National American Woman Suffrage Association, a position she held until 1913.

Review the source; write short responses to the following questions.

1. What argument did Shaw make for women's suffrage?
2. How is religion tied to the idea of suffrage in the NAWSA letter and why?

which remained a movement of loosely affiliated sects, provided a large forum for women to emerge as lecturers, teachers, writers, and publishers of mind cure philosophy.

Describing Women's Place in the Art World[13]

Women began to train at established arts schools and academies in 1844 when the Pennsylvania Academy of the Fine Arts opened its doors to them. Much like women set on a career in medicine, those who could afford to study abroad chose Europe as their destination. The great majority, as in the case of other aspiring professionals, relied on women's institutions. The Philadelphia School of Design for Women, founded in 1844, and the Woman's National Art Association, formed in 1866, became the first links in an emerging network of professional women artists. By the 1880s, women artists, much like women educators and physicians, had created a place for themselves in their profession that was determined as much by their gender as by their work. No group of professional women garnered as much respect and admiration as artists. Yet, like other professionals, women artists triumphed mainly in their own, separate circles or on the periphery of the larger profession.

Born in Philadelphia, Anna Lea traveled to Europe shortly after the Civil War to study art. In 1871, she settled in England, where she later married Henry Merritt, a fellow artist and critic, who died just three months after their wedding. Anna Lea Merritt established herself as a successful portrait painter and developed strong feelings about the place of women in the world of professional artists.

THE NEW WOMAN AT HOME

Despite the increasing number of women earning wages, and despite their impressive advances into professional occupations, the overwhelming majority of women

continued to work exclusively within "woman's sphere." As late as 1920, 75 percent of women identified themselves as full-time homemakers, fulfilling their seemingly timeless roles as wives, mothers, and housekeepers.

However, in urban areas and especially among the middle classes, home and family life had changed so dramatically since the Civil War that homemakers, in their own way, had joined the ranks of the New Woman.

Smaller Families, Better Babies

American families had shrunk in size over the course of the nineteenth century, so much so that by 1900 a middle-class household rarely comprised more than four or five members. In rural areas, families tended to be a little larger, as were those among African Americans and new immigrants. In the growing metropolis, however, disparities among various groups and regions lessened.

Smaller family size did not necessarily translate into more time for nondomestic pursuits. In a book published in 1909, the Swedish writer Ellen Key heralded *The Century of the Child*, capturing the essence of the new era. Poor families and rural mothers continued to regard their children as extra hands, sending them into the factories or fields as necessary; in contrast, urban middle-class mothers worked harder themselves to provide their children a beneficial emotional environment from the moment of birth. Such mothers no longer simply *tended* to their children's basic needs but *reared* them. They encouraged them along a developmental path, which was based on the most up-to-date scientific findings rather than common sense or folk wisdom.

A wealth of new literature on "scientific motherhood" appeared by the turn of the century, warning mothers to go beyond "instinct and mother love" and to follow the new precepts. The popular advice book, *Infant Care* (1914), for example, instructed mothers to begin toilet training when their child reached the age of two or three months. The author acknowledged that such early training demanded "much time and patience" on the part of the mother but insisted that proper toilet habits adopted at an early age would be "of untold value to the child, not only in babyhood, but throughout the whole of life." She also advised mothers to weigh their infants before and after each feeding to make certain they received the proper nourishment. By 1920, women were skimping more on household chores than their counterparts a half century earlier but devoting many more hours to child care and to shopping.

Woman's Sphere Transformed

The second industrial revolution transformed the way women handled their domestic chores. In comparison to the open hearth, the cast-iron stove not only used less fuel but made cooking easier and safer. After the turn of the century, gas replaced wood and coal in the newest designs of cook stoves, while electricity gradually took the place of gas as a source of indoor lighting in urban homes. For the middle-class housekeeper, electricity also powered a widening range of appliances, including some models of stoves and such luxuries as automatic dishwashers, ironing machines, and vacuum cleaners. By 1912, when the price of electricity became more affordable, about

16 percent of residences had electric service; by 1920, 37 percent did. Farm women, however, had to wait until the 1930s for rural electrification under the New Deal.

Perhaps no technology lightened the load of the housekeeper or marked the differences between the classes as much as indoor plumbing. Hauling water for cooking, laundry, cleaning, and bathing the entire family—and then carrying out the slops—was one of the housekeeper's most backbreaking chores. At the turn of the century, a sizable proportion of middle-class homes had indoor plumbing; for rural and working-class households, back-porch water faucets or nearby hydrants and outdoor privies remained the norm.

Middle-class housekeepers welcomed the new labor-saving technology, although as a whole it did little to reduce the amount of time spent in housework. Full-time and especially live-in servants disappeared at nearly the same rate that the new technologies came in. As a consequence, the matron of the house took on most of the chores that in earlier times a domestic "helper" or maid would have done. At the same time, domesticity, much like child care, achieved a new aura as reformers and experts proclaimed it a science.

Since the publication of *The American Woman's Home: Or, Principles of Domestic Science, Being a Guide to the Formation and Maintenance of Economical, Healthful, Beautiful, and Christian Homes* (1869) by sisters Catharine E. Beecher and Harriet Beecher Stowe, the topic of housekeeping kept many pens in motion. In the late 1860s, Melusina Fay Peirce proposed a scheme of cooperative housekeeping, whereby women would pool their efforts to reduce what she described as "the dusty drudgery of house ordering." She convinced a group of women in Cambridge, Massachusetts, to rent a neighborhood facility where they collectively managed all the cooking, baking, sewing, and laundry that they ordinarily performed in their individual homes, and then charged their husbands the going market rate for such services. The experiment ultimately failed, a fate Peirce attributed to "husband-power." Charlotte Perkins Gilman, writing nearly forty years later, came up with a variation on this scheme. In *Women and Economics* (1898), she advocated the integration of household chores into modern industry. Meal preparation, laundry, cleaning, and even child care would all become commercial enterprises. Like Peirce, Gilman advocated the removal of chores from individual homes; unlike her forerunner, she did not assume that only women would perform them.

Contrary to the expectations of visionaries like Peirce and Gilman, the home remained the site of women's domestic labor, and, much like child rearing, domesticity developed into a vocation demanding both dedication and training. The first public universities that admitted women in the 1860s and 1870s made **home economics** central to the curriculum designed for women, while groups of reformers established cooking schools for adult women and campaigned to introduce cooking and sewing classes into the public schools.

African American women's colleges encouraged students to learn cooking and sewing, viewing mastery of the domestic arts as a means of establishing respectability. At Spelman, for example, all senior women took turns, in groups of five, living in the Practice College, learning these arts by doing their own housekeeping, meal planning, and cooking. The educators did not envision this program as training for domestic service but as preparation for managing the home. Southern public schools, however, required black female students to study home economics specifically as preparation for future jobs as servants.

In 1908, the American Home Economics Association (AHEA) was organized to make home economics for girls what industrial education was for boys. Under the leadership of Ellen Swallow Richards, the first woman to receive a degree from the Massachusetts Institute of Technology and the first woman to serve on its faculty, the AHEA promoted the scientific study of nutrition and housekeeping. Richards herself aspired to make home economics a career track for the college woman who would then apply scientific principles "not only in her own home, but in all work for the amelioration of the condition of mankind." By the second decade of the twentieth century, when many secondary schools embraced vocational education, home economics became a staple in the curriculum. By 1920, one-third of all female high school students were enrolled in home economics courses, the majority preparing not to become researchers or teachers like Richards but full-time housewives.

From Production to Consumption

Over the course of the nineteenth century, commercial industries gradually took over the production of more and more items that women customarily made at home. Canned and prepared foods, toiletries and pharmaceuticals, soap and candles, clothing and bedding of all kinds were not only readily available in urban shops or through mail-order catalogs but were often cheaper and better than similar items made at home. Rural and urban working-class families nevertheless continued to regard their homes as active workplaces where butter could be churned before brought to market or where shirts could be stitched before collected by the contractor. Middle-class families, however, viewed their homes as distinct from the marketplace and assumed that homemakers would become the primary purchasers of basic necessities as well as luxuries.

Legions of advertisers stepped forward to persuade women to embrace a new identity—consumer. By the 1880s, national advertising agencies were selling their services to manufacturers, promising to create a demand among housewives for all kinds of brand-name products ranging from packaged cereals to patent medicines and cigarettes. Vast displays of advertisements supported the publication of a host of new magazines devoted to domesticity, such as *Ladies' Home Journal*, which interwove short stories and advice columns about women's role as consumer.

Mass retailers also helped to shape this new identity. Having debuted in the 1870s, department stores quickly grew into palaces of consumption, enticing women with an ever-expanding array of goods as well as providing them with a pleasant destination. Retailers such as Filene's in Boston, Marshall Field's in Chicago, Wanamaker's in Philadelphia, and Macy's in New York seemed to spare no expense in constructing grand, well-lighted buildings and in staging magnificent displays for their wares. Huge plate-glass windows filled with the latest fashions lured women inside. Elaborately decorated aisles marked seasonal holidays like Christmas and Easter or provided an imaginary escape to such exotic places as "the streets of Paris" or a Japanese garden. The department store offered a host of amenities: restaurants, travel bureaus, beauty parlors, writing rooms, post offices, libraries, butcher shops, and even roof gardens and child-care facilities.

Department stores catered to an urban clientele of women, whereas the chain stores reached the small towns and mail-order catalogs reached the countryside.

Montgomery Ward, founded in 1872, built its mail-order business by marketing to the Patrons of Husbandry; Sears, Roebuck and Company, by offering a nearly endless line of goods, became Ward's chief competitor in the 1890s. By this time, chain stores such as Woolworth's had begun to cut into the small-town market for cheap variety items, while supermarkets like A&P competed with independent grocers by offering a greater range of items at lower prices.

Not all married women embraced this new identity with equal fervor. Many immigrants were either too poor or bound to traditional ways. Many men simply refused to turn over their wages to their wives, thus curtailing their ability to shop. Yet, for most women with the means to do so, shopping became an important social ritual, a reason to meet friends for lunch or tea, and, equally important, a major domestic responsibility.

Conclusion

"The destiny of the world today lies in the hearts and brains of her women," pronounced Mary Seymour Howell in 1887. "The world can not travel upward faster than the feet of her women are climbing the paths of progress." Seymour's prognosis was shared by many of her contemporaries who had witnessed significant changes in women's work since the Civil War. Whether women now earned a small pittance in the nation's factories or fields, or commanded a sizable salary as the first generation to make a significant inroad into the professions, the most optimistic believed women were breaking sharply with the circumscribed life of the past. Nevertheless, the majority eventually withdrew from the world of work to marry and care for a family. But even then, their activities within the home bore only a superficial resemblance to their mothers'. The ideology of separate spheres, still resilient, had begun to break down under the challenge of the New Woman.

 Study the <u>Key Terms</u> for New Women, 1857–1915

Critical Thinking Questions

1. Why did women prefer jobs in manufacturing over those in domestic service?
2. Why did Jewish immigrant women predominate in the garment trades?
3. How did the rise of the southern textile industry affect race relations between women?
4. Why did women often rely on their own networks and create separate institutions to pursue careers in the professions?
5. How did child care change at the turn of the century?

Text Credits

1. Walter D. Kampheofner, Wolfgang Helbich, and Ulrike Sommer, eds., Susan Carter Vogel, trans. *News from the Land for Freedom: German Immigrants Write Home*, (Ithaca, NY: Cornell University Press, 1991), pp. 95–97.

2. Rose Cohen, *Out of the Shadow: A Russian Jewish Girlhood on the Lower East Side* (New York: George H. Doran Co., 1918), pp. 108–111.

3. Clara Lanza, Women as Clerks in New York, *Cosmopolitan* 10 (1891).

4. Everybody Works but Father" (1905).

5. Library of Congress.

6. From "The Working Girls of Boston," in Carroll Wright, 15th Annual Report of the Massachusetts Bureau of Statistics of Labor (Boston, 1884).

7. Library of Congress.

8. Mary Antin, from The Promised Land (1912).

9. The Independent, January 24, 1907, pp. 181–186.

10. Ida Wells Barnett, *A Red Record* (Chicago: Donohue & Henneberry, 1895), pp. 8–15.

11. Mabel Newcomer, *A Century of Higher Education for American Women* (New York: 1959), p. 46.

12. Anna Howard Shaw and Elizabeth G. Jordon, *The Story of a Pioneer* (New York: Harper & Brothers, 1915).

13. Anna Lea Merritt, A Letter to Artists: Especially Women *Artists, Lippincott's Monthly Magazine* 64 (March 1900): pp. 463–69.

Recommended Reading

Susan Porter Benson. *Counter Cultures: Saleswomen, Managers, and Customers in American Department Stores, 1890–1940*. Urbana, IL: University of Illinois Press, 1986. A three-way study of department stores with keen attention to the dynamics of class as well as gender. Fascinating analysis of the operation of women's culture in the workplace.

Renee Bergland. *Maria Mitchell and the Sexing of Science: An Astronomer among the American Romantics*. Boston: Beacon, 2008. A major biography of the first woman astronomer at Vassar College. Bergland offers a detailed narrative of Mitchell's life as well as an insightful examination of the transformation of astronomy from a hobby to a profession and the implications of this transformation for the gendering of science.

Virginia G. Drachman. *Hospital with a Heart: Women Doctors and the Paradox of Separatism at the New England Hospital 1862–1969*. Ithaca, NY: Cornell University Press, 1984. Traces the career of Dr. Marie Zakrzewska as founder of the long-lived women's hospital and insightfully examines the history of the hospital within the larger context of a general shift from gender separatism to integration and especially the consolidation of medicine as a profession.

Susan A. Glenn. *Daughters of the Shtetl: Life and Labor in the Immigrant Generation*. Ithaca, NY: Cornell University Press, 1990. Glenn makes a powerful case for the impact of wage-labor on immigrant women's behavior and expectations. A brilliant, well-researched study of Jewish New Women.

Jacquelyn Dowd Hall, Mary Murphy, James Leloudis, Robert Korstad, Lu Ann Jones, and Christopher B. Daly. *Like a Family: The Making of a Southern Cotton Mill World*. Chapel Hill, NC: University of North Carolina Press, 1987. Based in part on oral histories, this book examines the transformation of the Piedmont into a center of industrial production.

Evelyn Brooks Higginbotham. *Righteous Discontent: The Women's Movement in the Black Baptist Church, 1880–1920.* Cambridge, MA: Harvard University Press, 1993. A rich narrative tracing the rise of the Woman's Convention of the black Baptist Church, highlighting women's role in social activism and in establishing a place for themselves in church governance and interpretation of theology.

Tara W. Hunter. *To 'Joy My Freedom: Southern Black Women's Lives and Labors after the Civil War.* Cambridge, MA: Harvard University Press, 1997. A study of African American women who worked in household service in the New South. Hunter's research extends well beyond the workplace to consider neighborhood life as well as commercial amusements as focal points for women's fight for dignity and self-respect.

Sarah Abigail Leavitt. *From Catharine Beecher to Martha Stewart: A Cultural History of Domestic Advice.* Chapel Hill, NC: University of North Carolina Press, 2002. An insightful and compelling survey of the major trends in tips to homemakers and in the setting of standards for domesticity.

Laura R. Prieto. *At Home in the Studio: The Professionalization of Women Artists in America.* Cambridge, MA: Harvard University Press, 2001. A close study of the emergence of professional identity among women artists, their use of domestic and "feminine" metaphors to break into the art world and the contradictions that such practices bequeathed to future generations.

Beryl Satter. *Each Mind a Kingdom: American Women, Sexual Purity, and the New Thought Movement, 1875–1920.* Berkeley, CA: University of California Press, 1999. A deeply researched and highly engaging study of women's leadership in the New Thought movement. Satter links the role of women as mind-cure healers and the turn-of-the-century woman's movement.

Sharon Hartman Strom. *Beyond the Typewriter: Gender, Class, and the Origins of Modern American Office Work, 1900–1930.* Urbana, IL: University of Illinois Press, 1992. Examines the processes by which women became the prime targets for recruitment to office work in the early twentieth century. Strom vividly illustrates the office hierarchy and the place of scientific management in maintaining male dominance.

Diane C. Vecchio. *Merchants, Midwives, and Laboring Women: Italian Migrants in Urban America.* Urbana, IL: University of Illinois Press, 2006. Makes a strong case that Italian immigrant women often worked outside the home, depending on the local economy. The author compares labor force patterns in Milwaukee, Wisconsin, a heavy-industry town, and Endicott, New York, a center of light manufacturing.

Judy Yung. *Unbound Feet: A Social History of Chinese Women in San Francisco.* Berkeley, CA: University of California Press, 1995. Chooses the theme of foot binding to frame her remarkable study of social change. Yung begins with the cloistered lives of nineteenth-century immigrant women and ends with the activism of the World War II generation.

CHAPTER 13

THE WOMAN MOVEMENT, 1860–1900

LEARNING OBJECTIVES

- What strategies did various women's organizations develop to address the needs of wage-earning women?
- How did federation improve the ability of organized women to wage their campaigns?
- Lacking the vote, how did women participate in the great political campaigns of the 1890s?
- What role did women play in the missionary movements of the late nineteenth century?

Explore Chapter 13
Multimedia Resources

TIMELINE

1861	Woman's Union Missionary Society forms
1869	Wyoming territorial legislature grants women the right to vote National Woman Suffrage Association formed American Woman Suffrage Association formed
1877	Women's Educational and Industrial Union forms
1879	Frances E. Willard assumes WCTU presidency
1881	Willard introduces "Do-Everything" Policy at WCTU annual meeting WCTU Southern organizing drive
1882	U.S. Senate and House crate committees on woman suffrage
1887	Kansas women vote in school board and municipal elections
1888	National and International Council of Women Illinois Woman's Alliance, together on the second line in the 1888 section. Illinois is incorrectly positioned here. Illinois Woman's Alliance forms
1890	WCTU membership tops 150,000 General Federation of Women's Clubs forms AWSA and NWSA merge to form the National American Association of Woman Suffrage Wyoming becomes first state to enfranchise women
1892	Ida B. Wells publishes *Southern Horrors*
1893	National Council of Jewish Women forms First African American YWCA organizes in Dayton, Ohio Colorado grants women the right to vote
1894	World YWCA organizes

1896	**National Association of Colored Women forms**
	Women gain right to vote in Utah and Idaho
1897	**National Congress of Mothers forms**
	Victoria Earle Mathews establishes White Rose Home
	and Industrial Association
1898	**World YWCA holds first convention**
1906	**National League for the Protection of Colored Women forms**

ELIZABETH CADY STANTON AND SUSAN B. ANTHONY HAD PROPOSED AN INTER-NATIONAL MEETING OF SUFFRAGISTS TO COMMEMORATE THE FORTIETH ANNI-VERSARY OF THE FIRST WOMAN'S RIGHTS MEETING AT SENECA FALLS, NEW YORK. As the anniversary approached, leaders from various women's organizations decided to broaden the agenda by extending an invitation to "women workers along all lines of social, intellectual, moral or civic progress and reform . . . whether they be advocates of the ballot or opposed to women's suffrage."

In March 1888, representatives from fifty-three women's organizations gathered in the nation's capital to celebrate the progress of women. The railroads offered reduced fares to travelers from across the country, while steamships brought delegates from as far away as England, Finland, and Germany. After more than a week of meetings, the delegates adopted a platform that, to Stanton's dismay, did not include woman suffrage but instead listed its "cardinal tenet" as woman's right to "equal wages for equal work." Moreover, the delegates chose to honor Frances Willard for her outstanding leadership in the Woman's Christian Temperance Union by naming her, rather than Stanton, as president of the new organization. The meetings concluded with the formation of the **International Council of Women** (ICW), which would build trans-Atlantic bridges between women activists and the National Council of Women (NCW), which would link American organizations.

The formation of the ICW and the NCW marked a high point in what the delegates referred to as the "woman movement." Deeply involved in public affairs, the rising generation of women continued to rely on single-sex voluntary organizations to advance their goals, and activists were less invested in the right to vote than in the imperative to reform society. Organized women would—in the words of one of the speakers—"plead for freedom for themselves in the name of and for the good of humanity."

However, this devotion to "the good of humanity" did not dispel the biases and prejudices of the era. While white activists reached out to their working-class "sisters," they rarely crossed the lines of race, ethnicity, or religion. Nor did white activists do much to protest the rise of Jim Crow and the increasing violence waged against African Americans. Moreover, although strongly committed to democratic ideals, they associated much of the merit of their "civilization" with the Anglo-Saxons who predominated. Few of these women opposed the imperialism that took the nation into the overseas war that forced new territories and new populations under the rule of the United States.

 Read how "To Legislate for Womanhood, for Childhood, and the Home"

Frances Willard[1] outlined a plan to create a "republic of women" within the United States at the first meeting of the **National Council of Women** (NCW). The NCW, organized in 1888, comprised the presidents of national organizations of women dedicated to the advancement of women's work in education, philanthropy, reform, and social culture. As president of the new organization, she used her office to push the delegates to think boldly about their prospects for power.

Review the source; write short responses to the following questions.

1. What was the "republic of women"?
2. What were some of their goals, as outlined by Frances Willard?

CROSS-CLASS ALLIANCES

During final decades of the nineteenth century, the NCW's commitment to "equal wages for equal work" inspired a large number of middle- and upper-class women activists to create a vast array of social services specifically for wage-earning women. This enterprise, however well meaning, failed to bridge a growing gap between the classes or to ameliorate poverty. In an era marked by labor strife and massive strikes, by social dislocations caused by a huge wave of rural black migration into industrializing cities and European immigration, and by poverty growing in the wake of a major depression, inequality grew larger rather than smaller.

Young Women's Christian Association

Shortly after the Civil War, the Young Women's Christian Association (YWCA) organized as an offshoot of the Ladies' Christian Union, which had formed in New York City in 1858 to assist "young women who are dependent on their own exertions for support." Bringing souls to Christ was their primary goal, but the Protestant women who founded the YWCA also aspired to instill in young women a respect for labor and to encourage them to develop their talents to the fullest. "It is manifestly the arrangement of Providence," one director wrote, "that a large proportion, not of men only but also of women, should procure the necessities of life by labor, in some of its various forms, bodily or mental, with hands or brain." Many of the well-to-do founders also hoped to bridge "the gulf that divides the favored from the less fortunate."

By 1875, when twenty-eight associations had formed in the nation's major cities and on several college campuses, more than half of the local chapters maintained employment committees to help newcomers to the city secure reputable employment, and the

majority sponsored inexpensive housing. One of the early directors asked rhetorically what the association could do for young women separated from their families. The obvious answer was: "It can build them a home—not a boardinghouse—with cheerful warmth, baths, public parlors, a library with stimulating books for leisure, morning and evening worship."

The leaders of the YWCA aimed to improve women's skills so they could compete more effectively in a labor market dominated by men. The New York YWCA offered the first class in typewriting in 1870. Most YWCAs ran training schools for domestic servants and helped to place them with respectable families. Because most women preferred to work in manufacturing or retail trades, classes in dressmaking, millinery, and stenography were the most popular. In smaller numbers, women also studied woodworking, industrial drawing, and upholstery. Programs in calisthenics and gymnastics grew in number from their introduction in the late 1870s, while the advanced classes on anatomy and hygiene prepared women to become teachers of physical training in the city's public schools. By the end of the century, the educational component had become so successful that many local Ys converted residential rooms into classrooms.

View the Profile of <u>Grace Hoadley Dodge</u>

In 1881, Grace H. Dodge helped to organize a club of working women in New York City and later became the president of the National Board of the YWCA in 1906. The following year, she organized the New York Travelers' Aid Society to protect young women new to the city, which, under her leadership, grew into national and international organizations.

The YWCA did not operate as a charity, although local associations covered much of their operating expenses through endowments maintained by wealthy women affiliated with Protestant churches. Residents paid for room and board. The superintendent supplied additional services, such as laundry, cleaning, and even visiting nurses and physicians if necessary. They also maintained a library and encouraged the young women to organize reading clubs and Bible study classes. Each resident, as a professed Christian, was expected to attend a church of her choice every Sunday and was "affectionately invited," although not required, to participate in evening devotional services. By 1906, more than six hundred local chapters had affiliated with the National Board of the YWCA.

By this time, the YWCA had become an international organization. The World's YWCA organized in 1894, with headquarters in London and thriving chapters in Norway and Sweden. Although the British YWCA dated only to 1885, it had deep roots in women's social services and soon joined Americans to add affiliates in countries such as India, Argentina, France, Italy, Japan, and China.

University of Delaware Library.

The advertisement for this book, which was published in 1901, read: "A Book Giving Full Information on all the Mysterious and Complex Matters pertaining to Women." Dr. Mary R. Melendy, a devotee of the WCTU, advised women on maternal health and well-being and child rearing.

Christian Homes for African American Women Workers

The YWCA at first opened membership to African American women, but toward the end of the century, as the black urban population grew and as Jim Crow took hold, the all-white boards encouraged the formation of racially segregated facilities. In 1893, in Dayton, Ohio, the first black YWCA formed, followed by similar associations in Philadelphia, Baltimore, Harlem, Brooklyn, and Washington, D.C. In the South, black Y s formed mainly on college campuses. The black branches operated separately and subordinately to the white YWCAs in their localities but offered similar programs inspired by the determination to provide Christian influence and protection to young working women.

In addition to the YWCA, and occasionally in association with the local branch, African American women in northern communities created their own array of organizations to address the plight of young working women, particularly displaced

southerners. In 1897, Victoria Earle Mathews, president of the Brooklyn Women's Club, helped to establish the **White Rose Home and Industrial Association** to "protect self-supporting colored girls who were coming to New York for the first time." Incorporating the symbolism of purity and virtue into its name, the White Rose Home offered temporary room and board to job seekers. Mathews also organized groups of women to meet newcomers at the train and boat depots, hoping to protect them from the unscrupulous recruiters who tried to lure the naive young women into less-than-honorable jobs, including prostitution. The sponsors of the White Rose Home offered instruction in domestic skills as well as in etiquette and "proper" dress and also sponsored a kindergarten for working mothers.

African American women in other cities founded dozens of similar institutions. In 1895, clubwomen established the **Sojourner Truth Home for Working Girls** in Washington, D.C. In 1908, a group of prominent black Chicago clubwomen opened the **Phyllis Wheatley Home**, which provided temporary lodging for young women and secured reputable employment for them. In 1905, in Philadelphia, the Association for the Protection of Colored Women offered similar services, in one year dispensing aid to more than thirteen hundred young black women.

From this small beginning, the **National League for the Protection of Colored Women** formed in 1906. The league coordinated activities among affiliated chapters and reached out to southern organizations, such as church groups and women's clubs, for help in distributing information about securing employment and lodging in northern cities.

Jane Edna Hunter, a daughter of sharecroppers who had left the South to find a better life for herself in Cleveland, understood the difficulties of finding suitable housing and employment. "Sometimes I feel I just been living my life for the moment when I can start things moving toward a home for poor Negro working girls in the city," she later recalled. In 1911, she invited a group of black domestic servants to join together in establishing the Phillis Wheatley Association and within a year they opened a boardinghouse. The association and home quickly became a prominent institution within Cleveland's black community, supported by funds and the sweat power of local African American women. Eventually Hunter tapped the goodwill of prominent whites, including those who benefited directly from her training programs for domestic servants. By the 1930s, the Phillis Wheatley Home had provided the model for similar homes across the country, as far away as Seattle and Atlanta.

Women's Educational and Industrial Union

As early as 1868, the members of the New England Women's Club (NEWC) asked themselves what they could do to better the conditions of the growing number of women working in Boston. The Civil War had given local industry a major boost, making Boston the major manufacturing center of cheap, ready-to-wear garments. Alongside the garment industry, other branches of light manufacture and retail sales grew. Moreover, young women from throughout New England, Canada, the South, and Europe hoped to find work in domestic service in the city with the highest ratio of servants per family of any northern city.

The NEWC drew up a plan of action that called for the establishment of boarding-houses, the creation of vocational schools, and a program to assist new arrivals in the city. Little came of this plan until 1877, when clubwomen found the resources to inaugurate the **Women's Educational and Industrial Union** (WEIU). This time, the idea of forming "a Union of all classes and conditions of women" caught on. Within a year, the WEIU had recruited four hundred members; within the next decade, membership tripled.

The WEIU, known as the "most cherished plan" of the NEWC, became an umbrella for a wide assortment of programs that were similar in design to those operated by Christian voluntary organizations. The Industrial Department operated a retail establishment where house-bound women could sell their handiwork or prepared foods. The Employment Committee maintained a job registry; the Reception Committee kept open its large headquarters, which included offices and a well-stocked reading room and library, and the Lunch Committee managed an inexpensive restaurant for women who worked in downtown stores and offices. The Protective Committee recruited lawyers who worked pro bono to help women gain wages withheld by dishonest employers. The Befriending Committee oversaw a mutual sick benefit program that helped women get through periods when they were too incapacitated to work and a second program to assist newcomers to Boston.

Even more than YWCA officials, the WEIU directors promoted their institution as a **cross-class alliance** of women. "We meet," the Boston president insisted, "not purse to purse or talent to talent or acquirement to acquirement, but heart to heart . . . on the common ground of humanity." Although the services offered to wage-earning women were the most extensive, the WEIU-sponsored programs aimed specifically at women embarking on professional careers. The Lecture Committee employed the talents of such veteran reformers as Lucy Stone and Mary Livermore. The Committee on Moral and Spiritual Development encouraged dozens of women, including Julia Ward Howe, to develop their ministerial talents in one of the few venues available to them; its Sunday afternoon meetings provided a pulpit to aspiring women preachers.

The WEIU thrived in at least a dozen other cities, including Buffalo, Providence, Cleveland, and San Francisco. Hundreds of smaller societies with similar agendas proliferated in many other communities. The Woman's Union for Good Works of Haverhill, Massachusetts, which dated to 1891, operated a home for young working women; the Flower Festival Society of Los Angeles, which organized in 1885, hosted an annual exhibition of flowers and used the proceeds to fund a boarding home for working women.

Illinois Woman's Alliance

Like Boston, Chicago offered women many jobs in domestic service, retail sales, and light manufacturing and in the last decades of the nineteenth century pushed ahead to become the nation's foremost industrial city. By 1890, the size of its garment industry surpassed that of Boston, and eight thousand women—more than half of the total female workforce in manufacturing—worked in the production of clothing. Moreover,

Chicago was home to the most vibrant sector of the labor movement at this time, and its thriving immigrant community ensured a sharp radical edge. As a consequence of this unique combination of industrial conditions and local politics, women with allegiance to the labor and socialist movements spearheaded the efforts to befriend the working woman.

In 1888, a group of women activists led by British-born Elizabeth Morgan formed the **Illinois Woman's Alliance** (IWA). Morgan, whose husband headed the local Trades and Labor Assembly and the Socialist Labor Party, was one of the first women to join the Knights of Labor and went on to become the main organizer for the local **Ladies' Federal Labor Union**, which took in workers from various trades and which affiliated with the American Federation of Labor. Morgan's associate was Corinne Brown, who had worked for thirteen years in the Chicago public school system. Brown, like Morgan, considered herself a socialist, but as a wife of a prominent banker, she also moved comfortably within the circles of the prestigious Chicago Woman's Club. The two activists secured delegates from thirty local women's organizations and the Trades and Labor Assembly to form the IWA, which took as its motto "Justice to Children, Loyalty to Women."

The IWA announced its intention "to prevent the moral, mental, and physical degradation of women and children as wage-workers by enforcing the factory ordinances and the compulsory education law" as well as "to secure the enactment of such new laws as may be found necessary." The IWA also conducted clothing drives for the poor, managed to persuade the city government to establish public bath houses in working-class households, and campaigned against police harassment of prostitutes.

Although the IWA lasted only six years, the coalition of Chicago women's organizations had a major impact on public policy in Illinois. In response to their campaigning, in 1893, the Illinois legislature passed the most important sweatshop legislation of the decade. To enforce compliance with the new law, which limited the hours of labor for women and children to eight, the governor appointed Florence Kelley as the state's chief factory inspector.

However, employers in turn organized the Illinois Manufacturers' Association and challenged key aspects of the law. In 1894, the Illinois Supreme Court struck down the **Illinois Factory Inspection Act**, and the IWA soon dissolved. Yet, despite this reversal, the IWA had managed to take an important step in securing the commitment of the state to the principles of social justice.

SPANNING THE NATION

By the end of the century, more than a dozen national organizations consolidated the power of American women. Some were relatively small, such as the National Council of Jewish Women, created in 1893; in contrast, the National Congress of Mothers, formed in 1897, grew quickly to become the Parent-Teachers Association, which continues to review policy in schools across the country. By the turn of the century, the largest organizations had established branches overseas.

National Woman's Christian Temperance Union

The WCTU had become the single largest organization of women in the United States by the time Frances Willard took over the presidency in 1879.

The WCTU became the first women's organization to build a base in the South. Willard, regarded as a "foreigner" by most southerners, conducted a successful four-month tour of the region in 1881. Sallie Chapin of Charleston, South Carolina, added so many chapters that by the end of the decade the South, previously considered a missionary field, had become fully integrated into the national organization and capable of supporting its own cadre of organizers. The southern WCTU nevertheless set its own standards, for example, by refusing to endorse woman suffrage and by maintaining separate chapters for black and white members.

By 1890, the National WCTU wielded considerable power and influence. Local chapters organized parallel to the established legislative districts, a strategy that allowed temperance activists to pressure their state representatives effectively. They lobbied for bills limiting or abolishing the sale of alcoholic beverages, imposing high license fees on retail establishments, or enacting local option laws. It was, however, Willard's **"do-everything" policy** that transformed the WCTU into an organization with far-reaching goals.

In 1881, Willard first advised WCTU members to "do everything" necessary to restrict the sale and consumption of alcohol. A few years later, she had broadened her agenda For example, at the 1889 National WCTU convention, delegates passed an antivivisection resolution and voted to petition Congress to prohibit the manufacture of cigarettes. They also decided to appeal to the Russian Czar for the humane treatment of Siberian exiles and to lobby state legislatures to fund free kindergartens, separate reformatories for women, and police matrons and women administrators in women's prisons. Issues of health and hygiene also figured prominently on their agenda. Willard herself campaigned for the use of whole-wheat flour in the baking of bread and better regulation of drugs prescribed by physicians. The *Union Signal*, the WCTU newspaper, urged women to fight for local ordinances to guarantee smoke-free environments. By 1896, the National WCTU had created thirty-nine departments, twenty-five of which involved women in social activism that did *not* involve temperance.

The Chicago WCTU, Willard's home chapter, emerged as a model of the "do-everything" policy. The Chicago union maintained two day nurseries, two Sunday schools, a vocational school for young people, a mission that sheltered four thousand homeless or destitute women within a twelve-month period, a free medical dispensary that treated more than sixteen hundred patients per year, and a lodging house for men that included a low-cost restaurant. The National WCTU also supported a temperance hospital in Chicago, a thirty-five room facility dedicated to treating all diseases without the use of medicinal alcohol.

"Were I to define in a sentence, the thought and purpose of the Woman's Christian Temperance Union," Willard offered, "I would reply: *It is to make the whole world HOMELIKE.*" By 1890, membership topped 150,000; including auxiliaries, such as the Young Women's Christian Temperance Union, that figure grew to more than 200,000.

A few years later, the WCTU had collected dues sufficient to support a twelve-story national headquarters in Chicago, known as the Woman's Temple. By this time, the fruits of international organizing, which had begun shortly after the WCTU formed, had also ripened into the World WCTU, the strongest, most vital international organization of women. Willard had succeeded in transforming the WCTU from a single-issue campaign against drink to a massive organization with a multifaceted agenda for social change.

National American Woman Suffrage Association

In contrast to the WCTU, which had early on endorsed the woman's ballot, both the National Woman Suffrage Association (NWSA) and the American Woman Suffrage Association (AWSA) advanced very slowly. By 1890, women enjoyed the right to vote in a few western territories, and they had gained partial suffrage in nineteen states. Kansas women, for example, had won the right to vote in school board and municipal elections in 1887. But these few victories could not disguise the fact that the prospect of full voting rights was no brighter than it had been at the end of the Civil War. Between 1870 and 1890, eight states held suffrage referenda, and all eight were defeated. At the federal level, the situation was even gloomier. In 1882, the House of Representatives and the Senate both created committees on woman suffrage. Their hearings, however, went nowhere; and in January 1887, the Senate voted to quash the measure and end discussion.

The differences between the NWSA and the AWSA during the Reconstruction era now seemed insignificant compared to their shared failure to bring women to the ballot box. It was time, advised Alice Stone Blackwell, the activist daughter of Lucy Stone and Henry Blackwell, for the NWSA and the AWSA to put aside these differences and maximize their resources by merging the two organizations.

After three years of negotiations and with steady encouragement from Susan B. Anthony, a convention held in February 1890 marked the formation of the **National American Woman Suffrage Association** (NAWSA). Initially, the old guard reigned over the new organization, with Elizabeth Cady Stanton serving as the first president. After just two years, Stanton turned over the office to Anthony, who determinedly nurtured a new generation of activists. Anthony held on to the presidency until 1900 and remained dedicated to the movement until her death in 1906.

At annual NAWSA conventions, delegates continued to debate the surest route to woman suffrage, that is, state *versus* federal strategies. Meanwhile, state campaigns went forward. Between 1870 and 1910, suffragists waged 480 campaigns in thirty-three states, most west of the Mississippi, but they managed to get referenda before the voters only seventeen times. Even more discouraging, all but two went down in defeat. These years became known, rightly so, as "the doldrums."

Although victory remained elusive, even at the state level, the NAWSA itself thrived. The new leadership streamlined operations and planned national conventions along more formal lines. With the induction of a sizable number of new members, the NAWSA became a truly national and diverse organization. Recent college graduates,

many employed outside the home, represented a growing constituency. Some very wealthy women added their luster to the new organization. In California, Mrs. Leland Stanford, wife of the railroad magnate, made generous financial contributions; in Illinois, Mrs. Potter Palmer played a similar role. Working-class women also emerged as a powerful force for suffrage. In the mid-1880s, the Knights of Labor, then at its peak, endorsed woman suffrage.

Read about the "Suffrage Visionary"[2]

Mary Seymour (1844–1913) was born and raised in Livingston County, New York. After her marriage to George Howell, a Presbyterian minister, she moved to Albany, where she became a leader in the woman suffrage movement. She also was a very popular speaker on the NAWSA campaign circuit and for the WCTU. In her address, "The Dawning of the Twentieth Century," she expressed her optimism about the times ahead, when woman would achieve full political rights and use them to improve society and the world.

Review the source; write short responses to the following questions.

1. Why is Howell so optimistic about the future in terms of women's status in the United States?
2. In what ways do her observations reflect her faith in women's participation in social reform movements and organizations?
3. Why does she argue for woman's rights by referencing their maternal roles?

The NAWSA had far less success in the South. In 1892, heeding Laura Clay's warning that the movement would go down in defeat "unless you bring in the South," the organization named the prominent Kentucky suffragist the chair of a new "Southern Committee" charged with organizing below the Mason-Dixon Line.

The NAWSA's "southern strategy" had a dramatic impact on the organization. To gratify the white southern delegation, the NAWSA chose Atlanta as the site of its 1895 convention. Anthony followed up by asking the elderly but still devoted Frederick Douglass to forgo the meeting. Abiding her request, Douglass was spared the insult of hearing the band play "Dixie" and the subsequent round of rebel yells. Nor did he hear Henry Blackwell, his erstwhile ally from antislavery campaigns, advocate woman suffrage on the grounds that "in every state save one there are more educated women than all the illiterate voters, white and black, native-born and foreign." In 1903, in the keynote address to the NAWSA convention held in New Orleans, Belle Kearney made her case by claiming that women's enfranchisement would "insure immediate and durable white supremacy, honestly attained."

The NAWSA's southern strategy advanced the racist drift of the organization but did little to further the suffrage cause. Southern white men proved intractable, preferring to deny the vote to black men rather than enfranchise any women, including their wives and daughters. Admitting defeat, the NAWSA leadership that succeeded Anthony decided simply to abandon the South. Meanwhile, the NAWSA's reliance on racist tactics drove away many African American suffragists.

Proportionately more committed to woman suffrage than their white contemporaries, black women chose to campaign for the ballot under the auspices of their separate WCTU chapters, church societies, or women's clubs. A few black leaders attended the annual NAWSA conventions and, on occasion, addressed the assembly. In 1900, club leader Mary Church Terrell appeared, mainly to condemn the NAWSA's racist policies.

General Federation of Women's Clubs

In April 1890, representatives from ninety-seven women's clubs met in New York City and formed the General Federation of Women's Clubs (GFWC). The leaders stepped into their new roles with a great deal of fanfare. They themselves were already prominent members of society; the first treasurer, for example, was Phoebe Hearst, wife of a wealthy U.S. Senator and mother of William Randolph Hearst of newspaper fame. Given the social composition of the leadership, it was not surprising that descriptions of their biennial national conventions—as well as of the sumptuous settings, elaborate dinners and lavish entertainments, and elegant gowns and precious jewelry of the attendees—appeared prominently in the society pages of newspapers.

However, at the local level, the second generation of club members advanced not as celebrities but as community leaders. They emphasized home life more than their predecessors did and developed programs to help members become better mothers and housekeepers. But as New Women, often college-educated themselves, they took up this work in a systematic manner. Committees formed to survey the problems associated with home sanitation; nutrition, including food preparation; and the management of servants. Some clubs established schools of domestic science and persuaded local school boards to incorporate their programs into the standard curriculum for high school girls.

From this point, women's clubs commonly branched out into educational reform, for example, by urging the creation of kindergartens within the public school system and presenting members as candidates for local school boards or as truant officers. Local women's clubs also worked with other organizations, such as the Association of Collegiate Alumnae and the WCTU, to secure better equipment for classrooms and higher salaries for teachers. Some clubs endowed scholarships in the women's colleges. The Rhode Island Women's Club worked relentlessly to create the women's college at Brown University, later known as Pembroke.

In the 1890s, statewide federations began to coordinate activities at the local level and to pool their resources for civic betterment. The New Hampshire Federation, for example, saved the forests of the White Mountains from the "vandals who would convert them into lumber and paper." Each state federation sponsored a committee on the Industrial Condition of Women and Children, which investigated conditions of labor, including wages. Massachusetts clubwomen collected so much data on the "dangerous trades" that the committee conducting this work secured an official investigation by the Board of Health. The New York State Federation, which began with ninety-nine clubs in 1895, grew so quickly that two years later more than two hundred clubs had affiliated, representing twenty-five thousand women.

Although at the time the GFWC represented no more than half of all the women's clubs in the United States, the national organization succeeded in showcasing women's involvement in civic reform. Indeed, as one club member observed, clubwomen were especially suited to these kinds of engagements, not least because "women's function, like charity, begins at home and then, like charity, goes everywhere." However, the generosity of the GFWC did not extend to women of color.

Read about "Women's Clubs: Shaping Public Opinion"

Women's clubs began in this environment of exclusion from most men's clubs and organizations. Groups of women decided to form their own clubs to provide their members with the cultural and intellectual outlets they craved. Many of these clubwomen found even greater fulfillment in social activism, in heading projects such as kindergartens, libraries, playgrounds, and beautification endeavors. They lobbied local governments for quality-of-life issues such as safe food and milk and clean cities and towns. Much to the dismay of their critics, who believed women should limit themselves to household concerns, women's clubs grew at a fast rate, and by 1915 comprised two million. Grover Cleveland, one such critic, judged the women's club movement as a threat to the sanctity of motherhood and predicted that their involvement would spell national disaster.

What started out as a way to socialize with other women became, in part, a movement that helped shape public opinion. Despite the fact that suffrage remained a goal, women achieved their greatest success in local civic endeavors and, after time, gained a political voice.

Review the sources; write short responses to the following questions.

Martha E.D. White, *Work of the Woman's Club* [1904][3]
Grover Cleveland, *Woman's Mission and Woman's Clubs* [1905][4]

1. What projects and/or advances did White cite as being a direct outcome of the work of women's clubs?
2. What was Grover Cleveland's main objection to women joining clubs?

National Association of Colored Women

African American organizers built on a long tradition of women's benevolent societies affiliated with various black churches, and by the late 1880s, they had organized their own clubs to address the many problems facing their communities. The foundation for a national organization was laid by the Colored Women's League, founded in 1893 by Mary Church Terrell, Anna Julia Cooper, and Mary Jane Patterson. The league claimed 113 branches in cities as scattered as Boston, Washington, Chicago, and St. Louis. Two years later, *The Women's Era*, a magazine dedicated to strengthening the network of black women activists, called a convention, and delegates concluded their meetings by forming a second organization, the National Federation of Afro-American Women. Then, in 1896, the two national organizations united as the National Association of Colored Women (NACW).

Mary Church Terrell served ably as the first president of the NACW. Born in 1863, the year of the Emancipation Proclamation, she had grown up in a middle-class family in Memphis and earned bachelor's and master's degrees at Oberlin College. After teaching at Wilberforce University in Xenia, Ohio, she took a position at the distinguished M Street High School in Washington, D.C., where she met and later married Robert Heberton Terrell, a fellow teacher who also practiced law. As president of the NACW, Mary Terrell developed into one of its most popular lecturers and writers.

The NACW passionately embraced the cause of racial uplift while developing programs of self-improvement for members. "The old notion that woman was intended by the Almighty to do only those things that men thought they ought to do is fast passing away," clubwoman Fanny Barrier Williams noted. "In our day and in this country, a woman's sphere is just as large as she can make it and still be true to her finer qualities of soul." Mainly middle-class, college-educated women, often the wives of successful professional or businessmen and teachers themselves, club leaders prided themselves on being both good Christians and highly respectable members of their communities.

Some NACW leaders also believed that women were better suited than men to lead the battle for racial justice. Frances Ellen Watkins Harper, for example, appealed to women to embrace their responsibilities, insisting that women evinced little of men's "lust for power" and instead were "grandly constructive" in their work. Women, in her opinion, displayed a higher morality and could therefore serve better as ambassadors of the race.

The NACW also formed in part as a response to their exclusion from white women's organizations. Especially as Jim Crow tightened its grip on the nation, most tenaciously in the South, the majority of white women's clubs refused to admit black women or to cooperate with them in campaigns. In 1900, for example, Josephine St. Pierre Ruffin traveled to the fifth biennial convention of the GFWC to represent the Massachusetts Federation of Women's Clubs (as its single black member), the New England Woman's Press Club, and the Woman's Era Club of Boston. Upon her arrival, white women balked at her request to be seated as a delegate from the Woman's Era Club, which the Executive Committee had admitted to the federation before realizing

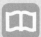 **Read about "African American Women and the Women's Club Movement"**

African American women were, for the most part, excluded from the clubs formed by white women. As a result, they formed their own clubs not only to pursue cultural and intellectual activities but also to contribute to the welfare of their communities. African American club women also sought to challenge the stereotype of black women as sexually promiscuous and to provide services to young women to protect them from sexual predation.

African American club women adopted as their motto "lifting as we climb" to advance their mission to improve conditions for African American women through greater racial equality and opportunities for all people of color. The National Association for Colored Women (NACW), founded in 1896, was the first nationally organized civil rights association in the United States.

Like their white counterparts, black clubwomen designed programs to educate mothers, strengthen the family, and advocate temperance. Mary Church Terrell, for example, condemned segregation with the same force she extolled motherhood and home life. "Nothing lies nearer the heart of colored women," she once declared, "than the children." She encouraged the local clubs to support kindergartens, day nurseries, and orphanages, as well as homes for the aged and hospitals.

Review the sources; write short responses to the following questions.

National Association of Colored Women, *Club Activities* [1906][5]
Mary Church Terrell, "In Union There is Strength," 1897[6]

1. Summarize the achievements of the three women's clubs profiled in the document.
2. What are some of the specific goals of the Sojourner Truth Club?
3. How did NACW president, Mary Church Terrell, combine her call to women to work for racial uplift and to fulfill their responsibilities as mothers?

that it was an all-black club. After a huge debate, Ruffin was granted a seat but only as a delegate from the Massachusetts Federation and the New England Woman's Press Club. Unable to represent the Woman's Era Club, Ruffin refused to participate. Only in 1900 did the NACW receive delegate status from the NCW.

The strength of the NACW continued to center in the Northeast, with Boston and Washington, D.C., the most active chapters. In 1897, the association claimed five thousand members; by 1904, the NACW represented fifteen thousand women from thirty-one states. As the association grew in size, so did its range of programs. By 1904, the NACW boasted twelve departments of work, which reflected the interests of women in literature and culture as well as in professional occupations such as business, medicine, and the law.

CAMPAIGNS OF THE 1890S

While creating various single-sex organizations designed to redress the growing inequalities in American society, many women also joined men in the protest movements that took shape during the 1890s, especially as hard times worsened with the Depression of 1893. Even without the vote, women participated in local and state electoral politics, hoping they could wield their moral authority as guardians of the home to make government more responsive to the needs of women and children. Several achieved renown as national figures or regional leaders in an uphill battle to halt the increasingly racist and imperialist tenor of the nation and to revive and extend the democratic principles that inspired its foundation. However, the presidential election of 1896, which established the expansionist, probusiness administration of Republican William McKinley, put a damper on this heated contest over who ruled America.

Populism

Women in the country's heartland joined their menfolk in creating a new political movement—Populism. The movement forcefully challenged the reigning corporate monopolies that were destroying the family farmer's way of life. Populists, men and women alike, demanded such major reforms as an overhaul of the monetary and banking systems, a progressive income tax, and public ownership of the railroads. Compared to Republicans and Democrats, Populists encouraged women to participate in the movement. "If politics means anything," one Populist contended, "It concerns women."

The **Farmers' Alliance** had prepared women for political action (see Chapter 10). Women had often performed customary services, such as providing food for picnics. They also sewed banners with slogans like "Death to the Monopolies." Many of these women also had experience in either women's clubs, suffrage associations, or the WCTU. Like their male counterparts who sought alliances with such organizations as the Knights of Labor and urban reformers, women, too, had reached out to build bridges. Populist women also sent delegations to meetings of the NAWSA, the ICW, and the NCW.

> ### View the Profile of <u>Mary E. Lease (1853–1933)</u>
>
> Populist Mary E. Lease was one of the most famous political orators of the late nineteenth century, a proud proponent of woman's rights, and a distinguished member of the first generation of women lawyers in the United States.

In Kansas, a group of urban Populist women tried to launch a **National Woman's Alliance**. They published a monthly newspaper, *The Farmer's Wife*, which promoted the "natural unity" of temperance, suffrage, labor, and agrarian movements and claimed representation in at least twenty-six states.

However, the National Woman's Alliance lived longest on paper and foundered when the Populists, meeting in convention in 1892, revealed the limits of their goodwill toward women. The assembly voted to form the People's Party and, at the same time, refused to endorse the woman's ballot. Frances Willard left the meeting in despair. A few die-hard loyalist women continued to serve alongside men on important committees, militantly expressed their views at conventions, and on occasion even ran for

Read about "Woman Suffrage in the West"

As early as 1869, the Wyoming legislature granted the right to vote to the twelve hundred women who were living in the territory at the time. In 1890, Wyoming achieved statehood, becoming the first state allowing women to vote. Three years later, Colorado, a state since 1876, became the first state to pass a popular referendum entitling women to vote.

The Colorado campaign showcased a remarkable alliance among various Populist, labor, and women's organizations. In the late 1880s, suffragists took advantage of the burgeoning Populist movement and although the national party refused to endorse the woman's ballot, Colorado Populists followed their recent electoral victory in the state by calling for a referendum.

With the endorsement of many newspapers and ultimately all major parties, the suffrage referendum passed 55 to 45 percent statewide and did even better in counties where Populists were strong. Eighteen days later, the Populist Governor Davis Waite presented a proclamation granting women the right to vote. After celebrating their victory, the leaders of the Colorado campaign traveled to Utah to help local women, who had been disfranchised since passage of the Edmunds-Tucker Act in 1887, win back the right to vote. In 1896, Utah and Idaho joined the small constellation of woman suffrage states.

Although victorious in Wyoming, Colorado, Utah, and Idaho, overwhelming defeats in Kansas in 1894 and in California in 1896 proved far more indicative of popular sentiment. Instead of riding the crest of a Populist victory, suffragists sank with their erstwhile allies. Only in 1910 did suffragists' fortunes turn brighter with referendum passed in Washington (1910); California (1911); Kansas, Oregon, and Arizona (1912); and Montana (1914).

Review the sources; write short responses to the following questions.

Judge Bromwell's "Minority Report on Suffrage: Read, Ordered Printed, and Laid on the Table for Future Consideration"[7]
Albina L. Washburn letter to the Editors of the *Woman's Journal*[8]

1. What is the main argument for suffrage made in Bromwell's minority opinion?
2. Compare Bromwell's opinion with the argument made by Albina Washburn at the People's Party Convention. How did she want women to be viewed in relation to the men at the convention and in terms of voting rights? Is this at odds or similar to Bromwell's view of women and their place in the debate?

local office. Local Populists demonstrated their commitment to woman's rights most vividly in the West, where they played a major role in revitalizing the state campaigns for woman suffrage.

Antilynching Crusade

Virginia clubwoman Janie Porter Barrett remarked perceptively on the upsurge in racial discrimination and violence in the 1890s. "No one can deny that the Negro race is going through the most trying period in its history. Truly these are days when we are 'being tried as by fire.'" In the South, African Americans were losing their hard-won civil liberties as new laws regulating employment contracts and crop liens virtually bound them to the land or sent them to prison. New poll taxes and property and literacy qualifications robbed black men of the right to vote in most southern states. In 1883, the Supreme Court overturned the Civil Rights Act of 1875 and thereby allowed private and public establishments, including schools and libraries, to turn away African Americans. The era of Jim Crow gained official sanction in 1896 when the U.S. Supreme Court, in its *Plessy v. Ferguson* decision, upheld segregation by condoning "separate but equal" facilities for black and white people.

In 1898, race riots broke out in the small town of Phoenix, South Carolina, and in Wilmington, North Carolina. In 1900, four days of rioting in New Orleans killed as many as a dozen African Americans. Lynching, which was widespread in rural areas, took an even greater toll. Between 1889 and 1898, more than eleven hundred African American men, women, and children were murdered by lynch mobs. In 1892, the year that lynching peaked, African American women mobilized to form an antilynching crusade.

At the forefront of this movement was Ida B. Wells, a journalist who had been born a slave in Holly Springs, Mississippi, in 1862. In 1892, a series of lynching in Memphis, which included the brutal killing of a close friend, prompted her to write a series of scathing editorials condemning the acts. While a white mob destroyed her newspaper office and threatened to kill her, Wells fled first to Philadelphia and then to New York, where she became the most vocal antilynching crusader in the nation.

Wells made her case against lynching in her widely circulated pamphlet, *Southern Horrors: Lynch Law in All Its Phases*, which was published in 1892. Describing the South as a "white man's country," she refuted the most commonplace myths about lynching. The majority of incidents involved accusations of murder, not rape, she insisted, and, moreover, as far as illicit sexual encounters went, white women were often the initiators. The more common perpetrators of sexual violence, Wells countered, were the white men who formed the lynch mobs, and *their* victims were primarily black women and little girls.

The politics of lynching nearly split apart the WCTU. In 1893, Willard persuaded delegates at the annual convention to pass an antilynching resolution but nevertheless suggested, contrary to Wells's argument, that black men were culpable of ghastly crimes against white women. The next year, at the twentieth anniversary of the WCTU meeting in Cleveland, Willard restated her position. "It is my firm belief," she announced, "that in the statement made by Miss Wells concerning white women having taken the initiative in nameless acts between the races she has put an imputation upon half the white race in

this country that is unjust, and, save in the rarest exceptional instances, wholly without foundation." In holding firm to this position, Willard became, in the minds of many black women, such as Boston clubwoman Josephine St. Pierre Ruffin, an "apologist" for lynching.

The politics of lynching also had a direct impact on the tenor of black women's organizations. In 1895, Wells published a book-length exposé of lynching, *The Red Record*, that provoked vitriolic attacks not only on Wells but on black womanhood in general. A white newspaper editor in Missouri, James W. Jacks, published a public letter impugning the character of all African Americans and describing black women as prostitutes, natural liars, and thieves. In July, the First National Conference of the Colored Women of America assembled in Boston gave Wells its "unanimous endorsement," agreed to continue her crusade against lynching, and also pledged to prove the respectability of African American women by making "purity" a major item on its educational agenda.

The Spanish-American War

The nineteenth-century woman movement peaked just as the United States embarked on its first major imperialist venture, the Spanish-American War. Ostensibly fought to liberate Cuba from the tightening grip of the Spanish Empire, this "splendid little war," as it was called, ended with the acquisition of territories beyond the nation's continental border and the prospect of new and highly desirable markets. The war, especially the jingoism that propelled it, also promised to enhance American manhood through the rigors of combat and simultaneously to encourage women to embrace their roles as helpmates.

Since the mid-1890s, Americans, dedicated to the spread of democracy abroad, had called upon their government to aid the Cuban nationalists in their struggle for independence from Spain. Finally, the tide turned when, on February 15, 1898, a huge explosion sank the *USS Maine*, a battleship that had been dispatched to the Havana harbor ostensibly to protect American citizens on the island. Clara Barton, who was in Havana directing the Red Cross effort to bring supplies to the beleaguered civilian population, described the scene. "They had been crushed by timbers, cut by iron, scorched by fire, and blown sometimes high in the air, sometimes driven down through the red hot furnace room and out into the water," she reported. The American press capitalized on her lurid description and, along with patriotic groups, clamored for retaliation (although, it was later learned, the explosion had actually resulted from an accident): "Remember the Maine, to Hell with Spain." On April 25, the U.S. Congress issued a formal declaration of war.

Amid the surge of patriotism, many women turned to relief work. "Will the women of our state falter or fail when they are needed? No! A thousand times no!" read a leaflet of the Massachusetts Woman's Relief Corps. More than 320 chapters formed in just this one state. Women set themselves to rolling bandages, collecting donations, preparing food for the troops, and tending to the wounded in the hospitals. However, the mobilization was short-lived. The fighting ended after just 113 days.

The war that began to liberate Cuba from Spain set the United States firmly on the path to empire. The United States not only occupied Cuba until 1902 and annexed Puerto Rico and Guam but also fought one of the bloodiest wars in the nation's history to colonize the Philippines.

The ranks of the woman movement split on this issue. Elizabeth Cady Stanton and Susan B. Anthony both favored the overseas missions, envisioning them as benevolent acts to bring democracy and "civilization" to "backward" nations. "I am strongly in favor of this new departure in American foreign policy," Stanton remarked. "What would this continent have been if left to the Indians?" Anthony, a Quaker, ultimately resigned herself to the war as a means to pacify the Philippine rebels. But for those women in the WCTU, the GFWC, and the NCW, who for decades had been lobbying for peace and international arbitration, the Spanish American War represented a catastrophe in world affairs.

Indeed, there were numerous women who agreed with the premises of the jingoist argument for war as an opportunity to revivify manhood: armed combat was the apogee of masculinity. However, they did not condone this development, and the most militant became leading members of the Anti-Imperialist League. Mary Livermore took a strong stand, while Jane Addams condemned the war for its especially brutish character. Nevertheless, despite their fervor, Livermore and Addams represented a minority within the turn-of-the-century woman movement, which for the most part embraced the principles—if not all the practices—of U.S. imperialism.

WOMAN'S EMPIRE

Throughout the nineteenth century, American missionary women advanced what one historian termed "beneficent imperialism." They ventured to distant outposts to bring Christianity as well as the alleged benefits of their own civilization, which they deemed superior to all others. By the end of the century, as the United States entered into an age of aggressive territorial expansion, the missionary impulse quickened, sending ever larger numbers of women to foreign lands. With the approval of the U.S. government, women missionaries often came to wield considerable power, especially in realms concerning the welfare of women and children.

These missionaries shared the prevailing assumption that women's status was a key indicator of "civilization," and they believed that Christianity was the only religion that acknowledged the dignity and worth of womanhood. Among the heathen, one missionary wrote, woman is still regarded "as a scandal and a slave, a drudge and a disgrace, a temptation and a terror, a blemish and a burden." To remedy this situation, they identified three general areas for improvement—education, family, and sexuality.

Women's Foreign Mission Movement

In the last half of the nineteenth century, middle-class women transformed missionary service into a major female avocation. Wives of male ministers continued to play important roles, but, in weighing the multiple problems of managing households in foreign lands, the missionary societies decided to enlist unencumbered, unmarried women instead. Bred on exciting stories of travel abroad, many of these women responded enthusiastically to the call and found a career potentially more exciting and definitely more challenging than teaching at school at home.

In 1861, the Woman's Union Missionary Society of America for Heathen Lands formed as a nondenominational organization to recruit never-married or widowed

women to serve in foreign lands. By 1873, all the major evangelical denominations had created their own women's boards, making "**Woman's Work for Woman**" a guiding spirit for both fund-raising and active service. New magazines, such as the *Heathen Woman's Friend* (Methodist), appeared to publicize this activity, featuring letters, stories, poetry, graphics, and didactic essays like "Girl Life in the Orient" and "High-Caste Women in India." Several of these magazines achieved readerships of nearly twenty-five thousand. By the end of the century, women missionaries in foreign lands outnumbered men, representing more than 60 percent of active missionaries.

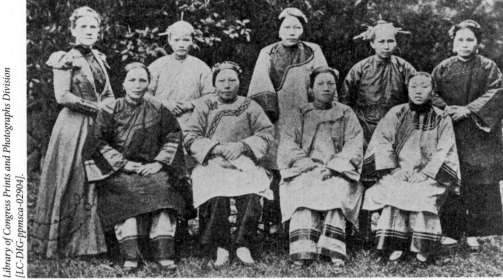

Library of Congress Prints and Photographs Division [LC-DIG-ppmsca-02904].

By the turn of the century, women represented about 60 percent of American foreign missionary service. Emily S. Harwell, who graduated from Mt. Holyoke College in 1876, stands alongside her Chinese students at the Foochow Mission in 1902. She wrote letters describing the difficulty Chinese women had in walking to church with their bound feet and the hardships they endured from their powerful mothers-in-law.

Women missionaries, like their male counterparts, performed evangelical work and, if trained in medicine, brought health services to the mission field. For the most part, women focused on educational programs, building and maintaining schools from the elementary grades through college. The American teachers took pride in their pupils' accomplishments, claiming at times that the proficiency of the young girls in their care outdistanced that of their male peers or even their American counterparts. In most countries, women missions aimed to prepare girls and young women for public service, to train them as teachers, nurses or physicians, and administrators of schools, hospitals, and orphanages. In China, missionaries established schools for girls far in advance of government-supported institutions and simultaneously aided the locally run campaigns to abolish the custom of foot binding. However, most missionaries

Read "Overseas Missionary"

Amanda Berry Smith (1837–1915)[9] achieved an international reputation as a charismatic holiness preacher and dedicated missionary. In 1879, she embarked for India to deliver sermons on the gospels. In Bombay and Calcutta, she attracted sizable audiences who were curious to see an African American woman who had been born in slavery. In 1881, she traveled to Liberia, which she called "the land of my forefathers," a nation that had been settled in the 1820s by former slaves and free African Americans. Suffering from both malaria and arthritis, she stayed for eight years, conducting Christian missionary work and organizing temperance societies.

Review the source; write short responses to the following questions.

1. What did Smith hope to accomplish in Liberia?
2. Why did she work primarily among women and children?
3. Why did she simultaneously conduct Christian missionary work and temperance agitation?

anticipated that ultimately these girls would grow to women fully prepared to make a Christian marriage and keep a Christian home. Child marriages and polygamy therefore became special targets of their efforts.

World WCTU

By 1892, it was said that the sun never sets on the WCTU. By that time, the organization enjoyed at least nominal representation in every continent except Antarctica and claimed forty national affiliates. Although the United States accounted for the largest number of members, representing about 50 to 60 percent worldwide, the WCTU was proportionately just as strong in Japan and Australia. The World WCTU functioned as a major emissary of Protestant morality and Anglo-American culture, including a strong commitment to women's rights. It had, in sum, realized Frances Willard's aspiration "to belt the globe, and join the East and West."

Temperance missionary Jessie Ackerman traveled for seven years as a temperance missionary before returning to the United States in 1895. In that time, she had traveled around the world twice, and she took equal pride in her temperance accomplishments and personal exploits. When traveling by sea, she boasted, she liked to climb the mastheads to hail other vessels, a dangerous practice that once landed her in the Indian Ocean during a fierce storm. Similarly, the Kalahari Desert and the Himalaya mountains presented minor physical obstacles. One July 4th found her celebrating on an iceberg inside the Arctic Circle. She spent six weeks deep in the interior of China, dressed in Chinese clothing and eating nothing but boiled rice.

Ackerman was one of thirty-five women who served between 1888 and 1924 as round-the-world missionaries for the WCTU. Another thirty-four worked on short-term

assignments to countries outside the United States, and perhaps another twenty-five did ancillary work. After 1900, Canada and Great Britain also sent women abroad.

Temperance missionaries organized WCTU chapters wherever they went, winning local women to temperance but also addressing unique issues. They preached against foot binding in China, for example, and for dress reform and physical fitness in Japan. Despite their Protestant zeal, these missionaries proved very tolerant of non-Christian religions. The World WCTU meeting in 1892 voted to remove "heathen" from all descriptions of non-Christian lands and identified a "great virtue" in Islam in its aversion to the consumption of alcohol. The *Union Signal* featured a chart of the world great religions—Buddhism, Hinduism, and other faiths—as links in a great chain of "one supreme being." However, few temperance missionaries ever doubted the superiority of Christianity, especially in regard to women. The most "civilized" nations, in their opinion, were those that promoted evangelical Christianity.

The WCTU became the prime mover for woman suffrage in Anglo-American settlements throughout the world. In Australia and New Zealand, for example, the WCTU led the campaign that resulted in women's enfranchisement by the turn of the century. Indeed, the WCTU emerged as such a powerful force for woman suffrage that many women with scant interest in temperance joined local chapters to work for enfranchisement.

Outposts of the YWCA

The World YWCA held its first convention in 1898 and quickly became so successful that the American association in 1906 divided into two, coordinating home and foreign services, and undertook to train women for service overseas. By the mid-1920s, when overseas work reached its peak, the YWCA had mobilized more than one thousand women as lay missionaries. Aspiring to achieve "the evangelization of the world in this generation," these women were especially eager to experience the excitement of foreign service.

In 1894, the American YWCA assigned its first agent on overseas duty. Agnes Hill, despite her university education, arrived in India with only superficial knowledge of the country and its caste system. Although the British YWCA had begun to pave the way as early as the 1870s, Hill got off to a rough start. For example, she attempted to export the Y's physical fitness programs, which were very popular in the United States, to a population that equated exercise with manual labor and sought to avoid it. Moreover, Hill faced an uphill battle proselytizing Christianity among women who were mainly Muslim or Hindu. Hill, however, was unwilling to give up. She established the administrative structure for the Indian National Association, which became a model for federation within the World YWCA. Working for the YWCA, Hill stayed in India until 1942.

YWCA missionaries to China received elaborate rounds of welcome from huge, well-established delegations from various European and Asian nations, as well as from the American business and missionary communities. In contrast, the Chinese often expressed strong anti-Western feelings, which had erupted dramatically in the Boxer Rebellion of 1900. Nevertheless, YWCA missionaries persisted, targeting the condition of women and speaking out on such issues as arranged and plural marriages, foot

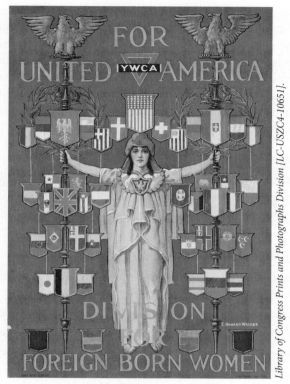

During the 1890s, the YWCA in major urban areas began to develop programs for foreign-born women. By 1910 nearly sixty branches were sponsoring special activities, including bilingual classes. This poster, which dates to 1919, celebrates the international outlook of the Y.

binding, prostitution, and the opium trade. They established chapters in the leading cities and recruited Chinese women to serve on boards and to staff the organization. After meeting with initial resistance, the Y missionaries established thriving physical fitness programs and dress reform. They also played an instrumental role in introducing hygiene programs to combat the contagious diseases like malaria, tuberculosis, and typhoid, which were deadly and prevalent. Like missionaries affiliated with various Protestant denominations, the agents of the YWCA stressed education for Chinese girls and women as a station on the path to Christianity.

CONCLUSION

"The cruel kindness of the old doctrine that women should be worked for, and should not work, that their influence should be felt, but not recognized, that they should hear and see, but neither appear nor speak," wrote Julia Ward Howe in 1891, "—all this belongs now to the record of things which, once measurably true, have become fabulous." The many women who had joined Howe in activism would have agreed with her statement, measuring their accomplishments in terms of the massive national and international

organizations that made up the woman movement. They would have shared her optimism about the future, anticipating a prominent role in the massive protest and political movements of the 1890s. If their success was cut short during the tumultuous decade, they could take solace in having built a foundation that would blossom into social activism during the Progressive Era that lay ahead. However, the majority of these activists—white, native-born, and Protestants—had yet to deal with the reality that along with power came responsibility. The increasing racism of their society, fueled in part by imperialist ventures, dimmed the prospects for the "sisterhood" they so fervently extolled.

 Study the <u>Key Terms</u> for The Woman Movement, 1860–1900

Critical Thinking Questions

1. How did racial tensions and animosities affect the various campaigns waged by the late-nineteenth-century woman movement?
2. What role did imperialism play in shaping the programs of women activists?
3. Discuss the importance of national and international federations of women in the 1890s.
4. How successful were women activists in bridging class differences?
5. How effective was volunteerism in providing women access to power outside the realms of government and business controlled by men?

Text Edits

1. *Transactions of the National Council of Women of the United States*, Assembled in Washington, DC, February 22 to 25, 1891 (Philadelphia, PA: J.B. Lippincott & Co., 1891), pp. 27, 31.
2. Mary Kavanaugh Oldham Eagle, ed., *The Congress of Women Held in the Woman's Building World's Columbia Exposition* (Chicago: American Publishing House 1894), pp. 679–680.
3. Martha E.D. White, Work of the Woman's Club, *Atlantic Monthly* 93 (May 1904).
4. Grover Cleveland, Woman's Mission and Woman's Clubs, *Ladies Home Journal* 22 (May 1905).
5. The National Association of Colored Women's Annual Report, 1906.
6. Church Terrell, In Union There Is Strength, 1897.
7. Judge Bromwell, Minority Report on Suffrage: Read, Ordered Printed, and Laid on the Table for Future Consideration (8 February 1876), pp. 1–9, Records of the Colorado Constitutional Convention (1875–1879), -M1599, Western History Collection, The Denver Public Library, Denver, Colorado.
8. Colorado Suffrage Items, *Woman's Journal* 23 (27 August 1892), p. 276.
9. Mrs. Amanda Smith, *An Autobiography* (Chicago: Meyer & Brother, 1893), pp. 318–320.

Recommended Reading

Gail Bederman. *Manliness and Civilization: A Cultural History of Gender and Race in the United States, 1880–1917*. Chicago and London: University of Chicago Press, 1995. A wide-ranging analysis, conducted through a series of biographical case studies, of the related discourses of gender, race, and society. Bederman offers a thorough interpretation of the masculinist perspectives of Theodore Roosevelt as well as an insightful analysis of the use of "civilization" by the antilynching reformer Ida B. Wells.

Rebecca Edwards. *Angels in the Machinery: Gender in American Party Politics from the Civil War to the Progressive Era*. New York: Oxford University Press, 1997. Edwards demonstrates, in the era of "separatism as strategy," many women played important roles in the major partisan parties and in movements such as Populism. She pays close attention to regional variations.

Jane Hunter. *The Gospel of Gentility: American Women Missionaries in Turn-of-the-Century China*. New Haven, CT: Yale University Press, 1984. An evocative study, based on letters and diaries, of the experiences of American women who sought to convert the "heathen" Chinese to Christianity.

Martha S. Jones. *All Bound Up Together: The Woman Question in African American Public Culture, 1830–1900*. Chapel Hill, NC: University of North Carolina Press, 2007. Explores the emergence of African American women as prominent activists in their communities by the 1890s. Jones provides vivid details of women's role in associational life as well as in the print culture that took hold in the aftermath of emancipation.

Rebecca J. Mead. *How the Vote Was Won: Woman Suffrage in the Western United States, 1868–1914*. New York: New York University Press, 2004. Mead places the woman suffrage campaigns within the context of regional politics, including race relations and coalitions with other reform movements, such as Populism.

Priscilla Murolo. *The Common Ground of Womanhood: Class, Gender and Working Girls' Clubs, 1884–1928*. Urbana, IL: University of Illinois Press, 1997. Traces the rise and fall of a unique cross-class alliance from its origins in the 1880s to its demise as the dream of sisterhood faded in the early decades of the twentieth century.

Susan J. Pearson. *The Rights of the Defenseless: Protecting Animals and Children in Gilded Age America*. Chicago: University of Chicago, 2011. Examines the advance of the discourse of rights, its grounding in the sentimental culture of the nineteenth century, and its application to public policy during the Gilded Age. Pearson illustrates the many ways reformers of the era connected the harms done to animals and children as an outgrowth of their earlier involvement in abolitionism.

Alison L. Sneider. *Suffragists in an Imperial Age: U.S. Expansion and the Woman Question, 1870–1929*. New York: Oxford University Press, 2008. Shows the ways suffragists intertwined arguments for the vote to the expansionist goals of the United States in the late nineteenth century. Sneider offers an analysis at once provocative and complicated.

Ian Tyrrell. *Woman's World, Woman's Empire: The Woman's Christian Temperance Union in International Perspective, 1880–1930*. Chapel Hill, NC: University of North Carolina Press, 1991. Tells a fascinating story of the emergence of the WCTU as major force in making temperance as well as the woman movement an international endeavor. Tyrrell provides an integral chapter in the larger history of U.S. expansion.

CHAPTER 14

THE NEW MORALITY, 1880–1920

 Explore Chapter 14 Multimedia Resources

TIMELINE

1870s	"Voluntary Motherhood" is discussed as means to control fertility
1873	Dr. Edward H. Clark publishes *Sex in Education*
	Comstock Act passed by Congress
1875	Page Act prohibits immigration of prostitutes
1883	First Florence Crittenton mission opens in New York City
1885	The WCTU established Department of Social Purity
1886	Age of Consent campaign
1892	Jane Club established in Chicago
1897	Havelock Ellis published *Sexual Inversion*
1903	President Theodore Roosevelt warns of "race suicide"
1904	Riverview, Chicago amusement park opens
1905	Edith Wharton's *The House of Mirth* published
1910	Divorce rate reaches rate of one marriage in six dissolves in any one year
	The term *feminism* first used in the United States
	Mann Act passed by Congress
1912	White slavery panic peaks
	Heterodoxy forms
1913	Feminist Alliance formed
1915	Birth control campaign gains force
1916	National Birth Control League founded
	Emma Goldman arrested for lecturing on birth control

| 1920 | Edith Wharton awarded Pulitzer Prize for *The Age of Innocence* |
| 1921 | American Birth Control League founded |

WOMEN IN THE AGE OF THE NEW MORALITY READ THE NEWLY TRANSLATED WORKS OF SIGMUND FREUD WHO, in developing the theory of psychoanalysis, had established the centrality of the sexuality to the human psyche. Woman's desire in this realm equaled that of men, he noted, and it was only because sexuality was a subject shrouded in silence that women suffered from an "artificial retardation" of their sexual instinct. The British sexologist Havelock Ellis surpassed Freud in condemning the current restraints on sexual expression. Sex, he wrote, is, simply, "ever wonderful, ever lovely."

The "new moralists" endorsed the "repeal of reticence" that was, in fact, sweeping the nation and much of Europe. They wrote novels, plays, and various treatises on the subject; carried their convictions into new forms of art; and spearheaded political campaigns, such as the birth control movement. However, others disagreed with their assessment and rejected their prognosis for a better future. To the contrary, they viewed with alarm the rising divorce rate and the spread of prostitution. The "promiscuous mingling" of the city's youth at dance halls and amusement parks especially offended the sensibilities of those who stubbornly held on to the old ideas about the piety and purity of womanhood. Nevertheless, despite very strong differences in opinion, it was without doubt, as one commentator noted, "sex o'clock" in America. Whether the changes represented a revolution in manners and mores or merely a variation on a theme, no one could yet determine.

Read **"Being a Woman in the Age of a 'New Morality'"**

Phyllis Blanchard[1] married in 1925 at age thirty, but rather than settling into the conventional role of wife and mother, she became a prominent child psychologist. With a doctorate in psychology from Clark University, she easily found an intellectual rationale for her rejection of customary gender roles. As she notes, she discovered the works of an assortment of European writers who, in various ways, were exploring the tenets of a "new morality."

Review the source; write a short response to the following question.

1. How does Blanchard use science to support her feelings regarding her "normal sex emotions"?

URBAN PLEASURES, URBAN DANGERS

"No amusement is complete in which 'he' is not a factor," commented Belle Israels, a reformer who keenly observed the behavior of young working women out with their boyfriends. From her vantage point in New York City, she could see that the city

provided these women, many of them from immigrant families, with unparalleled opportunities to shed the role of dutiful daughter and mingle with the opposite sex. These women may have earned paltry wages, but the shortened workday—less than ten hours a day or sixty hours a week by 1910—left enough time for not only leisure but also romance.

Young working women determinedly explored the delights of the city—amusement parks, movies, restaurants, and department stores—and did so, as often as possible, in the company of men. They forged a path, embracing the emerging consumer-oriented culture and fashioning new social relationships that brought men and women closer together—heterosociality, which would become the hallmark of modernity.

Library of Congress Prints and Photographs Division [LC-DIG-ppmsca-02925].

The two paths—What will the girl become? This illustration from *Social Purity*, a book published in 1903, is meant to warn young women against the dangers of the "new morality" while commending the virtues of old-fashioned notions of womanhood.

"Women Adrift"

In the nation's cities, one-fifth of all wage-earning women lived apart from their families and kin and many took advantage of their residential independence to establish new codes of sexual conduct. Not a few of these **women adrift**, as they were called, had fled their hometowns because their fathers had refused to let them go out with

boys. Others resented turning over their earnings to their parents. "I wanted more money for clothes than my mother would give me . . ." one young woman explained. "We were always fighting over my pay check. Then I wanted to be out late and they wouldn't stand for that. So I finally left home." Some young women simply found the family farm or small town unbearably dull compared to the attractions of the big city.

The low wages that women earned could rarely cover more than a small, simply furnished room. Some landladies were sensitive to the disadvantaged position of wage-earning women and charged them lower rent than they did male lodgers, often in return for help with household chores or child care. However, the majority of wage-earning women did not seek a "home away from home" and instead favored contractual tenant relationships with their landladies or landlords. "A place like that should have a strictly hotel basis," one young Irish woman commented, "no Christian stuff; and a decent name." Lodging houses, more common after the turn of the century, offered fewer amenities, such as meals, but more freedom from the oftentimes strained intimacy of the small boardinghouse.

Read **"Weighing Marriage Against Career"**

Raised on a farm in Colorado, Jessie Haver entered Smith College in 1906 and after her graduation worked as a statistician, first in Boston and, later, in Washington, D.C. Determined to forgo marriage, she finally relented and married Hugh Butler in 1920. In an oral history interview conducted in 1972, she recalls her equivocation.

Review the source; write short responses to the following questions.

1. How did Jessie Haver Butler respond to the desire for male companionship and her career ambitions?
2. What role did sex play in her strivings?

Apartments in large cities were beyond the reach of the average working woman, although by 1910 small groups began to pool their resources to rent flats or even entire houses. One of the most highly publicized adventures in "cooperative housing" was the Chicago **Jane Club**, named after settlement director Jane Addams. Established with her financial backing during a strike in 1892, the club housed a small group of factory workers, each paying room and board and contributing one hour per week to housekeeping chores. "The social spirit was just as cooperative as the financial relationship," recalled one early member. "We enjoyed doing things together." Unlike the YWCA, the Jane Club posted no curfews and did not monitor sexual behavior.

The neighborhoods known as furnished room districts provided a setting where the youthful and usually transient residents could defy conventions with impunity. It was not uncommon for women to invite men to their rooms for casual sexual encounters

or for others to share their space with "women sweethearts." Although the majority lived "adrift" for only a few years, usually until they married, the experience allowed young women to make the transition from childhood to adulthood without direct parental supervision.

Cheap Amusements

Whether they lived alone or with parents or friends, young women frequented the growing number of commercial entertainments. Employers complained that wage-earning women played so hard during the weekend that they came to work on Monday morning "worn to a frazzle." Then, throughout the workday, they chatted over the din of the machines, recounting their adventures or sharing their romantic fantasies. As soon as the shift ended, young women quickly discarded their practical shirtwaists for fancy clothes, large hats, dancing slippers, and even feather boas and artificial hairpieces—and embarked on yet another evening on the town.

Fashion became a major preoccupation and for immigrant women a means to identify as American. At work, wage-earning women talked incessantly about the latest trends in clothing and hairstyles and traded cosmetics. To put a damper on such activities, strict employers posted rules prohibiting the "excessive use" of face powder and rouge. Determined to "put on style," most women were undaunted by such restrictions. "A girl must have clothes," one garment worker explained, "if she is to go into high society at Ulmer Park or Coney Island or the theater. A girl who does not dress well is stuck in a corner, even if she is pretty." The rapid expansion of ready-made clothing at the turn of the century made cheap but fancy garments and accessories readily available at pushcarts, neighborhood stores, and the bargain basements of the large department stores. During the slow season, garment workers used their sewing machines to make summer outfits from the remnants.

The main topic of conversation, however, was "gentlemen friends." One middle-class observer commented that at Macy's there was "more smutty talk in one particular department than in a dance hall." While their parents scrupulously avoided the subject of sex, young working women eagerly offered advice. One Jewish woman recounted that she learned the "facts of life" from a coworker. "From that time on I began to look at life differently," she recalled: "I started to make the acquaintance of young men."

During the warm-weather months, young working-class men and women flocked to the new amusement parks, such as Coney Island in New York and Riverview in Chicago, which opened in 1904. Just two years later, there were more than fifteen hundred amusement parks nationwide. Traveling by trolley, boat, or elevated railway, as many as five hundred thousand New Yorkers and an equal number of Chicagoans reached the popular resorts on summer weekends. The boardwalks provided scores of games and attractions, including strong jets of air that blew women's skirts to shocking heights, exposing ankles and even knees! The popular roller-coaster rides encouraged young couples to hold each other tight, while the tunnel of love provided a darkened environment where kissing could take place beyond watchful eyes. The amusement parks charged little for either admission or the numerous attractions, in all making

for a cheap date for white working-class youth. Most of these new parks, including Atlanta's "White City," barred African Americans.

Dancing was perhaps the favorite pastime. In New York City, the more than five hundred public dance halls proved, according to reformer Belle Israels, that "the town is dance mad." Some of the largest dance palaces accommodated between five hundred and three thousand patrons, the majority of whom were factory or office workers.

The dance halls provided women the best opportunity to elude their parents' control of dating and courtship, to experiment with new styles, and to meet men on their own. Women, paying reduced admission fees, often attended with friends or coworkers and readily accepted invitations to dance from strangers. Casual encounters, especially with the help of a few cocktails, could advance quickly into intimacy, if only for the duration of the evening. One middle-class observer reported that "most of the younger couples were hugging and kissing . . . [and] almost every one seemed to know one another and spoke to each other across the room."

Popular dance styles further encouraged such behavior. "Spieling" brought men and women into close, rigid contact as they spun rapidly around the dance floor. "Tough dancing," which included the turkey trot, the bunny hug, the dip, and the grizzly bear, allowed yet more physical contact, particularly in the pelvic region.

Many of these new dance forms originated in southern cities, where "jook joints" and "dives" encouraged young African American men and women to reclaim their bodies as instruments of pleasure rather than manual labor. One of the most popular dances was the "slow drag," which one observer described: [C]ouples would hang onto each other and just grind back and forth in one spot all night. Other dances, such as fanny bump and ballin' the jack, also depended on pelvic movements and other erotic gestures capitalizing on the rhythmic beats of ragtime and the blues, the "lowdown" music that was becoming increasingly popular in urban areas across the United States.

The movies, which cost only a nickel, provided a darkened setting where heterosexual romance could blossom. "Note how the semi-darkness permits a 'steady's' arm to encircle a 'lady friend's' waist," one observer pointed out. But it was not just young wage-earning women who attended the picture shows. By 1910, when women represented 40 percent of the working-class movie audience, older married women were going to their neighborhood theaters just as frequently as young wage-earning women. Married couples and mothers with babies in arms sat in the dark alongside the many young couples on dates. In 1909, every Sunday, up to five hundred thousand people attended the more than 340 nickelodeons in New York's Lower East Side. At the same time, African Americans in Atlanta flocked to the cheap, all-black or segregated movie theaters lining Decator Street, the center of the city's commercial entertainment district.

In watching the early silent films, working-class women across the generations could see the beautiful Mary Pickford portraying a young woman who leaves her small town for the big city. The movie heroine at first tries to earn a livelihood working in an office but soon secures better wages and more excitement as a chorus line dancer in a cabaret. The story ends on a happy note: Pickford's character picks up a handsome man who, after treating her to numerous urban delights, proposes marriage. At the same time, in a nearby

theater, the Jewish film star Theda Bara and the Italian-born idol Rudolph Valentino were making the silver screen sizzle with their bold projections of sexual desire. In various ways, motion picture shows and other commercial entertainments encouraged young women to imagine a relationship as romantic as that celebrated on the screen.

"Charity Girls"

To pay for the new fashions and entertainments, wage-earning women often went without lunch or saved carfare by walking to and from work. Just as frequently, they relied on the largess of their male companions. The higher wages paid to men, as well as long-standing customs, encouraged women to depend on men for an evening on the town. Men paid for dinner, perhaps tickets to a movie or dancehall, and even a few luxuries such as gifts of perfume or flowers. "Pleasures don't cost girls so much as they do young men," one saleswoman explained. "If they are agreeable they are invited out a good deal, and they are not allowed to pay for anything."

Charity girls earned their reputations in this fashion, venturing unescorted to amusement parks and dance halls to "pick up" strangers who would then "treat" them, perhaps to drinks and dinner at a cabaret. In return, the women provided companionship and favors ranging from a brief kiss good night to fondling and even sexual intercourse. These women "draw on their sex as I would on my bank account," one man complained, "to pay for the kind of clothes they want to wear, the kind of shows they want to see."

A charity girl expected nothing more from a night on the town than a good time, or she could hope to strike it lucky and find a boyfriend or even a future husband. However, her plans for marriage, more often than not, included the joys and pleasures that she came to know during courtship.

CHANGING RELATIONS OF INTIMACY

The British new moralist Edward Carpenter optimistically predicted that "marriage shall mean friendship as well as passion, that a comrade-like equality shall be included in the word love." In the United States, a generation of women stood poised to test his hypothesis. At the turn of the century, 85 percent of American women over the age of twenty-five were married, widowed, or divorced, and many had nurtured an expectation for companionship in marriage that far exceeded that of their mothers. At the same time, the generation born between 1865 and 1895 produced the highest proportion of never-married women in U.S. history, and a sizable portion of this number formed loving relationships with members of their own sex. But neither group, it seemed, had much use for the time-worn ideology of "female passionlessness."

Courtship and Marriage

With the flow of European immigrants into the United States and the migration of African Americans to northern cities, marriage customs in any one location varied tremendously from group to group. Many African Americans, for example, continued to practice serial monogamy and often preferred common-law marriages to those sanctioned by church or state. One woman in Mississippi commented that "a man is

your husband if you live with him and love each other . . . [M]arriage is something for the outside world." Meanwhile, some groups such as Chinese and Jews did their best to preserve the Old-World custom of arranged marriage against the wishes of increasingly resistant daughters. Other immigrant parents, like Italians, allowed daughters to select their future husband but assumed the right to approve their choice.

For many working-class women, despite the allure of romance, marriage offered foremost the possibility of escaping the deadening routine of factory work. A stanza in a Jewish folk song went: "Day and night and night and day,/ And stitching, stitching, stitching!/ Help me, dear God, may my handsome one come along,/ and take me away from this toil." Many young women nevertheless sought a husband who would be both friend and lover as well as provider.

Advice experts encouraged this trend, disputed the older notion of female passionlessness (see Chapter 5), and endorsed sexual pleasure as "normal" for both men and women. One of the earliest surveys of women's sexual attitudes and behavior revealed that many white middle-class women agreed. Clelia Duel Mosher, a physician affiliated with Stanford University, collected data on forty-five women, 80 percent born between 1850 and 1880, and found that two-thirds admitted to sexual desire and enjoying sexual intercourse. "I consider this appetite as ranking with other natural appetites," one woman explained, "to be indulged legitimately and temperately." The majority in Mosher's sample nevertheless named reproduction as the primary and proper purpose of intercourse.

Divorce

Rising expectations for marriage, including sexual compatibility, accompanied an accelerating rate of divorce. By 1900, in any one year, nearly one marriage in six ended in divorce, giving the United States the highest divorce rate in the world. A distinguished professor at Columbia University attributed this shocking trend to the "emancipation of women." Because many women could now support themselves, he argued, they no longer felt compelled to stay in a marriage that brought them unhappiness or, in some cases, personal injury.

"Restlessness! Restlessness!" exclaimed the popular author Margaret Deland, writing in the *Atlantic Monthly* in 1910. "And as it is with the young woman, so it is with the older woman." Middle-class homemakers, another observer noted, had their appetites "whetted for more abundant and diverting interests than the mere humdrum of household duties." Men, too, put a larger stake in finding a compatible partner. The advice columnist Dorothy Dix, writing in 1915, noted that the young man's ideal mate was a "husky young woman who can play golf all day and dance all night, and drive a motor car, and give first aid to the injured if anybody gets hurt, and who is in no more danger of swooning than he is." Sex appeal and companionship outscored good housekeeping skills. Men and women were demanding more from relationships than their parents did and were more willing to end a marriage if their mates failed or refused to live up to their expectations.

However, the majority of Americans, fearing the demise of the family, continued to view divorce with disfavor. State legislatures tightened up the existing divorce laws and enacted new ones. New York, for example, limited divorce only to cases of adultery; South Carolina barred divorce altogether. Despite these restrictions, marriages continued to break down at an alarming pace.

View the Profile of <u>Kate O'Flaherty Chopin</u>

After publishing more than a hundred short stories, Chopin published *The Awakening* (1899), an extraordinary and highly controversial novel that explored the sexual feelings and actions of Edna Pontellier, a woman vacationing with her husband and children.

Female Friends and Women Lovers

Quite a few self-supporting women resisted the pressure to marry and instead pursued the companionship of other women. During their college years, many had become love struck with a classmate or a teacher and engaged in the popular practice of "smashing."

In the last half of the nineteenth century, **Boston marriages** were very common as well. Same-sex couples set up households together and established networks of other women who also lived independently of men. They sometimes bought houses jointly, vacationed and celebrated holidays together, and shared the parenting of adopted children.

It is unclear if these relationships were sexual in a physical sense or principally romantic and spiritual. Earlier in the century, the ideology of female passionlessness did little to encourage women to carry out their bodily desires with either men or women. However, as pleasure and self-expression emerged as markers of heterosexual intimacy, the love between women undoubtedly took on erotic dimensions, at least for some couples.

By the end of the century, physicians and researchers had begun to create a taxonomy of sexual behavior, fashioning a spectrum ranging from "normal" to "morbid" and establishing the modern categories of "heterosexuality" and "homosexuality," which they positioned at the opposite ends of a continuum. The British sexologist Havelock Ellis, for example, published *Sexual Inversion* in 1897 and, using the terms *homosexual* and *lesbian*, designating as "abnormal" those women who loved only other women, particularly those women who dressed or acted like men. In this context, the notion of an intensely romantic yet entirely sexless relationship between two women lost much of its credibility, especially if one partner matched the new stereotype of the "mannish lesbian."

With the help of both the scientific and popular presses, "homosexuality" and "heterosexuality" emerged as broad categories by which individuals could identify and be identified. Women were less visible in these emerging gay communities, but they managed to stake out a presence in all the major cities. And many couples, despite the new stigma attached to same-sex intimacy, persisted in their relationships.

Review the sources; write short responses to the following questions.

<u>Dr. Irving Steinhardt, *Ten Sex Talks to Young Girls* [1914][2]</u>
<u>Margaret Sanger, *What Every Girl Should Know*[3]</u>

1. Summarize Dr. Steinhardt's advice to young women as to how to avoid homosexual entanglements.
2. Compare Margaret Sanger's advice to Dr. Steinhardt's.

Curbing "Social Evils"

Society shall rise to "higher levels," Frances Willard predicted in 1885, "by holding men to the same standard of morality . . . and by punishing with extreme penalties such men as inflict upon women atrocities compared with which death would be infinitely welcome." Willard responded to changes in sexual behavior, as did large sectors of the public, with a combination of displeasure and fear. Women—that is, white women—seemed too vulnerable, in their opinion, in a society where men held power. The era of the new morality therefore ushered in a second trend—a growing number of prohibitions and regulations of both speech and behavior, which were increasingly maintained with the force of law. In different ways, the social purity campaigns, the movement against prostitution, and the legislation regulating interracial sex all struck out at men's alleged licentiousness.

Social Purity Campaigns

Social purity advocates targeted the so-called double standard of morality, which granted men sexual license while demanding purity from women. By bringing men into line with the prevailing standards for women, they aspired to create controls over sexual behavior that would ensure women's safety and establish stringent penalties for the male violators. Reformers went so far as to insist that sexual activity in marriage occur only under conditions of mutual assent.

Legal efforts to advance social purity dated to 1873 when Anthony Comstock drafted the Act for the Suppression of Trade In and Circulation of Obscene Literature and Articles of Immoral Use. Better known as the **Comstock Act of 1873**, the federal law made it a criminal act to send through the mail "obscene, lewd or lascivious materials" as well as items intended "for any indecent or immoral use," that is, information or devices for contraception or abortion. Comstock succeeded not only in silencing Victoria Woodhull and Tennessee Claflin but in securing for himself a special appointment in the U.S. Post Office that authorized him to pursue violators (see Chapter 10).

Despite Comstock's visibility, it was the WCTU that mobilized masses of women to promote social purity. Frances Willard secured the establishment of the WCTU's Department of Social Purity in 1885 and enthusiastically endorsed its major program, "The White Life for Two." Local branches sponsored mothers' meetings, lobbied to obtain instructional programs in the public schools, and on occasions joined Comstock to advance a vigorous censorship campaign of books and other printed materials. The WCTU also formed the White Shield campaign, which enrolled hundreds of thousands of women who pledged to lead a "pure life." The White Shield became the popular sister society of the all-male White Cross, which had organized with the support of Protestant churches and the YMCA.

The WCTU crusaded against various forms of "immorality," such as prostitution, rape, and the sexual exploitation of children. One of its most successful campaigns targeted the **age of consent**, the age at which a girl could legally agree to

Table 14-1 Premarital Pregnancy Rate
Eighteenth–Nineteenth Century

1681–1720	14%
1721–1760	21%
1761–1800	27%
1801–1840	18%
1841–1880	10%
1881–1910	23%

(Based on pregnancies of under 8.5 months from date of marriage in Daniel Scott Smith and Michael S. Hindus. "Premarital Pregnancy in America 1640–1971: An Overview and an Interpretation," *Journal of Interdisciplinary History*, Vol. 5, No. 4, (Spring, 1975), pp. 538, 561.)

Premarital pregnancy serves well as a measure of change in sexual behavior.

"carnal relations with the other sex." Most states had fixed the age of consent at the common-law practice of ten years. Delaware had the lowest, age seven. A massive petition drive spearheaded in 1886 with assistance from the Knights of Labor resulted in new congressional legislation raising the age of consent from ten to sixteen years in all territories and the District of Columbia. A decade later, the majority of states had raised the age of consent to sixteen or, in a few cases, eighteen, making men who had consensual sex with a woman under that age liable for arrest and prosecution for statutory rape.

Although the National Association of Colored Women did not become actively involved in the campaigns to raise the age of consent, fearing that young black women would be unfairly targeted and arrested, the organization strongly endorsed the broader goals of the social purity movement. The NACW had formed partially in response to a slanderous letter printed in a British newspaper in 1895. The letter, written by the president of the Missouri Press Association to the secretary of the Anti-Lynching Society of England, described African Americans as a race bereft of morality and labeled black women as thieves, liars, and prostitutes. Although such derogatory commentary was not unusual in the white press, leading African American women found these allegations especially outrageous. According to Margaret Murray Washington, black women were "suddenly awakened by the wholesale charges of the lack of virtue and character." Club women instructed their members to guard their reputations and to strive to present themselves as exemplars of purity. In 1904, delegates to the national convention of the NACW endorsed "temperance, educational mothers' meetings, and the elimination of immoral literature."

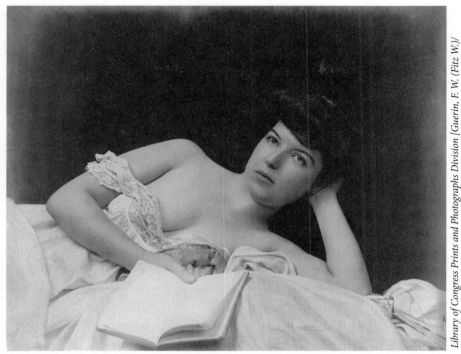

Library of Congress Prints and Photographs Division [Guerin, F. W. (Fitz W.)/ LC-USZ62-117926].

In the first decade of the twentieth century, Fritz Guerin became a famed photographer of women, often posed in only partial dress, who appeared to delight in their personal beauty and sensuality. Images such as this one, which circulated through newspaper tabloids and postcards, drew the ire of social purity reformers.

Crusading against Prostitution

During the Civil War, venereal disease spread so rampantly among soldiers that several prominent physicians proposed a licensing program of prostitutes modeled on the recently enacted Contagious Diseases Act in England. After the war, the president of the American Medical Association endorsed this plan as a public health measure. While the New York legislature considered several bills, the municipality of St. Louis instituted an official licensing plan that required regular medical inspections of prostitutes. The program lasted for scarcely four years, from 1870 to 1874, when a coalition of clergy and women reformers forced the city to end it.

Social purity advocates, as well as many suffragists, sought not to regulate but to eradicate prostitution by "rescuing" fallen women and "punishing" sinful men. "There is no escape from the conclusion that while woman's want of bread induces her to pursue this vice," Susan B. Anthony reasoned, "man's love of the vice itself leads him there."

The White Cross: I Promise by the Help of God
1. To treat all women with respect, and endeavor to protect them from wrong and degradation.
2. To endeavor to put down all indecent language and coarse jests.
3. To maintain the law of purity as equally binding upon men and women.
4. To endeavor to spread these principles among my companions, and to try and help my younger brothers.
5. To use every possible means to fulfill the command, "Keep THYSELF pure."

The White Shield: I Promise by the Help of God
1. To uphold the law of purity as equally binding upon men and women.
2. To be modest in language, behavior and dress.
3. To avoid all conversation, reading, pictures and amusements, which may put impure thoughts into my mind.
4. To guard the purity of others, especially the young.
5. To strive after the special blessing promised to THE PURE OF HEART.

Read **"Why Evil Should Be Combatted"**

During the first two decades of the 20th century, Progressive reformers set out to improve society. One strategy they employed was eradicating vice. Termed vice crusaders, these reformers attempted to stamp out prostitution, especially in large cities, as well as homosexuality. The pinnacle of the antivice movement was the passage of the Mann Act of 1910, which made it illegal to transport women across state lines for "immoral purposes." The excerpt describes the ideology behind the antivice crusades.

Review the source; write short responses to the following questions.

1. According to this report, why should "evil be combated"?
2. Why does the report depict "fallen women" as victims?

One of the largest organizations to conduct "rescue" work was the **Florence Crittenton Mission**, founded by merchant-philanthropist Charles Crittenton and named for his beloved daughter who had succumbed to scarlet fever at age four. The first Crittenton mission opened in April 1883 on Bleecker Street, a few doors away from one of the most notorious brothels in New York City. The mission's volunteer workers formed "rescue bands" to comb the nearby streets, inviting prostitutes and their clients to attend the regular midnight services conducted in the mission chapel. A half century later, a chain of more than sixty-five Florence Crittenton homes offered assistance to women, primarily unmarried mothers who lacked a place to live.

By the end of the century, virtually every large city and many small towns were sponsoring "houses of refuge" of various kinds. For example, a group of Presbyterian women opened the Chinese Mission Home in San Francisco in 1874 to provide "shelter and protection" to those Chinese women who had been sold into a "slavery worse than death." The mission's all-white staff aspired to teach these women sufficient skills so that they could redeem themselves through "honest labor." However, most of the prostitutes who moved into the mission home did so only after they became engaged to marry. Settled into the mission for a term up to one year, which was financed by their prospective husbands, these women immersed themselves in an intensive course of instruction on the domestic arts so that they could prepare to keep a Christian home. By the turn of the century, the Chinese Mission Home was "rescuing" approximately eighty prostitutes a year.

The high point of rescue work occurred between 1908 and 1914, when the **white slavery panic** swept the country. Reformers told melodramatic tales of white slavers luring unsuspecting young women and girls into dance halls or amusement parks, forcefully drugging or seducing them, and then holding them in bondage in houses of prostitution. In response to such lurid tales and high-pressured lobbying, Congress passed the **Mann Act** in 1910, making it a federal crime to take a woman across state lines for "immoral purposes." Meanwhile, settlement houses, Chicago's Immigrants' Protective League, and the National Council of Jewish Women launched programs to protect young women from the snares of procurers. In addition to organizing international conferences on white slavery, they sent volunteers to the major ports of entry and immigration centers, such as Ellis Island and Angel Island, to offer assistance to newcomers traveling alone. "Beware of those who give you addresses, offer you easy, well-paid work, or even marriage," read one of their broadsides, which was printed in three languages.

Civic-minded men joined women reformers in the accelerating crusades against prostitution. Together they proposed the establishment of municipal vice commissions and special grand juries, first, to gauge the extent of prostitution and, second, to prescribe a remedy. More than forty cities and states set up investigative committees that collectively uncovered, as one reformer put it, "the debauchery of tens of thousands of both sexes." A major cause of prostitution, they concluded, was the inability of many women to support themselves. They also blamed parents for failing to supervise their children amid the many temptations that accompanied spread of commercial amusements. However, it was organized vice, they concluded, that bore the major responsibility for turning approximately two hundred thousand women nationwide into prostitutes.

These well-intended efforts made little headway against the commercialized prostitution that did indeed flourish in virtually every city, large or small, and among all classes of men. In New York, in the middle-class price range, there were twice as many brothels as the fifty-cent cribs that working-class men could afford, and boys of both classes commonly turned to prostitutes for their first experience in sexual intercourse. In 1912, there were fourteen brothels in the small town of Janesville, Wisconsin, nearly thirty in midsize Lancaster, Pennsylvania, and more than eighteen hundred in metropolitan New York, where no less than fifteen thousand prostitutes

plied their trade. "Sporting guides" and "blue books" mapped the city's red-light districts, describing the various specialties of individual prostitutes and the prices they charged.

Legislating against Miscegenation

Laws banning interracial marriage dated to the mid-seventeenth century, but only with the abolition of slavery did states begin to tighten and enforce such legislation as a means to control race relations and to bolster white supremacy. One white southerner expressed his fear of race mixing, or **miscegenation**, a term popularized in the early 1860s: "If we have intermarriage we shall degenerate; we shall become a race of mulattoes . . . ; we shall be ruled out from the family of white nations. Sir, it is a matter of life and death with the Southern people to keep their blood pure." The laws enacted after the Civil War carried harsh penalties; the "antimiscegenation" law in Alabama, for example, stipulated imprisonment or a sentence of hard labor for not less than two nor more than seven years.

Relationships between white women and black men provoked the most censure, although such liaisons had been tolerated to some degree among poor southerners before the Civil War. The "blood" of white women must remain "absolutely pure," one postbellum writer pronounced, "and it is the inflexible resolution of the South to preserve that purity, no matter how dear the cost."

In the South shortly after the Civil War, the Ku Klux Klan provided extra-legal force to this conviction (see Chapter 10). The Klan terrorized white women who violated the code of behavior and inflicted horrifying abuse on their black partners that ranged from tar-and-feathering, torture, genital mutilation, and severe beatings, to burning and lynching. "If the negro marries an outcast white woman . . . ," white supremacist Hinton Rowan Helper opined in 1867, "both he and she ought to be hung three minutes after the conclusion of the ceremony, or as soon thereafter as the necessary preparations could be made."

In contrast, interracial marriage and sexual relations between white men and black women continued to draw little more than scorn or ridicule because such liaisons mirrored and reinforced the existing patterns of race and gender domination. White men, for example, frequently kept black women as mistresses. The new laws, moreover, did little to protect black women from sexual abuse by white men. To the contrary, following the demise of slavery, the brutal assault and rape of black women increased, serving as a commonplace "weapon of terror."

By the turn of the century, states throughout the South and West had adopted some form of "antimiscegenation" laws. Legislatures, for example, forbade marriages between Indians and whites. In California, white Americans raised the specter of the "Yellow Peril" to convince legislators to amend the state's civil code in 1880 to prohibit marriage between a white person and a "Negro, Mulatto, or Mongolian." Ultimately, twelve states or territories banned marriages between "Orientals" and whites.

This legislation made marriage virtually impossible for an entire generation of Chinese men in the United States. The **Page Act of 1875**, the first federal law to restrict immigration by prohibiting the entry of prostitutes, effectively singled out women from China (see Chapter 12). Within just two years, the number of Chinese women disembarking in San Francisco, the major point of entry, had fallen by as much as 80 percent. By the end of the century, this restriction caused a severe imbalance in the sex ratio. The number of Chinese women in the United States did not rise above five thousand and represented just 7 percent of the entire Chinese population. Although repeatedly challenged, the U.S. Supreme Court upheld the constitutionality of these state laws, a decision that was not reversed until 1967.

While social purity activists were striking out against "illicit" sexual behavior, other reformers were organizing to expand the range of "normal" activities and "proper" attitudes. After the turn of the century, these two groups stood firmly in opposition to each other. However, they touched common ground in rejecting the double standard of morality. But whereas social purity activists hoped to bring men into women's realm of purity and restraint, others aspired to grant women more of the privileges that men had been enjoying for centuries.

WOMEN'S BODIES AND REPRODUCTION

By the time Margaret Sanger stepped forward to proclaim the birth control movement as "the most far-reaching social development of modern times," groups of reformers had already incited what Sanger described as "the revolt of woman against sex servitude." Experts ranging from physicians and educators to the president of the United States weighed in on this subject, delivering a strikingly wide range of opinions. Controversies erupted with such fervor that it seemed as if the fate of the nation depended on the future of the female body, particularly its ever-mysterious and awesome capacity to bear children.

Designed for Motherhood

It was as if, a male physician contended, "the Almighty, in creating the female sex, had taken the uterus and built up a woman around it." In the last half of the nineteenth century, most physicians assumed that a woman's reproductive organs connected directly to the central nervous system and thereby controlled the actions of all other organs and systems in her body. Consequently, in their opinion, menstruation and ovulation had a dramatic impact on women's health, emotions, and behavior and, to a large extent, worked in concert to prepare her for motherhood and, by extension, for domesticity.

The emergence of the New Woman caused great concern among the medical community and spawned an outpouring of commentary on this subject. Physicians warned that puberty, when the reproductive organs were just beginning to function, made girls peculiarly vulnerable to all kinds of stress. Dr. Edward H. Clarke, a former

professor at the Harvard Medical School, warned that "brain-work" and menstruation were incompatible. The combination, he claimed, resulted in "monstrous brains and puny bodies; abnormally active cerebration, and abnormally weak digestion; flowing thought and constipated bowels; lofty aspirations and neuralgic sensations." He therefore advised mothers to keep their daughters from nerve-draining intellectual work, especially the rigors of higher education.

Clarke's treatise, *Sex in Education: Or, A Fair Chance for Girls* (1873), which described female college graduates as "mannish maidens," generated considerable criticism. Administrators at the women's colleges refuted Clarke's claims and responded by establishing fitness programs to complement the intellectually demanding academic curriculum. Nevertheless, even decades after the publication of Clarke's book, Bryn Mawr president M. Carey Thomas noted that her students "were haunted . . . by the clanging chains of that gloomy little specter."

Controlling Reproduction

When physicians had begun to carve out the specialty field of gynecology, the physiology of conception was largely unknown, but those who wrote on the subject commonly condemned any form of contraception. They insisted that the widespread practice of *coitus interruptus*, or withdrawal, had an injurious effect on a woman's delicate nervous system. Rather, the antebellum physician William A. Alcott advised "the submissive wife" to "do everything for your husband which your strength and a due regard to your health would admit." In late 1860s, medical societies passed formal resolutions condemning birth control practices and abortion.

At the same time, a few courageous reformers flaunted expert opinion to speak out on "voluntary motherhood," that is, the right of women to control their fertility. In the early 1870s, both Elizabeth Cady Stanton and Victoria Woodhull wrote and lectured on the topic (see Chapter 10). They, too, rejected contraceptives, fearing that "artificial" methods would allow men to demand yet more sex from their wives. However, they did insist, in line with social purity advocates, that women had the absolute right to determine the frequency, timing, and form of sexual relations within marriage.

In a trend that one historian has termed **domestic feminism**, American women appeared to gain more power over marital relationships. Among white women surviving to menopause, the average number of children born fell from 7.04 in 1800 to 3.54 a century later. The drop for urban middle-class women was even sharper because immigrant and rural women brought up the average by bearing more children. But even for African American women, the majority of whom still lived in rural areas, the fertility rate dropped by one-third between 1880 and 1920. For many Americans, two children represented the ideal number.

By the turn of the century, middle-class women were using the variety of methods to control fertility that dated to the early nineteenth century (see Chapter 5). While many encouraged their husbands to practice withdrawal, an increasing number of women relied on contraceptive devices like condoms, sponges, and pessaries. In

Mosher's sample, 42 percent of the women who used contraceptives listed douching as their preferred method and named sulphate of zinc, alum, alcohol, soap suds, and plain water as solutions of choice. Still other women used the rhythm method, some carefully charting their menstrual cycles in a special diary. However, most of these methods were either unreliable or inefficient. As a last resort, women turned to an underground network of abortionists.

Educated white women achieved the lowest fertility rates of all women, simply by marrying later than average or choosing not to marry at all. For example, more than half of the women who graduated from Bryn Mawr between 1889 and 1908 never married; for Wellesley and the University of Michigan, the percentages were just a bit lower, 43 percent and 47 percent, respectively. Three-quarters of all women who received doctoral degrees between 1877 and 1924 remained unwed. Highly educated women who did marry tended to have fewer children than the average or none at all.

The drop in fertility among educated white women was so striking that some worried citizens predicted an impending crisis for the nation. Their fear dated to 1870 when the Massachusetts census bureau reported higher birthrates among the immigrant population than among the native-born Americans and among poor people than among the affluent. In 1903, no less than the president of the United States, Theodore Roosevelt, cautioned that the low birthrate among white Anglo-Saxon Protestants was sure to result in **race suicide**. His advice—breed larger families—found few takers.

The Birth Control Campaign

The campaign launched by Margaret Sanger targeted the masses of working people. A neo-Malthusian, she believed that working people, by limiting family size, could utilize their meager resources more efficiently and put themselves in a better position to foment revolution—or at least to demand higher wages. In endorsing these principles, Sanger won support of large numbers of socialists and anarchists, who became the backbone of the birth control movement in its first years.

In 1915, following William Sanger's arrest, the most talented radical activists headed a widespread campaign. The labor agitator Elizabeth Gurley Flynn spoke at dozens of meetings sponsored by the Industrial Workers of the World (IWW). Flynn sent words of encouragement to Margaret Sanger, then in exile, and described the upbeat mood of the crowds that turned out to hear about birth control. The socialist Kate Richards O'Hare reported from the Midwest that her newspaper, the *National Rip Saw*, had been "flooded" with letters from women demanding the secret to family limitation.

The most prominent agitator was Emma Goldman, who was by then well known as an anarchist and a free lover. Like Sanger, Goldman had worked as a nurse in New York's Lower East Side and understood well the urgency of getting birth control information to the burgeoning population of poor immigrant women. She decided to test the limit of the Comstock laws by giving graphic descriptions of contraceptive

techniques in her public lectures. After a cross-country tour, Goldman was finally arrested in New York City on February 11, 1916.

Hundreds of people stormed Carnegie Hall to hear Goldman defend herself. "I have simply given to the poorer women in my audiences information that any wealthy woman can obtain secretly from her physician who does not fear prosecution," she explained. "I have offered them advice as to how to escape the burden of large families without resorting to illegal operations." Goldman's highly publicized trial and incarceration in the workhouse prompted Margaret Anderson, the editor of the *Little Review*, to write: "Emma Goldman was sent to prison for advocating that women need not always keep their mouths shut and their wombs open."

View the Profile of Margaret Sanger

Margaret Sanger, a nurse, was a pioneer in the campaign for birth control. In 1921 she founded the American Birth Control League, which later became the Planned Parenthood Federation. She lived long enough to witness the 1965 Supreme Court decision, *Griswold v. Connecticut*, which removed the last legal obstacle for married women to gain access to birth control.

Meanwhile, a group of middle-class women and men moved to the forefront of the movement. Several in New York City formed the **National Birth Control League** (NBCL), directed by suffragist Mary Ware Dennett. The NBCL built a campaign not by appealing to working-class women but by enjoining physicians and wealthy individuals to demand a repeal of the existing state and federal laws that designated birth control information and devices as "obscene." Dissatisfied with the singular legislative approach, Margaret Sanger organized the rival **American Birth Control League** (ABCL), which by the mid-1920s boasted a membership of more than thirty-seven thousand. The ABCL also promoted legislative reform and depended on professionals for leadership but provided practical services, such as educational programs and clinics, and funded research and conferences to attract international affiliates.

By the end of the 1910s, groups of African American women were actively campaigning for the creation of birth control clinics in black communities. In 1918, the Women's Political Association of Harlem initiated a series of lectures on the subject, and several years later Margaret Sanger spoke to black audiences in the Bronx. In 1925, at the request of the Urban League, the ABCL began to lay plans for a clinic in Harlem, which opened in 1929.

REBELS IN BOHEMIA

"We were healthy animals and we were demanding our right to spring's awakening," one college woman recalled. Between 1910 and 1914, this idea inspired small circles of radicals and so-called bohemians to insist on greater honesty in sexual relations and

an end to the double standard. They gave testimony to this aspiration not only through their social activism and artistic works but through the way they lived out their personal lives. It was within this context that a new, distinctively modern form of politics emerged.

Living the New Morality

In the late-1870s, small groups of radicals began to challenge Anthony Comstock's anti-"obscenity" laws by publicly denying that marriage was the only proper context for sexual relations. Like Victoria Woodhull, they proudly proclaimed themselves to be free lovers (see Chapter 10). Theirs was an uphill and unpopular battle. For more than twenty years, Ezra and Angela Heywood published *The Word* in an attempt to break what they believed was a conspiracy of silence about all topics related to human sexuality; Moses Harman and Lois Nichols Waisbrooker did the same with *Lucifer, the Light-Bearer*.

After the turn of the century, a new generation of mostly middle-class women and men took advantage of the greater freedom they discovered amid the diverse populations of the nation's big cities. They typically congregated in the furnished room districts and immigrant neighborhoods, forming distinctive enclaves that became famous for their "bohemian" character. In the environs of Chicago's Bug House Square and San Francisco's North Beach, these adventurers tampered with the moral values prescribed by their parents and attempted to create a new lifestyle wherein men and women lived together honestly and loved freely as equals.

The low-rent neighborhood of Greenwich Village, located on the west side of downtown Manhattan, became the most celebrated bohemian mecca. Mabel Dodge's nearby salon on Fifth Avenue provided a forum for discussions of sexuality, enlivened by the preaching of Margaret Sanger, who served, according to her host, as "an ardent propagandist for the joys of the flesh." Sanger and her companions felt no compunction in denigrating chastity for either men or women and instead insisted on the right to sample various pleasures on the way to marriage. Some chose to avoid the institution altogether, while others condemned the artificial restraints imposed by monogamy. Louise Bryant and John Reed, both journalists and political activists, and Susan Glaspell and her husband George Cram Cook, both playwrights and novelists, were only the most prominent denizens of "Bohemia" who attempted to live by the precepts of the new morality.

If they married, bohemian women refused to sacrifice their independence. They continued to pursue careers and shunned domesticity. A few couples joined together in cooperative housekeeping arrangements, sharing cooking, cleaning, and child care; others chose to live in a comparatively barren flat rather than a fully furnished house that demanded constant upkeep. In the fashion world, bohemians became known as trendsetters. Women abandoned the popular body-molding corsets for the comfort of loose-fitting garments, men avoided business suits for casual wear, and in warm weather both put aside clunky shoes for sandals. Women often smoked and drank as freely as men. A favorite meeting place

was the "Working Girls Club," not a charity home but a saloon in Greenwich Village. Young men were drawn to the defiant woman, the writer Floyd Dell later recalled, because she "was comparatively freed from the home and its influence; because she took the shock and jostle of life's incidents more bravely, more candidly and more lightly."

Open marriage, or free love, proved far more attractive as an ideal than as an actual practice. A customary prerogative for men, multiple sexual partners continued to place women at a disadvantage, not least by raising the chances of unwanted pregnancy. Moreover, even the most determined and well-educated woman found it nearly impossible to secure employment that would bring her financial security—or allow her to raise children without depending on a husband for support. Nevertheless, many women were willing to pay a steep emotional price for their experimentation and took comfort in the sense that they were helping to seal the fate of the culture of separate spheres.

> ### Read **"Red Emma" Critiques Marriage**[4]
>
> Emma Goldman issued some of the most forceful critiques of the institution of marriage. Born in Lithuania, she had immigrated to the United State when she was seventeen, married briefly, and then devoted her life to anarchism. Goldman also promoted free love and published a popular "little magazine," *Mother Earth*. Known as "Red Emma," she was deported for her incendiary views during World War I and spent the remainder of her life in the Soviet Union.
>
> Review the source; write short responses to the following questions.
>
> 1. How does Emma Goldman make her argument for free love and against marriage?
> 2. What role does sex play in her critique of contemporary marriage practices?

Heterodoxy and Feminism

In New York, a self-described "little band of willful women, the most unruly and individualistic you ever fell upon," came together in 1912 to form an innovative women's club, **Heterodoxy**. In its thirty-year history, the club admitted only a little more than one hundred members, but its small roster listed some of the most eminent professional women of the time. This "club for unorthodox women" rebuffed philanthropy and instead served as a forum for women to air their opinions on an endless range of topics. Its biweekly luncheons attracted scores of bohemian women such as Ida Rauh, her sister-in-law Crystal Eastman, Susan Glaspell, Henrietta Rodman, and Mabel Dodge Luhan. Most of the members were trying to sustain their careers while taking pleasure in personal relationships. Perhaps as many as one-quarter of Heterodoxy members were lesbians.

As individuals, the members of Heterodoxy maintained strong political profiles. Some supported trade union campaigns among working women and stood at the forefront of the woman suffrage movement. Others had strong opinions on politics, including socialism, anarchism, syndicalism, and progressivism, as well as the Republican and Democratic parties. But what set them apart from their contemporaries was a determination to give their personal lives a political dimension.

The members of Heterodoxy were among the first women to use the term **feminism**, which appeared in the United States around 1910 as a French import. "We have grown accustomed . . . to something or other known as the Woman Movement. That has an old sound," one journalist noted. "Therefore, no need to cry it down. But Feminism!" Was it possible that the century-long campaign for women's emancipation could take on an astonishingly new dimension? The answer was a resounding YES!

> ### Read "If I Were a Man"
>
> Many aspects of Charlotte Perkins Gilman's[5] life found their way into her writing, both fiction and nonfiction. Gilman wrote about issues, such as depression and mental illness, that were often taboo, and she satirized the societal restrictions and hypocrisy women faced in their daily lives. Largely self-educated, Gilman was a prolific writer who lectured on topics ranging from ethics to labor to the artificiality of gender roles.
>
> Review the source; write short responses to the following questions.
>
> 1. What does Mollie, now Gerald, experience as a man? How does her life change?
> 2. Perkins references that Molly "learned and learned" at the end of the story. What do you think she learned? Was life better or worse for Mollie as a man?

Despite the enthusiasm for the new term, a precise definition eluded most enthusiasts. They understood that "feminism" was not the same as the demand for the ballot, equal wages, or access to higher education and the professions. The founder of Heterodoxy, Marie Jenny Howe, insisted that feminism of course included all these endeavors. In 1913, Crystal Eastman and Henrietta Rodman sponsored the Feminist Alliance precisely to demand "the removal of all social, political, economic, and other discrimination which are based upon sex." But in addition to these familiar aspirations, Howe pointed out, feminism stood for the "social revaluation of outgrown customs." Howe offered a simple definition of feminism as an "appropriate word to register . . . woman's effort toward development," which included foremost a "changed psychology, the creation of a new consciousness in women."

Feminists continued to work for women's advancement, and they played an especially vital role in the birth control movement. They tended, however, to emphasize the highly personal and individualistic goal of self-realization. Much like Kate Chopin's protagonist in *The Awakening*, Edna Pontellier, they focused not so much on gains in the public sphere as achieving satisfaction in the interstices of private life, that is, in their relationships. Intimacy and sexual freedom therefore ranked very high on their agenda. For feminists, the personal was, indeed, political.

Art and Politics

Many feminists found that the questions they foremost sought to answer were best posed through the medium of art. Kate Chopin was merely one of dozens of women who turned to writing to explore the social and psychological realities of women's lives. Ellen Glasgow, Willa Cather, and Mary Austin all created complex fictional protagonists who challenged the orthodoxy of the day. Edith Wharton's *The House of Mirth* (1905) detailed the outworn marriage customs of New York's high society and the emotional damage they inflicted on women. Her ravishing yet financially needy protagonist, Lily Bart, refused to marry for money but at the same time knew that love alone would not satisfy her craving for luxuries. In 1921, Wharton was awarded a Pulitzer Prize for *The Age of Innocence* (1920), which also explored the themes of love, marriage, and divorce among the upper classes.

The Greenwich Village bohemians excelled in contributing a satiric dimension to the feminist critique of love and marriage. Cornelia Barnes, a cartoonist on the staff of *The Masses*, drew a playful cover for the magazine that featured two modern women in conversation. One is saying: "My Dear, I'll be economically independent if I have to borrow every cent!" Susan Glaspell wrote and produced equally wry plays, several parodying her own circle of friends. She tapped her friends to act in her plays, which she staged in Lower Manhattan or on Cape Cod, where she and her husband helped to sponsor a little theatrical company, the Provincetown Players. Glaspell's female protagonists invariably resembled women in her milieu, all expressing a "diffused longing for an enlarged experience" that usually involved sex.

The dancer Isadora Duncan made waves both in the United States and abroad by attaching her revolutionary politics to freeing the female body from conventional constraints. Developing what would later be called modern dance, Duncan rejected classical ballet for a style of dance based on natural, expressive movements. She also rejected corsets, petticoats, and stockings for a loose-fitting, sheer tunic that emphasized the contours of her body. "Spectators in the front rows gasped when they saw the famous barefoot dancer leaping forward . . . clad only in the lightest, scantiest, and most translucent silk," one reviewer observed. "One glance sufficed to show that beneath this airy raiment . . . nature was unadorned. . . . Anthony Comstock himself would have been surprised."

The poet Gladys Oaks offered perhaps the most succinct summary of feminism and the new morality. She not only affirmed woman's sexuality but celebrated her right to express it in her short poem entitled simply "Climax":[6]

> I had thought that I could sleep
> After I had kissed his mouth
> With its sharply haunting corners
> And its red.
> But now that he has kissed me
> A stir is in my blood,
> And I want to be awake
> Instead.

CONCLUSION

By the turn of the century, a new morality had swept much of urban America, pushing aside the remaining vestiges of "female passionlessness" and affirming not only the existence but the merits of the female sexual drive. Working-class women played a large role in this process, providing an inspiration to many other women who were attempting to break away from the middle-class mores of their parents. At the same time, the era ushered in a new "heterosociality," signifying a companionship between men and women that superseded the old ideology of "separate spheres." In sum, the era heralded a great change in the relations between the sexes, one that was bringing men and women closer together in all aspects of life, including sexual companionship.

Yet, these monumental changes, which one historian has grouped together under the heading of the "first sexual revolution," did not come easily or without the introduction of new restrictions on sexual behavior. To the contrary, sexuality became subject to increasing scrutiny, as medical and other experts codified behavior into "normal" and "deviant," as legislators outlawed interracial relationships, and as large sectors of the public attempted to bring men into the fold of the presumably pure. Indeed, what would become known as "sexual modernism" would prove to be a highly contested arena.

 Study the <u>Key Terms</u> for The New Morality, 1880–1920

Critical Thinking Questions

1. What was the role of working-class women in advancing heterosocial relationships? What was the importance of leisure time and the spread of amusement parks, dance halls, and movie theaters?

2. With the decline of "female passionlessness," how did middle-class marriage change? What was the impact on same-sex relationships?
3. What were the causes and effects of the panic over white slavery?
4. Was the birth control movement successful in reaching its goals?
5. What did contemporaries mean by "feminism"?

Text Credits

1. Elaine Showalter, ed., *These Modern Women: Autobiographical Essays from the Twenties* (New York: The Feminist Press, 1989), pp. 107–108.
2. Irving D. Steinhardt, *Ten Sex Talks to Girls, 14 Years and Older* (Philadelphia: J.B. Lippincott Company, 1914).
3. Margaret Sanger, What Every Girl Should Know, 1913.
4. Emma Goldman, *Anarchism and Other Essays* (New York: Mother Earth Publishing Association, 1911), pp. 233–245.
5. Charlotte Perkins Gilman, If I Were a Man, 1914.
6. Climax by Gladys Oaks (1925).

Recommended Reading

Cynthia M. Blair. *I've Got to Make My Livin': Black Women's Sex Work in Turn-of-the-Century Chicago*. Chicago: University of Chicago Press, 2010. A multifaceted analysis of African American women in the sex trade. Blair emphasizes their agency while portraying prostitution as an institution fostering abuse and exploitation.

Crista DeLuzio. *Female Adolescence in American Scientific Thought, 1830–1930*. Baltimore: Johns Hopkins University Press, 2007. A groundbreaking study of expert opinion on "femininity" and psychological development. DeLuzio covers the scholarship from several fields of medical and behavior science that defined "normality" in terms of the "adolescent girl."

Elizabeth Francis. *The Secret Treachery of Words: Feminism and Modernism in America*. Minneapolis, MN: University of Minnesota Press, 2002. A brilliant study of a group of Bohemians who combined their quest for women's liberation with an affirmation of revolutionary politics. Francis offers an insightful analysis of Isadora Duncan's ideas about the liberated female body.

Linda Gordon. *Woman's Body, Woman's Right: Birth Control in America*. New York: Grossman/Viking 1976, rev. 1990. A sweeping overview of Margaret Sanger's career within a political context.

Chad Heap. *Slumming: Sexual and Racial Encounters in American Nightlife, 1881–1940*. Chicago: University of Chicago Press, 2009. Covers the activities of both social reformers concerned about changing sexual mores and the adventurers who found entertainment and titillation in the city's immigrant and working-class neighborhoods and red-light districts.

Martha Hodes. *White Women, Black Men: Illicit Sex in the Nineteenth-Century South*. New

Haven, CT, and London: Yale University Press, 1997. Focused on sexual liaisons between white women and black men, Hodes's book traces a history of relative tolerance for such relationships during the slavery era to the extreme taboo and violent enforcement of the postbellum South.

Peggy Pascoe. *Relations of Rescue: The Search for Female Moral Authority in the American West, 1874–1939*. New York: Oxford University Press, 1990. An intercultural study of the home mission movement at the turn of the twentieth century. Pascoe examines the efforts of Protestant women in the American West to "rescue" Chinese prostitutes, Mormon polygamous wives, unmarried women, and Indian women.

Kathy Peiss. *Cheap Amusements: Working Women and Leisure in Turn-of-the-Century New York*. Philadelphia: Temple University Press, 1986. The classic study of commercial entertainments as a setting for the emergency of heterosocial relationships, pioneered by working-class men and women.

Ruth Rosen. *The Lost Sisterhood: Prostitution in America, 1900–1918*. Baltimore: The Johns Hopkins University Press, 1982. Examines both the campaigns to curtail prostitution and the experiences of the women who practiced it.

Emily Toth. *Unveiling Kate Chopin*. Jackson, MS: University Press of Mississippi, 1999. A full biography of Chopin, with special attention to her fiction as well as to her career.

THE PROGRESSIVE ERA, 1890–1920

LEARNING OBJECTIVES

- How did women transform their domestic concerns into public issues?
- What role did cross-class alliances play during the Progressive Era?
- What impact did "maternalism" have on progressive reform?
- What changes did World War I bring to American women?
- How did women finally win the right to vote?

Explore Chapter 15 Multimedia Resources

TIMELINE

1889	Jane Addams opens Hull House
	National Consumers League formed
1895	The NAWSA inaugurates "southern strategy"
1897	National Congress of Mothers formed
1898	Illinois legislates juvenile court system
1900	College Equal Suffrage League formed in Boston
1903	National Women's Trade Union League formed
1907	Equality League of Self-Supporting Women formed
1908	Lugenia Burns Hope establishes the Neighborhood Union
	Muller v. Oregon establishes protective labor legislation
1909	New York shirtwaist makers strike
1910	Chicago garment workers strike
1911	Illinois passes first mothers' pension law
	Triangle Fire happened in New York City
1912	U.S. Children's Bureau formed
	Textile workers in Lawrence, Massachusetts, strike
1913	Alice Paul and Lucy Burns form Congressional Union
1914	World War I begins
	Woman's Peace Parade protests war
	The GFWC endorses woman suffrage
1916	Congress passes National Defense Act
	Woman's Peace Party formed
	Women's International League for Peace and Freedom formed
	The Great Migration begins
	Carrie Chapman Catt proposes the "winning plan"
	Protocol of Peace is signed

1917	National Woman's Party formed
	United States enters World War I
	Committee for the Protection of Women and Girls formed
	Suffrage referendum wins in New York
1918	Armistice ends World War I
1920	U.S. Women's Bureau formed
	Nineteenth Amendment ratified

THE PROGRESSIVE ERA REPRESENTED A GREAT AGE FOR WOMEN AS POLITI-CAL ACTORS. They joined other like-minded Americans in seeking solutions to the many problems caused by unbridled social and economic changes, particularly the excesses associated with the second industrial revolution and the tremendous growth in urban—mainly immigrant—populations. Child labor, poor working conditions, impure food and water, overcrowded and dirty neighborhoods, and inefficiency and corruption in government were just a few of the issues that propelled them toward activism. At the national level, progressive reformers, as they were called, demonstrated their strength in the 1912 presidential election, when four candidates ran on similarly reformist platforms. But lacking the right to vote and hold public office in most states, women reached out first to their own networks.

Although women reformers relied on many of the organizations and institutions that dated to the late nineteenth century, they embraced a new strategy. They realized that the solutions to the poverty and injustices overflowing in urban America demanded more resources than those women could provide in their separate voluntary associations. Following in the footsteps of Florence Kelley, who had fought for legislation in the 1890s that made the Illinois state government accountable for the working conditions in factories, women reformers now joined forces to demand that the state—that is, government at all levels—take on broad responsibility for the welfare of its citizens, especially its women and children.

During the Progressive Era, the collective influence of women was greater than at any previous time in American history and not equaled again until the resurgence of the women's movement in the mid-1960s. Ultimately, it was the claim to power that brought the majority of women into the suffrage camp. If women were to be the vanguard in transforming the state in the service of social justice, they needed to participate fully in the political process. In short, women needed the ballot foremost as an instrument of reform.

"MUNICIPAL HOUSEKEEPING"

"Women's place is Home," Rheta Childe Dorr explained, "but Home is not contained within the four walls of an individual home. Home is the community." Reformers like Dorr took it upon themselves to make the nation's urban neighborhoods the

Read "I Came a Stranger"

Hilda Satt Polacheck[1] emigrated from Poland in 1892 when she was ten years old and settled with her family in Chicago near Hull House. By the time she met Jane Addams, the founder of the most famous social settlement in the nation, she had already taken a job, along with her sister, in a nearby knitting factory, where she put up with what she described as the "monotony of work" for far too many years. Unlike those immigrants who mistrusted reformers, Polacheck revered Addams, not as a "lady bountiful," as she was sometimes called, but as a friend and mentor.

Review the source; write a short response to the following question.

1. What was Hilda Polacheck's concern about going to Hull House originally? What happened when she arrived?

center of the **Progressive movement**. Theirs was a loose coalition of activists who sustained a long tradition of involvement in civic betterment and, at the same time, pressured the government to take responsibility for matters that had been primarily the province of the family, the church, or voluntary associations. During the Progressive Era, these reformers succeeded in transforming many domestic or private concerns into public issues while insisting on women's right to play a major advocacy role.

Jane Addams and Hull House

While touring Europe, Jane Addams (1860–1935) found herself, she later recalled, "irresistibly drawn to the poor quarters of each city." In England, she visited Toynbee Hall, the first settlement house in the slums of London's East End. Addams returned to the United States determined to create a settlement that, like Toynbee Hall, would recruit university students and college graduates to improve the lives of the poor. With this idea in mind, Addams convinced with her former classmate, Ellen Gates Starr, to join her in Chicago.

Using her substantial inheritance and donations from wealthy Chicagoans, Addams purchased an old, dilapidated mansion in the city's Near West Side, a bustling working-class community of immigrants, and named it **Hull House**. After a round of renovations, in September 1889, the two young women opened their doors and invited their neighbors to spend their evenings with them. Soon, they attracted other college-educated women who also took up residence in Hull House.

Hull House served as a major center of progressive reform, combining philanthropy and social science research. A large component of programs catered to children and their mothers. The complex included a day nursery, kindergarten, playground, gymnasium, and medical dispensary. Other programs served the adult immigrant population.

Respectful of the unique cultural practices of various ethnic groups yet convinced of the benefits of assimilation, Hull House offered English-language classes; employment referral services; a boardinghouse, library, and art studio; instruction in cooking and housekeeping; and even a post office. By 1907, Hull House had grown into a thirteen-building complex covering an entire city block.

Addams never envisioned Hull House as merely a social and educational center. She understood that the solutions to the most pressing problems such as chronic poverty and inadequate housing could not be solved within the neighborhood alone. She therefore promoted the settlement as a base for political action.

Read about **Jane Addams and Her Quest for Social Justice**

In the name of social justice, Addams and her coworkers tackled problems large and small, from garbage collection in the neighborhood to corruption in city politics. Hull House reformers like Florence Kelley bravely took on the local political machines and rallied the community to demand legislation abolishing child labor and making school attendance compulsory. In recognition of Hull House's many accomplishments, Addams was chosen to second the nomination of Theodore Roosevelt for president on the 1912 ticket of the Progressive Party, which incorporated many of Hull House's reform measures into its national platform. By 1920, Hull House reigned as the most famous of nearly five hundred other social settlements.

But Addams also inserted herself into the suffrage debate, drawing a parallel between a woman's ability to nurture in the home and her ability to make an impact in the political world. She saw the social justice efforts that she embraced in direct correlation with her thoughts on the vote and was a tireless champion for both.

Review the sources; write short responses to the following questions.

Jane Addams, *The Clubs of Hull House* [1905][2]
Jane Addams, *Ballots Necessary for Women* [1906][3]

1. Describe the different clubs that were under the Hull House name and their general purposes overall.
2. What can women bring to the political table, so to speak, according to Jane Addams?

The Settlement Movement: A Community of Women

The women's colleges sent a disproportionate number to the settlements. The motto of Smith College expressed the imperative to contribute to the public good: "Add to your virtue, knowledge." In addition to instilling in their students a sense of mission, Smith, Wellesley, Vassar, and Bryn Mawr established innovative curricula highlighting the

new social sciences. Their students studied political economy and systems of government and grappled, often at close range, with the problems of poverty and labor unrest. Undergraduate students also formed small but tight-knit communities that respected in equal measure intellectual achievement and social service. Upon graduation, these young women refused to be, in Jane Addams's words, "smothered and sickened with advantages" typical of their middle-class upbringing and took their mission to the nation's cities.

Unlike other forms of benevolence, settlements functioned as homes for activists. Although the few male settlement workers at Hull House rented rooms in nearby houses, the longest-term workers were the women residents who, according to Addams, were held together by the "companionship of mutual interests." Florence Kelley, for example, in waging the campaign for the Illinois Factory Inspection Act, found not only political allies but intimate friends among her coresidents at Hull House. Addams herself lived at Hull House until her death in 1935.

Read **"Good Metal in Our Melting Pot"**[4]

At the **Henry Street Settlement** in the Lower East Side of New York City, a group of women, under the leadership of Lillian Wald, lived and worked together for more than a half century. Wald's mission was clear: to provide affordable health services with emphasis on maternal and infant care. With this mission in mind, Wald, a nurse, went on to found the Visiting Nurses Association of New York City, an organization that is still flourishing and serving people.

Review the source; write short responses to the following questions.

1. What was Lillian Wald's general philosophy?
2. What was Wald's experience working as a nurse in hospital wards? How did that time influence her?

By living in the heart of the city's working-class and mainly immigrant neighborhoods, settlement residents gained an intimate knowledge of the problems of the poor that most other reformers lacked. "I can see why life in a settlement house seemed so great an adventure," recalled Alice Hamilton, who had moved to Hull House in 1897. "It was all so new, this exploring of a poor quarter of a big city. The thirst to know how the other half lived had just begun to send people pioneering in the unknown part of American life." From this vantage point, settlement workers gained the knowledge, skills, and constituencies they needed to effect change and, in several cases, to rise to positions of national leadership.

"A Power for Good": Neighborhood Activism

Not all women who targeted the community as the locus of their reform activism lived in settlements. To the contrary, married women who lived with their families in their own homes served, through various women's organizations, as the rank-and-file of

the progressive movement. Settlement workers were careful to nurture their relationships with these dedicated activists. Hull House, for example, worked closely with the dynamic Chicago Woman's Club and additionally depended on other local women's organizations such as the WCTU and the YWCA.

Club women were the principal sponsors of settlements among African Americans, who in most locations were excluded from the racially segregated mainstream settlement houses. Lugenia Burns, an activist in the Southeastern Federation of Colored Women's Clubs, founded the **Neighborhood Union**, a settlement directed and financed by African Americans. Born in St. Louis, Hope had lived and worked for awhile at Hull House before she married and then moved to Atlanta with her husband, who became the president of Morehouse College. "People living in slums do not have to die in slums," she concluded, "nor do slums have to continue to be slums." In 1908, Burns began to recruit activists from the local black women's clubs and other voluntary organizations, divided the city into districts, and established a network of community-based programs, all affiliated with the Neighborhood Union. Like Hull House, the Neighborhood Union served as a center for cultural events, educational programs, and political action. The injustices caused by segregation guided most campaigns, with the public school system of Atlanta, sanitary and health facilities, and employment and transportation at the top of their agenda.

To carry out their campaigns of "**municipal housekeeping**," African American club women depended on larger networks of black reformers. In Chicago, as in many other northern cities, they allied themselves with the men who ran the local branches of the Urban League and the National Association for the Advancement of Colored People (NAACP). In southern cities, however, Jim Crow had effectively pushed black men to the sidelines of politics, and clubwomen found their most seasoned allies among churchwomen.

The **Women's Convention of the Black Baptist Church**, numerically the most significant Protestant sect among African Americans, responded to the spread of Jim Crow in a variety of ways, not least by building institutions as alternatives to the public spaces reserved for whites only. Clubwomen and churchwomen played the leading roles in opening schools, establishing libraries, sponsoring cultural events such as concerts, providing recreational facilities such as playgrounds, and organizing vocational training programs in their communities.

Southern white women also organized to improve their own communities, although more slowly than their northern counterparts. For example, in Memphis, the Nineteenth Century Club was organized only in 1890 and then as a literary and cultural endeavor. By the turn of the century, Memphis clubwomen responded to the reform fervor sweeping the nation and inaugurated projects more political and public in nature. For example, the club formed a special committee to secure police matrons who would protect women prisoners from sexual abuse in the city's jails. Similarly, in El Paso, Texas, women organized to study literature before broadening their horizons. By 1914, the local newspaper commended the El Paso Woman's Club for outstripping all other local organizations working for "civic improvement."

Clubwomen, white and black, North and South, rallied to improve public health and sanitation, and in at least forty cities local activists formed **women's health protective associations** (WHPAs). The WHPA of Galveston, Texas, for example, did heroic work in the aftermath of the hurricane of 1900, which nearly demolished the city. The activists of WHPA continued their work throughout the Progressive Era, securing trash cans in public places, urging residents to burn their garbage, demanding cleaner streets and alleys, and sponsoring a "Swat the Fly" effort to curb the spread of contagious diseases like typhoid. The Philadelphia association campaigned for the construction of functional filtration systems for the local water supply and, in league with the County Medical Society, inaugurated a program of medical inspection in the schools. The WHPAs raised money for building and maintaining hospitals, predominantly for the treatment of tuberculosis, a leading cause of illness and death that was especially rampant in urban slums. Determined "municipal housekeepers," clubwomen conducted the major campaigns to secure the passage and enforcement of pure food and milk acts.

THE ERA OF WOMEN'S STRIKES

"[W]e have now a trade-union truism, that 'women make the best strikers.' " So proclaimed Helen Marot of the New York Women's Trade Union League. Marot wrote in the aftermath of the largest strike of women in American labor history, the uprising of the city's shirtwaist makers that capped nearly a decade of slow but steady mobilization spearheaded by women trade unionists and their middle- and upper-class allies. Not just in New York but in other centers of manufacturing, cross-class alliances of women were formed to investigate the shops and to report on the conditions they found there. They made the public keenly aware of the injustices associated with the factory system, such as low wages and long hours, unsanitary working conditions, and the problems caused by unsafe buildings. Equally important, they worked together to transform the image of the "working girl." No longer simply the victim of the excesses of industrial capitalism but a hero in her own right, the working girl advanced from "the outcast of today," as one writer put it, to "the pioneer of tomorrow."

Women's Trade Union League

The leaders of the American Federation of Labor (AFL), which was founded in 1885 and succeeded the Knights as the premier labor organization, chose to focus on highly skilled white men and did little to welcome women to their ranks. In northern cities, groups of seasoned women reformers tried to fill the void. Settlement workers, for example, invited wage-earning women to use their facilities as a meeting place to organize trade unions. When striking garment workers in Boston needed help in forming a union, the leaders turned not to the AFL but to Denison House, a settlement in the city's South End.

Meanwhile, various women's organizations supplied the personnel and resources to form the National Consumers League (NCL) in 1899. Local branches and the national

organization campaigned against sweatshops and sponsored investigations of labor conditions in factories employing women and children. They also created a "White List" of stores and factories that maintained fair wages and hours and a sanitary environment and advised shoppers to patronize only these establishments.

In 1903, wage-earning and middle-class women allied to form one of the most successful cross-class alliances in American history, the **National Women's Trade Union League** (NWTUL) in 1903. The constitution of the new venture specified that membership include both workers and their "allies," that is, middle- and upper-class women who were committed to trade unionism, and additionally specified that wage-earning women hold the majority on the executive board. Within a decade, the alliance proved successful, and the NWTUL stood at the forefront of a campaign to organize unions in trades where women predominated. The most active branches were located in New York, Chicago, and Boston, whereas at least a dozen other cities claimed small organizations.

Read **"The WTLU and its Legislative Goals"**[5]

The Women's Trade Union League (WTUL) was formed in 1903 during the American Federation of Labor (AFL) convention. AFL leaders did recognize the WTUL, but they did not offer significant assistance to women workers. WTUL leaders subsequently established the Women's Bureau of the Department of Labor.

Review the source; write short responses to the following questions.

1. In your opinion, is there anything in this document that would outline a "protection" that might be harmful to women?
2. What provisions, if any, does this document make for children?

League tactics reflected the complexity of its membership. The WTUL sponsored "sociables" for working women with the intention of combining the discussion of unionism with the drinking of tea. More successful in attracting new members, however, were daily street meetings. During the lunch break, WTUL speakers would set up a platform, fly their banner, and, according to one trade union member, preach "the gospel of trade unionism at and near the factory door." In this fashion, the WTUL managed to increase the number of wage earners in its ranks, recruiting successfully among the young Jewish and Italian immigrants who predominated in the garment trade as well as among retail clerks, textile operatives, and even laundresses and waitresses.

League members often referred to themselves as a "sisterhood," insisting that what they shared as women could override the differences of class. Like their settlement peers, WTUL activists formed strong networks based on friendship and mutual dedication to reform. Still, such relationships, especially those that bridged large differences of wealth and education, were far from easy, and members could never agree if the WTUL was foremost an arm of the labor movement or a branch of the women's movement.

Uprising in the Garment Industry

In 1907, Leonora O'Reilly wrote to "ally" Helen Marot: "We are looking forward to a revolution in New York among working women." Just two years later, her prediction came true, and the New York WTUL experienced its greatest moment amid the shirtwaist makers' strike, the so-called **Uprising of 30,000**.

The 1909 strike had been preceded by a series of fitful attempts to establish a viable union in the garment trade. Workers had repeatedly protested unsanitary shop conditions; unlimited hours of overtime in the busy season and no work—and no pay—during the summer months; extreme variations in wages from one shop to another; and a wage system that included charges for electricity, needles, and thread. But at the heart of their grievances was the expanding system of subcontracting.

The subcontracting system, which depended on large firms putting out work to smaller firms, had caused a nearly intolerable speedup in piecework throughout the industry. In response, the shirtwaist strikers demanded a standardized wage system and a fifty-two-hour workweek. To enforce these policies, they insisted on the right to establish a union industrywide and named their bargaining agent as Local 25 of the **International Ladies' Garment Workers' Union** (ILGWU).

The strike, which began on November 23, 1909, made heroes of the thousands of teenage Jewish women who predominated in the garment trades. They had gathered the night before in Cooper Union in the Lower East Side and listened while a series of speakers addressed the crowd in English and Yiddish. Mary Dreier represented the WTUL, and even Samuel Gompers, president of the AFL, put in an appearance. Finally, Clara Lemlich from Leiserson's shop, which had already been on strike for eleven weeks, stood up. "I have listened to all the speakers," she cried in Yiddish, "and I have no further patience for talk. I am one who feels and suffers for the things pictured. I move we go on a general strike!" The crowd jumped to its feet, stomping and cheering.

Close to thirty thousand shirtwaist makers, three-quarters of them Jewish, walked out of nearly five hundred shops. Although a number of employers settled within a few days, the large manufacturers held out, pushing the strike into the bitter cold of December. The WTUL helped the strikers maintain their picket lines against frequent assaults and arrests. They also organized marches and planned rallies and recruited volunteers from the settlements, the NCL, various women's organizations, and northeastern women's colleges to join the picket lines and to staff the twenty halls that served as organizational headquarters. "Friends, let us stop talking about sisterhood," one appeal read, "and MAKE SISTERHOOD A FACT!" News of the strike dominated the front pages of the city's newspapers and spilled over to the society pages.

The strikers eventually won many of their demands, but they deadlocked with the largest manufacturers on the issue of union recognition. In mid-February, the ILGWU called an end to the strike.

Despite this disappointing outcome, the shirtwaist strikers had scored major victories. Local 25 signed up nearly twenty thousand new members to become the largest local in the ILGWU. The strikers thus proved that women could not only strike

courageously but organize themselves into a union and achieve positions of leadership. Moreover, their actions inspired hundreds of thousands of women workers in cities across the nation.

The shirtwaist strike immediately spread to Philadelphia following an attempt by New York manufacturers to shift production there. By 1910, workers in the menswear industry in Chicago, representing a variety of Eastern European immigrants, joined the protest against the subcontracting system and closed down the city's garment industry. Garment strikes spread to Cleveland, Milwaukee, Kalamazoo, and St. Louis and on to San Francisco. In ladies' apparel, the strikes continued intermittently until 1916, when the famous Protocol of Peace established for the first time the principle of collective bargaining throughout the industry.

"Bread and Roses": The Lawrence Textile Strike, 1912

On January 11, 1912, a bitterly cold, snowy day in Lawrence, a group of Polish women weavers at the Everett Cotton Mills opened their pay envelopes to find that their wages had been cut as a result of new legislation in Massachusetts that reduced the weekly maximum hours of work for women and children from fifty-five to fifty-four hours. The cut amounted to only thirty cents, but even this small sum was more than their already tight family budgets could bear. "Better to starve fighting than to starve working," they concluded. The workers promptly fled the factory, calling others to join them. They linked arms and carried their appeal to mills throughout the city. Two days later, nearly thirty thousand workers—men, women, and children representing forty nationalities—shut down Lawrence's great textile industry.

The wives of millworkers joined the outpouring, carrying signs reading "We Want Bread and Roses, Too." Housewives ran soup kitchens from their homes and cared for strikers' children. They also paraded through the neighborhoods to jeer at scabs, police, and city officials.

Read the Poem **"Bread and Roses"**[6]

James Oppenheim, a poet, novelist, and editor, first published this poem in December 1911, one month before the Lawrence Textile Strike began. The poem, soon set to music, became the anthem of the strike. The title, translated into Italian as "pan e rose," is said to have appeared on strikers' banners.

Review the source; write short responses to the following questions.

1. What does Oppenheim hope to express by the line "hearts starve as well as bodies," and how does this sentiment relate to social conditions of the working people of Lawrence in 1912?

2. How does Oppenheim's poem relate to the "maternalism" employed by women's groups during the Progressive Era?

The militancy of the strikers and their families attracted attention throughout the country. The radical **Industrial Workers of the World** (IWW), rival to the AFL, sent organizers to Lawrence. The IWW, which had formed just a few years earlier, in 1905, aimed to organize all workers, regardless of craft or trade, race, ethnicity, or gender, into one big union and ultimately to overthrow the employing class. One of the IWW's most charismatic speakers, the youthful "Rebel Girl," Elizabeth Gurley Flynn, enthralled crowds with appeals for solidarity.

Flynn headed the famous "**children's crusade.**" She had learned that it was common in France and Italy to send the children of strikers to sympathizers in other villages to keep them out of harm's way. Flynn began to organize a similar plan for the children of Lawrence strikers. Margaret Sanger traveled from New York to fetch children and transport them to temporary homes in, for example, New York, Philadelphia, and Barre, Vermont. The children's exodus generated so much favorable publicity on behalf of the strikers that the mill owners and city officials tried to put a stop to it, sending out the police who proceeded to beat children and women, including a pregnant Italian woman who later miscarried. Public reaction was swift and strong. Finally, after eight weeks, the beleaguered mill owners began to negotiate with strike leaders; and on March 12, the strikers accepted the new wage offer and voted to go back to work. The IWW leader Bill Haywood announced that "the women won the strike."

Protective Labor Legislation

The national WTUL's support of protective legislation dated at least to 1908, when the U.S. Supreme Court, in its ruling on *Muller v. Oregon*, upheld Oregon's law limiting women to ten hours of work in factories and laundries. Florence Kelley, who had helped to prepare the brief, called on the WTUL to join the NCL in lobbying for additional regulatory legislation. The two organizations cooperated in campaigning for shorter-hours bills as well as a state-regulated "living wage."

Read an Excerpt from *Muller v. Oregon* [1908][7]

The campaign for protective legislation generated a lot of controversy within the women's movement. Equal rights' feminists such as Alice Paul posited that the protection promised by the landmark decision would cause more harm than good to working women. Others felt the opposite. The decision was debated because many felt that by restricting the number of hours a woman could work, it set a precedent based on sex—and a woman's child-bearing capacity—as a basis for separate legislation while promoting the idea that the family, as a unit, had priority over women's rights as a worker.

Review the source; write short responses to the following questions.

1. What did a woman's role as mother play in this decision?
2. How are men portrayed, vis-à-vis women, in this decision?

If implemented, many of the proposed laws would improve conditions for both male and female workers by mandating better lighting and seats for workers, industrial safety and fire regulations, and the appointment of factory inspectors. However, the most controversial were restrictive or prohibitive laws that, like *Muller v. Oregon*, affected women alone. With the support of both the WTUL and the NCL, individual states passed hundreds of such laws.

By 1917, all but nine states had limited the number of hours a woman could work in specific occupations. "Women's physical stature and the performance of maternal functions place her at a disadvantage," the Supreme Court declared in upholding this legislation. Many states passed legislation barring women from working at night, for example, arguing that women needed those hours to care for their families. Night work, the framers of these new laws added, also exposed women to the "moral" dangers that mounted following sundown. At the same time, only a handful of states instituted minimum wage laws, in effect "protecting" women while reducing their salary and restricting their options for employment.

Read "Surviving the Triangle Fire"

Rosey Safran,[8] a young Jewish immigrant from Galicia, had been working at the Triangle Shirtwaist Company for two and a half years when a deadly fire broke out. More than 140 young garment workers, many in their teens, died in the fire or jumped to their deaths. The WTUL, which joined Local 25 of the ILGWU to prepare a mass funeral march for the victims, immediately began an investigation into working conditions and consolidated its campaign for protective labor legislation.

Review the source; write short responses to the following questions.

1. The Asch Building, the site of the Triangle Fire, was considered one of the safest buildings in New York City. In Safran's description, who is responsible for the tragedy, the owners of the building or the managers of the factory?

2. In what ways do Safran's descriptions of the Triangle Fire provide data for arguments for protective labor legislation?

Asked why women were being treated as children, one AFL writer answered: "Because it is to the interest of all of us that female labor should be limited so as not to injure the motherhood and family life of a nation." The WTUL leadership echoed this argument: such laws were necessary "to permit efficient motherhood and healthy children."

"Mother-Work"

"Some of us who are not really mothers in the narrow sense," Leonora O'Reilly, explained, "express the mother instinct in the sense of social motherhood." By giving a public dimension to women's traditionally private work of child care, she identified the premise

of an important aspect of progressivism that historians have labeled "**maternalism**." O'Reilly assumed that women could play active, even leading roles as policymakers in an emerging **welfare state** that expanded the responsibilities of government to ensure the social and economic security of its citizens through programs such as protective labor legislation, public schools, health care, and pensions for the elderly.

View the Profile of <u>**Charlotte Perkins Gilman**</u>

At the turn of the century, Charlotte Perkins Gilman reigned as the nation's chief writer on the "woman question." A scion of the prominent Beecher family, she had grown up in poverty but went on to have success as a writer and advocate for women's rights.

The majority of the lobbyists for social legislation were white middle-class women. African American women had little reason to place their trust in any government that allowed Jim Crow to flourish, and most black and working-class activists continued to focus on building institutions within their own communities. Nevertheless, the new agencies that were established during the Progressive Era reached far and wide to families across the nation.

Juvenile Courts

The Chicago Woman's Club played the leading role in lobbying for one of the first social welfare measures in the United States, the juvenile court system. Responding to the growing rate of juvenile delinquency in the 1890s, club members tried a variety of measures to help keep working-class children out of trouble, from establishing kindergartens in poor neighborhoods to conducting mothers' classes focused on child-rearing practices to campaigning for child labor and truancy laws.

Members of the Chicago Woman's Club tried, too, to help children arrested and detained for petty crimes. Often in conjunction with the local WCTU, they worked to establish matrons in the city's jail, placed teachers there to conduct classes, and supported legislation to establish a separate reformatory for girls. Their steady demand that children be tried quickly and separately from adults finally formed the basis for statewide legislation, and in 1899 Illinois became the first state to legislate juvenile courts. Pushed by women's organizations, particularly the General Federation of Women's Clubs (GFWC), twenty-two more states enacted similar legislation by 1920.

In claiming to protect and rehabilitate working-class offenders, the **juvenile court system** treated boys and girls differently. Whereas the majority of boys were picked up for thievery, disorderly conduct, or crimes against property and frequently placed on probation, girls were arrested primarily as sex delinquents and detained. Often it was their own parents who initiated the proceedings in an effort to impose traditional moral codes on daughters determined to assert their autonomy. Reformers aspiring

to make "the State as near as possible a real mother to the girls," according to one California activist, advocated the establishment of temporary detention homes and the construction of new reformatories.

The rehabilitation programs focused primarily on domestic skills, with the goal of transforming sexually energetic teenagers into women ready to take on the responsibilities of marriage and motherhood as defined by their middle-class overseers. It was not uncommon for girls to spend several years in these institutions, living in a cottage system that grouped them into small "families." In Los Angeles, for example, the juvenile courts remanded girls arrested at age fourteen to an average stay of 3.7 years. The juvenile court movement improved conditions of incarceration for teenage delinquents and at the same time facilitated the surveillance of female sexual behavior by the state.

Mothers' Pensions

The **National Congress of Mothers** (NCM)—now known as the PTA—played a leading role in making child rearing a major item of Progressive Era politics. In 1897, two thousand women, mostly members of local mothers' clubs, attended the organizational meeting that laid the basis for a movement that would grow to nearly two hundred thousand by 1920. The NCM encouraged women to educate themselves to fulfill their maternal responsibilities.

Although the NCM had long endorsed mothers' pensions, three Hull House staffers—Julia Lathrop, Sophonisba Breckinridge, and Edith Abbott—did much of the research behind the first statewide legislation, which was passed in Illinois in 1911 and, in effect, subsidized the domestic work of impoverished women with dependent children. The Mothers' Pensions Division investigated applicants and appointed a probation officer who would handle the benefits, arrange for home visits and evaluate the quality of housekeeping, and monitor the children's school record. In maintaining such standards, the program directors awarded the greatest share of pensions to widows and the least to never-married mothers, who were categorized as "morally unfit." In 1913, an addendum to the legislation restricted entitlements to citizens, thus excluding large numbers of recent immigrants. African Americans, who had the highest ratio of female-headed households, made up only a very small portion of those mothers receiving pensions.

Within two decades, all but two states had passed similar legislation, making mothers' pensions one of the most successful programs of the Progressive Era. Mothers' pensions laid the foundation for Aid to Families with Dependent Children, the program that would be enacted in the 1930s as part of the New Deal. At the same time, many college-educated, middle-class women found social work careers within these programs, ironically, often by arguing that other women belonged in the home to care for their families.

The Children's Bureau

Maternalist reform reached its apex in the creation of the **U.S. Children's Bureau** in 1912. Florence Kelley and Lillian Wald of the Henry Street Settlement came up with the

idea of a federal agency and managed to win the endorsement of President Theodore Roosevelt. In 1909, at a White House Conference on the Care of Dependent Children, two hundred prominent activists jumped on the bandwagon; and three years later, President William Howard Taft signed the legislative bill establishing the Children's Bureau and appointed Hull House resident Julia Lathrop (1858–1932) the first director.

"The first and simplest duty of women," according to Lathrop, who never married or had children, "is to safeguard the lives of mothers and babies, to develop the professional dignity of all motherhood, as motherhood has too long suffered from sheer sentimentality." As director, she set out to coordinate the activities of women reformers engaged in child-welfare programs across the United States and to assess systematically the needs of the nation's children. As the first woman to head a federal agency, she assembled a staff of fifteen—all women—to comply with the legislative charge "to investigate and report" on such matters as infant mortality, childhood diseases and accidents, child labor, and juvenile courts.

Read about **Women and Health Care**

In advocating birth control and family planning, Margaret Sanger made it her life's work to help women make better and more informed decisions about their bodies and overall health. Other activists of her generation promoted the establishment of the U.S. Children's Bureau. They believed that something had to be done to help poorer women have better access to prenatal care, with the goal being to reduce infant mortality and improve their health during childhood. They also insisted that the government bore the responsibility to fund prenatal and maternity care and were somewhat successful; Congress passed the Sheppard-Towner Act in 1921, which provided federal funds for instructing women in maternal and infant health care and allotted 50-50 matching funds to the states to open women's health care clinics. However, with the ultimate collapse of the women's movement, the wave of political support for women and health care issues waned, and Congress repealed the act in 1929.

Review the sources; write short responses to the following questions.

Ann Martin, *We Couldn't Afford a Doctor* [1920][9]
Letter to Margaret Sanger [1928][10]

1. What examples does Ann Martin give to support her contention that women needed government-funded health care?
2. Do the letters that Margaret Sanger received support her feeling that women needed better access to birth control?

Lathrop made the health of infants and children the first priority of the Children's Bureau. The bureau published small books and pamphlets of medical advice to mothers and shorter bulletins featuring up-to-date information on nutrition, childhood diseases, and other aspects of baby care. Nearly 1.5 million copies of *Infant Care* (1914)

were circulated by 1921. Meanwhile, Lathrop's staff worked closely with local women's organizations, hosted health conferences, and replied personally to the thousands of mothers who sent letters asking for advice. One of their most successful campaigns, conducted with the help of the GFWC, culminated in the passage of state legislation setting up procedures for registering all births. As a consequence of a systematic collection and review of massive data, the Children's Bureau staff established the close correlation between poverty and infant mortality. Before she stepped down as bureau chief in 1921, Lathrop outlined the Sheppard-Towner Act, the landmark maternity bill that committed federal aid to state governments to protect the health and well-being of all mothers and their dependent children (see Chapter 16).

WORLD WAR I

World War I began in August 1914 following the assassination of the heir to the throne of the Austro-Hungarian Empire by a Serbian nationalist. Although many Americans were shocked and saddened by the outbreak of a devastating war that soon engulfed Europe, the United States pledged neutrality. However, as the war raged on, Congress began to prepare, passing the National Defense Act in June 1916, which doubled the size of the army and increased funding for battleships and armaments. Finally, after German U-boats sank seven U.S. merchant ships, President Woodrow Wilson, promising to make the world safe for democracy, signed a declaration of war on April 6, 1917.

While the U.S. army enrolled four million men, sending half to Europe, American women responded to the crisis in a variety of ways. The majority, swept up in a wave of patriotism, shifted their volunteer work to efforts to win the war. Other longtime activists resisted this impulse and instead formed a vital peace movement. Meanwhile, the rapid expansion of production during wartime brought new opportunities to wage-earning women, including the hundreds of thousands of African American women who moved from the rural South to industrial cities in the North.

Wartime Employment

With one of every six male workers enrolled in the armed forces and immigration cut off, World War I provided women with new opportunities for wage earning. Nearly one million women joined the labor force for the first time during World War I, while a far greater number already working outside the home were able to quit such low-paying jobs as domestic service for better-paying employment in industry. Women showed up in unfamiliar places—on the assembly lines in munitions plants and chemical plants, behind the switches on train locomotives, on the platforms of streetcars, and under big bags of mail on the city's streets. U.S. military installations, including hospitals and offices, employed a large number of women in civilian jobs.

African American women took advantage of the new opportunities available to them. Before the war, upward of 90 percent of all black female wage earners worked as either agricultural laborers or domestic servants, mainly in the South. Now, with the incentive of wartime employment, they helped to form the mass exodus from the

South known as the **Great Migration**. Between 1916 and 1921, about 5 million African Americans—5 percent of the southern black population—headed for northern industrial cities like New York, Chicago, and Philadelphia. Black women took over the domestic and janitorial jobs that white women abandoned for better-paying positions in industry. With the help of African American women's clubs, churches, and the Urban League, they also managed to break into factory work.

At the end of the war, returning servicemen replaced women in most industrial jobs. White women gained most in fields that they already dominated, such as nursing and clerical work, and only a small portion returned to domestic service. African American women found themselves squeezed out of industrial jobs and taking up the slack in household work.

The upsurge in women's employment in wartime industries had prompted government officials, with the assistance of women reformers, to increase federal oversight of women wage earners. In 1920, the WTUL and other groups called for a continuation of this policy in the form of a permanent Women's Bureau, housed within the Department of Labor. Mary Anderson, longtime member of the WTUL, became the first director and set herself to educational work and the investigation of conditions in trades where women prevailed.

The Women's Peace Movement

"I Didn't Raise My Boy to Be a Soldier," the title of a popular song of 1915, expressed well the sentiments of a segment of American women who opposed the war. Within weeks of the outbreak of the European war, on August 29, 1914, a band of fifteen hundred women—all dressed in black—staged the Woman's Peace Parade on New York's Fifth Avenue. Over the next year, groups of women began to organize against the war, as well as the preparedness movement that was gaining steam in the United States.

In January 1915, Jane Addams and suffrage leader Carrie Chapman Catt called a meeting in Washington, D.C., in response to a request from European peace activists to rally American women to their cause. Approximately, eighty-six delegates representing various women's organizations attended and established the **Woman's Peace Party** (WPP), which became the most influential component of the larger peace movement.

The WPP was headquartered in Chicago, with Jane Addams as its head. Addams had advanced the cause of peace for a long time. Once the European war broke out, she lectured frequently, speaking forcefully against a U.S. entry. With the formation of the WPP, Adams mobilized peace leaders in each state to form branches. The activists proceeded to deploy maternalism as their campaign strategy, insisting that women's role as nurturers gave them a distinctive perspective on war that men could not readily understand and therefore empowered them to seek solutions to international disputes. Former president Theodore Roosevelt, a prominent promoter of hypermasculinity who, even in peacetime, urged compulsory military training for all men, referred to the WPP as "silly and base," their demands as "hysterical."

Undaunted, the leaders of the WPP quickly moved into the international arena. In April 1915, they sent delegates to an international conference of thirteen hundred women pacifists from twelve nations that met at The Hague, the Netherlands, to protest the mass killing. The conference resulted in the formation of the International Women's Committee, which in 1919 became the **Women's International League for Peace and Freedom** (WILPF). After returning to the United States, Jane Addams led a delegation to President Wilson, asking him to maintain the nation's neutrality during the European war and to call a conference of other neutrals. When Wilson stalled, Addams turned to automobile magnate Henry Ford and, with his financing, embarked on the Ford Peace Expedition to Stockholm, where international peace advocates met.

As the United States moved closer to war, the WPP, along with other peace societies, called for a popular referendum. Once the United States entered the war, in a burst of patriotism, some of the most influential members, such as Catt and Florence Kelley, resigned. The WPP refrained from protesting the war and instead supported the plan for a League of Nations as a forum to settle future disputes among nations. Addams, then president of WILPF, continued to hold that office until 1929 and became honorary president for the remainder of her life. In December 1931, she received the Nobel Peace Prize.

In National Defense

Shortly after the outbreak of the European war, a few courageous American women rushed to France to join the ambulance corps, while others positioned themselves overseas to work with refugees. Following the U.S. entry, American women were allowed, for the first time, to serve in the armed services. Although the majority spent the war working as clerical workers or nurses, more than sixteen thousand women received overseas assignments, mainly in France. For example, three hundred women served as bilingual telephone operators for the army, running switchboards that connected soldiers at the front lines to their commanding officers. However, the armed services refused to commission women as doctors, and those women physicians determined to serve signed up with the French army or with relief agencies, including the Red Cross. The majority of American women stayed home, showing their patriotism through volunteer work with various defense and relief organizations.

The war served to revivify traditional concepts of gender. Men became manlier in fulfilling their military duty to nation, while women in their supportive roles became yet more maternal. Both peace activists and patriots tapped into common rhetoric. The call to form the WPP singled out women and children as "innocent victims of men's unbridled ambitions." Those women lining up with national defense stepped forward in the name of motherhood with equal passion. But rather than opposing armed conflict as a masculinist act of aggression, they reaffirmed their own femininity by embracing sacrifice, even to the extent of giving up their sons for the greater good.

Read "American Women and World War I"

Ida Clyde Clarke (1878–1956),[11] a member of the Equal Suffrage League, was a devoted suffragist before the outbreak of World War I. After the United States entered the war, she suspended her suffrage activism and worked to recruit women to national defense. In 1918, she published this book to encourage women to take up the "opportunities and responsibilities" offered by the world conflict and provided a detailed record of the many programs sponsored by the Woman's Committee of the National Council of Defense and by various women's organizations. This selection deals only with the health and recreational programs developed during World War I.

Review the source; write short responses to the following questions.

1. Summarize the role of the Woman's Committee as outlined in the document.
2. How was *hospitality* defined in this document? What would the members of the Woman's Committee provide for the men involved in the war effort?

Building on these sentiments, the **Council of National Defense** (CND) successfully created Women's Committees at the state level, which in turn engaged masses of women to make efficient use of human resources for war. The Red Cross additionally attracted many women. With little more than a hundred chapters when the European war began, the Red Cross comprised more than four thousand chapters by November 1918, when the Armistice was signed. The YWCA offered assistance to the families of men stationed at training centers or recovering in military hospitals and provided temporary housing for single women moving to take advantage of wartime employment.

In southern states, wartime patriotism loosened the grip of Jim Crow on some women's organizations. In North Carolina, for example, the Women's Committees of the CND integrated black and white volunteers at the county level and achieved considerable success in joint work in the selling of Liberty Bonds. However, most campaigns generated cooperation among organizations that remained segregated in terms of membership, such as women's clubs, churches, and the YWCA. African American women, for example, organized separately to support "colored soldiers" and also collected money, rolled bandages, and assembled first-aid kits for their own auxiliary of the Red Cross. Black and white women active in the YWCA also sponsored separate Hostess Houses and comfort stations, which aimed to keep soldiers away from prostitutes. Nevertheless, for women at the leadership level, the wartime experience suggested a model for the future of women's politics in the South, in particular the organization of women's committees of the Commission on Interracial Cooperation.

Meanwhile, women reformers rallied to preserve the "purity" of those women who volunteered at military camps. The Committee for the Protection of Women and Girls, a federal agency formed in September 1917, established protective programs to prevent

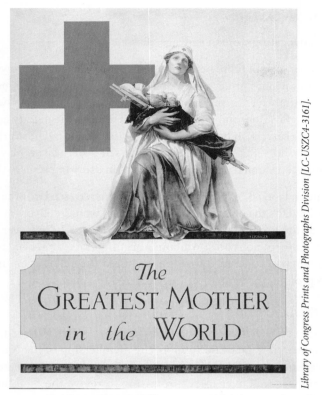

Library of Congress Prints and Photographs Division [LC-USZC4-3161].

This poster, "The Greatest Mother in the World," was created by the muralist Alonzo Earl Forginer to raise funds for the American Red Cross in 1918, after the United States had entered World War I. Suggested by an advertising executive, the image of patriotic maternalism proved immensely and enduringly popular. Ten million copies were distributed at the time, and it became a symbol for the Red Cross well into the 1940s.

what occurred in one town following the construction of a military base: over half of the girls of the senior class at the local high school became pregnant within the year. However, the director soon complained that the government routinely put the soldiers' interests above the civil rights of civilian girls and women. By 1918, when the Armistice was declared, many Americans no longer viewed women as victims of men's wanton behavior: women now carried the full weight of responsibility for their own moral transgressions.

World War I presented many opportunities to women, allowing women to take new jobs, move to new locations, and serve their government in new ways. Nevertheless, like other wars, the "war to end all wars" also reinforced conventional notions of gender by spotlighting men's heroic role in combat and emphasizing women's self-sacrificing role as nurturer. It was therefore a tribute to the shrewd strategy of suffragists that women emerged from World War I on the precipice of a new political era.

VOTES FOR WOMEN

Jane Addams, advocating woman suffrage, reasoned:

> [T]hat if woman would fulfill her traditional responsibility to her own children; if she would educate and protect from danger factory children who must find their recreation on the street; if she would bring the cultural forces to bear upon our materialistic civilization; and if she would do it all with the dignity and directness fitting one who carries on her immemorial duties, then she must bring herself to the use of the ballot—that latest implement for self-government. May we not fairly say that American women need this implement in order to preserve the home?

This argument, labeled "expediency" by historians, stressed not the justice of equal rights but the benefits to society that women voters would deliver. By the early twentieth century, as the Progressive Era and, later, World War I drew ever larger numbers of women into reform activities, Addams's argument became ever more appealing. Masses of women had concluded that they required the ballot as an instrument of reform. On this ground, the woman suffrage entered the mainstream.

📖 Out of the Doldrums

After the western state victories of the 1890s, no more states followed, and the federal amendment appeared to be dead. In 1900, the membership of the National American Woman Suffrage Association (NAWSA) barely topped nine thousand, with an average age of members well over forty. Promising to revive the flagging organization, the energetic Iowan Carrie Chapman Catt stepped forward. Catt served ably as president until 1904, when the NAWSA presidency came into the hands of the popular, dedicated—but inefficient—Anna Howard Shaw.

Shaw did manage to hold on to new constituencies, college women in particular. With a move to New York City, the suffrage movement continued to gain cachet, adding a few luminaries, including the movie star Mary Pickford. Then, in 1910, women in Washington won the right to vote. With a victory in California in 1911, the NAWSA leaders began to put the period of doldrums behind them. Finally, in 1914, delegates to the biennial meeting of the GFWC officially endorsed "the principle of political equality regardless of sex."

Meanwhile, Harriot Stanton Blatch, a daughter of the early woman's rights advocate Elizabeth Cady Stanton, decided to recruit working women to the suffrage movement calling her organization the Equality League of Self-Supporting Women. Within a year, the Equality League counted twenty thousand members and in 1910 was renamed the Women's Political Union; at this point, the organization began to focus on lobbying politicians. The WTUL soon took up the slack among wage-earning women.

The suffrage movement not only emerged from its doldrums but expanded its ranks considerably. No longer the preserve of white, middle-class Protestant women who were middle age at best, the movement more closely mirrored the diverse society of early twentieth-century America.

Review the sources; write short responses to the following questions.

Anna Howard Shaw, _NAWSA Convention Speech_ [1913][12]
NAWSA, _A Letter to Clergymen_ [1912][13]
Carrie Chapman Catt, _Mrs. Catt Assails Pickets_ [1917][14]

1. How does Anna Howard Shaw depict men and their behavior in this document? How does her description support her argument, if at all?
2. According to NAWSA, why should religious institutions have supported women in their question for suffrage?
3. What was the "psychological mistake" that women made, according to Carrie Chapman Catt?

View the Profile of **Carrie Chapman Catt**

The architect of the "winning plan" of the twentieth-century woman suffrage movement, Carrie Chapman Catt emerged as an unrivaled organizer and pragmatic leader. In 1902, Catt emerged as the guiding force in the new International Woman Suffrage Alliance; and by 1913, she had presided over its congresses held in Berlin, Copenhagen, Amsterdam, London, Stockholm, and Budapest. Between 1911 and 1913, she conducted a world tour, facilitating the creation of woman suffrage organizations in Africa and Asia. At the final convention of the NAWSA in 1919, Catt proposed the formation of a League of Women Voters, while turning over the reins to a younger generation of women. She revived her pacifist principles and spearheaded the formation of the Committee on the Cause and Cure of War.

Southern Strategy

It was the former abolitionist and husband of Lucy Stone who first proposed that woman suffrage could solve the "Negro problem" in the South. In 1867, Henry Blackwell argued that the number of white voters added by enfranchising women would guarantee the preservation of white supremacy. A generation later, more than a few suffragists were contending that women's enfranchisement would overcome the influence of immigrant voters and were reiterating Blackwell's contention that women's ballots would counter the southern black vote.

In 1895, in an attempt to woo white southern women, the NAWSA chose Atlanta as the site for its convention; in preparation for the meeting, Susan B. Anthony asked the aging but loyal Frederick Douglass to stay away. In 1903, still hoping to appease white southerners, the NAWSA held its convention in New Orleans and, in addition to excluding black women from the assembly hall, invited Belle Kearney of Mississippi to give the keynote address. The prominent suffragist and WCTU activist proceeded

to describe the woman's ballot as "the medium to retain the supremacy of the white race over the African." In addition to greeting Kearney's remarks with enthusiasm, the delegates acceded to the southern demand for states' rights and approved a policy that would allow individual states to define the terms of their positions on woman suffrage, which could include the property, literacy, and educational restrictions that already disfranchised most African American men throughout the South.

The NAWSA's "southern strategy" did not pay off. African American women continued to support woman suffrage in proportionally greater numbers than white women. But, continually rebuffed by the NAWSA and required to sit at the back of convention halls or march at the end of parades, they tended to keep to their own organizations and to campaign for universal suffrage. For their part, white southern women managed to overcome much of the deeply embedded hostility to a movement historically linked to abolition and created for themselves a small, racially segregated woman suffrage movement. However, the white southern men who held power remained stubbornly opposed, preferring to protect white supremacy not by adding the votes of their womenfolk but by preventing black men from voting. Recognizing the stalemate, the NAWSA abandoned the South.

Winning Campaign

The widow Catt returned to the presidency in 1915 and transformed the NAWSA into a well-oiled political machine, fully primed to lead the forces to victory. The NAWSA embraced a two-armed strategy: (1) lobbying members of Congress to pass a federal amendment and (2) mobilizing the troops in states that seemed the most likely to approve referenda for woman suffrage. The leadership therefore kept their distance from the suffrage movement in the South, where several state campaigns had ended in failure; they hoped, too, to keep at bay the controversial issue of race.

The Washington, D.C., lobby initially fell to Alice Paul, a young Quaker activist who had recently returned from England. A convert to the militant tactics developed by British suffragettes, Paul had little patience with the educational campaigns typical of the NAWSA or their polite lobbying of politicians. She admired the British suffragettes who took to the streets, staging huge parades, holding open-air meetings, and, on occasion, chaining themselves to lampposts and, when arrested, going on hunger strikes. Paul also liked the way the publicity-seeking British suffragettes directed their message, without restraint, to the party in power. When Woodrow Wilson returned from his presidential inauguration, Paul and her coworkers followed their lead to stage a protest march. Within a short time, the NAWSA leaders, who had pledged themselves to nonpartisanship, grew impatient with Paul's relentless attack on Wilson's administration and, indeed, on all Democrats and pushed out Alice Paul and her Congressional Union, which had formed in 1913.

Paul and her allies such as Lucy Burns appealed to women voters of the western states to join them in forming the **National Woman's Party** (NWP) in 1917. The NWP began to push even more strongly for a federal amendment by targeting the Wilson administration. Even after the United States entered World War I, the NWP continued to heckle Democrats and picket the White House. Like the British suffragettes who inspired them,

the NWP protestors were assaulted by passersby and police alike and arrested in droves. Imprisoned, they, too, went on hunger strikes and were force-fed. Their militant tactics did not always generate sympathy for the cause but unfailingly created publicity.

Read "A Suffrage Militant"

Alice Paul (1885–1977) led the National Woman's Party, a break-away group from NAWSA that embraced militant tactics in the campaign for woman suffrage. In 1917, Paul and her coworkers picketed the White House to protest President Woodrow Wilson's refusal to endorse the ballot. In this book, in a letter to Doris Stevens,[15] Paul recounts her imprisonment in the Occoquan Workhouse in Virginia. Alice Paul was one of the first American suffragists to stage a hunger strike.

Review the source; write short responses to the following questions.

1. How were Alice Paul's tactics different from those used by the majority of suffragists affiliated with the NAWSA?
2. Why did the doctor who examined her dismiss her arguments for woman suffrage?

Meanwhile, Catt's "**winning plan**," which was formally adopted by the NAWSA in 1916, gained speed. Catt herself lobbied on Capitol Hill, crisscrossed the country on speaking tours, and raised huge amounts of money to fund an army of suffrage agitators to work for referenda at the local and state levels. In 1917, New York, long considered by suffragists to be the swing state, approved the referendum, with heavily immigrant New York City providing the decisive votes.

By the time the United States entered World War I, the NAWSA membership had swelled to two million, and seventeen states had passed referenda. President Wilson endorsed woman suffrage as a "war measure," that is, to recognize and widen women's contribution to the war effort. The president called upon Congress to pass the Susan B. Anthony Amendment, which would grant women the right to vote. Victory was in sight.

Nineteenth Amendment, 1920

Under pressure from the president, the House of Representatives voted on January 10, 1918, to approve the **Nineteenth Amendment**, which read: "The right of citizens of the United States to vote shall not be denied or abridged by the United States or by any States on Account of sex. The Congress shall have the power by appropriate legislation to enforce the provisions of this article." On June 4, 1919, the U.S. Senate belatedly endorsed the amendment, voting fifty-six to twenty-five, and then sent the amendment to the states for ratification.

Suffragists kept up their campaigning, quickly lining up Illinois, Wisconsin, and Michigan as the first states to ratify the new law. Unsurprisingly, they made little headway in the South, where Georgia and Alabama were the first to deliver negative votes. The antis also swung into action and succeeded in slowing the process.

MAP 15-1 Woman Suffrage by State

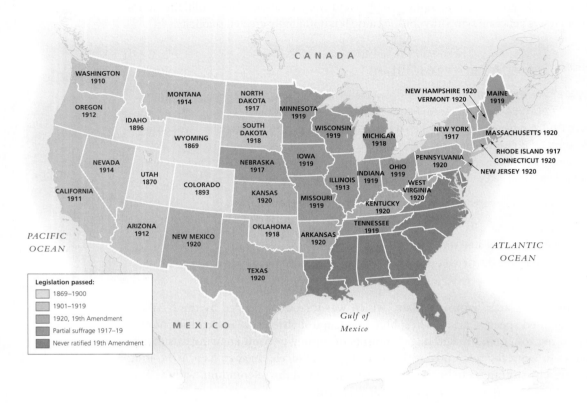

This map shows the dates for the extension of suffrage to women in the states. Whereas several western states granted women the right to vote in the late nineteenth century, a majority of southern states held out and, in addition, refused to ratify the Nineteenth Amendment.

Read "The Nineteenth Amendment"[16]

The Nineteenth Amendment to the Constitution, first proposed in 1878, was introduced into every session of Congress until 1919, when it finally garnered the necessary two-thirds vote and was sent to the states for ratification.

Review the source; write short responses to the following questions.

1. Why did it take so long for this amendment to be passed by the Congress?
2. What is the relationship between the federal amendment and the successful state referenda that preceded it and women's voting rights in the United States?
3. Which states ratified the amendment?

After thirty-five of the required thirty-six states had ratified the amendment, all eyes turned to Tennessee, where the governor, pressured by President Wilson, had called a special session of the state legislature. The vote was scheduled for August 18, 1920. A young man who had stood firm with the antis until this time surprised everyone by casting the decisive vote in its favor. Echoing the sentiments of many Progressive reformers, he claimed afterward: "I know that a mother's advice is always safest for her boy to follow and my mother wanted me to vote for ratification." But he added: "I desired that my party in both State and Nation might see it was a Republican from the mountains of East Tennessee, purest Anglo-Saxon section in the world, who made woman suffrage possible."

On August 26, 1920, the Nineteenth Amendment to the U.S. Constitution became law, in time for women to vote in the upcoming presidential elections.

CONCLUSION

The woman suffrage victory marked the ebbing of women's separate political culture. Women's organizations, such as women's clubs, the WCTU, and the WTUL, continued well into the twentieth century, but these organizations could make little headway by claiming that women's domestic and maternal roles provided either the imperative or the justification for their involvement in public affairs. Having learned to work with men in effecting major legislation and in shaping the foundational institutions of the welfare state, the women who spearheaded Progressive Era reform could no longer rally women by appealing to them to become "municipal housekeepers." They had successfully relinquished, for better or worse, a large chunk of those responsibilities to the government. If women were to continue on the path of reform, they would have to find a niche within the halls of government and mainstream politics.

 Study the Key Terms for The Progressive Era, 1890–1920

Critical Thinking Questions

1. What is the relationship between women's voluntary organizations and Progressive reform?
2. What is the significance of the garment and textiles strikes to the history of wage-earning women?
3. Why was the notion of "mother-work" so powerful and effective during the Progressive Era?
4. How did the experiences of women vary during World War I?
5. How did the passage of the Nineteenth Amendment affect women's role in politics and reform?

Text Credits

1. Hilda Satt Polacheck, *I Came a Stranger: The Story of a Hull-House Girl*, edited by Dena J. Polacheck Epstein (Urbana: University of Illinois Press, 1989), 51–52.

2. Jane Addams and Ellen Gates Starr, Hull House: A Social Settlement, in *Hull House Maps and Paper* (Boston: Thomas Y. Crowell and Co., 1895), pp. 2-7-230.

3. Jane Addams, Ballots Necessary for Women (1906).

4. Edward Marshall, Good Metal in Our Melting Pot, Says Miss Wald, *New York Times* (November 16, 1913).

5. Ellen Skinner, *Women and the National Experience: Sources in Women's History* (2 volumes), pp. 260–262.

6. James Oppenheim, *The American Magazine* (December 1911).

7. Muller v. State of Oregon, Supreme Court of the United States, 1907, 208 U.S. 412.

8. Rosey Safran, The Washington Place Fire, *The Independent 70* (April 20, 1911), pp. 840–841.

9. Ann Martin, We Couldn't Afford a Doctor, *Good Housekeeping* (April 1920), pp. 19–20.

10. Margaret Sanger, *Motherhood in Bondage* (New York: Brentano, 1928).

11. Ida Clyde Clarke, American Women and the World War (1918).

12. Anna Howard Shaw, Remarks on Emotionalism in Politics Given at the National American Women Suffrage Association Convention in 1913, in *History of Women Suffrage*, Susan B. Anthony, ed. (Indianapolis: Hollenbeck Press, 1920), p. 5.

13. *Report of the Church Work Committee*, Proceedings of the Forty-Fourth Annual Convention of the National American Woman Suffrage Association (New York: National American Woman Suffrage Association, 1912), pp. 55–57.

14. Mrs. Catt Assails Pickets, *The New York Times* (November 13, 1917).

15. Doris Stevens, *Jailed for Freedom* (New York: Boni and Liveright, 1920), pp. 220–223.

16. The Nineteenth Amendment, U.S. Constitution.

Recommended Reading

Katherine H. Adams and Michael L. Keene. *Alice Paul and the American Suffrage Campaign.* Urbana, IL: University of Illinois Press, 2008. A fine biography and close study of the militant yet nonviolent tactics promoted by suffragist Alice Paul.

Judith A. Allen. *The Feminism of Charlotte Perkins Gilman: Sexualities, Histories, Progressivism.* Chicago: University of Chicago Press, 2009. A thorough examination of Gilman's opinions and theories on the power of androcentric culture, particularly in shaping women's political agenda. Allen details Gilman's writings on major Progressive Era campaigns, such as the abolition of prostitution and the emergence of the birth control movements.

Paula Baker. "The Domestication of Politics: Women and American Political Society, 1780–1920," *American Historical Review*, 89 (June 1984): 620–49. Important essay tracing the expansion of "woman's sphere" into the community. Baker makes a strong case that women's political culture changed dramatically after the Civil War to account for the consolidation of the state.

Linda Gordon. *Pitied but Not Entitled: Single Mothers and the History of Welfare, 1890–1925.* New York: Free Press, 1994. With the federal welfare policy implemented during the New Deal as its concluding point, this study traces the emergence and development of legislation addressing the needs of single mothers. Gordon documents the role of the activists who shaped welfare policy and assesses the impact of those programs on the mothers they had hoped to serve.

Cheryl D. Hicks. *Talk with You like a Woman: African American Women, Justice, and Reform in New York, 1890–1935.* Chapel Hill, NC: University of North Carolina Press, 2010. A careful study of black working-class women, mainly migrants from the rural south, and their interaction with the racial uplift and social justice programs of middle-class women.

Evelyn Brooks Higginbotham. *Righteous Discontent: The Women's Movement in the Black Baptist Church, 1880–1920.* Cambridge: Harvard University Press, 1993. Argues convincingly that African American women worked principally through the church to establish a powerful reform network and created for themselves positions of power within the black community.

Molly Ladd-Taylor. *Mother-Work: Women, Child Welfare, and the State, 1890–1930.* Cambridge: Harvard University Press, 1994. An interpretive study of "mother-work" in the community, as conducted by such organizations as the National Congress of Mothers and by the state. Ladd-Taylor offers a penetrating analysis of the U.S. Children's Bureau, mothers' pensions, and the Sheppard-Towner Act.

Mary E. Odem. *Delinquent Daughters: Protecting and Policing Adolescent Female Sexuality in the United States, 1885–1920.* Chapel Hill, NC: University of North Carolina Press, 1995. Examines the juvenile justice system with regard to new policies to control female sexuality. Odem provides an acute analysis of the role of the juvenile court and new state reformatories by considering the complex negotiations among women reformers, working-class parents, and teen-age girls.

Anastatia Sims. *The Power of Femininity in the New South: Women's Organizations and Politics in North Carolina, 1880–1930.* Columbia, SC: University of South Carolina Press, 1997. A close study of women's voluntary associations, especially women's clubs, that flourished during the Progressive Era. Sims examines both African American and white women's ventures in "municipal housekeeping" and their contests and conflicts in claiming the mantle of the southern lady.

Lara Vapnek. *Breadwinners: Working Women and Economic Independence, 1865–1920.* Urbana, IL: University of Illinois Press, 2009. Examines the major cross-class women's organizations with an emphasis on the class tensions arising from their programs and politics. Vapnek assesses the policies that resulted in the marginalization of domestic workers.

Marjorie Spruill Wheeler. *New Women of the New South: Leaders of the Woman Suffrage Movement in the Southern States.* New York: Oxford University Press, 1993. With an emphasis on race and states' rights, this book offers a detailed history of the movement for woman suffrage in the southern states. Wheeler shows that even the most progressive of the elite women she studied did not deviate from the ideas of most white southerners on issues of race and class.

CHAPTER 16

THE JAZZ AGE, 1920–1930

Explore Chapter 16
Multimedia Resources

TIMELINE

1920	Nineteenth Amendment granting women suffrage ratified
	The Women's Bureau formed within the Department of Labor
1921	The Sheppard-Towner Act passed
	The League of Women Voters formed
	First immigration quotas established
1923	Amy Jacques Garvey becomes the unofficial leader of the United Negro Improvement Association
	Adkins v. Children's Hospital blocks minimum wages for women
	The Equal Rights Amendment introduced
	Jazz singer Bessie Smith records her first album
	The Women of the Ku Klux Klan formed
1927	Judge Ben Lindsey published *Companionate Marriage*
	Journalist Dorothy Bromley writes "Feminist—New Style"
1929	Helen and Robert Lynd publish *Middletown*
1930	The Association of Southern Women to Prevent Lynching formed

THE 1920S WAS A TIME OF RENEWED OPTIMISM THAT BECAME KNOWN AS "THE JAZZ AGE." Author F. Scott Fitzgerald coined the phrase to describe the decadent hedonism of the young and the rich who reveled in the new sounds flowing out of New Orleans, Chicago, and New York. Parties where, in the aftermath of Prohibition in 1920, illegal gin flowed and drunken flappers enjoyed the Charleston dance craze were only the most obvious sign that a new age had dawned. Beyond the speakeasies and jazz clubs, ordinary American women imbibed a popular culture devoted to leisure, consumption, and youth. Fueled by the growth in the national economy, a modern sensibility emerged, encouraging women to express themselves through the many new products pouring into shops and homes across the country.

Read about Madame C.J. Walker[1]

Madame C.J. Walker, the first self-made black female millionaire, made a fortune selling beauty products geared specifically to African American women. Having worked hard in the fields of the South as a young girl, she understood laboring women's desires for affordable luxury goods. At the same time, she saw her wealth as a means to help promote economic opportunities for other women. She not only gave women the chance to work as commissioned agents for her company instead of working long solitary hours as domestics but also put the promise of beauty and sex appeal within the reach of ordinary women of color.

Review the source; write short responses to the following questions.

1. What led Madame Walker to start her own business?
2. How did she sell her products?

The culture of consumption, oriented around the array of new consumer goods, leisure activities, and entertainment venues, continued to bring profound changes to women's lives. Like their counterparts at the end of the nineteenth century, working women in the 1920s found growing opportunities for wage work outside the home and new places to spend their few extra pennies. Cities like New York and Chicago led the way. Yet, unlike the 1890s, the emerging mass media broadcast this latest "revolution in morals and manners" across the country through phonograph recordings of popular music, radio shows, magazines, and Hollywood movies. These new forms of popular culture, with their emphasis on individualism and pleasure, linked young women to everything that was new and modern.

Women helped to spur the tremendous upsurge in the U.S. economy, which in the aftermath of World War I was driven by consumer goods. By 1926, women did their housework in the nearly sixteen million homes that had electricity and a host of new appliances for families who could afford them. The commercial application of new technologies linked homemakers to advertisers through new products and new modes of dress and kept small-town girls informed of new trends in music, fashion, and dating styles. Homemakers spent their leisure hours at movie theaters, listening to records and radio, and reading magazines that emphasized consumption, leisure, and sexual attractiveness. Perhaps the most transformative product in the 1920s for both women and men was the automobile. For young people, in particular, the automobile played an important role in the revolution in morals and manners, enabling them to get together and get away from the watchful eyes of their parents.

The consolidating culture of consumption did little to promote political activism. As the United States pulled away from the progressivism of the prewar years, women

activists saw their influence fade and their numbers dwindle. The much anticipated women's "voting bloc" never materialized after the passage of women's suffrage, while the reform impulse that had prioritized the human costs of industrialization collapsed under a rising tide of conservatism and nativism. The American Immigration Act of 1924 limited immigration, slowing to a trickle the massive wave of immigration that had been going on since the 1880s. The specter of hordes of immigrant women, who worked long hours and left their children untended on street corners, appeared to threaten the very foundation of American family life. To many Americans, the modern woman's primary duty remained to her children and her primary occupation, homemaking, whether she was a flapper or an immigrant.

"Revolution in Manners and Morals"

The generation of young women coming of age in the 1920s embraced individualism and rejected nineteenth-century notions of collective single-sexed activism as old fashioned. They embraced **heterosociality**—mixed-sexed activities and leisure. In courtship, marriage, and family making, women of the 1920s set a new and decidedly modern course by casting off the old values, dismissed as "Victorian," of selflessness and piety for lives that were not at all like those of their mothers.

Read "A Flapper's Appeal to Her Parents"[2]

Lampooned by editorials and celebrated as a trendsetter for her bobbed hair, makeup, short skirts, and cigarettes, the flapper became one of the pervasive images of the Jazz Age. Popularly, the flapper was portrayed as a free spirit, partying without a chaperone and dancing to hot jazz with her skirt pulled up over her knees. The flapper personified the rejection of the older generation's decorum and restraint. "I mean to do what I like . . . undeterred by convention," announced a fictional flapper in a magazine short story.

Review the source; write short responses to the following questions.

1. How did Page describe herself in the role of a "flapper"?
2. By today's standards, would a flapper's behavior or dress cause alarm with an older generation? What comparisons can we draw between today's young people and modes of dress and behavior, if any?

View the Profile of Georgia O'Keeffe

Georgia O'Keeffe stands as one of the twentieth century's greatest American artists and one of a few American women to win critical acclaim in a field dominated by men. O'Keeffe's representations of the landscape of the American West stood in stark contrast to the art world's attention to chaos and urban experience in the 1920s.

Courtship in Transition

In 1924, sociologists Robert and Helen Lynd began their landmark study of Muncie, Indiana, to examine changes in Americans' views of home, work, religious and civic beliefs, and behaviors. In *Middletown* (1929), the Lynds found that teenagers had experienced the most change over the previous twenty years. Adolescents moved in their own social world where they could spend unsupervised time together. Three-quarters of teenagers attended some high school in the 1920s, providing almost daily opportunities for boys and girls to interact. Teenagers socialized at dances, at parties, and in the car where they experimented with new rituals of dating. Teenagers regularly hugged and kissed on dates, referred to as "petting" or "necking," and a small minority went farther. Rates of premarital intercourse doubled in the 1920s, yet most women reported having restricted coitus to the partner they intended to marry. Opportunity for casual contact between the sexes set this generation apart from their parents and placed them at the leading edge of the changing morality of the 1920s. In the rural South, however, poor African American teenagers socialized in mixed-generational settings, like at church, festivals, picnics, and work.

The heterosociality of teenagers, rich and poor, took place through a growing commodity culture, replete with sexual imagery and advice on attractiveness and romance. Columns in newspapers and women's magazines instructed female readers on the thrill of romantic love and ways to win a man's affection, while advertisement for soap, face creams, and girdles joined romantic success with beauty products. Teenage women of all ethnicities and classes used aspects of the growing consumer culture to teach themselves how to fit in to their peer groups, what to wear to be stylish, and what to say to be popular. For Hispanic immigrants, like those reading the Los Angeles newspaper *La Opinion*, consumption became a major form of assimilation. In 1926, the paper regularly ran advertisements for clothes and makeup, as well as offering readers tips on teenage dating and advice through quizzes like "How do you kiss?"

Immigrant daughters, like their white counterparts, regularly went to movies and dances, followed fashion trends, attended high school, and participated in school activities. The earlier generation of immigrant daughters who evaded parents and social workers to attend nickelodeons and dance halls pioneered public and urban leisure that by the 1920s had become commonplace. Yet immigrant women participated in American popular culture against a backdrop of their own community's—and parents'—values, carefully navigating two cultures in an effort to enjoy the freedom of the new morality while preserving their heritage.

Worried parents who sought to protect their daughters from dangerous behaviors and dangerous boys found it almost impossible to separate dating from the other aspects of teenage life. Attending public school put new ideas in the minds of teenagers that could lead them to question their family's values. But with an abundant consumer culture advertising the thrill of falling in love and the melting pot of public high schools bringing teenagers together, parents had more and more difficulty keeping teenagers within traditional ethnic enclaves.

The Companionate Marriage

Marriage experts took note of the "revolution in manners and morals" sweeping over the country. The **companionate marriage**, as it became known, emphasized companionship, compatibility, and mutuality between husband and wife. It called for greater equality between the sexes, easier divorce laws for childless couples, and less formality between partners. According to sociologists, journalists, and educators, young women expected marriage to provide both economic security and sexual satisfaction.

The companionate marriage rested on a growing ethos of sexual liberalization that reached more and more Americans in the 1920s. Pre–World War I writings of Sigmund Freud, Ellen Key, and Havelock Ellis explored the place of sexuality in men's and women's psychological development and sense of identity (see Chapter 14). By the 1920s, their influence extended beyond small groups of radicals and bohemians to doctors, journalists, and marriage counselors and became part of the popular culture. More than two hundred books on Freud's theories appeared in print in the 1920s alone, giving Americans ample opportunity to grow familiar with terms such as *libido*, *repression*, *id*, and *ego*. Despite the complexity and originality of Freud's theories, popularizers in the United States altered his message into one that simply promoted the healthiness of sexual expression for men and women. Popular magazines bulged with articles on modern marriage, concluding that the distinguishing factors of modern marriage were romantic love and sexual satisfaction.

Read "Happiness in Marriage"

At the turn of the twentieth century, birth control was considered to be immoral and radical. This attitude gradually changed due to the tireless efforts of Margaret Sanger[3]. As a young woman, Sanger had witnessed the death of her mother at the age of forty-three after delivering eleven children. As a nurse she witnessed the plight of poor women who were unable to support unplanned children and afford proper medical care. Beginning in 1914, Sanger worked to educate women about birth control and to make inexpensive contraception available. Sanger also founded the American Birth Control League, the forerunner to today's Planned Parenthood organization. This document conveys her attitudes regarding marriage in the 1920s.

Review the source; write short responses to the following questions.

1. What connection did Margaret Sanger see between a woman who is happy and fulfilled in her marriage and "maternal desire"?
2. How did Sanger see women in the time when she was writing? How had they changed?

While sexual satisfaction figured more prominently in modern ideas of marriage, marriage itself remained at the center of debates about morality in the 1920s. Colorado judge Ben Lindsey, in his popular 1927 book *Companionate Marriage*, unleashed a

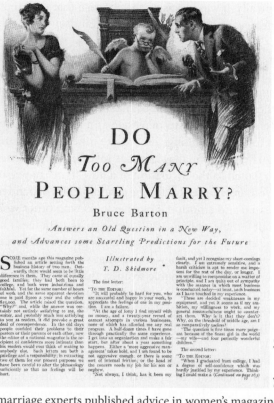

A new generation of marriage experts published advice in women's magazines like *Good Housekeeping* in the 1920s. A new style of marriage that emphasized compatibility between husband and wife and easier divorce laws became popular. The companionate marriage, with its promise of greater equality for women, displaced older ideals of male authority at home.

storm of controversy when he called for sex education, greater availability of contraception, and, for childless couples, access to easy divorce. Critics, including religious leaders, attacked Lindsey as a "bolshevik" for his "anti-Christian" ideals. Episcopal bishop William Manning of New York explained, "The family is the most fundamental institution of human life. Civilization depends on the sanctity of the home. The life of our country depends upon this."

Lindsey joined a chorus of voices addressing the growing divorce rate. The escalating divorce rate that had so troubled the Progressive generation continued to rise in the 1920s. In the 1890s, neglect and failure to provide had been the reasons most frequently given for divorce. But in the 1920s, experts pointed to "the mood of the age," with its "yeasty unrest" as being the root cause. A 1923 *Atlantic* article blamed the speedup of modern life, the higher cost of living, and the overinsistence of women on their rights for driving couples to divorce. A generation divide opened up between mothers who viewed divorce as unthinkable and daughters who viewed it as

unremarkable. Ironically, it was precisely the concern that the sanctity of marriage was being lost under the new morality that motivated Lindsey and others to update it.

Invention of the Lesbian Threat

As Freudianism entered the popular culture, new aspersions were cast on female friendships, lifelong partnerships or Boston marriages, and spinsterhood. Psychologists and educators cast female friendships that had once been seen as an ordinary part of girlhood as potential obstacles to marriage and heterosexuality. By the 1920s, the term *lesbian* began to circulate alongside the late nineteenth-century term *invert*. This shift in terminology helped to make same-sex love between women more visible. The act of naming contributed to the formation of a new "type" of person and a new way of life: the mannish woman who refused to be economically dependent on men and who willingly desired sexual and emotional partnerships with other women.

Critics singled out female-only institutions, such as settlement houses, female academies, and women's colleges, as breeding grounds for **sexual inversion**, an early term for same-sex desire. Commentators worried that sexual deviance could spread like a germ among young and impressionable women through the overpowering attentions of disordered teachers or residents. The language of sexual deviance also became useful to antifeminists who equated feminism with pathology. Critics of feminism cast feminists as sexually perverse women who desired to usurp men and their roles within the family and society.

As ideas about homosexuality and deviance became more widespread, communities of sexual minorities that had existed in ports and urban centers since the eighteenth century continued to grow. Neighborhoods in major urban centers, centered in theater districts, cabarets, speakeasies, and brothels, served as gathering places for women seeking sex with other women. As more women could sustain themselves economically without the support of husbands or family, women began to participate in urban gay life. Public curiosity about homosexuality drew spectators to New York's African American neighborhood of Harlem to witness spectacular drag balls held in the Hotel Astor and the huge Madison Square Garden in the 1920s and 1930s. Officially sanctioned by police and city officials, public drag balls displayed women dressed as men dancing with women, men dressed as women dancing with men, and a parade of well-dressed men in costume.

For teenage women, a culture of consumption oriented toward heterosexual romance aided them in their movement away from their parents' traditionalism. For women who desired emotional and sexual romance with women, the 1920s' emphasis on female sexual expression brought more opportunities for social gatherings and sexual self-knowledge that went hand in hand with greater surveillance by doctors, educators, and police.

WOMEN AND WORK

Many of the era's commentators suggested that changes in women's work fueled the "revolution in morals and manners." As the economy shifted from production to consumption, new **pink-collar jobs**, done in offices not factories, opened up for young

white women. Banks, real estate, insurance offices, publishing houses, and trade and transportation industries required an army of clerks to handle the mountains of paperwork. By 1930, women filled over 52 percent of these clerical positions. A fresh supply of young high school–educated women from the middle and working classes flooded into offices, newly equipped with typewriters, telephones, and dictating and adding machines. However, not all women could find work in offices. The majority of pink-collar jobs remained reserved for white and native-born women. While African American or newly immigrated whites made up 57 percent of all employed women, both groups found the only work open to them was in domestic service or in the garment industry as factory operatives. Job segregation based on race persisted, testifying to all that had not changed in the boom years of the 1920s.

Read **"Women Streetcar Conductors and Their Fight for Jobs"**[4]

World War I, which took scores of men out of their home and, ultimately, many women out of service professions, proved a liberating time for working women. Women increasingly abandoned low-wage work that had been their sole purview before—as domestics and in service jobs—for the factory jobs that had been the domain of men. Female workers poured into munitions factories, public transport occupations, and government jobs during the four years that the war was waged, with over a million and a half women joined the workforce. Women were now doing "men's work" and getting paid a more competitive wage. (Research from www.firstworldwar.com/features /womenww1_four.htm)

The scarcity of male labor proved to be a boon for women, and many women wished to remain in these better-paying jobs after the war. Unions and management, however, had other ideas, pressuring them to leave in favor of giving jobs back to the men who had returned from overseas. Workingwomen found themselves struggling to redefine their work lives, refusing to go quietly back to what men—and a lot of women—felt was their appropriate place in society and the workforce.

Review the source; write short responses to the following questions.

1. What were the two factors which "were to influence the future employment of women" in the occupation of streetcar conductor? How do these factors shed light on what it was like to be a woman in a nontraditional job in the early 1920s?
2. What role did the union play in mediating the dispute between male and female workers?

Married Women Workers

By the 1920s, American women no longer viewed work and home as mutually exclusive domains. Whereas the typical female worker in 1900 had been single and under twenty-five years of age, by 1930, she was over thirty and married. Married women

entered the workforce at five times the rate of other women in the 1920s and constituted 40 percent of the female workforce. One-third of these new workers had children under the age of thirteen. Married women's work enabled some families to meet their basic needs. For others, these extra wages enabled to purchase an array of new consumer products, from fans and refrigerators to silk stockings and automobiles. Married women increasingly found themselves in the unique position as both wage worker and primary consumer.

Women's role as the family shopper, so important to the growth of new industries, worked against them as they sought work. Ideas about gender and women's proper role in the family limited the kinds of work available to women as well as the wages they earned. Employers believed that women worked for "pin money," or extra money for frivolous expenses, or luxury items that helped to justify the low pay women received relative to men. Women workers earned between 52 and 55 percent of what men earned by being restricted to unskilled jobs classified as "women's work."

Pink-Collar Workers

Women in the 1920s found new work in the rapidly growing service sector of the economy. The number of service and secretarial jobs expanded rapidly in the 1920s, spurred on by new communication and business technologies. Unlike her counterpart at the turn of the century, the pink-collar worker of the 1920s had a high school diploma and often had taken additional commercial courses.

Engrained ideas about the inherent skills of women shaped understandings of both office work and office workers. Employers viewed office work as particularly suitable for women, explaining that women could more easily adjust to the routines of the office. Employers saw young women in particular as ideal clerks for what they understood as young women's careful attention to details, their nimble and dexterous fingers, and willing deference to male authority. Employers assumed that women lacked ambition because they worked only until they could marry and raise a family, a belief that neatly folded into the built-in limits of clerking and secretarial work.

Most women viewed pink-collar work as a step-up in status, if not as an increase in the amount of money they earned. Employers expected women to dress in an attractive and feminine manner, a requirement that meant spending more money on clothes. Work in offices often included niceties like recreational lounges for breaks, free meals, medical services, and loans. Despite such perks, pink-collar workers were not paid a wage sufficient enough to support a family. The Women's Bureau reported that the median weekly earnings of women were $13.80, a figure that fell well below the estimates of $20 minimum income needed for city workers.

Pink-collar workers earned only a bit more than did factory operatives and had similarly dead-end careers. Despite the dead-end nature of the work, pink-collar work was clean, safe, and steady and women flocked to it. By 1930, two million women worked in offices and retail sales, outnumbering women in domestic service, teaching, and factory jobs. One-third of these workers were married.

Budget Estimates for a Single Woman Worker by the Ohio Council of Women in Industry, 1925

Boarding and lodging	$5.50
Clothing	$4.50
Laundry	$.75
Carfares	$1.00
Doctors and dentists	$0.38
Church	$0.13
Newspapers	$0.12
Vacation	$0.37
Recreation	$1.50
Savings for reserve	$1.50
Incidentals	$0.75
Organization dues	$0.13
Insurance	$0.37
Self-improvement	$0.25
Total	**$17.25**

Professional Workers

The peak of the trend of women's ascendancy into the professions, begun in the late nineteenth century, was reached during the 1920s. In the 1920s, women professionals doubled in number. Three-quarters of professional women worked in areas opened up by Progressive Era reformers, such as social work, medicine, academics, and law. The proportion of doctorates earned by women rose from 10 percent in 1910 to 15 percent in 1930, with women earning one-third of all graduate degrees and making up 30 percent of the nation's college and university faculties. Academic women entered departments of psychology, social science, behavioral science, and anthropology and made important contributions to the study of sex differences, personality development, and intelligence.

Social work, teaching, and nursing remained professional strongholds for women. Women's hold over teaching reached a historic high of 86 percent at the beginning of the 1930s. The percentage of female nurses held steady at 96 percent. Salaries for these women-dominated fields were low, making it difficult for women to support themselves or their families on their earnings.

Black women faced unique circumstances in the 1920s as they entered professional occupations. In Boston, African American businesswomen who owned laundries, dress shops, beauty parlors, and groceries formed their own trade associations and social clubs, while others served as officers in the Boston Trade Association, the black equivalent of the white-controlled Chamber of Commerce. Such organizations proved to be essential for their members as they weathered economic downturns, providing

much needed capital in years when banks routinely refused to extend credit to women. Entering managerial positions or owning a business, however, was no guarantee of equal treatment or equal opportunities. One African American woman qualified thirty-five times for a civil service appointment without being assigned a position. The **National Urban League**, an organization founded in 1910 to improve housing, medical care, and work conditions for African Americans, worked to open managerial opportunities for black women in department stores and secretarial work but met with limited success.

While black professional women constituted a mere 4 percent of all working married women in the 1920s, they became the focus of an anxious discourse on the effects of work on their domestic and community responsibilities. Historically, middle-class African Americans put a premium on women's homemaking duties as a way to resist racist beliefs that cast aspersions on the health and respectability of black families. Black female professionals, who also embraced modern notions of companionate marriage and women's rights, struggled against critics who linked racial uplift to female domesticity and motherhood on the one hand and male authority on the other. Despite such resistance, black women in the 1920s made opportunities for themselves. One such person was Sarah Breedlove, or Madame C.J. Walker, a wealthy African American business woman. By 1917, she had built her business into the largest black-owned company in the country. Walker took great pride that her company afforded a profitable alternative to domestic service for the thousands of black women who worked as commissioned agents for her products. Her agents could earn from five to fifteen dollars a day, in an era when unskilled white laborers were making about eleven dollars a week.

BEYOND SUFFRAGE

For women active in the suffrage movement, the ratification of the Nineteenth Amendment on August 18, 1920, was a historic moment, long awaited and much anticipated. Yet the powerful coalition of groups and organizations that had achieved suffrage, each with their different goals for wanting the vote, quickly fragmented upon its passage (see Chapter 15). According to the seasoned reformer Frances Kellor, "The American woman's movement . . . is splintered into a hundred fragments under as many warring leaders." Kellor's use of the singular "woman's" movement was precisely what the suffrage victory had destroyed. Throughout the 1920s, women followed a number of paths toward social reform and activism, many of which were diametrically opposed to one another. For a younger generation of activists, "self" or individual consciousness challenged the dominance of "sex" or group consciousness. Only for the seasoned activists of Progressive Era fame did maternalism, activism based on women's roles as mothers, continue to shape their political goals.

Feminist—New Style

With the growth of more commercial places to mingle with men and with the popularity of more daring dress styles (see Chapter 14), modern women integrated their public and private identities in ways that demanded a change in feminism. Young women frequently characterized former suffragists and women reformers as overly antagonistic toward men. With their "old-style" emphasis on building separate institutions from

men, suffragists had exacerbated problems between the sexes, according to young women. For this generation, separatism from men was no longer a strategy for political mobilization. Rather, it was a sign of backward thinking.

Read about **The Antifeminism Campaign**

The passage of the suffrage amendment was a significant victory for women, but antisuffragists remained unbowed in their opposition. For them, women's authority rested on her distance from the dirty world of politics; to become more like men by voting would, they feared, undercut women's moral authority.

Review the source; write short responses to the following questions.

1. Why did antifeminists think "the best way to have defeated Feminism would have been to have prevented woman suffrage"? Why were they so vehemently opposed to women having the right to vote?
2. What role did the antifeminists see proponents of suffrage and women's rights playing in the government?

For women in their twenties and thirties who did not identify themselves as suffragists, reformers, or activists, the new style of feminism in the 1920s combined a popular mix of antifeminism, a recognition of a de-escalation in women's formal political activism, and a new attention to heterosociality. The suffrage victory represented more than the right to vote. It represented women's right to set their own course as individuals. For some young women, this meant casting off a life narrowly scripted by old-fashioned views of women's duty to family or to reform.

Read **"Feminist—New Style"**

Journalist Dorothy Dunbar Bromley[5] (1897–1986) was among a cohort of young women who were more than ready to cast off what they felt were the restrictive preoccupations of an older generation of career suffragists. According to Bromley, "feminist—old style" wore flat heels, disliked men, and chose work over love. "Feminist—new style" enjoyed fashion, looking attractive, and, most important, men. Bromley was born on a farm in Ottawa, Illinois, and graduated from Northwestern University. Her first marriage ended in divorce. She remarried and worked as the editor of the women's activities page and wrote a regular column for the *New York Herald Tribune*. In this piece, published in 1927, Bromley set out a new vision of feminism that she crafted especially for modern women.

Review the source; write short responses to the following questions.

1. What makes the "feminist—new style" distinctive from her foremothers?
2. How does Dunbar understand modern women's obligations to men, marriage, and family?

The League of Women Voters

The language of individual over group rights dismantled the sense of solidarity forged during the suffrage campaign, but it did not end women's political activism. The umbrella issue that suffrage had been for a loose coalition of women disappeared and, with it, some of the political energy of those who had participated in its passage. But for other activist women, the 1920s represented the new age of political equality and political involvement for women.

Activist women debated the merits of maintaining women's political groups or joining the Democratic and Republican parties. Some older women, raised on the view that women were nonpartisan and ought to stay out of the fray of the rough-and-tumble world of backroom politics, were uncomfortable with the idea of joining the major political parties, fearing it would undermine the special perspective of women that the political system sorely needed. Others eagerly jumped into parties politics, like former suffragist Molly Dewson who became a Democratic Party activist, while former antisuffragist Elizabeth Lowell Putnam chose the Republican Party. Others formed new women's organizations. Some followed Alice Paul into the National Woman's Party (NWP), while others followed Maud Wood Park into the newly formed League of Women Voters (LWV). Park, who had served in the National American Women's Suffrage Association (NAWSA), became the first president of the LWV, the

Rollin Kirby's political cartoon captured the sense of accomplishment many women felt at the passage of the Nineteenth Amendment in 1920 granting women the right to vote. After a 72-year long effort, suffragists succeeded in winning broad support for their cause.

all-white successor organization to the NAWSA, in 1921. The LWV devoted itself to providing a nonpartisan education that would help women, who had never been interested, participate in politics. Toward this end, the LWV encouraged women to join political parties and to take on leadership roles in them.

If men were not reconciled to having women in politics, then neither were the majority of women. The LWV's attempts to get women to vote did not result in the high turnouts they had hoped for to sustain the attention of the two political parties. Only one-third of women voted in the 1920 presidential elections. The much-talked-about "women's bloc" that critics and supporters imagined to be potentially strong enough to elect Progressive candidates and enact Progressive reforms never materialized. Even the LWV's own ranks, which were one-tenth the size of the suffrage organization that preceded it, testified to the declining cohesion of the woman's movement.

The Equal Rights Amendment

In contrast to the nonpartisan efforts of the LWV, the NWP, with its eight thousand members, turned its sights on the passage of another federal amendment, the **Equal Rights Amendment** (ERA). For Alice Paul, the ERA promised to establish equality between the sexes by ending all legal barriers faced by women on account of sex. Using the language that echoed the 1848 Seneca Falls Declaration of Sentiments, the proposed amendment read: "of rights under the law shall not be denied or abridged by the United States or by any State on account of sex." For ERA supporters, any law that affirmed women's difference from men was seen as an obstacle to women's freedom. According to Paul, "enacting labor laws along sex lines is erecting another handicap for women." With this, she exposed the fundamental fault line dividing political women in the 1920s: women's equality as established by the ERA stood in stark contrast to women's difference from men established in protective legislation.

The "clean sweep" proposed by Paul and others immediately raised the ire of women reformers who had worked for decades to enact protective legislation for women. The success of the protective legislation enacted during the Progressive Era rested on the legal establishment of women's biological difference from men and the government's interest in women's potential motherhood. Such workplace legislation required the state to limit the hours and type of work women could do as a way to ensure a woman's potential for a healthy pregnancy. For these reformers, the ERA represented a threat to all the sex-based protections for women workers they had worked for, undermining their hopes for women's equality based on their difference from men. Mary Anderson, director of the Women's Bureau, a stronghold of protective legislation supporters, called the ERA a "slogan for the insane" introduced by elite women who had little understanding of the lives of working women.

Coming as it did on the heels of the suffrage victory, the proposed ERA played a crucial role in the political atmosphere of the 1920s. While few Americans supported it, the ERA cast a long shadow over legislative struggles related to women and children. The larger debate over how best to promote women's equality went on, even as Congress rejected the proposed amendment in 1923.

The Sheppard-Towner Act

The Sheppard-Towner Maternity and Infancy Protection Act of 1921 represented the high-water mark for protective legislation activists. Passed when Congress was most eager to curry the favor of women voters, the Sheppard-Towner Act provided matching federal funds to states to provide health services to women and children. The act was overseen by the Women's Bureau, which established prenatal and child health centers and paid for nurses to visit new mothers at home. The Sheppard-Towner Act brought to a national level many of the local programs women reformers had established in urban centers.

Despite the tremendous effort put forth by women's social welfare activists, a series of setbacks curtailed their attempts to establish safer, cleaner, and healthier conditions for women and children. In 1923, in *Adkins v. Children's Hospital*, the Supreme Court declared a federal minimum wage law for women unconstitutional because it deprived women of the right to bargain directly with their employer. Further, the Court argued that the Nineteenth Amendment obviated the need for protective legislation. Summing up the paradox of postsuffrage politics, the justices wrote: "We cannot accept the doctrine that women of mature age . . . require or may be subjected to restrictions upon their liberty of contract which could not lawfully be imposed in the case of men under similar circumstances." The Supreme Court also declared unconstitutional the child labor laws passed by Congress in 1918 and 1922. An attempt to pass a federal child labor amendment, approved of by Congress in 1924, ended in defeat when only six states had ratified it by 1930.

In such a climate, the Sheppard-Towner Act, with its ambitious course of maternal and child welfare, faced growing opposition. Since its inception, the act had faced strong opposition from the American Medical Association whose members did not want federal officials or women reformers involved in the business of health care. Some women activists, most notably birth control advocate Margaret Sanger and the NWP, fiercely criticized the act. The NWP rejected it because it defined all women as mothers, while Sanger disliked it for not including birth control information or services. The Sheppard-Towner Act, the achievement of which had inspired such confidence in the efficacy of women's activism, by 1929 fell victim to a different reality and was allowed to expire.

WOMEN'S ACTIVISM

By the 1920s, the separate organizational networks that had dominated women's political activism in the nineteenth century no longer dominated. Women actively participated in a variety of mixed-sex political movements and organizations in the 1920s. In Harlem, New York, black women participated in the multinational Pan-African movement headed by the charismatic Marcus Garvey, while in Muncie, Indiana, white women joined the revived nativist Ku Klux Klan (KKK). As more women moved away from women's groups and into groups with men, they faced new battles over authority and direction. While some activists formed separate women's auxiliaries in which

they could control their own agendas, as with the Women of the Ku Klux Klan, others openly challenged male leadership, as did women in the antilynching campaign. As sex separatism no longer worked as an effective strategy for advancing women's political visions, women had to devise new ways to assert their politics.

"Race Women" and Pan-Africanism

Black women greeted the Nineteenth Amendment with high hopes and registered to vote in large numbers. They faced stiff opposition from whites who worried that women's suffrage would encourage black men to assert their voting rights in the deeply segregated South. In cities and towns across the South, African American women were kept from voting by a number of familiar tactics. Registrars kept them waiting for hours or required payment for a new tax before they could vote. Some women were asked to read and interpret the state and federal constitutions before they could register to vote. Reporting on low turnout, white-owned newspapers reported that black women simply had no interest in voting. African American women activists looked to the National Association for the Advancement of Colored People (NAACP) for help in bringing their complaints to Congress and to national suffrage leaders but received little aid. "**Race women**," African American female activists, continued to nurture their own political networks and to advance their political goals in city, state, and national antiracist organizations.

One major reform movement was the Universal Negro Improvement Association (UNIA), an international self-help organization, the largest **Pan-African movement** of the twentieth century, founded by Jamaican-born Marcus Garvey in 1917. Commonly known as Garveyism, the movement sought to bring together African American people with people living on the African continent by stressing the need for black people to organize globally for their advancement through Garvey's phrase "One God! One Aim! One Destiny!" Garvey emphasized progress through education and acquiring of skills. By 1923, the UNIA had six million members in nine hundred world branches. When Garvey was arrested on mail fraud in 1923, his second wife Amy Jacques-Garvey became the unofficial leader of the UNIA. Jacques-Garvey had emigrated from Jamaica in 1917, joined the UNIA in 1919, and married Garvey in 1922. Jacques-Garvey brought her belief in women's equality to her Pan-Africanism. As with other race women, Jacques-Garvey understood women's domestic duties to their families as part of racial progress and respectability. But like the new generation of modern women, Jacques-Garvey did not see women's maternal role as precluding their involvement in politics, and she herself struck a balance between being a professional woman and wife. Jacques-Garvey served as the associate editor for the international UNIA journal *Negro World* from 1924 to 1927 and wrote a regular column titled "Our Women and What They Think." Unlike other women's columns in the growing Negro press, this one addressed current issues and politics, demonstrating that "Negro women are great thinkers as well as doers." At the same time that she used her column to urge women to actively participate in the Pan-African movement, she paid particular attention to working-class black women whose often unrecognized efforts sustained local communities.

Jacques-Garvey was not alone in her commitment to Pan-Africanism. Led by Margaret Murray Washington, the National Association of Colored Women took an active interest in forging international ties. In 1920, the **International Council of Women of the Darker Races of the World** (ICWDRW) was formed and worked with women from other countries to promote the teaching of "race literature," writings by and about African Americans, in schools. Learning the rich traditions of African diaspora was key to the liberation of the race, according to Jacques-Garvey, who wrote that "when the mind is enslaved, physical slavery, in one shape or another, soon follows."

View the Profile of Amy Jacques Garvey (1896–1973)

Amy Jacques Garvey is a political activist who emigrated from Jamaica in 1917, joined the Universal Negro Improvement Association (UNIA) in 1919, and married Marcus Garvey in 1922. Jacques Garvey brought her belief in women's equality to her Pan-Africanism.

The deportation of Marcus Garvey in 1927 marked the decline in the progress of UNIA and of Jacques Garvey's influence in the United States, as she and her husband returned to Jamaica. Other race women, like Mary Church Terrell, Mary B. Talbert, and Charlotte Atwood, continued to participate in international black activism. They joined the Women's International League for Peace and Freedom, founded by reformers Jane Addams and Emily Greene Balch, where they argued for the necessity for African Americans to join forces with third-world people in their fight against oppression (see Chapter 15).

The Antilynching Crusade

In the 1920s, lynching remained a tool of political and social intimidation in the South. Lynching, a vigilante practice in which white mobs seized, tortured, and killed their victims, was directed at African American men and women whom perpetrators perceived as having overstepped their place in the social hierarchy of the Jim Crow South by running successful businesses, acquiring a home or car, or not showing deference. By policing the behavior of southern African Americans through the omnipresent threat of lynching, the practice played a key role in the racial and sexual system of Jim Crow. Between 1890 and 1930, more than thirty-two hundred lynchings took place.

Throughout its long history, white southerners justified the practice of lynching as a necessary punishment to protect white women from the mythic black male rapist. Yet, as activists noted, Americans who had been lynched included women and children. Anxiety over the assertiveness of black soldiers, newly returned from military service in Europe where they did not face racial segregation, triggered a new wave of lynchings. In the wake of seventy lynchings in the immediate postwar years, white southerners hoped that reasserting Jim Crow would end the strife.

African American women, most notably journalist Ida Barnett Wells and activist Mary Church Terrell, worked for years to bring national attention to the crime of lynching (see Chapter 13). Yet it took the economic pressure caused by the migration of African Americans out of the rural South in the 1910s and 1920s for southern leaders, black and white, to address lynching as part of a larger system of racial intimidation. In an attempt to stem the flow of workers north, moderate white businessmen and community leaders formed the **Commission on Interracial Cooperation** (CIC) in 1920. The CIC acknowledged and worked with the emergent black middle class in southern cities, yet remained unwilling to challenge Jim Crow segregation by sharing authority with black leaders within the organization. As one white participant explained, "The Negroes draw up a prospectus of what they think they should have in the way of aid and recognition from the whites. The white committee then meets, considers the complaints of the Negroes, and devises means for bettering their condition." Under pressure from the NAACP, however, the CIC became more integrated. At the 1924 annual meeting, twenty-two African American men attended, winning the approval of black leaders, including Pan-Africanist and civil rights leader W.E.B. DuBois.

Incorporating women into the CIC proved harder than integrating it. Bringing African American men and white women together under any circumstances appeared to many white southerners as a threat to southern social relations. Progressive southern white women, however, saw themselves as key players in the modernization of southern race relations. In October 1920, the CIC sponsored a southern women's conference in Memphis, Tennessee. Ninety-one women from the major Protestant denominations, white women's clubs, and the YWCA gathered at the Memphis YWCA and were surprised to find themselves listening to four African American women. The final speaker of the conference, Charlotte Hawkins Brown, electrified the crowd when she placed the responsibility for ending lynching on white women. Brown rejected justifications for lynching that rested on racist myths of the black rapist and the promiscuous black woman. Linking white racism to everyday practice, she spoke of whites' refusal to address a married black woman as "Mrs.— whether she be cook, criminal or principal of a school." Inspired by all they heard, white listeners remembered the Memphis meeting as transformative.

Despite such auspicious beginnings, the new Interracial Woman's Committee quickly reasserted the traditional racial hierarchies the organization hoped to dismantle as white women established segregated groups and assigned to themselves control over state organizations. In many states, local black women's groups found they had no white counterparts with whom to cooperate. With change being slow and interracial cooperation episodic, middle-class black women continued to use their own institutions. In Colored Women's Clubs, church groups, the NAACP, and the YWCA, black women trained themselves in political activism as they worked to improve the lives of people in their communities.

White southern women, like Texas suffragist and businesswoman Jessie Daniel Ames, also grew impatient with the CIC and led Ames and others to form the **Association of Southern Women to Prevent Lynching** (ASWPL) in November 1930.

The association organized middle- and upper-class white women into a single-issue movement to oppose lynching. Bringing together lessons learned from their contact with African American women activists and their own experiences as southerners, they denounced a racial system that exploited sexual anxieties to uphold white supremacy. The ASWPL launched a campaign to change the understanding of lynching as not an act of protection but an act of lawlessness. It urged southerners to recognize how lynching undermined citizens' respect for the law and for law enforcement more generally and called on sheriffs and police officers to protect victims by ending vigilantism. In their first eight years, the ASWPL contributed to a 50 percent reduction in the incidence of lynching in the South.

Ku Klux Klan

In the Midwest the KKK drew a half-million white Protestant women into its ranks in the 1920s to become one of the largest and most politically powerful racist movements in U.S. history. The new KKK, which had grown to five million strong by 1925, filled its secret membership rolls with anxious white Americans in the North and West who feared that their way of life and their values were under assault from groups they considered to be newcomers and troublemakers, particularly religious or political groups that they perceived to have allegiances to foreign leaders, nations, or institutions. Unlike the first KKK who reasserted white rule following Reconstruction (see Chapter 10), the new KKK was part of the wave of nativism and anti-immigration that swept the country in the 1920s. Like the old KKK, it targeted anyone who challenged Jim Crow segregation. But the new KKK expanded its list of enemies to include immigrants, Catholics, Jews, and socialists. With its inclusion of boys, girls, and women, the new KKK of the 1920s became a family affair.

Read the "Creed of the Klanswoman"[6]

The Ku Klux Klan (KKK) consisted of women as well as men. Women were first initiated into the KKK in 1923. Nationwide, as many as half a million women eventually joined the KKK. Their role was similar to that of men. They supported militant patriotism, racial segregation, national quotas for immigration, and anti-miscegenation laws. They also established rules and beliefs that were to be followed by the members of the Women of the Ku Klux Klan. These beliefs were recorded in the document "Creed of Klanswomen," which follows. In this document the women focused on heritage, the great and glorious United States, eligibility, and what they believed to be best for their country.

Review the source; write short responses to the following questions.

1. According to this creed, where did the KKK stand on female equality?
2. What role did religion play in the drafting of this creed and its language? Why is the word *enlightened* used to describe some Protestant churches?

Elizabeth Tyler was the first woman to gain leadership in the new KKK, and she played an instrumental role in the creation of the **Women of the Ku Klux Klan (WKKK)** in 1923. As with many activist women of her generation, Tyler began her political education in the 1910s as a volunteer hygiene worker who visited new mothers living in tenements as part of Atlanta's "better babies" movement. After meeting Edward Clarke, the two organized the Southern Publicity Association and sold their marketing skills to organizations like the Anti-Saloon League and the Salvation Army before landing the KKK as a client. Together, Tyler and Clarke applied modern marketing and advertising techniques to KKK recruitment with impressive results. Tyler's success and the authority she claimed within the organization threatened the all-male leadership of the KKK, which moved her out of the organization by promising her control over a women's organization equal to and separate from the male KKK.

As early as 1922, women protested their exclusion from the KKK. According to one letter to the editor of the KKK publication, *Fiery Cross*, in these "new days of freedom" women wanted to shed their role as the protected and join their men in protecting their homes, families, and communities. Before the WKKK formed, women participated in informal KKK auxiliaries and patriotic societies. These auxiliaries allowed them to do KKK work in large, national organizations like the Ladies of the Invisible Eye and the Queens of the Golden Mask, as well as more local and regional ones such as Atlanta's Dixie Protestant Women's Political League and Houston's Grand League of Protestant Women. Women's auxiliaries combined white supremacy with social service work. They ran boarding homes and training schools for women looking for work, staffed day-care centers, and collected food for the needy, while opposing racial equality and interracial marriage and advocating a return of the Bible to public schools and immigration restrictions. When the WKKK is officially formed in 1923, membership was opened to all white, Gentile, female, native-born citizens over eighteen who had not pledged allegiance to any foreign government or religion and who had been endorsed by two Klanswomen. In 1923, 125,000 women living in the Midwest, Northwest, and the Ozarks region joined the WKKK. Within months, the WKKK reported its membership at 250,000 with followers throughout the country.

Klanswomen had a political agenda through which they blended a new consciousness of women's rights with anti-Catholic, anti-Semitic, and racist beliefs. Many had been active in the temperance and suffrage movements and believed that women's inherent moral natures could clean up government and help rid the nation of the vices of liquor, prostitution, and gambling. They were fierce **nativists** in their hatred of socialists and immigrants and in their support of efforts to root out so-called Jewish influence in the movie industry and to expose rumored conspiracies of the Catholic Church to gain political control of the nation. At the same time and unlike their male counterparts, women of the KKK used the language of suffrage to call for greater equality between Protestant men and women. Paradoxically, through their separate organization, an organization that embraced racist vigilantism, Klanswomen forged a critique of male power that empowered them to move out of their traditional roles.

The inclusion of women and children in the KKK contributed to its normalization during its heyday in the 1920s. Yet, even with the incorporation of bigotry into schools, leisure activities, and homes, the second KKK collapsed rapidly. By 1930, its membership dropped to fewer than fifty thousand men and women. The number of foreign-born residents in the United States declined drastically as immigration laws took effect; and after 1929, the economic depression altered the landscape of national politics. Racism, anti-Semitism, and anti-Catholicism did not disappear in the 1920s, but most white Protestant women no longer looked to the KKK as the vehicle for expressing those sentiments.

The Culture of Modernity

Women in the 1920s both symbolized and struggled to redefine what it meant to be modern. To be a modern woman included a range of new values and activities. Foremost among them was to discover and express oneself in the growing commercial world of new products. Motion pictures and advertising created a visual language of what modern women looked like, how they behaved, and what they bought, while women singers who appeared in cabarets, clubs, and theaters forged a new language for women's aspirations and their disappointments. Running throughout these venues was a new attention to modern women's contrary pulls for romance and independence, work and play, and families and self-expression. Popular culture nurtured these tensions and offered solutions to them in the marketplace of goods.

Dance Crazes

The music of the early 1920s was fast and energetic, and new kinds of dancing evolved along with the new music. The Jazz Age spawned a number of dance crazes that took the nation by storm. In speakeasies, dance halls, and private parties, young Americans took to the dance floor, shaking their upper bodies in the shimmy, gleefully throwing their arms and legs in the air, and hopping or "toddling" every step of the fox-trot. No dance was more popular than the Charleston, a dance named for the city Charleston, South Carolina. Associated with white flappers, the dance became popular after it appeared in the all-black show *Runnin' Wild* in 1923. The dance took its name from "The Charleston," a song written by African American composer James P. Johnson who incorporated popular jazz sounds with rhythms from West Africa. It became a national phenomenon when it was introduced by the dancing girls of the Ziegfeld Follies. Charleston dance contests, where hundreds of dancers took the floor for hours, were held in dance halls, hotels, and resorts and on street corners. In Hollywood, starlet Joan Crawford made a big splash when she debuted as a flapper who won numerous Charleston contests. The Charleston involved the dancer turning her knees and toes in as she shifted her weight between her legs, intended to mock the "drys," or citizens who supported the Prohibition amendment. The dance was so popular that hospitals reported increasing numbers of people complaining of "Charleston knee." Critics of the new dance disliked its frenetic gestures, and some ballrooms went so far as to post signs that read "PCQ," or "Please Charleston Quietly."

The Black Bottom, a dance that originated in New Orleans in the 1900s, overtook the Charleston in popularity. It was brought to New York City in the theatrical show *Dinah* in 1924 and at the Apollo Theater in Harlem in 1926. Jazz player and composer Jelly Roll Morton wrote the tune "Black Bottom Stomp," which referred to Detroit's Black Bottom area. Another popular dance was the cakewalk, a dance that had its origins in slavery. The dance parodied the formal European ballroom dances. Couples linked at the elbows, lined up in a circle, and danced forward, alternating a series of short hopping steps with a series of very high kicking steps. The Lindy Hop became popular at the end of the decade, named for the American aviator Charles Lindbergh who completed the first solo flight, or "hop," across the Atlantic in 1927.

It seemed that the whole country had dance fever, not only flappers and Hollywood stars. Middle-class families began sending their children to dancing schools like those run by Arthur Murray, where they learned ragtime dances like the One Step and the Tango, made famous by film star Rudolf Valentino. Murray published a long series of "how to dance" books that, along with new magazines like *The American Dancer* and *Dance Magazine*, promoted the growing popularity of dancing. Yet the new jazz and jazz dancing were not popular with everyone. Some called the new style "decadent" and "dangerous," and frankly racist reviewers referred to it as "jungle music." Arch conservative Henry Ford loathed jazz and steadfastly continued to promote old-fashioned waltzing and square dances.

The Harlem Renaissance

The new music and dance that filled the nation's speakeasies and ballrooms testified to the importance of black artists to modern America. With its seventy-five thousand black residents, the New York City neighborhood of Harlem had become the "Negro Capital of the World." Between 1910 and 1940, 1,750,000 African Americans left the South, many of them young men and women who had high hopes for a better life in the North. Most southerners who migrated north continued to settle in all-black neighborhoods such as Harlem in New York City, the South Side of Chicago, and Cleveland's East Side. Such segregated neighborhoods created strong communities as well as new sites of cultural and political conflict among African Americans. The black middle class that had long worked to be seen as respectable leaders of the race came into contact with rural and working-class blacks that brought a different set of goals and aspirations.

The artistic and intellectual life that took hold of Harlem in the 1920s grew out of the class politics brought on by the great migration. The writers who became associated with the Harlem Renaissance were often among the black elite, a highly educated group of men and women that included Zora Neale Hurston, Jessie Fauset, and Nella Larson. Hurston, who grew up in Eatonville, Florida, attended Morgan State University, Howard University, and Barnard College. Jessie Fauset came from an affluent family in Philadelphia and graduated Phi Beta Kappa from Cornell University and earned a master of arts degree from the University of Pennsylvania in romance languages.

In their fiction, authors Jessie Fauset and Nella Larson depicted conflicts between a sophisticated urbane black elite and the "folk" of the rural South. Yet they came out on different sides of the most heated debate taking place among intellectuals, journalists, writers, and artists over the role of art, broadly defined, in the struggle over equality. Fauset, like activist W.E.B. DuBois and intellectual Alain Lock, hoped black literature and arts could change racist stereotypes by promoting positive images of black life. Larson and Hurston, along with poet Langston Hughes and writer Claude McKay, used art to explore the realities of black life and argued that art ought best be measured on its own merits, not by its duty to the race.

Singing the Blues

The blues, a southern and rural style of music, gained popularity after World War I. It emerged in African American communities from spirituals, rhymed English and Scotch-Irish narrative ballads, and shouts and chants. The use of blue notes and the call-and-response patterns, where the singer calls to the listeners—who then respond, drew from West African musical traditions. In the 1920s, it became a major element of African American and American popular music and reached white audiences. The blues moved from bars to theaters and nightclubs like Harlem's Cotton Club and Beale Street in Memphis. Several record companies, such as the American Records Corporation and Paramount Records, began to record country blues singers like Charlie Patton and Blind Lemon Jefferson. Female singers, like Mamie Smith, Gertrude "Ma" Rainey, Bessie Smith, and Victoria Spivey, sang city or urban blues in the 1920s. Mamie Smith's 1920 "Crazy Blues" sold seventy-five thousand copies in its first month.

View the Profile of Bessie Smith (1892–1937)

Blues artist who sang what were commonly known as "race songs," songs that painted a picture of black life. Her first recording included "Downhearted Blues" and "Tain't Nobody's Business If I Do." In 1925, she recorded with Louis Armstrong, who said of Smith, "She could phrase a note with a certain something in her voice no other blues singer could get." Smith toured major cities where crowds lined up at clubs to hear her.

In 1923, Bessie Smith began her assent as "the Empress of the Blues" when she signed a contract with Columbia Records and by 1928 had become one of the most successful black performing artists of her time, touring with the era's great jazz players in the North and South and playing to huge audiences. In her life and her music, Smith represented much of what middle-class blacks most disliked about working-class and southern newcomers. She sang about alcoholism and drank heavily herself; she sang about love and had many lovers; she sang about crime and she personally was drawn to dangerous clubs where, in her words, "the funk was flying." At two hundred pounds, Smith also posed a sizable challenge to the slender ideal of white

femininity that became prominent in the 1920s, even in Harlem. The famous Cotton Club in Harlem hired only African American dancers who were more than 5′6″ tall, less than twenty-one years of age, and of light brown complexion. Smith, Rainey, Ethel Waters, Clara Smith, and Alberta Hunter, many of whom got their start traveling with vaudeville shows and circuses, were among the singers who dominated the blues in the 1920s.

 View the Profile of <u>Gertrude "Ma" Rainey</u>

Frank Driggs Collection/Getty Images.

Gertrude Malissa Nix Pridgett was a classic female blues singer and one of the first generation of blues singers to record. Her first recordings came in 1923; she signed with Paramount Records and recorded some hundred songs between 1923 and 1928, often with top blues artists like Louis Armstrong, Kid Ory, and Fletcher Henderson.

CONCLUSION

Whether or not the notorious flapper of the 1920s was as new as critics made out or represented a new age of equality between the sexes as her supporters argued, she nevertheless represented a change in many young women's sense of themselves and their place in society. Young working-class girls, department store clerks, rural newcomers to cities, and college students insisted that they were different from their mothers and grandmothers, that the world was new, and that they were at the forefront of the twentieth century.

While the Jazz Age's celebration of modernity and youth and, in particular, its emphasis on individual pleasures changed the ways that Americans entertained themselves, the Jazz Age weakened the Progressive reform impulse of the prewar years. Consumption of a new array of products like cars and radios rose in importance, while anti-immigrant feelings and ongoing Jim Crow segregation spoke the nation's conservative turn in the 1920s. Women activists face apathy from younger women and reform fatigue from former suffragists. The culmination of the nineteenth-century suffrage movement, the passage of the Nineteenth Amendment giving women the right to vote, did not bring about lasting change in the nature of politics that suffragists had imagined.

One of the most important and far-reaching changes of the 1920s was the rising numbers of working women in the fast-growing pink-collar sector of the economy. As consumer spending and service work grew into major engines of economic growth, women found their dual roles as primary shopper and pink-collar worker to be at the heart of modern America.

 Study the <u>Key Terms</u> for The Jazz Age, 1920–1930

Critical Thinking Questions

1. What made marriage different or modern in the 1920s? What were some of the causes for the companionate marriage?
2. What changes in the economy helped women wage workers? What spurred the growth of the pink-collar job sector?
3. Did winning the vote change women's political activism in the 1920s? In what ways? In what ways did it not?
4. How did women participate in the culture of the Jazz Age?

Text Credits

1. Mamie Garvin Fields and Karen Fields, *Lemon Swamp and Other Places: A Carolina Memoir* (New York: Free Press, 1983).
2. Ellen Welles Page, A Flapper's Appeal to Parents, *Outlook 132* (December 6, 1922).
3. Margaret Sanger, from Happiness in Marriage (1926).
4. Controversies Regarding the Right of Women to Work as Conductors, in *Women Streetcar Conductors and Ticket Agents* (Washington, DC: U.S. Government Printing Office, 1921).
5. Dorothy Dunbar-Bromley, Feminist—New Style, *Harper's* (October 1927).
6. The Creed of the Klanswoman, *The Kluxer* (March 8, 1924), p. 20.

Recommended Reading

Beth Bailey. *From Front Porch to Back Seat: Courtship in Twentieth Century America.* Baltimore, MA: Johns Hopkins University Press, 1988. Bailey examines advice literature, youth cultures, popular culture, and American courtship behaviors in this classic study.

Kathleen M. Blee. *Women of the Klan: Racism and Gender in the 1920s.* Berkeley, CA: University of California Press, 1991. Klee, a sociologist, reconstructs the rise and fall of the new KKK of the 1920s in the Midwestern United States. She uses KKK publications and oral histories to analyze the KKK's use of gender and its appeal to white Protestant women in their search for equality.

Mari Jo Buhle. *Feminism and its Discontents: A Century of Struggle with Psychoanalysis.* Cambridge: Harvard University Press, 1998. Buhle covers the cultural and intellectual context in which the psychoanalytic theory took hold of both American notions of self and feminists' engagement with sexuality, gender, and subjectivity.

Hazel Carby. " 'It Jus Be's Dat Way Sometime': The Sexual Politics of Women's Blues," Ellen DuBois and Vicki Ruiz, eds., *Unequal Sisters: A Multicultural Reader in U.S. Women's History.* New York: Routledge, 1990. Carby contrasts women in the Harlem Renaissance and female blues singers for their understanding of female sexual desire and its relationship to class differences among African Americans.

Nancy Cott. *The Grounding of Modern Feminism.* New Haven, CT: Yale University Press, 1987. Cott's is an encyclopedic study of women's activism in the years following the Nineteenth Amendment. She pays close attention to the transformations between nineteenth-century women's movement to modern feminism in both ideology and application.

Sarah Deutsch. *Women and the City: Gender, Space, and Power in Boston, 1870–1940.* Oxford and New York: Oxford University Press, 2000. Deutsch's strength in multicultural history is applied to the clashing cultures of class and race in Boston.

Angela J. Latham. *Posing a Threat: Flappers, Chorus Girls, and Other Brazen Performers of the American 1920s.* New York: Oxford University Press, 2000. Latham studies women whose public transgressions of gentile femininity helped open up new styles and attitudes for women in the 1920s.

Rosallyn Terborg-Penn. "Discontented Black Feminists: Prelude and Postscript to the Passage of the Nineteenth Amendment," in Kathryn Kish Sklar and Thomas Dublin, eds., *Women and Power in American History, Volume II, from 1870.* Upper Saddle River, NJ: Prentice Hall, 1991. Terborg-Penn's account covers the successes and disappointments of black feminists as they join with black men and white suffragists in their efforts to eradicate racism.

CHAPTER 17

THE GREAT DEPRESSION, 1930–1940

TIMELINE

1929	Stock market crash occurs
	Female textile operative stage walkout takes place in Elizabethton, Tennessee
1930	Department of Labor estimates 4.2 million unemployed workers
1932	Franklin D. Roosevelt (FDR) wins landslide victory over Herbert Hoover
	Mary (Molly) Dewson appointed head of the Democratic National Committee's Women's Division
	Birthrate drops to all-time low
1933	Frances Perkins becomes the first female cabinet member as secretary of labor
1934	Dust storms ravage the western plains states
	Hollywood codes established
1935	The Social Security Act enacted
	Mary McLeod Bethune heads the Negro Division of the National Youth Administration
	Dorothea Lange hired by the resettlement administration
1936	FDR reelected
1937	Chinese Ladies' Garment Workers' Union chartered
1939	Mexican American women stage walkout against California Canning industry

ELEANOR ROOSEVELT RECEIVED THOUSANDS OF LETTERS FROM AMERICANS THAT SHARED DETAILS OF THEIR DAILY STRUGGLE TO SURVIVE THE WORST ECONOMIC DEPRESSION IN THE NATION'S HISTORY.

The causes for the Great Depression lay not only in the crash in 1929 of an overly in-flated stock market but in structural changes in the economy, in international relations, and in national politics. While the causes of the Depression were multiple, the experience for most Americans was not. Layoffs, foreclosures, and bankruptcies resulted in mass unemployment. In 1930, the Department of Labor estimated that 4.2 million Americans had lost their jobs. This figure nearly doubled in 1931; and, by 1933, a quarter of the labor force, 12.6 million workers, was unemployed. Middle-class families fell from relative economic security into not knowing week to week how to get by. Farming families, already poor, found little relief. Dust storms and bank foreclosures forced a mass migration of hundreds of thousands of small landowners and sharecroppers from the Southwest. Photographed by Dorothea Lange and others, faces of Okie (Oklahoma) women, lined with worry and fatigue, and their thin dusty children came to stand in for the harsh realities of rural poverty in the 1930s.

Many women had few resources to help ward off homelessness and hunger for their children. Yet they did not wait for help to appear. Women organized themselves as workers, consumers, and renters to pressure employers, landlords, and local officials to address their problems. At the same time, women reformers mobilized to put pressure on the government to address the needs of struggling families. While Roosevelt's New Deal gave much needed aid to poor families, key legislation reinforced the ideal of a family wage paid to men and men alone. The foundation for the liberal welfare state, established in the crucible of the 1930s, rested on the gendered view of women as mothers and fathers as workers, with consequences that profoundly shaped women's status for years to come.

Read about **The Reality of the Great Depression**[1]

This letter from a young girl growing up in the Great Depression is similar to the thousands of letters that First Lady Eleanor Roosevelt received during her time in the White House. This letter underscores how bleak things were for people during this time of overwhelming economic strife.

Review the source; write a short response to the following question.

1. What is it that sixteen-year-old J.B. would like Mrs. Roosevelt to do for her family?

FACING THE DEPRESSION

No era ended as abruptly as did the Jazz Age of the 1920s. In the course of a year, the icons of the 1920s—the flapper, the feminist, and the teenager—went from trendsetters to the very epitome of frivolity. The optimism of the 1920s was first tested by the stock market crash in October 1929 and then strained by President

Herbert Hoover's slow response to the crisis. Finally, by the 1932 election, hope had been replaced by fear and despair. Massive layoffs put husbands, brothers, and fathers out of work. Savings were wiped out when banks failed. Foreclosures, eviction, and hunger became commonplace. Women's skills at home were pressed to the limit.

The Economics of Running a House

With money scarce and work unpredictable, most American families lived by the credo: "Use it up, wear it out, make it do, or do without." Unlike the 1920s, when women rushed to fill their kitchen and living rooms with new appliances and radios, the Great Depression forced many women to practice a number of small economies. They bought day-old bread, filled the oven with many dishes to save on gas, relined old coats with old blankets, patched sleeves, and cut adult clothes to fit children. If they could afford meat, they bought cheaper cuts; if they had a car, they drove it less. Families moved in together to save on rents, creating households of extended families and multiple adults who pooled their wages to keep the family fed and clothed.

Over half the families in the country had incomes of twenty dollars per week to feed, clothe, and house a family. Deflation pushed down the cost of goods, meaning that a budget-conscious woman could feed her family on five dollars a week, if she had the money. Women did at home what they had once purchased ready-made. They began canning their own fruits and vegetables; others took up baking their own bread. As families saw their livelihoods dwindle, middle-class homemakers began making dresses, doing laundry, and letting out rooms for much needed money. Neighbors exchanged tasks, such as doing a woman's hair in return for use of her pots and pans or trading bread for a glass of milk. One Washington, D.C., social worker recounted the actions of "Auntie Jane," a strong, forty-year-old African American woman, who dressed in men's clothes and led a group of women and children into two partially demolished buildings where they gathered firewood for their apartment courtyard.

For women living in the southern Great Plains, an environmental crisis caused by years of drought and large-scale agriculture triggered massive dust storms. Black blizzards of dust blew across the region and left great drifts of dust in their wake. Humans and animals suffered respiratory strain or "dust pneumonia," leaving young children and the elderly particularly vulnerable. With so much topsoil blown away, crops and trees were destroyed; car, truck, and train engines that are choked with dust often broke down, stranding travelers and closing off commerce. The scale of the storms was unprecedented. A Chicago newspaper reported that a storm on May 10, 1934, dumped 12 million tons of Plains soil on that city.

Postponing Marriage and Children

Faced with economic uncertainty, couples postponed marriage during the Depression, opting to wait it out while they lived at home with parents or family.

MAP 17-1 The Dust Bowl

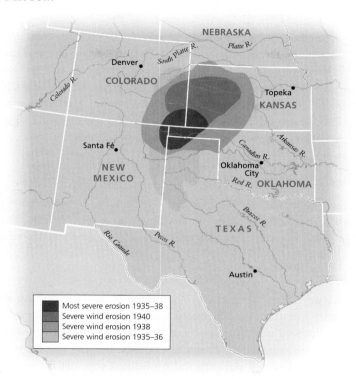

After several years of drought conditions, high winds blew up violent dust storms in the mid-1930s. Federal programs sought to improve soil conditions and water management, but years of stripping the landscape of its natural vegetation limited the effectiveness of such efforts.

The marriage rate fell to new lows in the 1930s. One estimate claimed that 1.5 million people had postponed marriage. For the cohort of women in their twenties and thirties during the Great Depression, the proportion of single women was 30 percent higher than it had been in the 1920s. Divorce was also out of reach because of the expenses involved in legally dissolving a marriage. Many couples found getting federal relief was easier as a family and so weathered marriages until the crisis passed.

For those couples who did marry, many deferred having children until economic times improved. The U.S. birthrate fell below the replacement level for the first time. Birth control, long controversial and illegal for all who did not have a doctor's order, became more acceptable as families struggled to feed themselves. Associated with radicalism and women's rights in the 1910s, birth control had by the 1930s become firmly under the control of doctors and professional health care workers. Many of the clinics that had been forced to close their doors in the 1920s suddenly found their services in great demand.

Read "Dust Bowl Diary"[2]

The drought that gripped the Great Plains region of the United States throughout the 1930s not only devastated the land but also changed the life course of many women. Struggling against encroaching poverty, families that chose to stay on their farms found that life was full of sacrifices. For young Americans, it often meant sacrificing wedding plans until economic times improved. Living in North Dakota, college-educated Ann Marie Low kept a diary during the 1930s. In it, she recorded her feelings about the exacting cost of the Depression and the dust bowl on her work and family aspirations.

Review the source; write short responses to the following questions.

1. Low's feelings toward marrying Cap were complicated by her family obligations as well as her desire for a more romantic hero. What kept her from marrying him?
2. In what ways does Low's diary reflect the larger issues women faced in the 1930s?

The African American birthrate had been steadily dropping since the end of the nineteenth century and continued to do so in the 1930s. For generations, black women had devised methods for birth control and ending unwanted pregnancies that did not require the help of white doctors. During the Depression, the need for planned or deliberate parenthood mobilized support for birth control clinics in black communities, with some advocates linking it to a larger program of better health services for women and children. Community-sponsored birth control clinics for African Americans were opened in Baltimore, New York, Louisville, Fredericksburg, and Boston. These community-based clinics became the foundation in 1939 for the Division of Negro Services in the Birth Control Federation of America.

Gender and the Politics of Providing

During the Depression, more married women and older women entered the workforce, continuing a trend that had begun in 1920s. Driven not by self-fulfillment or a feminist initiative, married women worked to help their families weather the economic crisis.

Even as families depended on the wages working wives brought in, many Americans accused them of being selfish for taking jobs away from men, ultimately a false argument. Working women did not compete for jobs historically reserved for men. Women worked as domestics and in pink-collar work. Ironically, the sex typing of jobs that limited the job opportunities available to women granted women workers a degree of protection from the worst effects of the Depression. The sectors of the economy that lost the most jobs in the 1930s were heavy industry and manufacturing, both strongholds of men's employment. While, in reality, men did lose more jobs than did women,

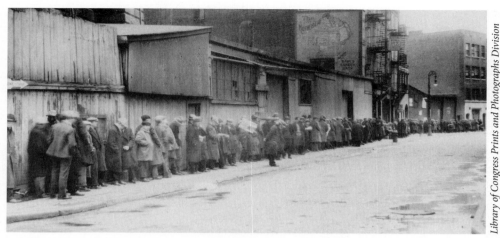

Library of Congress Prints and Photographs Division [LC-USZ62-91536].

Such nuances proved irrelevant to a public looking for quick solutions to widespread unemployment.

the overall number of men in the workforce had been and remained substantially higher than that of women.

Legislatures and organizations restricted married women's work opportunities. College-educated and professional women fared particularly poorly in the 1930s. The number of women teachers in elementary and secondary schools fell from 85 percent in 1920 to 78 percent in 1940. Those who married were forced to resign. For those who remained, promotion to superintendents of schools was rare.

Women across the job spectrum were paid less than men as well, even when they held identical jobs. Across all industries, women earned 50 to 65 percent of what men were paid. As a result, many working women could not meet their basic living costs on such low pay.

The public outcry against working married women expressed a tangle of anxieties about manhood, family, and survival in an uncertain time. Working women, historically segregated to lower-paying, nonmanagerial, and menial jobs, were not literally taking jobs away from men who were desperate to work in the 1930s, and neither did married women, a group who made up only 35 percent of all working women. The threat that women workers posed, then, was not to unemployed men but to the ideology of men as the principal breadwinners in the family, a status so important to the definitions of healthy masculinity.

Activism

Coming out of class and ethnic traditions of labor unionism, working-class women came together to protect their jobs and protest their falling hours and wages. In 1932, the American labor movement had only 2.8 million union members. Yet, thanks to the

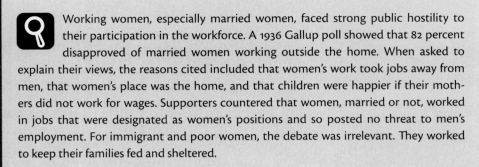

Working women, especially married women, faced strong public hostility to their participation in the workforce. A 1936 Gallup poll showed that 82 percent disapproved of married women working outside the home. When asked to explain their views, the reasons cited included that women's work took jobs away from men, that women's place was the home, and that children were happier if their mothers did not work for wages. Supporters countered that women, married or not, worked in jobs that were designated as women's positions and so posted no threat to men's employment. For immigrant and poor women, the debate was irrelevant. They worked to keep their families fed and sheltered.

Review the sources; write short responses to the following questions.

Ruth Shallcross, *Shall Married Women Work?* [1936][3]
Caroline Manning, *The Immigrant Woman and Her Job* [1930][4]

1. According to Shallcross's research, from what sectors of society did opposition to working women come?
2. Why were men affected more by unemployment than women?
3. How was the immigrant woman's working experience different from the women described in Shallcross's research? What types of jobs were available to immigrant women looking to survive in a depressed economy?

unionizing of mass production industries like automobile, steel, rubber, and textiles, union membership hit over 10.5 million by the outbreak of World War II. Changes in the labor movement made it possible for more women to join unions. Historically, the craft-oriented American Federation of Labor (AFL) ignored workers in mass production and unskilled laborers, job classifications in which women dominated. In 1935, a group of more militant AFL union officials and communists committed to workers' rights formed the Committee for Industrial Organization with the goal of organizing mass production workers by industry rather than by craft, a goal that promised to be friendlier to women workers. By 1938, the committee had nearly four million members, withdrew from the AFL, and renamed itself the **Congress of Industrial Organizations** (CIO). At the same time, women supported the labor movement by joining women's auxiliaries of unions in which their husbands, brothers, or fathers were members. These auxiliaries, like the Women's Emergency Brigade for the 1936 United Automobile Worker strike at two General Motor plants in Flint, Michigan, sent tangible support to striking workers, many of whom occupied factories for weeks at a time.

Appalachian Women in the Textile Industry

By the mid-1920s, Appalachia, once the home of farms and farmers, had been criss-crossed by railroad tracks and dotted with mill villages, and the Piedmont had

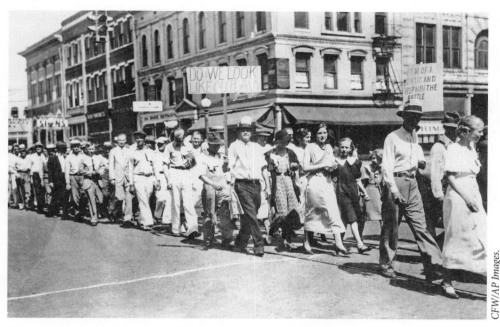

CFW/AP Images.

Women were active in the wave of labor protests that broke out in the 1930s in response to falling wages and violations of labor codes. In the General Textile strike of 1934, shown here, approximately 44,000 million workers in Georgia participated.

eclipsed New England as the world's leading producer of yarn and cloth. By 1933, southern mills produced over 70 percent of the country's cotton and woolen textiles. The cash wages earned by daughters in textile mills continued to be vitally important to working families. Technological improvements made the mill machines faster, but higher levels of productivity did not translate to higher wages for mill operatives. Overproduction, along with falling need for cotton after World War I, and growing international competition depressed textile workers' already low wages. Factory owners tried to squeeze more work from their employees through what workers called stretch-out, speeding up production by increasing the number of looms assigned to each factory hand, limiting break times, and increasing the number of supervisors to keep workers from slowing down. The stretch-out triggered a wave of walkouts throughout the Southeast.

One such walkout took place in 1929 and was led by a group of women. In 1928, two large artificial silk or rayon plants operated in the small East Tennessee town of Elizabethton. Town officials had courted the rayon giant, Glanzstoff, by promising the German industrialists that they would have an abundant supply of docile and cheap labor. The first plant, Bemberg, employed 886 men and 384 women; the larger mill, Glanzstoff, employed 1,099 men and 854 women. While all employees worked a fifty-six-hour week, wages for women remained considerably lower than those for men. The women worked ten-hour days winding, reeling, twisting, and inspecting rayon

yarn. Teenage women made up 44 percent of the Glanzstoff workforce. Like the Lowell textile workers of the nineteenth century (see Chapter 7), these daughters of farm families blended home life and work life through bonds of friendship and solidarity as they commuted each day in packed caravans of Model Ts or shared crowded rooms in nearby boardinghouses.

On March 12, 1929, Margaret Bowen, a worker at Glanzstoff, led a walkout of women operatives. Four days later, Bemberg workers joined them. The workers' protests centered on low wages, unfair promotion policies, and petty regulations that applied only to females, which included wearing no makeup, purchasing their own uniforms, and submitting to supervised washrooms where their pay was docked if they lingered too long. The courts quickly granted injunctions against the strikers, and Tennessee Governor Henry Horton immediately sent two companies of national guardsmen to Elizabethton.

On March 22, a "gentleman's agreement" was reached between the company and the United Textile Workers (UTW), in which the Glanzstoff owners agreed to a new wage scale for "good girl help" and fair treatment of union members. When the raises never materialized and two union leaders were kidnapped and run out of town, a second, more violent phase of the strike began. The women in the Glanzstoff reeling room staged a walkout. "When they blew that whistle everybody knew to quit work," Flossie Cole recalled. "We all just quit our work and rushed out. Some of 'em went to (the nearby plant) Bemberg and climbed the fence. [They] went into Bemberg and got 'em out of there." With both plants closed, the UTW promised support. The plants became fortresses when the National Guard arrived with machine guns on the rooftops and armed guardsmen on the ground. The company sent buses manned by soldiers farther up the hollows to recruit new workers and to escort them back to town. Angry workers blocked narrow mountain roads. An estimated 1,250 individuals were arrested.

As men in the union battled the National Guard, women strikers engaged in playful "feminine" actions to advance the strike. Hundreds of "disorderly" working girls from the surrounding hills crowded in taxis and buses and rode through the main street, laughing and pointing at the people watching them. They teased national guardsmen, ridiculed strikebreakers, and disrupted traffic and the flow of goods and workers into plants. Some strikers used theatrical measures. In Elizabethton, twenty-eight-year-old Trixie Perry, a reeler in the Glanzstoff plant, and Texas Bill, a female textile worker, led women who had wrapped themselves in the American flag in front of guardsmen who were forced to present arms each time they passed a flag. At trial, both women continued to use their gender against their accusers in creative ways. When asked if she had blocked a road, Perry answered: "A little thing like me block a big road?" When asked why she was out on the road so early, Texas Bill answered: "I take a walk every morning before breakfast for my health."

Using ordinary language in ways that empowered them and ensnaring the court in its own definition of ladylike behavior, these women and others found novel ways to

assert their class-based politics. Leaving family homes for a day or a week and working with other women also fostered a gender solidarity that proved instrumental in the textile strikes—if not their outcome. When the strike ended on May 26, 1929, the women returned to work with little improvement in their wages, hours, or work conditions.

Textile strikes continued, like those at Gastonia in 1929 where the National Guard violently suppressed a strike led by the UTW. Workers initially greeted the **National Recovery Administration** (NRA), established in 1933 to reduce overproduction, raise wages, control hours, and guarantee the right of workers to form unions, with optimism. But their optimism faded as the codes created to regulate industries favored owners over workers. New Deal legislation brought some improvement to the conditions in textile factories. However, employers kept the speedup in place, requiring the same amount of work to be done in forty hours as in the previous sixty, and the NRA codes did little to stop it. Frustrated at their union leadership, textile workers pushed for a strike. On Labor Day, September 3, 1934, four hundred thousand workers went on strike and the textile industry was shut down. While the strike did not result in an end to the speedup or improvement in wages, it represented growing power of the labor movement in the 1930s.

Chinese Women in San Francisco's Garment Industry

Newly arrived Chinese women found wage work in the small nonunion garment factories near Chinatowns on the East and West coasts. With the labor movement gaining ground each year of the Depression, the **International Ladies Garment Workers Union** (ILGWU) hoped to convince Chinese garment workers to join the union.

The ILGWU was one of the first unions to have a primarily female membership and one of the original unions of the CIO. Founded in 1900 and comprised mainly of Jewish women, the membership of the ILGWU had diversified by the 1930s, reflecting the changing ethnic makeup of the industry's workforce. The union had expanded its ranks 400 percent in the 1930s by opening membership to African American and Mexican American women. In addition to higher wages and shorter hours, the union pioneered benefits such as pension funds, cooperative housing, health care, education, and cultural activities.

Class and ethnic divisions complicated efforts to unionize Chinese garment workers. In San Francisco's Chinatown, the garment industry employed one thousand women in Chinese-owned factories, most with fewer than fifty workers. The majority of women were foreign born and mothers of young children. San Francisco's Chinese factories paid their workers less than half of what union workers earned and were able to underbid unionized factories. As with an earlier generation of immigrant women, many of whom worked in the textile factories at the turn of the century, newly arrived Chinese women with few marketable skills had little choice but to accept the harsh work conditions. The ILGWU hoped to either organize the Chinese workers or drive nonunion factories out of business to raise the overall condition of the industry's workers. Despite attention from the ILGWU since the early 1930s, Chinese garment workers remained leery of unionizing.

At first, Chinese women garment workers did not see the union as offering them anything they needed. Chinese neighborhoods were comprised of a web of economic and social relationships that protected their residents through a combination of paternalistic business practices and charities. Associations, churches, and other charity organizations provided help in emergencies, including the *hoi fan*—dinner for a nickel. There were no breadlines or Hoovervilles, the encampments of cardboard shacks where homeless people lived, in American Chinatowns. Yet there were also few opportunities for wage work.

View the Profile of <u>Jennie Matyas Charters</u>

Jennie Matyas Charters is a union organizer who worked on behalf of the International Ladies' Garment Workers' Union; Charters developed a career of unionizing women.

As conditions worsened under the economic crisis, union organizer Jennie Matyas gained the trust of the Chinese women garment workers. In November 1937, the Chinese Ladies' Garment Workers' Union (LGWU) was chartered and three months later endorsed the ILGWU to be their collective bargaining agent. The Chinese LGWU launched a strike against the California retailer the National Dollar Stores in 1938. Its owner, Joe Shoong, was one of the wealthiest Chinese businessmen in the country. The store said it paid its workers California's minimum wage of $13.33 for a forty-eight-hour week. Yet, according to the National Dollar Stores workers, 80 percent of whom were immigrant women and the chain never followed either of the state's labor laws. The Chinese LGWU and the retailer agreed to wage increases, to a fully unionized workforce, and that all hiring would be decided by the union. Two weeks later the National Dollar Stores sold its Chinatown factory allowing it to evade the union contract with the Chinatown workers. The Chinese LGWU called a strike.

The strike divided the Chinese in San Francisco, pitting as it did union protestors against Shoong, an active and generous member of the Chinatown community. Chinatown's powerful businesses resented being labeled "capitalists" and turned their back on the strikers. Stores that would have typically given aid to strikers denied them credit, while Chinese organizations offered strikers no support. Class divisions within Chinatown, once covered over by community aid and strong ethnic affiliation, became points of conflict as the Chinese garment workers forged conditional alliances with white female factory workers. Eventually the workers won a closed shop, a 5 percent raise, a forty-hour workweek, and an agreement to use Golden Gate Company for a portion of their work.

The 105-day strike was the longest strike in the history of San Francisco's Chinatown. It showed the power of women workers to shape the conditions in which they worked. Yet, the strike created less positive results. The Golden Gate Company, the new owner

of the factory, went out of business in 1939. The union helped place workers elsewhere, but shortly after, the Chinese LGWU disbanded. The ease with which low-cost textile factories could be shut down and reestablished left textile workers with little recourse. Despite such vulnerabilities, the ILGWU remained a powerful force. At its height in the 1930s and 1940s, the ILGWU had a membership of three hundred thousand and was one of the most important and progressive unions in the United States.

Latinas and the California Canning Industry

In the fields of California, women agricultural workers began to protest their difficult and worsening work conditions. Relief agencies in California's San Joaquin Valley did not offer aid to agricultural laborers, and farmers repeatedly reduced the wages with little consequence. The **United Cannery, Agricultural, Packing, and Allied Workers of America** (UCAPAWA), founded in 1937 and an affiliate of the CIO, was particularly strong among Mexican and Mexican American workers. As union leaders and organizers, women pushed for benefits that aimed to improve the situation of working women, such as maternity leave and equal pay for equal work.

In 1939, 430 Mexican American women staged a massive walkout at California Sanitary Canning Company, or Cal San. Earlier in the year, Dorothy Ray Healey, a national vice president of UCAPAWA, had begun to recruit Cal San workers to the union, and, within weeks, 400 workers had joined. The workers initiated their strike at the height of peach season and demanded union recognition, elimination of the piece rate system (payment based on the number of fruit picked), and wage increases. The management refused to bargain with the union local, claiming, in error, that it did not represent a majority of workers. Healey immediately organized workers into a number of committees to pressure the company and support the strike. The food committee proved to be the most innovative in its tactics by winning the support of Latino shop owners. Not only did it persuade East Los Angeles grocers to donate staples like flour, sugar, and baby food to the Cal San strikers, it also requested grocers to refuse Cal San products and to remove current stocks from their shelves. If a grocer was unsympathetic, a small band of women picketed the shop during business hours.

> ### 🔍 View the Profile of <u>Dorothy Ray Healey</u>
> Healey was a Communist born to Hungarian-Jewish immigrants who fostered a commitment to social justice and equality in their daughter. She was one of the first to support the rights of Black and Chicano field workers.

After two months with little progress, striking workers took their contract dispute to the affluent neighborhood of Cal San's owners, George and Joseph Shapiro. Reminding onlookers that they were mothers as well as workers, they began round-the-clock picket lines, often including their children who held signs with "I'm underfed because my Mama is underpaid." Such actions forged lines of sympathy across ethnicity and

class that worked in the strikers' favor. After several days, the owners met with the union's negotiating team and ended the strike. The workers won a five-cent wage increase and new supervisors who would support the union. Under their own leadership, Mexican American women made the Cal San local the UCAPAWA's second largest.

Women's labor activism reached a historic high point in the 1930s. By 1938, female membership in unions saw a fourfold increase from 1924. Despite an upsurge in labor activism by women, the downward spiral of the economy and the unevenness of the recovery throughout the 1930s meant working women's efforts to better their situations were limited. Successes in specific industries did much to help those workers in their day-to-day lives, yet for the majority of American workers, male and female, the Depression kept their wages down, their anxieties high, and their belts pulled in tightly.

WOMEN AND THE NEW DEAL

A generation of women reformers who had devoted their professional lives to helping working women, children, and the poor found new ways to implement their social and political goals in the 1930s. From the Progressive Era through the New Deal, women's political activism moved beyond the sphere of voluntary association to lobbying and working within government at all levels to create a governmental apparatus to do what women had done in their own societies in the nineteenth century. Caring for the nation's less fortunate citizens, particularly women and children, moved from being a private charity to a public obligation. Like their male counterparts, many women in the New Deal saw the economic situation as a crisis in manhood. And like commentators who blamed men's unemployment on working women, the architects of the New Deal applied a gendered logic to the host of new programs they created. In legislation like the Social Security Act of 1935, assumptions about male wage work and female dependency were written into the new welfare state.

Eleanor Roosevelt and the Women's Network

Democratic women activists found a powerful friend in First Lady Eleanor Roosevelt. Women actively involved with nongovernmental organizations such as the Women's Trade Union League, the League of Women Voters, and the National Democratic Party knew Eleanor Roosevelt professionally and personally and together forged a tight-knit network of female activists within New Deal agencies.

Born on October 11, 1884, to wealthy New York parents, Anna Hall and Elliott Roosevelt, Eleanor was orphaned by the age of ten. She lived with her grandmother Hall until she went to boarding school in London. She returned to New York City to make her debut in 1902. While traveling from New York City to Grandmother Hall's home, she became reacquainted with her fifth cousin once removed, Franklin Delano Roosevelt (FDR). FDR and Eleanor married two years later, and Eleanor's uncle, President Theodore Roosevelt, escorted his niece down the aisle. The couple moved to New York City; and within a year, Eleanor began a decade in which, she later wrote, "I was always just getting over having a baby or about to have one. . . ." In 1911, Dutchess County elected her

husband to the New York State senate. The family moved to Albany. In 1913, Eleanor followed FDR to Washington where he served as assistant secretary of the navy. In 1921, FDR was stricken with polio. With the help of Eleanor and close friend Louis Howe, FDR resumed his political career and was elected governor of New York in 1928. This private crisis marked the beginning of Eleanor's political career. In the 1920s and during her husband's years as the governor of New York, Eleanor participated in the four centers of political power open to women in New York State: the Women's Division of the New York State Democratic Committee, the League of Women Voters, the Women's Trade Union League, and the Women's City Club. At the City Club, she met and worked with politically active women such as social workers Lillian Wald and Molly Dewson and labor reformers such as Frances Perkins, all of whom were leading reformers during the Progressive Era.

As first lady, Eleanor provided a crucial bridge between female activists and the president. Eleanor assembled a list of women qualified for executive-level appointments; urged the Roosevelt administration to hire them; and, when their suggestions did not get a fair hearing, she did not hesitate to take their ideas to her husband. As Molly Dewson, director of the **Women's Division of the Democratic National Committee** and avid Roosevelt campaigner, said, "When I wanted help on some definite point, Mrs. Roosevelt gave me the opportunity to sit by the President at dinner and the matter was settled before we finished our soup." As with other Democratic women, Eleanor wanted to see the federal government adopt many of the remedies Progressive women had successfully established on the state level through protective legislation: to ban child labor, to limit the number of hours an employer could force a woman to work, and to remedy the unsafe and exploitative conditions many women faced. The network of women activists who relied on Eleanor in part included women who held top federal jobs in Washington in the 1930s as well as other well-known reformers like Grace Abbott, director of the Children's Bureau, Mary Anderson, director of the Women's Bureau, and Rose Schneiderman of the Women's Trade Union League.

Read "Letter to Walter White"[5]

Hundreds of African American men were lynched in the South in the late 1800s and early 1900s. By the 1930s, the National Association for the Advancement of Colored People (NAACP) was pushing for a federal antilynching law. It hoped to gain the support of the president and first lady. In the letter to NAACP's executive secretary Walter Francis White, Eleanor Roosevelt describes a conversation she had with the president about the law.

Review the source; write short responses to the following questions.

1. According to Eleanor Roosevelt, why did Franklin Roosevelt have concerns about taking "one step" into the lynching situation?

2. What did she say the president thinks will effect change regarding this horrific act?

The Roosevelts had an unconventional marriage. While Eleanor's relationship with Franklin was successful as a political partnership and the couple raised five children, he had a long-standing romantic relationship with Lucy Mercer, Eleanor's friend and personal secretary, and later with his private secretary, Missy LeHand. Eleanor turned to other important people in her life for emotional intimacy. Her bodyguard since 1929, Earl Miller was an athletic man who charmed Eleanor with his attention and affection. She also formed a deep and long-standing relationship with journalist Lorena Hickok, whom she met during the presidential campaign of 1932. Hickok, who was covering Eleanor for the Associated Press, became the first lady's close friend and confidante, so much so that Hickok left Associated Press because she could no longer be objective while covering the Roosevelts. Hickok provided invaluable political and personal advice to Eleanor as the first lady struggled to adjust to Washington politics and her role in the White House. The two women traveled together to vacation spots and on official trips. In 1940, Eleanor invited her to live at the White House. Eleanor's many relationships, including the committed and supportive one with her husband and those of the women's network, sustained her in a variety of ways, enabling her to be the political force in Washington that she was.

View the Profile of <u>Mary Williams (Molly) Dewson</u>

Nicknamed "the little general" by Franklin D. Roosevelt, Molly Dewson was one of the most effective female party politicians of the twentieth century. She served as secretary of the Commission on Minimum Wage Legislation for Massachusetts, was active in the Massachusetts suffrage movement, worked as Florence Kelley's principal assistant in the National Consumers' League campaign for state minimum wage laws for women and children, served as president of the New York Consumers' League, and played a central role in the passage of a 1930 New York law limiting women to forty-eight-hour workweeks. In 1928, she was appointed head of the Democratic National Committee's Women's Division.

Women in the New Deal

By the time the Roosevelts moved into the White House, the economic crisis had worsened. An estimated 140,000 women and girls were homeless, and almost four million women were unemployed. Dismayed that no specific program existed to alleviate the suffering of women, Eleanor Roosevelt sponsored a White House Conference on the Emergency Needs of Women in November 1933, which so many of the women's network attended that a reporter quipped that the White House was becoming "Hull House on Pennsylvania Avenue." Harry Hopkins, head of the **Federal Emergency Relief Administration** (FERA), the agency that gave federal money to state governments to fund work and relief programs, worked together with Ellen Sullivan Woodward, head of the Women's Division of the FERA, and Frances Perkins, FDR's secretary of labor, to design work programs for women. The FERA work programs for women used commonplace understandings of "women's work," such as sewing and canning, as well as jobs in clerical, nursing, and teaching fields. By the end of 1933, over three hundred thousand

women were employed. The **Works Progress Administration** (WPA), the agency that replaced the FERA, was the largest of the New Deal programs and provided recipients work in federally funded programs, including women. The WPA programs built many public buildings, projects, and roads and operated large arts, drama, media, and literacy projects. Over 25 percent of the women employed by the WPA were professionals: teachers, athletic directors, artists, photographers, librarians, nurses, performers, musicians, technicians, and administrators. However, the majority of the women were unskilled and reemployed in domestic services, mattress and bedding projects, surplus cotton projects, or sewing and craft projects. Federal programs paid women less than men and limited their access to better-paying federal work. For example, the administrators of the **Civilian Conservation Corps** (CCC), a relief program designed to combat poverty by giving young men work in construction and conservation projects, barred women from "outside" work and prohibited them from the numerous reforestation and environmental projects. The CCC men received a wage of one dollar a day; women who worked at the camps, feeding and doing laundry, received "an allowance" of fifty cents a week. Women's reemployment was slow. By 1938, over three million women remained unemployed; almost two million women suffered the insufficiency of part-time work.

Read about **Discriminatory Practices in Federal Relief Assistance**[6]

Pilcher's letter to President Roosevelt not only is a cry for help but also brings to light the pro-white bias in the delivery of federal relief assistance in the South.

Review the source; write short responses to the following questions.

1. Why did Pilcher write to President Roosevelt? To what was she objecting?
2. What examples did she give to support her contention that discriminatory practices were at work in federal relief assistance?

The first lady's activism and the strong network of political and personal allies made the Roosevelt administration uniquely willing to appoint women to high-level positions in the government. Two women—Frances Perkins and Mary McLeod Bethune—became among the most prominent women in the New Deal. Mary McLeod Bethune headed the Negro Division of the **National Youth Administration**, a program designed to help young people learn skills and wages. Bethune was the undisputed leader of Roosevelt's "Black Cabinet," an informal group comprised of twenty-seven high-ranking men and three women who worked in emergency agencies. The group met every Friday in Bethune's Washington home. Like Eleanor, Bethune connected generations of black women's activism to the New Deal. After years as an educator, Bethune became the leader of the National Association of Colored Women (NACW), the umbrella organization that coordinated black women's clubs. Under her leadership, Bethune tried to turn the focus of the NACW away from self-help and moral uplift and toward broader social issues. When institutional change

proved difficult, she formed the **National Council of Negro Women** (NCNW) to co-ordinate women's efforts to improve African American rights. As with other women active in the New Deal, her friendship with Eleanor granted her access to the president to whom she could advocate for establishing a Negro division of the National Youth Administration (NYA).

Frances Perkins, the first woman to serve as a cabinet member, served as secretary of labor for all twelve years of the Roosevelt administration. Her political biography demonstrates the deep roots of New Deal liberal reform in Progressive activism. Born in Boston on April 10, 1880, Perkins graduated from Mount Holyoke College in 1903. The following year, she took a teaching job at Ferry Hall, a girls' preparatory school in Lake Forest, Illinois, where she met Dr. Graham Taylor, head of Chicago Commons, one of the city's famous settlement houses. Through him, Perkins learned about trade unionism and met other reform leaders including Jane Addams and Grace Abbott. By the time she returned to the East in 1907, she was firmly committed to social work. In 1910, Perkins became secretary of the New York Consumers' League (NYCL). Florence Kelley, the NYCL's national director, helped Perkins become a recognized expert on industrial conditions by assigning her to survey unsanitary cellar bakeries, unsafe laundries, and overcrowded textile sweatshops. On March 25, 1911, Perkins witnessed the Triangle Shirtwaist Company fire, a tragedy that galvanized the city's reform agencies into action. As secretary of labor, one of the most enduring contributions Perkins made was the **Fair Labor Standards Act of 1938.** The Fair Labor Standards Act was a culmination of Perkins's long-standing advocacy for minimum wage and maximum hour legislation. The last of the New Deal's major social measures, this act covered twelve million workers, immediately raised the pay of three hundred thousand people, and shortened hours for a million more. Child labor, a major concern of Perkins since her days as a social worker, was prohibited in many industries.

Read about "Silicosis and the Plight of the Industrial Worker"[7]

Former residents of Hull House, Perkins and Hamilton took up the cause of industrial workers for whom premature aging, various ailments, and sometimes death were a reality of their occupations. Industrial standards for occupational safety, long thought to be a nonissue, were a cause supported by Hamilton in particular, who sought to make working conditions safe and to hold employers responsible for the conditions under which their workers toiled.

Review the source; write short responses to the following questions.

1. According to Perkins, what was the mandate of the Department of Labor?
2. What did Dr. Alice Hamilton find in Missouri after having been away for 25 years? Had things changed since she had last visited?

With high-level appointments of Perkins and Bethune, women reformers had at last achieved some governmental authority. Women staffed and headed New Deal agencies where their commitment to improving the lives of women and the political power of women could be translated into policies. Yet, in casting their lot with the Democratic Party, women reformers turned away from women-run institutions that had for so long supported women's political organizing. As women moved into government, they risked becoming token representatives of equality rather than true political players. For example, Perkins, perhaps the strongest woman after Eleanor Roosevelt in the government, could not parlay the fundamental feminist goal of equal pay for equal work. Integration, or the end of gender separation as a strategy to advance women's causes, had paradoxical outcomes. The appointment of reformers like Perkins and Bethune in the federal government was important. At the same time, as the idea of a powerful women's bloc of voters vanished along with many female-run voluntary organizations, women also lost the infrastructure that had supported and strengthened an organized women's movement for generations.

Gender in the Welfare State

The women's political network that helped envision and enact New Deal social programs hoped to use the federal government to help poor and struggling Americans survive the Depression. The women in the network were among a generation of reformers who hoped to create a social safety net for the poor, sick, and unemployed. Through these women's efforts, the **modern welfare state** was born. At the same time, New Deal policy makers, male and female, brought to their work a set of gendered assumptions about the distinctions between men's and women's work. The attention they paid to the issue of female poverty did not lead them toward programs that would enable working mothers, many of whom were single or supporting an unemployed husband, to earn better wages and more equitable workplaces. Rather, the relief programs offered by the government rewarded women who stayed at home with their children. By classifying women primarily as homemakers, the government directed its relief efforts to enable women to stay at home and men to earn a living wage.

The government offered two kinds of relief: work and pensions. Public work programs like the FERA, the Civil Works Administration (CWA), the Public Works Administration (PWA), and the Works Progress Administration (WPA) hired men and women for federally funded projects that ranged from building libraries and parks through writing state guide books and recording oral histories. These federally funded jobs were the best kind of aid the government offered because the jobs came with higher wages and, as work-based relief, conferred a level of dignity that public assistance could not. For example, the wages for WPA work in North Carolina were six times higher than the relief granted through a mother's aid grant for one child. However, desirable wage-based relief programs were targeted at men. Of the 1.6 million Americans employed by the federal government in 1934, women made up 11 percent. Women who did receive government jobs were directed into sex-typed jobs. In 1936, 56 percent of women on the WPA worked in sewing rooms. The assumptions

that male-headed households were the healthiest and that women did not deserve higher-paying jobs as much as men did conspired to make women's unemployment seem less important. Most Americans inside the government viewed the economic crisis as one of men's employment and crafted federal programs to rehabilitate men's jobs, wages, and savings.

The **Social Security Act of 1935**, the pillar of the new welfare program, offered relief by work-based entitlements and by aid to children, widows, the elderly, and the infirm. To address the crisis in male employment, unemployment insurance and old age pensions were based on entitlements and on white masculine employment categories and work patterns such as primarily full-time, preferably unionized, continuous, industrial breadwinning work. A payroll tax was taken from workers' salaries and matched by contributions made by their employer, an arrangement that underscored the contributory—and thus more dignified because earned—nature of the program. Retired women workers in jobs covered by the act took part in the same old age security programs as did men, as long as they met the same work requirements. But most women workers did not meet those requirements because most were in jobs that were disqualified from the bill. Workers with low and irregular contributions were seen as unable to contribute enough to provide decent benefits. The program excluded household domestic workers and agricultural laborers, who made up 16 percent of the employed workforce and in which women of color were overrepresented. The program excluded federal, state, and local government jobs (clerical workers and teachers); nonprofits; orphanages; and hospitals—all sectors in which women were heavily represented. The result was that 55 percent of African American workers and 80 percent of all women workers, including 87 percent of African American women workers, were excluded from the program. The National Association for the Advancement of Colored People characterized the bill as "a sieve with holes just big enough for the majority of Negroes to fall through."

The Social Security Act included relief for single mothers of children and for children in poverty. The new program, **Aid to Dependent Children** (ADC), absorbed the programs that were once a part of the recently expired Sheppard-Towner bill (see Chapter 16), a bill that had provided funds for child and maternal health services throughout the 1920s. While less generous than public work program jobs, ADC relief nevertheless helped keep children with their mothers and a minimum of food on the table. The aid, helpful as it was, came at a cost. ADC funds came from both state and federal funds and as such were under the control of state-instituted eligibility guidelines in addition to those required by the federal government. Local administrators could distribute funds, which varied from state to state, based on their standards of a "suitable home." Illegitimate children, male friends, alcoholic beverages, boarders, or forms of housekeeping and child rearing deemed unconventional could be enough to classify a family unfit for aid. Recipients experienced the visits of these local administrators as invasive, often humiliating encounters.

Women's efforts to expand federal programs to include work programs for unemployed women and aid to poor mothers and children created the foundations for the modern welfare state. These programs often made the difference between a family

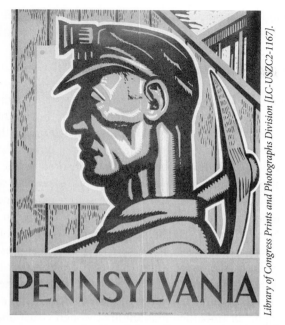

Library of Congress Prints and Photographs Division [LC-USZC2-1167].

Celebrating strong men as a source of national strength was a major visual theme of New Deal public art. This WPA poster by Isadore Posoff in 1937 highlights the representation of work as the domain of strong men. Administrators of the public art funds hoped to sponsor art that would inspire faith in national values and reassure the country that it would endure the crisis, all through a distinctively American vernacular.

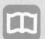 **Read about <u>Discrimination in the Works Project Administration</u>**

Racist practices were ingrained in every aspect of American life in the 1930s, including the New Deal relief and welfare programs. Administrators, investigators, and welfare workers on state and local levels were typically white and followed what they referred to as "local practice" of racial segregation. Black families found they were the last to receive relief, the first to be cut off, and the last to be hired for work. Black women wrote to the federal government in an effort to rectify the multitude of injustices they faced.

Review the source; write short responses to the following questions.

1. How did "local practice" operate against Brimson? Why did she appeal to the federal government?
2. How did Brimson use her role as mother to strengthen her case? What other examples of gender can you see in this document?

going hungry or not. New Deal programs ameliorated some of the worst effects of widespread unemployment and poverty. Yet the huge sums of money the government pumped into the sagging economy were not enough to end the Depression. It would

take the massive industrial output of arming Britain and the Soviet Union in their war against Germany in the late 1930s to bring about an end to the crisis.

CULTURES OF THE 1930S

Concern with the health and stability of families, along with a restoration of traditional gender roles, appeared not only in government activism but in the art sponsored by the government. Government funding of the fine arts fell under the Public Buildings Administration, the agency that oversaw the building of hundreds of post offices and courthouses. One percent of funds for federally sponsored public buildings were reserved for embellishments, and these murals, sculptures, and frescos became among the most visible legacies of the New Deal. Another source of government funding came through the **Farm Security Administration** (FSA) and became an unexpected source of work for a generation of photographers and writers as they went into the rural South to document the lives and needs of America's farm communities. Advocates hoped that documenting the lives of poor Americans would play a part in creating a popular consensus on Roosevelt's New Deal. Last, popular culture of the 1930s, particularly motion pictures, relied on funny women rather than sexy ones to amuse audiences. In each arena, shoring up an embattled masculinity through visual images participated in restoring men's sense of authority through containing women in domesticity.

Representing Gender in New Deal Public Art

Administrators used public art funds to create uplifting images of the American past and the American worker. The program granted commissions through competitions overseen by New Deal administrators and local officials. Between 1934 and 1943, the program sponsored more than 850 artists who produced eleven hundred murals and three hundred sculptures for public buildings. These works appeared in train and air terminals, post offices, federal courthouses, and government offices across the country.

Celebrating strong men as a source of national strength was a major visual theme of New Deal public art. Public art created images of working men in factories and in the fields that drew attention to the physicality of the male figure while also emphasizing the nobility of work itself. The masculinity of work rested on the autonomy granted by skill and the visibility of productive work as measured by tangible products like baskets of food or automobiles, planes, or machines. It also suggested that the male worker earned enough to support a family. The attention paid to the male laborer—and, implicitly, the male breadwinner—was achieved by excluding women as wage earners. Images of women wage earners, either in factories or in offices, simply did not exist. By associating wage work with manhood, such images associated a man's wage earning to his rightful authority over his wife and family at home.

This message of the natural authority bestowed on the male breadwinner also appeared in representations of the farm. Images of bountiful harvests, rolling pastures, idealized homes, and the fruits of hard work showed men and women doing sex-specific work for a common goal. Building on and revising the companionate marriage of the 1920s, the representation of farm families showed the importance of women's work while

emphasizing that women's natural place was at the home caring for the family through a round of domestic work like gardening, canning, and child care. This comradely ideal addressed the contemporary crisis in manhood by showing men as strong, capable, and autonomous and emphasizing the natural authority of the husband over his wife, children, and farm. Such iconography used the ideal of a marriage between equally valued partners, each with his or her specific task to do, as a model for an idealized national life.

Through public art, administrators hoped not only to promote the New Deal but to reassure Americans that the nation was strong enough to weather any crisis. To do so, government-sponsored public art avoided any references to the political and economic crisis of the 1930s. The manly worker of public art echoed with imagery widely used in the Communist and labor movements, yet administrators insisted that no references to labor conflicts, oppressive work conditions, or protest appear in public-funded art. To do so would go against the New Deal program of representing American democracy through nostalgic images of harmonious communities based on autonomous individuals.

Documenting the Depression

Another form of visual iconography, produced in part by New Deal funding, was documentary photography. Upholding the long-standing practice of representing the home through women and the nation through men, photographers turned to images of mothers to document the toll of economic hardship. Among the most famous of this genre was the work of Dorothea Lange. In 1935, Roy Stryker, who administered the Historical Section of the Resettlement Administration, hired Lange to be on the staff of the agency's photographers who were sent out to document the effects of the Depression on rural Americans. Lange did most of her work in California. Lange's "Migrant Mother," taken in 1936 in a pea picker's camp, became one of the most memorable images of the despair and resignation of migrant workers. While many viewed such pictures uncritically as a simple reflection of human experience, Lange constructed the image by selecting elements and excluding others. In "Migrant Mother," Lange chose to emphasize the woman and only two of her many children and to keep the husband out of the frame, implying that the mother, a hardworking citizen, could lead her family to a better future if she was given the chance.

Margaret Bourke-White, another photographer for the FSA, also captured national suffering on the small scale of a single female face. Before the Depression, Bourke-White was known for her industrial photography and was hired by Henry Luce for his new magazine *Fortune* in 1929. In 1935, her editor sent her to cover the Dust Bowl. In her autobiography, *Portrait of Myself*, she wrote, "Here were faces engraved with the very paralysis of despair. These were faces I could not pass by." She began a project to photograph tenant farmers with writer Erskine Caldwell in 1935, which would become the influential *You Have Seen Their Faces* (1937), a description of the harsh day-to-day experience of sharecropping. In 1937, she was hired as one of the first staff photographers of the newly launched *Life* magazine and shot the first cover. Bourke-White's photos vividly captured the tension between poverty and affluence, none more than the cover photo for *Life* in 1937, which featured black victims of a flood in Louisville, Kentucky, standing in a breadline under a billboard of a smiling white family in a car. The billboard read: "World's

Highest Standard of Living. There's no way like the American Way." Bourke-White was affiliated with Communist Party front organizations such as the American Youth Congress and the American League for Peace and Democracy, groups that urged the government to do more to secure economic rights for ordinary Americans.

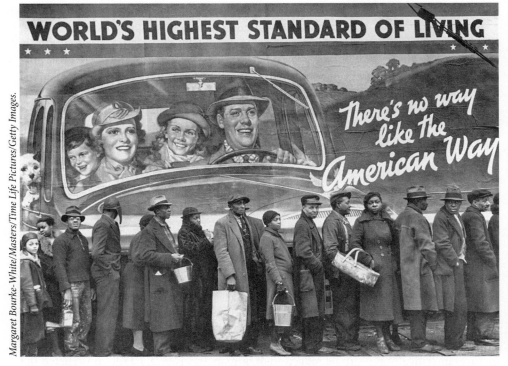

Photographer Margaret Bourke-White took this famous photo of black flood victims lining up in front of a billboard showing a prosperous white family in a car after the 1937 flood in Louisville, Kentucky. Bourke, who had photographed the human toll of the Dust Bowl, joined the staff of the newly created *Life* magazine in 1935 where she traveled the country documenting the lives of ordinary Americans.

New Deal images of mothers were useful in justifying the need to create a new governmental safety net to protect mothers and children from the worst effects of poverty. Women, cast solely as mothers in the art and imagery of the New Deal, needed the government's help to do their part in maintaining the strength of the nation. Likewise, images of men as worker-citizens provided a visual language that seemed to promise better days if only the natural gender order was restored. Such imagery worked hand in hand to justify an array of new government initiatives designed to help the male breadwinner and programs to help mothers care for their children.

Regulating Hollywood

The visual language of gender, in which masculinity represented the nation and femininity the domestic, shaped popular culture in the 1930s, most notably in motion

pictures. Despite the hard times, 60 percent of Americans went to the movies at least once a week. One of the most common female characters of 1930s films was the spunky heroine who, unlike her flapper predecessor, did not challenge women's primary place in the domestic world. The spunky sidekick took her place among other dominant images of women, including the mother, bifurcated as noble and strong or domineering and henpecking and briefly by the sexy vamp.

From the earliest years of motion pictures, many critics regarded movies as morally suspect for their display of dancing women and exotic foreigners. In the 1920s, states and cities had formed their own censorship boards that could order the deletion of shots, scenes, and title cards before a film could be shown or, in some instances, ban films outright. By 1922, spurred by several high-profile scandals involving Hollywood celebrities, calls for some type of federal action were heard. In self-defense, motion picture producers passed a succession of moral rules or "codes" intended to guide the content of motion pictures and overseen by former postmaster Will Hays. Although most producers followed these voluntary rules, after a few years the guidelines started to relax as the addition of sound to movies in the late 1920s intensified the filmic treatment of crime, violence, sexual infidelity, profanity, and even nudity. In 1930, a new code—which came to be known as the **Hollywood Production Code**—was written. The industry accepted it nominally, although many movies stretched it to its limits or simply ignored it. Movies made between 1930 and 1934 came to be known as "precode," even though the Production Code was theoretically in effect. In 1934, a mechanism was set up to enforce the code. For the next thirty years, virtually every film produced or exhibited in the United States had to receive a seal of approval from the office of Joseph Breen, the head of the Production Code Administration.

In precode films, women initiated sexual encounters and pursued men without being stigmatized as unfeminine or predatory. In the wake of more stringent regulation, twin beds for husbands and wives became mandatory. Mae West perhaps fared the worst from the enforcement of the Production Codes. Her raunchy talk, peppered with verbal double meanings, paired to great effect with her swaggering body language, all of which had made her a unique filmic presence. With sexuality rendered taboo, she was forced to clean up her image or resign herself to becoming a star of the past.

Depression-Era audiences enjoyed screwball and romantic comedies that disguised sexual passion in antagonistic and flirtatious word play. The screwball comedy involved a number of characteristics that resonated with worried audiences in the 1930s. These comedies poked fun at class snobbery, implying that common folk were superior to the wealthy. Associated with this was the belief that even the wealthy had the potential to exhibit the nobility of ordinary folk. The stories almost always revolved around the idle rich and often came into conflict with the guy who has to work for a living. The screwball comedies frequently depicted a couple who was destined to fall in love but had a difficult time getting together. The best-known screwball comedy of the era was *It Happened One Night* (1934). The mismatched couple in the movie are a snobbish runaway heiress and a gruff out-of-work reporter who is actually looking for a story, helps her, but ends up falling in love. Directed by Frank Capra and starring Claudette Colbert and Clark Gable, it was the first film in history to win all five major Oscars.

Zany screwball comedies, with their mixed messages of female autonomy and domesticity and women's power and their dependency, literalized the contradictory pulls of femininity in the 1930s. In ways not unlike the comradely ideal of Section Art, which idealized women at home, and the weary mothers of Dorothea Lange's photographs, screwball comedies worked because they relied on gender normality—in this case, temporarily suspending it—for their humor. The ideology of gender functioned in complex ways to represent security and hope during hard times through the joined images of men hard at work and women happily at home.

CONCLUSION

American women in the 1930s faced the difficult tasks of keeping home intact and family healthy as the country suffered through the long years of economic crisis. They greeted President Roosevelt's New Deal with a mix of gratitude and skepticism. Even though millions of Americans benefited from the alphabet soup of agencies and programs, the New Deal did not end the Depression. It did, however, expand the reach of the federal government and placed it squarely in the daily lives of ordinary Americans.

Women who had long been active in reform politics achieved on the national level many of the social welfare programs they had established on the state level. Their presence in the federal government proved important to the generations of political women who followed them. Similarly, working women established a place for themselves in male-dominated labor unions. As leaders, organizers, and members, women participated in the surge of labor activism that profoundly shaped the era and its legacy. As the country anxiously watched the gathering storm of war, women were posed to do what was necessary to face the next national crisis.

 Study the <u>Key Terms</u> for The Great Depression, 1930–1940

Critical Thinking Questions

1. Did women's lives change during the Great Depression?
2. Did wage-earning women respond to the economic crisis of the 1930s?
3. What kind of activism did women engage in during the 1930s?
4. Did women active in the government accomplish during the New Deal?
5. What role did American popular culture play during the Depression?
6. Did the Depression change Americans' views of gender roles?

Text Credits

1. Letters to Mrs. Roosevelt, http://newdeal.feri.org/elenor/jb1137.htm.
2. Ann Marie Low, *Dust Bowl Diary* (Lincoln: University of Nebraska Press, 1984), p. 100.

3. Ruth Shallcross, Shall Married Women Work? (1936); in Skinner, Volume 2, p. 289; source: From Ruth Shallcross, Shall Married Women Work? *National Federation of Business and Professional Women's Clubs*, Public Affairs Pamphlet No. 40, New York, 1936. Reprinted by permission of Business Professional Women/USA, Washington, DC.

4. Caroline Manning, The Immigrant Woman and Her Job (1930).

5. Eleanor Roosevelt, Letter to Walter White (March 19, 1936).

6. Pinkie Pilcher, Letter to President Roosevelt (1936); in Skinner, Volume 2, p. 291; source: From Pinkie Pilcher, Letter to President Roosevelt (December 23, 1936). From the WPA Collection of the Manuscript Division of the Moorland-Spingarn Research Center, Howard University. Reprinted by permission.

7. Tri-State Conference—Joplin, Missouri. Frances Perkins, Secretary of Labor, presiding. April 23, 1940, National Archives, Washington, DC Record Group 100 (Division of Labor Standards).

Recommended Reading

Linda Gordon. *Pitied but Not Entitled: Single Mothers and the History of Welfare*. New York: The Free Press, 1994. Gordon's important book set out the contours of what would become a crucial analysis of gender in the origins of the modern welfare state. She combines a history of the progressive women who devoted their lives to helping single mothers from the turn of the century to the New Deal with an analysis of the effects of gender in the creation and limitations of social policies.

Alice Kessler-Harris. *In Pursuit of Equity: Women, Men, and the Quest for Economic Citizenship in 20-Century America*. New York: Oxford University Press, 2001. Kessler-Harris, long-time scholar of women's wage work, examines the role of "racialized gender" in the construction of economic opportunity, in the ideas of fairness, and in social policies. Throughout she addresses the role gender played in the ideas about citizenship.

Barbara Melosh. *Engendering Culture: Manhood and Womanhood in the New Deal Public Art and Theater*. Washington, D.C.: Smithsonian Institution Press, 1991. Melosh's lively and interdisciplinary study documents the art and theater produced by New Deal art programs. She does so through source materials little used by historians, including agency correspondence with artists and writers, comments by local juries who selected specific works, and the hundreds of other governmental records. Melosh also brings to her work an engaging eye for visual details that strengthen her analysis.

Vicki Ruiz. *Cannery Women, Cannery Lives: Mexican Women, Unionization, and the California Food Processing Industry, 1930–1950*. Albuquerque, NM: University of New Mexico Press, 1987. Ruiz examines the role of Mexican American women in major strikes that led to important changes in the cannery industry. She highlights the role of communities and consumption to the success of labor strikes.

Susan Ware. *Beyond Suffrage: Women in the New Deal*. Cambridge: Harvard University Press, 1981. Ware's study of twenty-eight women examines the network of Democratic activist women who held prominent jobs in the government and who brought to their work a deep-seated commitment to women's issues. Their influence on New Deal programs, and on the Democratic Party itself, represented the institutional pinnacle of first-wave feminist political influence.

WORLD WAR II HOME FRONTS, 1940–1945

TIMELINE

1937	Japan invades China
1939	Britain and France declare war on Germany
1941	Japanese air force bombs the U.S. Naval fleet stationed in Pearl Harbor, Hawaii
	The United States declares war on Japan
	Germany declares war on America
	President Roosevelt issues Executive Order 8802, outlawing discrimination in hiring practices by defense contractors
	Women's Army Corps formed
1942	The Office of War Information created
	Sojourner Truth housing project riots take place in Detroit, Michigan
	President Roosevelt issues Executive Order 9066, ordering the forced evacuation of all Japanese Americans
1943	The All American Girls Baseball League founded
1944	Nineteen million women employed
1945	Germany surrenders
	Japan surrenders

THE UNITED STATES FORMALLY ENTERED THE WAR AGAINST THE AXIS POWERS OF GERMANY, Japan, and Italy on December 8, 1941, the day after Japanese pilots attacked the U.S. Naval Base at Pearl Harbor, Hawaii. Fearing espionage and sabotage along the Pacific, the government removed American men, women, and children of Japanese descent from their homes and placed them in internment camps in the interior of the country. Two-thirds of the internees were U.S. citizens and half were women.

While the Japanese attack on Pearl Harbor formalized the United States' entry into World War II, the country had since the late 1930s been anxiously watching the saber rattling of Japan in its war against China and of Germany with the rise of Adolf Hitler's National Socialist Party. In 1939, Germany had incorporated or conquered Austria, Czechoslovakia, and Poland, and, the following year, the army of the Third Reich smashed through Denmark, Norway, the Netherlands, Belgium, and Luxembourg. With the surrender of France in 1940, Hitler moved against Britain. Throughout the 1930s, Japan was flexing its military might in the Pacific. The Japanese ambition to dominate Asia began with its invasion of the northern Chinese province of Manchuria in 1931. In 1941, while still in Manchuria, Japan had set its sights on the Dutch East Indies and the Philippines. Adding to the mounting anxiety in the United States that war was coming, Italy, Germany, and Japan entered a defensive alliance. Americans' efforts to remain isolated from the conflict ended abruptly with the attacks on Pearl Harbor.

In the wake of the attacks, civilian and military leaders rushed to secure the nation against other possible enemy attacks, beginning a massive military mobilization that would at last pull the country out of the Great Depression. Government contracts flowed to large corporations such as General Electric, Ford, and U.S. Steel, worth one hundred billion dollars in 1942 alone. During the war, the gross national product doubled and the federal budget swelled to ten times larger than that of the New Deal. Able-bodied men became a limited resource. Sixteen million men served in the armed forces at the same time that the economy needed thousands of new workers.

As the nation mobilized for war, the United States faced a labor shortage, setting the conditions that would recast women—married, single, with or without children—as valuable workers. At home, women faced food and gasoline rationing, housing shortages, and other war-related restrictions, adding to the difficulty of maintaining their families during wartime. Women filled jobs left vacated by fighting men, jobs ranging from architecture to baseball, welding to doctoring. Upsetting as it was for families to send their fathers, husbands, and sons to war, the home front disruptions of the war enabled women to take measure of all they could do for themselves and the nation.

WOMEN AT WORK ON THE HOME FRONT

In 1940, nearly one worker in seven was still without a job and the nation's factories ran far below their productive capacity. Once the United States entered the war, a rush to produce military supplies transformed the economy, at last pulling the country out of the decade-long Depression. Manufacturers converted their factories from producing cars and trains to building tanks and airplanes. War industries reluctantly turned to women to fill the dwindling ranks of male workers. Women eagerly filled jobs vacated by men, drawn in part by the rhetoric of patriotism and duty to nation but certainly by higher wages and, for some, by the excitement of learning new skills. Yet women faced many of the same work-related obstacles they faced before the war. Employers

and union leaders persisted in discriminating against women by reclassifying the work they did as "women's work" and paying them on a different pay scale. Women workers earned no seniority or job security. The phrase "last hired, first fired" and "there for the duration" characterized the roller coaster of women's work during the war years.

Working for Victory

As the economy shifted from the Depression to mobilization, women workers were poised to take advantage of the new opportunities. As was the case during World War I, women found jobs in areas previously closed to them. Millions of American women left their homes to take a place on assembly lines in defense industries. Yet the labor reserves of single women, many of whom were already in the workforce, were quickly depleted. By mid-1942, economists calculated that only 29 percent of the United States' fifty-two million adult women had jobs. The **War Manpower Commission**, the government agency charged with balancing the labor needs of agriculture, industry, and the armed forces, started a campaign to recruit women. The popular press jumped in to do its part, stressing the glamour of war work and stories abounded about women who jumped into war work. The federal government lowered the age limit for the employment of women from eighteen to sixteen years.

By July 1944, nineteen million women were employed and 72 percent of those women were married. For the first time in American history, married women outnumbered single women in the female workforce. Yet, a full three-quarters of the women who worked for wages during the war had worked before and would have worked regardless of the national crisis. Less than five million of the nineteen million women who worked during the war had not been in the labor force before the emergency. The war gave already working women new opportunities. Postwar estimates concluded that 75 to 85 percent of women worked during the war wanted to keep their jobs after the war ended.

The greatest change in women's wartime wage work was less in the numbers of women working than in the kind of work they did. Between 1940 and 1944, the number of women working in the historically male-dominated manufacturing sector increased 141 percent. Women worked in shipyards welding hatches, riveting gun emplacements, and binding keels. They assembled tanks in Flint and Detroit and B-29 bombers in Washington. According to the Office of War Information, war production work had "disproved the old bugaboo that women have no mechanical ability." Not all women found work in manufacturing. One million women worked for the government, an increase of 260 percent from 1941 to 1943. By the end of the war, women comprised 38 percent of all federal workers. Drawn by the lure of earning a higher wage doing "man's work" and by new working conditions, waitresses, saleswomen, and maids became riveters and welders. Women greased and repaired locomotives, serviced airplanes, took the place of lumberjacks, and worked as blacksmiths and drill-press operators. They drove taxis and public buses, drafted blueprints, and oversaw government expenditures, proving that women could fill any job.

FIGURE 18-1 Women's Wartime Work

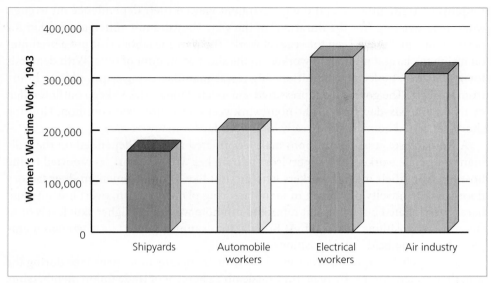

Women entered the workforce at record numbers during the war and made gains in historically male industries like electrical work, automobile assembly, and shipyards.

Wartime labor shortages led to new opportunities for Latinas who lived in the urban areas of Southern California where the aircraft and shipbuilding industries were centered. Chinese American women found new opportunities to participate outside their ethnic enclaves. Defense industries in San Francisco, for example, posted jobs in local Chinese newspapers, hired and trained Chinese women for skilled war work, and even went so far as to provide shuttle buses between Oakland's Chinatown and the shipyard.

Black women and professional women, accustomed to working, took advantage of the labor crisis to improve their job situations. Twenty percent of black women left domestic service for better-paying jobs. In the South, white women left jobs in laundries for factory work and black women readily took the jobs they vacated. Professional women found their services suddenly in demand. Large corporations like Du Pont and Standard Oil hired women chemists for the first time. Seattle's airplane producer Boeing hired women engineers, and the Puget Sound Navy Yard had women doing drafting work. In Washington, women lawyers found ample work and Wall Street brokerage houses scrambled to hire women analysts and statisticians. The number of women journalists covering Capitol Hill tripled. Groups like the American Association of University Women and the National Federation of Business and Professional Women's Clubs met with the Women's Bureau with optimism to plan for retaining women's gains after reconversion.

For the Duration

Employers, trade unions, and the government viewed their dependence on women workers as existing "for the duration" of the war. They did not anticipate or plan for permanent equality between the sexes at work. The wartime labor crisis put a premium on hiring the largest number of workers in the shortest amount of time. With demands for war planes, tanks, and munitions high, war manufacturing required long hours from workers. The government pressured war-related industries to keep outflows high by mandating six-day, forty-eight-hour workweeks. Overtime was common. Housing shortages added hours to the already long workday for many women.

A woman's successful entry into male-dominated factories depended on the willingness of male workers and supervisors to train her. Women workers reported facing hostility from their male coworkers who did not like having women on their factory floors. As the novelty of women in manufacturing plants wore off, overt hostility and harassment abated but persistent refusal to promote women to higher skill levels or to supervisory positions remained. At Boeing, for example, of the 14,435 women it employed, only 109 held skilled positions.

The struggle for equal pay continued. As women literally took men's jobs during the war, they joined unions. By 1944, they made up 22 percent of trade union membership. Yet, union leaders worried that paying women the same wages men earned would undermine men's wages once they returned from military service. Union leadership did not want management to use the presence of women workers to lower wage scales for all workers and so opted to accept women as dues-paying full members, with the wage protections that afforded, to protect the wages of their overwhelmingly male membership. Women of the International Association of Machinists (IAM) and the United Auto Workers (UAW) earned the same wages as a man earned for the same job.

While pay differentials between men and women diminished, full economic equality never materialized. One major cause for the persistence in gender-based pay differences lay in the government's willingness to go along with union contracts that insisted on maintaining job classifications such as "light" and "heavy" to keep men's wages higher. Another strategy used by trade unions to protect their male membership was to invalidate union women's claims to job seniority, a distinction based on the numbers of years of employment. For example, the Seattle Local 104 of the Boilermakers Union kept women on a separate seniority list from men by classifying them as temporary workers. Other unions supported systems in which a male employee retained his job seniority regardless of whether he did wartime work or military service. Most trade unions overlooked work-related issues of particular importance to women, such as day care and time off to care for sick children. The principle of equal pay did not protect women from an institutionalized pattern of discrimination in terms of pay or promotion. Labor unions offered benefits to women only to the extent it was necessary to ensure the pay, seniority, and labor standards their contracts guaranteed for men. As a result, as a group, women war workers earned considerably less than their male counterparts.

Women did not fare badly in every union. The competition for workers helped some unions to achieve demands they first laid out in the 1930s. Workers in the canning industry found their union's demands for better wages met with greater success during the war. The UWA integrated women into the union administrative structure as well. In the spring of 1944, the UAW set up its own Women's Bureau to serve the union's three hundred thousand members. It was charged with giving special consideration to seniority, workplace safety, maternity leave practices, and "other problems relating to the employment of women." As positive as such union support was for women, trade unions faced a tricky issue in how to involve women unions while also preparing them for the inevitable postwar layoffs.

Double V Campaign

At the outbreak of the war, President Roosevelt urged the country to move past prejudice in the name of mobilization. However, the pressure of a labor crisis only selectively broke down racial barriers in the labor market. Black Americans, hoping to take advantage of the labor crisis, found themselves barred from lucrative defense jobs. At the same time, the war against Nazi Germany and its ideology of Aryan racial supremacy confronted Americans with their own ongoing racism. Articulating the mounting frustration among black Americans, the *Pittsburg Courier*, a popular black newspaper, called for a **double V campaign**, a campaign for victory that would overcome fascism abroad and racism at home.

Black leaders mounted a political effort to open up defense industries. In 1941, A. Philip Randolph, head of the Brotherhood of Sleeping Car Porters, promised that one hundred thousand African American men and women would descend on Washington if the president did not integrate the defense industries. Faced with mounting political pressure, President Roosevelt issued **Executive Order 8802** in June 1941, outlawing discrimination in hiring practices by defense contractors and established the Committee on Fair Employment Practices.

Five and a half million black Americans moved from the South during the war to cities in the North and West looking for better wages. When black women found employment, they tended to be clustered in undesirable jobs such as janitors or matrons. In Detroit and Baltimore, cities where black women made up approximately 18 percent of the female labor force, employment agencies continued to refer them to jobs in hospitals, restaurants, and private homes. Employers justified their discriminatory practices by claiming that having African American women in their factories would provoke resistance in white women. In many instances, managers proved correct in their view of how much contact with black women white women would tolerate. In Detroit, white women participated in five separate walkouts in two weeks to protest African American workers, claiming they did not want to share bathrooms and other facilities. Some industries were more covert in their refusal to hire minority women by telling applicants there were no current openings or by hiring them for work that did not involve interacting with the public, such as jobs in wrapping and stock departments.

Women at work during the war years gained footholds in unions and industries where they might never have had the opportunity to join without the labor shortage brought on by the war. At the same time, a job market shaped by gender and race placed limits on how far women could go in high-paying industrial work. Employers reluctantly let women into their factories, suspending their belief in men's superiority in heavy industry—but only for so long. Skilled industrial work remained men's domain in terms of hiring and job classification. Despite the reality that most women at work during the war would need jobs after the war, the message that war work was temporary was hard to ignore.

GENDER AND WARTIME POPULAR CULTURE

Americans eagerly turned to movies, music, sports, and radio for a welcomed diversion from the day's worries and fatigue. A veritable campaign to encourage women to "join" the workforce for the duration redrew the boundaries of proper femininity. Popular culture helped to create a picture of the home front that stressed both women's opportunity to do new work and their willingness to sacrifice for their country. Wartime popular culture stressed the appeal of combining masculine skill with feminine charms, a strategy that perfectly fit the wartime labor crisis. Athletic women, whose participation in organized sports had been limited to local leagues, found themselves with new opportunities to play for wages and tour nationally. Likewise, female musicians took advantage of the wartime shortage of men to promote their all-girl bands.

Advertising the War

The need to mobilize women as workers to fill jobs and as consumers to make the sacrifices needed to support American troops abroad led the government to create a massive advertising campaign around patriotism and sacrifice. To do so, it launched a coordinated effort between advertising agencies, industries, and government that utilized billboards, magazine advertisements and fiction, and Hollywood's *March of Time* newsreels. In November 1941, one month before the Japanese attack on Pearl Harbor, the government created the **War Advertising Council** to enlist the power of advertising in presenting war-related issues to the public. After the United States entered the war, the **Office of War Information** (OWI) directed a major advertising project to recruit women into war production. The OWI distributed special newspaper stories targeted for rural and African American newspapers and women's pages. The agency also circulated informational films to churches, schools, war plants, and citizens' groups on topics ranging from war work to absent fathers and delinquent children. The OWI placed billboards in any community with a population of twenty-five thousand and supplied radio stations with three daily announcements on seventy-five programs.

Women's magazines became important tools in the government's mobilization efforts. The Magazine Bureau of the OWI, established in 1942, worked closely

with magazine editors to develop stories that would encourage women to take jobs where they were needed. The *Magazine War Guide* suggested that fictional characters be shown buying war bonds, conserving sparse resources, renting rooms, planting victory gardens, and maintaining positive and patriotic attitudes. It suggested that mundane government regulations like conserving rubber through gas rationing and carpooling could be the premise of a romantic or adventure plotline. Special effort was directed toward pulp publications whose audiences were primarily working-class women. Government agencies hoped that such stories would encourage readers to take war jobs, conserve rationed goods, and support the war.

The popular culture of World War II indelibly imprinted patriotic images of women's home front service in the national consciousness. No image dominated more than Rosie the Riveter, the plucky white war worker who put down her vacuum cleaner for a welding flame. Norman Rockwell drew one of the most popular images of Rosie for the May 29, 1943, cover of the middle-class family magazine, *The Saturday Evening Post*. Rockwell's Rosie was a thirtyish-year-old white woman, eating her lunch with a large riveting tool on her lap. Under her feet lay a copy of Adolf Hitler's *Mein Kampf*, which, along with the American flag behind her, established the patriotism of her war work. The image's meaning was clear: it urged women to join the workforce "for the duration" as a way to contribute to the war effort. Yet the image reassured viewers that doing "a man's job" would not fundamentally alter women's femininity. The image of Rockwell's Rosie neatly blended masculine signs of gender (overalls, industrial tool, and muscular arms) with feminine ones (rouge and lipstick on her face, necklace of merit buttons, lace hanky, and compact visible in her pocket). Rockwell's painting did not show the work Rosie did side by side with men on a factory floor. Rather, she sat, eyes closed, nose upturned, relaxing with a homemade sandwich. The image of Rockwell's Rosie reflected the complex gender accommodations required of women for the duration.

Read about **Life on the Homefront**

In this oral history, Helen Brown describes how her life changed as a result of the war. She describes herself as "Rosie the Riveter" for her work at the Goodyear Aircraft plant in Akron, Ohio. She describes the patriotic mood of the country that nudged her to take a war job as well as the ever-present sorrow of lost friends, neighbors, and coworkers. Helen gave her story to Harold Phillips for the Hanley Library Archives and the Winchester-Frederick County Historical Society on September 4, 2002.

Review the source; write short responses to the following questions.

1. What shaped Helen's decision to do war work?
2. How did the war years change the ways Helen spent her leisure time?

Hollywood's War

Urged by the OWI and the Office of War Manpower, the motion picture industry undertook a concerted effort to recruit and inspire women to work and "do their part" for the war. Wartime newsreels and short Victory Films chronicled women's work in the factory, the hospital, the shipyard, and the combat zone. Hollywood feature films also honored women's work on the home front, such as *Since You Went Away* (1944), which showed Claudette Colbert managing her rationing points cheerfully, and *So Proudly We Hail!* (1943), which featured Veronica Lake struggling against lecherous Japanese.

Hollywood's wartime films managed gender anxieties about women becoming too dominating in the absence of men by recreating traditional domestic gender roles in unconventional work settings. In *Tender Comrade* (1943), Ginger Rogers plays a recently wed factory worker who learns to be a more loving and supportive wife through her wartime work experiences. In John Ford's *They Were Expendable* (1945), Donna Reed plays a Bataan nurse whose feminine ways in the surgical operating room won praise from her male peers. "That's a nice kind of gal to have around in wartime," admitted John Wayne. After a long night of hard work, the all-male squadron invited the nurse to dinner where she again inspired devotion from the sailors for her perfect balance of competency and submission. For Hollywood, women's wartime importance as workers was cast as an addition to their prime roles as sweethearts, wives, and mothers, with films rarely straying from the message that women's role in the home was always the first line of national defense.

Not all images of women in the 1940s were focused on women as wives and mothers persevering until their men came home. Pinup art flourished during the wartime years. Pinup pictures of glamorous Hollywood starlets like Veronica Lake, Rita Hayworth, and Betty Grable appeared in calendars and posters, which are hung in auto shops, locker rooms, and barracks across the country. Air crews in World War II decorated their planes with pictures of pinups and pretty girls, typically modeled after the "cheesecake" art of Gil Elvgren, with the hope that attaching a good-luck charm to the aircraft would keep them safe.

View the Profile of <u>Rita Hayworth</u>

Rita Hayworth became the first Hispanic American sex goddess during Hollywood's Golden Age. Margarita Carmen Dolores Cansino was born in 1918 in Brooklyn, New York, the daughter of a Spanish flamenco dancer Edward Cansino and Ziegfeld girl Volga Hayworth. Her photograph in a 1941 issue of *Life* magazine portrayed her as a "love goddess," and it became one of the most requested wartime pinups, with over five million copies of it published. Rita Hayworth became one of Columbia's biggest stars of the 1940s.

Wartime Fashion

Cut off from Paris designers, from whom it took its inspirations, the American fashion industry turned its sights on New York City during the war years. The major fashion magazines *Vogue* and *Harper's Bazaar*, along with newspapers and magazines that ran fashion columns, featured American designers like Claire McCardell, Jo Copeland, and Hattie Carnegie, propelling a generation of home-grown talent into the international limelight.

Wartime designers faced a unique challenge when materials like cotton, brass, and leather were commandeered by the military. In 1943, the government issued L-85, restricting the amount of clothing that could be made out of materials needed for the war effort. Buttons, zippers, cotton, wool, silk, and rayon were severely limited. L-85 was intended to freeze the silhouette, or popular shape, of dresses to avoid costly changes in machinery, technique, and labor that came with changing styles. It banned turned-back cuffs on shirts and blouses, double yokes, sashes, scarves, and hoods and permitted only one patch pocket. In a display of patriotism, designers pledged to use less fabric than L-85 allowed and popularized the shoestring silhouette.

The wartime silhouette was tailored and narrow. The new visual imagery reaffirmed traditional gender roles even as it embraced the era's emphasis on women's abilities to do "a man's job." Hollywood designer Adrian created the most well-known wartime look when he introduced narrow dresses with broad shoulders and graceful tailored waistlines and narrow, pleatless skirts that fell just below the knees. The padded broad shoulders lent women an air of strength and authority, traits seen as crucial to surviving the war. Most outfits were topped with a hat, making milliners such as Lilly Dache and Sally Victor famous. Many women tucked a small piece of lace in the pocket or collar of these outfits as a feminine contrast to the military look that was so popular.

All-Girl Players

With fewer and fewer young men on the home front, women found unlikely opportunities to be Rosies on baseball diamonds and in jazz clubs. With few bands to entertain and sports teams to watch, enterprising men and women capitalized on the absence of men and stepped into the limelight. In each arena, female players walked the line of playing "like a man" while dressing very much like a woman.

The **All American Girls Baseball League (AAGBL)** was founded in 1943 by Chicago Cubs owner Philip Wrigley amid fears that Major League Baseball could shut down for the duration of World War II. At its peak in the late 1940s, the ten teams of the AAGBL drew approximately one million fans. In June 1943, *Time* magazine estimated there were forty thousand women's softball teams in the United States, including popular touring clubs like Barney Ross's Adorables and Slapsie Maxie's Curvaceous Cuties. The AAGBL had an unwritten policy against hiring women of color. Not until

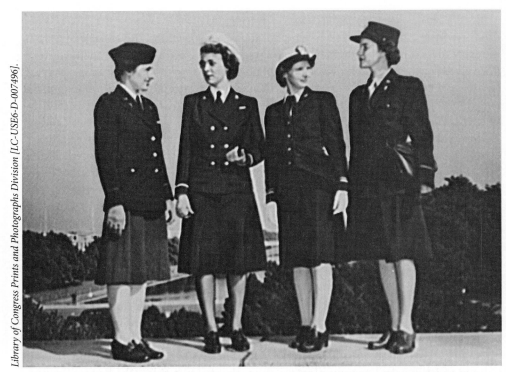

Library of Congress Prints and Photographs Division [LC-USE6-D-007496].

Wartime designers faced a unique challenge as raw materials like cotton, brass, and leather were commandeered by the military. In 1943, the government issued L-85, restricting the amount of clothing that could be made out of materials needed for the war effort and froze the silhouette for the duration. At the same time, American designers molded women's civilian clothes on the women's military uniforms, shown here.

1951, five years after the integration of men's baseball, did the league discuss hiring black women.

Wrigley wanted his players to epitomize middle-class respectability and to avoid the image of "short-haired, mannishly dressed toughies" and so required the women to attend mandatory charm lesson as part of spring training. Many of the players resented the charm and beauty requirements for playing in the league, including their knee-high skirt uniforms, which often left their legs bruised and bleeding.

Along with all-girl baseball teams, all-girl swing bands became popular during the war. For the duration, female bands found themselves enjoying new popularity and exposure. As with the fictional Rosie the Riveter, many audiences assumed that when the boys returned from the war, the girl musicians would gladly give up their instruments and return home. However, most women in all-girl bands were professional musicians and belonged to the American Federation of Musicians (AFM), which had enabled them to work in hotels, restaurants, ballrooms, and radio before the outbreak of war.

Like women war workers and baseball players, women musicians faced a sex- and race-segregated labor market. Few men's bands hired women musicians, and few white all-girl bands hired African American women. Nevertheless, black women formed some of the era's most popular swing bands and played for both black and white audiences. Black all-girl bands that traveled had the additional difficulty imposed by Jim Crow segregation. Road trips involved searching for "colored" washrooms and restaurants that would let them take their food out. Bands like the International Sweethearts of Rhythm toured in the South with white band members when it would have been safer for them to have not. For those bands with white and black members, traveling together in the South was a crime, as was walking down the street together or eating together. White Bobbie Morrison said she felt "we were more accepted in the black community playing [swing] music." Black women who played with white women saw integration as simply more democratic: "The white musicians and colored musicians, I don't care where we were, we had no prejudice in us. If they say gig . . . we would all get together like a family."

Popular culture provided much-needed relief from the painful realities of wartime. While Rosie is remembered as representing women's abilities and the opening of opportunity for women in work, in sports and music, she also functioned to mask the other message her novelty signified: women would return "home" after the war. As much as popular entertainment promoted the careers of women, the message endured that these thrilling and entertaining women would return home once the boys returned.

Read about "Joining the Band"

Clora Bryant,[1] jazz trumpeter, recalls how she found her way to jazz in the 1940s as a high school student in Denison, Texas. After graduating, she joined the Prairie View Co-Eds, a band out of Prairie View Agricultural and Mechanical University near Houston, and toured.

Review the source; write short responses to the following questions.

1. What conditions enabled Clora to become a musician? How much did the war affect those conditions?
2. Describe the racism that Clora faced. What enabled her and others in her band to carry on despite such obstacles?

WARTIME DOMESTICITY

Across the country, families altered their daily patterns to adjust to wartime issues: absences of husbands and fathers, shortages in everyday goods, and food rationing. Nylon hosiery, rubber car tires, and aluminum cans, as well as meat and gasoline, all

necessary for the military, were rationed. Wartime homemakers supplemented their families' diets by growing and canning their own fruits and vegetables and bought **war bonds**. Yet, while American women wanted to do whatever they could for the war effort, many found themselves facing a daunting number of obstacles in their efforts to sustain home and hearth. Even as many struggled through profound wartime dislocations, long work hours, and new family disruptions, domesticity and motherhood continued to define women's identity.

Feeding a Family

To feed troops abroad, the government imposed rations on meat, flour, sugar, milk, and gasoline through a system of ration cards and points. Twelve weekly ration points were granted per person. Out of those twelve points, a homemaker could buy one pound of porterhouse steak or could use only seven points for a pound of ground beef. Chicken, which was not rationed, was costly. Overall, Americans were granted an average of six ounces of meat a day during the war.

In 1941, the Agricultural Department informed the American people that if they wanted fresh fruits or vegetables in their kitchens, they should plant a "victory garden." By 1943, over twenty million victory gardens produced an estimated eight million tons of food and nearly 50 percent of all the fresh vegetables consumed in the country. Victory gardens also freed freight cars for supplying raw materials to be used in the manufacture and transportation of munitions and helped conserve coal and steam power required in shipping fruits and vegetables.

Housing Shortages

War jobs drew thousands of Americans from their homes to booming industrial centers. Newcomers strained these cities' transportation, education, and recreational facilities, causing housing shortages. Facing a labor market structured by gender and race, shortages in housing, and inadequate day care, working women struggled to create and sustain homes for themselves and their families.

Women with children who moved to new cities for war jobs had few choices. Housing shortages gave landlords power to set high rents and to discriminate against families with children and minorities. Families often doubled up to meet soaring rents. Single men could find rooms in dormitories, tents, or abandoned buildings and trailers, but it was harder for families to find decent and affordable places to live. Housing in boom cities like Detroit, the nation's largest defense producer, was segregated, often unsanitary and crowded, made worse for African Americans by de facto segregation of public housing. Many black families lived in "kitchenette" apartments or small homes without indoor plumbing, yet paid rent two to three times higher than did families in white districts. Cramped living quarters heightened the possibilities of fire, made adequate garbage disposal nearly impossible, and bred rats.

Conflicts over housing broke out in many U.S. cities. In Detroit, a riot broke out when defense housing for African Americans was built in a white neighborhood. The

Sojourner Truth housing project, named in memory of the nineteenth-century female African American activist, opened its doors in February 1942 to a cross burning on its lawn and a crowd of 150 angry whites. By dawn the following day, the crowd had grown to twelve hundred, many of whom were armed. The first black tenants, who had already paid their rent, signed leases, and given up whatever shelter they had in anticipation of their new homes, arrived at 9 A.M., but crowds barred them from claiming their apartments. Days of clashes broke out. By the end of the riot, 34 people had been killed and 675 had been injured. Detroit's middle-class clubwomen joined with the city's working-class African American women to picket the Detroit Housing Commission for access to affordable and safe housing. Activists picketed City Hall for four hours a day for nearly two months. Two hundred black families moved into the Sojourner Truth housing project in April 1942 under the protection of 1,750 police and militia.

Homemaking in the Internment Camps

"My new address is now: Blk 328-11-A," wrote teenager Louise Ogawa in a letter to her friend, librarian Grace Breed, back home in San Diego, California, in November 1942. The day after the attack on Pearl Harbor, the government froze the financial resources of the Issei, or the first generation of Japanese-born immigrants, while the FBI seized community leaders they believed to be pro-Japan. Two months later, on February 19, 1942, President Roosevelt issued Executive Order 9066, ordering the forced evacuation of all Japanese Americans living on the West Coast to internment camps in Arizona, California, Washington, and Idaho. Women had less than a week to store or sell their family possessions, help husbands close businesses, and clear out of their homes, often selling their assets far below their market value. Each person was allowed to bring only as many clothes and personal items as she could carry. Shelters for one hundred thousand evacuees were constructed in three weeks. Located in isolated areas of the United States on either deserts or swampland, the camps were surrounded by barbed wire and guarded by armed sentries. Of the 110,000 evacuated, over two-thirds were native-born American citizens and half were women.

Internment brought the second-generation Nisei women, who grew up listening to the week's most popular songs on the *Hit Parade* and Jack Benny on the radio, talking to friends in English, and celebrating Thanksgiving and Christmas, into contact with many more Japanese than ever before. Young Nisei women found unexpected opportunities as camp life suspended traditional family relationships. Issei women, most of whom had spent their adult lives in Little Tokyo or on rural western farms, found little to redeem camp life. Their roles as housewives and their identities as wives and mothers eroded under the harsh conditions of internment.

The conditions of camp life profoundly changed Japanese American family life. Many of the daily domestic tasks a homemaker was responsible for were stripped away in the camps. Washing clothes, bathing a child, preparing food, and keeping an eye on children and teenagers were no longer done in the privacy of a home but

became all-day tasks, done communally and publicly. Residents ate at large central dining halls where they waited for hours in long lines for American food. They used silverware, not chopsticks, and ate bread, not rice, with meals. Dirty dishes were washed in an assembly line and thrown on shelves to drain. The loss of control a woman once exerted over meals reverberated to a loss of control over her family life. Family members gradually started to eat separately: mothers and small children, fathers with other men, and teenagers with their friends. Table manners were forgotten. "Guzzle, guzzle; hurry, hurry, hurry. Family life was lacking," recalled the artist Miné Okubo, in her twenties when evacuated. She recorded her experience of the camps in an illustrated novel, *Citizen 13660*, published in 1946. Similarly, Jeanne Wakatsuki Houston, in *Farewell to Manzanar*, recalled that within weeks of arriving at Manzanar, "we stopped eating as a family. Mama tried to hold us together for awhile, but it was hopeless."

Camp housing was made up of long narrow barracks that were divided by partitions into four or six rooms, each furnished with steel army cots. "Apartments" held an average of eight people. Nights were noisy, filled with the crackling of straw as bodies shifted, loud snores, the crying of babies, and hushed conversations from other stalls. Collective washrooms, showers, and latrines were difficult to adjust to.

Camp jobs paid the same wage to all working women, regardless of sex or prior experience. Doctors and teachers, for example, earned nineteen dollars a month. Many female residents took jobs in camp administration offices, in the canteen, in the fields, or in the mess halls, jobs that paid eight to sixteen dollars per month for full-time work. Earning money gave some women a new sense of autonomy. On July 15, 1942, Louise Ogawa described the experience of receiving her first paycheck. "The distribution of our second checks began today. It was, of course, my first check. I felt so proud to receive it because I really earned it all by myself. It makes me feel so independent." Other women developed new skills in accounting, optometry, and clerking. Residents were also released to do voluntary seasonal farm work in neighboring areas with labor shortages.

Teenagers found unexpected bright spots living in close proximity to each other. Those from isolated regions discovered ideas, styles, and activities more typical of urban youth. Freed from the lack of transportation and strict parental supervision, teenagers created a social world of their own made through school, work, sports, shared meals, and dances. Camp life intensified the already-existing generational divide between Issei mothers and Nisei daughters. Teenagers maintained connections to the world outside the barbed wire fences through listening to the radio, watching movies brought in on the weekends, and reading magazines sent by friends. Such consumption confirmed their sense of themselves as Americans. When the evacuation was lifted, the second generation of Japanese Americans no longer felt as tied to the little Tokyos of their youth. For these women, the evacuation had opened doors and suggested new ways to live, despite the hardships of camp life.

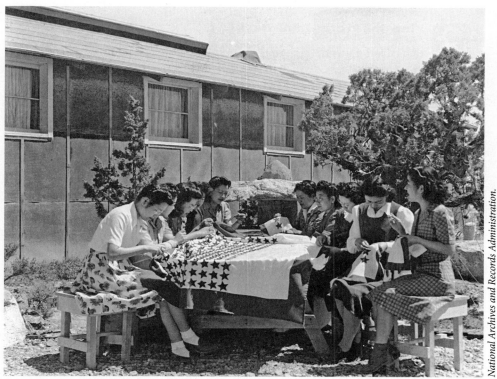

National Archives and Records Administration.

Japanese American women, like the ones shown here in the Central Utah Relocation Center, Utah, on April 23, 1943, left behind friends, jobs, and homes when President Roosevelt issued Executive Order 9066, ordering the forced evacuation of all Japanese Americans living on the West Coast.

Parenting During the Crisis

As the war went on, family life itself seemed to have become a casualty. The family, a focal point of the country's understanding of its health and well-being since the Depression, again seemed to stand in for the state of the nation. While some commentators celebrated the family as the central institution of American life, others feared for its future, worried about its delinquent youth, and wondered why the divorce rate was so high. Experts who sought to explain such changes lay the responsibility on working mothers.

During the war, Americans rushed into family making. Between 1940 and 1943, 1,118,000 more couples married than would have been expected at national prewar rates, and those that did so were younger. Quick romances and marriages, followed by a husband's lengthy absence, left many new wives dissatisfied. A Women's Bureau reported that a surprisingly high number of servicemen's wives were planning on divorcing their husbands after the war, explaining that their marriages had been rocky

View the Profile Miné Okubo

Miné Okubo was born on June 27, 1912, in Riverside, California, to Japanese immigrant parents. The Japanese attack on Pearl Harbor, Hawaii, in December 1941 profoundly and abruptly changed Okubo's life. In May 1942, she and her brother were among the 110,000 Japanese Americans evacuated from the West Coast by Executive Order 9066. They were separated from the rest of their family, who were interned in Montana and Wyoming. Okubo published *Citizen 13660* in 1946, the first book on the Japanese American internment. *Citizen 13660* won the 1984 American Book Award, and Okubo received a Lifetime Achievement Award in 1991 from the Women's Caucus for Art. Okubo died in 2001 at the age of 88 in New York City.

before their husbands were called up. Separations were no easier for those women whose husbands left to find higher-paying war work in a new city. Housing shortages made it difficult for wives and children to join men who found work in the defense industries. Once they did move, women found themselves living in crowded housing projects. Marriages also frayed and broke over women's wartime work. Working in mixed-sex settings increased the opportunity for women to socialize with other men. Sex researcher Alfred Kinsey reported that infidelity among very young married women increased during the 1940s, making them the only group to experience such a change.

Work- and war-related stresses on the family, however, did not dominate popular accounts of the growing divorce rates in the United States or explain the country's "family crisis." Rather, the working mother, who "neglected" her children to work, was identified as the culprit. Ironically, the same magazines that celebrated the patriotism of working women just as often railed against those whom they accused of letting their wage work get in the way of their parenting. Hand-wringing stories about "latchkey children" and "eight-hour orphans" overshadowed most surveys of working women that reported the vast majority made arrangements for the care of their children before they took jobs. Rather than addressing the difficulties of balancing work and family, the popular press focused on whether or not working women had healthy "maternal instincts." Magazines were not the only voices that blamed working mothers for a host of social problems including divorce and generally unhappy family life.

The reality of the home front did weaken the traditional family structure. Children spent more time with grandparents or babysitters, and parents were less able to supervise older children. Parents worked long shifts, with changing schedules, further straining parents' ability to keep track of teenagers. Few factories offered help to working mothers who, as *Fortune* reminded its readers, had "marketing, cooking, laundering and cleaning to attend to" after a twelve- or fourteen-hour day. Community officials

FIGURE 18-2 Women Serving in the American Military

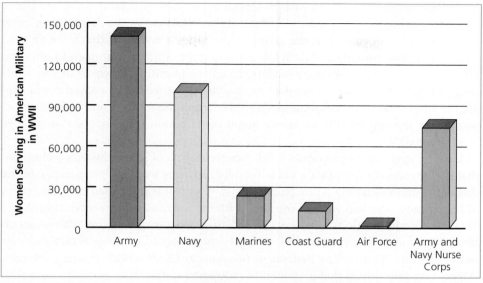

Women jumped at the opportunity to enlist; 350,000 women served in all branches of the U.S. military during World War II.

who had become well versed of the dangers of poverty during the Great Depression now worried that wartime prosperity posed its own threat to children. Teenagers spent more time away from their families participating in voluntary activities or working. One million teenagers dropped out of high school during the war. Juvenile delinquency, particularly that of teenaged girls, symbolized a frightening moral crisis for the country as well.

CREATING A WOMAN'S ARMY

As the country mobilized for the war, many women wanted the opportunity to enlist in the military. Like the skilled industrial work Rosie the Riveter did for the duration, military service was understood as men's work. While only 12 percent of male soldiers faced combat and 25 percent remained stateside doing support work, the ideological underpinnings of "the soldier" forged a strong congruence between men and soldiering that made women's entry into the armed services uniquely challenging. In the cultural imagination, the "soldier" was a man, whether or not he faced a combat situation. For the approximately 350,000 women who served in all branches of the U.S. military during World War II, wartime service offered new opportunities as well as familiar restrictions.

The Women's Army

More than 150,000 American women served in the Women's Army Auxiliary Corps (WAAC) during World War II. Members of the WAAC were the first women other than nurses to serve within the ranks of the U.S. Army. Both the army and the American public initially had difficulty accepting the concept of women in uniform. However, political and military leaders, faced with fighting a two-front war while continuing to send material support to the Allies, realized that women could supply the additional resources so desperately needed in the military and industrial sectors. Given the opportunity to make a major contribution to the national war effort, women seized it.

Early in 1941, Congresswoman Edith Nourse Rogers of Massachusetts announced that she intended to introduce a bill to establish an army women's corps, separate and distinct from the existing Army Nurse Corps. Rogers was motivated by the memory of the women who had worked overseas with the army as volunteers during World War I as communications specialists and dietitians. Serving the army without an official status meant that they received no legal protection and no medical care and were not entitled to the disability benefits or pensions available to U.S. military veterans. Rogers was determined that if women were to serve in the army again during a wartime theater they would receive the same legal protection and benefits as their male counterparts.

Although Rogers believed the women's corps should be a part of the army so that women would receive equal pay, pension, and disability benefits, the army did not want to accept women directly into its ranks. The bill proposing the WAAC intended it to work *with* the army, not be a part of the army. The army would provide up to 150,000 "auxiliaries" with food, uniforms, living quarters, pay, and medical care. Women officers would not be allowed to command men and received less pay than their male counterparts of similar rank. While WAACs could serve overseas, they would not receive overseas pay, government life insurance, veteran's medical coverage, and death benefits granted to regular army soldiers. If WAACs were captured, they had no protection under existing international agreements covering prisoners of war.

Rogers introduced her bill in Congress in May 1941, but it failed to receive serious consideration until the Japanese attack on Pearl Harbor in December. Army leadership realized it could not afford to spend the time and money necessary to train men in essential service skills such as typing and switchboard operations when highly skilled women were already available. The bill passed on May 14, 1942.

The day the bill became law, Secretary of War Henry L. Stimson appointed Oveta Culp Hobby to be director of the WAAC. Major Hobby and the WAAC captured the fancy of press and public alike. Her husband William Hobby was quoted often when he joked, "My wife has so many ideas, some of them have got to be good!" Although she was bombarded with questions as whether the WAACs would be allowed to wear makeup and date officers, Hobby handled the press with aplomb. In frequent public

speeches, she explained, "The gaps our women will fill are in those noncombatant jobs where women's hands and women's hearts fit naturally. WAACs will do the same type of work which women do in civilian life. They will bear the same relation to men of the Army that they bear to the men of the civilian organizations in which they work." Both WAAC officers and auxiliaries accepted this philosophy. A WAAC recruit at Fort Oglethorpe, Georgia, wrote her friend that "The WAAC mission is the same old women's mission, to hold the home front steadfast, and send men to battle warmed and fed and comforted; to stand by and do dull routine work while the men are gone." In 1943, the WAAC was converted to a full branch of the army and renamed the Women's Army Corps (WAC).

"Wacs" were assigned to every department of the military. They worked as draftsmen, mechanics, and electricians, and some received training in ordinance engineering. Some women were trained as glassblowers and made test tubes for the army's chemical laboratories. Other work included field-testing equipment such as walkie-talkies and surveying and meteorology instruments; managing tracking of stockpiles of supplies scattered in depots across the country; and working as laboratory, surgical, X-ray, and dental technicians as well as medical secretaries and ward clerks, freeing army nurses for other duties. WAC members also served worldwide—in North Africa, the Mediterranean, Europe, the Southwest Pacific, China, India, Burma, and the Middle East.

Gender Anxieties in the Women's Army Corps

Critics of women's armed service saw the military and women as fundamentally incompatible. The military was a masculine institution in which women could never function successfully. In such an environment, the woman soldier could succeed only if she put aside her femininity and performed "like a man," that is, became authoritative, strong, and well-disciplined. For many in the public, these traits were those of men, leading to labeling women who demonstrated such traits as mannish.

Nationally syndicated cartoons lampooned the female Wac, showcasing the ways that femininity and soldiering were fundamentally incompatible. In one series, a Wac dumped her purse all over a general's desk to find a message for him and she reported to reveille with her hair in curlers and dressed in a bathrobe. The counterpart to the featherbrain Wac was the mannish Wac. The mannish Wac expressed the belief that only mannish women would want to be soldiers. In cartoons, the mannish Wac drilled soldiers, towering over smaller servicemen of lesser rank or marching a soldier into the justice of peace. Another showed a man at home knitting a sweater for his Wac wife. All of these underscored the ways that women in the army had the potential to emasculate men and overmasculinize women.

The ambivalence over what kind of women would join the army reflected the concerns over women's sexual morality. Some worried that in establishing a women's corps the army had created a pool of prostitutes. To address such concerns, WAC

officials imposed a system of protection on female enlistees that regulated their sexuality to a greater extent than the army regulated men's. While the military encouraged men's heterosexual activity, the need for manpower meant that the male soldier was not punished for behavior resulting in pregnancy or venereal disease. Instead, the women with whom the soldiers were involved were held responsible for the consequences of heterosexual behavior. At the other end of the spectrum, others worried that military service would encourage not heterosexual promiscuity but lesbianism. Colonel Oveta Hobby dismissed such concerns by comparing the resistance to women's suffrage to that of women entering the army: "Just as a startled public was once sure that women's suffrage would make women unwomanly, so the thought of 'woman soldiers' caused some people to assume that WAC units would be hotbeds of perversion." Others assumed that the army was an ideal breeding ground for lesbianism.

Worries about lesbianism in the WAC were not only symbolic. Military service provided women with economic autonomy and a social space away from their families and communities that enabled some to experiment with and express a wider range of their sexual desires. Lesbian WACs faced a homophobic discourse that pathologized any trait deemed "masculine" that a Wac could demonstrate. At the same time, lesbians in the armed services found each other through the visibility of butch or masculine women. One Wac explained that she knew her commanding officer was a lesbian because she had a man's haircut and demeanor. Double-talk, or speaking in coded phrases that presumably only other lesbians would understand, helped women determine who was gay. Signals included whistling "the Hawaiian War Chant," talking about parties as "gay times," and referring to friends as "dykes" or "queers." On one army base, the lesbian WACs claimed the service club as their own, going so far as to dance with each other. Other clubs held "girls' nights," when the men on base were barred from attending. Going off the base to bars and clubs that made up the growing gay nightlife in larger cities enabled women to meet up and relax away from army officials who could discharge a woman for "sex perversion." Black and white lesbians at bars and service clubs enjoyed such settings as temporary refuges during the war, settings made all the more special by the strict scrutiny the army focused on any "mannish" behavior.

Women in the armed services were perceived by other soldiers, commanders, and the public as being a threat to the gender order in which women served men, not served alongside men. Combat, preserved for male soldiers alone, remained a line no woman in the armed services was permitted to cross. Maintaining lines between male and female, through ridicule, separate auxiliaries, pay and benefit scales, and combat contained the worrisome potential that women could claim too many of the rights and privileges derived from military service.

Prejudice in the Women's Army

Women who served in the military entered an institution that represented the duty and rights of male citizenship. As such, women of all races saw military service as

crucial to their claim for equality at home. Black leaders framed African American women's service in the larger struggle for racial equality or the "double V": victory abroad in the war against fascism as well as victory at home against racial injustice. Japanese Americans saw military service as compelling proof that their loyalties as a community fell squarely with the United States.

African American women who entered the military shared with their male peers a racially segregated institution characterized by hostility, racial quotas, and Jim Crow segregation. The NAACP, editorial writers for the black press, and political leaders like Mary McLeod Bethune called for inserting a nondiscrimination clause into the law creating the WAC, but the War Department refused, claiming such a clause was unnecessary. Yet the WAC imposed a 10 percent quota on the number of African American women it would accept. Of the 440 women selected for officer training in 1942, forty were African American. The WAC also rigidly enforced the military's policy of racial segregation. Like their counterparts in industry, many white women refused to live or work near African American women and demanded segregated bunks and cafeterias. Black women were segregated into all-black platoons in which they were trained, dined, socialized, and slept. Women with professional skills were too often assigned to menial work because of the stigma placed on their race.

Prejudice left black WACs vulnerable to a host of humiliating and potentially dangerous situations; black WACs became disheartened by their treatment. In 1945, four African American WACs were court-martialed and dishonorably discharged for refusing to obey a direct order. According to the *Washington Post*, "a colonel had refused to let them perform more advanced duties to which white WACs were assigned because 'I don't want black WACs as medical technicians in this hospital. I want them to scrub and do the dirty work.'" The women, and nearly fifty others, refused to carry out their menial duties, even after a general personally ordered them to do so. The court-martial was voided only after three congressmen launched an investigation into the incident claiming that such blatant discrimination undermined the morale in the WAC. In the spirit of racial equality that many women in the army found illusive, the congressmen stated, "There is no room for racial discrimination among the men and women who wear the uniform of the United States."

Japanese women who joined the WAC faced little of the personal animosity and institutional prejudice that African American WACs encountered. Some of their better treatment was because of the Japanese American WACs being assigned to units based on skill and training, not segregated on the basis of race. In January 1943, the War Department began a special effort to recruit Japanese linguists for the WAC whose primary responsibility would be in cryptography and communications. Recruiters turned to second-generation or Nisei women from internment camps. For potential Nisei WACs, their loyalty to the United States was the issue: each woman was interviewed by at least two sergeants of the loyalty investigative branch of the combined service commands and one American male soldier of Japanese ancestry to determine if she supported the United States in the war.

Military service for Japanese American women also involved laying claim to the promise of American democracy. Military service would help a Japanese American woman be considered as much of an American citizen as a person of Japanese descent. Applicants stressed that they saw themselves as "modern American women" who had outgrown "oriental ideas." One woman from Manzanar explained that she wanted to join the WAC because "I wanted to serve my country. I also thought that all Japanese Americans might find it easier to return to a normal way of life after the war if we did our share during the war." Japanese WACs were assigned to work as clerical or administrative personnel, mechanics, radio operators, intelligence analysts, photographers, carpenters, painters, parachute riggers, and postal workers. Like the few Chinese, Korean, and Filipino WACs, most Nisei WACs were encouraged to enlist in the clerical positions so that Military Intelligence could utilize their language skills. Nisei WACs were not forced to live, socialize, and eat separated from white women and tended to emphasize the equality they felt within the army.

Demobilization

By 1945, the war was fast reaching a conclusion. In April, German Chancellor Adolf Hitler committed suicide and, a week later, Germany surrendered. In August, American bombers dropped atomic bombs on the Japanese cities of Hiroshima and Nagasaki, leading to the Japanese surrender on August 14, 1945. American families eagerly awaited the return of their fighting men and women.

The WAC was demobilized along with the rest of the army. Not all the women were allowed to return home immediately, however. To accomplish its occupation mission, the army granted its commanders the authority to retain some specialists, including WACs, in place as long as they were needed. On June 12, 1948, the WAC became a permanent part of the regular army. It remained part of the U.S. Army organization until 1978, when its existence as a separate corps was abolished and women were fully assimilated into all but the combat branches of the army.

Most women felt their service had changed them for the better. Ex-WACs took advantage of the readjustment allowances of twenty dollars a week for one year after discharge; one-third began college or made plans to go to school after the war. Fifty percent of ex-WACs returned to the workforce upon discharge, many of whom opted to try their chances at new jobs for which the skills they learned in the military had prepared them. A handful took advantage of the **GI Bill or the Servicemen's Readjustment Act of 1944**, which provided college or vocational education for returning veterans or GIs as well as one year of unemployment compensation. It also provided loans for returning veterans to buy homes and start businesses. Former WACs used the low-interest business loans to open cafés, beauty shops, and bookstores. Loretta Howard summed up the war's legacy when she wrote: "I have gotten so much as a direct result of my service, my degree which gave me a better job and consequently better pay, which of course, resulted in a better standard of living. I have always been so thankful I did enter the WAC."

📖 Read about **"Life after the War"**

While many women were happy to be home, having found personal and career fulfillment during the war, other women found the home they returned to was not as happy as it had been before the war. For Doris Samford, the war's end brought an end to the sense of camaraderie and adventure that now made home life seem dull and lonely by comparison. "The war was over. I was out of the army. There were no wartime buddies, no strict regulations, no practical jokes, no uniform of the day, no long working hours. . . . I hung my uniform on a hook on the back of the bathroom door. . . . I was, and felt, stripped and exposed. I stepped into the tub. . . . I held the washcloth in trembling hands and pressed it to my face. I would have to figure out later why I was crying, when I knew that I must be so very happy." Women struggled to find their place, just as many men did, but with the added pressure of having to return to the domestic norms that no longer seemed appropriate or practical after their service. When the war ended, many women workers yearned to be part of the postwar labor force, only to have the government and the private sector pressure them to return to prewar, full-time domestic roles that they had played before they left. Considered "unpatriotic" if they remained in the workforce, they even faced opposition from Eleanor Roosevelt who articulated national sentiment in an article entitled "Women's Place After the War."

Review the sources; write short responses to the following questions.

Eleanor Roosevelt, *Women's Place After the War* [1944][2]
Postwar Plans of Women Workers [1946][3]

1. According to Eleanor Roosevelt, what was the main job of the average woman in the United States post–World War II?
2. What was the role of government and business in terms of employment, according to Roosevelt?
3. According to the research on postwar plans of women workers, what was the primary reason that women wanted to keep their jobs?

CONCLUSION

Months before peace broke out, U.S. industries that had been converted to military production began preparing for reconversion to domestic and civilian production. Labor leaders optimistically assumed women workers would voluntarily leave their jobs. Women's exit from industrial work, however, was far too important to be left to the individual worker. Federal law required employers to rehire veterans to their former or similar positions even when this meant letting go workers with more seniority. Women's low seniority combined with employers' preferences toward hiring men resulted in a nearly universal replacement of women workers with men.

"Mother blaming" proved a useful tool in the efforts to ease women out of the workforce to make room for returning veterans. In the wake of the wartime expansion of women's wage work for the duration, journalist Philip Wylie introduced the term *momism* to explain the myriad ways mothers undermined their sons' confidence and independence. Wylie's wartime definition of dangerous mothers joined gender anxieties of the 1930s to those of the postwar years. Psychological care of children, which now demanded mothers to be neither overinvolved nor rejecting of children's budding development, became a science that required full-time devotion from mothers. With its stress on maternal failure, Wylie set the stage for the high-stakes domesticity that came to characterize the United States in the 1950s.

Study the <u>Key Terms</u> for World War II Home Fronts, 1940–1945

Critical Thinking Questions

1. Why did women enter the industrial workforce in unprecedented numbers during the war?
2. How did the government mobilize the country for war? In what ways did it target women?
3. How did the representation of women change during the war years?
4. Did minority women experience greater freedom and opportunity during the war?
5. How was the home front different in World War II than in other eras?
6. Did Japanese American women gain anything from the war?

Text Credits

1. UCLA Library Center for Oral History Research. Copyright © Regents of the University of California, UCLA Library.
2. Eleanor Roosevelt, *Women's Place After the War* (1944), Originally published in Click 7 (August 1944), pp. 17, 19.
3. *Women Workers in Ten War Production Areas and Their Postwar Employment Plans* (Washington, DC: U.S. Government Printing Office, 1946) (Women's Bureau Bulletin, 209).

Recommended Reading

Karen Anderson. *Wartime Women: Sex Roles, Family Relations, and the Status of Women During World War II.* Westport, CT: Greenwood Press, 1981. Anderson compares the war's effect on women's consciousness of themselves as women and as workers in Detroit, Baltimore, and Seattle.

Susan Hartmann. *The Home Front and Beyond: American Women in the 1940s.* Boston: Twayne Publishers, 1982. Hartmann offers a general overview of American women's wartime experiences.

Maureen Honey. *Creating Rosie the Riveter: Class, Gender, and Propaganda During World War II.* Amherst, MA: University of Massachusetts Press, 1984. Honey examines the tension between traditional views of womanhood and women's entry into nontraditional occupations during the war.

Leisa Meyer. *Creating GI Jane: Sexuality and Power in the Women's Army Corps During World War II.* New York: Columbia University Press, 1996. Meyer provides a detailed and engaging study of gender anxieties in and around the Women's Army Corps.

Vicki Ruiz. *Cannery Women, Cannery Lives: Mexican Women, Unionization, and the California Food Processing Industry, 1930–1950.* Albuquerque, NM: University of New Mexico Press, 1987. Ruiz examines Mexican women's work and union activism in California's cannery industry.

Megan Taylor Shockley. *"We, Too, Are Americans": African American Women in Detroit and Richmond, 1940–1954.* Urbana, IL: University of Illinois Press, 2004. Shockley offers a detailed and engaging study of the work, activism, and race consciousness of African American women in two very different cities.

Sherrie Tucker. *Swing Shift: "All-Girl" Bands of the 1940s.* Durham. NC: Duke University Press, 2000. Tucker provides a fascinating examination of white and black female jazz musicians during the war.

THE FEMININE MYSTIQUE, 1945–1965

TIMELINE

1945	Japan and Germany surrender
	American troops start to come home
	The War Brides Act enacted
1946	Benjamin Spock publishes *Baby and Child Care*
	The baby boom begins
	Harlem psychologists Kenneth and Mamie Clark publish doll studies on the impact of racism on black children
1947	One million women laid off from war-related factory work
1953	The United Electrical, Radio and Machine Workers of America holds its first women's conference
	Hugh Hefner publishes *Playboy*
1954	*Brown v. Board of Education* overturns separate but equal doctrine
	The Immigration and Naturalization Service removes eighty thousand illegal immigrants in Operation Wetback
	The Miss America contest airs on television
1955	Daughters of Bilitis forms in San Francisco
1958	Levittown completed in Buck County, Pennsylvania
1959	Barbie, the fashion doll, debuts

THE WOMEN WHO CAME OF AGE BETWEEN 1945 AND 1965 WERE SHAPED BY A SOCIETY DRIVEN BY A DESIRE FOR SECURITY AS WELL AS BY A PERVASIVE ANXIETY. After the roller-coaster uncertainty of the Great Depression and World War II, most people in the United States were eager for stability and they sighed a breath of relief after the troops came home and factories returned to producing consumer goods. Wartime shortages disappeared. After years of putting off

buying a new dining room set, a washing machine, a car, or a home, U.S. consumers in the 1950s spent freely, spurring one of the longest periods of economic growth in U.S. history. In turn, the rapidly expanding economy drew more women into the workforce so that their families could buy yet more consumer goods and services. Two-income families, in which both women and men earned wages by working outside the home, became a linchpin in the postwar economic growth that kept at bay the prospect of another depression.

Paradoxically, at the same time that more women entered the workforce, the craving for security led U.S. citizens to create a new "traditionalism" that centered on the nuclear family with the stay-at-home mother. This idealized family, maintained by husbands who earned the bread and by mothers who cared for the home and raised the children, seemed to many to promise stability that the Great Depression and World War II had disrupted. At the same time, this ideal appeared to be the best buffer against a new threat—Communism.

As the "hot" war against Fascism in World War II ended, U.S. foreign policy shifted to one of strategic containment of the military and economic power of the Soviet Union. Adding to the sense of political insecurity, the atomic age that began in the wake of the bombing of the Japanese cities Nagasaki and Hiroshima in 1945 produced a nuclear arms race, with both the United States and the Soviet Union building arsenals that made the threat of nuclear war all the more pressing. The two superpowers avoided direct conflict by mapping the globe through their zones of influence and waging proxy wars in Korea, Cuba, and Vietnam. Not incidentally, the development of new military technologies fueled defense spending, the second linchpin in the postwar economy.

The "age of anxiety" furthered by the Cold War recast the U.S. home as the primary defense against Communism and elevated motherhood into a national symbol of U.S. freedom. Could U.S. mothers raise children who would grow into strong citizens and be able to resist the dangers of Communism, homosexuality, and, by the decade's end, racism? Not since the American Revolution had motherhood seemed so important.

BEYOND DOMESTICITY

People in the United States embraced and celebrated motherhood and homemaking in the 1950s as expressions of U.S. values of home, family, and freedom. Yet the celebration of domesticity in the 1950s covered over the ongoing reality that more and more women worked outside the home for wages. In no other era were women's roles in the wage economy so hidden by the image of a stay-at-home mom and primary consumer of the family's food, clothes, and other domestic necessities. Yet, in reality, women's economic contribution came not solely through **consumption**. Women's workforce participation increased during the 1950s. And no group increased its presence more than married mothers.

Rosie Does Not Go Home

With the end of World War II, the four-year heightened schedule of military production cooled off, resulting in widespread layoffs. By 1947, women had lost one million factory jobs. Women who wanted to work for wages soon discovered that the war

had little long-term impact on the historic division of work along gender lines. The persistence of the sex-segregated labor market meant that most women in the post-war period worked mainly in nonunionized and lower-paying "female" or pink-collar occupations. Clerical work expanded, helping to further widen the wage gap between men and women. In 1939, women earned 62 percent of what men earned, but in 1950, they earned only 53 percent. For example, a married woman who had earned $40 a week in an aircraft plant earned $29 in a hat factory; an electrical apprentice who earned $48 saw her wages cut nearly in half as a salesclerk, earning $28 a week. Two-thirds of women in retail and service reported wanting other kinds of work.

Black women workers felt the impact of demobilization before white women work-ers. A government researcher noted unemployment rates for African Americans were double those for whites in the immediate postwar years. By 1948, most of the gains that African Americans had achieved during the war had been wiped out. Without a short-age of workers, the peacetime economy shut its doors to black women and forced many to return to domestic service. The chances were greater in 1950 than in 1940 that a black female wageworker was a domestic. Leaving war jobs meant returning to working condi-tions unregulated by federal labor legislation. Forty-one percent of black, wage-earning women lacked minimum wage or maximum hour standards, unemployment compensa-tion, and Social Security. Restricted work choices, unregulated wage standards, a reliance on tips rather than wages, and a heightened expectation of personal loyalty lent service work more of the characteristics of bound labor than did the jobs held by white women. Despite such setbacks, women continued to enter the workforce. By 1950, nearly 29 per-cent of all adult women, approximately 18.5 million, worked for wages.

Read about **Women After the War**

Eleanor Roosevelt, in spite of the progressive views she espoused later on, took a more traditional view of domestic norms post–World War II. Over time, her views changed, but immediately after the war, she was more in favor of women as full-time domestic caretakers. This view was in contract to a government survey that revealed that the majority of working women wanted to continue working after the war. Still, despite this overwhelming response to the survey of working women and their desire to keep working, government and the private sector did not support them and many lost their jobs.

Review the sources; write short responses to the following questions.

Eleanor Roosevelt, *Women's Place After the War* [August 1944]
Postwar Plans of Women Workers [1946]

1. What exceptions did Mrs. Roosevelt think there were to a woman staying home full time? What would make it necessary for her to work outside the home?
2. According to the government survey, from where did the highest percentage of prospective postwar working women come?

Working Mothers

The National Manpower Council reported in 1954 that married women's work had become an integral element in the lives of many middle-class families. Married women made up half of all women workers, and by 1960 the numbers of mothers who worked had increased by 400 percent to 6.6 million. Over one-third of these married women had children between the ages of six and seventeen. Before World War II, predominantly working-class married women worked for wages. By 1960, middle- and working-class married women were equally likely to be in the labor market. Women with a college education were more likely to work than their high-school-educated peers. Seventy percent of women with more than five years of higher education worked.

The rapid growth of the consumer market as well as changing standards of economic need motivated women to work outside the home. Women worked not only to secure their survival but to have things that had been out of many Americans' reach for more than a decade: their own homes, a new car, and newly available and affordable products like washing and drying machines. One survey of nine thousand women trade unionists in 1952 found that 66 percent of working women were saving for a home and that between 14 and 26 percent worked to educate their children, pay medical bills, or buy new furniture.

While wage work increased fastest among women whose children were school aged, married women made gains mainly in the pink-collar category, that is, in sex-segregated jobs that did not place women in competition with men. At the same time, service, clerical, and sales jobs resembled the helpful role women were expected to play at home. A second paycheck helped the families of middle-class women enjoy more affluent lifestyles. In this way, the needs of businesses for relatively inexpensive secretarial and sales help and for more free-spending customers dovetailed neatly. But for working-class women, whose wages kept food on the table, the sex-segregated marketplace and lower wages associated with pink-collar work were hardly avenues to buying extras. These paychecks supplied their family's bread and butter.

Challenging Segregation at Work

The legality of job segregation by race and sex came under scrutiny in the postwar era, thanks in part to women active in the labor movement. Much like the Progressive-Era reformers Florence Kelley, Rose Schneiderman, and Jane Addams, postwar women trade unionists believed there were multiple sources of women's disadvantages in the workplace that required multiple reforms to eliminate (see Chapter 15). Their efforts to break down sex-segregated job classifications proved important to the larger goal of eliminating job segregation by race.

In the immediate postwar period, the number of women in industrial unions dropped sharply as returning veterans reclaimed blue-collar jobs. But by mid-decade, women had regained their numbers. By 1956, 3.5 million women belonged to various unions and represented 18 percent of the total membership, double the 1940 rate. The

sizable influx of women into the labor movement reflected the tremendous growth of trade unions across industries, with membership reaching fifteen million and including nearly 40 percent of all wage earners.

Two unions played important roles in challenging the race- and **sex-segregated labor market**. Both had strong alliances with the Communist Party, one of the few groups that actively fought against racism and for the rights of black workers. The first was the **United Packinghouse Workers of America** (UPWA). African Americans comprised 30 percent of the membership, one of the largest groups of organized black workers after the Brotherhood of Sleeping Car Porters. Women made up 20 percent of the UPWA, one-third of whom were black. In the flagship meatpacking plants of Armour and Swift in Chicago, for example, women were the majority in the workforce and in the union. However, black women and white women did not do the same work in the factories. White women trimmed meat or weighed, sliced, packed, and wrapped it after it had been cut into sections. Black women were restricted to the dirty task of flushing the intestines of slaughtered animals. Yet, within the union, a sense of solidarity across race existed.

The black-led Chicago UPWA Local 28 set up a separate women's committee to encourage women to talk about their work grievances more freely. In 1950, the women's committee began a campaign to document discrimination in the hiring practices of Swift and Company by sending black women to apply for jobs in the all-white pork trim unit, all of whom were denied. The newly established UPWA Anti-Discrimination Department joined in by sending white women to the same jobs and documenting their subsequent hiring. To protest, unionists organized factory slowdowns and stoppages. In 1951, a government arbitrator ruled in favor of the union and required Swift to hire thirteen black women.

The success of Local 28, publicized through the pamphlet "Action Against Jim Crow," inspired other locals to fight discriminatory practices and win new contracts prohibiting racial segregation inside plants. While many white women supported the union, not all supported desegregation in the plants. For example, at the Cudahy plant in Kansas City, black and white women worked in the same room but at different tables: the black women worked on hog casings and the white women worked on sheep casings, work that all the women preferred. When African American Marian Simmons was elected steward for the entire casing department, she argued that seniority, not race, ought to determine work. According to her, "all women were given the privilege, regardless of color, of working on sheep casing." Together, the UPWA Women's Committee and the Anti-Discrimination Department worked for the full integration of nonwhite women into the industry. Their efforts bore fruit. In many plants, white and black women worked together in the same departments, used the same restrooms and locker rooms, ate in the same cafeteria, and were entitled to the same union rights and benefits.

Other unions used fair wage standards as a way to combat race and sex discrimination. The **United Electrical, Radio and Machine Workers of America** (UE), one of the most radical postwar labor unions, had a membership that was

approximately 40 percent female. In 1946, two hundred thousand UE women strikers helped shut down seventy-eight plants nationwide in demanding equal pay at General Electric and Westinghouse. Against great odds, the UE also worked to improve the seniority system for women. A young labor journalist, Betty Goldstein, soon to be Betty Friedan, wrote articles for *UE News* on the economic origins of women's oppression, discrimination against African American women, and women's secondary status in a variety of institutions, including the family. She challenged stereotypes of women as physically weaker and temporary workers. In 1953 in New York, the UE held its first national women's conference, which became an annual event.

The racial integration of women's service and semiprofessional jobs proved harder to accomplish. Many pink- and white-collar occupations were not integrated until the 1960s. Women of color held a larger proportion of low-paying service jobs, but outside the South, few were hired into "interactive service jobs," or jobs that entailed sustained personal contact with white women. In the hotel industry, for example, white women worked the "front of the house" as desk clerks, hostesses, or waitresses, and women of color worked in "back-of-the-house" positions like housekeeping or in the kitchen. Even as waitress work doubled between 1940 and 1960, employers refused to hire nonwhite women. Some employers justified their racism by arguing that only white women could achieve the desirable femininity, beauty, and professionalism. Others believed that white patrons would reject nonwhite servers. Such prejudices extended to voice-to-voice contact and the airline industry as well. By 1960, less than 3 percent of the female telephone workforce was black and almost all were concentrated in large northern cities.

Cold War Mothering

The **Cold War** played out in multiple arenas, not all of them military. Anti-Communism in the United States targeted not only threats it posed abroad in places like China and Africa but also the infiltration of Communism beliefs at home. The postwar Red Scare from the late 1940s to the late 1950s expressed fears that Communists had taken over key U.S. institutions like the State Department and the film industry. In this context, where the enemy was battled on the terrain of ideology and influence as well as nuclear and military might, family life took on added significance. Mothers who nurtured independent judgment in their children made citizens who could resist what critics of Communism saw as the Soviet's blind obedience to centralized authority. In the symbolism of the Cold War, families headed by strong husbands and tended to by loving mothers acted as bulwarks against the threat of Communism.

Bringing Up Baby

The **baby boom**, the upsurge in babies born between 1946 and 1963, changed what people in the United States understood as family life. The baby boom was caused

by a number of factors. Americans in the 1950s married at younger ages than had their parents. In addition, young newlyweds rushed to establish their families and had children in close succession. By the end of the decade, about thirty-two million babies had been born, eight million more than those in the 1930s. In 1954, annual births first topped four million and did not drop below that figure until 1965. In the United States alone, approximately seventy-nine million babies were born during the baby boom. In this context, motherhood returned as the dominant meaning of womanhood.

Read "Young Mother"[1]

After the end of World War II, women who had entered the workforce during the war were expected to return to the home; "Rosie the Riveter" was to have been a wartime aberration. As these women married returning servicemen, the greatest increase in the native-born population in U.S. history, known as the baby boom, began.

Review the source; write short responses to the following questions.

1. What is a typical day like for the young mothers depicted in this article?
2. In your opinion, do the women seem satisfied and fulfilled in this article? Give examples to support your viewpoint.

With the rise of psychology to explain parenting and child development, mothers faced a daunting array of advice about how much they could help—or harm—their young charges. Since the days of the early republic, family making had been seen as a civic value, but, during the 1950s, concern about raising citizens ready to meet the challenges of an ever more dangerous and complex world lent a specific cast to motherhood. Experts in the 1950s warned that overly dominant or overly indulgent mothers ran the risk of emasculating their sons, creating a generation of sissy boys and homosexuals who would be vulnerable to blackmail or Communist manipulation. The best mothers were those who knew their place as helpmates to their husbands, who did not overreach their proper spheres of influence by challenging the principle of "father knows best," and who applied gentle but firm discipline to their children. Love brought security to children, but too much discipline made nervous children who became anxious and uncertain adults. Experts whose writing appeared in newspapers and magazine columns and mass-marketed paperbacks helped mothers to strike the proper balance in parenting matters.

The Black Mother and Racism

During the 1950s, the black family and, specifically, the black mother came under new scrutiny. Part of the renewed attention stemmed from the Cold War. In the scramble

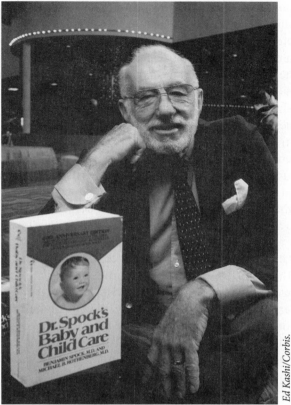

Ed Kashi/Corbis.

The baby boom created a need for parenting advice that was updated for the nuclear age. Pediatrician Benjamin Spock advocated a child-centered approach to parenting and spoke to mothers directly, encouraging them to see their children as individuals and to trust their own instincts.

for postwar international influence, Jim Crow segregation at home undermined U.S. policy initiatives in Africa where the Soviet Union supported African nations in their struggles for independence against their former colonial rulers. At the same time, black mothers were not immune from the domestic climate in the United States, which warned mothers against neurotic overinvolvement with their children. The idea of the "black matriarch," the domineering and powerful black mother who emasculated her sons, built on and amplified the anxious rhetoric of momism.

Since the 1930s, experts studying the black family had found a high degree of what they called family disorganization that they said stemmed from the high proportion of working mothers and female-headed households. According to these studies, black women's wage earning tilted the balance in power dynamics within the black family, giving women too much authority over men. Experts suggested that black families would have healthier children when fathers were restored to their rightful place at the head of the household. But the problem of strong mothers was not only economical.

Horace Cayton and St. Clair Drake, authors of *Black Metropolis*, explained that black women undermined black men by women being too critical of their husbands and too indulgent of their sons, leaving both weak and dependent. Others explained that too many black men retained an infantile dependence on their dominant mothers that left them without the necessary discipline and self-reliance to overcome racial prejudice. The discourse of the black matriarch stressed that women would have to learn to subordinate themselves to men and to allow properly gendered family roles to flourish if their communities were to overcome generations of racial prejudice.

At the same time that black mothers were criticized for the ways their parenting created weak men, other experts harnessed the language of psychology to fight against segregation. In 1946, African American psychologists Kenneth and Mamie Phipps Clark conducted experiments on racial biases in education. They designed experiments to show that racial prejudice—not family disorganization or bad mothering—damaged the psychology of black children. One famous experiment involved showing groups of black and white children two black and two white dolls purchased from Woolworth's for fifty cents and then asking the children to choose which doll was nice, pretty, or bad. The results showed that both groups of children associated the white dolls with positive characteristics. The Clarks concluded that "the Negro child, by the age of five is aware of the fact that to be colored in contemporary American society is a mark of inferior status." They presented their findings at school desegregation trials in Virginia, South Carolina, and Delaware. Their research also appeared in the 1954 *Brown v. Board of Education of Topeka*, the landmark Supreme Court decision that ruled public-school segregation unconstitutional.

View the Profile of __Mamie Phipps Clark__

Mamie Phipps Clark is best known for her work with her husband Kenneth on the effects of segregation on the self-esteem of African American children. Together they established the ground research used in the *Brown v. Board of Education* segregation case in 1954.

REMAKING THE AMERICAN HOME

After years of housing shortages, rationed foods, and few consumer goods, people in the United States entered the postwar years eager to establish a new sense of family life. At the top of the list of priorities was decent housing. Consumers bought previously hard-to-get household appliances such as vacuum cleaners, refrigerators, electric ranges, and freezers. A seemingly endless demand for housing propelled massive increases in building, resulting in some fifteen million housing units being built in the United States from 1945 to 1955. By 1960, 60 percent of U.S. families owned their own homes. The Veterans Administration enabled many returning soldiers to buy homes

with virtually no down payment as part of the GI Bill (see Chapter 18). However, U.S. family life was far from uniform. New immigrants, legal and illegal, changed rural and urban enclaves. Immigrant women and their daughters adapted traditional home-making to new circumstances and created celebrations and rituals to reflect their dual identities. Suburban living, represented by the media as new and modern, was only one way U.S. women in the 1950s remade family life.

The Suburb

The suburb captured, like few other neighborhoods, the spatial and gender separation of public and private life. Wageworkers, predominantly men, left suburban neighbor-hoods to work, while homemakers stayed put, tending to the daily round of domes-tic work and child care. The growth of suburbs went hand in hand with the growth in the automobile industry. The popularity of cars remapped the landscape, fueling construction of suburban housing developments and shopping centers and signaling the decline of downtowns with their blocks of apartments and lack of parking spaces. Cities on the West Coast, where millions of workers settled to take advantage of the aerospace and defense industries, saw the most dramatic growth. Single-family hous-ing suburbs ringed West Coast cities like Los Angeles, Sacramento, and San Francisco.

The suburbs, with their highly scripted gender roles, were a distinctive product of the postwar years. The most famous of suburbs were those built by William and Alfred Levitt who innovated both the plan and production of suburban housing by applying assembly-line techniques to track housing. At its peak, a Levitt team of builders could put up a house using preassembled materials in sixteen minutes, including plumbing. The first "Levittown" was built, in 1958, thirty miles outside of New York City near Hempstead, New York, on Long Island. It had seventeen thousand homes with eighty thousand residents and had amenities that stay-at-home mothers needed. It had seven village greens and shopping centers, fourteen playgrounds, nine swimming pools, two bowling alleys, and a town hall. The two-story Levitt house, organized to reflect the postwar nuclear family, was comprised of a kitchen, a living room, two bedrooms, a bathroom, an expandable attic, and, in later models, a carport. A house included cen-tral heating; built-in bookcases and closets; a refrigerator, stove, and washing machine; and an eight-inch Bendix television set. Houses cost $7,990, approximately two-and-a-half times the median family income and $1,500 less than other comparable houses. Average mortgages were $58 per month for twenty-five years. Eager buyers lined up the night before houses came up for sale.

Many women embraced the gender roles the suburbs embodied, while others found them confining. Sociologist Herbert Gans reported that for Levittowners, suburban life was very satisfying. "Most Levittowners grew up in the Depression and remember-ing the hard times of their childhood, they wanted to protect themselves and their chil-dren from stress." Children and husbands enjoyed the home as a stress-free haven, but for women, it was a place of labor. Homemakers threw themselves into a daily round of housekeeping, cooking, and child care. Women's role as primary consumer took more and more time. Shopping, driving, and selecting goods from the supermarket became

major tasks. All together, full-time homemakers put in fifty-five-hour workweeks. In addition to the round of housework, suburban women joined a range of community activities organized by church groups, parent-teacher associations, the YMCA, local branches of the League of Women Voters, and women's leisure and religious clubs.

Chinatown

While symbolically the suburbs represented 1950s America, not all Americans lived there. Women in urban neighborhoods, who long a stronghold for ethnic communities, continued to create homes for themselves and their families. Such was the case with Chinese American women, many of whom were newcomers, aided by changes in immigration law. In 1943, Congress had repealed all Chinese exclusion laws, a shift that granted Chinese living in the United States the right to naturalize into U.S. citizens, and established a very small immigration quota. The 1945 **War Brides Act** allowed Chinese American veterans to bring brides into the United States. The following year, Congress granted the rights of wives and children of Chinese American citizens to enter as nonquota immigrants. As the Cold War intensified with the establishment of the Communist People's Republic of China in 1949 and the Korean War (1950–1953), the United States allowed a trickle of educated Chinese to enter the country as political refugees. With many obstacles to immigration removed, Chinatowns on the East and West coasts welcomed an influx of women to their neighborhoods.

New Chinese immigrants to New York City tended to be from wealthier families and to have come from larger cities than their counterparts earlier in the century. Many had attended colleges or universities in China and had been exposed to Western culture before they arrived in the United States. Importantly, more women immigrated, bringing the sex ratio into a near balance.

With the arrival of more women, traditional Chinese family values and paternal authority were reestablished. In groceries, restaurants, and laundries, women worked alongside their husbands, sharing in the daily round of work that kept the businesses running. All family members, including older children, were expected to help. Chinese women in the United States found relief in these nuclear households from the traditional authority wielded by their mothers-in-law, yet they also complained of feeling cut off from female relatives and of shouldering the entire burden of child care and household duties. Some husbands barred their wives from moving about the city and learning about their new country. One woman told a Chinese press reporter that her life was like "being in jail." The long hours of work, coupled with the dismantling of traditional networks of female relatives, left many Chinese women isolated.

Marriage difficulties were common among new or reunited families. Most Chinese women who came to the United States in the immediate postwar period came as war brides, never having met their husbands or having been separated from them for years. In both cases, women found themselves adapting to a new country and to new marital circumstances. The reunited wives who had experienced long periods of separation from their husbands had often developed their own survival strategies. The younger war brides faced greater pressure from their more assimilated husbands to adapt to

their lives in the United States. As the press reported, women were frequently battered, abused, and even forced to divorce their husbands. High suicide rates and high divorce rates among newly united families were recognized as major problems.

Younger and more affluent Chinese women assimilated with relative ease. Many urban women with formal educations moved around the city in Western clothes, shopped, and made friends with their white neighbors. The assimilation of the U.S-born Chinese both frightened and excited the older generations. They wanted the younger generation to succeed in the United States, yet they did not want them to lose their Chinese heritage. Like most second-generation immigrants, the Chinese youths quickly adopted the dominant culture's language and customs. To help their children retain their Chinese heritage, the Chinese community established language schools and participated in ethnic events, such as the Chinese New Year celebration. Chinatowns adopted U.S. rituals and made them their own. Young women competed in the first Miss Chinatown USA beauty pageant in 1958. While the pageant required all participants to speak English, winners traveled the country acting as ambassadors of Chinese culture. Yet even assimilated Chinese women reported incidences of discrimination. Mrs. Yu, writing in the *China Daily News*, described the difficult time she and her husband had when trying to rent a home because of the racial bias of white home owners. "I knew people had different feelings, but I did not expect I would be discriminated just because of the color of my skin."

The Barrio

In the Southwest, Mexican migration increased dramatically in the postwar period. Mexican men and women were drawn to the United States during the war by labor shortages, particularly in agriculture. Long-standing Mexican enclaves grew in San Antonio, Los Angeles, El Paso, and Denver. As important as Mexican workers were to ensuring that crops were harvested during the labor shortages of the 1940s, by the 1950s, the attitude toward illegal aliens had changed. President Dwight D. Eisenhower became worried that profits from illegal labor led to corruption. An on-and-off guest worker program for Mexicans operating at the time had allowed farmers and ranchers in the Southwest to become dependent on low-cost labor of illegal aliens. As illegal immigration from Mexico continued in the 1950s, the federal government moved to close the porous border in Texas, California, and Arizona. The Immigration and Naturalization Service removed eighty thousand illegal immigrants in its 1954 **Operation Wetback**, many of whom were women and their U.S.-born children, who by law were U.S. citizens.

Throughout the 1950s, conditions in many rural barrios were difficult. One study published in 1947 described Mexican Americans as the nation's "stepchildren" for the stark poverty most faced. In San Antonio, the number of infant deaths among Mexican Americans was three times that of Anglos. Of seventy thousand migrant agricultural workers in Colorado, Montana, and Wyoming, sixty thousand had no toilets, ten thousand used ditch water for drinking, and thirty-three thousand had no bathing facilities. Yet, despite such conditions, Mexican American women found ways to raise children and keep their families intact.

Despite its lack of amenities and living conditions that rivaled those of Anglos, the barrio fostered a sense of community. Regular school and church attendance were important. Mexican American students, however, were routinely placed in less academically oriented classes. Tracking and segregation limited Mexican American teenage women to vocational classes in homemaking and sewing, skills they already had. Attending school did, however, immerse young Mexicans in U.S. culture, changing their clothing and food preferences and social behaviors.

In migrant communities, women cared for their homes and families while also looking for ways to bring much needed cash into their families. In rural areas, women raised cows or chickens and sold eggs and milk, while others took in laundry and sewing. To make ends meet, women like union activist Jessie de la Cruz worked alongside the men during weekends and holidays, picking grapes, apricots, peaches, walnuts, tomatoes, and cotton at nearby farms, often bringing along their infants and young children. Women's responsibilities for home life included spiritual as well as material help. Women nurtured their children's religious identifications to the Catholic Church, insisting on attendance, daily prayers, and proper behaviors from them. Through food and religion, Mexican American women were central in maintaining their cultural heritage.

Women at home managed their roles as primary consumer, homemaker, mother, and wife by drawing on both traditional and contemporary resources. For some, this meant drawing on communities of women who shared similar circumstances in ways that were similar to what their mothers did in ethnic enclaves. For others, it meant starting life by moving beyond traditional networks of communal ties in new housing developments or in new countries. Caring for children and home, materially and psychologically, remained the anchor of most women's daily life.

The Heterosexual Imperative

For many young women coming of age in the 1950s, the search for a boyfriend, a fiancé, and eventually a husband constituted the highest priority of life and a major social, sexual, and economic activity. Marriage was viewed as the ultimate goal for women, yet part of winning that prize involved navigating the fraught terrain of dating, a social ritual that by the 1950s had been stripped of adult supervision. With the anxiety and dislocation of the Depression and war firmly in the past, a new cohort of young women lived their teenage years in ways that would have been unthinkable to all but the most wealthy in previous generations. They stayed in school longer, and most of them completed high school and planned to attend college. As a group, they had far fewer responsibilities, held only part-time jobs, and, crucially, had far more money at their disposal than had their parents during their teenage years. Cars allowed girls and boys private time away from friends and families, radio stations offered romantic and sexual ballads designed for teenagers, and beauty products emphasized sex appeal—all of which were used by teenagers to forge their own standards of behavior and sexual subculture in the 1950s.

Beauty Icons

The message directed at young women in the 1950s obsessively focused on the pleasures and dangers of the female body. Young women actively constructed themselves with the purpose of being seen. Advertising agencies, armed with an array of new strategies, targeted the lucrative teen market. Magazines directed at young women appeared, including *Seventeen* and *Modern Teen*, and were filled with advertisements for products especially designed for teenage women. The teenage body became a location for new products. Halitosis or bad breath, sweat, menstrual odors, and pimples became social perils that required scrubbing, bathing, and a range of new products. Controlling the body was one way to contain postwar fears of changing teenage morality.

Young women sculpted their bodies through undergarments and form-fitted outfits. They wore clothes that drew inspiration from designer Dior's "New Look"—full skirts, narrow waists, form-fitting tops. Skirts came to mid calf and were held out with stiff petticoats. Breasts were formed through padding and underwiring to be large, high, and pointy. Manufacturers invented the "training bra" to introduce their products to younger and younger girls. Hollywood film star Jane Russell, a "bombshell," became famous in one of the era's most seen advertising campaigns that showed women doing ordinary activities dressed only in their Maidenform bras. Girdles, which had all but disappeared during the war, came rushing back into popularity. Tight, with slender bones and rigid elastic casing, the girdle gave women a look that was at once curvy and armored. Young white women wore larger curlers to bed and, upon waking, relied on cans of hairspray to achieve styles that were big and stiff. African American women ironed and curled their hair to achieve the smooth full look that dominated.

The most famous beauty icon was Miss America, the winner of a pageant that was broadcast on television for the first time in 1954. By the end of the 1950s, Miss America had become an international symbol of the ideal young woman. For many, their earliest memories of television were of Bert Parks surrounded by intelligent, talented, and beautiful young women vying for the crown. Miss World (1951) and Miss Universe (1952), founded by California clothing company Pacific Mills to showcase its swimwear, brought pageantry to international heights.

In another vein, magazine editor Hugh Hefner introduced a decidedly sexy icon of female beauty, the *Playboy* playmate. Hefner began publishing his monthly men's magazine, *Playboy*, in 1953 with Hollywood star Marilyn Monroe as the first playmate. Hefner's vision of women combined sex appeal with Americanism, and he sought out women for his magazine who were like the "girl next door." Hefner's playboy bunny, sexy, ubiquitous, and available, joined Barbie and Miss America to offer U.S. teenage women a confusing message about sexual allure.

Sexual Brinkmanship

Dating became a central activity for teenage girls in the 1950s. Whereas in the 1920s, flappers stood at the edge of changing sexual behaviors, in the 1950s, high-school-aged women experimented with premarital sexual behaviors. The continued growth in

high-school attendance made school the single most important institution for establishing peer-group dating standards. Once the last dance ended or the movie credits rolled, teenage women began their weekly struggle to enjoy and control their sexuality. The double standard put these women in the position of guarding their virtue by remaining chaste, despite the ardor of their boyfriends. A woman's reputation was tied to her sexual behavior and her ability to say no at the right moment. One sociologist commented on the contradictory values teenage women faced. "It seems that half the time of our adolescent girls is spent trying to meet their new responsibilities to be sexy, glamorous and attractive, while the other half is spent meeting their old responsibilities to be virtuous by holding off the advances which testify to their success." Girls were expected to be virgins until marriage. They were overwhelmed with advice about not "going all the way" without being prudish and unpopular. "Virginal" had racial meanings as well. Many men expected white girls to be virgins and viewed minority women as always available.

As a young woman decided whether to "go all the way," she was informed both by her peers and by popular culture that sexual intercourse would be the most important and the ultimate romantic experience in a girl's life. Yet, for many women, sexual intercourse with their boyfriends did not live up to their high expectations of a life-changing event. In novels and memoirs of the 1950s, women often asked, "Was this all there was? Was this IT?" Hanging over the head of young women was the ever-present threat of exposure and pregnancy. Birth control, which was not readily available to unmarried women, was very difficult for teenage women to obtain. Some women opted to marry their sexual partner as a way to protect themselves from becoming a woman with a reputation. The preoccupation with virginity and sexual intercourse created an extreme double standard in which women bore the responsibility and punishment for breaking sexual and social norms.

View the Profile of **Mary Steichen Calderone**

Mary Calderone was a physician and public health advocate, known for her work in the advancement of sexual education. She served as president and cofounder of the Sexuality Information and Education Council of the United States from 1954 to 1982. She was also the medical director for Planned Parenthood and helped overturn the American Medical Association's policy against the dissemination of birth control information to patients.

Beats and Bohemians

Not every girl could or would try so hard to adhere to the rigid strictures of the double standard. Some disaffected young women adopted a bohemian lifestyle made infamous by the **Beats**, a group of mostly male writers and poets centered in Greenwich

Village, New York, and North Beach, San Francisco. Allen Ginsberg and Jack Kerouac were the best-known Beats. As a group, the Beats exposed their sexual fantasies and prioritized authenticity over conformity and experience over materialism. Beats, bohemians, and other disaffected youths rejected the foundations of postwar domesticity: making money, maintaining a home, having children, and planning for the future. Joyce Johnson, Jan Clausen, Janis Joplin, Hettie Jones, and Diane di Prima each recalled the restrictions placed on women in the 1950s as unbearable. Johnson, who lived with Kerouac, wrote that "The 'looking for something' Jack [Kerouac] had seen in me was the psychic hunger of my generation. Thousands were waiting for a prophet to liberate them from the cautious middle-class lives they had been reared to inherit." Rebellious girls ran away from home and adopted lifestyles more akin to men than to women: they experimented with sex, drugs, and alcohol; explored their creativity; and decided to avoid domesticity at all costs. Joplin wrote of her adolescence, "I was raised in Texas, man, and I was an artist and I had all these ideas and feelings that I'd pick up in books and my father would talk to me about it, and I'd make up poems and things. And, man, I was the only one I'd ever met. There weren't any others." African American jazz and rhythm and blues artists influenced the Beats and bohemians as did an exoticized view of black culture as being outside of and oppositional to mainstream U.S. society.

Beat women's experience of bohemia was complicated by the sexism of their male companions. Johnson described a woman's place in the Beat scene: "As a female, she's not quite part of this convergence. A fact she ignores, sitting by in her excitement as the voices of the men, always the men, passionately rise and fall and their beer glasses collect and the smoke of their cigarettes rises toward the ceiling and the dead culture is surely being wakened. Merely being here, she tells herself, is enough." Female Beats also faced the vulnerability that came with sexuality in an age of restricted birth control and illegal abortions. Beat men preached a credo of no responsibilities, no commitments, and the value of male friendship or "Beat brotherhood." They defined themselves in opposition to the domesticated masculinity of mainstream white society, thereby placing their girlfriends in the position of bearing full responsibility for pregnancies with no promises of support or marriage. Beat women, like their mainstream counterparts, struggled alone to manage the contradictions of liberating sexuality without more available birth control.

Writing Womanhood

Women writers represent the paradoxes of growing up female in the 1950s, fictionalizing the sexual dramas and gender scripts they and their cohorts internalized and often rebelled against. Grace Metalious's *Peyton Place* (1954), Mary McCarthy's *The Group* (1963), and Marilyn French's *The Women's Room* (1977) were best sellers that explored the paradoxes of femininity in the postwar years. Erica Jong, looking back on her coming of age in the 1950s in *Fear of Flying* (1973), explored the ways girls learned to replace larger life goals with the empty pursuit of beauty. Jong's heroine, Isadora Wing, recalled her growing up as intimately bound up with advertisements that implored girls to "be kind to your behind!" and "That shine on your face should come from him, not from your skin."

Authors recounted the wrestling matches in the backseat of cars on Saturday nights, as their boyfriends pushed them to go farther, without understanding the terrible cost it might entail for the women. Sasha, the heroine of Alix Kates Shulman's *Memoirs of an Ex-Prom Queen* (1969), described the evolution toward "going all the way" with her boyfriend Joey: "The kissing and petting I had so enjoyed had been reduced to a five-minute warm up before the struggle, and I had been forced to trade abandon for vigilance." Under pressure from her boyfriend, Sasha reluctantly decided to give in to him. "This is it! I said to myself. This is love! Enjoy it. I tried to enjoy it, at least to attend to this celebrated moment in the most touted of acts," yet "I wondered: is this all there is to it?"

Many of the novelists explored in rich detail the problems of marriage for women. Marilyn French's *The Women's Room* described the boredom of suburban marriage, with its round of coffee klatches with women in the daytime and cocktail parties with women and their husbands flirting in the evening. In between, French's heroine struggled to find meaning in the piles of laundry, the shuttling of her two sons to baseball practice and music lessons, and the endless meals. Exploring the psychological experience of discontent, these novels narrated the deep contradictions of the 1950s' celebration of motherhood and domesticity.

SEXUAL DANGERS

Sexuality fascinated people in the United States in the 1950s. The blonde bombshells and curvaceous pinup girls vied with images of sexual danger that also abounded in the 1950s. The abortionist and the homosexual stepped into public debates as immoral, potentially left-leaning Communists who preyed on innocent victims. Abortion was seen as dangerous and shameful, and a crackdown on abortionists made getting the procedure dangerous and difficult. Gay and lesbian people in the United States faced growing persecution at the same time neighborhoods and enclaves encouraged more sociability and nurtured community. The pleasures of sexual expressiveness at the midcentury came at a cost for many women.

Back-Alley Abortion

The 1950s ushered in a new anxiety about abortion. During the crisis of the Great Depression, when U.S. families had limited their families, and World War II, when employers immediately dismissed women known to be pregnant, abortion became an open secret. It also became more visible after hospitals and clinics took up the procedure. Medical advances, such as safer blood transfusions, penicillin, and other antibiotics, improved women's chances of surviving infections and injuries from abortion. But as the country returned to peacetime and celebrated family life, critics of abortion moved to limit its availability. At the same time, critics linked their efforts to suppress abortion to the Cold War, citing the legal abortion Soviet women enjoyed as a sign of the country's "godlessness." The renewed suppression of abortion became another front in the Cold War battle for strong U.S. families and against the immorality of Soviet Communism.

Raids of abortionist offices rose in the postwar period, in an adaptation of a technique used by police to crack down on gambling, prostitution, and other illegal

activities to medical clinics and practitioners. In 1945, police arrested a San Francisco abortionist who was known as "a careful and clean operator" and who functioned so openly that a city official described her business as a public utility. The number of raids rose in the postwar period and included the offices of longtime abortionists in Akron, Ohio; Detroit, Michigan; Baltimore, Maryland; and Portland, Oregon. The Los Angeles police department devoted a six-member team solely to pursuing abortion cases. Corrupt officers often cashed in by conducting fake raids and extorting abortionists. The crackdowns resulted in the arrest of the abortionists as well as the women who had had abortions. Newspaper accounts of police kicking down doors and arresting dangerous abortionists spread the message that seeking out an illegal abortion was very risky. The *Chicago Daily Tribune* reported that during one raid the police had gathered thousands of patient records with the names of doctors, nurses, and druggists who were involved. Some papers printed photos of the women caught in the raids. Such tactics relied on fear, shame, and exposure to discourage women from seeking an abortion.

Abortions became harder to obtain, more expensive, and more dangerous in the 1950s and 1960s. Women with access to medical doctors and psychiatrists could be approved for "therapeutic" abortions, granted to save the life of the woman. Hospitals voluntarily took on a new role in enforcing abortion laws and acting as an arm of the state. Hospital abortion committees defined when an abortion was therapeutic and legal and regulated which doctors could perform the procedure. The majority of therapeutic abortions were performed on white women. One study showed that white women received over 90 percent of all therapeutic abortions in New York City between 1943 and 1962. When poor women won board approval for abortion from their municipal hospital boards, they ran the risk of being sterilized. Some physicians routinely sterilized black women without their consent. One doctor critical of forced sterilization explained that a staff member at his hospital in the Southwest "would lie to the patient if he felt she had too many kids and tell her uterus needed to come out when it didn't." In New York City, Puerto Rican women were sterilized six times more often than white women. Black, Hispanic, Native American, and poor white women were targeted by covert and overt eugenic efforts.

Read about **Postwar and the Celebration of Motherhood**

Faced with the prospect of an unplanned pregnancy, Joyce Johnson[2] had few options in postwar America. Her story highlights the challenges with which women were confronted, trying to support themselves with meager salaries while also trying to take control of their social and sexual lives.

Review the source; write a short response to the following question.

1. What options were available to Johnson for dealing with her unplanned pregnancy?

Women looking for abortions without the bureaucratic obstacles or who wanted their pregnancies to be kept secret relied on an underground network of abortionists for their **illegal abortions**. The service was expensive, dangerous, and secretive. In Chicago, the average fee for abortion had more than quadrupled, from $68 in the early 1940s to $325 in the 1950s. Finding the money needed to pay for an abortion was often difficult. One woman reported that she had dropped out of school to earn the $500 needed for an illegal abortion. When she was six months pregnant, she had an abortion in "an apartment with no medical backup services." Locating an abortionist had to be done secretively. One woman explained that "you had to ask around. You asked friends and they asked friends, and the ripples of asking people widened until some person whose face you might never see gave over the secret information that could save you." Once an appointment was made, women were continually made aware of the clandestine nature of illegal abortions. When one woman met her contact man in Baltimore, he blindfolded her and walked her through hallways in an effort to confuse her before taking her to the designated apartment.

Some women turned to self-induced abortions, douching with soap or bleach. Desperate and low-income women used many of the same methods used by previous generations. Some aborted themselves with instruments found at home; others ingested alcohol or castor oil. Thousands of women poured into emergency rooms needing urgent care for botched abortions. The number of women who died because of abortion increased. Between 1951 and 1962, the number of abortion-related deaths nearly doubled, from twenty-seven deaths per year to fifty-one. The risk of dying from an abortion was closely linked to race and class. Nearly four times as many women of color as white women died as a result of back-alley abortions.

The Homosexual Menace

Cold War anti-Communism, with its attention to creating citizens who were able to resist Communist influence, set the stage for a new wave of hostility against homosexuals. Senator Joseph McCarthy, a Republican from Wisconsin who became prominent nationally in 1950 when he asserted that he had a list of State Department employees who were spies and members of the Communist Party, joined the sexual threat of homosexuality to the threat of Soviet Communism. He accused the State Department with knowingly harboring homosexuals and thus placing the nation's security at risk. Homosexuals, he asserted, were vulnerable to blackmail as they furtively struggled to keep their desires hidden. McCarthy's voice was not the only one raised against homosexuals. Republican National Committee Chairman Guy George Gabrielson wrote in the official party newsletter in 1950 that "perhaps as dangerous as the actual Communists are the sexual perverts who have infiltrated our government in recent years."

Despite figures that Alfred Kinsey gathered in the postwar period, which showed that 50 percent of U.S. men and 28 percent of U.S. women had what could be considered "homosexual tendencies," homosexuals became targets of persecution. According to a leading expert, Doctor Frank Caprio, lesbians were unable to experience personal happiness, and if they said they did they were lying to themselves. "Theirs is

only a surface or pseudo happiness. Basically, they are lonely and unhappy and afraid to admit it." Unlike earlier conceptions of middle-class Boston marriages between two women, experts crafted a new version of same-sex relationships, one that cast off middle-class refinement and emphasized a more assertive and working-class woman. The "dyke," the lesbian whose dress and demeanor set her apart from "normal" hetero-sexual and feminine women, received most expert attention. She claimed masculine prerogatives in the sexual arena, was pathologically jealous, and was so dominant as to pull unsuspecting women into her clutches.

The medical establishment and the government fell into lockstep around their ac-counts of the nature of sexual deviance. Between 1947 and 1950, the military and civil-ian agencies dismissed 4,954 men and women for being homosexual. By April 1950, ninety-one homosexuals were fired from the State Department alone. It became na-tional policy to persecute outcasts by dismissing them not only from the State Depart-ment, the military, and Congress but from any government job. While gay men bore the brunt of government dismissals, lesbians too faced discrimination for their life-styles. Fewer women held government positions than did men, but they understood that they were as vulnerable to persecution as their male counterparts. By 1951, federal agencies routinely used lie detectors in loyalty investigations of men and women in "sensitive" government jobs to determine if they were either Communist or homo-sexual. The head of the Washington, D.C., Vice Squad requested new funding to es-tablish a "lesbian squad" to "rout out the females." One female civil service employee in Albany, New York, was summoned to New York City in 1954 and put through four days of interrogation for her homosexual and Communist leanings. Evidence of her Communism included dancing with a Soviet male officer in Seoul, Korea, after the war and of her homosexuality was having traveled overseas with a woman. She was barred from the federal government for "security reasons, on the grounds of moral turpitude."

Lesbian Subcultures

At the same time that the State Department dismissed homosexuals, gay and lesbian people in the United States continued to build visible subcultures. According to one historian, the war had been one big "coming out party." Homefront dislocations such as moving to a new city for war work or joining the military enabled many gay and lesbian people to forge new, if temporary, communities. Demobilization did not signal the return to their hometowns where many had felt isolated. In cities like New York and San Francisco, neighborhoods, cafés, drive-in theaters, and bars where gay men and lesbian women could mingle became important. Thanks to the affluence of the 1950s, for the first time a number of bars could survive catering exclusively to lesbians.

Facing intense social disapproval, lesbian women had to seek out safe spaces for themselves where they could socialize. For working-class urban women, the bar be-came an important community hub, working as an entry point for newcomers and as a welcoming harbor to old-timers. Writers like Ann Bannon fictionalized lesbian bars as meeting places, and memoirists like Joan Nestle and Leslie Feinberg testified to the lesbian bar's importance to their survival. In the bar, "butch" women in particular

felt comfortable and temporarily safe. Butch women rejected the mandatory workday skirts and dresses for slacks or blue jeans, collared shirts or jackets, and haircut short over their ears. More femininely attired lesbians, "femmes," and butches danced openly in the bars. Butch women made lesbianism visible and as such were the target of hostility. It was illegal to "impersonate" the other sex, so even masculine women had to be sure to have three pieces of women's clothing on them.

Police regularly raided lesbian bars, making them treacherous places for women who did not want their names published in the arrest lists. Class and race divided lesbians, despite the force of a mainstream society that deemed all lesbians deviant. Middle-class lesbians did not want their sexual orientation to be known. Fearing they would lose their jobs, middle-class women socialized privately in their own homes or apartments. Many were critical of butch-femme couples and avoided the bars. Playwright Lorraine Hansberry felt strongly that social acceptance for lesbians required conformity to middle-class decorum, including proper feminine dress and proper public behavior. Hansberry criticized masculine women who announced their sexual preference by wearing slacks and cutting their hair short. "Someday I expect the 'discrete' lesbian will not turn her head on the streets at the sight of the 'butch' strolling hand in hand with her friend in trousers and definitive haircuts. But for the moment it still disturbs. It creates an impossible area for discussion with one's most enlightened (to use a hopeful term) heterosexual friends." Because of the consequences, lesbians often felt reluctance to trust even close acquaintances with knowledge of their personal life.

Forming institutions in such a climate was difficult and dangerous. The first such effort was the **Daughters of Bilitis** (DOB), which was originally founded in 1955 as a private social group for middle-class lesbians looking for an alternative to the gay bar. It soon became active in "improving" the image of lesbians and lesbianism and demanding rights (see Chapter 21). The DOB ensured privacy for its members by having a greeter at meetings who would allow only members to pass through. Its official magazine, *The Ladder*, arrived covered in brown paper with no return address. Despite promises to keep members safe, police informants infiltrated several DOB chapters.

Conclusion

In the summer of 1947, *Life* magazine ran a thirteen-page essay, "The American Woman's Dilemma," that introduced readers to what would become a dominant motif of the post–World War II years—the centrality of motherhood to the health of the family and the nation. Eleven years later, *Look* magazine articulated a new problem of adjustment when it asked "The American Male: Why Is He Afraid to Be Different?" The writer described the problem starkly: "One dark morning this winter, Gary Gray awakened and realized he had forgotten how to say the word 'I'. . . . He had lost his individuality." As the decade came to a close, the gendered pillars of the Cold War came under question—foremost, the construction of femininity through motherhood and homemaking and masculinity through conformity and work. It led many to wonder if a

generation of men had lost its ability to be bold, to act independently, and to break away from the "gray flannel" pack mentality and if a generation of women suffered from "the feminine mystique."

The consensus about gender roles that had created a baby boom, a new national family life, and protection from Communism frayed and collapsed by the mid-1960s. No longer able to contain the fears of a rapidly changing world, traditional definitions of men, women, and family would become the focal point for liberal reform and radical social protest movements. Women's roles both in social change and as bearers of tradition and continuity became the grounds on which a new style of politics emerged.

 Study the <u>Key Terms</u> for The Feminine Mystique, 1945–1965

Critical Thinking Questions

1. In what ways were motherhood and domesticity different in the 1950s from other periods of U.S. history?
2. What role did psychology play in U.S. Cold War family life?
3. How did the era's emphasis on teenagers affect women? Was it a hard time to be a teenager?
4. How did people in the United States discuss sexuality in the 1950s?

Text Credits

1. Young Mother, *Ladies' Home Journal* (1956).
2. From Minor Characters by Joyce Johnson. Copyright © 1983, 1994 by Joyce Johnson. Reprinted by permission of Houghton Mifflin Harcourt Publishing Company. All rights reserved.

Recommended Readings

Dorothy Sue Cobble. *The Other Women's Movement: Workplace Justice and Social Rights in Modern America.* Princeton, NJ: Princeton University Press, 2004. Cobble reframes the history of modern feminism by placing it squarely in the history of women's labor activism from the 1930s to the 1980s.

Lizabeth Cohen. *A Consumers' Republic: The Politics of Mass Consumption in Postwar America.* New York: Vintage, 2003. Cohen argues that between the 1930s and the 1960s, good citizenship and good consumption became joined in the post–World War II era, with mixed results, particularly for women and minorities.

Daniel Horowitz. *Betty Friedan and the Making of the Feminine Mystique: The American Left, the Cold War, and Modern Feminism.* Amherst, MA: University of Massachusetts Press, 1998. Horowitz connects the Left of the 1940s to the feminist movement of the 1960s through his biography of Betty Friedan. Her years as a labor journalist during the Cold War force a new interpretation of the origins of modern feminism.

Elaine Tyler May. *Homeward Bound: American Families in the Cold War Era.* New York: Basic Books, 1988. May's classic study of post–World War II American family life links atomic anxieties to gender and sexuality through the trope of domestic containment.

Elizabeth L. Kennedy and Madeline Davis. *Boots of Leather, Slippers of Gold: The History of a Lesbian Community.* New York: Penguin Books, 1993. This groundbreaking book traces the emergence and growth of a lesbian community in Buffalo, New York, from the mid-1930s to the 1960s.

Leslie Reagan. *When Abortion Was a Crime: Women, Medicine, and Law in the United States, 1867–1973.* Berkeley, CA: University of California Press, 1998. An important study of medicine, law, and women's experiences of abortion before *Roe v. Wade.*

CIVIL RIGHTS AND LIBERAL ACTIVISM, 1945–1975

LEARNING OBJECTIVES

■ What role did women play in the civil rights movement?
■ How did women's role in the civil rights movement change?
■ How did women use the government to promote equality for them?

Explore Chapter 20
Multimedia Resources

TIMELINE

1954	Supreme Court rules in *Brown v. Board of Education* Women's Political Council formed
1955	Rosa Parks arrested Montgomery bus boycott begins Emmett Till lynched
1957	The Southern Christian Leadership Conference founded Little Rock Central High School desegregated
1960	Student Nonviolent Coordination Committee founded Greensboro sit-ins begin
1961	Eleanor Roosevelt chairs the President's Commission on the Status of Women Peace Corps begins Freedom rides begin
1963	The Equal Pay Act of 1963 passed
1964	The Civil Rights Act of 1964 passed
1966	The National Organization for Women founded
1967	The National Welfare Rights Organization founded

THE SEPARATE BUT EQUAL DOCTRINE, established in 1896 with the Supreme Court case *Plessy v. Ferguson*, upheld the racial segregation of public facilities such as schools, hospitals, libraries, and drinking fountains as well as the rights of restaurant and store owners to serve whites and "colored" customers separately. Frustrated by the legalized segregation they encountered and looking for ways to change it, some African American women attended workshops on nonviolent protest. In February 1960, Diane Nash, one of the participants, helped organize the city's first sit-in. Inspired by a similar demonstration in

North Carolina, she and a group of black and white students sat down together at an all-white lunch counter, asked for food, and refused to leave when they were denied service. Within a few months, the sit-ins had forced the desegregation of Nashville's lunch counters and initiated the process of desegregating other public facilities.

African American women like Nash moved to the forefront of civil rights activism, and their bravery inspired a generation of women to join a range of liberal reform movements in the 1960s and 1970s. This tide of women's social activism brought about significant legislation that outlawed discrimination based on race and sex. The first impetus to liberal reform had come from the civil rights movement, which developed in the wake of World War II. The double V campaign linked the United States' fight against Fascism in Europe to ending racism at home. The movement grew and diversified in the 1950s and 1960s as a generation of African Americans demanded full equality. The second impetus came from the institutions and networks built by women activists during the New Deal and World War II. Women in the labor movement and in the Democratic Party urged newly elected President Kennedy to establish the President's Commission on the Status of Women, chaired by former first lady Eleanor Roosevelt. The commission connected a generation of seasoned women reformers to the new movements of the 1960s. Together, reformers trained in the labor and civil rights movements and young women, black and white, who were willing to put themselves in harm's way for what they believed in, helped to bring the promise of equality all closer to a reality.

Read **"A Personal Reflection on Segregation"**

Diane Nash[1] grew up in Chicago, Illinois, where she had only heard of the segregation in the South. Nash enrolled at Fisk University in Nashville, Tennessee, in the late 1950s, and for the first time she was forced to follow Jim Crow customs. This document includes her reflection on the Jim Crow South.

Review the source; write a short response to the following question.

1. What was the incident that drove home the idea of segregation for Nash? What did she encounter from her classmates when she brought up her reaction to segregation?

THE CIVIL RIGHTS MOVEMENT

Long-standing resentment and frustration at the country's reluctance to end racial discrimination reached a critical point in the years following World War II. The war raised expectations of many African Americans who had migrated to cities in the North and West for higher-paying war work or who had joined the armed services

and experienced, firsthand, less racially segregated societies. In the first push to challenge Jim Crow segregation, church-based and female-dominated community networks nurtured the civil rights movement. As the movement grew and diversified, these women were joined by a new generation of younger women, many of whom were college educated and from the North. Old and young, church-based and university-trained women influenced each other and the direction of the movement from its inception.

Challenging Segregation

Women in the civil rights movement saw that their best hopes for ending segregation lay in the law. Jim Crow state and local laws, written in 1876 and centered in the South, enforced the legal or **de jure segregation** of the races in everyday life. Such laws supported unequal and poorly funded public facilities for African Americans in the South. In this way, legal segregation lent support for a range of extralegal and nonlegal or **de facto segregation** practices. These two forms of segregation merged to create a system of racial apartheid in all arenas of Southern life, ranging from politics and work to housing and schools. Education had become one of the most glaring examples of the inequalities suffered by Southern blacks. Racially segregated schools had left generations of African Americans poorly educated, taught in run-down schoolhouses heated by wood stoves and lit by kerosene lamps, with out-of-date books and few resources. Civil rights activists targeted separate and unequal education as their opening battle in the struggle for racial equality.

In the fall of 1951, the National Association for the Advancement of Colored People (NAACP) asked the parents of Linda Brown, a Topeka, Kansas, elementary school student, and twelve families to try to enroll their children in their neighborhood white schools. Linda Brown, a seven-year-old, had to cross a railroad yard and busy boulevard to wait for a bus that would take her twenty blocks to all-black Monroe Elementary in East Topeka. Her father wanted her in the nearest public school just four blocks away. The NAACP filed a suit, but, in August 1951, a three-judge federal panel threw out the case, ruling that although segregation might be detrimental to Topeka's black children, it was not illegal, because all Topeka schools had equal facilities and programs. The NAACP then filed a lawsuit against the Board of Education, written by the African American lawyer Constance Baker Motley and was heard by the Supreme Court. That lawsuit and others brought on behalf of plaintiffs in Virginia, South Carolina, Delaware, and Washington, D.C., resulted in a historic victory against legal segregation. In May 1954, the Supreme Court ruled in ***Brown v. Board of Education of Topeka*** that the long-standing principle of separate but equal had no place in public education.

However, while the Court declared that "separate but equal facilities are inherently unequal," it did not specify the pace and process by which schools were to desegregate.

The decision was followed by a second ruling, known as *Brown II* (1955), which called for the dismantling of separate school systems for blacks and whites to proceed with "all deliberate speed." Many white Southerners interpreted the ruling to mean desegregation would take place in the distant future, whereas black Southerners understood it to mean an immediate end to segregation. In 1955 and 1956, desegregation began successfully in the states of Maryland, Kentucky, Delaware, Oklahoma, and Missouri but was slow to come to the Deep South.

Black female students figured centrally in one of the civil rights movement's most dramatic confrontations involving education. Three years after the *Brown* ruling, a federal court issued an order mandating Little Rock, Arkansas, to desegregate the city's schools. The order met stiff resistance from local residents and from the governor of Arkansas, Orval Faubus. On September 4, 1957, Faubus refused the order to desegregate and called the Arkansas National Guard to prevent the African American teenagers, six women and three men, from enrolling. President Eisenhower believed that he had convinced the governor to use the guard to protect the black students from white crowds, but when Faubus returned to Little Rock, he dismissed the troops and left the black students exposed to the angry white mob. Within hours, the jeering mob had beaten several reporters and the local police rescued the nine students from the high school. President Eisenhower sent armed troops to the city to restore order. Under federal protection, the "Little Rock Nine" finished out the school year. Yet they faced daily confrontations with white students. One student, Minnijean Brown, recalled a lunch period when a group of angry white male students surrounded her. She dropped a bowl of chili on the head of one of the white students and was suspended. The white students faced no punishment. Progress was slow. By 1960, only seventeen school systems had been desegregated.

As race relations strained under new scrutiny, long-standing justifications for segregation took on new life: foremost, white Southerners' concern for protecting white women from black men. The murder of Emmett Till in Money, Mississippi, in 1955 made the gender underpinnings of Jim Crow segregation impossible to ignore. As a Northerner, Till was not aware of the Southern racial code of behavior and had casually said good-bye to a white shop owner's wife, Carolyn Bryant, on his way out of the grocery store. Two days later, Bryant's husband and brother-in-law kidnapped the boy out of his uncle's home at gunpoint and murdered him. An all-white jury later acquitted the two men under the glare of national press. The acquittal triggered protest rallies around the country. Mamie Till Bradley, Till's mother, insisted her son's casket be open "to let the people see what they have done to my boy!" Till's violent death and his mother's efforts to bring national attention to the ongoing practice of lynching helped U.S. citizens across the country to see the need for concerted political action to combat racism. For the first time, many Northern blacks understood that racial violence in the South had the potential to touch them.

Read "Rosa Parks and the Montgomery Bus Boycott"[2]

The growing consensus that change had to come to the South infused local communities of black women who, in conjunction with national organizations like the NAACP, formed the core of the civil rights movement in the 1950s. A month after Emmett Till's murder, Rosa Parks, a 43-year-old department store seamstress and civil rights activist, refused to give up her seat to a white bus rider in Montgomery, Alabama. Parks had just attended a summer program at the Highlander School in Tennessee where she learned protest tactics. When Parks did not vacate her seat to the white man on a crowded bus, she was arrested for violating Montgomery's transportation laws. Her arrest set in motion a citywide bus boycott.

The Women's Political Council in Montgomery had been planning such a boycott since the 1954 *Brown* decision. When word of Parks's arrest spread, Professor Jo Ann Robinson at Alabama State College set in motion the existing plan for a one-day boycott of all city buses. To coordinate the protest, the activists formed the Montgomery Improvement Association, headed by the young and charismatic minister, Martin Luther King Jr. The boycott, planned as a day-long event to show the city the economic power of African Americans, lasted more than a year. For the working women who depended on the bus, the boycott required commitment and sacrifice. To get to work or to do errands once done quickly with the help of buses now took hours. Women walked, taxied, or organized car pools. The boycott took 65 percent of the bus company's business and hurt white businesses, but the city did not give in until the Supreme Court ordered an end to Montgomery's bus segregation policy in *Browder v. Gayle* in 1956. Eager to keep the political momentum nurtured by the boycott, black ministers formed the **Southern Christian Leadership Conference** (SCLC) in 1957 and appointed Martin Luther King Jr. as its first president.

Review the source; write short responses to the following questions.

1. What role does Robinson's description of Rosa Parks play in the retelling of this story? What is she trying to establish?
2. What was the black community's initial response to the news that Rosa Parks had been arrested?

Women's longtime custom of informal leadership in Southern black communities, rooted in their majorities in Baptist and Methodist congregations, made them important participants in the growing movement. While Martin Luther King, Jr. and other male ministers took formal leadership positions, seasoned female activists continued to provide important guidance. Ella Baker joined the SCLC in hopes of creating a grassroots organization that would be welcoming to young people and women. But she soon felt constrained by the SCLC's top-down organizational style.

Baker, the granddaughter of slaves, graduated from Shaw University in 1927 and moved to New York City where she worked for the federal Works Progress Administration (see Chapter 17). Her political education began in earnest during World War II, when she directed the New York City branch of the NAACP. After joining the SCLC, Baker met Fannie Lou Hamer, a former sharecropper who headed the SCLC office in Atlanta. Hamer shared Baker's interest in keeping the civil rights movement tied closely to the concerns of ordinary men and women and committed to empowering those people in the United States who had been politically disenfranchised for generations. Together, the two women helped to bring about a new generation of leaders and a new style of activism.

View the Profile of Fannie Lou Hamer

The youngest of twenty children, Hamer, born October 6, 1917, grew up in a sharecropping family. Hamer cofounded the Mississippi Freedom Democratic Party, a group that in 1964 challenged the all-white Mississippi delegation to the Democratic National Convention. Hamer helped to develop a number of programs to aid the poor in her community, including the Delta Ministry, an extensive community development program, and the Freedom Farms Corporation in 1969, a nonprofit operation designed to help needy families raise food and livestock, provide social services, encourage minority business opportunities, and offer educational assistance.

Over the next decade, the women whose church and community networks proved so instrumental to the success of the early movement saw their efforts contribute to the growth of a more national and diverse movement. The movement drew thousands of new supporters as it spread to high schools and college campuses in the North and the South. The movement of the 1950s and 1960s that had been "carried out largely by women," according to Ella Baker, was now in the hands of a new generation of activists.

Freedom Struggles

As the civil rights movement became national and more Northern, its leadership grew younger and more confrontational. College students adopted new tactics to challenge the deeply entrenched social patterns of racial segregation such as the sit-in and freedom rides, both of which triggered crowds of angry white protesters.

On February 1, 1960, four black male students, active in their college NAACP group in Greensboro, North Carolina, took seats at the lunch counter of a Woolworth's five-and-dime store. The waitresses refused to serve them, yet the students stayed at the counter, doing their homework, until the store closed. Inspired by the men's determination, black women students from Bennett College and a few white women from the University of North Carolina Women's College joined the men at the counter. Soon, hundreds of well-dressed African American students filled the downtown store.

Sympathetic blacks and whites across the country supported the sit-in by picketing local stores of national chains that supported segregation in their Southern stores.

As news of the sit-ins spread, more and more students determined to use them to challenge segregation. Diane Nash of Fisk University in Nashville, Tennessee, was among a group of students who had begun planning for nonviolent confrontation before the Greensboro sit-in. When the students organized a sit-in in Nashville, hundreds faced down angry white mobs before they were beaten and arrested. In Atlanta, Spelman College freshman Ruby Doris Smith convinced her friends to join with Atlanta University students to launch a series of sit-ins in Atlanta on March 15, 1960. Students who participated in Atlanta sit-ins broadened their calls for desegregation to include all public facilities, voting rights, and equal work and educational rights. Organizer Ella Baker quickly recognized the untapped leadership of high school and college students now eager to join the movement. To capitalize on their energy, Baker organized a conference for 150 high school and college students at Shaw University in Raleigh, North Carolina, to discuss the future of the movement. The meeting led to the creation of the nationwide **Student Nonviolent Coordinating Committee** (SNCC), which gave younger African Americans, including women and the poor, more opportunity to set a political course for the movement.

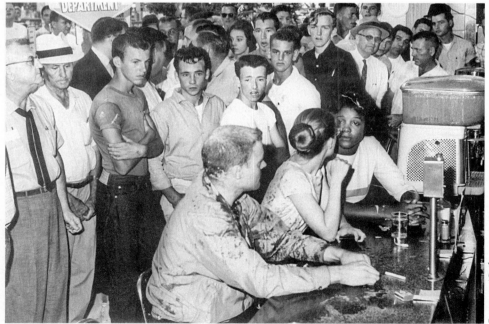

Bettmann/Corbis.

Angry white locals surround protesters John Salter, Joan Trumpauer, and Annie Moody during a sit-in at a lunch counter in Jackson, Mississippi, in 1963. Through these forms of direct and nonviolent confrontations, civil rights activists succeeded in showing the need for change in the segregated South.

The idea of the "freedom rides" extended the principle of the nonviolent sit-in, in which women took primary roles, to interstate travel. To mark the seven years that had passed since the *Brown v. Board of Education of Topeka* ruling with little tangible progress achieved, the Congress of Racial Equality (CORE), with the support of the SNCC, initiated "freedom rides" in the summer of 1961. The CORE leaders hoped to pressure the federal government to enforce the desegregation of interstate travel, mandated when the Supreme Court ruled in *Boynton v. Virginia* that segregation in interstate travel was unconstitutional. A freedom ride left Washington, D.C., on May 4, 1961, with two buses. White riders took seats in the back of the bus and black riders in the front. At rest stops, whites entered colored-only areas, and black riders entered white-only areas. On Mother's Day, May 14, the freedom riders split up into two groups to travel through Alabama. The first group was met by a mob of two hundred in Anniston who stoned the bus and slashed the tires. The bus managed to get away, but when it stopped about six miles out of town to change the tires, it was firebombed. The other group fared no better. It was greeted by a mob in Birmingham, and the riders were severely beaten. No arrests were made.

Diane Nash of the SNCC and students from Nashville were determined to continue, despite the violence. Attorney General Robert Kennedy, who was determined to enforce law, pressured the bus company to carry the freedom riders and the Birmingham police to protect them. The freedom riders left Birmingham for Montgomery on Saturday, May 20, with police protection until the buses entered the city limits, when the police disappeared. The quiet bus terminal erupted when the riders disembarked; over one thousand white men, women, and children attacked the riders with bricks, chains, and baseball bats. Newspapers and television cameras circulated the images of racial violence across the country and the world. Martin Luther King Jr. flew to Montgomery and held a mass meeting in support of the freedom riders. Freedom riders continued on to Jackson, Mississippi. Under mounting pressure to resolve the crisis, the Interstate Commerce Commission outlawed segregation in interstate bus travel in 1961.

A MOVEMENT TAKES SHAPE

The civil rights movement and the passage of the Civil Rights Act of 1964 played central roles in the revival of feminism in the 1960s and 1970s. This **second-wave feminism**, named to underscore its connections to the battle for suffrage in the early decades of the century, utilized civil rights victories to bring about new challenges to women's secondary status. The origins of feminism also lay in the labor movement and the efforts by reformers to end workplace discrimination. These reformers shared with civil rights activists the belief that the government held the answer to the problem of inequality. Pressuring the government to write and enforce new laws establishing women's equality at work, in politics, and in education became the focus of liberal feminist activism.

Labor Activism

The majority of U.S. women in the labor market in the 1960s and 1970s worked out of economic necessity, not for extra "pin money" or for personal satisfaction alone.

Trends that began at the midcentury strengthened in the postwar years. During World War II, only one-fourth of all women worked and the majority of those who did were married women over thirty-five with no children at home. By the 1950s and 1960s, more mothers with school-age children entered the workforce. In the 1970s, women of all ages, including mothers of young children, did full-time wage work. For the first time in U.S. history, there were more women in the labor force than out of it.

Women labor leaders hoped the 1955 merger of the American Federation of Labor (AFL) and the Congress of Industrial Organizations (CIO) would bring about a change in the treatment of working women's issues by the union movement. As a result of the merger and the growing power of labor in the wake of World War II, union membership reached fourteen million in 1950 and increased to nineteen million by 1970. The merger brought the CIO's more progressive perspectives—such as its commitment to Social Security Disability Insurance that provided income to people unable to work because of injury and equal pay for equal work—into the AFL-CIO. Yet, even as the labor movement adopted a more progressive political agenda, many female labor activists wanted the AFL-CIO to offer a more substantial program to address the needs of working women.

In 1958, Esther Peterson, a lobbyist for the AFL-CIO, brought together a group of women labor leaders to "take a fresh look at women's protective legislation"—specifically, the eight-hour maximum placed on women and restrictions on night work—that was used to justify discrimination against women workers. The group also examined the possibility of implementing unemployment compensation for pregnant women, creating maternity leaves, enhancing training programs, and expanding the number of jobs covered by minimum wage. To advance their ambitious agenda, labor feminists threw their support behind the Democratic Party in the elections of 1960. They began through the women's division of the Committee on Political Education (COPE), the recently formed political arm of the AFL-CIO. The COPE sponsored a national voter registration drive that focused not only on women and union members but on all registered voters. They signed up more than 1.5 million new voters and coordinated a massive election-day voter drive. Women took the lead in telephone brigades, neighborhood canvassing, and local get-out-the-vote campaigns. Complementing the efforts of COPE, Esther Peterson and other women labor leaders organized the "Committee of Labor Women for Kennedy and Johnson," a powerful new national organization with ties to labor's volunteer army of women in communities across the country. When Democrat John F. Kennedy narrowly won the presidency in 1960, he did not forget his labor allies. He appointed Peterson to head up the Women's Bureau.

Peterson brought to her job a close-knit network of labor women and ties to millions of women in trade unions and auxiliaries to her work. At the same time, she also brought a new perspective to the Women's Bureau, one that renewed the agency's focus on working women. "We wanted equality for women," she wrote in her memoir, "but we wanted bread for our low-income sisters first." Peterson's labor movement peers valued the union as an important means of improving working women's lives. Yet, by the 1960s, they had grown frustrated with its male-dominated leadership. Peterson convened a meeting in 1961 of 175 labor women from twenty-one international unions

in Washington, D.C. The group met for three days and laid out the pressing issues confronting women workers and the labor feminists' growing alienation from their male-dominated unions. The group called for a federal law guaranteeing equal pay for equal work; prohibition of sex discrimination in federal contracts; and the extension of minimum wage to millions of women in service occupations such as restaurant, laundry, hotel, agricultural, and domestic work. The group also recommended increased funding for child-care centers and after-school activities at public schools, as well as maternity leave guarantees. The agenda set out by feminist labor leaders called for the federal government to play a role to ensure equality for women workers. Like their peers in the civil rights movement, labor reform women hoped to use laws guaranteeing women's equality as primary tools to bring about social change.

The President's Commission on the Status of Women

Women active in the labor movement and in the presidential campaign of John F. Kennedy wanted to see the federal government do more to level the economic field for women. In December 1961, at Peterson's suggestion, Kennedy issued Executive Order 10980, creating the **President's Commission on the Status of Women** (PCSW). The PCSW was chaired by former first lady Eleanor Roosevelt until her death in November 1962 and staffed by notables like historian Caroline Ware; Dorothy Height, president of the National Council of Negro Women; and Dr. Mary Bunting, president of Radcliffe College. The commission had twenty-six members who staffed subcommittees focused on specific issues pertaining to women, such as inequities in pay, the problems facing poor women, and civil rights. In October 1963, Peterson presented the commission's report, *American Women*, to the president, noting that the report offered no "avant-garde recommendations," only "the art of the possible." *American Women* became a best seller, with sixty-four thousand copies distributed in the first year.

The report accomplished a great deal. Foremost, it documented discrimination against women, including the disparity between men's and women's earnings. In 1960, women with full-time, year-round jobs earned 60 percent of what men earned and black women earned just 42 percent. The report showed that women college graduates gained little wage advantage from their degrees. On an average, they earned less than men with high school diplomas. The report made twenty-four specific recommendations—including that marriage should be seen as an economic partnership, that any property acquired during the marriage should belong to both spouses, and that child care should be available to families of all income levels—and supported paid maternity leaves and the principle of equal pay for equal work. Although the report ended up concluding that constitutional changes like the Equal Rights Amendment (ERA) "need not be sought," it set out concrete recommendations for achieving gender equality. Equally important, the experience of working for the commission galvanized participants into liberal feminism.

The commission directly and indirectly acted as a catalyst for a number of liberal reforms. In July 1962, before the commission issued its final report, Kennedy directed all federal agencies to hire, train, and promote employees regardless of sex.

A year later, Congress passed the **Equal Pay Act of 1963**, the first federal law forbidding sex discrimination by private businesses, extending what had previously been a ban on discrimination in hiring practices by defense contractors established in 1941 (see Chapter 18). By 1967, all fifty states had State Commission on the Status of Women in operation, establishing an important network for liberal activists.

Building a Movement

In 1964, and as Congress readied itself to pass the landmark Civil Rights Act, liberal women lobbied for the inclusion of women into the section of the law called Title VII that prohibited employment discrimination. More sweeping than the Equal Pay Act, Title VII, which included sex in its list of prohibited forms of discrimination, applied to jobs, public education, and all federally funded programs. It marked a historic turning point for labor feminists' efforts to dismantle protective labor laws that limited the number of hours women could work and the types of jobs they could perform. With the passage of Title VII, protective legislation, found to discriminate against women, once the crowning accomplishment of labor women in the Progressive Era, had been swept away with the full support of labor feminists. In addition, Title VII established a government agency to investigate employment discrimination complaints, the **Equal Employment Opportunity Commission** (EEOC). President Lyndon Johnson appointed Aileen Hernández to the five-person commission. Hernández brought years of experience to her position. The daughter of Jamaican immigrants, Hernández was educated at Howard University before taking a position as a labor organizer for the International Ladies' Garment Workers Union. She later worked as deputy chief of California's Division of Fair Employment Practices where she learned firsthand about the range and extent of work-related discrimination. While the EEOC established a set of guidelines that spelled out the parameters of what constituted "discrimination," the agency tended to focus on racial discrimination more than sex discrimination. Michigan Congresswoman Martha Griffiths, who had been actively involved in Title VII debates, denounced the EEOC on the floor of the House in June 1965: "I charge that the officials of the Equal Employment Opportunity Commission have displayed a wholly negative attitude toward the sex provision of Title VII. . . . What is this sickness that causes an official to ridicule the law he has sworn to uphold and enforce? . . .What kind of mentality is it that can ignore the fact that women's wages are much less than men's and that Negro women's wages are least of all?"

In October 1965, civil rights lawyer Pauli Murray called for an outside pressure group—"an NAACP for women"—to ensure that the EEOC would enforce the law. Betty Friedan, author of the best-selling *The Feminine Mystique* (1963), had the visibility to head up such an organization. At the Third Annual Conference on the Status of Women in June 1966, Friedan, Murray, and a small group of other attendees initiated the concept of the **National Organization for Women** (NOW) and began plans for a founding convention in the fall. Hernández later noted that the EEOC became "the disinterested parent of the NOW and many other feminist groups that sprang up in the decade between 1965 and 1975."

The founders of the NOW intended it to bring together a small group of women who could work quickly on the enforcement of Title VII, but the group mushroomed into a wide-ranging organization devoted to promoting women's rights in all aspects of their lives, not only employment discrimination. The National Organization for Women encouraged local chapters to take on relevant issues in their communities and not to follow in lockstep with the agenda and priorities of the national organization. Much like the "Do Everything" policy of the nineteenth-century Woman's Christian Temperance Union, the NOW "wanted [members] to move in their own style, according to their own priorities" (see Chapter 13). Jennifer Macleod, first president of the Central New Jersey chapter of the NOW, explained to new members that "they were not buying into a whole package. They could devote their efforts to something they believed in."

Read "NOW's Statement of Purpose"[3]

One of NOW's focus was on gender roles and the idea that men and women could and should share domestic and child-care duties. The NOW also proposed the idea of child-care institutions that would allow women to combine career with motherhood.

Review the source; write short responses to the following questions.

1. What is the purpose of the NOW, according to this document?
2. What does the NOW charter say about the status of American women in society?

With the formation of the NOW, liberal feminism grew in force and reach, drawing a diverse group of women to participate in its sweeping reform agenda. Women of color played central roles in liberal feminist groups. Black women such as Texas Congresswoman Barbara Jordan, activists Shirley Chisholm and Fannie Lou Hamer, and Hispanic women from the group La Raza Unida Party took leadership positions.

The goal of many liberal feminist activists was to get more women into politics. Chisholm, Friedan, and other leaders formed the **National Women's Political Caucus** (NWPC) in 1971 with the goal of increasing the number of women in politics by recruiting, training, and supporting women who sought elected and appointed offices. The NWPC formed permanent caucuses for African Americans, Chicanas, Puerto Ricans, and Native Americans. In later years, permanent caucuses emerged for Asian Americans, lesbians, and Capitol Hill staff members. The NWPC was uniquely diverse, and the creation of permanent caucuses helped to tailor liberal feminism to the needs of all women and gave women space from the concerns of white middle-class women. The caucuses functioned as an important political network for minority women who wanted to participate in organizations that articulated their needs.

Q **View the Profile of <u>Shirley Chisholm</u>**

Shirley Chisholm's political reputation for social justice began formally in 1964 when she was elected to the New York State Assembly; she served until 1968. After finishing her term in the legislature, Chisholm campaigned to represent New York's Twelfth Congressional District. She won the election and became the first African American woman elected to Congress. In 1972, she became the first African American woman to run for president. Although she did not win the nomination, she received 151 of the delegates' votes. She continued to serve in the House of Representatives until 1982.

Read <u>"Shirley Chisholm: Equal Rights Champion"</u>[4]

Shirley Chisholm gained national fame in 1972 as the first African American to run for president when she campaigned for the Democratic nomination. In the speech reproduced here, Chisholm calls for a constitutional amendment to guarantee equal rights for women.

Review the source; write short responses to the following questions.

1. How does Chisholm compare the plight of women in the United States to that of blacks?
2. What statistics did Chisholm use to support her argument?

Not all minority women felt their voices were heard. The black caucuses of the NOW and the NWPC joined to form the National Black Feminist Organization (NBFO) in 1973, realizing that the predominantly white feminist organizations often failed to adequately address the concerns of black women and that the only way to encourage more black women to join was to form black feminist groups. One member, Carolyn Handy, explained why the movement needed the NBFO: "It's time that minority women stand up and say, 'Listen, it's our movement, too, and we're supportive of our white sisters and if you have any questions about our commitment, here we are. Ask us.'" Within four months, the NBFO had a mailing list of one thousand. Puerto Rican feminists, motivated by the same liberal impulses, began meeting in 1970 but found that lines between Mexican, Chicana, Puerto Rican, and Cuban women were less easy to shed. One Puerto Rican feminist explained that in 1970, "Latinas were not ready to have that kind of unity for each group needed first to develop by itself." But Latina feminists continued to organize their own groups. In 1972, the National Conference of Puerto Rican Women formed and grew to more than twenty local chapters.

Liberal women focused on institutional discrimination against women and formed organizations intended to work within existing systems to bring about more equality for all women. Workplace issues and political representation were important focuses

for all feminists, no matter their country of origin or their race. But as the movement expanded and diversified, activists found that the number of differences between women also multiplied. Differences in education, contrasting experiences of wealth and poverty, and ongoing political debates over the agenda for feminism emerged and made the dream of a united movement elusive.

The National Welfare Rights Organization

Working-class and poor women directed their political energies in the 1960s and 1970s to reforming welfare. Inspired by the surge in activism and unwilling to wait until middle-class feminists took up the issue of poverty, women on welfare formed their own feminist groups. Welfare rights groups from Boston to Los Angeles confederated into the National Welfare Rights Organization (NWRO) in 1967. Voting members were poor—most were mothers receiving Aid to Families with Dependent Children (AFDC). The multiracial organization drew heavily from urban areas, so, although white women constituted more than half the nation's AFDC population, the majority of NWRO leaders and members were African American. Johnnie Tillmon, a welfare mother from Los Angeles, was elected chair. Former college professor and civil rights leader George Wiley, who had raised the money for the founding convention, became executive director. At its peak in 1969, the NWRO membership was estimated at twenty-two thousand families nationwide, mostly black, with local chapters in nearly every state and major city (Figure 20-1).

FIGURE 20-1 Percentage of Women in Poverty by Race, 1960–1990

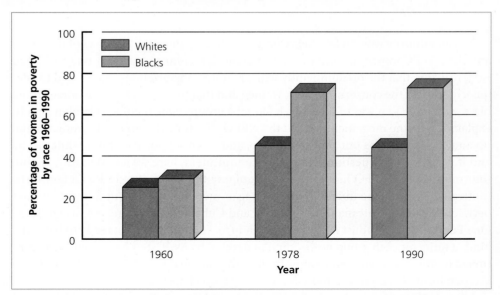

Despite growth in the economy and in the pink-collar sectors that women dominated, women fell into poverty at higher rates than did their male counterparts, a situation that only worsened as the century wore on.

Read "Welfare Is Like a Supersexist Marriage"[5]

Johnnie Tillmon, a founding chairperson (and, in 1972, the director) of the National Welfare Rights Organization, described her life as a welfare mother. She describes the difficulties that poverty and racism bring to mothers and the misconceptions of welfare mothers that only heap shame on welfare recipients. Tillmon is particularly critical of the ways that welfare programs promote a cycle of dependency that, she says, is akin to "supersexist marriage."

Review the source; write short responses to the following questions.

1. What are the problems Tillmon identifies that make welfare a woman's issue?
2. How does Tillmon understand the place of men and of ideas of masculinity in welfare debates?
3. What are the connections between "a man" and "the man"?

The organization worked to bring tangible improvements in the welfare system. Largely as a result of the NWRO "minimum standards" campaigns that gave grants to welfare recipients for necessities like furniture and clothing, welfare payments in New York City alone increased over thirty-fold from $1.2 million in 1963 to $40 million in 1968, an income transfer that went directly into the pockets of the poor. By 1968, militant action taken by welfare recipients across the country had resulted in a changed atmosphere inside welfare offices, as these agencies established community relations departments, provided access to state welfare manuals, and began to treat recipients as clients rather than supplicants. For the first time, organized recipients negotiated with agency directors as peers.

The NWRO reframed the right of welfare to be a civil right, not a handout. By claiming that women and poor people deserve to be treated with dignity and respect, the NWRO was the first organization to create a distinct political identity among poor black women, who comprised 90 percent of its membership.

Reform-minded women in the 1960s, like their counterparts in the civil rights movement, viewed the federal government as a crucial part of the solution to social problems. The networks of activists in the Democratic Party, in labor organizations, and in welfare rights groups organized to help women improve their lives and the lives of their children. Liberal women's groups sought to work politically within existing social and economic institutions to secure reforms for women and to promote equality of opportunity between the sexes. Ultimately, the goal of liberal feminists was assimilation, not separatism—to end separate spheres and to see women as individuals without regard to their sex.

AGENDA FOR REFORM

Liberal feminists adopted the civil rights movement's demand for equality and its use of the government to ensure rights to their own ends. Through new networks, political organizations, and key legal victories, many formal aspects of economic, political,

and educational sex discrimination ended. The strength of those gains could be seen in the growing number of women in politics; professional training schools; and previously male-dominated arenas like business, law, and athletics. Although these victories opened new opportunities for women, pressing issues continued to divide women. No consensus emerged among women over divisive issues like the proposed ERA and a woman's right to abortion. Women's growing presence in the mainstream of U.S. life in the 1960s and 1970s showcased their differences as well as their similarities.

Legislating Equality

Liberal activists in the late 1960s and early 1970s enjoyed a rising tide of influence and witnessed historic victories in their efforts to establish legal equality for women. A number of important laws were passed, making the 1970s the high-water mark of liberal feminist reform. Ironically, these years also marked the failure to achieve the ERA as conservative women mobilized to block its passage.

A movement to pass the ERA reemerged in 1946 in recognition of the work women did during World War II. Yet the tension between the ERA supporters and those who favored protective legislation for women that had emerged during the 1920s when the ERA was first introduced into Congress had not disappeared.

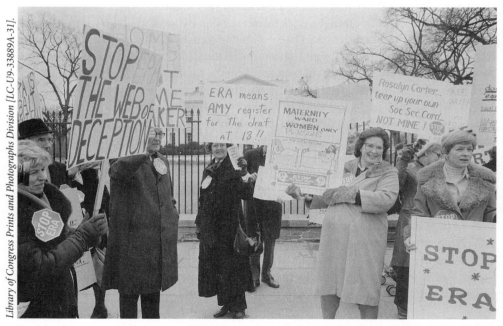

Library of Congress Prints and Photographs Division [LC-U9-33889A-31].

On March 22, 1972, both houses of Congress approved the Equal Rights Amendment, and, within the year, twenty-two states had ratified it. As support for the ERA grew, opponents began to mobilize against its passage. In 1972, Republican activist Phyllis Schlafly organized a grassroots campaign, the STOP ERA, and held protests like this one in front of the White House. To the surprise of its supporters, the ERA was narrowly defeated in 1982.

Despite the high hopes of its supporters, political support for the amendment did not materialize, and it fell short of the two-thirds majority required for passage. Throughout the 1950s, the majority of women's organizations continued to line up against the ERA, supporting the notion that women's difference from men demanded different treatment in the workplace. The National Woman's Party, the main organization supporting the ERA, saw its influence decline and its membership dwindle.

The surge of liberal reform changed the prospects of passing the ERA. By 1970, the proposed amendment enjoyed wide support among women's organizations, many of which had previously opposed it: the League of Women Voters, the YWCA, and the American Association of University Women. The goal of equality for all citizens and the discrediting of the separate but equal doctrine had effectively undermined the rationale for protective legislation. The ERA, which stated that "Equality of rights under the law shall not be denied or abridged by the United States or by any state on account of sex," now seemed possible. In 1970, President Richard Nixon endorsed the ERA in a report on the status of women, and on March 22, 1972, both houses of Congress approved the amendment. Within the year, twenty-two states had ratified it, bringing the amendment close to the thirty-five states needed for passage.

Yet, as the ERA gained supporters, opponents began to mobilize against its passage. In 1972, Republican activist Phyllis Schlafly organized a grassroots campaign to stop more states from ratifying the ERA. Her strategy emphasized to all that the ERA would diminish women, arguing that "the ERA would lead to women being drafted into the military and to public unisex bathrooms." Under her charismatic leadership, the STOP ERA campaign took off. To the surprise of its supporters, the ERA was narrowly defeated in 1982.

Despite the defeat of the ERA, the movement to establish legal equality for women reached new heights in the mid-1970s. Liberal feminists concentrated on a series of pragmatic reforms that emphasized compliance with equal opportunity legislation and the passage of laws to guarantee the equal treatment of men and women. New York Congressional Representative Bella Abzug described 1972 as "a watershed year. We put sex discrimination provisions into everything. There was no opposition. Who'd be against equal rights for women? So we just kept passing women's rights legislation." The legislative push was wide ranging, covering consumer credit and mortgages, wages and hours, and greater access to sports. Congress passed the **Equal Opportunity Act** (1972) to give the EEOC a broader jurisdiction, strengthening its ability to enforce its rulings. Congress passed the Equal Credit Opportunity Act, which banned credit discrimination on the basis of an applicant's sex, marital status, or age. Previously, women could not open a credit card account or take a home mortgage out without permission from her husband. The law applied to retail stores, credit card companies, banks, and home finance and home mortgage lenders for which a broad pattern of discrimination against extending credit to women had long existed.

Liberal feminists also lay the foundations for ending discrimination in education. In the late 1960s, the Women's Equity Action League (WEAL) began legal action against sex discrimination in all levels of U.S. education. On January 31, 1970, the WEAL filed a class action suit with the U.S. Department of Labor against all the colleges and universities in the country, claiming illegal admission quotas and discrimination in financial assistance, hiring and promotion practices, and wages. In October, the WEAL filed a class action suit against all the medical schools. The following year, the Professional Women's Caucus filed a suit against all the nation's law schools. The materials gathered for these cases yielded ample proof of sex discrimination in education. The congressional hearings on discrimination in education contributed to the passage of **Title IX of the Education Amendments of 1972**. The preamble to Title IX stated, "No person in the United States shall, on the basis of sex, be excluded from participation in, be denied the benefits of, or be subject to discrimination under any educational programs or activity receiving federal financial assistance." Two years later (1974), the Women's Educational Equity Act was passed, which focused on gender bias in all levels of educational curriculum and included funding for women's studies programs, seminars for teachers, and the creation of nonsexist textbooks. Liberal feminist groups like the NOW, the Women's Equity Action League, the NWPC, and the Center for Women's Policy Studies had succeeded in strengthening their influence over the legislative process and winning a place at the table of U.S. politics.

The number of women delegates to party conventions grew impressively up from 17 percent to 30 percent among Republicans and from 13 percent to 40 percent among Democrats. Women who had been active in local and state political campaigns and had years of experience in civic affairs now ran for public office. The number of women candidates for state legislatures increased 300 percent in the early 1970s. The combined efforts of policy-oriented feminists, savvy political insiders, union activists, civil rights leaders, and ordinary women who were newly aware of their political clout transformed the political landscape of the country.

Education and Athletics

Women active in politics placed educational reform high on their agendas. Throughout the 1940s and 1950s, educational texts routinely confirmed deeply held gender convictions that girls ought to be trained for their roles at home, not for professions. Mathematics and science classes were often closed to female students, and teachers and guidance counselors discouraged young women from studying traditionally "male" occupations. Women applying to college had to score much better than men typically did, and graduate and professional schools set quotas on the number of female applicants they accepted (Figure 20-2).

Title IX became one of the most important vehicles to combat discrimination against women in education. In June 1972, Congressional Representative Patsy Mink from Hawaii—the first Asian American woman elected to Congress—drafted and helped build the coalition that supported Title IX. Because virtually all public schools

FIGURE 20-2 Women and the Professions

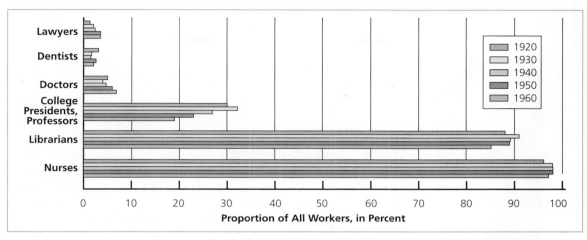

Women's entrance to the professions, in the doldrums through much of the century, surged in the wake of feminism in the 1970s. (From *The Routledge Historical Atlas of Women in America*, edited by Sandra Opdycke [New York: Routledge, 2000], p. 112.)

and colleges, as well as many private colleges, received federal assistance, the bill cast a wide net. At the time of its passage, few people realized Title IX would affect such things as athletics, classes that did not admit women, policies on maternity leave, and the question of whether schools could expel pregnant students. Once the full extent of the bill was known, it became the focal point of controversy, most often centered on athletics.

Critics opposed the mandatory redistribution of resources required by Title IX. Bias against girls in sports had gone without notice for most of the twentieth century. School districts regularly allotted far more funds to boys' teams than they did to girls' teams. One district in Texas in the 1970s budgeted $250,000 for athletics, but the only sport women were permitted to play was tennis, which received a mere $970. Such poor funding continued all the way to college. College and university women's sports teams typically received 1 or 2 percent of what was budgeted for men. With the passage of Title IX, high school and college sports administrators complained that making women's teams equitable to men's would take too much money from men's teams. One coach at a Wisconsin high school captured the feeling of many of those opposed to Title IX in 1973 when he said, "I think girls have a right to participate but to a lesser degree than boys. If they go too far with the competitive stuff, they lose their femininity."

It took Congress nearly two years to develop regulations for Title IX and then another year until the regulations went into effect. The agency that was granted powers to enforce compliance, the Office of Civil Rights, however, had few funds and, according to the National Women's Law Center's attorney Marcia Greenberger, was recalcitrant and had "no will to enforce" the regulation. By 1976, only 20 percent of its caseload for

elementary and secondary schools had been resolved; by 1978, only 13 percent of what was spent on men's sports was spent on women's intercollegiate athletics, an improvement from the 2 percent in 1974.

> ### View the Profile of Patsy Matsu Takemoto Mink
>
> Hawaiian Patsy Takemoto Mink, the first Asian American woman elected to Congress, was born on Maui in 1927 to Nisei or second-generation Japanese American parents. In 1965, she was elected to the House of Representatives where she drafted Title IX of the Education Amendments of the Higher Education Act and proved instrumental in creating a political coalition to ensure its passage. She also introduced the Early Childhood Education Act, which gave funding for childhood education from preschool through kindergarten, and the Women's Educational Equity Act. In 1977, President Jimmy Carter appointed Mink to his cabinet as assistant secretary of state.

Despite poor enforcement, sex discrimination in athletics diminished in the 1970s. Studies found that women who were under age ten when Title IX passed had higher sports participation rates than women who grew up before Title IX. Title IX increased the number of women who received athletic scholarships and improved the salaries of female coaches. At the Olympics of 1984, three-fourths of the U.S. women who competed said they would not have participated if not for Title IX.

Reproductive Freedom

Under the climate of reform, the movement to relegalize abortion gained strength. But despite the support it enjoyed from many feminists, a woman's right to abortion was a divisive issue. The movement for relegalization began in 1967 when the NOW came out in support of lifting restrictions on women's right to the procedure. It was joined by radical feminists who staged a wave of sit-ins, speakouts, and other demonstrations to highlight the dangers and trauma of illegal abortion (see Chapter 21). Both liberal and radical feminist groups asserted that abortion was a decision only a woman could make for herself in consultation with partners and doctors. Even feminists who focused on workplace issues saw the right to abortion as essential. As one California woman stated, "We can get all the rights in the world. . . and none of them means a doggone thing if we don't own the flesh we stand in."

By 1967, Colorado, North Carolina, and California passed new laws liberalizing restrictions on obtaining an abortion. Efforts to repeal state laws met with opposition from antiabortion advocates like the Catholic Church, which mobilized a counteroffensive to block abortion reform efforts. Despite its critics, the abortion rights movement grew more radical. In February 1968, 350 abortion activists from twenty-one state organizations met in Chicago to garner support for the repeal of all laws restricting women's right to abortion. Out of the meeting, the National Association for the Repeal

of Abortion Laws (NARAL) formed. In 1970, the NARAL spearheaded a campaign in New York to decriminalize abortion in the first six months of pregnancy. It succeeded, establishing New York as having the most liberal abortion law in the country. Critics of the law mobilized immediately. In 1971, the New York Commissioner of Social Services announced that Medicaid, a medical insurance program for the poor, would not cover "elective" abortions, effectively restricting women's access to the procedure.

The debate over the legal status of abortion headed to the Supreme Court. The Court's historic decision to legalize most abortions involved two cases, *Roe v. Wade* and *Doe v. Bolton*. The decisions were issued on January 22, 1973. The more famous *Roe* case challenged a Texas law that permitted an abortion only if the life of the woman was at risk. The *Doe* case challenged the complex and forbidding process by which a woman could gain an abortion in Georgia, which permitted abortion only in cases of rape, severe fetal deformity, or severe danger to the life of the mother. The Supreme Court struck down both states' abortion laws, arguing that the laws invaded a woman's right to privacy. In the place of state laws, a new formula was created that allowed abortion before the end of the first trimester, after which the state could regulate abortion procedures to protect a woman's health. Once the fetus was viable, or capable of surviving outside the womb, the state could regulate and even prohibit abortion in the interest of preserving potential life. This aspect of the ruling gave states with more liberal statutes the authority to rewrite their abortion laws and make them narrower. At the same time, the use of fetal viability as the time after which an abortion became illegal lay the groundwork for the idea of fetal rights, which became a rallying point of pro-life groups who opposed abortion (see Chapter 22). The ruling established a woman's control over her body when the Court struck down state laws that required a woman to get approval of a hospital committee or independent doctors before being allowed to have the procedure. With this, the Supreme Court reinstated abortion guidelines that prevailed throughout the nineteenth century when abortions before "quickening" took place were legal.

Media and the Movement

The 1970s brought important changes in women's legal status and new opportunities for women in formerly male-dominated political, economic, and educational institutions. Yet, the impact of the women's movement in the 1970s was also felt more broadly. The concept of sexism and the need for greater equality between the sexes were packaged and sold through the court of popular opinion as much as they were through the courts and Congress. Feminists focused on the pernicious impact negative representations of women in the media had on women of all ages. Prominent feminists, like writer and activist Kate Millett and magazine editor Gloria Steinem, argued persuasively that images of women as sexual objects undermined their effort to establish full equality at home and work.

Images of women in magazines before the women's movement centered on women's roles as wife, mother, housewife, and primary consumer, with regular inspirational pieces on extraordinary women or women active in politics. In the pages of

the nation's magazines, women's primary interests in life appeared to be shiny kitchen floors, wholesome and home-cooked family meals, and their appearance, images that seemed mired in female fantasies of the 1950s. Feminists challenged the image of woman as mother and helpmate-playmate to her husband, arguing for representations of women that showed their diversity, complexity, and autonomy. However, from the beginning of the women's movement, the print media had been actively covering feminist activism with a mixture of dismissive humor and appreciation. Politically oriented magazines such as *Newsweek*, *Time*, and the *Atlantic Monthly*, as well as women's magazines like *Ladies Home Journal*, *Mademoiselle*, and *Seventeen*, covered the movement, spreading its ideas to thousands of readers otherwise untouched by feminist ideas. Feminists were quick to take advantage of the media coverage and tried with mixed results to communicate their vision of women. New York radical women capitalized on the huge amount of media outlets centered in the city by staging protests and other attention-garnering activities designed explicitly to win media coverage. The most famous of these was the March 1971 takeover of the *Ladies Home Journal* by over one hundred feminists. The eleven-hour takeover resulted in the publication of an eight-page supplement titled "The New Feminism" in the August edition that went out to the journal's sizable readership.

While they called for less sexist and sexualized images of women in the media, feminists looked for ways to improve the institutional status of women in journalism. They called for the end of sex discrimination in hiring and promotion in news and magazine organizations. In the 1970s, women filed complaints of sex discrimination against *Newsweek* and *Time*. Feminists also tried to support women journalists by seeing them as "natural" allies in their struggle for equality. Radical feminists protesting the Miss America pageant in 1968 refused to talk to any male reporters (see Chapter 21).

Finding themselves riding a wave of media interests in the new movement, feminists had a hard time controlling the ways they and their ideas were represented. Media coverage tended to legitimate feminist complaints of economic discrimination because of the statistical strength of the assertion and because the message fit neatly with the view of the United States as a society based on equality. Yet media coverage of individual feminists, particularly young and more radical women, cast them as angry, man hating, and ugly. The media coverage of the women's movement moved between casting it as a joke and taking it seriously. Whether feminism was a joke or not played itself out throughout the late 1960s and 1970s in a wide venue of ways, from athletics to politics.

In an effort to combat the discriminatory representation of women, activist and journalist Gloria Steinem in 1972 founded the first glossy women's magazine run by women and committed to feminist goals, *Ms.* magazine. Steinem had worked as a journalist in New York in the 1960s and had been active in liberal causes and in the Democratic Party. Steinem's feminist concerns were first sparked when she went to a meeting of the Redstockings, a New York women's liberation group. Although she went as a journalist with the intention of writing a story about the group, she found herself deeply moved by the stories the women told, particularly of the dangers of

illegal abortions. In 1971, she joined Bella Abzug, Shirley Chisholm, and Betty Friedan to form the NWPC, encouraging women's participation in the 1972 election. Steinem herself was active in the National Democratic Party Convention in Miami that year, fighting for an abortion plank in the party platform and challenging the seating of delegations that included mostly white males. Those efforts drew attention to the issue of underrepresentation of women in politics and the centrality of political issues for women's lives. In 1972, Steinem, as part of the Women's Action Alliance, gained funding for *Ms*. The preview issue sold out, and within five years *Ms*. had a circulation of five hundred thousand. As editor of the magazine, Steinem gained national attention as a feminist leader and became an influential spokesperson for women's rights issues.

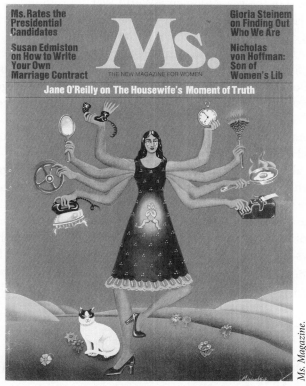

Ms. Magazine.

In an effort to combat the discriminatory representation of women in the media, activist and journalist Gloria Steinem founded the first glossy women's magazine committed to feminist goals, *Ms*. magazine in 1972.

Television also covered the women's movement, as well as the other social protest movements of the 1960s, through situation comedies and family dramas. The first television show that dealt with feminism was the enormously popular Mary Tyler Moore Show, which debuted in September 1970. In the show, Mary Richards, a single woman, negotiated her work life through the very same skills most women applied to their

families: caretaking and listening. Maude debuted in 1972 and addressed such once-taboo issues as abortion, menopause, and bankruptcy. The first divorced woman to star in a sitcom appeared in *One Day at a Time* (1975), a sitcom that followed the newly divorced Ann Romano as she began a new life with her two teenage daughters. These shows introduced the ideas of women's liberation without demanding fundamental change to U.S. gender roles. At the same time, the characters represented a new kind of television heroine who assumed she would work, as well as parent, and for whom marriage did not represent a lifetime of security.

Conclusion

Women's activism in the years following World War II profoundly changed U.S. society. The civil rights movement challenged the long-standing view that segregation could exist in a democratic society. Civil rights activists argued that segregation, be it based on race or gender, created inequality, and they called on the federal government to use its force to uphold basic rights and equal opportunity for all Americans. The generation of activists who directly confronted Jim Crow segregation at schools, at lunch counters, and on buses discredited, at last, the legal doctrine of separate but equal.

The movement to end racial discrimination started a wave of reform movements, including liberal feminism, that reinvigorated debates about equality, opportunity, and democracy for all citizens. Liberal feminists forged political organizations that pressured the government to outlaw gender discrimination, while a generation of women entered state, local, and federal government and the political parties themselves to ensure that change would come. The movement for women's equality spread out from its activist and reformist roots to reshape all aspects of U.S. life, from work and politics to television shows and athletics. Liberal women, from the civil rights, labor, and women's movements, watched as a new cohort of activists took the ideas of equality and citizenship they had so effectively promoted to a new moment of political engagement and conflict.

 Study the Key Terms for Civil Rights and Liberal Activism, 1945–1975

Critical Thinking Questions

1. What motivated women to participate in the civil rights movement? What did they do to bring about social change in their communities? In their cities? Nationally?

2. How did women petition the federal government to promote gender equality? What groups and organizations did women create?

3. How did women embrace liberal reform in these years? What did liberal women accomplish? What role did the federal government play?

4. Why are reproductive rights important for women's equality? How did women mobilize around this issue?

Text Credits

1. Interview with Diane Nash. Copyright © 2004 Washington University Libraries, Film & Media Archive, Special Collections. Reprinted by permission.

2. From *The Montgomery Bus Boycott and the Women Who Started It: The Memoir of Jo Ann Gibson Robinson*, edited with a Foreword by David J. Garrow, Copyright © 1987 University of Tennessee Press. Used with permission.

3. National Organization for Women, Statement of Purpose (1966), reprinted with permission from the National Organization for Women. This is a historical document and may not reflect the current language or priorities of the organization.

4. Equal Rights for Women by Shirley Chisholm, US House Representative from New York, Address to the United States House of Representatives, Washington, DC, May 21, 1969.

5. Johnnie Tillmon, Welfare is a woman's Issue, *Ms. Magazine* (Spring 1972). Reprinted by permission of *Ms. Magazine* © 1972.

Recommended Reading

Raymond Arsenault. *Freedom Riders: 1961 and the Struggle for Racial Justice*. New York: Oxford University Press, 2007. A detailed account of the freedom rides of 1961 and the dramatic events that surrounded them.

Vickie Crawford, Jacqueline Rouse, and Barbara Woods, eds. *Women in the Civil Rights Movement: Trailblazers and Torchbearers*. Orlando, FL: Carlson, 1990. An important anthology on the often overlooked or neglected contributions of women to the civil rights movement.

Sara Evans. *Tidal Wave: How Women Changed America at Century's End*. New York: Free Press, 2003. An important examination of liberal, radical, and multicultural feminist activism from the 1960s to the present. Evans is very strong on showing the involvement of feminists of color in liberal reform.

Cynthia Harrison. *On Account of Sex: The Politics of Women's Issues, 1945–1968*. Berkeley, CA: University of California Press, 1988. An examination of women's activism in political parties and reform, particularly the history of the Equal Rights Amendment.

Annelise Orleck. *Storming Caesar's Palace: How Black Mothers Fought Their Own War on Poverty*. Boston: Beacon Press, 2005. Orleck examines the political activism of poor women and their efforts to remake welfare in the 1960s, 1970s, and 1980s.

Jo Ann Robinson. *The Montgomery Bus Boycott and the Women Who Started It: The Memoir of Jo Ann Gibson Robinson*. Knoxville, TN: University of Tennessee Press, 1987. An account of the role of African American working women in the civil rights movement.

THE PERSONAL IS POLITICAL, 1960–1980

 Explore Chapter 21 Multimedia Resources

TIMELINE

1957	Supreme Court loosens obscenity standards in *Roth v. United States*
1959	The United States enters the Vietnam War
1960	The birth control pill becomes available Students for a Democratic Society founded
1961	Helen Gurley Brown publishes *Sex and the Single Girl*
1965	SDS organizes a massive antiwar march
1966	Transgender women fight San Francisco police at Gene Compton's Cafeteria
1967	Women begin meeting in small consciousness-raising groups Hippies stage a "human be-in" in San Francisco Jane, an underground abortion service, forms
1968	Feminists protest the Miss America Contest The Jeannette Rankin Brigade coins the phrase "sisterhood is powerful" The Third World Women's Alliance forms
1969	Woodstock festival takes place California adopts no-fault divorce laws Stonewall riot occurred in Greenwich Village, New York Chicana feminists form Las Hijas de Cuauhtemoc Women Artists in Revolution founded
1970	The Boston Women's Health Book Collective publishes *Our Bodies, Ourselves* Chicana feminists form Concilio Mujeres The Presidential Commission on Obscenity and Pornography liberalizes the definition of *obscenity*

1971	Feminist Art Program begins at Fresno State College
1972	The Women's Caucus for Art holds its first conference
1973	The Supreme Court legalizes abortion in *Roe v. Wade* The American Psychological Association removes homosexuality from its list of psychological disorders First Chicana feminist journal, *Encuentro Feminil,* begins publication
1974	Larry Flynt publishes *Hustler*
1975	The National Women's Health Network founded Vietnam War ends
1976	Maxine Hong Kingston publishes *The Woman Warrior*
1978	The first report issued on the "feminization of poverty"
1979	Judy Chicago's *The Dinner Party* opens in San Francisco

As in the 1920s, U.S. women in the 1960s and 1970s found themselves facing a revolution in morals and manners. Heterosexual couples opted to "live together" before getting married. The double standard that endorsed sexual experimentation for men but not for women faded, helped along by the birth control pill that became available in 1960. Changes in divorce laws made it easier to end marriage. First young people but soon middle-aged Americans adopted a spirit of experimentation and embraced personal growth in the quest for relevance and vitality in their lives. Cold War gender conformity, once seen as markers of health and maturity, was now seen as "square" and "uptight," no longer in the spirit of the times.

The turn toward self-discovery in what some commentators called the "me generation" took place against a backdrop of social protest and the escalating war in Southeast Asia, a war justified by presidents Kennedy, Johnson, and Nixon as crucial in the U.S. battle against the spread of Communism. The civil rights movement of the 1950s and 1960s, which had confronted people in the United States with the ongoing reality of racism and inequality, entered a more militant Black Power phase, changing the role of young black women in the movement. The liberal feminist movement that built on the political accomplishments of the civil rights movement brought awareness to the restrictions on women's equality based on gender, and its successes inspired a younger generation of women of all races to embrace a more "radical" style of feminism. Adding to the ferment of social protest was the growth of the New Left, the student-led protest movement against U.S. involvement in the Vietnam War that helped end it in 1975.

At the same time, broad economic forces also shaped changes in family and had profound consequences for women. The affluence that had characterized the post–World War II period came to an end as high inflation and ongoing recession stalled the

nation's economic machine. An oil crisis in 1973 only worsened the economic picture and added pressure to U.S. families already rocked by generational and gender conflicts. By decade's end, working-class and poor women found that the dreams of equality nurtured by a decade of civil rights activism and feminism did little to help lift them out of the poverty or help combat economic insecurity. The spirit of experimentation and political engagement of the late 1960s appeared to have disappeared into what President Jimmy Carter described in 1979 as the "malaise" that had settled over the nation.

SEXUAL REVOLUTIONS

Family life in the 1950s had been celebrated as the bulwark against Communism and the source of U.S. values. But by the mid-1960s, a renewed celebration of youth, individualism, and autonomy swept over the country and pushed family life out of the rhetorical center it had enjoyed. Sexual expressiveness and experimentation became central values of the new lifestyle revolutions. The Supreme Court advanced the liberalizing of sexuality by further narrowing the definition of *obscenity*, which resulted in the rapid growth of sex-related businesses and more sexualized images of women to adorn advertisements, movie posters, and magazine covers. Gay men and lesbians launched a movement for equal rights and against discrimination based on sexual preference. Changing standards of heterosexual behavior and new tolerance for homosexuality combined to create a sexual revolution.

Liberation for All

If the United States' favorite bachelor in the 1950s was *Playboy* magazine founder Hugh Hefner, its favorite single woman in the 1960s was Helen Gurley Brown, author of the 1961 best-selling book *Sex and the Single Girl* and editor of the revamped *Cosmopolitan*. Echoing a message similar to the one found in *Playboy*, she told her readers to enjoy all the pleasures being free and single could give them, without becoming ensnared in romance and marriage. Brown tutored her readers in how to dress for sexual success, how to enjoy restaurants and nightclubs without paying a cent, and how to manage "the affair" with a married man. Brown made actions once viewed as acceptable for bachelors only as signs of sophistication and glamour for single women.

Prosperous urban Americans in the 1960s created a new kind of singles scene. Once informally structured through friends, single life became organized through commercial venues like restaurants, singles bars, and parties that were advertised in city newspapers. Guidebooks and computer dating services serviced the same desire, to date and mate, but not necessarily to find "Mr. Right." Unlike the young working-class women in the turn of the century whose appearance at commercial dance halls shocked respectable onlookers, the young women who went to singles bars and used dating services were not pitied. They very quickly became, according to one commentator, "a new, privileged, spotlighted, envied group." These young urban women adorned themselves with the symbols of single life—clingy blouses, miniskirts, and boots or shoes that set off bare legs.

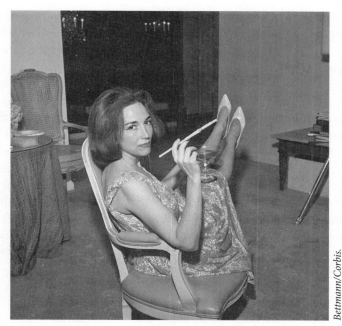

Bettmann/Corbis.

Helen Gurley Brown—author, editor, and responsible for the rejuvenation of *Cosmopolitan* magazine, which stated a philosophy—that women could be smart, sexy, and without the ties of husband and children—intriguing to women of the 1960s.

While some young singles embraced consumerism in their quest for sexual liberation, others broke from the materialism of the postwar period. Hippies found countercultural ways to reach ecstasy, mainly through music, drugs, and an ethos of "free love." Young women experimented with alternative group-living situations and explored open relationships in an attempt to "smash monogamy." Living in communes in western cities like San Francisco and in rural areas such as northern Vermont, hippies abandoned sexual restraint and their allegiance to the nuclear family. They made their own rituals, like the 1967 "human be-in," modeled on civil rights' sit-ins, and focused on changing consciousness through drugs and intimacy. Twenty thousand people attended the be-in, making San Francisco the epicenter of the **counterculture**. Many of the participants stayed, creating the Summer of Love and catapulting hippies and flower power to national attention. But no rituals were as historic as the concert that took place in August 1969 when five hundred thousand young people converged in Woodstock, New York, for a three-day rock festival that included female singers Joan Baez and Janis Joplin.

All lifestyle revolutions were aided by the introduction of the birth control pill in 1960. Young women who came of age during the sexual revolution found the pill was part of a larger change in their path to sexual maturity. In the 1920s, young women shocked their elders when they kissed men they might not marry, but strict guidelines remained that kept female sexuality firmly in marriage. By the 1960s, the commitment

to marriage was no longer the gateway to sexuality. Young Americans lived together with their boy or girl friends before they married. The decision to live together without marriage was one of the sharpest parts of what social commentators called the "generation gap."

Married couples were not impervious to the new attention placed on "liberating" sexuality. As in the 1920s, marriage experts viewed sexual satisfaction as a crucial ingredient to marital happiness. The most famous team of sex experts in the 1960s was that of William Masters and Virginia Johnson. While one of their goals was to help define *sexuality* as a healthy human trait and the experience of sexual pleasure and intimacy as socially acceptable, they also provided new information about female sexual response, doing away with the notion of women as less sexual than men. Other sex experts soon followed, opening treatment programs, sponsoring couples weekends, and publishing self-help manuals. *The Joy of Sex* by Alex Comfort and *Everything You Always Wanted to Know about Sex: But Were Afraid to Ask* by David Reuben became best sellers, at last replacing Theodore Van de Velde's 1926 *Ideal Marriage* on night tables across the country.

Obscenity Redefined

The Supreme Court set the stage for the explosion of the business of selling sex through a series of rulings that narrowed the definition of *obscenity*. Between 1957 and 1967, a number of obscenity cases came before the Court, which responded by affirming the right for adults to consume and use sexual materials and images. In the 1957 *Roth v. United States* decision, the Court stated that "sex and obscenity are not synonymous" and only materials that appealed to "prurient interest" could be prosecuted. In rulings like these, the Court did away with the remnants of Comstockery.

In response to these rulings, more sexualized imagery became a part of daily life. The pornography industry quickly grew more visible and accessible. Thousands of movie houses featured X- and triple-X-rated films. Adult bookstores displayed hardcore sex magazines and paperbacks. Larry Flynt's *Hustler*, started in 1974, offered readers full frontal nudity. The introduction of the videocassette recorder, or VCR, in the late 1970s opened a booming business of sex films for home use. But the effect could be felt in mainstream popular culture as well. In 1967, Hollywood dropped the Production Code that had been in place since 1934 and instituted a film-rating system that specified the suitability of a movie for younger audiences. The number of films released with "R" ratings, suitable for audiences over the age of 17, skyrocketed from 25 in 1968 to 276 in 1973. Sexually explicit novels like William Burroughs's *Naked Lunch* (1962) and poems like Allen Ginsberg's *Howl* (1957) became best sellers.

To assess the effects of the mainstreaming of pornography, President Johnson appointed the Commission on Obscenity and Pornography in 1967. Its final report, issued in 1970, concluded that "interest in sex is normal, healthy [and] good." It called for the repeal of all federal, state, and local laws against the showing and selling of pornographic films, books, and other materials to adults while also acknowledging the need to shield pornography from minors. Not all people in the United States agreed

with the report's findings. President Nixon, elected in 1968, denounced the report as "morally bankrupt." Yet, by the 1980s, economists regarded the "sex industry" as a multibillion-dollar business.

The growing tolerance for sexual imagery in public had mixed consequences for women. Women rarely owned or managed sex-related businesses but remained poorly paid employees of an industry that depended on the display of their bodies. Yet the influence of the growing pornography industry could be seen beyond the red-light districts. Scantily clad women appeared in more advertisements selling cigarettes, liquor, and cars. It became more fashionable for women to show more skin. Both feminist and conservative critics complained that these sexualized images taught girls and women that their value lay in their sex appeal. Others viewed sexually explicit images as expressions of women's greater freedom to be as sexually expressive as they wanted. Obscenity and pornography became political flashpoints.

Gay Liberation

The sexual revolution also reshaped the experiences of gay, lesbian, bisexual, and transgendered Americans in intimate and public ways. For much of the century, homosexual men and women had chosen to remain "in the closet," hiding their true sexual identities from almost everyone, often including their parents, siblings, and coworkers. In the social activism of the 1960s, gays and lesbians began to speak out for their own rights to live their lives as they wanted, without risking harassment or arrest.

The first major protest took place on a hot summer night in 1966 in San Francisco's Tenderloin district, when a group of transgender women and gay street hustlers who socialized at Gene Compton's Cafeteria fought back against the police harassment they regularly faced. Transgender patrons threw bottles, tables, and chairs against windows and set a police car on fire. A second and more widely publicized riot took place three years later on June 28, 1969, when police raided the Stonewall Inn in New York City's Greenwich Village neighborhood. Rather than enduring the harassment as they had in the past, the two thousand patrons hurled insults and debris at the police. Announcing the birth of a new politics of sexuality, the slogan "Gay Power" appeared in graffiti on buildings and sidewalks across Greenwich Village.

By 1970, more than 150 gay activist groups had been organized. College students in the United States and Canada formed local Gay Liberation Fronts and Gay Activists Alliances. They created new magazines such as the *Advocate* and *Out* to serve the homosexual community. Gay-pride parades became yearly events commemorating the events of Stonewall. Thanks to a persistent campaign of gay and lesbian activists, the American Psychological Association removed homosexuality from its list of psychological disorders in 1973. Prominent lesbian feminists Ti-Grace Atkinson, Rita Mae Brown, and Karla Jay experienced their political awakening at this time, and even the confrontational Daughters of Bilitis, a homophile organization founded in the 1950s, found itself radicalized by the surge in gay activism.

The **sexual revolution** of the 1960s and 1970s changed the understandings of both homosexuality and heterosexuality for women. For gay and straight women, sexual

experimentation became an important expression of their generational identities. However, new freedoms did not do away with old patterns of gender discrimination. Women's experiences of the sexual liberation of the 1960s were not all positive, a discovery that led many young women to feminism.

Read about **Lesbians in the Civil Rights Movement**

Joan Nestle[1] recalls participating in the civil rights movement as a white Northern woman and the inspiration she drew from the bravery of ordinary men and women who put their bodies on the line to vote. Yet, as she describes in her memoir, Nestle felt compelled to keep her homosexuality hidden from her activist peers.

Review the source; write short responses to the following questions.

1. Did Nestle suggest commonalities between the struggle for equality of African Americans and that of gay and lesbian Americans?
2. What was the "double mask" Nestle felt she donned in the early 1960s? In what ways did her identity as a white woman mask her lesbianism?
3. Why did Nestle refer to her lesbianism as seeming like "a little thing"?

WOMEN'S LIBERATION

Second-wave feminism, which emerged out of the civil rights movement, the labor movement, and liberal reform, also had roots in the student New Left and Black Power (see Chapter 20). For younger women coming into new consciousness about the role of gender in their lives, politics and private life were difficult to separate. They developed a distinctive analysis of sexism by exploring the politics of private life.

Women of the New Left

Angered by U.S. involvement in an escalating war in Vietnam and inspired by the civil rights movement, college-age students formed a student antiwar movement called the **New Left**. The New Left was a loosely connected network of campus groups that sought not only an immediate end to the war but also broad and wide-reaching reforms of U.S. society. New Left radicals, male and female, opposed racism at home and imperialism abroad and called for a more just distribution of wealth among all Americans. The main organization of the New Left, **Students for a Democratic Society** (SDS), held its first meeting in 1960 in Ann Arbor, Michigan.

Women were drawn into the New Left by concerns over the war in Vietnam and the powerful combination of military and industrial interests that supported it. Even if they could not be drafted, many women felt keenly that their generation was being sent to fight in a war they did not support. In April 1965, the SDS organized twenty thousand protesters to converge in Washington, D.C., to demonstrate against the war.

By 1969, nearly two million Americans protested the war through demonstrations, marches, and antiwar events. By 1970, the antiwar movement shut down college campuses in what *Time* magazine called "a nationwide student strike."

As the war dragged on, more mothers, sisters, and girlfriends of soldiers joined the antiwar movement. Even family members of prisoners of war began demanding immediate withdrawal of U.S. troops. For soldiers and the ten thousand nurses serving in the military, such calls were often painful. On the opening day of Congress on January 15, 1968, a coalition of women's peace groups called the Jeannette Rankin Brigade staged a protest in Washington, D.C., to show women's opposition to the war. Five thousand women attended, the largest gathering of women for a political purpose in decades. The Brigade, named in honor of the first woman elected to the U.S. Congress and who had cast her vote against both World War I and World War II, was the brainchild of **Women Strike for Peace** (WSP), a group formed in the 1950s to protest nuclear weapons that had evolved into an antiwar network for liberal women. Older and younger women, both liberal and radical in their politics, participated in the demonstration. However, a group of more radical women disliked the link WSP activists drew between motherhood and antiwar activism, finding it too traditional for their liking. Over thirty women staged a counterdemonstration over the following two days. The protest was the first time where the slogan "sisterhood is powerful" was used.

Women activists grew angry at the sexism they experienced in their antiwar activities and complained that they were assigned to do the tedious movement work of stuffing envelopes, making coffee, and typing instead of participating in decision making. In 1965, SDS activists Mary King and Casey Hayden, wife of Tom Hayden, mailed a long memo to forty women protesting what they saw as the existence of a "sex caste" system in a movement supposedly committed to equality and democracy. When activist women raised the issue of women's equality, they were met with indifference, ridicule, and anger. Disrespect from male political allies motivated radical women to form a separate movement for women's liberation.

Read "A Vietnam War Nurse Writes Home"

Lynda Van Devanter[2] (1947–2002) served as a U.S. Army nurse at the 71st Evacuation Hospital in Pleiku, Vietnam, from 1969 to 1970. In 1979, a year after the founding of Vietnam Veterans of America, she helped launch and became the head of Vietnam Veterans of America Women's Project. In this letter written to her parents in 1969 from Pleiku Air Force Base, Lynda explains her feelings of patriotism and her ambivalence over the antiwar movement at home.

Review the source; write short responses to the following questions.

1. What makes the antiwar movement painful for Lynda?
2. What gives Lynda the conviction that "nobody can tell me we don't belong here"?
3. What does Lynda mean when she says "fight fire with fire"?

📖 Women's Liberation Movement

As common as the experience of sexism was, radical women found that there was much that divided them. The radical women's groups that formed in the late 1960s, referred to as the **women's liberation movement**, differed from each other in orientation, political analysis, and strategy. "Politicos" or socialist feminist groups such as Bread and Roses in Boston, the Chicago Women's Liberation Union, and New York's WITCH analyzed women's condition through economics. These groups maintained close ties with the New Left while calling for an end to sexism within it. Another faction was called simply "feminists." Feminists pioneered an analysis of sexuality and private life. Groups like the New York Radical Feminists, Redstockings, and Cell 16 argued that women's oppression predated economic systems like capitalism and that sexism and control over women were embedded in all political systems. Radical feminism, as it came to be known, was never a coherent and centralized movement but rather a ground swelling of various politically active women who organized themselves, built temporary coalitions among groups, and articulated new theories of women's oppression.

Review the sources; write short responses to the following questions.

Gloria Steinem, *Statement to Congress* [1970][3]
Redstockings Manifesto [1969][4]

1. What "legal and social discrimination" did Gloria Steinem describe having endured during her statement to Congress?
2. What are some of the "same-sex myths" that Steinem describes?
3. How does the Redstockings Manifesto describe the status of women in the United States?

📖 Black Feminism and the Birth of the "Feministas"

Feminists within the **Black Power movement** also reacted to the sexism of their male peers and felt the need for their own liberation movement. The black feminist movement began when Frances Beal and others formed a women's liberation group within the Student Nonviolent Coordinating Committee (SNCC) but broke away to form the Third World Women's Alliance (TWWA) in 1968 when they could no longer support the SNCC's calls for women to step back from leadership positions. The TWWA accused black militant men of "being white" and middle class when they expected black women to be "breeders" for the revolution. By November 1970, the TWWA had grown to two hundred members, including Puerto Rican and Asian American women, and had established connections to white radical feminist groups.

Black feminists found themselves navigating ties to both Black Power and women's liberation movements. Many black women hesitated working with white feminist groups that did not recognize race and class as feminist issues and were wary of

alliances with white women who had not educated themselves enough to understand other women's experiences and political priorities. Issues of family life, including birth control and abortion, had different meanings for white and black feminists. At the same time, many in the Black Power movement saw feminism as a "white" movement and viewed black women who embraced it as traitors to the cause of black liberation. Black women—but not *just* black women—could organize based on their own experiences of the multiple forms of oppression they faced. By acknowledging differences among women, feminists could form coalitions among diverse groups of women, each using feminism in their own community-specific way.

Like their white and black peers, Latina and Chicana women in the 1960s discovered their men were slow to support their feminist aspirations. Chicana feminists confronted the view that they ought to return to domestic roles as wife and mother to protect their unique cultural heritage—and resist Anglo society. By doing so, they could restore a strong sense of masculinity in their men whose experience of racism undermined their authority and status. Chicanas in the movement found themselves increasingly marginalized, ignored at political meetings, given clerical tasks, and shut out from decision making and had to fight against a view of feminism as Anglo and not relevant to their communities or to their political struggle.

In 1969, Chicana feminists formed Las Hijas de Cuauhtemoc at Long Beach State University in California and, in 1970, Concilio Mujeres at San Francisco State College. Campus groups participated in the underground abortion movement and worked on community welfare rights issues. In 1973, Las Hijas's newspaper became a national Chicana studies journal, *Encuentro Feminil* (Women's Encounter/Meeting). Chicana feminists refused to allow their gender and race activism to be separated.

While many Chicana feminists were sympathetic with what they called Anglo and black feminism, they remained wary of building alliances. Reluctant to bring on more conflict with their movement brothers, yet fed up with dealing with unchecked machismo, Chicanas cultivated their feminism within the larger Chicano movement. Black feminists provided useful models for producing culturally specific ideas about gender, and they applied them to strengthen, not sever, connections to their male peers. Most activism in the 1970s took place within women's caucuses of larger groups and within community organizations.

Review the sources; write short responses to the following questions.

National Black Feminist Organizations, *Manifesto* [1974][5]
Chicana Demands [1972][6]

1. Compare the structure of the two documents. What issues are of most important to Chicana women? Black feminists?

2. According to black feminists, what are the various characterizations that have existed for black women throughout the years in American society?

The Woman Warrior

Asian American women forged a place for themselves in the era's social protest movements. Asians who immigrated to the United States after the Immigration and Nationality Act of 1965 were well educated, affluent, and willing to organize to ensure equal opportunity for themselves. Most settled in East and West Coast cities. As the myth of the high-achieving Asian immigrant—the "model minority"—took hold, Asian American women found themselves in an uneasy relationship with Latinas and African American women, making feminist alliances around racial discrimination difficult. Coastal communities of Asian American feminists emerged in the 1970s, like Unbound Feet in San Francisco and the Basement Workshop in New York City. Asian Pacific women's conferences took place in New York, Hawaii, and California in the late 1970s, helping to consolidate networks of activist women.

Leaders of the Asian American women's movement such as poet Mitsuye Yamada provided crucial connections between earlier generations of Asian American women who prioritized assimilation into U.S. society and a younger generation of women eager to preserve their cultural distinctiveness. Yamada was born in Japan in 1923 and immigrated to Seattle in 1926. At the outbreak of World War II, Yamada was interned with her family in Camp Minidoka, Idaho, until she and her brother left the camp to work and attend college. When people of Asian origin were granted the right to become U.S. citizens with the passage of the Immigration and Naturalization Act of 1952 (the McCarran-Walter Act), Yamada became a naturalized citizen of the United States. She became a writer to encourage other Asian American women to speak out.

A burst of Asian American women's writing followed, capturing the unique experiences of growing up Asian and female in the United States. Maxine Hong Kingston was born in 1940 in Stockton, California, where her parents operated a laundry. After graduating from Berkeley in 1962, Kingston became active in the antiwar movement. That same year, she moved to Hawaii, where she taught English and wrote *The Woman Warrior*, which was published in 1976 to great acclaim. *The Woman Warrior* told the stories of five women: "No-Name Woman"; a mythical female warrior Mu Lan; Brave Orchid, Kingston's mother; Moon Orchid, Kingston's aunt; and, finally, Kingston herself. The chapters integrated Kingston's personal experiences with a series of talk-stories—spoken stories that combined Chinese history, myths, and beliefs—that her mother told her.

The young women—white, black, Chicana, and Asian—who embraced feminism cultivated a new definition of politics. Radical feminists understood power as a relationship enacted between differently situated people, not only as decisions made in Washington, D.C., by elected officials. This expansive definition of politics and power enabled feminists to connect intimate relationships that lived outside the public eye to larger structures of power.

PERSONAL POLITICS

One of the most famous slogans to emerge from the radical feminism in the 1970s was "**the personal is political**." While changes in laws and legislation were important,

legal, political, and economic transformation could not be achieved and, indeed, were not possible without the full liberation of women from the internalized confines of femininity. Laws alone could not wipe out generations of gender practices that taught women to curb their intelligence, assertiveness, and sexuality. As women met in small and large groups to understand their status as women in a patriarchal society, the female body and sexuality became focal points for feminist thoughts and revolution.

Rethinking Heterosexuality

Called "radical" for its critique of men, heterosexuality, and the nuclear family, an analysis of sexuality that insisted that the personal sphere had political significance was pioneered by feminists. To explore this dynamic, radical feminists promoted the practice of **consciousness raising**, modeled on the Chinese practice called "speaking bitterness." Between 1967 and 1975, thousands of small groups formed to raise their consciousness about sexism by voicing their private fears, discussing their intimate relationships, and sharing their experiences as women. The interrogation of private life for the symptoms of male dominance was the vehicle through which radical feminism politicized "the personal."

To dramatize the confining aspects of sex roles, radical feminists turned to street theater and other media-oriented events. One of the more outrageous protests came in 1968 when a group of feminists picketed the Miss America pageant in Atlantic City to show how women are degraded and judged as sex objects. Using the confrontational style of civil rights and other protest movements, demonstrators outside the hall drew attention to the sexual objectification of women by ridiculing the beloved pageant. They crowned a live sheep "Miss America" and filled a "freedom trash can" with items of "female torture" like curlers, bras, girdles, and high-heeled shoes. Protesters linked standards of female beauty to women's political oppression, explaining that all women, not just Miss America contestants, were "forced daily to compete for male approval, enslaved by ludicrous 'beauty' standards we ourselves are conditioned to take seriously." Miss America, as an icon of white womanhood, "represents what women are supposed to be: inoffensive, bland, apolitical."

The New York group Women's International Terrorist Conspiracy from Hell (WITCH) staged one of the more dramatic examples of feminists' public consciousness-raising events. Dressed as witches, the group stormed a bridal show held in New York's Madison Square Garden in 1969, warning brides against marriage by singing "Here come the slaves/off to their graves" and then releasing live white mice into the hall. Other actions included a "whistle-in," which involved groups of women whistling and catcalling to men walking on the street and defacing billboards that represented women as sex objects. In actions like these, feminists pioneered a political analysis of private life, exposing the pervasiveness of male dominance and privilege.

Radical feminists embraced "the personal is political" to argue that the intimate and domestic spheres were the arenas where power relationships between men and women were played out. As such, what took place in private between couples and within families must be analyzed as part of the larger system of male dominance. They argued that through the experience of growing up female, women were trained for the job of being

a submissive wife and taught to feel subservient to their husbands in all arenas of life, including the sexual. In her article "The Myth of the Vaginal Orgasm" (1969), Anne Koedt argued that the legions of marriage counselors constructed the myth of the vaginal orgasm and the myth that women did not enjoy sex as a way to justify male power in heterosexual relationships. Women, according to Koedt, could enjoy sex as much as men, but only if their male partners understood that women might want more than missionary-style intercourse. Kate Millett, author of the best-selling *Sexual Politics* (1970), argued that a long history of patriarchy and sexism had undercut the promise of sexual liberation for women. While the sexual revolution granted women the right to say yes to sex, radical feminists insisted that sexual freedom also depended on the right to say no. Sexual self-determination became a feminist goal in the late 1960s, intended to empower every woman to claim more rights over her own body and desires. For some women, this meant withdrawing from men temporarily, experimenting with lesbianism, and questioning the authority of male experts. Radical feminists created networks of women's shelters to give women and children a place to stay as they left abusive husbands and boyfriends. They held speak-outs on rape to raise the awareness of the legal obstacles women faced when they pressed charges against their attackers and on the dangers of illegal abortion. They brought new attention to sexual harassment at the workplace, where generations of women had had little recourse against bosses, supervisors, or male peers who sexualized the workplace. In doing so, radical feminists pioneered the politics of sexuality.

Lesbian Feminism

An outgrowth of radical feminism, lesbian feminists extended the critique of heterosexuality to include a new understanding of lesbianism as a political and sexual alternative to heterosexuality and a way to fight patriarchal oppression. Lesbian feminists played a role in the women's movement that was larger than their actual numbers. Some radical feminists experimented for a few months or years with lesbianism, feeling that to not adopt a woman-identified life compromised their politics. Called "political" lesbians, these feminists adopted lesbianism as a political lifestyle. However, for some lesbians who felt that homosexuality was not a matter of choice, straight women experimenting with a gay lifestyle led only to confusion and resentment. Some straight feminists resented the idea that the only way to be a feminist was to be a lesbian and felt as if the lesbian-feminist agenda was taking over the movement. The split between straight and gay feminists widened in the mid-1970s, dividing the movement.

Lesbian feminists helped to create a feminist counterculture of bookstores, music festivals, and dances, all of which nurtured a thriving women's community. Women's bookstores and publishing houses grew in the 1970s. Run collectively and carefully to enact feminist values in such things as pay and decision making, the women's publishing industry flourished for a number of years and produced a new and much more positive literature on lesbianism. The synergy between readers and publishers in the lesbian publishing world was impressive enough to attract mainstream attention. Established presses began to bid on books that dealt with lesbian issues. By the end of the 1970s, every major publishing house in New York had published at least one novel or nonfiction book that represented lesbianism in a positive light.

Review the sources; write short responses to the following questions.

Lesbian Feminist Liberation, *Constitution* [1973][7]
National Organization for Women, *General Resolution Lesbian/Gay Rights* [1973][8]

1. What were the goals of the Lesbian Feminist Liberation as set forth in their constitution?
2. Summarize the National Organization for Women's general resolution in terms of lesbian and gay rights. Given what you know today about gay rights in the United States, have the goals been met?

View the Profile of <u>Kate Millett</u>

Kate Millett's 1970 best seller *Sexual Politics: The Classic Analysis of the Interplay Between Men, Women, and Culture* put radical feminism on the national map and made Millett a celebrity, despite the controversy surrounding her views. Millett's book was a mix of literary criticism and feminist theory, a combination that highlighted the connections between literary and social values. She argued that generations of women had learned about female sexuality from novels written by men who viewed them as sexual objects.

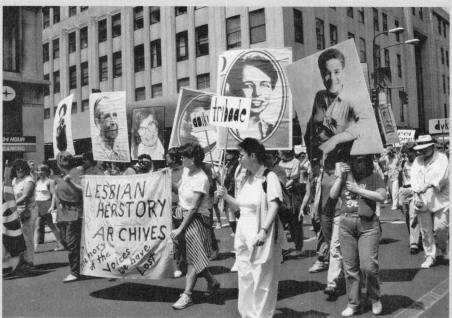

Pearson Education/PH College.

Representatives of the Lesbian Herstory Archives march with a banner beneath the portraits of various famous lesbians in a street in New York. An outgrowth of radical feminism, lesbian feminism extended the feminist critique of heterosexuality to include a new understanding of lesbianism as a political and sexual alternative to heterosexuality and a way to fight patriarchal oppression.

The Feminist Art Movement

Contemporary feminist art originated in the early 1970s, inspired by the women's liberation movement. Although women had increasingly swelled the enrollments of art schools in the middle of the century, very few had been successful in the transition from amateur to professional. Georgia O'Keeffe was the most well-known exception (see Chapter 16). Throughout the 1940s and 1950s, only a few female artists made a name for themselves in the all-male world of fine art in which galleries carried only one or two works by women. Influential art history textbooks routinely had neither the name nor the work of a single woman artist. Women of color were doubly discriminated against, with artists like Faith Ringgold told they could exhibit only in museums devoted to African American art. Adding to women's invisibility in the art world, only few women taught on the faculties of art schools.

By the early 1970s, the women's liberation movement inspired women artists, art educators, and activists to protest their marginalization at museums, galleries, and art schools. In terms of content, they also challenged what counted as "art." Women visual artists, art educators, and art historians formed consciousness-raising groups, woman-centered art education programs, women's art organizations, and cooperative galleries to provide women artists greater visibility.

In 1969, Women Artists in Revolution (WAR) was formed within the male-dominated Art Workers Coalition, a group of radical artists. WAR was triggered by the Whitney Museum's 1969 Annual, which included only 8 women among the 143 artists shown. WAR demanded that the museum change its policies to include more women. In 1970, Women, Students, and Artists for Black Art Liberation, led by artist Faith Ringgold, mobilized to bring more attention to the reality of gender and race discrimination in the art world. Together with the Ad Hoc Women Artists Group, such pressure proved effective. The percentage of women in the Whitney Sculpture Annual of 1970 rose to 22 percent, a big jump from the 5 to 10 percent of previous years. Feminist artists on the West Coast organized the Los Angeles Council of Women Artists to pressure the Los Angeles County Museum of Art to show more work of women. It also served as an important network for women artists, where artists shared their stories of discrimination and compiled statistics about sex discrimination.

The first program in feminist art was started by Judy Chicago and Miriam Schapiro at Fresno State College in 1970 and moved to California Institute of Arts in 1971. Using techniques like consciousness raising, students in the Feminist Art Program explored how "growing up female" had shaped and often limited women's artistic horizons. Feminist workshops explored the expression of "femaleness" in art in terms of shape, pattern, decoration, color, and texture. Students incorporated "female" materials like lipstick, sequins, pins, lace, and paper dolls into their paintings and constructions and emphasized the female body through work on menstruation, rape, sexual pleasure, and childbirth.

The **feminist art movement** was diverse in its goals. Some artists wanted to transform traditional fine art with feminist awareness. Other artists sought to

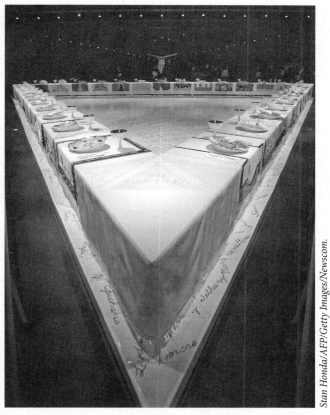

Stan Honda/AFP/Getty Images/Newscom.

Artist Judy Chicago's *The Dinner Party* (1976) became one of the most well-known works from the Feminist Art Movement of the 1970s. The Women's Liberation Movement inspired women artists, art educators, and activists to protest the lack of representation at museums and galleries and their marginalization at art schools. *The Dinner Party* challenged what counted as "art" with its use of handwork, needlework, and forgotten techniques of women's crafts (© 2008 Judy Chicago/Artists Rights Society [ARS], New York).

introduce aesthetics and values from non-European traditions or abandon object making in favor of performance art and video, questioning the division between craft and fine art. Many women artists sought to reclaim the female body from the sexualized and idealized representations that dominated the images of women created by men. Judy Chicago's well-known and controversial *The Dinner Party* (1979) installation was created collaboratively and celebrated women's traditional needlework. It also visualized a new women's history with each of its ornate settings devoted to a famous woman in history, including Sacajawea, Sojourner Truth, and Susan B. Anthony.

Throughout the 1970s and 1980s, the Women's Caucus for Art (WCA), created in 1972, held a series of conferences in which feminist artists debated if significant differences between the art of men and women existed and the value of separatist art

training for women. In 1979, the WCA inaugurated the first Honor Awards for Lifetime Achievement by women artists at the White House. The awards given included African American artist Selma Burke and Georgia O'Keeffe.

The Women's Health Movement

In the spring of 1969, a small group of women met at a workshop on "women and their bodies" at Emmanuel College in Boston, and several decided to continue meeting as a group, do research into specific areas of women's health, and put together a course on women's health. Out of this, the Boston Women's Health Book Collective formed and in 1970 published *Our Bodies, Ourselves*. Through the processes of research and discussion, the collective established themselves and, by extension, individual women as experts in their own right. Since 1970, 3.5 million copies of the book have sold in twelve languages. Throughout *Our Bodies, Ourselves*, the collective stressed that medical experts had rendered natural events like menstruation, childbirth, and menopause into medical conditions, alienating women from their bodies and their health care.

Our Bodies, Ourselves was a part of a growing grassroots **women's health movement** (WHM) sweeping across the country in the 1970s, fueled by social protest movements, struggles for reproductive rights, and consumer action groups. The feminist practice of "consciousness-raising" and "know-your-body" group experiences altered participants' outlooks on their bodies and their medical experiences and gradually helped them see these private events for the first time in political terms. In women's groups across the country, activists advocated gynecological self-examination, alternative remedies, fertility awareness, and basic body knowledge and sparked the formation of self-help groups. Natural childbirth and midwifery also returned as options to hospital births.

As with radical feminist groups, no single individual or group founded or fully represented the WHM. Women of various ages, races, and classes participated in their own groups. Latinas, black women, and Native American women knew firsthand about clinic care, illegal abortions, infant mortality, sterilization abuse, and population control and organized in response to issues most pressing to themselves and their communities. Feminist women's health centers in several U.S. cities provided women-controlled settings for self-help programs and, once abortion became legal in 1973, abortion services. Simultaneously, other women's communities across the country launched their own well-woman health and abortion centers as alternatives to conventional care.

The WHM focused on harmful drugs—specifically, the birth control pill that in its early days delivered unhealthy amounts of hormones. Activists also focused on unnecessary hysterectomies, ovariectomies, mastectomies, and sterilization. Reproductive rights activists in groups like the Coalition to End Sterilization Abuse in New York and the Coalition for Abortion Rights and Against Sterilization Abuse in California brought to national attention the racist pattern of forced sterilization against poor and minority women. Congressional hearings in 1972 revealed that sixteen thousand

women and eight thousand men had been sterilized with federal government funds, and more than three hundred of these patients had been under the age of twenty-one. In 1977, ten Mexican American women tried unsuccessfully to sue the Los Angeles County Hospital for obtaining their consent to be sterilized while they were in labor—and in English, when they spoke only Spanish. Bureau of Indian Affairs hospitals were particularly aggressive in their sterilization practices, with over three thousand women being sterilized between 1973 and 1976.

Outraged by the forced sterilization of poor women, mostly women of color quickly took up the issue of population-control practices. In the 1970s, the policies of the U.S. Agency on International Development made aggressive, high-technology birth control programs a precondition for loans and economic aid to Third World countries. When U.S. WHM activists realized their efforts were effective in protecting U.S. women by keeping dangerous or questionable drugs and devices off the U.S. market such as the "high-dose" pill, the Dalkon Shield IUD, and the birth control pill Depo-Provera, they saw these products simply dumped on Third World women who ran the risk of being harmed by these rejected products. By 1975, the National Women's Health Network was formed, the nation's first and only public-interest membership organization devoted exclusively to all women's health issues, especially those related to federal policy.

> ### Read "Women's Night at the Free Clinic"[9]
>
> This document was written in response to what many women saw as a male-centered approach to dealing with female medical issues. It describes what a woman-centered approach might be like.
>
> Review the source; write short responses to the following questions.
>
> 1. What was *Women's Night*? Why was it started, according to the authors?
> 2. What examples do the authors give for their support of *Women's Night*?

Abortion Activism

No issue defined the feminist politics of sexuality more than did abortion. The ongoing reality of illegal abortions and the dangers they posed to women mobilized a new wave of abortion activism in the mid-1960s. Abortion rights activists responded in two ways. One was to directly challenge abortion laws (see Chapter 20); the other was the creation of their own networks of underground abortion services. In Chicago, a group of women formed "Jane," a feminist network that helped women get abortions under more healthy conditions. Heather Booth, a student at the University of Chicago who had participated in sit-ins at Woolworth lunch counters in New York and in Freedom Summer in Mississippi, organized "the Service" in 1967, which provided abortions to

women without questioning the validity of their requests. In the beginning, Jane members transported women to doctors who would perform the operation. Yet, seeing that these doctors were not certified physicians, they decided to learn to perform abortions themselves. The Chicago Women's Liberation Union, a city coalition of women's liberation groups, advertised the Service through underground newspapers and by word of mouth. When a woman called the union about an abortion, she was given a phone number and told to ask for "Jane." Between 1969 and 1973, Jane provided over eleven thousand abortions. The women who went to the Service represented every age, racial, and ethnic group and every class.

On the eve of the Supreme Court case **Roe v. Wade** (1973), abortion law was a patchwork of different state laws. One-third of the states had liberalized abortion restrictions, and four had repealed them. Women with enough money could travel out of state to obtain an abortion if they wished so. Women with fewer resources still turned to illegal abortionists. More than one million illegal abortions were done every year during the 1960s. Of these, more than 350,000 women suffered complications serious enough to be hospitalized and between five hundred and one thousand died. In the court of public opinion, support for abortion rights had grown. In 1965, 91 percent of those polled opposed changing laws. In 1972, a Gallop poll reported that 64 percent of respondents said the abortion decision should be made by a woman and her doctor and not by legislators. The strategy to use the courts to establish abortion as a woman's right culminated in the Supreme Court's historic 1973 decision in *Roe v. Wade*. Justice Harry Blackmun, writing for the Court, maintained that the Fourteenth Amendment's definition of personal liberty included a woman's right to determine when or if to carry a pregnancy to term.

While *Roe*'s rights-based strategy triumphed, it had the paradoxical effect of weakening the political coalitions and institutions needed to sustain abortion as a matter of women's health. Opponents of abortion, unable to directly challenge *Roe* without a Constitutional amendment, used the language of rights established by *Roe* to chip away at federal health programs and the financial support and political shelter abortion received through them. In the years following *Roe*, opponents of legal abortion amended a wide variety of bills to restrict federal funding for abortion, in addition to monies for family planning and contraception services abroad. Medicaid funding became the central battleground. As one of the largest federal health programs and the one that provided health care primarily to young women, Medicaid provided between forty-five and fifty million dollars' worth of abortion funding in 1973. It was an easy target for conservatives because it was funded through annual appropriations processes. In 1976, Congress passed the Hyde Amendment, which excluded abortion from the comprehensive health care services provided to low-income people by the federal government through Medicaid. In 1980, the Supreme Court upheld the Hyde Amendment in *Harris v. MacRae* by declaring that the rights of women to obtain an abortion established in *Roe* did not require the federal government to fund abortion. Writing for the majority, Justice Potter Stewart stated, "[I]t simply does not follow that a woman's freedom

of choice carries with it a constitutional entitlement to the financial resources to avail herself of the full range of protected choices." Without a firm basis in federal health policy, the right to abortion conferred through *Roe* carried with it none of the institutional and political support needed to protect women's access to the procedure.

Review *"Roe v. Wade"*[10]

In 1969, a Texas woman known by the pseudonym Jane Roe challenged a Texas law that allowed abortions only to save the mother's life. In March 1971, the U.S. Supreme Court agreed to hear the case, known as *Roe v. Wade*. (Henry Wade was the district attorney of Dallas County, where Roe filed the suit.) On January 22, 1973, by a 7–2 vote, the Court held that a woman's right to an abortion fell within the right to privacy (recognized in the 1965 Supreme Court decision *Griswold v. Connecticut*) that was protected by the Fourteenth Amendment. The ruling awarded a woman total autonomy over her pregnancy during the first trimester and defined different levels of state interest for the second and third trimesters. *Roe v. Wade* exerted a tremendous impact throughout the country, as at the time of the ruling only four states had enacted laws guaranteeing a woman widespread access to an abortion. The abortion issue continues to be a major source of controversy within U.S. politics and society.

Review the source; write short responses to the following questions.

1. What states' rights did the Court confirm in its decision on *Roe v. Wade*?
2. To whom is left the decision regarding abortion at its earliest point in the pregnancy and why, according to the ruling?

The feminist politics of sexuality was far-reaching in its effects. From the women's health movement to abortion rights, women claimed the right to control their bodies and their medical treatment. From radical feminists reformulating the terms of heterosexuality to lesbian feminists who pioneered a positive view of lesbianism, women claimed their rights to sexual self-determination. Feminists politicized issues of sexuality and mapped them onto the political life of the United States.

FAMILY LIFE, ONE DAY AT A TIME

The politics of private life was shaped by economic transformations that, in turn, profoundly altered the formation of U.S. family life in the 1970s. Trends in married women's work that had begun at midcentury strengthened. In the beginning of World War II, only one-quarter of all women worked and the majority of those who did were married women over age thirty-five with no children at home. By the 1970s, working women and working mothers had become the new norm and they were motivated to

work not by a feminist goal of equality but because of broad economic downturn that brought the post–World War II affluence to an end. Women worked to support their families, be they middle or working class. However, the combination of low wages and changes in divorce law meant that women fell into poverty at higher rates than did men. During the 1970s, the number of poor families headed by women increased by nearly 70 percent.

Women at Work

While Betty Friedan suggested in 1963 that middle-class women could find personal fulfillment in careers, the majority of U.S. women who worked in the 1960s wanted to have two paychecks in the family so that they could buy more consumer goods. By the 1970s, women's wage work had become an economic necessity for most families. Middle-class families experienced a drop in their standard of living, driven by falling wages and the higher cost of living. The 1973 oil crisis, triggered when the Organization of Petroleum Exporting Countries placed an embargo on shipments of oil to the West, left the United States with skyrocketing fuel costs and the first gas shortage since World War II. The oil crisis set off economic recessions and high inflation. To make ends meet, Americans tightened their belts and more women took paid jobs. For the first time in U.S. history, there were more women in the labor force than out of it. As the Carnegie Council on Children observed in 1977, "We have passed a genuine watershed: this is the first time in our history that the typical school age child has a mother who works outside the home." The growing presence of married women and mothers in the workforce was accompanied by a declining birthrate. A study conducted by the Census Bureau found that while 26 percent of young wives had expected to have four children or more in 1967, the average family in 1972 now had only 2.3 children.

Two trends in women's work converged in the 1970s. The first was the impressive gain women made in the professions, caused by the expansion of women's postgraduate education. In the 1940s, 1950s, and 1960s, women entering medical, law, and business schools constituted 5 to 8 percent of their classes. With the legal gains of the 1970s, that percentage rose dramatically. By the mid-1980s, women made up more than 40 percent of all students entering traditional professional schools. Women who might have been secondary school teachers, nurses, or social workers were now able to command competitive salaries in law firms and business. Such gains did not mean that significant barriers to women's professional advancement had disappeared. Most professional women earned 73 percent of what men did.

Despite gains and advancements by professional women, the second and more persistent trend in women's work continued and made women workers more economically vulnerable. Sex segregation of the labor market, a feature of women's work throughout the century, continued to cap women's earnings. Furthermore, many of the new jobs created after 1950 were in the service sector, part of the gradual shift in the U.S. economy away from heavy industries and toward service work. Women were

perceived as particularly suitable for work in the service sector. Women stayed clustered in these sex-segregated female job classifications that paid less and had less opportunity for advancement. Eighty percent of all women workers worked in 5 percent of all jobs, the five lowest-paying jobs. For example, in 1970, American Telephone and Telegraph hired five times as many black women as it had in 1960, yet the jobs they held—clerical workers and telephone operators—were the lowest rung of the occupational ladder. Between 1955 and 1981, women saw their actual earnings fall from 64 percent of what men earned to 59 percent, meaning that women's earnings were barely sufficient to keep their family above the poverty level. Saleswomen earned only 50 percent of what salesmen earned, and waitresses 72 percent of waiters. The higher-paying jobs remained male controlled. Women made up only 6 percent of engineers, 3 percent of mechanics, and 1 percent of plumbers.

Long-term trends in the economy—specifically, the growth of clerical and service jobs—locked most women into low-paying jobs at the same time the impact of the women's movement opened new avenues for advancement in the professions. This set the stage for a widening wage gap between those women who had gotten out of the pink-collar ghetto and those who had not.

The "Second Shift"

With pressure from the women's movement still fresh, more women expressed concern of the pressures of the "**second shift**," the full-time domestic work women did when they came home. As one woman put it, "You're on duty at work. You come home, and you're on duty. Then you go back to work and you're on duty." While time studies in the 1970s found that men spent more time with their children, household work like cleaning and cooking remained women's domain. In a parallel to the wage gap working women faced, a leisure gap opened between husbands and wives.

Studies on time management in the 1970s showed that for the first time in fifty years, the average number of hours spent doing housework had declined—and for women in general, not only for working women. Whereas the Cold War media directed at women had expanded the duties of household management, in the 1970s, women's magazines stressed time-saving devices and a lowering of the high standards of bygone days. Between the mid-1960s and the mid-1970s, the amount of time spent on household work went from forty-four hours to thirty hours a week for full-time housewives and to twenty-one hours a week for employed women. Some of the change came from more efficiency and the setting of more realistic standards, but some came from the new idea that housework was the responsibility of all family members. However, while the survey reported that men increased the time they spent on domestic work from nine hours in 1965 to ten hours in 1975, women, who had done 80 percent of the housework in 1965, ten years later still did the lion's share of the work of maintaining the house—some, as much as 75 percent of it. While time spent on housework had declined since the 1950s, the length of a woman's workweek expanded. Major time

studies from the 1960s and 1970s documented that women worked fifteen hours longer each week than men.

While men did not do much more housework than their fathers, they did spend more time with their children. Studies found that men were psychologically more invested in their families than their jobs and that both parents spent more time with their children than they had earlier in the century. Fathering itself increasingly mattered for those men interested in liberating themselves from work to be more involved with their families. Fathers more regularly attended their children's births, and new attention was paid to the "fathering instinct."

In many respects, the situation of white, middle-class U.S. women in the 1970s became more like African American women for whom juggling work and family had long been familiar. Married black women were the original superwomen who managed the competing demands of being mothers and full-time wageworkers who suffered from both the wage and leisure gap. Middle-class women in the 1970s discovered the limits to the "superwoman" ideal. As married working women struggled with their multiple roles, more and more discovered how much harder it could be to be without a husband, no matter how little he helped around the house.

Marriage and Divorce

In *The Inner American*, three sociologists compared U.S. attitudes toward marriage and divorce in 1957 and 1976 and found a sea change had taken place. Only 33 percent of the public held negative views of the unmarried. Divorce had been upgraded from a sign of mental instability to "a viable alternative." The divorce rate that had slowly grown over the course of the twentieth century doubled between 1965 and 1975. California first adopted the no-fault divorce in 1969, virtually eliminating the adversary principle in divorce. Within four years, thirty-six states had made it an option. New divorce laws viewed both mothers and fathers as potential earners and caretakers, requiring that material assets be divided equitably and that alimony and child support be gender neutral and reciprocal. Women typically won custody. According to the National Children's Survey conducted in 1976 and 1981, two-thirds of divorced fathers had had no contact with their children for ten years. The number of U.S. families with a mother and father living together declined. In 1950, almost 80 percent of U.S. households contained husband–wife couples. By 1980, this had dropped to just over 60 percent.

While feminists had supported liberalizing divorce laws, many recognized women's vulnerability in an unequal socioeconomic system. The National Organization for Women (NOW) opposed the unilateral no-fault divorce statutes because such laws made it easy for men to legally abandon their families. While women found it easier to leave bad marriages in the 1970s, it did not improve their economic situations; in fact, men initiated divorce more frequently than did women. Divorced men experienced a 42 percent rise in their standard of living, whereas divorced women and their children experienced a 73 percent decline.

The connection between divorce and poverty for women in the 1970s translated into poor housing, few funds for recreation and education, and intense pressures on women's time and money. The unequal earning capacity of men and women and the unequal focus on the man's career during marriage meant that most divorced women in the 1970s found their economic situation far worse after divorce than that of their ex-husbands.

The Feminization of Poverty

The combination of divorce, which left women heading their own households; women's labor segregation in lower-paying service industries; and the ongoing slowdown of the U.S. economy left more women vulnerable to falling into poverty. In 1978, Diana Pearce, a visiting researcher at the University of Wisconsin, issued the first warning that poverty was becoming "feminized" in the United States. According to Pearce, almost two-thirds of the poor over age sixteen were women. Women's economic status had declined from 1950 to the mid-1970s, Pearce claimed, even though more women had entered the labor force in those years. Pearce blamed the **feminization of poverty** on the lack of government support for divorced and single women. She argued that, "for many the price of that independence has been their pauperization and dependence on welfare." Following Pearce's study, other population researchers blamed the feminization of poverty on changes in the family that had uncovered women's latent economic vulnerability. Among working-age adults, the growth of single-parent families was the crucial factor. The increase in divorce, coupled with the decline in marriage and age of marriage overall, meant that an increasing proportion of adult women were living separately from men and relying on themselves for economic support. Because women generally earn less than men, single women have a higher risk of being poor than single men.

The government had targeted poverty as a national problem in the 1960s. President Johnson's War on Poverty (1964–1968), part of the federal attempts to bring about greater equality among U.S. citizens, created a range of federal programs designed to end poverty in the United States. The Medicare program, which Congress approved in 1965, was a first step toward creating the system of national health insurance that liberals had been advocating since World War II. It provided federal funding for many of the medical costs of older Americans, and it overcame resistance to the idea of "socialized medicine" by making its benefits available to everyone at or over age sixty-five, regardless of need, and by linking payments to the existing private insurance system. A year later, the government extended the system to welfare recipients of all ages through the Medicaid program. These programs, like those of the New Deal, distributed federal funds through Aid to Families with Dependent Children (AFDC) and Social Security insurance. After 1970, the trends in AFDC and social insurance diverged sharply. Social Security pensions were raised and indexed to inflation in the early 1970s, and the value of these benefits continued to rise throughout the 1970s. In contrast, welfare benefits, which were not linked to inflation, peaked in the mid-1970s and then began to fall, due in part to high inflation in the later 1970s,

leaving mothers with shrinking support. Elderly women fell into poverty more frequently than did men, given that Social Security pensions for never-married women were lower, on average, than pensions for never-married men because women earn less than men while they are working and women live longer and alone more than men.

Poverty rates reflected the particular economic vulnerability of minority women. Working-class black women fell into poverty at higher rates than white women and were less able to use new programs to help pull themselves out of poverty. The percentage of female-headed households for African Americans was double that for white households and rose from 17.6 percent in 1950 to 40.2 percent in 1980. Black women who headed households were more likely to be young and separated rather than divorced, mothers of children under the age of eighteen, and unemployed—all which conspired to keep their earnings very low. Wives in two-parent black families had household incomes in 1981 of $19,620, whereas single women earned less than half that—$7,510 on average.

AFDC caseloads swelled as the tide of poverty rose, growing from 3 million in 1960 to 11.4 million by 1975. As President Jimmy Carter prepared to take office in 1976, he struggled to respond to the growing ranks of the poor. Sixty percent of wage earners and 94 percent of AFDC recipients still fell below the poverty line. A government report explained that only one-tenth of AFDC mothers were chronically unemployed, with 40 percent moving "back and forth between low-income employment and welfare," and 50 percent were on welfare temporarily.

The examination of the nation's growing poverty rates exposed the forces that uniquely conspired to push more women into poverty and onto welfare in the 1970s. Low wages paid to women, changes in divorce law that left women without financial support from ex-husbands, and more female-headed households pushed working and poor women into poverty. At the same time that middle-class women enjoyed the fruits of expanding opportunities for work, working-class and poor women struggled to keep their families fed and intact. Women with husbands and jobs, those of the middle and upper classes, found that their duties and responsibilities at home had not changed along with their work prospects. The second shift remained burdensome to a new generation of "superwomen" who "had it all."

CONCLUSION

The 1960s and 1970s brought a consolidation of gains made by women since World War II and were particularly visible in the realms of politics and education. The age of liberal reform and social protest came to an end by the 1970s, having achieved historic legislation, including the Civil Rights Act of 1964, the legalization of abortion in the Supreme Court case *Roe v. Wade*, and Title IX. A generation of young Americans rewrote the rules of political engagement. The antiwar movement helped to end the United States' unpopular involvement in Vietnam in 1975, and the women's movement

had made sexism part of the vernacular. A new analysis of the connections between public power and private life created a radical feminism. A second "revolution" in morals and manners brought greater tolerance about issues of sexuality and sexual identity. Yet the same years marked the first stirring of changes that would threaten the very gains women achieved. Women's economic vulnerability, masked by post–World War II affluence, was laid bare by the end of the 1970s.

 Study the <u>Key Terms</u> for The Personal Is Political, 1960–1980

Critical Thinking Questions

1. Where did women come across changing ideas of sexuality? How did women's sexual behavior change in these years?

2. How did younger American women become active in feminism? How were their paths to feminism different from liberal activist women?

3. How did radical women change feminism in the United States? What organizations did radical women form in these years?

4. How did American women's work lives change? How did their home lives change? How much of these changes can we attribute to feminism?

Text Credits

1. Reprinted by permission of the author, Joan Nestle, *A Restricted County* (New York: Firebrand Books, 1987), pp. 51–53.

2. Reprinted from Home Before Morning. Copyright © 2001 by Lynda Van Devanter and published by the University of Massachusetts Press.

3. Gloria Steinem, The Equal Rights Amendment Hearings Before the Subcommittee on Constitutional Amendments of the Committee on Judiciary of the United States Senate, in *91st Congress, May 5, 6, 7, 1970* (Washington, DC: U.S. Government Printing Office, 1970), pp. 331–335, 338–341, 575–578.

4. The Redstockings Manifesto was issued in New York City on July 7, 1969. It first appeared as a mimeographed flyer, designed for distribution at women's liberation events. Further information about the Manifesto and other materials from the 1960's rebirth years of feminism is available from the Redstockings Women Liberation Archives for Action at www.redstockings.org or P.O. Box 744, Stuyvesant Station, New York, NY 10009.

5. Margaret Sloan, Black Feminism: A New Mandate, *Ms. Magazine* (May 1974). Reprinted by permission of Ms. Magazine © 1974.

6. Ms. Staff, Women of "La Raza" Unite, (December 1972). Reprinted by permission of Ms. Magazine © 1972.

7. Reprinted with permission from the National Organization for Women. This is a historical document and may not reflect the current language or priorities of the organization.

8. Reprinted with permission from the National Organization for Women. This is a historical document and may not reflect the current language or priorities of the organization.

9. Reprinted with permission from the National Organization for Women. This is a historical document and may not reflect the current language or priorities of the organization.

10. Roe v. Wade, January 22, 1973.

Recommended Reading

Beth Baily. *Sex in the Heartland*. Cambridge, MA: Harvard University Press, 2002. Bailey looks at the sexual revolution as it happened in one decidedly tame city, Lawrence, Kansas.

Norma Broude and Mary D. Garrad, eds. *The Power of Feminist Art: The American Movement of the 1970s, History and Impact*. New York: Harry N. Abrams, 1994. A comprehensive look at the key players, institutions, and events of the feminist art movement.

Flora Davis. *Moving the Mountain: The Women's Movement in America Since 1960*. Chicago and Urbana: University of Illinois Press, 1991. Davis documents the half-won revolution in women's struggle for equality between 1960 and 1990 through a focus on organized feminism.

Alice Echols. *Daring to Be Bad: Radical Feminism in America, 1967–1975*. Minneapolis, MN: University of Minnesota Press, 1988. A close look at the formation, ideas, and demise of radical feminist groups.

Karla Jay. *Tales of the Lavender Menace*. New York: Basic Books, 1999. A mix of memoir and history, Jay describes the convergences of women's and gay liberation movements and what kept them at odds from the 1960s to the 1980s.

Benita Roth. *Separate Roads to Feminism: Black, Chicana, and White Feminist Movements in America's Second Wave*. New York: Cambridge University Press, 2004. Roth shows the similarities and differences among radical women's groups.

Natasha Zaretsky. *No Direction Home: The American Family and the Fear of National Decline, 1968–1980*. Chapel Hill, NC: University of North Carolina Press, 2007. In this study of U.S. families in the 1970s, Zaretsky links gender, foreign policy, and popular culture.

ENDINGS AND BEGINNINGS, 1980–2011

LEARNING OBJECTIVES

- What role did women play in the conservative movement?
- How did anxiety about changing gender roles and sexual morality shape conservative activism?
- How was immigration after 1980 similar to and different from earlier eras?

Explore Chapter 22
Multimedia Resources

TIMELINE

1962	The Supreme Court bans school prayer in *Engel v. Vitale*
1967	*The Phyllis Schlafly Report* begins
1972	The Equal Rights Amendment passes STOP ERA forms
1973	The Supreme Court legalizes abortion in *Roe v. Wade*
1974	School board of Kanawha County, West Virginia, battles with conservative parents over public school curriculum
1975	Congress passes the Child Support Enforcement Amendments
1976	Congress passes the Hyde Amendment Women admitted to military academies
1977	International Women's Year Anita Bryant successfully leads campaign to overturn antidiscrimination ordinance in Miami Beach, Florida
1978	White House Conference on Families
1979	Beverly LaHaye forms Concerned Women for America
1980	Ronald Reagan becomes president
1981	The first case of the acquired immune deficiency syndrome reported Sandra Day O'Connor becomes the first female Supreme Court justice
1982	Ratification for ERA expires
1989	*Webster v. Reproductive Health Services* restricts state funds to be used for abortion
1990	*Planned Parenthood v. Casey* upholds parental consent

1992	**Bill Clinton becomes president**
1993	**Family and Medical Leave Act enacted**
1996	**Defense of Marriage Act defines marriage as taking place between a man and a woman** **Personal Responsibility and Work Opportunity Act passed, linking welfare to work**
2002	**Illegal Immigration Reform and Immigrant Responsibility Act passed, restricting immigrants from receiving welfare**
2004	**The State of Massachusetts issued marriage licenses to same-sex couples**
2008	**Barack Obama elected president**

SINCE THE 1980s, globalization and the growing disparity of wealth between the developed and developing worlds pulled record numbers of immigrants to the United States. Women made up nearly half of all new immigrants. Legal and illegal immigrant women alike found work in all sectors of the economy—in garment and service industries, managerial and sales, medicine, and research. Many found domestic work and child-care jobs as more middle- and upper-middle-class women worked longer hours outside the home. As the country faced the largest influx of immigrants in its history, political debates intensified over immigration policy, while communities embraced or battled newcomers in their schools, hospitals, and neighborhoods.

Domestically, a new generation of conservative activists revitalized the Republican Party and challenged the liberal notion of the state as a social provider that had been in place since Franklin D. Roosevelt's New Deal. Reasserting the family as the proper caregiver against state-supported welfare and promoting self-reliance and religious morality, conservative activists reshaped politics and government. This action brought women into the political process through local issues like school prayer and on national campaigns designed to undermine reproductive rights and return working women to the home through the antiabortion and pro-family movements.

Feminists and liberals clashed with conservatives over many issues, including the role of the United States in global affairs. The Middle East had replaced the Communist Soviet Union as the new center of U.S. foreign policy concerns, driven in part by an expansion of a global economy that made access to the oil-rich supplies of the region a new political priority. The Middle East stormed onto U.S. newscasts with the oil crisis of the 1970s, the takeover of the U.S. embassy, and the hostage crisis in Iran in 1979. As the new century opened, attacks on the Pentagon and the World Trade Center on September 11, 2001, sparked an ideological "war on terrorism" and ground wars in Afghanistan and Iraq. Women found a place in the all-volunteer army of the new century and deployed to militarized areas where no clear combat front existed. People in the

United States grew familiar with media stories of working-class families in which both mother and father were deployed. The growing sense of being part of a single world where national boundaries had grown porous and problems too large for a single state to tackle informed a new global feminist movement. Feminist activists joined pressing issues of women's health to larger international concerns with human rights. At home, a third wave of feminism redefined activism as a generation of women joined the on-going battle to define equality for women.

THE NEW RIGHT

As the twentieth century drew to a close, the progressive milieu that had sustained feminism and women's activism for decades vanished. In its place, a new conservatism developed. Disillusioned with what many deemed the lifestyle excesses of the 1960s and 1970s, particularly the sense that the sexual revolution had promoted homosexuality and heterosexual promiscuity, U.S. voters elected Republican Ronald Reagan in 1980. He promised to restore the United States' status internationally, to reign in the social activism of a federal government too focused on "special interests" and to promote what conservatives called "traditional family values." Reagan's victory was only one sign that feminists would be swimming against a conservative tide. Between 1970 and 1990, evangelical churches added more than six million new members, with the fastest growth taking place in the West rather than in the Southern Bible belt. The synergy between Republicans and conservative Evangelicals set in motion a powerful surge of social activism concerned with issues of family and morality and brought religious conservatives into school boards, town councils, and other local offices. Women played key roles in the New Right in local and national groups, bringing their organizational skills and determination to a range of issues. Along the way, these women re-politicized gender and private life in distinctively conservative ways and undermined many of the gains of second-wave feminism.

The STOP ERA Campaign

Conservative women had built strong networks in the 1970s in their successful campaign to defeat the Equal Rights Amendment (ERA). When the ERA passed in 1972, few suspected that it would become the epicenter of a political transformation. Phyllis Schlafly, a Catholic mother of six and longtime activist in the National Federation of Republican Women (NFRW), had not paid much attention to feminism or the ERA. But with its passage, she turned away from her preoccupation with Republican Party politics and embraced issues associated with women and the family. In her widely read newsletter, *The Phyllis Schlafly Report*, begun in 1967, Schlafly launched a full-force attack on the ERA and laid out the tenets of the antifeminism that would define the conservative agenda.

A savvy organizer, Schlafly soon realized that in the ERA she had an issue that would mobilize the grassroots of the Republican Party. The national campaign

against ERA began on July 7, 1972, when Schlafly and other members of the NFRW formed STOP ERA (Stop Taking Our Privileges). These women brought to the movement tremendous organizational experience. By early 1973, STOP ERA organizations existed in twenty-six states. Much like the Woman's Christian Temperance Union at the end of the nineteenth century, STOP ERA was a loosely organized group with strong local leadership. Schlafly appointed state directors who then developed their own campaign tactics and raised their own funds. Other women's groups joined STOP ERA, and, as the campaign grew, it pulled in women previously not involved in politics, including younger Evangelical Christians, Southern Baptists, Mormons, Orthodox Jews, and Roman Catholics. Demographically, women who opposed the ERA had much in common with ERA supporters. Both were predominantly white middle-class women, married, over thirty years of age, and college educated. The major distinction between pro- and anti-ERA supporters was church attendance. Surveys showed that 98 percent of anti-ERA activists claimed church membership.

Schlafly drew on traditional ideas of femininity to accomplish her political goals. To support the army of activists, Schlafly traveled and offered workshops on how to debate and testify at a public hearing and offered advice about what colors look good on television and how to be poised under pressure as well as provided point-by-point rebuttals to ERA arguments. STOP ERA supporters, wearing dresses and heels, delivered homemade bread and pies to their legislators, many of whom they knew from their church and neighborhood communities. Such tactics were well suited to win over the middle-aged white male legislators who dominated the state legislatures. These were women whom local politicians feared to alienate because they not only were well informed but also volunteered in political campaigns.

By 1974, the STOP ERA campaign helped defeat ratification of the ERA in seventeen state legislatures. Its success lay in its focus on local contests, a strategy the more nationally oriented pro-ERA movement did not share. Even with the endorsement of Democratic President Jimmy Carter, by 1978, a total of five states had overturned their previous votes ratifying the ERA. An intensive lobbying effort by ERA supporters resulted in a thirty-nine-month extension of the ratification deadline to June 1982, but conservatives had turned the tide against the amendment, and it expired with three states short of the thirty-eight required for ratification.

The Pro-Family Movement

In alliance with Evangelical ministers, Catholics, and Republican politicians, conservative women formed a pro-family movement to challenge the liberal definitions of the family that had gained ground in the 1970s.

The pro-family movement grew out of a series of clashes between conservatives and feminists over the definition of the family. The first clash took place at the national conference for International Women's Year (IWY) held in Houston in 1977. Twenty thousand people attended the conference, including notable feminists Bella Abzug and Barbara Jordan and three first ladies—Rosalynn Carter, Betty Ford, and

Lady Bird Johnson. The IWY movement with its support of abortion rights and lesbian rights and a rejection of traditional gender roles proved to be a galvanizing event in the pro-family movement. Conservative women were so dismayed by the liberal orientation of the conference agenda that they organized a counterdemonstration, the Pro-Family Rally, in Houston in the same weekend. While it did not garner the same level of media attention as did the IWY, the Pro-Family Rally testified to the rising importance of religious values in U.S. political life. It also led to the establishment of conservative women's political networks that monitored the impact governmental actions had on families as other political groups did for taxes and defense issues.

In 1978, President Carter organized a second conference, the White House Conference on Families, which also provided an impetus for conservative women to mobilize in defense of the traditional family. Conservatives viewed the conference's use of "families" in plural instead of "the family" as indicating support for homosexual families. Beverly LaHaye, who founded Concerned Women for America (CWA) in 1979, explained, "Early in 1980 we saw that homosexuals were driving in, because they wanted to be part of the whole definition of the family. And we objected to that." Conservatives ultimately organized over three hundred pro-family groups into the American Family Forum to strengthen their collective voice.

Throughout the 1980s and 1990s, the pro-family movement expanded. In 1980, child psychologist James Dobson organized the Family Research Council, which became the premier pro-family research organization in Washington, D.C. The pro-family **Eagle Forum**, founded by Schlafly in 1972, boasted fifty thousand members in state chapters across the country. New organizations—including Teen-Aid, which focused on abstinence-only sex education curricula; the Liberty Counsel, which provided antiabortion legal services; and Morality in Media—brought further institutional force to the pro-family movement.

At the same time, conservative women targeted public education and curriculum as areas for activism. Gaining seats on local school boards became a goal of organizations like the **Christian Coalition**, which held hundreds of training seminars across the country on how to win local offices. The Supreme Court's 1962 banning of officially sponsored prayer and Bible reading in public schools in *Engel v. Vitale* had earned the Court tremendous animosity from Evangelical Protestants and Catholic groups. The Court ruled on First Amendment grounds that prayer in public school violated the separation of church and state. Critics viewed the decision as a declaration of war against Christianity and complained that it put in the hands of school issues of morality that were the rightful purview of parents. Curricula also became an issue. In 1974, the first of many textbook battles began in Kanawha County, West Virginia, where Alice Moore, the wife of a fundamentalist minister, organized a group of parents against a textbook she saw as "obscene" and "anti-American." The West Virginia conflicts received national media coverage, extending their impact beyond the state. To avoid similar conflicts, many school boards and administrators refused to adopt any textbook containing any potentially controversial material. Libraries also felt pressure

from religious groups who wanted books like J. D. Salinger's *The Catcher in the Rye* and Judy Blume's *Forever* banned from public libraries. The teaching of science was under attack as conservatives introduced the notion of intelligent design as an alternative account of evolution in the late 1990s.

Moral Panics and Culture Wars

Conservatives who were concerned with the health of the U.S. family turned to the media to spread their message. Mass media enabled key Evangelicals to reach huge audiences spread across the country. The **culture wars** between conservatives and liberals reached a fevered pitch. *Focus on the Family*, the syndicated radio ministry headed by Dr. James Dobson, declared the 1990s "the Civil War Decade." He pointed to controversies over homosexual rights, abortion, and obscenity as the battles over values in which Christians served as foot soldiers.

Religious activists saw in feminism a multileveled assault on the foundation of Christian social order. Women of the religious Right understood feminism as a symptom of how far the country had fallen into the pathology of secular humanism, with its attention to individual and minority rights. Conservatives viewed changes in family life, women's workforce participation, teenage sexual promiscuity, and drug use as direct results of feminism's power to undermine families. Some of the most pointed attacks against feminism came from Beverly LaHaye's CWA. Beverly LaHaye, the wife of one of the founders of the Moral Majority, Tim LaHaye, emphasized submission to God's plan, which, for women, included an acceptance of the authority God gave to men to lead women and families. Unlike Schlafly's Eagle Forum, CWA was more frankly evangelical, organizing prayer circles for its six hundred thousand members and calling for religious activists to become more politically involved. By the mid-1980s, CWA had a membership of five hundred thousand, far larger than that of the NOW.

In 1977, the antigay rights cause surged to the top of the Christian Right's political agenda when popular singer Anita Bryant led a successful fight to overturn a Miami, Florida, ordinance designed to end discrimination against homosexuals. Christian Right activists saw state ordinances like Miami's and bills passed in the 1980s to protect gay and lesbians from housing and employment discrimination as part of a growing movement to establish special rights for homosexuals and a strategy to force Americans to accept homosexuality as just as natural as heterosexuality. They launched their own local and state ballot initiatives to limit the extent of discrimination based on sexual orientation. In 1996, the Supreme Court ruled that discriminatory ballot initiatives limiting gay civil rights were unconstitutional.

The acquired immune deficiency syndrome (AIDS), first reported in 1981, and initially hitting the gay male community hardest, further intensified the conservative Right's antigay activism. In the face of the growing AIDS epidemic, Surgeon General Dr. C. Everett Koop proposed federal funding for AIDS education programs in schools. He faced stiff opposition from Senator Jesse Helms who attempted a series of unsuccessful antigay bills to ban federal funding for any sex-related public education,

Read **"Confessions of a Closet Baptist"**[1]

In this first-person account, Mab Segrest—devoted to her fight against racism, homophobia, and anti-Semitism—discusses how accepting that she was a lesbian helped her in her fight against diverse forms of hatred and bigotry.

Review the source; write short responses to the following questions.

1. How did Segrest's students feel about homosexuality?
2. What happened when Segrest's students debated gay rights?
3. Why do you think Segrest titled her essay "Confessions of a Closet Baptist" rather than "Confessions of a Closet Lesbian"? What point is she trying to make?

including for AIDS education, explaining that funding was tantamount to promoting homosexuality. Characterizing AIDS as a disease that only gay men contracted fueled Christian Right denunciations of homosexuality, with extremists charging homosexuals with deliberately spreading the virus.

Concern over special rights for homosexuals reached new heights when newly elected President Bill Clinton announced in 1992 his intention to lift the ban on openly gay military personnel. A wave of calls to the White House against lifting the ban, coupled with strong Congressional opposition, led Clinton to back off his promise. The result was a Congressional compromise of "don't ask, don't tell" that was later amended to include "don't harass." The compromise dictated that the armed forces would no longer ask recruits about their sexual activity or orientation and self-identified homosexual servicemen and women would agree not to engage in homosexual acts or announce that they were homosexual. In 2007, the policy came under new scrutiny when twenty-eight retired generals called for a repeal of "don't ask, don't tell," citing data that showed that, in 2006, sixty-five thousand gay men and lesbians served in the armed forces and that there were over one million gay veterans. President Barak Obama repealed the policy in 2011.

Gay marriage became another flash point. Building on networks established during years of antigay rights organizing, the New Christian Right mounted successful campaigns to limit marriage as a right for heterosexual couples only. In 1996, the National Campaign to Protect Marriage began. Its steering committee was made up of leaders from the American Family Association, the Family Research Council, and CWA. Gay marriage became a centerpiece of the 1996 presidential campaign. President Clinton, whom many gay and lesbians saw as a potential ally, responded by endorsing the Defense of Marriage Act, which defined marriage as a relationship between one man and one woman and gave states the right whether to recognize same-sex marriages performed in other states.

The issue of same-sex marriage, which would grant gay and lesbian couples the same rights and privileges as heterosexual couples, continued to divide the country,

particularly in the wake of the 2000 election of George W. Bush. At stake were such matters as visiting a sick partner in the hospital, adoption of children, and spousal benefits. In 2004, Massachusetts recognized same-sex marriage. Connecticut, Vermont, New Jersey, California, and New Hampshire created legal unions that offered all the rights and responsibilities of marriage under state law to same-sex couples. By 2012, New York became the sixth state to allow gay marriage. At the same time, thirty states passed constitutional amendments explicitly barring the legal recognition of same-sex marriage. In 2011, President Obama announced that his administration would uphold the Defense of Marriage Act but no longer defend it in court.

Embattled Feminists

The majority of women who identified themselves as feminists found the change in the political climate of the country to be alarming. On the defensive, feminists focused on the worsening economic situation of working and poor women, a consequence of the growing number of single-female-headed households. The **Child Support Enforcement Amendments**, part of a retooling of the Social Security Act in 1975, strengthened child support agencies' abilities to get money from the nonresidential parent of children on Aid to Families with Dependent Children (AFDC) for medical expenses and cost of living. To help older women, feminists supported the **Retirement Equity Act** of 1984, which made it easier for divorced and widowed women to access their husbands' pensions and enabled more women to qualify for private retirement pensions.

View the Profile of Sandra Day O'Connor

Sandra Day O'Connor, the first female justice to sit on the Supreme Court, served from 1981 to 2006. She was appointed by Republican President Ronald Reagan, whose commitment to appoint a woman to the Court threatened to clash with his commitment to his conservative and antiabortion supporters, many of whom felt O'Connor was too liberal on abortion. O'Connor's judicial independence won out, winning her the ire of conservatives and reluctant support from abortion supporters who, by the late 1990s, viewed her as the crucial swing vote in any case that might overturn *Roe v. Wade*.

Historic "firsts" for women continued throughout the 1980s despite the climate of backlash against feminism. Sandra Day O'Connor became the first female Supreme Court Justice in 1981, and New York Representative Geraldine Ferraro became the first woman to run as vice president on a major political ticket in 1984 with Democratic candidate Walter Mondale, enjoying the support of both Republican and Democratic women, many of whom reported admiring her for her three terms in the House of Representatives.

Read "Feminism: Battles Won"

Feminists had successes, despite the conservative turn of the country. Some major accomplishments were in the area of rape law, funding for battered women's shelters, and new protections against sexual harassment. In the late 1970s, feminists succeeded in changing the rules of evidence and corroboration in rape cases, making it illegal to bring up a woman's sexual past in a rape trial. Laws were rewritten to cover women who were victims of rape. By the 1980s, concern over date rape on college campuses resulted in special programs to teach men and women about coercion and violence and to combat the commonly held view that there was nothing wrong with a man using a little force to get what he wanted. "Take back the night" marches, in which young women marched at night to demand their rights to be safe from rape and sexual violence, became yearly rituals on many college campuses. Laws on wife rape changed as well. In 1980, thirteen states had laws in which a man could not be charged with raping a woman if they were living together, even if they were not married. By 1991, only five states still had such laws. Despite feminists' success in redefining marital rape as rape, thirty-three states continue to view it as a lesser crime.

Review the sources; write short responses to the following questions.

A Letter from a Battered Wife [1983][2]
Paula Kamen, *Acquaintance Rape: Revolution and Reaction* [1996][3]

1. Why did the author of *A Letter from a Battered Wife* stay with her husband? Have things changed since this letter was written in 1983? If so, how? What options, if any, would this woman have today?
2. What is "date-rape hysteria" according to Paula Kamen? What did she do to refute the claims of people who support the charge of date-rape hysteria?

Conservatives and feminists found themselves at odds over how best to help women. On some issues, such as the antipornography movement, conservatives and feminists were allies, brought together by their concern over violent and sexual images of women. Feminist activist Andrea Dworkin and feminist legal scholar Catharine MacKinnon found support from the New Christian Right in their efforts to regulate pornography. Likewise, concern with the health of families often brought feminists into alliance with conservatives. In 1984, Congress passed the **Family Violence Prevention and Services Act**, which provided funds for shelters and family violence programs. By 1991, approximately sixteen hundred battered women's shelters, "safe" homes, hotlines, and advocacy projects existed. Despite the growth in programs, shelters were forced to turn away 40 percent of the women who contacted them. Yet, on other issues, conservatives and feminists clashed. One such conflict was the confirmation hearings in October 1991 for Clarence Thomas when one of his former employees at the Equal Employment Opportunity Commission, Anita Hill, accused him of sexual harassment.

Read **"A Fight Against Sexual Harassment"**[4]

Anita Hill had been an employee at the Equal Employment Opportunity Commission working under Clarence Thomas. When Thomas was nominated for a seat on the Supreme Court, Hill came forward with allegations of sexual harassment, bringing the issue to the nation's attention. Hill testified in front of the Senate Judiciary Committee, and Thomas defended himself; he was appointed to the Supreme Court in spite of Hill's testimony and evidence of sexual harassment on his part.

Review the source; write short responses to the following questions.

1. How was Hill's experience early on in her employment under Clarence Thomas? What made it change, and what precipitated her testimony before the Senate Judiciary Committee?
2. What is the tone of Hill's remarks? How does she feel about having to make the statement about her work with Clarence Thomas?

OVERVIEW

Abortion Rights Time Line

1973	January 22	The U.S. Supreme Court issues its ruling in *Roe v. Wade*, finding that a "right of privacy" it had earlier discovered was "broad enough to encompass" a right to abortion and adopting a trimester scheme of pregnancy. In the first trimester, a state could enact virtually no regulation. In the second trimester, the state could enact some regulation but only for the purpose of protecting maternal health. In the third trimester, after viability, a state could ostensibly proscribe abortion, provided it made exceptions to preserve the life and health of the woman seeking abortion. Issued on the same day, *Doe v. Bolton* defines *health* to mean "all factors" that affect the woman, including physical, emotional, psychological, and familial factors and the woman's age.
1975	March 10	The first Human Life Amendment is introduced in the U.S. Senate by Senators James L. Buckley (Conservative, New York) and Jesse Helms (Republican, North Carolina).
1976	June 28	The first Hyde Amendment, sponsored by Representative Henry Hyde (Republican, Illinois), is approved by the U.S. House. The Amendment to the Department of Health and Human Services appropriations bill prohibits Medicaid funding of abortions with narrow exceptions.

1977 June 20	In *Maher v. Roe, Beal v. Doe,* and *Poelker v. Doe,* the U.S. Supreme Court holds that federal and state governments are under no obligation to fund abortion in public assistance programs, even if childbirth expenses are paid for indigent women and even if the abortion is deemed to be "medically necessary."
1981 March 23	In *H. L. v. Matheson,* the U.S. Supreme Court approves a Utah parental-notification law. The law requires an abortionist to notify the parents of a minor girl who is still living at home as her parents' dependent when an abortion is scheduled.
1989 July 3	In *Webster v. Reproductive Health Services,* the U.S. Supreme Court, upholding portions of a Missouri law, finds that the federal Constitution does not require government to make public facilities such as hospitals available for use in performing abortions.
1990 June 25	In *Ohio v. Akron Center for Reproductive Health,* the U.S. Supreme Court upholds a one-parent-notification requirement with a judicial bypass procedure. The Court also rules, in *Hodgson v. Minnesota,* that a two-parent-notification law with a judicial bypass is Constitutional.
1991 May 23	In *Rust v. Sullivan,* the U.S. Supreme Court upholds the Bush administration's regulations that prohibit routine counseling and referral for abortion in four thousand clinics that receive federal Title X family planning funds. (In November, President Bush vetoes a $205 billion Health and Human Services appropriations bill because it includes a provision that would have blocked the enforcement of the pro-life regulations; the veto is sustained by a twelve-vote margin.)
1992 June 29	In *Planned Parenthood v. Casey,* the U.S. Supreme Court reaffirms the core holdings of *Roe* but modifies it by discarding the trimester scheme, upholding certain restrictions on abortion, and adopting the "undue burden" test of abortion laws that requires opponents of an abortion regulation to prove the provision would create an undue burden on a woman's right to abortion in order for it to be declared unconstitutional. The vote is 6 to 3.
1994 June 30	In *Madsen v. Women's Health Center Inc.,* the U.S. Supreme Court says judges may create buffer zones to keep pro-life demonstrators away from abortion clinics.

2000	June 28	*Stenberg v. Carhart* rules that the Nebraska statute banning so-called partial-birth abortion is unconstitutional for two independent reasons: the statute lacks the necessary exception for preserving the health of the woman, and the definition of the targeted procedures is so broad as to prohibit abortions in the second trimester, thereby being an undue burden on women. This effectively invalidates twenty-nine of thirty-one similar statewide bans.
2000	September 28	Food and Drug Administration approves mifepristone (RU-486) as an option in abortion care for very early pregnancy.
2007	April 18	*Gonzales v. Carhart* and *Gonzales v. Planned Parenthood* upheld the Partial Birth Abortion Ban Act of 2003.

The Antiabortion Movement

Conservatives and many in the New Christian Right equated feminism with self-gratification and freeing women from their family obligations. Within this framework, they cast abortion as the ultimate selfish act. When the Court removed all existing legal barriers to abortion in the United States in its 1973 *Roe v. Wade* decision, the United States had the most lenient abortion laws of any non-Communist country in the Western world. While individual states and physicians could impose restrictions on late-term abortions, the Court did not. The historic ruling launched one of the most heated and controversial debates of the twentieth century.

Immediately following the *Roe* decision, conservatives drafted the Human Life Amendment defining life as beginning from the moment of fertilization. Yet the measure met with little success. Antiabortionists adopted a new tactic in the mid-1970s to restrict abortion in any way they could, chipping away at the freedoms *Roe* established. In 1976, Congress passed the **Hyde Amendment**, which reframed the government's responsibility to offer abortion services. Although the amendment did not directly challenge a woman's right to an abortion, the amendment asserted that the government was under no obligation to ensure a woman's access to the procedure. The Hyde Amendment also restricted abortion from the comprehensive health care provided by Medicaid. By the early 1980s, Congress had passed similar restrictions affecting programs on which an estimated twenty million women relied for their health care or insurance. In 1984, the United States announced that it would no longer contribute to international family planning agencies that provided abortions or counseled women to have abortions.

Right-to-life groups pressured state legislatures to write more restrictions on abortion into their laws. During the 1970s and 1980s, state laws were passed that decreed a woman must have her husband's permission to get an abortion and others mandated that she must sign a consent form twenty-four hours before getting the procedure. Some statutes said the doctor must show the woman photographs of fetuses before

performing an abortion. Legislators focused on teenage women, and, in more and more states, minors could not have an abortion without the consent of one or both parents. By 1991, seventeen states had some form of required parental notification or consent laws.

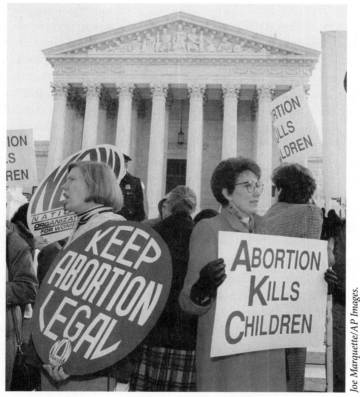

Joe Marquette/AP Images.

No issue captured the culture wars more than abortion, with its ties to both female sexual freedom and women's role as mothers. The anniversary of the Supreme Court ruling, *Roe v. Wade*, was often a time when opposing sides met, as they did here, in front of the Supreme Court in 1993.

Antiabortion activists, emboldened by a growing alliance between Catholics and Evangelicals, become more extreme in the 1980s. The Roman Catholic Church organized the first antiabortion demonstrations after the *Roe* ruling and sponsored the formation of the National Right to Life Committee, which had a membership of eleven million when Reagan took office. In 1984, right-to-life extremists targeted abortion clinics and service providers as a way to limit access to abortion services, resulting in twenty-four bombings and arson attacks on abortion and birth-control facilities. Eighteen clinic directors received death threats. Under this assault, abortion clinics struggled to find funding or insurance and doctors willing to work under such threatening and dangerous conditions. Law enforcement officials estimated that by 1990 abortion

clinics had experienced 8 bombings, 28 attempted bombings or arson, and 170 acts of vandalism.

Creating legal restrictions on abortion, without outrightly overturning *Roe*, continued as a viable strategy for antiabortion activists. In 1989, the Supreme Court ruled in *Webster v. Reproductive Health Services* to uphold restrictions on the use of state funds in performing, assisting with, or counseling on abortion, including the use of facilities and the work of paid staff. The decision allowed states to regulate an area that had been previously thought to be forbidden under *Roe*. Abortion supporters hoped that the restrictions imposed by *Webster* might rouse the large numbers of Americans who supported a woman's right to obtain an abortion—or who found that the government had no role in deciding such matters—to action. Two years later, in *Planned Parenthood v. Casey*, the Court upheld the "informed consent" rule that required doctors to provide women with information about the health risks and possible complications of having an abortion before one could be performed. The Court also upheld Pennsylvania's parental consent rule for minors and its rule requiring a twenty-four-hour waiting period before obtaining an abortion. The case overturned the strict trimester formula used in *Roe* to weigh the woman's interest in obtaining an abortion against the state's interest in the life of the fetus. The Court recognized viability as the point at which the state's interest in the life of the fetus outweighed the rights of the woman and abortion could be banned entirely.

The antiabortion movement's ability to popularize a view of the fetus as a human and abortion as murder proved politically effective. In 2006, South Dakota passed a law outlawing all abortion except to save the mother's life, the most restrictive antiabortion law since the passage of *Roe*. Even supporters of a woman's right to abortion have adapted their rhetoric to deal with the moral issues raised when the fetus is granted rights as a human. Since 2005, pro-choice groups have added the new goal of bringing down the number of abortions performed annually.

Work and Family in the 1990s

At the end of the century, balancing work and family remained a pressing issue for women. The backlash against feminism culminated in the dismantling of the welfare state by both Republican and Democratic administrations. Many women found that they had to take time away from work to care for infants or elders, and many hoped to resume work after a few years at home. However, the reality of the job market made those plans difficult to achieve for many women. At the same time, the gender pay gap meant that after a decade of advancements, women faced worsening economic conditions. Throughout, working women pressed for changes in work and welfare that would enable them to reconcile work and family.

Work and Welfare

Reagan rode to office on the wave of hostility toward and dismay at the size and influence of the federal government. Reaganomics, as it was immediately dubbed, gave

private entrepreneurs and investors greater incentives to take risks and start new business as a way to improve the overall economic health of the nation. Reagan passed deep budget cuts in a range of antipoverty programs and welfare benefits begun in the 1960s by President Johnson's War on Poverty, including housing subsidies, child nutrition programs, food stamps, public assistance, student loans, low-income energy assistance, and Medicaid payments to the states. Although such programs made up less than 10 percent of the total federal budget in 1980, they absorbed one-third of Reagan's budget cuts. The cuts fell on women and racial minorities especially hard. The average black family lost three times as much in cash and noncash benefits as did the average white family. Despite the impact on children of such cuts, the Reagan administration focused on the image of the bad welfare mother—dubbed the "Welfare Queen" for allegedly ripping off $150,000 from the government, using eighty aliases, thirty addresses, a dozen Social Security cards, and four fictional dead husbands—who abused government help to justify welfare cuts. States assumed control over distributing federal funds. Women active in the welfare rights movement complained about this new funding structure because it left poor women vulnerable to the political whims of their state governments.

The structural changes in the economy created a gap between rich and poor, and more families—particularly, female-headed families—fell into poverty. Deindustrialization shifted work away from historically higher-paying and male-dominated industrial work to service sector work. The new jobs created tended to be clustered in low-paying service sectors, in which women and minorities were overrepresented. With no job security, no benefits, and low wages, service sector work left many unable to make ends meet. The poverty rate jumped from 11 percent of the population in 1979 to 14.5 percent in 1992, with nearly 22 percent of all U.S. children under the age of eighteen living in poverty. Black and Hispanic women were particularly hard hit, intensifying the feminization of poverty that had begun earlier (see Chapter 21). In 1992, 33 percent of all African Americans and 29 percent of Hispanics lived in poverty.

The mushrooming numbers of Americans in poverty took place alongside a surge in consumer spending of the upper and middle classes. Most families enjoyed VCRs, televisions, personal computers, cell phones, and the growing number of inexpensive products that filled new supersized stores. Stores like Wal-Mart thrived in the shifting winds of consumerism and poverty. The low wages earned doing service work made staying off welfare difficult. Service jobs were plentiful but did not offer health insurance or child-care leave and thus provided little help for most women struggling to support their families. Forty-six percent of the jobs with the most growth since 1994 paid less than sixteen thousand dollars a year.

Cuts in welfare continued, enacted not only by conservatives critical of creating a permanent caste of people in the United States who depended on government relief but also by new Democrats like Bill Clinton, elected in 1992. In 1996, President Clinton signed the **Personal Responsibility and Work Opportunity Act**, ending sixty years of guaranteed federal aid to poor Americans, 80 percent of which were women and children. He also did away with the AFDC, a program started in 1933. In its place,

a new program called Temporary Assistance to Needy Families (TANF) was established. Under the new law, poor families received aid for two consecutive years, with a total limit of five years. States received bonuses for significantly reducing their public-assistance rolls and lowering rates of illegitimacy. States could be penalized if they did not enforce the rule that mothers receiving aid work a minimum of twenty hours monthly. The law required that poor single mothers take any job available to them, even when most of the jobs offered them none of the benefits that welfare brought them, such as health care and housing help.

Getting off welfare did not translate into getting out of poverty. A 2003 report by the Congressional Budget Office found that even as TANF shrank, other federal benefit programs—like the earned income tax credit, food stamps, Medicaid, and Supplemental Security Income—swelled. As states moved more families off welfare to qualify for federal funds, more U.S. families struggled with homelessness, hunger, and poverty. In 2003, 12.4 percent of all people in the United States—almost thirty-five million people—lived under the federal poverty rate, which included 12.2 million children.

Gender Gaps

At the end of the twentieth century, women of all classes and races struggled to reconcile wage work and family. As more women entered the workforce or found that their state governments required them to work forty hours a week for welfare support, they found themselves pulled between the competing demands of family and work. Sick children, needy elders, and the rising costs of child care left women vulnerable to being fired, demoted, or passed over for advancement at work.

View the Profile of Hillary Rodham Clinton

Few women have experienced firsthand the dramatic transformation in women's role in politics than Hillary Rodham Clinton. From her days as a young Republican at a small northeastern liberal college to those as the first First Lady to head a failed presidential health care task force and as the first woman to be a serious contender for president from a major political party, Rodham Clinton has been at the center of many culture wars. Rodham Clinton made a successful bid to become a senator from New York in 2000 (she won reelection in 2006) and, after Barack Obama became president in 2008, was appointed secretary of state.

To ease the burden on working families, President Clinton signed the **Family and Medical Leave Act** (FMLA) in 1993. The act provided twelve weeks of unpaid family leave for workers to care for a sick family member, bond with a new baby, or recover from their own illness without losing their jobs or health insurance. While millions of Americans took advantage of job-protected leave after the law was passed, nearly half of the nation's private-sector employees were not covered by the FMLA in 2000

because they worked part time or for businesses with fewer than fifty employees. Nearly half of all workers had no paid sick leave. For those women who qualified, the FMLA gave them one more bridge to span the gender gap at work, enabling more women to take time out without fear of losing their jobs.

While women's participation in the labor force rose, women still earned less than men. In 2000, women earned seventy-seven cents to a man's dollar, a gap that widened as women had children. When women entered the workforce, they earned almost as much as men. But when they had children, women fell behind. By the time women reached their forties, they earned seventy-one cents to a man's dollar. Economists described this as a "motherhood penalty" that stemmed in part from discrimination and in part from interruptions in a woman's work life. One study found that before childbearing, the wages of highly skilled mothers and nonmothers were not significantly different but highly skilled women experienced an 8 percent reduction in their wages during the first five years after they had a child compared to childless women. After ten years, it rose to 20 percent, even after taking into account any reduction in mothers' working hours. The motherhood penalty fell heavier on women with a high-school diploma than on women with a college degree.

Facing such difficulties, many women opted to stay home. A Hunter College sociologist found in 2002 that many professional women gave work-related reasons—such as being placed on "the mommy track" with poor assignments and a lack of advancement opportunities once they became mothers—as the reasons they left work for parenting. For other women, the combination of male chauvinism at work and strains on their family from two full-time working parents motivated them to leave. For women who stayed in the professions, the ongoing reality of the **glass ceiling** kept many from reaching full equity with their male peers. "There have been women in the pipeline for 20 to 25 years; progress has been slower than anybody thought it ever would be," said one leader of an executive search firm. The low number of female chief executive officers was often the result of women leaving work for family, a lack of networking or mentoring programs, and the tendency for women to end up in dead-end positions.

GLOBAL AMERICA

At the beginning of the twenty-first century, U.S. women experienced a number of historic transformations. The powerful effects of economic globalization, rising rates of immigration, and the revolution in communication connected women to friends, families, and strangers around the globe. In the past, globalization had been associated with the expansion of U.S. business and culture to other countries. After 1990, U.S. women experienced globalization within their own local communities. A surge of immigration, twenty million immigrants between 1980 and 2005, remade the population. In 2006, more than one in every ten Americans was foreign-born. American women also felt the effects of globalization in the kinds of work they did and the wages they received. Educated women of all races fared better than their less-educated peers in the information-driven job market, resulting in a widening gap between rich and poor

women. Terrorism, war, and ongoing violence against women at home and abroad, as well as the speed by which information traveled, fostered a global women's movement that raised women's health and safety as pressing human rights issues.

New Faces, New Families

The 2000 census reported the largest population surge in U.S. history, with the population reaching a historic high of 281.4 million people. Aided by changes in the immigration law since 1965 (see Chapter 20), the population growth was driven by immigration, with the majority coming from the Eastern Hemisphere and bringing specialized job skills with them. Large numbers also came from Mexico and Latin America, bringing fewer skills, often without legal status. By 2000, the number of Hispanic Americans exceeded thirty-five million. Immigration from China, Japan, Vietnam, Thailand, Cambodia, Laos, the Philippines, Korea, and India swelled the number of Asian Americans to more than twelve million in 2000, an increase of 63 percent from 1990. The Arab population rose by 41 percent in the 1980s and 38 percent in the 1990s. In 2000, 1.2 million people of Arab ancestry lived in the United States. Since the 1990s, immigrants have settled predominantly in California, Texas, Florida, New York, Hawaii, New Jersey, and New Mexico. Combined, these states added ten million voting-age Hispanics and Asians in the 1990s alone; in 2000, Hispanics and Asians made up more than 29 percent of the voting-age population.

Once here, immigrant women participated in the vibrant social and economic lives of their communities. In Los Angeles, Koreans created the thriving community of "Koreatown"; in Brooklyn, Russian Jews settled in "Little Odessa"; while Latinos occupied entire sections of Chicago, Dallas, and Washington, D.C. With the number of immigrants rising, new businesses grew up, started by ethnic entrepreneurs, male and female, who catered to their community's tastes for food, clothing, newspapers, and music from their home countries. Women socialized through mosques, temples, and churches, made meals and parties for their extended family networks, and joined together to improve their collective situation. Daughters joined Girl Scout troops and town sports clubs. Many women worked outside their neighborhoods. Like immigrant women at the turn of the twentieth century, these newcomers worked for wages, bringing in much needed income to their families (see Chapter 12). Educated Asian Indian women fared best in the new economy, often finding professional employment in management, engineering, and health fields. Immigrant women without specialized skills found jobs in the garment industry, agriculture, and domestic service. Unlike earlier waves of immigrants, more families sent their daughters to school and to college.

Many trends converged to change U.S. families at the end of the twentieth century, particularly the rising numbers of divorced families, single mothers, and multigenerational families. In 1950, 90 percent of all households were families related by birth, marriage, or adoption, but in 2000, fewer than 70 percent were. Forty percent of U.S. children lived with two working parents, 40 percent lived with a single working parent, and 20 percent lived with the traditional working father and homemaker mother.

Married couples with children for the first time accounted for fewer than one in four households. Families themselves became more racially diverse. Mixed-race marriages had become more commonplace since the 1970s, resulting in a large jump in the numbers of multiracial children living in the United States. In 1999, two million U.S. children had parents of different races. The number of foreign adoptions also grew in the 1990s. More foreign babies were adopted in the United States than in any other country. The number doubled in the 1990s to more than twenty thousand in 2000 (one in every two hundred births). China and Russia each supplied 25 percent of those adoptions, with most of the rest coming from Guatemala, South Korea, and the Ukraine. A survey of U.S. teenagers taken in 1998 reported that 47 percent of white teens, 60 percent of African American teens, and 90 percent of Hispanic teens had dated someone of another race.

Read about **One Women's Journey**[5]

Leila Ahmed is a professor of women's studies in religion at Harvard's Divinity school. This excerpt from her book *A Border Passage: From Cairo to America—A Woman's Journey* talks about her journey from Egypt, where she was raised in a devout Islamic family, to the United States.

Review the source; write short responses to the following questions.

1. What is "men's Islam," according to Ahmed? How does it compare to "women's Islam," if at all?
2. How has Islam served to repress women?

Architects and city planners responded to the growing numbers of three-generational households, in which grandparents live with their children and grandchildren. The 2000 census showed that these "multigenerational households" as those of three or more generations—were growing faster than any other type of housing arrangements. The number of multigenerational households was still relatively small: 4.2 million, or 4 percent of all types. But they had grown by 38 percent from 1990 to 2000. Sixty-two percent of multigenerational households were led by the first generation, that is, the grandparents. Multigenerational living, especially those in which grandparents cared for their grandchildren, have long been common in Asian and Hispanic countries, and the arrangement remained popular among immigrants from those nations. Immigrant families, particularly those from Latin America, used the 1965 immigration reform to join their relatives in the United States, creating large families and networks of extended relatives where children lived with relatives or moved between the homes of their parents, aunts and uncles, and grandparents. Illegal immigrants used these networks to ensure safe and familiar homes for their U.S.-born children whose status as citizens protected them from being deported.

The Gulf Wars

The Middle East erupted as the opening U.S. conflict in the post–Cold War era. The first Gulf War took place after Iraqi leader Saddam Hussein invaded the bordering state of Kuwait on August 2, 1990, to expand Iraq's boundaries. When economic sanctions failed and Hussein did not withdraw the Iraqi army from oil-rich Kuwait, President George H. W. Bush launched "Operation Desert Storm" on January 16, 1991, with the support of a broad coalition of nations under the United Nations. To avoid a protracted war, President Bush did not try to occupy Iraq or remove Hussein from power. Instead, with support of the United Nations, he imposed economic sanctions against Iraq until it allowed weapon inspectors unfettered access to the country's munitions factories to ensure that no chemical, biological, or nuclear weapons were being produced.

As the nation watched the first Gulf War unfold on their nightly newscasts, audiences saw women soldiers prominently displaced in what the media called "the new American military." In some ways, women's place in the military had improved since World War II when 350,000 women served in noncombat positions in auxiliaries and, eventually, as part of the military (see Chapter 18). The passage of the Women's Armed Services Integration Act of 1948 granted women permanent status in the military. A series of changes in military law enabled women to gain a foothold in the services. During the Vietnam War, President Johnson lifted the 2 percent legal cap on the number of women allowed in the military, yet most women served as combat nurses, not as soldiers. Five years later, in 1973, the military moved to an all-volunteer force and ended the draft, which gave women new opportunities for service. In 1976, women were allowed to attend the military academies like the U.S. Military Academy at West Point, New York, and the U.S. Naval Academy in Annapolis, Maryland. Such changes led to significant increases in the number of women in the military. In 1991, on the eve of the first Gulf War, women made up 11 percent of the all-volunteer armed forces and forty-one thousand served.

For many people in the United States, the idea of women in combat was disturbing. For social conservatives, women serving in combat duties represented a misguided and strident radical feminism. Equality with men, represented by the female soldier, harkened to a world in which protections for women had been stripped away. Conservative activist Phyllis Schlafly defeated the ERA in part by arguing that feminists wanted to send women into battle in the name of gender equality. For military leaders, the notion that a female officer may give orders to a subordinate male soldier reeked of humiliation and disorder. More frightening was the idea that a female soldier could be taken prisoner and paraded through the streets of a hostile city. Despite such sentiment, women in the military faced dangerous situations regularly. In 1994, female soldiers in the army were no longer barred from positions that posed a substantial risk of capture. Although not assigned to ground combat units, women flew helicopters, served in bomb-disposal squads, drove trucks, handled checkpoints, and treated the wounded on battlefields, leaving them open to lethal fire.

When the United States invaded Iraq on March 20, 2003, and the second Gulf War began, restrictions on combat duty did not keep women from enlisting. In 1992,

black women made up the largest percentage of female soldiers (48 percent) in the army, with white women a close second (4 percent). In 2002, white women comprised 57 percent of female enlistees, black women 33 percent, and Hispanic women 5 percent. Fifteen percent—one of seven—of the U.S. troops deployed in the Iraq War in 2003 were women, meaning that women were wounded and killed in greater numbers than ever before. According to U.S. military policy, women were not supposed to be placed in direct combat. But with no real front line in Iraq, combat had no bounds. "The war is everywhere," said retired Brigadier General Wilma Vaught, U.S. Air Force. "There's no real place that you can say for certainty that you are out of harm's way."

Terrorism at Home and Abroad

Ideas about women gender continued to shaped foreign policy debates as the conflict between Islamic fundamentalism and the West intensified and conflicts in the Middle East festered. On September 11, 2001, Al-Qaeda terrorists hijacked four commercial jets and flew two of them into New York City's World Trade Center, destroying its twin towers and killing over 2,600 people. The third plane crashed into the Pentagon, killing sixty-four passengers and 125 Defense Department employees. The fourth plane, presumably headed for the White House, crashed in Pennsylvania when the passengers fought back against the hijackers, killing all forty-five passengers and crew. United States troops descended on Afghanistan to find Osama bin Laden, who masterminded the attacks and who many felt was hiding in the country's rough mountainous terrain. As the United States fought a new war against "terrorism" instead of "Communism," concern about the status of Middle Eastern women, specifically Afghan and Iraqi women, became justifications for U.S. military intervention.

Third-Wave Feminism

Women coming of age at the end of the twentieth century entered a world markedly unlike that of their mothers. They faced a nation that was deeply divided over the issue of abortion and sexuality and viewed their own struggles in an ever more global framework that argued that women's rights could not be separated from human rights. This generation of U.S. feminists called themselves the *third wave*, invoking a history of activism most were familiar with from high-school and college classes, the wave of writing about women on the Internet, in newspapers, and in the thousands of books on women published each year.

Third-wave feminism had roots in black, Chicana, and Asian American feminists who had pioneered analyses of identity politics (see Chapter 21). A new generation of young women read the works of prominent second-wave feminists like Chicana Cherrie Moraga, African American Audre Lorde, and Chinese American Maxine Hong Kingston.

Thanks to such literary legacies, many young women had appreciation for the equality they enjoyed, understanding that their participation in sports teams, their nonsexist textbooks, and their right to have an abortion were products of an earlier struggle.

Read about **Global Feminism**

The militarism, immigration, and globalization that shaped the beginning of the twenty-first century helped create a groundswell of international feminist organizing. Particularly in the developing world, the United Nations and its myriad conferences became a focal point for political work. Feminists and women's rights activists formed nongovernmental organizations (NGOs) to help foster social mobilization on the new transnational stage.

A broad range of health concerns also mobilized feminists across the globe. They included AIDS, infant and maternal mortality rates, female genital cutting (FGC) with strides being made by women and various organizations around the world to identify and solve these problems. International feminists also turned their attention to the violence against women, specifically the issue of rape. International feminist groups, the United Nations, and other NGOs brought new attention to the use of rape and sexual violence against women during times of political conflict.

As national governments scale back social welfare and build up their military and businesses, feminists rely on international networks to bring about improvements for women.

Review the sources; write short responses to the following questions.

Hillary Clinton, *Speech, Beijing, U.N. Fourth World Conference on Women* [1995][6]
Melanne Verveer, *Written Testimony Before Congress* [2009][7]
Equality Now, Women's Action, *United States: Female Genital Mutilation and Political Asylum—The Case of Fauziya Kasinga* [1995–1996][8]

1. How does Clinton relate the emotional, physical, and economic health of women to families?
2. Why does Verveer think that violence against women should not be classified as a foreign policy issue? What evidence does she give to support her contention that it is a "global pandemic"?
3. Why was Fauziya Kasinga denied asylum? Do you agree or disagree with this decision? Why?

Yet, third-wave feminists were also unlike their foremothers. They embraced a politics of pleasure that was unlike their second-wave foremothers. For these younger women, femininity, with its products and frills, could be embraced as fun and empowering. In the hands of young women, popular culture—music, television, the Internet—could be pushed past its habitual stereotypes of dumb blondes and sassy black chicks to become a place where third-wavers could talk back against such narrow images. Women's zines, small self-produced magazines, as part of the girl movement, created new images of feminism and of feminists. More mainstream and glossy magazines like *Jane* and *Bust* sold the third-wave sensibility to readers across the country.

On issues such as motherhood and abortion, third-wavers differed from earlier generations. As the politics of abortion shifted in the 1980s toward recognition of the rights of the fetus, many third-wave feminists looked for a new formula to guide them through the thicket of unplanned pregnancies. Some felt that the pro-choice movement had failed to defend the value of motherhood in its attention to women's right to end pregnancies. Further, they felt that abortion rights rhetoric missed a crucial component of women's experience—that having an abortion was emotionally and psychologically, as well as physically, painful. In the words of one activist, "[T]he second wave is still focused on whether the woman can get the abortion, not what she does or how she feels after she chooses to have one." Women looked to controlling pregnancy as the solution to the problem of abortion, yet recognized that abstinence-only sex education in schools made this difficult.

CONCLUSION

Today's young women are quite likely to be daughters and granddaughters of baby-boomer women. Even if they are not, they are without doubt heirs to the unfinished revolution that women in the 1960s helped bring about. The lives of women are very different in 2006 than what they were several decades ago. Most women are breadwinners. Divorce and out-of-wedlock childbearing have become commonplace. Women have become largely independent of husbands and children for long parts of their days. More women finish college. Changes in the roles of women have affected every institution, from the family to the workplace to politics and the marketplace.

While such significant change has altered the experiences of women, ongoing prejudice against women continues to shape their daily lives. Women's second shift of domestic and child-care tasks at the end of an already long workday continues to be one of the most pressing aspects of the unfinished transformation of U.S. society. Poor women as well as professional women face high expectations for making their families healthy and happy, with little help by way of child care, or health care. Hostility toward immigration leaves too many women vulnerable and with little recourse to improve their lives. Long-standing women's issues like racism and access to abortion continue. Women's activism at the start of the twenty-first century remains an important way for U.S. women to bring about the promise of equality and to enhance their place in society.

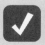 **Study the Key Terms for Endings and Beginnings, 1980–2011**

Critical Thinking Questions

1. What motivated conservative women into political activism in these years? What organizations and networks did they form? What were their central issues?

2. How did ideas about welfare change after the 1980s? How did ideas about the government's role in supporting family life change?

3. How did immigration after the 1960s change? What were the effects of this wave of immigration on American neighborhoods and cities? How did women experience immigration? How was it like the wave of immigration in the 1880s and 1890s?

4. In what ways did the globalizing economy affect women? How did it affect feminism?

Text Credits

1. Reprinted from *My Mama's Dead Squirrel: Lesbian Essays on Southern Culture*, by Mab Segrest. Copyright © 1985 by Mab Segrest. Reprinted by permission of Firebrand Books, Ithaca, New York. Material excerpted from pages 72–77.

2. A Letter from a Battered Wife, from Battered Wives by Del Martin. Reprinted by permission of Volcano Press, P.O. Box 270, Volcano, CA 95689.

3. Paula Kamen, Acquaintance Rape: Revolution and Reaction in Bad *Girls/Good Girls: Women, Sex and Power in the Nineties*, edited by Nan Bauer Maglin and Donna Perry (1996), pp. 139–144. Reprinted by permission of the author.

4. Anita Hill, *Statement to the Senate Judiciary Committee in Hearings before the Committee on the Judiciary*, U.S. Senate, 102nd Congress, 1st Session; nomination of Judge Clarence Thomas to be Associate Justice of the Supreme Court of the United States (Washington, DC: U.S. Government Printing Office, 1993), part 4, pp. 36–40.

5. Excerpt from "Harem" from *A Border Passage: Cairo to America—A Woman's Journey* by Leila Ahmed. Copyright © 1999 by Leila Ahmed. Reprinted by permission of Farrar, Straus and Giroux, LLC.

6. Hillary Clinton, Speech, Beijing, U.N. Fourth World Conference on Women (1995).

7. Melanne Verveer, Written Testimony Before Congress (2009).

8. Equality Now, Women's Action, United States: Female Genital Mutilation and Political Asylum—The Case of Fauziya Kasinga 1995–1996. Copyright © 1996, Equality Now.

Recommended Reading

George Chauncey. *Why Marriage? The History Shaping Today's Debate over Gay Equality*. New York: Basic Books, Perseus Books Group, 2004. A history of gay and lesbian activism and its political accomplishments since World War II.

Donald Critchlow. *Phyllis Schlafly and Grassroots Conservatism: A Woman's Crusade*. Princeton, NJ: Princeton University Press, 2005. Critchlow's biography of Phyllis Schlafly situates her public life in the struggles against Communism, the Soviet Union's nuclear power, and eventually her successful battle against the ERA. Critchlow uses Schlafly's story as a window into the history of conservatism and Republican Party activism from the 1940s to 2000.

Barbara Ehrenreich and Arlie Hochschild, eds. *Global Woman: Nannies, Maids, and Sex Workers in the New Economy*. New York: Henry Holt & Company, 2002. Articles address issues relating to women and work in the age of globalization.

Estelle B. Freedman. *No Turning Back: The History of Feminism and the Future of Women.* New York: Random House, 2002. Freedman examines the historical forces that have fueled the feminist movement and explores new feminist approaches to issues of work, family, and sexuality.

Marilyn Halter. *Shopping for Identity: The Marketing of Ethnicity.* New York: Schocken Books, 2000. Halter demonstrates that as immigrant groups gain economic security, they tend to reinforce, not relinquish, their ethnic identifications.

Janice Irvine. *Talk About Sex: The Battles over Sex Education in the United States.* Berkeley, CA: University of California Press, 2002. An examination of the debates around sex education from the 1960s to 2000, with special attention paid to the rhetoric and discursive tactics of the New Right as a social movement.

Rebecca Klatch. *Women of the New Right.* Philadelphia, PA: Temple University Press, 1987. One of the earliest accounts of women's activism in the New Right and the role of gender and sexuality in consolidating the movement.

William Martin. *With God on Our Side: The Rise of the Religious Right in America.* New York: Random House, 1996. A good overview of the institutional basis for the New Right from World War II to the 1990s.

Sam Robert. *Who We Are Now: The Changing Face of America in the Twenty-First Century.* New York: Times Books/ Henry Holt & Company, 2004. Based on the 2000 census, Robert explores the changes in the United States between 1990 and 2000, including population growth, ethnicity and immigration, and family structure.

GLOSSARY

A Vindication of the Rights of Woman Treatise by Mary Wollstonecraft published in 1792 in England arguing for the intellectual equality and rights of women.

age of consent Phrase referring the minimum age at which a person is considered capable of giving informed consent to any contract or behavior, with particular reference to sexual acts.

Aid to Dependent Children (ADC) A program that gave grants to states to use for the support of dependent children.

All American Girls Baseball League (AAGBL) Women's professional baseball league that began as a response to the lack of young male athletes who had joined the armed services.

American and Foreign Anti-Slavery Society Organization created in 1840 to oppose slavery through political channels but to ignore other issues such as the right of women to lead the reform movement.

American Anti-Slavery Society Organization founded by William Lloyd Garrison in 1833 committed to an immediate end to slavery.

American Birth Control League Founded in 1921 to provide services to women in need; later became Planned Parenthood.

American Woman Suffrage Association (AWSA) Formed in 1869 in Cleveland and led by Lucy Stone and Henry Blackwell to work for woman suffrage at all levels.

antebellum period Period in U.S. history extending roughly from 1830 to 1860.

antimiscegenation laws State legislation enacted to prevent interracial marriage.

Articles of Confederation Document adopted by Second Continental Congress in 1777 to create first government of the United States as a loose confederation of states.

Association for the Advancement of Women (AAW) Formed in October 1873 to promote the formation of women's clubs and to showcase women's accomplishments.

Association of Southern Women to Prevent Lynching (ASWPL) Founded by Jessie Daniel Ames in 1930 to mobilize white southern women to oppose lynching.

baby boom The cohort of babies born in the United States between 1946 and 1964.

Baltimore and Ohio Railroad First railroad built in the United States, opening in 1830.

Beats A group of mostly male writers and poets centered in Greenwich, who rebelled against 1950s social and sexual conventions.

Beecher–Tilton scandal The furor created by the revelation of the Rev. Henry Ward Beecher's affair with Elizabeth Tilton, one of his parishioners.

belles Wealthy young southern women of marriageable age presented to society in a series of balls.

Big House African American description of the house on the plantation where the master lived.

Black Codes Legislation enacted by former Confederate states, 1865–1866, to define the rights and limits of freedom of former slaves.

Black Death Bubonic plague that swept Europe beginning in the 1340s and continuing particularly through the seventeenth century.

Black Power movement A younger and more militant phase of the civil rights movement that highlighted the importance of black masculinity.

bond marriage Legal agreement to marry that was used as a substitute for marriage in the early days of settlement in Texas.

Boston marriage A term popular in the late nineteenth century that referred to women who set up housekeeping together and lived in a marriage-like relationship.

Brown v. Board of Education of Topeka The 1954 Supreme Court case overturning the "separate but equal" doctrine established in *Plessy v. Ferguson.*

Californios/Californias Men and women of Spanish descent in California.

camp meetings Religious revival meetings held in open fields, usually during the summer.

casta Person of mixed heritage.

charity girls A reference used in the early twentieth century for young women who traded sexual favors for treats and amusements.

Child Support Enforcement Amendments Act This act strengthened child support agencies' abilities to get money from the nonresidential parent of children on Aid to Families with Dependent Children (AFDC) for medical expenses and cost of living.

children's crusade Plan to send the children of the textile strikers to temporary homes outside Lawrence.

Christian Coalition A group formed by Roman Catholic and Evangelical Protestants to influence Republican Party politics.

Civilian Conservation Corps (CCC) Program was designed to tackle the problem of unemployed young men from ages 18 to 25.

coartacion Ability of a slave to purchase his or her freedom under Spanish law.

Cold War The foreign policy of containment directed at Communist Soviet Union and includes the alignments between foreign policy abroad and the expression of anti-Communism throughout U.S. culture.

Commission on Interracial Cooperation (CIC) Established in Atlanta in 1921 the Commission worked with white and black leaders to bring an end to lynching and improve the conditions of poor African Americans.

Comstock Act of 1873 The 1873 law that forbade the use of the U.S. Postal Service to mail "obscene" materials, which included contraceptive information and devices.

communitarian Referring to experimental collective communities meant to demonstrate how societies could be constructed around shared property and social responsibilities rather than around individual property.

companionate marriage A new style of marriage that emphasized companionship and compatibility between spouses, as well as sex education, birth control, and easier access to divorce.

complementarity Idea that men and women have different characteristics that complement one another.

complex marriage Form of marriage promoted in the Oneida community in which every man and every woman in the community were considered married to one another.

Compromise of 1850 Congressional act allowing New Mexico and Utah to decide if they will be free or slave but also allowing California to be admitted to the Union as a free state.

Comstock Act The 1873 law that forbade the use of the U.S. Postal Service to mail "obscene" materials, which included contraceptive information and devices.

Confederate States of America The union of the eleven southern states that seceded to preserve slavery and protect states rights.

Congress of Industrial Organizations (CIO) The labor union formed in 1935 by John L. Lewis as the result of a dispute with the American Federation of Labor.

consciousness raising A popular practice of groups of women sharing intimate details of their lives to study them for the effects of sexism and gender oppression.

consumption The purchasing of consumer goods.

contrabands of war Term for escaped slaves who sought refuge behind Union lines during the Civil War.

Council of National Defense Created by the U.S. Congress during World War I to manage the domestic aspects of the nation's war effort.

counterculture The youth culture of the mid-1960s that grew out of the student protest movements, with a focus on lifestyle liberation.

coureurs de bois French trappers.

coverture Legal status of a woman on marriage under common law, in which her legal identity is merged with that of her husband.

crillo Person of Spanish heritage born in a colony.

cross-class alliance A concept referring to the joint projects of middle- and upper-class women and working-class women based on the assumption of "sisterhood."

Cullom Bill Introduced into Congress in 1870 to strengthen the provisions of the Morrill Anti-Bigamy Act, which had been largely ignored during the Civil War.

culture wars A set of clashes between conservative and liberal Americans over issues pertaining to private life.

Daughters of Bilitis A political group formed by lesbians to promote greater tolerance of homosexuality.

Daughters of Liberty Women who organized to support the Patriot cause.

Daughters of St. Crispin Formed in 1869 as the woman's branch of the all-male Knights of St. Crispin, which supported the principle of equal pay for equal work.

Dawes Severalty Act Also called the Indian Allotment Act, this 1887 legislation divided reservation land in an effort to assimilate tribal members into the general American population as "responsible farmers."

de facto segregation Racial segregation based on social practice, not enforced by law.

de jure segregation Racial segregation based on law.

Declaration of Independence Written by the Second Continental Congress in 1776 rejecting the King of England as the leader of the British colonies and asserting the right of men to form their own government.

Declaration of Sentiments Statement produced at the Seneca Falls convention in 1848 listing injustices faced by women and rights they deserved.

Democratic Party Political party that formed around Andrew Jackson in the 1820s, supporting his policies of limited federal government.

deputy husband Position assumed by a woman who took on the responsibilities of her husband while he was gone.

"do-everything" policy This policy provided an umbrella for the promotion of a multitude of programs beyond temperance.

domestic feminism Coined by historian Daniel Scott Smith, refers to the increasing power of married women to control reproduction.

double V campaign Winning the fight against racial segregation, or Jim Crow, and against fascism.

Dred Scott decision Decision by the Supreme Court that Dred Scott could not sue for his freedom even though he lived in a free state because slaves were not citizens.

Eagle Forum A pro-family organization founded by Phyllis Schlafly in 1972.

Edmunds-Tucker Act Legislation disincorporating the Mormon church and disenfranchising supporters of polygamy, including women.

elect People chosen by God to be saved.

Ellis Island Located in the New York Harbor, the main port of entry for immigrants in the late nineteenth and early twentieth centuries.

empressarios Agents who brought parties of immigrant settlers from the United States to Texas.

Enlightenment Intellectual movement stressing human reason and the ability to achieve progress by applying reason to problems of science and society.

Equal Employment Opportunity Commission (EEOC) The federal agency charged with enforcing employment antidiscrimination laws.

Equal Opportunity Act This act legislated a broader jurisdiction for the EEOC and strengthened its ability to enforce its rulings.

Equal Pay Act of 1963 Federal legislation that prohibited pay differentials based on sex.

Equal Rights Amendment (ERA) A proposed constitutional amendment outlawing discrimination "on account of sex.

Erie Canal First canal built in the United States, connecting New York City with upstate New York.

Executive Order 8802 This order prohibited government contractors from engaging in employment discrimination based on race, color, or national origin.

Exodusters A term for the nearly fifteen thousand African Americans who moved to Kansas at the close of Reconstruction.

Fair Labor Standards Act of 1938 The federal law establishing minimum wages, standards for overtime work and pay, and restrictions on child labor.

Family and Medical Leave Act (FMLA) Passed in 1993, the act provided twelve weeks of unpaid family leave for workers.

family system of labor The practice of employing entire families, including young children, common in the production of textiles.

Family Violence Prevention and Services Act The 1984 act provided funds for shelters and family violence programs.

family wage The idea that a man should earn sufficient wages to provide the sole support of his family.

family-wage economy Term for the situation in which all members of a family must earn wages and share them for the family to survive.

Farm Security Administration (FSA) Created to assist poor farmers during the dust bowl and the Great Depression.

Farmers' Alliance Organized in the 1880s as the political wing of the Granger movement and became the backbone of Populism by the end of the decade.

Federal Emergency Relief Administration (FERA) Passed in 1933, the agency gave direct aid to the states, which funneled funds through such local agencies as home relief bureaus and departments of welfare for poor relief.

Federalists Political faction that supported the Constitution and a strong central government.

feme covert Status of married woman under common law in which her legal identity is merged with that of her husband.

feme sole Status of a single woman under common law in which her legal identity is independent of a man.

feminism A term introduced into the United States around 1910 to augment the demands for voting rights and economic equality with a psychological dimension akin to "self-realization."

feminist art movement A movement in the 1970s to redefine women's art and women's place in the art world.

feminization of poverty The gradual and proportionate increase of women living in poverty in the 1970s.

fictive kin People with strong emotional ties similar to those of family members but not related to each other through marriage or birth.

Fifteenth Amendment Prohibits the denial of suffrage because of race, color, or previous condition of servitude and leaves out "sex."

Florence Crittenton Mission A refuge for prostitutes and safe haven for women without homes named for the recently deceased daughter of founder Charles Crittenton.

filibustering Private military adventures to take over foreign governments with whom the United States is not at war.

Fourierists Followers of Charles Fourier who participated in his communitarian experiment in France and the United States.

Fourteenth Amendment Confers national citizenship on all persons born or naturalized in the United States and introduces the word *male* into the Constitution.

Free Soil Party Political party created in the 1840s around a belief that slavery should not be allowed in the territories acquired by the United States.

Freedmen's Bureau Established by Congress in March 1865 to provide assistance to Civil War refugees; the federal agency that coordinated relief efforts for former slaves and established schools for black children.

French and Indian War Also known as the Seven Years' War in Europe, it was fought between France and England from 1754 to 1763 in both Europe and North America.

gang system System for organizing slave labor that groups slaves together to work on successive tasks.

genizaros and genizaras Male and female Indian captives held as slaves in New Mexico.

GI Bill or the Servicemen's Readjustment Act of 1944 Provided college or vocational education, one year of unemployment compensation, and loans for returning veterans.

glass ceiling A term that refers to situations in which the advancement of a qualified person stops at a particular level because of some form of discrimination, most commonly sexism or racism.

Grange The popular term for the Patrons of Husbandry, an organization of family farmers that formed in 1867.

Great Awakening Series of religious revivals that swept the colonies in the middle of the eighteenth century.

Great Migration Movement of Puritans from England to New England between the 1620s and 1650s as a result of religious persecution.

Great Migration The migration of thousands of African Americans from the rural South to the urban North, which was especially pronounced during World War I when job opportunities opened up.

Henry Street Settlement Founded in New York City in 1893 by Lillian Wald to provide social and health services to mainly immigrant families.

Heterodoxy A club of "unorthodox women" formed by Marie Jenny Howe in 1912 that included the cream of New York's literary, artistic, and political activists.

heterosociality When women and men socialize together, as opposed to single-sex or homosocial settings.

Hollywood Production Code "Morality" codes imposed on Hollywood films in between 1930 and 1960.

home economics Originated in the 1880s as an academic discipline devoted to the care of home and family.

home protection The slogan promoted by WCTU president Frances E. Willard to secure the organization's endorsement of woman suffrage.

Homestead Act of 1862 Legislation allowing a household head, male or female, to obtain land in the public domain to establish a family farm.

Hull House One of the first settlement houses in the United States, founded in Chicago in 1889 by Jane Addams and Ellen Gates Starr.

Hyde Amendment A 1976 law that reframed the government's responsibility to offer abortion services and restricted abortion from the health care provided by Medicaid.

illegal abortions Illegal abortions, done in unsanitary and often dangerous nonmedical settings.

Illinois Factory Inspection Act Passed in 1893, this landmark act specified conditions of labor in sweatshops in the state of Illinois; it was declared unconstitutional the following year.

Illinois Woman's Alliance Formed in 1888 to assist working women and their children.

indentured servant Person bound to work for a master for four to seven years as payment for transportation to the New World.

Indian Country Land in British territory west of the Proclamation Line of 1763 reserved for Indians.

Indian Removal Act Act passed by both houses of Congress in 1830 allowing the president to negotiate treaties that would exchange Indian lands east of the Mississippi River for new territory west of the Mississippi.

Indian Territory Unorganized territory west of the Mississippi River where Indians were forced to relocate in the 1830s.

Industrial Revolution Transformation from craft-based system to mass production of goods.

Industrial Workers of the World Founded in Chicago in 1905, represented the radical wing of the labor movement and organized workers into "one big union" without regard to skill.

inner light Quaker belief that Jesus is a guiding light within each person.

International Council of Women Formed in 1888 as a counterpart to the National Council of Women with delegates representing women activists from nine nations.

International Council of Women of the Darker Races of the World Founded by African American Mary Talbert in 1922 to promote Pan-African activism.

International Ladies' Garment Workers' Union Founded in Chicago in 1905, the "Wobblies" represented the radical wing of the labor movement and organized workers into "one big union" without regard to skill.

Jane Club The Chicago cooperative housekeeping arrangement for a group of working women who wished to avoid boardinghouses.

Jeffersonian Republicans Political faction that opposed the Federalists and favored limited government and an agrarian republic.

jezebel White southern stereotype of young slave woman who was thought to seek out sexual relationships with white men.

juvenile court system Special courts established to handle children under the age of 18 who commit acts that would be crimes if committed by adults as well as children who run away from home or engage in behaviors dangerous to themselves or others.

Kansas-Nebraska Act Act that repealed the Missouri Compromise by allowing the residents of Kansas and Nebraska to choose whether to be slave or free.

la familia Spanish expression denoting the enduring bonds of affection and duty extending from biological kin to close friends.

Ladies' Federal Labor Union Chicago union of women working in several trades that did much of the campaigning for the passage of the Illinois Factory Inspection Act of 1893.

Ladies Industrial Aid Association of Union Hall Organized to provide aid to soldiers and their families in the Boston area only.

Liberty Party Political party created in 1840 around opposition to slavery in the United States.

libre Freed slaves and free persons of color in Louisiana Territory, particularly New Orleans.

Loyalists Colonists who sided with Britain during the American Revolution.

lyceums Lecture series or other forms of popular education.

mammy Stereotype of southern female slave who identified with the interests of her white charges and exercised great authority in their lives.

Mann Act Also known as the White-Slave Traffic Act of 1910, banned the interstate transport of women for "immoral purposes."

Manifest Destiny Belief that the borders of the United States were destined to spread westward.

manumission Granting of freedom to a slave.

Mariolatry Worship of the Virgin Mary as religious practice within the Roman Catholic Church.

maternalism A term used by historians to describe the emphasis of Progressive Era reformers on the health and welfare of women and children.

matrilineal Tracing inheritance and descent through the female line.

matrilocal Living with the wife's family.

medium A person who facilitates communication between the living and the dead.

mestizo Person of mixed Spanish and Indian heritage.

metis Mixture of French and Indian cultures.

Middle Passage Also known as the Atlantic Slave Trade, triangular trade route where millions of Africans were shipped to the New World.

Minor v. Happersett U.S. Supreme Court ruling in 1784 that allowed states to restrict the right to vote to male citizens.

miscegenation A term introduced into the United States in 1863, refers to an alleged mixing of "races" through sexual relations and provided the basis for laws prohibiting interracial marriage and cohabitation.

Missouri Compromise Agreement admitting Maine as a free state and Missouri as a slave state and stipulating that slavery not exist north of the 36°30′ parallel in the states created out of the Louisiana Territory.

modern welfare state Federal and state programs that offer working populations protections against unemployment, sickness, old-age insecurity, and the loss of a family breadwinner. FDR hoped the New Deal would create cradle-to-grave security against "the hazards and vicissitudes of life."

monogamous Marriage to one spouse.

Morrill Anti-Bigamy Act Passed by Congress in 1862, this legislation made plural marriage a federal crime.

Muller v. Oregon The landmark U.S. Supreme Court ruling that upheld Oregon state law restricting the hours a woman may work on the grounds that the state has an interest in protecting a woman's health.

municipal housekeeping A phrase popular during the Progressive Era to connote the extension of women's domestic skills to urban affairs.

National American Woman Suffrage Association Formed in 1890 to promote the ballot for women.

National Birth Control League Founded in 1916 to advocate changes in legislation that restricted the dissemination of birth control information and devices.

National Congress of Mothers Founded in 1897, the organization promoted education for childrearing and infant health; later became the Parent Teachers Association.

National Council of Negro Women (NCNW) Founded to bring together many different national and local organizations serving or representing African American women.

National Council of Women Formed in 1888 in commemoration of the fortieth anniversary of the woman's rights meeting at Seneca Falls, New York, as a representative body of women's reform organizations.

National Labor Union A federation of trade assemblies formed in 1866 that supported woman's right to labor.

National League for the Protection of Colored Women Formed in 1906 as a federation of organizations established to assist young African American women migrating to northern cities.

National Organization for Women (NOW) The feminist organization founded in 1966 to promote women's equality.

National Recovery Administration (NRA) The government agency established to coordinate businesses who voluntarily drew up "codes of fair competition" to enhance economic recovery. These codes were intended to help workers by setting minimum wages and maximum hours, and help consumers by setting fair prices.

National Urban League A nonpartisan civil rights organization formed to give support to newly arrived migrants from the South to northern cities.

National Woman Suffrage Association (NWSA) Formed in 1869 in New York City and led by Elizabeth Cady Stanton and Susan B. Anthony to advance a strategy to introduce a federal amendment to grant women the right to vote.

National Woman's Alliance A short-lived organization led by Populist women and their allies in the temperance and suffrage movements.

National Woman's Party Succeeded the Congressional Union as the militant wing of the woman suffrage movement and focused on amending the Constitution.

National Women's Political Caucus Founded as a bipartisan organization whose goal was to increase the number of women in politics.

National Women's Trade Union League Founded in Boston in 1903 to "assist in the organization of women wage workers into trade unions."

National Youth Administration A program to devise useful work for young people who were on relief in 1935.

nativist A person who supports the interest of native inhabitants against those of immigrants.

Neighborhood Union A social settlement founded in Atlanta in 1908 by Lugenia Burns Hope in response to the impoverished conditions of African Americans.

neophytes Indian converts in California missions.

New Left A loosely connected network of campus groups that sought an immediate end to the Vietnam War and broad and wide-reaching reforms of U.S. society.

New Lights People converted to evangelical religious beliefs in the Great Awakening.

Nineteenth Amendment The so-called Susan B. Anthony Amendment, which granted women the right to vote, was endorsed by the Senate on June 4, 1919, and became law on August 26, 1920.

Office of War Information (OWI) Created in 1942 and served as an important U.S. government propaganda agency during World War II.

Old Lights People who supported the status quo in churches and opposed the religious changes promoted by New Lights.

open marriage Refers to an agreement that recognizes the right of husbands and wives to engage in extramarital sexual relationships without the stigma of infidelity.

Operation Wetback A 1954 federal program to close the border between Mexico and Texas, California, and Arizona.

Owenites Followers of Robert Owen who participated in his communitarian experiment in England and the United States.

Page Act of 1875 Enacted by the U.S. Congress to restrict immigration from Asian countries, especially women identified as prostitutes.

Pan-African movement An international movement to promote unity among people of African nations and of African descent.

Panic of 1837 Economic depression in 1837 tied to the widespread failure of banks and businesses in the United States.

patriarchal order Society in which the father is the head of the family and the rest of the society is based on this hierarchy.

Patriots Colonists who opposed Britain during the American Revolution.

pawn A person who is held as security for a debt.

Personal Responsibility and Work Opportunity Act Passed in 1996, the act ended welfare as an entitlement program.

phalanx A Fouierist community.

Phyllis Wheatley Home Named after the famous African American poet, homes that were established to assist African American working women searching for work and residences.

pink-collar job A type of employment traditionally held by women, especially relatively low-paying office work.

plaçage Relationship in which a white man legally agreed to support a libre woman as part of an ongoing sexual relationship.

plural marriage The Mormon custom of taking more than one wife to maximize the number of children.

polygamy Marriage to more than one spouse.

President's Commission on the Status of Women (PCSW) A committee established by President John F. Kennedy to advise him on pending legislative issues concerning women.

presidio Spanish military garrison.

Proclamation Line of 1763 Boundary line designating British territory west of the Appalachian Mountains as Indian land.

Progressive movement A broad coalition of reformers who advocated efficiency in government and various legislative measures to alleviate the social injustices that accompanied the second industrial revolution.

putting-out system Form of industrialization in which the owner of raw materials distributes the materials to workers who are paid by the piece to assemble them in their homes.

race suicide A phrase attributed to President Theodore Roosevelt heralding the demise of "civilization" caused by the dropping birth rate among Americans of Anglo-Saxon ancestry.

race women A term that denoted politically active African American women.

Reconstruction The period 1865–1877 that reintegrated the former Confederate states into the Union and established the terms of freedom for former slaves.

regent Person who rules when a king or monarch is too young or enfeebled to do so.

Retirement Equity Act Attempted to meet the needs of women in the work force and those women married to, or divorced from, working men by providing more benefits for surviving spouses, lowering the age for participation to 55, and granting the divorce spouse rights to retirement pension if stipulated in the separation papers.

revival An intense religious awakening taking place in a series of evangelical services meant to promote conversion.

Roe v. Wade The 1973 Supreme Court case that established women's right to have an abortion.

Scottish Enlightenment Intellectual movement centered in Scotland that assumed inequalities and hierarchies were natural and necessary in society.

Second Continental Congress Representatives of the thirteen colonies in rebellion against England, meeting as a government body from 1775 to 1781 to direct the Patriot cause.

Second Great Awakening Series of religious revivals throughout the United States that spanned the first half of the nineteenth century.

second industrial revolution The major advances in the technical aspects of industrial production, including consumer goods, that occurred in the last half of the nineteenth century.

second shift The full-time and unpaid domestic work women did when they came home from work.

second-wave feminism The surge of feminist activism that took place in the late 1960s and early 1970s.

sectarian medicine Originated as an alternative to the harsh or "heroic" practices of mainstream or "allopathic" medicine and included such movements as homeopathy, hydrotherapy, and eclecticism.

separate spheres The idea that men and women operate in different worlds: women in the private world of the home and men in the public world of business and politics.

sex-segregated labor market The division of job classification along gender lines.

sexual inversion An early sexological term for same-sex desire.

sexual revolution The liberalization of U.S. attitudes toward sexuality that took place in the 1960s and 1970s.

shaman Spiritual leader, often with the power to heal.

social purity The ideal of a single standard of sexual morality for both men and women, advocating abstinence before marriage and restrained behavior after.

Social Security Act of 1935 A governmental program that created pensions for the elderly.

socialist In the antebellum period, a belief in collective sharing of wealth and work rather than a reliance on individual property holding as a basis of society and government.

Sojourner Truth Home for Working Girls Formed in 1895 for African American working women.

Sons of Liberty Organization of Patriots opposed to British taxes.

soral polygamy Marriage to two sisters by the same man.

Southern Christian Leadership Conference (SCLC) A principal organization of the civil rights movement that formed out of the Montgomery bus boycott of 1955–1956; led by Martin Luther King Jr.

sovereign Autonomous ruler or chief of state.

specie Coin rather than paper money.

speedup Increase in the speed of machinery in a factory to produce greater output.

Spiritualism A loosely organized movement around the belief that the living can communicate with the dead.

stretch-out Increase in the number of machines a factory worker tends in order to increase output.

Student Nonviolent Coordinating Committee (SNCC) A principal organization of the civil rights movement that formed in 1960 from student meetings led by Ella Baker.

Students for a Democratic Society (SDS) The main organization of the New Left.

"Susan B. Anthony" amendment Introduced in January 1886, the amendment specifies that the right to vote shall not be "denied or abridged" on account of sex.

sweatshop A workshop is supervised by a middleman, the sweater, whose employees produce mainly clothing under harsh conditions.

task system System for organizing slave labor that delegates to an individual slave entire responsibility for production of a crop, such as rice, on a particular plot of land.

Tejanos/Tejanas Men and women of Spanish heritage who settled in Texas.

International Ladies Garment Workers Union (ILGWU) Formed in 1900 by the amalgamation of seven local unions.

the Negro's hour Phrase used to describe the subordination of woman's rights to the campaign to advance the political rights of African American men.

the personal is political One of the founding principles of second-wave feminism; the phrase captured feminists' attention to the psychological, sexual, and privately experienced aspects of women's oppression.

Title IX of the Education Amendments of 1972 Passed on June 23, 1972, the law forbid sex discrimination in any educational program or activity funded by the federal government, including athletics.

tobacco brides Young women brought to Virginia in the 1620s who promised to marry men who would pay for their passage.

Trail of Tears Westward journey of sixteen thousand Cherokee Indians from Georgia to Oklahoma in 1838.

trash gang Gang of slaves composed of pregnant and older women as well as children, delegated to do lighter field tasks such as weeding and collecting trash.

Treaty of Paris Treaty that ended the French and Indian War between France and England.

truancy Process of a slave absenting himself or herself from a plantation for days or months as a form of protest.

U.S. Children's Bureau Created in 1912 within the federal government to investigate and report *"upon all matters pertaining to the welfare of children and child life among all classes of our people."*

United Cannery, Agricultural, Packing, and Allied Workers of America A labor union that made the greatest inroads with Mexican cannery workers and African American tobacco workers, many of whom were women.

United Electrical, Radio and Machine Workers of America One of the first unions to affiliate with the Congress of Industrial Organization in 1936.

United Packinghouse Workers of America A union that was committed to organize all workers in the meatpacking industry, regardless of skill or trade.

United States Constitution Document adopted by Constitutional Convention in 1787 to replace Articles of Confederation and to provide for a stronger centralized government of the United States.

Uprising of 30,000 Popular name for the strike of the shirtwaist makers who shut down the New York garment industry for several months beginning in November 1909.

War Advertising Council Charged with the task of selling wartime government programs and war bonds to the American public.

war bonds Issued by the government and purchased by civilians, war bonds functioned as a loan to the government to help finance the war effort.

War Brides Act The 1945 act that allowed Chinese American veterans to bring brides into the United States.

War Manpower Commission The federal agency charged with balancing the labor needs of agriculture, industry, and the armed forces.

War of 1812 War between the United States and England over trade restrictions, fought between 1812 and 1815.

welfare state Reference to a system of government in which the state assumes primary responsibility for the *welfare* of its *citizens* and accords them services as a matter of entitlement.

Whig Party Political party formed in opposition to the Democrats supporting an active role for the federal government in economic development.

White Rose Home and Industrial Association Formed in 1897 to assist African American women coming to New York in search of work.

white slavery panic A moral panic based on the assumption that thousands of young women were being lured into prostitution and held against their will.

winning plan Formally adopted by the NAWSA in 1916, this strategy introduced targeted key state woman suffrage referenda and simultaneously supported an amendment to the Constitution.

Woman's Central Relief Association Served as the foundation for the United States Sanitary Commission.

Woman's Christian Temperance Union (WCTU) Founded in November 1874 to curtail the use of alcohol and became the largest organization of women in the nineteenth century.

Woman's Convention Organized by women to carry out their social service within the black Baptist church.

woman's crusade The grassroots component of the temperance campaign that erupted in 1873–1874 that brought thousands of women into activism.

Woman's Peace Party Founded in Chicago in 1915 and chaired by Jane Addams, the WPP formed to protest World War I.

Woman's Work for Woman A phrase representing the agenda of the Woman's Foreign Missionary Society.

women adrift Common reference to women who set up households outside marriage or family.

Women of the Ku Klux Klan (WKKK) The women's auxiliary of the racist and nativist Ku Klux Klan.

Women Strike for Peace (WSP) A group formed in the 1950s to protest nuclear weapons.

Women's Convention of the Black Baptist Church The locus of the women's movement within the Black Baptist church.

Women's Division of the Democratic National Committee The group within the National Democratic Party that organized and coordinated women's volunteer efforts for Democratic candidates.

Women's Educational and Industrial Union Founded in 1877 to help women support themselves by offering social services and practical vocational training.

Women's Health Movement (WHM) A movement in the 1970s to bring women greater knowledge of and control over their own health.

women's health protective associations Local groups that sponsored public health initiatives and raised money for building and maintaining hospitals.

Women's International League for Peace and Freedom Formed in 1919, WILPF succeeded the Woman's Peace Party in advocating the end of militarism and world peace.

women's liberation movement The burst of radical feminist groups that formed in the mid- to late 1960s that pioneered an analysis of sexuality and private life.

Women's National Indian Association Founded in 1879 to promote assimilationist policies among Native American women.

Working Women's Protective Union Organized in New York to assist wage-earning women during the Civil War.

Works Progress Administration (WPA) A massive federal relief program launched that created paying jobs for unemployed.

Wounded Knee Massacre The attack by the U.S. 7th Calvary on December 29, 1890 that resulted in the deaths of nearly 190 Indians, the majority of whom were women and children.

yeoman farmer Independent farmer who owns a small plot of land that he works himself.

INDEX